Here I Stand

Luther Exhibitions USA 2016

Martin Luther: Art and the Reformation
Minneapolis Institute of Art
October 30, 2016 – January 15, 2017

Word and Image: Martin Luther's Reformation
The Morgan Library & Museum, New York
October 7, 2016 – January 22, 2017

Law and Grace: Martin Luther, Lucas Cranach, and the Promise of Salvation
Pitts Theology Library, Emory University, Atlanta
October 11, 2016 – January 16, 2017

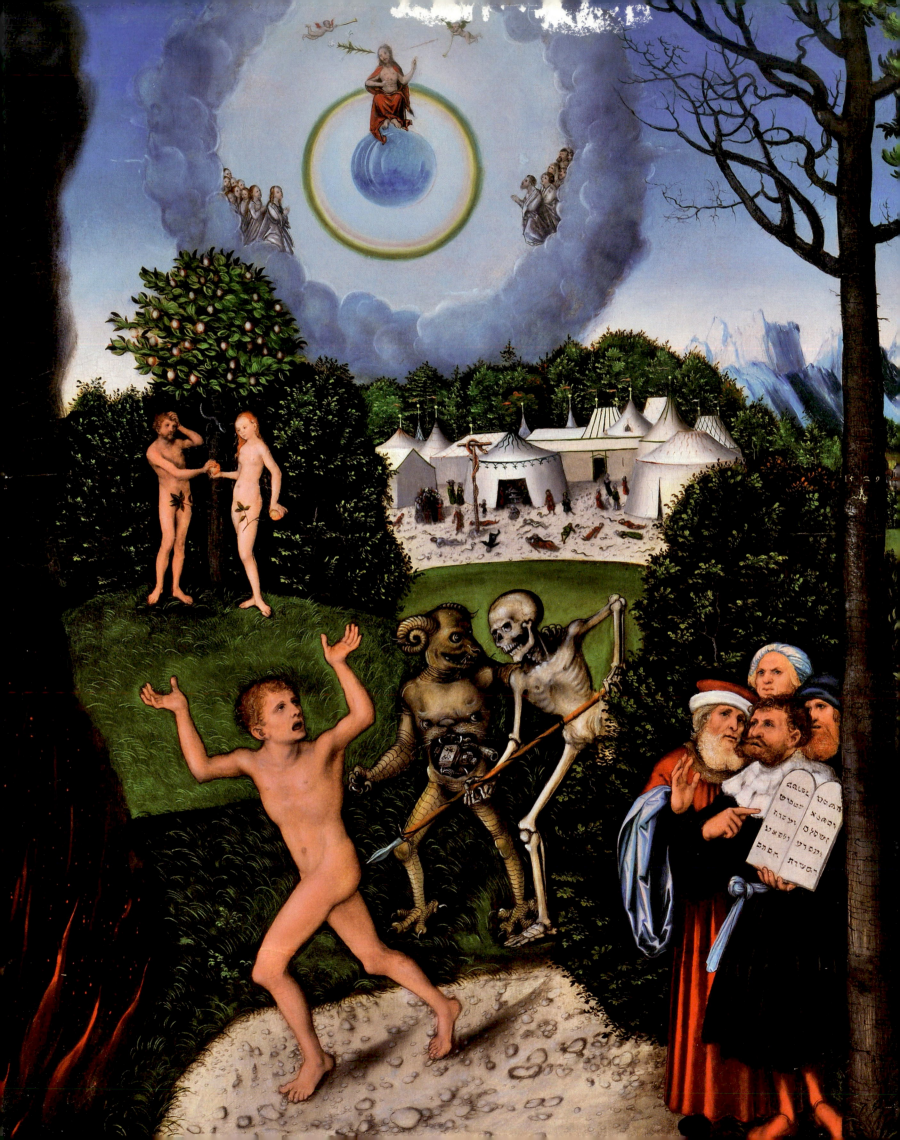

State Office for Heritage Management
and Archaeology Saxony-Anhalt –
State Museum of Prehistory
Luther Memorials Foundation of Saxony-Anhalt
Stiftung Deutsches Historisches Museum
Foundation Schloss Friedenstein Gotha
Minneapolis Institute of Art
The Morgan Library & Museum

Martin

TREASURES OF THE REFORMATION

Luther

Sandstein Verlag, Dresden

**We wish to thank
our supporters and sponsors**

The patron of the exhibition project
"Here I Stand" is the German Federal
Minister for Foreign Affairs,
Dr. Frank-Walter Steinmeier.
The realization of the project has been
made possible due to the support of the
Foreign Office of the Federal Republic
of Germany within the framework
of the Luther Decade

 Federal Foreign Office

**The exhibition project
has been supported by**

SACHSEN-ANHALT

Freistaat Thüringen Staatskanzlei

SACHSEN-ANHALT
Investitions- und
Marketinggesellschaft

Verein zur Förderung
des Landesmuseums für
Vorgeschichte Halle (Saale) e.V.

**The restoration of the Gotha Altar
has been enabled by**

Freistaat Thüringen Staatskanzlei

EvS
ERNST VON SIEMENS
KUNSTSTIFTUNG

 Federal Foreign Office

RAO
RUDOLF-AUGUST OETKER-
STIFTUNG

KULTUR
STIFTUNG · DER
LÄNDER

KUNST
AUF LAGER
BÜNDNIS ZUR ERSCHLIESSUNG
UND SICHERUNG VON MUSEUMSDEPOTS

The restoration of the Luther Pulpit from St. Andrew's Church in Eisleben has been enabled by

Minneapolis Institute of Art

The exhibition **"Martin Luther: Art and the Reformation"** at the Minneapolis Institute of Art is presented by

Lead Sponsors:

John and Nancy Lindahl

The Hognander Foundation

K.A.H.R. Foundation

The Bradbury and Janet Anderson Family Foundation

Jim and Carmen Campbell

Major Sponsors:

The exhibition **"Word and Image: Martin Luther's Reformation"** at The Morgan Library & Museum, New York

was also generously supported by

the **Johansson Family Foundation**

and **Kurt F. Viermetz, Munich**

with assistance by

the **Arnhold Foundation** and

the **Foreign Office** of the Federal Republic of Germany.

The exhibition **"Law and Grace: Martin Luther, Lucas Cranach and the Promise of Salvation"** at the Pitts Theology Library of Candler School of Theology at Emory University, Atlanta

has been supported by:

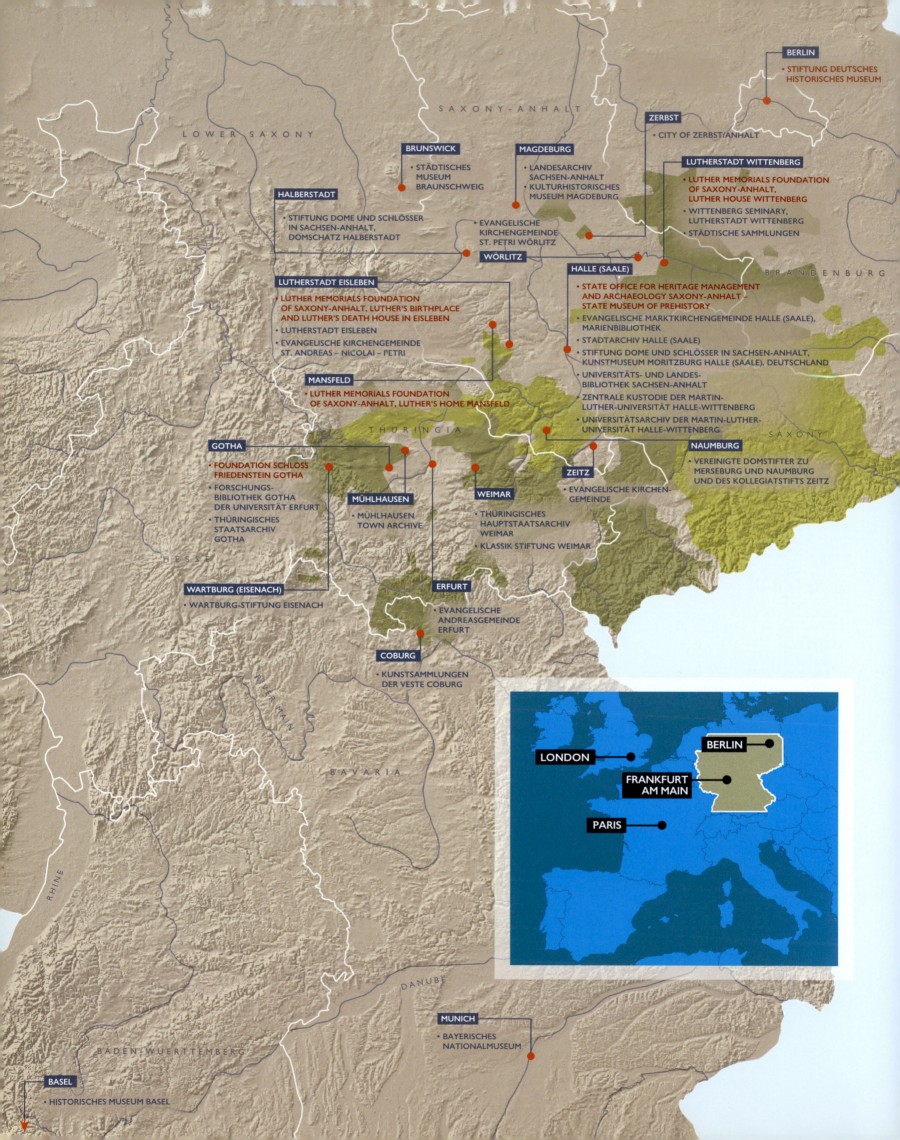

BERLIN
- STIFTUNG DEUTSCHES HISTORISCHES MUSEUM

ZERBST
- CITY OF ZERBST/ANHALT

BRUNSWICK
- STÄDTISCHES MUSEUM BRAUNSCHWEIG

MAGDEBURG
- LANDESARCHIV SACHSEN-ANHALT
- KULTURHISTORISCHES MUSEUM MAGDEBURG

LUTHERSTADT WITTENBERG
- LUTHER MEMORIALS FOUNDATION OF SAXONY-ANHALT, LUTHER HOUSE WITTENBERG
- WITTENBERG SEMINARY, LUTHERSTADT WITTENBERG
- STÄDTISCHE SAMMLUNGEN

HALBERSTADT
- STIFTUNG DOME UND SCHLÖSSER IN SACHSEN-ANHALT, DOMSCHATZ HALBERSTADT

WÖRLITZ
- EVANGELISCHE KIRCHENGEMEINDE ST. PETRI WÖRLITZ

HALLE (SAALE)
- STATE OFFICE FOR HERITAGE MANAGEMENT AND ARCHAEOLOGY SAXONY-ANHALT – STATE MUSEUM OF PREHISTORY
- EVANGELISCHE MARKTKIRCHENGEMEINDE HALLE (SAALE), MARIENBIBLIOTHEK
- STADTARCHIV HALLE (SAALE)
- STIFTUNG DOME UND SCHLÖSSER IN SACHSEN-ANHALT, KUNSTMUSEUM MORITZBURG HALLE (SAALE), DEUTSCHLAND
- UNIVERSITÄTS- UND LANDES-BIBLIOTHEK SACHSEN-ANHALT
- ZENTRALE KUSTODIE DER MARTIN-LUTHER-UNIVERSITÄT HALLE-WITTENBERG
- UNIVERSITÄTSARCHIV DER MARTIN-LUTHER-UNIVERSITÄT HALLE-WITTENBERG

LUTHERSTADT EISLEBEN
- LUTHER MEMORIALS FOUNDATION OF SAXONY-ANHALT, LUTHER'S BIRTHPLACE AND LUTHER'S DEATH HOUSE IN EISLEBEN
- LUTHERSTADT EISLEBEN
- EVANGELISCHE KIRCHENGEMEINDE ST. ANDREAS – NICOLAI – PETRI

MANSFELD
- LUTHER MEMORIALS FOUNDATION OF SAXONY-ANHALT, LUTHER'S HOME MANSFELD

NAUMBURG
- VEREINIGTE DOMSTIFTER ZU MERSEBURG UND NAUMBURG UND DES KOLLEGIATSTIFTS ZEITZ

GOTHA
- FOUNDATION SCHLOSS FRIEDENSTEIN GOTHA
- FORSCHUNGS-BIBLIOTHEK GOTHA DER UNIVERSITÄT ERFURT
- THÜRINGISCHES STAATSARCHIV GOTHA

ZEITZ
- EVANGELISCHE KIRCHEN-GEMEINDE

MÜHLHAUSEN
- MÜHLHAUSEN TOWN ARCHIVE

WEIMAR
- THÜRINGISCHES HAUPTSTAATSARCHIV WEIMAR
- KLASSIK STIFTUNG WEIMAR

WARTBURG (EISENACH)
- WARTBURG-STIFTUNG EISENACH

ERFURT
- EVANGELISCHE ANDREASGEMEINDE ERFURT

COBURG
- KUNSTSAMMLUNGEN DER VESTE COBURG

MUNICH
- BAYERISCHES NATIONALMUSEUM

BASEL
- HISTORISCHES MUSEUM BASEL

LONDON

BERLIN

FRANKFURT AM MAIN

PARIS

Lenders

Germany

Stiftung Deutsches Historisches Museum, Berlin

Stadt Braunschweig, Städtisches Museum Braunschweig

Kunstsammlungen der Veste Coburg

Wartburg-Stiftung Eisenach

Evangelische Andreasgemeinde Erfurt

Forschungsbibliothek Gotha
der Universität Erfurt

Foundation Schloss Friedenstein Gotha

Evangelische Marktkirchengemeinde
Halle (Saale), Marienbibliothek

State Office for Heritage Management
and Archaeology Saxony-Anhalt –
State Museum of Prehistory Halle (Saale)

Stadtarchiv Halle (Saale)

Universitäts- und Landesbibliothek
Sachsen-Anhalt, Halle (Saale)

Zentrale Kustodie der
Martin-Luther-Universität Halle-Wittenberg

Universitätsarchiv der
Martin-Luther-Universität Halle-Wittenberg

Evangelische Kirchengemeinde St. Andreas-
Nicolai-Petri, Lutherstadt Eisleben

Lutherstadt Eisleben

Luther Memorials Foundation
of Saxony-Anhalt

Wittenberg Seminary,
Lutherstadt Wittenberg

Städtische Sammlungen,
Lutherstadt Wittenberg

Kulturhistorisches Museum Magdeburg

Landesarchiv Sachsen-Anhalt

Mühlhausen Town Archive

Bayerisches Nationalmuseum, München

Stiftung Dome und Schlösser in
Sachsen-Anhalt, Domschatz Halberstadt

Stiftung Dome und Schlösser in Sachsen-
Anhalt, Kunstmuseum Moritzburg Halle (Saale)

Thüringisches Hauptstaatsarchiv Weimar

Thüringisches Staatsarchiv Gotha

Vereinigte Domstifter zu Merseburg und
Naumburg und des Kollegiatstifts Zeitz

Klassik Stiftung Weimar

Evangelische Kirchengemeinde
St. Petri Wörlitz der Evangelischen Landes-
kirche Anhalts in Deutschland

Evangelische Kirchengemeinde Zeitz

City of Zerbst/Anhalt

Switzerland

HMB – Historisches Museum Basel

United States of America

Thrivent Financial Collection of Religious Art,
Minneapolis

The Metropolitan Museum of Art, New York

Luther Seminary Library, St. Paul

Scheide Library, Princeton University Library

◀ **Map of the European lenders**
In red: the initiators of the
exhibition project "Here I Stand"

Content

Greeting

While returning from the Diet of Worms, where he had refused to recant—according to the legend by declaring "Here I stand; I can do no other"—Martin Luther wrote a letter to Charles V, Holy Roman Emperor. The letter was never delivered, but its contents became public knowledge via a transcript. Hundreds of years later, the financier Pierpont Morgan successfully bid for this document at an auction as a gift for Wilhelm II, Emperor of Germany, who gave it to the Luther House in Wittenberg to be exhibited. Now this letter is returning to the descendants of its erstwhile owner for the first time and is being shown in the exhibition "Word and Image: Martin Luther's Reformation" in New York.

Such objects, and other exhibits and stories, form the heart of this exhibition.

By criticizing the Roman Catholic Church, the sale of indulgences, and the lavish lifestyle of the Pope, Martin Luther challenged both clerical and secular power. Today, 500 years later, we remember this courageous man who lived on the cusp of the modern era and played such an important role in the development of a modern society. We owe the crucial impetus for how we understand freedom, education, and social coexistence today to Luther and other reformers. This includes the right to be wrong—also as regards Luther himself. Some of his statements on the Jews, peasants, or women cannot serve as examples to us. We now distance ourselves in particular from Luther's anti-Semitic views, which were exploited under National Socialism to foster anti-Semitism by the state.

The Reformation was certainly not limited to Germany or started by Martin Luther alone. It was a pan-European event. The movement triggered by the reformers, with Martin Luther leading the way, did not only have a lasting impact on societies in Germany and Europe—we also associate the Enlightenment and the notion of freedom with the United States in particular. In a world that appears to be out of joint as a result of crises and conflicts, it is worth our while to take a closer look at the questions on religion, order, faith, and peace inherent in the Reformation.

As patron of the exhibitions, "Here I Stand", I am pleased that it has proved possible to hold different versions of the show at the same time in Minneapolis, New York and Atlanta. The history of the foundation of the United States and the way the country defines itself are based on Reformation ideas. These include the separation of Church and state, religious tolerance, freedom of religion, and the Mayflower Compact by the Pilgrim Fathers (and Mothers)—the first democratic set of rules on American soil.

It is thus most worthwhile to explore Martin Luther's life, work, and impact, along with part of the sixteenth century world. All of the exhibits in "Here I Stand" could have been held by Martin Luther himself. The exhibitions present an impressive selection of objects, ranging from archaeological finds, manuscripts, and printed materials to large works of art, superb paintings by Cranach, and medieval sculpture. Most of these objects have never been exhibited outside Germany, and it is unlikely that they will ever be displayed again in this way.

My hope is that all visitors—be they in Minneapolis, New York, or Atlanta—will leave these exhibitions with many interesting impressions and perhaps also feel inspired to trace Luther's footsteps and see the places where he lived and worked in Germany for themselves.

Frank-Walter Steinmeier

Federal Minister for Foreign Affairs

Foreword

In 2017, we commemorate the 500th anniversary of the publishing of Martin Luther's Ninety-Five Theses condemning the sale of indulgences. This momentous event is now generally considered to mark the start of the Reformation and the birth of a movement that has had a profound influence on the course of world history to this day. In Germany, the birthplace of the Reformation, many of the authentic sites of Luther's life and work have been preserved to welcome a constant flow of visitors from all over the world. In addition, Germany will host nationwide festivities in 2017, which include national special exhibitions in Lutherstadt Wittenberg, Berlin, and at Wartburg Castle, as well as numerous other exhibitions and events. These activities will not only commemorate the birth of the Reformation, but also take a deeper look at its subsequent and enduring history and worldwide influence.

The prospect of the upcoming anniversary clearly had demanded an exhibition project of extraordinary dimensions—and we are very happy that we were able to conceptualize, plan, and realize this vision with the support of the German Federal Foreign Office. The result of these ambitions is the project called "Here I Stand," which is set to commemorate the Reformation Anniversary from October 2016 to January 2017 in three separate locations in the USA—a nation that has been strongly shaped by Lutheran and Protestant traditions. This huge undertaking encompasses no less than three exhibitions on Martin Luther, his life, and his achievements. While these events are roughly simultaneous, they each aim at a different target audience and focus on a particular subject selection.

We count ourselves lucky indeed to work with institutions in this endeavor that were undoubtedly predestined to host exhibitions of this scope and particular subject: The Morgan Library & Museum is certainly one of the most renowned cultural institutions in New York. Its founder was Pierpont Morgan, the famous banker, art patron and passionate collector, who maintained a sincere attachment to Germany throughout his life. An obvious testimony to this relationship is the famous letter which Martin Luther wrote to Emperor Charles V on April 28, 1521 (cat. 174). Registered as part of the UNESCO world documentary heritage program "Memory of the World," it will be displayed in the USA for the very first time. The manuscript belongs to the collections of the Luther House in Wittenberg today, thanks to Pierpont Morgan himself, who acquired the letter at an auction for 102,000 German Marks (a tremendous sum for the time) and then gave it to the German Emperor Wilhelm II as a gift. The Minneapolis Institute of Art is not only one of the largest art museums of the USA, with extraordinary collections covering all the major eras of world history, but an institution of the highest international renown. In addition, it is favorably situated within a part of the

American Midwest whose population is deeply influenced by Western European, particularly German, roots and Lutheran traditions. And finally, the Pitts Theology Library of Emory University in Atlanta (Georgia) houses what is probably the most important collection on the history of the Reformation in the USA.

Even with their full cooperation, the enormous task of bringing the exhibitions to these eminent institutions would hardly have been feasible but for the assistance and generous financial backing of "Here I stand …" provided by the Foreign Office of the Federal Republic of Germany. For this unstinting support, we owe a particular debt of gratitude both to the Foreign Office and the Federal Minister for Foreign Affairs, Dr. Frank-Walter Steinmeier, who graciously agreed to become the patron of the project. We would also like to thank the many colleagues in our American partner institutions for the fruitful and close collaboration which has led to the extraordinary results which are documented in this volume. Of this dedicated host, we can only name the directors Dr. Kaywin Feldman (Minneapolis Institute of Art) and Dr. Colin B. Bailey (The Morgan Library & Museum). Side by side with their teams, they exhibited a maximum of commitment in the joint production of the exhibitions and in their share of the editorship of this volume. Prof. Dr. M. Patrick Graham, the director of the Pitts Theology Library and his colleagues backed the idea of a Luther-themed exhibition in Atlanta from the very beginning, and like their colleagues in Minneapolis and New York, they never wavered in their professional cooperation. The exhibition shown at the Pitts Theology Library, Atlanta, is able to display a number of particularly important original objects from Germany thanks to the generous support of the Halle Foundation, Atlanta. We would like to express our sincerest gratitude to the chairman of the board, Dr. Eike Jordan, and the administrator of the Halle Foundation, W. Marshall Sanders, for their backing.

The unique range of Luther-related subjects that is covered by the three exhibitions in the USA could not have been achieved without the support of the lending institutions that obligingly opened the doors of their treasure vaults for this unique occasion. This also enabled us to realize another important aim of the project: We hope to use the exhibitions as a platform for drawing international attention to the authentic sites and important cultural treasures preserved in the central German homeland of the Reformation. This heritage still awaits the worldwide recognition it surely deserves. Many colleagues in the lending institutions have contributed directly to the completion of this volume, and we are deeply indebted to them for their valuable support. Finally, we would like to offer our thanks to the many colleagues who toiled, both in the foreground and in the wings, to make the project become reality. Among these, we would

like to single out the project team behind "Here I stand …," ably led by Dr. Tomoko Elisabeth Emmerling and including Dr. Ingrid Dettmann, Susanne Kimmig-Völkner M. A., Robert Kluth M. A., Franziska Kuschel M. A. and Prof. Dr. Louis D. Nebelsick. Throughout the process, they took on their various responsibilities with supreme dedication and a great deal of personal commitment. As if organizing the exhibitions was not enough, they also invested considerable energy into the production of this publication, the essay volume, and the accompanying website www.here-i-stand.com, which provides a digital and downloadable exhibition, #HereIstand, to visitors. Particular mention must be made of the outstanding work of the editors of the accompanying publications, Dr. Katrin Herbst, Dr. Ralf Kluttig-Altmann, Robert Noack M.A. and Dr. habil. Anne-Simone Rous. With all of these efforts, the diverse parts and elements of the project could not have been completed without the countless contributions of a great number of colleagues, beginning with those responsible for the loan process at the State Museum of Prehistory, Halle (Saale), to the conservators and curators of the collections and the untold minor contributors working for the cooperating partners. Without their support, it would never have been possible to access and process the available material in preparation for the exhibitions. Even though space is too limited here to name them all, we wish to extend our warmest thanks for their invaluable work.

Harald Meller
Director
State Office for Heritage Management
and Archaeology Saxony-Anhalt
State Museum of Prehistory

Martin Eberle
Director
Foundation Schloss Friedenstein Gotha

Ulrike Kretzschmar
President a.i.
Stiftung Deutsches Historisches Museum

Stefan Rhein
Chairman and Director
Luther Memorials Foundation
of Saxony-Anhalt

Foreword

The Minneapolis Institute of Art is honored to present "Martin Luther: Art and the Reformation," an unprecedented exhibition marking the five-hundredth anniversary of the presentation of the Ninety-Five Theses, an event that shook Europe to its core and gave rise to religious beliefs now shared by millions of Minnesotans and 800 million Protestants throughout the world. As you turn the pages of this book, you will learn about this momentous event and its aftermath as represented by archaeological finds from Luther's homes, his personal effects, letters and studies from his hand, and books that he published. You will also see the glorious art of the world into which he was born, the new types of art that he used to give shape to his views on faith, and the artwork that allowed his supporters and detractors to argue their positions. We are deeply grateful to our brilliant and generous partners working directly with the Minneapolis Institute of Art in this endeavor, beginning with project organizer, the State Museum of Prehistory, Halle (Saale), also working with the Luther Memorials Foundation of Saxony-Anhalt, Wittenberg; the Deutsches Historisches Museum, Berlin; and the Foundation Schloss Friedenstein Gotha. I am especially pleased to recognize the visionary leadership of the director of the State Museum of Prehistory (Halle), Prof. Dr. Harald Meller, who first offered us the opportunity to bring so many artistic, cultural, and religious treasures to Minneapolis. I am also grateful for the work of Dr. Tomoko Emmerling, whose curatorial and organizational excellence has kept this complex project on track. I appreciate the work of the entire team based in Halle, who helped to execute the exhibition and related publications. In Minneapolis, special recognition goes to Tom Rassieur, John E. Andrus III Curator of Prints and Drawings, for his dedicated work on this important project over a number of years.

We salute editors Dr. Katrin Herbst and Dr. Ralf Kluttig-Altmann and the many scholars who contributed to this remarkable catalogue volume, which documents the exhibition in Minneapolis as well as related exhibitions at The Morgan Library & Museum in New York and the Pitts Theology Library at Emory University in Atlanta. We are indebted to nearly twenty-five lending institutions for trusting their precious objects to our care. Without the generous support of the Foreign Office of the Federal Republic of Germany within the framework of the Luther Decade, the project would have never gotten off the ground. We are particularly grateful for the support of Thrivent Financial, our Minneapolis Presenting Sponsor of "Martin Luther: Art and the Refor-

mation." We also extend our appreciation to John and Nancy Lindahl, Joe Hognander/ The Hognander Foundation, Jeannine Rivet and Warren Herreid/K.A.H.R. Foundation, The Bradbury and Janet Anderson Family Foundation, Jim and Carmen Campbell/Campbell Foundation, Thomson Reuters, Delta Air Lines, and the National Endowment for the Arts for their additional support in helping bring this once-in-a-lifetime exhibition to Minnesota. On behalf of everyone at the Minneapolis Institute of Art, I extend our warmest thanks to everyone who made this important project possible.

Kaywin Feldman
Duncan and Nivin MacMillan Director and
President of the Minneapolis Institute of Art

Foreword

Martin Luther is one of the most important yet divisive figures in western history. His stand against some of the traditional practices of the Church completely altered the religious, political, and cultural landscape of Europe. This epochal shift in society was only accomplished through an innovative use of print and visual media. The Morgan Library & Museum is presenting "Word and Image: Martin Luther's Reformation" in honor of the 500th anniversary of the Reformation, one of the three exhibitions in the United States organized by the "Here I Stand" Luther Exhibitions USA 2016 project.

The publication of Luther's Ninety-Five Theses in 1517 initiated a series of events that were only made possible through the use of mass media. Printed texts and images, works of art, sermons, and music all played a critical role in the success of the movement. The unprecedented and rapid dissemination of much of this material was the first major demonstration of the way that the printing press could effect social change. This inherent impact of mass media is reflected in the distribution of information in the modern era, and exemplified by such events as the use of social media during the Arab Spring of 2011. The Morgan exhibition celebrates the revolutionary events of the Reformation in nearly 100 manuscripts, books, paintings, drawings, sculpture, and objects that transformed western culture.

We are grateful to the twenty-three lending institutions for helping the Morgan to celebrate the 500th anniversary of the birth of the Reformation. The Morgan joins the Minneapolis Institute of Art and Pitts Theology Library at Emory University in Atlanta in honoring the admirable leadership of Prof. Dr. Harald Meller, Director of the State Museum of Prehistory in Halle (Saale) and his colleagues at the other organizing institutions—Foundation Schloss Friedenstein Gotha, Luther Memorials Foundation of Saxony-Anhalt, and the Deutsches Historisches Museum in Berlin—who made this extraordinary exhibition event possible. Our sincerest thanks and gratitude go to the "Here I Stand" project team, admirably led by Dr. Tomoko Emmerling, along with Prof. Dr. Louis D. Nebelsick, Susanne Kimmig-Völkner, Franziska Kuschel, Dr. Ingrid Dettmann, Dr. Katrin Herbst, Dr. Ralf Kluttig-Altmann, Robert Kluth, Robert Noack, and Dr. Anne-Simone Rous.

The curator of "Word and Image: Martin Luther's Reformation" is John T. McQuillen, Assistant Curator of Printed Books and Bindings, who worked with the "Here I Stand" project team to organize the exhibition. John D. Alexander, Senior Manager of Exhibition and Collection Administration, and Paula Pineda, Registrar, supervised the exhibition. The materials were partly prepared for installation by Morgan conservators Frank Trujillo and Lindsey Tyne, and the exhibition was designed by Stephen Saitas with gallery lighting by Anita Jorgensen. Editorial and imaging support for the exhibition were provided by Patricia Emerson, Marilyn Palmeri, Eva Soos, and Graham Haber.

It is the tradition of The Morgan Library & Museum to celebrate the milestones of literary and artistic achievement that have shaped our culture; few historical events illustrated the power of words and images like Martin Luther and the Reformation.

Colin B. Bailey
Director
The Morgan Library & Museum

Contributors to the Catalogue

AM	Arnold Muhl		**RBdH**	Rosmarie Beier-de Haan
AR	Alfred Reichenberger		**RJ**	Ralf Jacob
AS	Andreas Stahl		**RK**	Robert Kluth
ASR	Anne-Simone Rous		**RKA**	Ralf Kluttig-Altmann
AT	Anja Tietz		**RN**	Robert Noack
AW	Andreas Wurda		**SH**	Scott H. Hendrix
BP	Barbara Pregla		**SK**	Stefanie Knöll
BR	Brigitte Reineke		**SKV**	Susanne Kimmig-Völkner
BS	Bernd Schäfer		**SL**	Sven Lüken
CW	Cornelia Wieg		**StA**	Steffen Arndt
DB	Dagmar Blaha		**SW**	Sybe Wartena
DBe	Daniel Berger		**TE**	Tomoko Emmerling
DG	Daniel Gehrt		**TL**	Thomas Labusiak
DL	Daniel Leis		**TR**	Thomas E. Rassieur
FK	Franziska Kuschel		**TT**	Timo Trümper
GS	Günter Schuchardt		**UD**	Ute Däberitz
HK	Holger Kunde		**UDr**	Ulf Dräger
HR	Holger Rode		**UE**	Ulrike Eydinger
ID	Ingrid Dettmann		**UW**	Uta Wallenstein
IRL	Irene Roch-Lemmer		**VR**	Vicky Rothe
JF	Johanna Furgber		**WH**	Wolfgang Holler
JR	Johanna Reetz			
JTM	John T. McQuillen			
KB	Kerstin Bullerjahn			
KH	Katrin Herbst			
KS	Katrin Steller			
KV	Katja Vogel			
KW	Klaus Weschenfelder			
LK	Leonore Koschnick			
LMcL	Lea McLaughlin			
LN	Louis D. Nebelsick			
MC	Markus Cottin			
MG	Mirko Gutjahr			
MGr	Mareike Greb			
ML	Matthias Ludwig			
MM	Matthias Miller			
MR	Michael Ruprecht			
MT	Martin Treu			
MvC	Marita von Cieminski			
PJ	Philipp Jahn			

I

Finding Luther

Until quite recently, the family background and childhood of Luther were largely shrouded in obscurity. According to Luther himself, his childhood home was poor and his father a simple miner. We know the place of his childhood: Luther's parental home in Mansfeld is a humble building that was dedicated as a memorial site in 1885. In 2003, the archaeological excavation of a refuse pit belonging to this site produced finds that date to around 1500 and can safely be attributed to the family of the Reformer. This is a rare stroke of fortune and a real highlight for archaeology considering that such connections between historical personalities and archaeological material are seldom possible. The objects are tangible evidence in a very literal sense and allow us to recreate the immediate environment of Martin Luther and his family.

These unexpected archaeological discoveries led to further research. A study of the historical building substance of the site was able to ascertain that the parental home of Luther had originally consisted of more than the preserved humble structure. It was actually an imposing complex that occupied a prime piece of urban real estate. The compound consisted of a courtyard that was surrounded on four sides by living quarters and outbuildings dedicated to various economical purposes.

Archival studies were able to shed light on the descent of Luther's parents as well as the economic background and social position of the Luther Family in Mansfeld. The overall impression of this recent research is that of a wealthy family that formed a part of the town's elite. The head of this family was Hans Luder, who certainly did not have to struggle to raise himself up from a lowly miner. He arrived in the Mansfeld region as an affluent mine operator with enough starting capital to become an investor. He was able to make his weight felt in the town's affairs and was to retain close ties with

The Luther Family in Mansfeld

Martin Luther's father Hans Luther (or Luder, after an older spelling that he used) was the descendant of a wealthy farming family from Möhra in Thuringia. His mother Margarethe, née Lindemann, came from a reputable middle class background in the town of Eisenach. Hans earned the qualification of a *Hüttenmeister*, or foreman, in his hometown. Thus, he was certainly qualified to set up his own business when he came to the town of Mansfeld in the foothills of the Harz Mountains. The young family—their first child, Martin, had been born in Eisleben on November 10, 1483—must also have had access to the considerable starting capital needed for this venture.

The subsequent wealth of the family was based on several foundations. Hans Luder was more than a mining and smelting entrepreneur. He also held the post of *Schauherr*, or member of the mining jurisdiction, which made him one of the highest-ranking officials in the mining administration of the County of Mansfeld. In addition, the family was also involved in moneylending, land ownership and agriculture. The father of the future Reformer was certainly considered one of the notables of the town. He executed the office of a *Vierherr*, the political representative of one of the four urban districts of Mansfeld.

The prosperity of the Luther family and their secure place in the upper class of Mansfeld are reflected in the location and size of their mansion. The quality of the recent archaeological finds from the site confirms this impression. The Reformer's family home was situated in an exclusive neighborhood, close to one of the town gates and right below the castle of the Counts of Mansfeld. The street was lined with the houses of other *Hüttenmeister* families, with whose sons Martin went to school, and who formed marriage ties with the Luthers. Although the Reformer left his hometown in 1497 to pursue his education in Magdeburg and Eisenach, he would always maintain friendly ties to the town, the other *Hüttenmeister* families and the Counts of Mansfeld. TE

1

Contract between Hans Luder and Tile Rinck

Mansfeld, August 1, 1507
21.7 × 32.6 cm
Landesarchiv Sachsen-Anhalt, F4, Mansfeldische Kupferschiefer bauende Gewerkschaft, AK no. 1, ff. 21v–22r
Minneapolis Exhibition

The County of Mansfeld was one of the most important mining regions in the Empire and attracted many miners. Martin Luther's father, Hans Luder, from the village of Möhra in southern Thuringia, also envisioned his future professional advancement there since the region's substantial copper deposits and dense network of roads held out hope of profitable sources of income. Luder's wife, Margarethe, from the respected Lindemann family of burghers in Eisenach, furnished him the right contacts to quickly establish himself as a smelter master there and to integrate himself among the elites of the city of Mansfeld. After all, being related to Antonius Lindemann, who held the position of chief mining superintendent, positioned him ideally to do business. Hans Lüttich, who was from one of the most important families of smelter masters in Eisleben and held the office of city magistrate, eventually became his business partner.

This also explains this contract of August 1507 between Tile Rinck, representing Hans Lüttich's underage children, and Hans Luder. Business relations were to be sustained despite Lüttich's death and both parties to the contract were to have a share in the profits from the smelting furnace at the foot of Rabenkupp Mountain. At this time, Hans Luder was already a member of the burgher class of smelter masters and thus of the middle or upper class in the city of Mansfeld. His family had probably always owned three to five fires (smelting furnaces) in the vicinity of Mansfeld, thus making them some of its wealthiest residents. This also explains how the family was able to pay for Martin Luther to attend school in Mansfeld, Magdeburg and Eisenach and, later, the university in Erfurt (1501–1505). VR

Literature
Fessner 2008 a · Freydank 1933, pp. 351 f. · Oelke 2001 · Westermann 1975

2

Marbles

Mansfeld, Luther's parents' home, Lutherstraße 24–26
Around 1500
Fired clay
D 1.1–1.5 cm
State Office for Heritage Management and Archaeology Saxony-Anhalt, State Museum of Prehistory, HK 2004:9232 g/3-5
Minneapolis Exhibition

Playing with marbles was a popular pastime for young and old in the late Middle Ages. Borders between the worlds of children and adults were not as clearly defined then as they are now. Thirteen year old girls married, boys went to war, and adults were passionate about all sorts of games. Medieval marbles were used in a variety of distractions, including a game related to Boules, wherein one player shoots his marble and the others try to get theirs to touch the first. In another variation, marbles are shot at each other to pop them out of a circle scratched in the dirt. A golf-like game was also popular, where the players tried to shoot the marble into a small hole dug into the ground. In all cases the winner takes all and the others "lose their marbles." As this was sometimes combined with wagering, adult marble playing was frowned on by the Church and discouraged on church property. Children, however, could play at will. In Luther's days marbles were modelled by children at home using clay or loam and fired in the family's stove. The somewhat lopsided marbles found in Mansfeld were clearly hand-made. It is not unlikely that young Martin Luther himself may have had a hand in making some of these marbles. LN

Literature
Heege 2002, · Meller 2008, p. 191, cat. C59 (ill.) · Schlenker 2008, p. 94, fig. 5

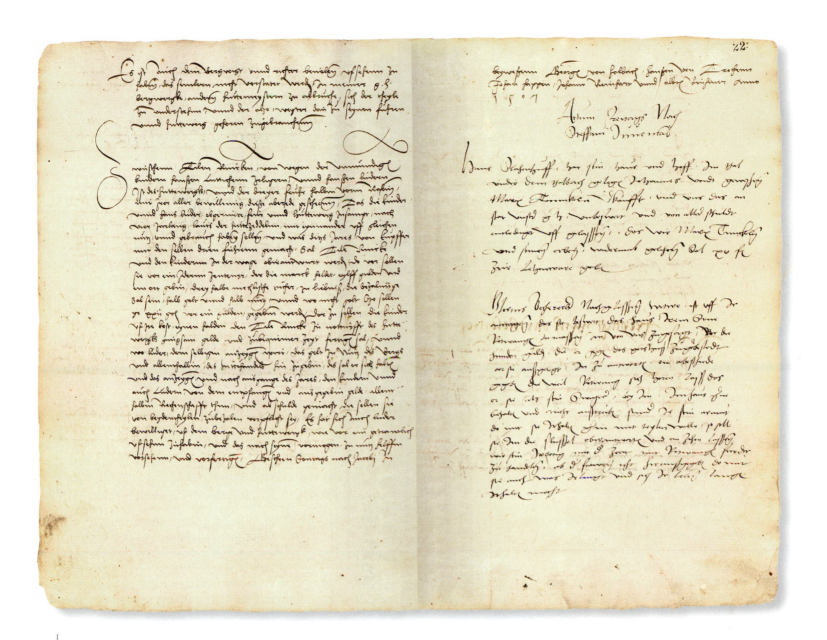

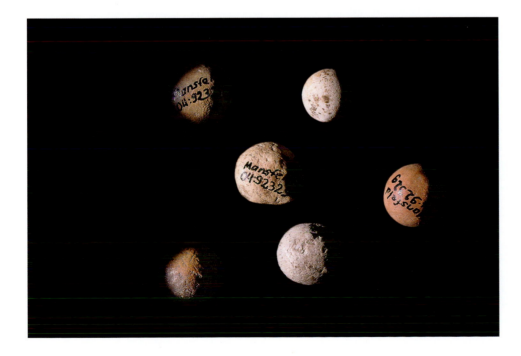

The "Luther Pit" in Mansfeld: What their Garbage Tells Us about the Luther Family

When a refuse pit was excavated on the site of the family home of Martin Luther in Mansfeld in 2003, it provided a number of remarkable insights. The most sensational aspect is the definite association of these archaeological finds with a known personality of immense historical importance. The material also allows us rare glimpses of the activities and circumstances of the people who once used it. Some of the objects offer an inside view of the everyday life and pastimes of the family. These include children's toys and bird whistles made from goose-bone (used as calls for hunting songbirds) which were obviously made in the household itself.

Information about eating habits is provided by the more than 7000 animal bones, fish bones, and vegetable remains. A particular fondness for the meat of young, barely grown pigs is suggested by the material, and geese and young chicken were also popular. Fig pips indicate that the family could afford delicacies from time to time. The impression that the finds from the dump are anything but the legacy of a poor household is reinforced by more than 250 silver coins and numerous brass ornaments from a female costume of highest quality. Fragments of windowpanes point in the same direction. Several elaborately decorated handles of eating knives imply that sophisticated table manners were also observed.

The finds have cast a new and unexpected light on the circumstances and the social status of the Luther family in Mansfeld. These revelations in turn triggered a number of new research projects. Surprisingly, it was not only domestic garbage which ended up in the refuse pit, as might be expected in any household of the time. The substantial number of silver coins from the infill certainly demands an explanation. The costly metal dress ornaments which were recovered imply that intact and valuable items of clothing were thrown away. In a time of widespread recycling, this can only be explained by exceptional circumstances, such as an outbreak of the plague. This might well have forced the inhabitants of the house to dispose of contaminated objects along with the usual household waste. Historical sources do actually record such an outbreak in Mansfeld for the year 1505, and two of Luther's brothers may well have been among the victims. TE

3

Bone Bowling Pin

Mansfeld, Luther's parents' home,
Lutherstraße 24–26
Around 1500
Bovine phalanx
L 6.6 cm
State Office for Heritage Management and
Archaeology Saxony-Anhalt, State Museum
of Prehistory, HK 2004:9232r
Minneapolis Exhibition

This bovine phalanx (toe bone) has been reworked. It has a flattened base and was hollowed out and filled with molten lead, allowing it to stand stably. The reason for this can be clearly seen on Pieter Bruegel the Elder's famous painting *Children's Games* (fig. 1). He shows phalanges being lined up in a straight row parallel to a brick wall and a group of children standing a few feet away, waiting to bowl a ball into them. Presumably, a combination of lateral spinning and rebounding off the wall would get the whole lot down. Of course, untreated phalanges would also do the job, but they would be very wobbly and apt to fall down by themselves. Leaded pins with even bases would be more stable and make the game more challenging. The question why all this effort went into preparing bovine toe bones, when whittled wooden pins would have done fine, goes back to antiquity. In the classical world, knucklebones or *astragali*, mainly derived from sheep or cattle, were used in a wide range of games of skill and luck. They mainly served as dice and thus became proverbial tokens of luck. The use of knucklebones and their fortunate symbolism continued into the Middle Ages and it is likely that phalanges would have partaken of their lucky nature. LN

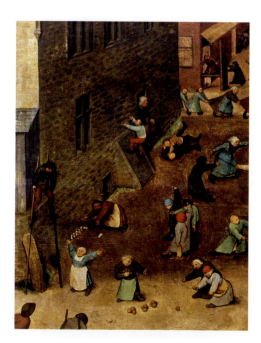

Fig. 1
Pieter Bruegel the Elder, Children's Games,
c. 1560 (detail)

Literature
Meller 2008, pp. 191f., cat. C 61 (ill.) · Orme 2003

4

Bird-shaped Whistle

Mansfeld, Luther's parents' home,
Lutherstraße 24–26
About 1500
White, fired clay
H 6.5 cm
State Office for Heritage Management and
Archaeology Saxony-Anhalt, State Museum
of Prehistory, HK 2004:9232 g/10
Minneapolis Exhibition

This hollow figure of a bird was reconstructed from small fragments, but the remains of the mouth piece in its front indicate that it was a type of whistle still used by children today. Partially filled with water and blown into, the whistle would warble like a songbird, hence the whistle's shape. Little whistles whittled from bones found in the same refuse pit had a more utilitarian background: blown by talented boys or men, they could imitate birdsongs exactly and be used to attract unsuspecting birds into snares and nets. Songbirds were eaten regularly in late medieval times and their bones were also found in refuse pits in the Luders' Mansfeld home. While hunting was a noble privilege, songbirds could be caught with impunity. Moreover, as is the case in southern Europe even up to today, their meat was considered a delicacy. Finally, we must understand the hunting and eating of songbirds in the context of subsistence strategies. Meat was a luxury even for wealthy families in the late Middle Ages and large cuts of meat were reserved for festive occasions. Thus even the smallest addition of concentrated protein was a welcome addition to the menu.

Musical instruments are rare archaeological objects, whether professional instruments or personal instruments for festivities or children's fun (cf. cat. 6 and 273). LN

Literature
Benker 1989 · Kluttig-Altmann 2015 b · Meller 2008, pp. 191f., cat. C60 · Schlenker 2015, p. 285, fig. 34.1–2 and p. 286, fig. 35 · Tamboer 1999

3

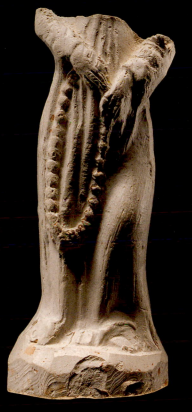

5

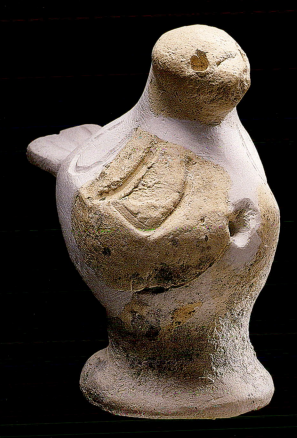

4

5

Female Figurine

Mansfeld, Luther's parents' home,
Lutherstraße 24–26
1st-half of the 16th century
Pipeclay
6.2 × 1.8 cm, D 2.5 cm
State Office for Heritage Management and
Archaeology Saxony-Anhalt, State Museum
of Prehistory, HK 2007:55721c
Minneapolis Exhibition

This pipeclay figurine and others like it were mass produced by forming soft white clay with a bivalve mold. Afterwards it was dried and fired. Despite its missing head this draped statuette clearly represents a female holding an oversized rosary. Comparable figurines suggest that this figure can be identified as a saint. It is probable that it was bought while on a pilgrimage as a souvenir or proof of participation and thus is an example of popular piety. Once at home, it may have served as a children's toy until it broke. The long gown and dangling rosary make it likely that the figure was a nun, possibly St. Monica of Hippo. She was the mother of St. Augustine and helped to convert him to Christianity. Her attributes include the Augustinian habit and a rosary hanging from her belt. There was a close connection between the Luder family and the Order of Hermits of St. Augustine, particularly through Martin himself. Young Martin Luther had joined the Augustinians in Erfurt on July 17, 1505. Besides foreshadowing his monastic vocation, this small figure of a saint represents young Martin's exposure to the cult of saints, which he would nevertheless vehemently condemn later in life. LN

Literature
Hermann 1995 · Kluttig-Altmann 2015 a, pp. 388–390, fig. 39 · Meller 2008, pp. 216f., cat. C110 (ill.) · Neu-Kock 1988 · Schlenker 2015, p. 288, fig. 36.1 · Vahlhaus 2015, p. 446, fig. 25

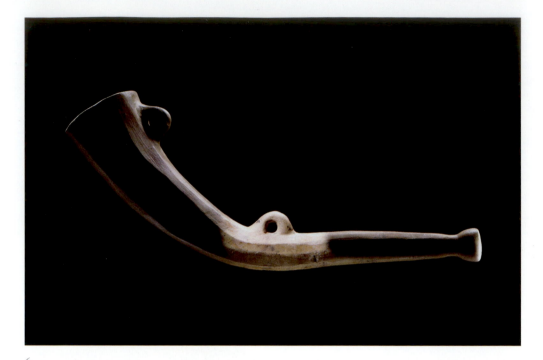

6

6

Pilgrim's Horn

Mansfeld, Luther's parents' home,
Lutherstraße 24–26
Around 1500
Earthenware
10.5 cm (original fragment), W (max.) with reconstructions 35 cm
State Office for Heritage Management and Archaeology Saxony-Anhalt, State Museum of Prehistory, HK 2004:9232 g/2
Minneapolis Exhibition

This pipeclay signal horn was originally a memento of a pilgrimage to Aachen/Aix-la-Chapelle in Germany. The town's cathedral, which once served as Charlemagne's palace chapel, still holds what was then considered to be the most important collection of textile relics in Europe. They include four major relics: a dress worn by the Virgin Mary, baby Jesus' diapers, Jesus' loin cloth, and the kerchief used at the decapitation of John the Baptist. The three minor relics, consisting of two belts belonging to the Virgin Mary and Jesus respectively, as well as a lash from the whip used to torture Christ at the palace of Pontius Pilate, added lustre to this splendid collection. Recent analyses have demonstrated that most of these relics date to late antiquity, and they are now treated as having symbolic value rather than being genuine relics. There was, however, no doubt about their veracity in the minds of the thousands of fervent 15th- and 16th-century pilgrims that crossed vast distances to see these holiest of garments. Moreover, the pious travelers also hoped to harness their amassed holy power to grant atonement and indulgence even when serious crimes were involved. The horns themselves were mass-produced in western German pottery workshops and sold in the thousands at the market stands crowded around the platform in the town's main square where the relics were shown. The "Aachhorns," as they were called, could be and were used much like the vouvouzelas that roar at South African soccer matches (if you buzz into the mouthpiece, a deep growl comes out of the horn). Contemporary sources describe the frenzied agitation of the pilgrims when the holy garments were shown: incoherent pleas for God's grace and mercy followed by a deafening roar when the seething throngs all blurted into their freshly bought Aachhorns.

Fragments of the virtually indestructible Aachhorns are regularly found in medieval excavations from London to Prague. They seem to have not only been pure mementoes, such as pilgrims' badges, but also to have found secular use as signal horns and children's trumpets (cat. 273). There may even be a close relationship between this fragment and the Luder/Luther family, since a member of the family is said to have attended a pilgrimage to Aachen to atone for manslaughter, but this is uncertain. Luther would later strongly condemn pilgrimage as he saw the belief in the saving power of relics to be a dangerous dead end. Belief in God's grace alone could save a soul. LN

Literature
Kluttig-Altmann 2013 · Kluttig-Altmann 2015 b · Meller 2008, pp. 205 f., cat. C90 (ill.) · Schlenker 2008, p. 95, fig. 6

7

Pupil of Veit Stoss
The Virgin and Child
with Saint Anne

Around 1515
Linden wood, polychrome
75 × 49 × 25 cm
Wartburg-Stiftung Eisenach, P0003
Minneapolis Exhibition

As the cult of Mary expanded in the late Middle Ages, it incorporated the veneration of Saint Anne as the Mother of the Holy Virgin. Depictions of the family group consisting of the Virgin and Child with Saint Anne became especially popular in Germany. Initially, these images would depict Saint Anne as a large matronly figure, dressed in red with a green cloak, a head scarf or a veil. On her knees, she would support both a small, child-like Mary and the infant Jesus. This composition developed at the close of the 15th century to a more realistic depiction with proportions that reflected the three generations more accurately. The feast of Saint Anne was a relatively new holiday in the Saxon territories, having been introduced at the behest of Frederick the Wise in 1496. Luther had first noted this veneration of Saint Anne during his school years in Eisenach when the Church of Saint George on the market-place incorporated it in the new regulations for divine services in 1499. He would also have been aware that an altar dedicated to Saint Anne was erected in the Church of Saint George in Mansfeld in 1503.

In his hour of terror and need, when he was nearly struck by lightning near Stotternheim in 1505, he called out to the saint and vowed: "Hilff du, S. Anna, ich will ein monch werden (Help me, Saint Anne, and I will become a monk)." The saint would have been an obvious choice for Luther, not only for her familiar role as a patron of miners, but also as the accepted guardian against lightning strikes and sudden death (cf. cat. 127). GS

Literature
Dörfler-Dierken 1992, p. 73 · Krauß/Schuchardt 1996, cat. 26, p. 151 (ill.)

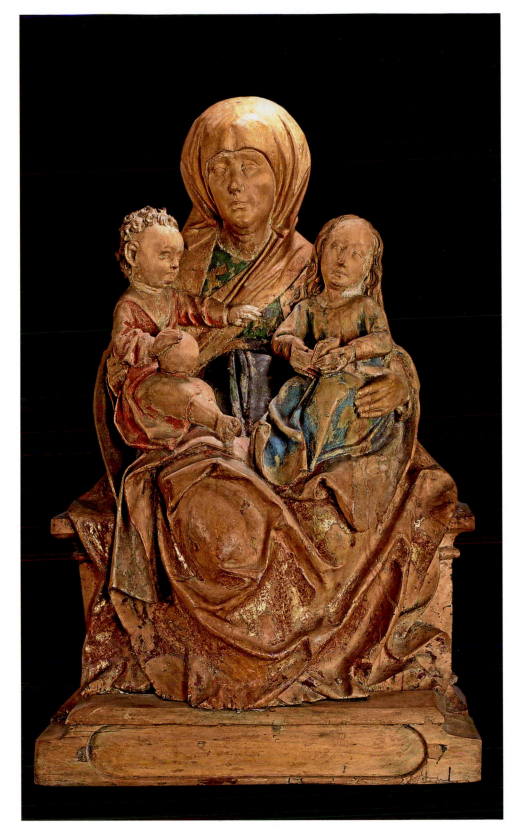

7

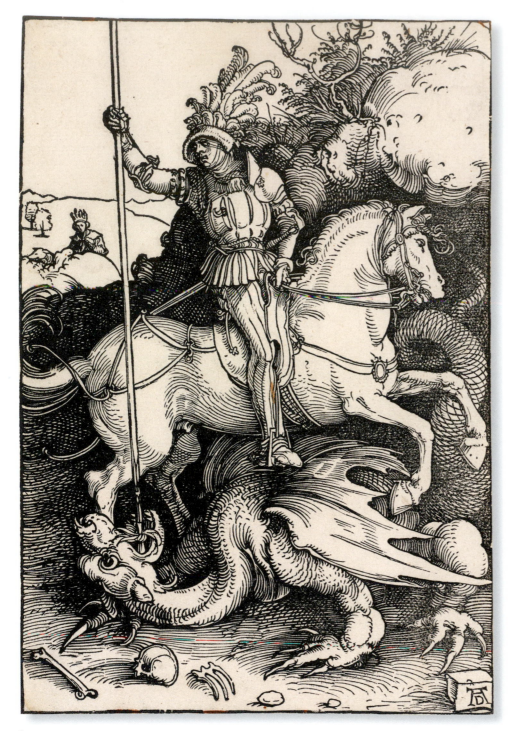

8

Albrecht Dürer (and workshop?)
Saint George Killing the Dragon

1501–1505
Woodcut
21.3 × 14 cm
Minneapolis Institute of Art, Gift of Miss Tessie
Jones in memory of her parents, Mr. and
Mrs. Herschel V. Jones, 1966, P.13,770
Minneapolis Exhibition

Signed in lower right corner with monogram

George was the patron saint of Mansfeld, the
town where Luther grew up from infancy until he
left to attend school in Magdeburg in 1497. The
local church, where Luther served as an altar boy,
was dedicated to George and the scene of the
mounted knight slaying a dragon would have ap-
peared on the church and any official buildings
in the community.

The story of Saint George comes from the *Golden
Legend*, a book of legendary lives of saints com-
piled in the 13th century. The invention of the
printing press led to so many editions that it be-
came a medieval best-seller. The colorful tales
have spurred artists' imaginations for centuries.
George's story is a long one, but in essence he
rescued a princess who was about to be sacri-
ficed to placate a dragon. When George protects
himself with the sign of the cross and kills the
beast, the locals give up their pagan ways and
convert to Christianity.

Though Luther later disregarded the intercessory
role of saints, George remained meaningful to
him. At a time when he was in hiding, he as-
sumed the identity of Junker Jörg (George the
Knight), a portrayal that continued to be associ-
ated with him long after his death (cat. 201). The
choice of a dragon slayer was perfect for a
reformer whose goal was to rid his Church of
powerful evil influences.

Though this woodcut was produced in Albrecht
Dürer's workshop, its stiffness and infelicities in
the details have prompted some to suggest that
it is the work of an associate. The lithe propor-
tions of the horse, and its bright profile against
a dark background recall Dürer's engraving, *The
Small Horse,* dated 1505. TR

Literature
Schoch/Mende/Scherbaum 2001 (ill.) · Strauss
1981, p. 387, no. 311

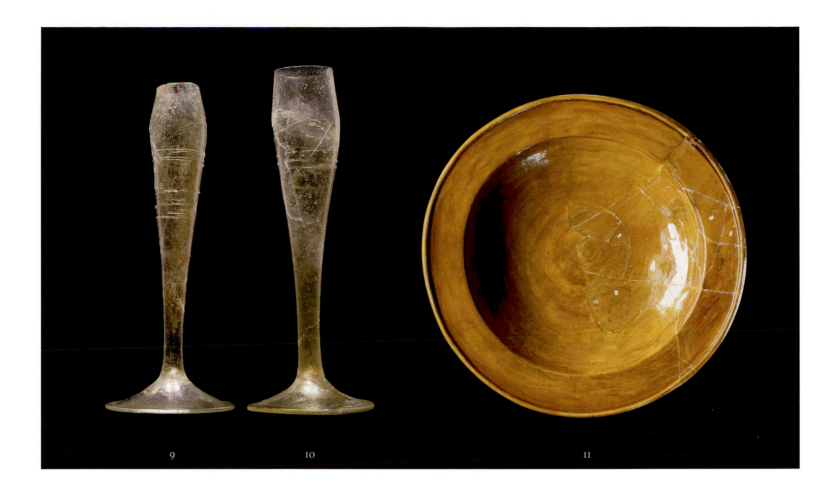

9　　　　10　　　　11

Club-shaped Glasses

Naumburg Marketplace
16th century
Forest glass, yellowish, circumferential thread overlay (retrofitted)
State Office for Heritage Management and Archaeology Saxony-Anhalt, State Museum of Prehistory, HK 2001:2198aa and ap
Minneapolis Exhibition

9
H 33.7 cm, D 13 cm

10
H 34.8 cm, D 12.8 cm

Large, tapered, club-shaped beer glasses like these handsome examples excavated from the Naumburg marketplace frequently figure in the late medieval and early modern depictions of beer drinking. They could reach a stately size, which then required a large foot to balance the glass, particularly when filled with frothing beer. Often these glasses are decorated with horizontal glass thread hoops, which gave the revellers a good grip, no matter how greasy their hands had become during the feast. These glasses from Naumburg were recovered in a latrine pit, which contained innumerable fragments of glass goblets and beakers. Similar glasses, in much more fragmented condition, were found in Luther's parents' home in Mansfeld, as well as in the Luther House in Wittenberg.

Glasses of this shape were invented in Bohemia in the early 15th century and became popular in central Germany at the turn of the 16th century. They are typical products made from "forest glass," produced by highly specialized teams of itinerant craftsmen on a seasonal basis in so-called glass houses deep within the forests of the Central European Middle Mountains. Glass makers needed sand, which they dug up from stream beds, but also wood ash in order to make molten glass. Making and shaping the glass required vast amounts of fire wood and charcoal. It is estimated that these glass workers needed 300 tons of timber per month in order to ply their trade. They leased marginal forest tracts from large landowners, in many cases the Church, in all but inaccessible regions. There, they built beehive-shaped ovens and temporary shacks near streams. They would then melt down, blow, and decorate their glasses, place them in straw-filled baskets, and take them to markets, where they were sold as cheap disposables. In the winter, they would leave the forest but returned in spring to the same site until the surrounding forest became so depleted that they needed to move to a new location. LN

Literature
Eichhorn 2014 a · Eichhorn 2014 b · Meller 2008, pp. 184 f., cat. C 49 and pp. 263 f., cat. E 74 (ill.)

11

Low Earthenware Bowl or Basin

Mansfeld, Luther's parents' home, Lutherstraße 24–26
Around 1500
Earthenware, yellow glazing (retrofitted)
State Office for Heritage Management and Archaeology Saxony-Anhalt, State Museum of Prehistory, HK 2004:9232a/6
Minneapolis Exhibition

This low bowl or basin found in Luther's parental home in Mansfeld belongs to a type that was still quite rare in households of the early 16th century. It may have been used for serving and offering food at table, alongside plates and platters made from other materials. While the bowl is relatively deep, the bordering flange is almost horizontal. On other finds of similar bowls, this broad flange was often used as a surface for relief decoration, wavy lines or other ornaments. While examples from Leipzig follow this style, the

piece from Mansfeld differs by only having a honey-yellow interior glazing as decoration.

The shape of the vessel is reminiscent of late medieval bowls that were used for washing hands. These, however, were generally made from metal or ceramic material. These so-called *lavabo* bowls would evolve in the Early Modern era when part of their rim was turned up to better fit them inside the special wooden cupboards in which a water container was mounted above the bowl. Thus, the find from Mansfeld may well have been used for washing hands.

The closest parallels to this particular vessel were found in the pottery refuse excavated in Bad Schmiedeberg, and another example that also has the honey-yellow glaze was excavated in Grimma. The type of vessel would therefore seem to have been quite widespread in central Germany in Luther's time. RKA

Literature
Beutmann 2012 · Kluttig-Altmann 2006 · Meller 2008, pp. 182 f., cat. C 41 (ill.) · Unteidig 2008

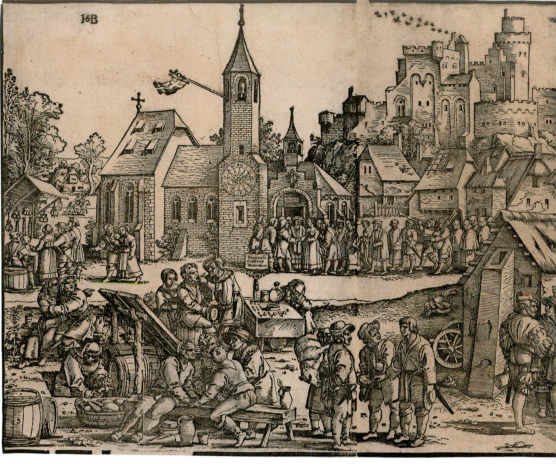

12, sheet 1 sheet 2

12

Hans Sebald Beham
The Big Church Festival

1535 (draft)
Woodcut in four parts, 5th state
Border line broken into sections,
signature reapplied to left segment,
break in fourth wood block
Foundation Schloss Friedenstein Gotha,
45,32 – 45,35
Minneapolis Exhibition

Sheet 1
Sheet: 36.6 × 29.3 cm
image: 36.6 × 28.7 cm
Signed at top: HSB
Inscription: Hi guet thiriact vnd wuermsam
(Good theriac and worm medicine for sale)

Sheet 2
Sheet: 36.6 × 29.4 cm
image: 36.6 × 28.7 cm

Sheet 3
Sheet: 36.6 × 29.3 cm
image: 36.6 × 28.8 cm

Sheet 4
Sheet: 36.7 × 29 cm
image: 36.7 × 29 cm

Since the Middle Ages, many communities have held large annual fairs to celebrate the consecration of their church, and in rural areas this has often taken on the form of a full-scale village festival. This woodcut, in a series of four blocks, by Hans Sebald Beham shows such an event in all of its facets. Its composition makes clear that, by the 16th century, the religious aspects of such events have already faded into the background. At the center of the action, which is rendered in considerable detail, is not the church but an inn, before which an illustrious society consisting of peasants, mercenaries and scholars are seated at a long table.

The viewer becomes the witness to a wide variety of situations: a peasant mediates a dispute; a couple fondling each other is interrupted by the innkeeper; a man who has drunk too much throws up in front of everyone; a scholar is taken aside by a peasant and a mercenary and, finally, five people get together to play dice. The observ-

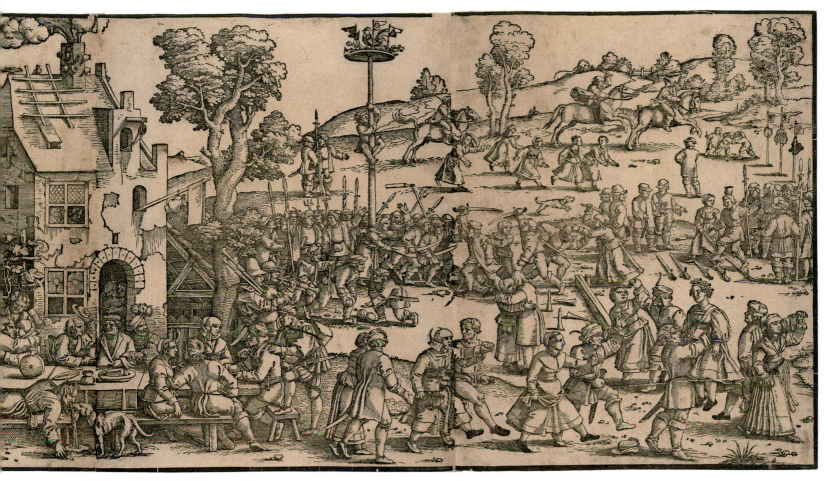

sheet 3

sheet 4

er's view is drawn from the inn towards a round dance at the right. Couples of different ages and classes are moving to the sound of bagpipes and shawms. In the middle ground to the right of the inn we can see swordplay, and a fight has broken out over a bowling game that is turning bloody: men and women are going at each other armed with bowling pins, swords and flails.

Our view wanders to the left behind the inn, stopping at a wedding party standing before the backdrop of the castle and the village. Men and women walk towards the church in rows of two, where the priest is already standing with the bride and groom. The wedding is taking place in front of the door of the church, as was common in those days. One pair has separated from the group and is about to go over to a peddler, who is selling wallets, hats and bags. In front of this scene, we see two lovers who have stopped their caressing in order to witness a theft, which they are watching with astonishment. A dentist (or is he a charlatan?) pulls out a patient's tooth, while his assistant grabs his wallet. Four people have gathered on a bench in the foreground to talk over a glass of wine, while four other peasants negotiate the price of a dead boar which one of them carries on his back.

In this work, Beham develops a festive village panorama that is comprised of numerous individual scenes but cannot be combined into a single narrative. The image cannot be taken in at once; rather, its considerable detail motivates and almost compels the viewer to look more closely. Those who do so will be rewarded with constant new discoveries which are, by turns, amusing, surprising and frightening. The in some cases ambivalent presentation of these festivities has given rise to repeated discussions as to how the woodcut is to be interpreted. The readings range from anti- to pro-peasant, at times paired with confessional criticism, which was particularly frequent at this time, for which both anti-Catholic and anti-Lutheran interpretations have been suggested.

Regardless of the various ways of interpreting the image, the woodcut offers a wonderful framework to view the cultural history of the Lutheran era. The detailed representation allows for a wide variety of observations with regard to typical clothing, contemporary customs and objects, such as the various types of vessels depicted throughout the image. The forms of the round-bellied jugs and cups, glasses, flasks and plates are consistent with those found in archaeological excavations from that time in the region of Mansfeld. Beham's depiction of a church festival is a vivid and certainly very authentic representation of how people in the country lived and, above all, how people celebrated in the 16th century. It presents the environment where Martin Luther grew up, and which he later criticized: "[...] Church consecration festivals should be eliminated entirely since they are nothing but taverns, fairs and gambling dens, existing only to dishonor God and increase the damnation of souls" (WA 6, 446, 19–21). UE

Literature

Moxey 1989, pp. 35–66, fig. 3.1 · Müller/Schauerte 2011, pp. 206 f., cat. 42 (ill.) · Raupp 1986, pp. 136, 157–164, no. F-23, fig. 138 · Rippmann 2012, pp. 49 f., 54–57, fig. 6a/b · Schäfer/Eydinger/Rekow (forthcoming), cat. 323 (ill.) · Seiter 2011, pp. 115–125 (ill.) · Stewart 2008, pp. 70–135, 317 f., fig. 2.1 · Zschelletzschky 1975, pp. 332–339, fig. 270

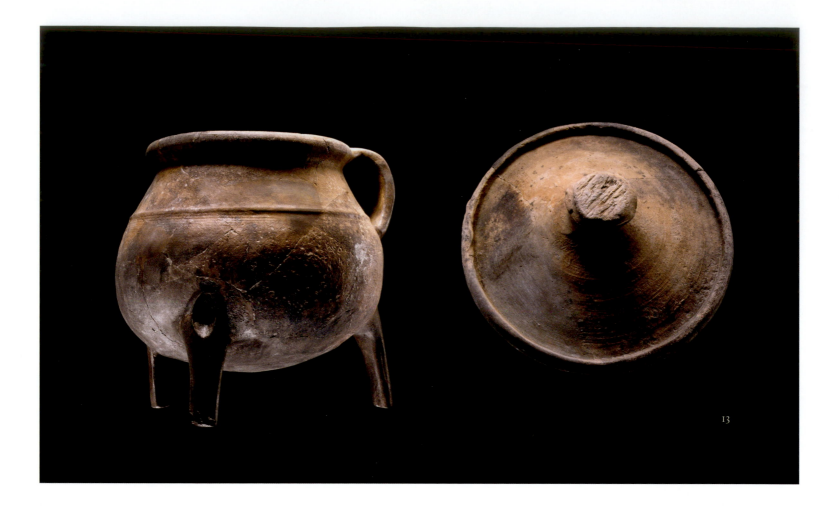

13

13

Tripod Skillet with Lid

Mansfeld, Luther's parents' home,
Lutherstraße 24–26
Around 1500
Earthenware
Skillet: 19.7 × 21 × 20 cm; Lid: 6.5 × 13 cm
State Office for Heritage Management and
Archaeology Saxony-Anhalt, State Museum
of Prehistory, HK 2004:9232a/15;
2004:9232f/25
Minneapolis Exhibition

This three-legged pot, found together with a dozen like it in the plague pit at Luther's parents' home, is known to archaeologists as a pipkin (German: *Grapen*). These cheap versions of cast brass tripod kettles are among the most common vessels to be found in excavations in medieval and early modern towns. There are two reasons for this: first, pipkins were the ubiquitous cooking pot of the later Middle Ages, cheap to buy, intensively used and readily discarded; and second, their stubby feet are almost indestructible and turn up anywhere soil is moved in old European towns. The three stubby feet are also the secret of the pipkin's success. Most cooking during the Middle Ages and Renaissance was

done in the large, open hearth which gaped at the end of the typical, ground floor kitchens. The pipkin could be placed anywhere among the embers or burning logs on the hearth's uneven flagstone floor without spilling. A tripod never wobbles or tips. Liquid-based dishes ranging from broth to porridge and stew would typically be placed on the edge of the fire. Particularly when fitted with a matching lid, as is probably the case here, stew could simmer for hours, a sure way of producing a savory, thick sauce. Our pipkin is a plain affair, of slapdash manufacture with splatters of glaze dribbled onto its shoulder. Nonetheless, Luther's mother and/or her maids used it intensively, as the telltale soot and smudges on its underbelly show, before it was discarded. LN

Literature
Meller 2008, pp. 172 f., cat. C 15 – 16 (ill.) ·
Schlenker 2007 · Stephan 2007 a

14

Protective Hood of a Plague Doctor

Presumably 17th century
Samite, leather, selenite
48 × 51 × 55 cm
Stiftung Deutsches Historisches Museum,
AK 2006/51
Minneapolis Exhibition

Plague hoods (also called plague masks) were an important part of a physician's protective clothing in the Early Modern era. The most striking feature of this protective hood is its leather beak. This nosepiece was filled with herbs or sponges impregnated with essential oils, which were intended to protect the physician during direct contact with infected individuals. This "beak" has ventilation holes through which the wearer could breathe through his nose, while his mouth remained covered by a leather protector. The hood enclosing the head was tightly laced at the neck, and the eyeholes are additionally protected: They are sealed with small round panes of selenite crystal.
A physician's protective clothing was usually completed by a long-sleeved leather gown with a shawl, a wide brimmed hat and a long staff with which the physician could keep patients or even

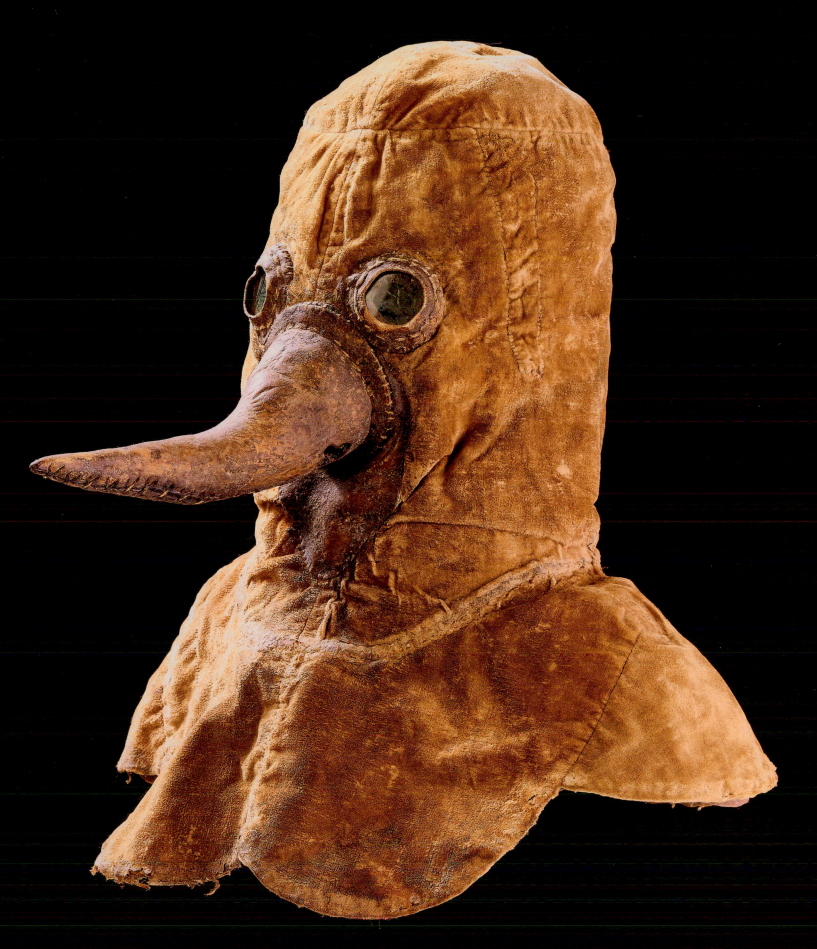

onlookers at a distance. The oldest surviving depiction of such a "beaked doctor" dates back to the mid-17th century; such protective clothing, however, presumably existed even before then. In the Middle Ages and the Early Modern era, the term "plague" not only denoted the actual plague disease caused by the bacterium *Yersinia pestis* but also any epidemic or pandemic infectious disease or plague. Rather than being attributed to viruses or bacteria, the cause of extremely infectious diseases was interpreted well into the 19th century to be the effect of so-called miasmas, bad vapors that spread from the ground into the air. The actions taken against them were governed by hygiene laws, calling for reduced contact and isolation. Healthy individuals left cities or regions whenever they were able. Plague victims were buried outside of cities and their belongings were often burned. Ill individuals were isolated from the rest of the populace in plague hospitals. Non-locals were placed in quarantine.

Luther also frequently experienced illness and epidemics. He witnessed outbreaks of the plague several times: He was present in Erfurt in 1505 when two of his professors died; two of his brothers in Mansfeld also fell victim to the plague. The plague also raged in Wittenberg in 1527. While the university faculty fled to Jena, Luther remained. He evidently had little fear of infection and took ill individuals into his home. In his tract *Ob man fur dem sterben fliehen muge* (Whether One May Flee from a Deadly Plague), printed in 1527, he answered the question as to whether one should attempt to flee the plague or accept it as the manifestation of divine judgment, a question that had been raised time and again for centuries even within the Church: In principle, people had to accept God's punishment. At the same time, attempts to save their God-given lives were not forbidden. Anyone holding religious or secular offices or with children or dependents in their care, however, had to stay put. Luther thus appealed to duty and charity. RBdH

Literature
Feuerstein-Herz 2005, pp. 118 f. · Meller 2008, pp. 213 – 215 · Naphy/Spicer 2003 · Vasold 2003

15

Mascaron Mounts

Mansfeld, Luther's parents' home,
Lutherstraße 24 – 26
Around 1500
Moulded brass sheet
D 1.3 cm/1.1 – 1.3 cm
State Office for Heritage Management and
Archaeology Saxony-Anhalt,
State Museum of Prehistory,
HK 2004:9232 I/187 to 189
Minneapolis Exhibition

These small grotesque masks punched out of brass sheet were riveted to a belt or choker of an elegant, early 16th-century woman's costume and are known as mascarons. With wild shaggy hair or manes, googly eyes, puffed-up cheeks, bulbous noses, as well as leering mouths, they are both hideous and fun.

Besides adding pizzazz to formal finery, these little grotesques illustrate the all-pervading influence of humanism in the early 16th century. "Grotesque" is a word used to describe a bevy of fanciful monsters, which were inspired by and named after the startling discovery of Emperor Nero's buried palace, the *Domus Aurea* in Rome, at the end of the 15th century, whose underground vaults seemed like vast grottos. They were decorated with gaudy frescoes showing sinuous monsters and frisky putti caught up in a jungle of blooming vines, with springy tendrils framing Gorgon heads and other "grotesque" masks.

This new world of ancient Roman fantasy electrified Renaissance architects and artists, who were looking for ways to express the luxury and exuberance of their age. At the same time, they were also acting in the spirit of humanism by paying respect to the artistic achievements of classical antiquity. Artists and architects proceeded to apply "grotesque" motifs to the festive interiors and facades of Italian palazzi (fig. 2). Soon northern nobles and house-proud burghers were incrusting their castles and homes with the same droll motifs.

The fashion quickly spread to other media, and ludicrous masks and fanciful monsters could be found entangled in flowery foliage on anything from ceiling panels, furniture, and stove tiles to cutlery. Book covers and title pages were often framed by highly imaginative grotesque compositions, sometimes in jarring contrast to their serious and even stern religious contents. Not surprisingly, jewellers also discovered this whimsical world, and jewelry and clothing were livened up with grotesque motifs. The shaggy wild faces preserved here, while clearly primarily decorative, would also have evoked the world of the legendary and shaggy "wild men," uncivilized

Fig. 2
Santi Buglioni/Lorenzo Marignolli, Stuccoed columns in the first courtyard of the Palazzo Vecchio, Florence

figures that represented a raucous otherworld to the prim and orderly realities of late medieval domestic life.

Thus, these small mascarons found in the plague pit from Luther's childhood home show the enormous pan-European impact of humanist ideology and Renaissance aesthetic adventure, bringing the world of Nero's frescos onto what may have been the fancy party dress of a Mansfeld mine owner's wife. LN

Literature
Meller 2008, p. 196, cat. C 69 (ill.) · Schlenker 2007, pp. 65 – 67 · Schlenker 2008, p. 99 pl. 1.10 – 12

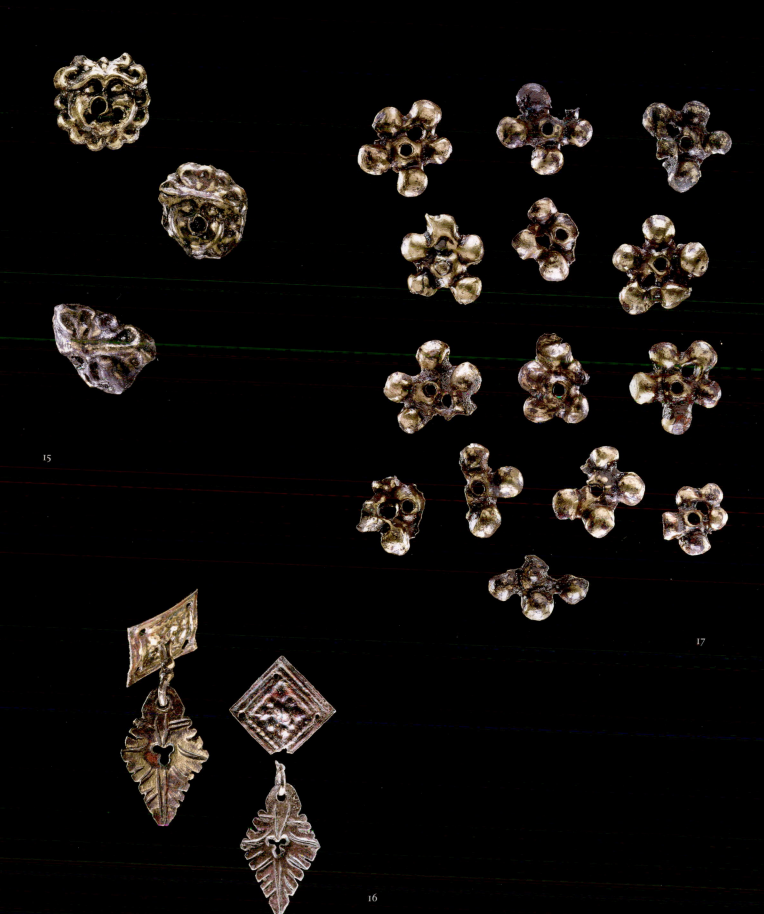

15

17

16

Brass Sheet Sequins

Mansfeld, Luther's parents' home,
Lutherstraße 24–26
Around 1500
Brass
State Office for Heritage Management
and Archaeology Saxony-Anhalt
Minneapolis Exhibition

16

Two Sequins

L 3.6 cm/Length of base 1.3 cm + Length
of fluttering sheets: 2.1 cm and 2.3 cm
State Museum of Prehistory,
HK 2004:9232 I/149 and 150

17

14 Rosette Mounts

1.3 × 1.4 cm
State Museum of Prehistory,
HK 2004:9232I-154-167

These clothing appliqués, both the rosette mounts and the sequins with a leaf-shaped jingle pendent, were stitched onto stylish velvet jackets and gowns or spangled chokers worn by well-to-do, young, fashionable women at events and parties. This fashionable costume jewelry was the property of Martin Luther's mother or another woman of Hans Luder's household. It certainly does much to correct the image of the plain, dowdy Margarethe Luder, whom Cranach painted when she was 68 years old, or indeed the God-fearing, stern woman of humble means that Martin Luther and Philip Melanchthon cast her as as part of their attempt to flesh out the legend of Luther's humble background. In fact, Margarethe was the wife of one of the wealthiest men in town and women in this position at that time would have had no qualms about showing off their wealth.

The practice of embroidering sequins on costumes can be traced to the ostentatious fashions of noble women and elegant courtiers, who indulged in the ruinously expensive conceit of having their satin and brocade costumes embroidered with masses of jewelry, particularly pearl and gem pendants. They tinkled and glittered with every movement the lady made, transforming the simplest movement or gesture into a spectacle of sound and light. Of course, a businessman's wife from a provincial mining town could not hope to compete with this extreme level of conspicuous consumption, but she could certainly afford the razzle-dazzle of a brass-sequined frock. LN

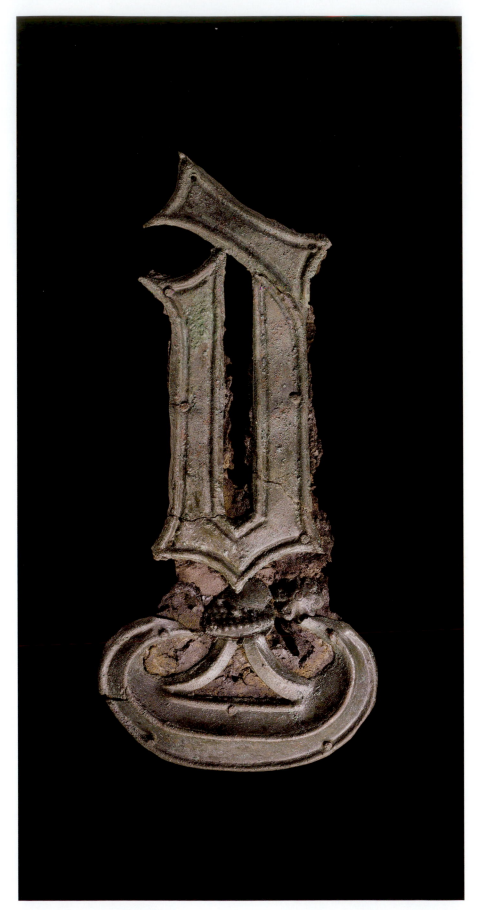

18

Literature
Krabath, 2001 · Meller 2008 pp. 168 f., cat. C 9
and pp. 194 f., cat. C66 – 68 (ill.) · Schlenker
2008, p. 99, pl. 1 (ill.)

Literature
Krabath 2001 · Meller 2008, pp. 170 f., cat.
C11 (ill.) · Schlenker 2008, p. 96, fig. 7 ·
Schlenker 2015, pp. 289 f., fig. 37

18

Belt Mount with Letter Appliqué

Mansfeld, Luther's parents' home,
Lutherstraße 24 – 26
Around 1500
Brass on leather
17.8 × 8 cm
State Office for Heritage Management and
Archaeology Saxony-Anhalt, State Museum
of Prehistory, HK 2004:9232I/300
Minneapolis Exhibition

Although Martin Luther later claimed to have
come from humble origins, an archaeological
excavation carried out in the yard of his parents'
home tells us a very different story. This ornate
belt mount is one of many surprisingly luxurious
finds that were recovered from a stairwell pit
filled with an assortment of household goods.
They had probably been buried there because
they had been "contaminated" during a plague
epidemic. This elaborate mount decorated the
tip of a belt, which was part of a 15th-century
woman's costume, and was popular in noble
courts. The long belts used at this time were
more decorative than practical. They loosely
gathered the woman's dress under her breasts,
passed through the ornate buckle, and swept
downwards with the tip dangling just above the
floor. The strap ends were fancy affairs sporting
tassels, sprays of beads, or, as in this case, elab-
orate metal mounts.
This unique mount shows the Gothic letter "D" and
interestingly, one of Martin's sisters was named
Dorothea. The fact that elegant and in particular
noble ladies began wearing letters, names, and
even short texts mounted or stitched on their
costumes in the late 15th century is illustrative of
the changes affecting late medieval society. Ob-
viously, a woman wearing such an accessory was
on the one hand imitating courtly fashion, but on
the other showing herself to be literate. This was
no commonplace in medieval society, where
schooling was largely reserved for boys. By the
15th century, however, the burghers in prosper-
ous towns were teaching their daughters to read
and write on a regular basis, allowing them to
participate more fully in public life. The success
of the Reformation was due in part to the fact that
women were exposed to and could respond to
the printed word. LN

The Counts of Mansfeld and the Copper Shale Mines of Mansfeld

The mining of copper shale in the Mansfeld region had already had a long history by Luther's time. The broad range of mineral resources found in the County of Mansfeld made it one of the wealthiest areas of Central Europe. With the Golden Bull of 1356, Emperor Charles IV had ceded all the mineral and mining rights in his dominion—hitherto a royal prerogative—to the dukes, the most powerful princes of the Empire. But as the Counts of Mansfeld were immediate to the Empire—that is, direct subjects of the Emperor—they enjoyed special privileges. In spite of the rival claims of the dukes of Saxony, they managed to gain control of the mining rights in their territory and exploited them ever since.

In the second-half of the 15th century, the development of a more effective segregation procedure triggered a renewed and intensified mining boom. The Mansfeld region became one of the most important proto-industrial areas of the Holy Roman Empire, and the economical and monetary power base of the Counts of Mansfeld grew enormously. But in 1466, the Duke and Elector of Saxony finally succeeded in convincing the Emperor that the seignory over the mines and smelting operations was by rights his. This led to a dispute between the Counts of Mansfeld and the Saxon Duke which was to last for nearly twenty years. In 1485, the duke was finally granted the royal prerogatives and rights connected with mining in the Mansfeld region as a Saxon fief. But as a compromise, he had to cede the rights of actual exploitation to the Counts of Mansfeld.

In 1501, the house of Mansfeld split into three branches of Vorderort, Mittelort and Hinterort. The mining of copper shale in the Mansfeld region was jointly administered, and it prospered by pioneering numerous technological innovations and improved mining methods. Overall production rose in the 16th century due to the introduction of man-, horse- or water-powered machinery and extensive underground drainage tunnels. Count Albrecht IV of Mansfeld-Hinterort hired highly skilled professionals. Contrary to the Emperor's will, he founded the Neustadt settlement next to Eisleben to house the urgently needed miners. Albrecht also ordered a new church to be built, introduced the Reformation to the county and became one of the founding members of the Schmalkaldic League. KB

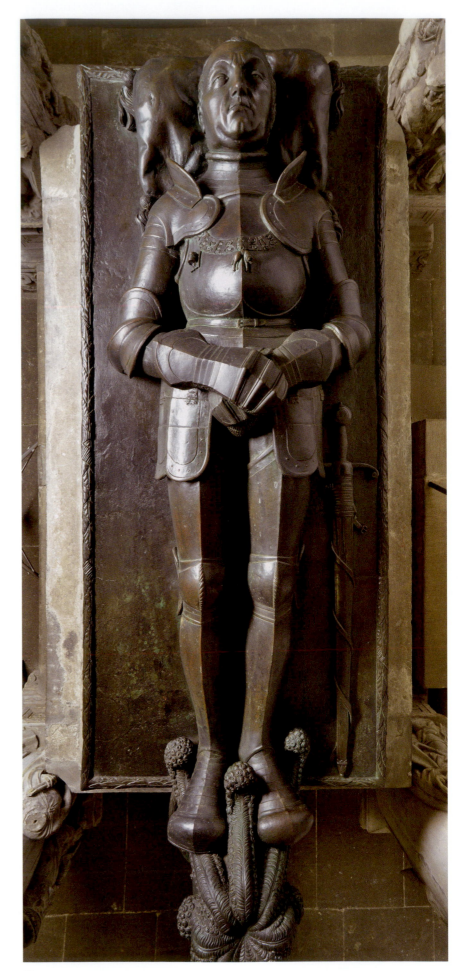

19

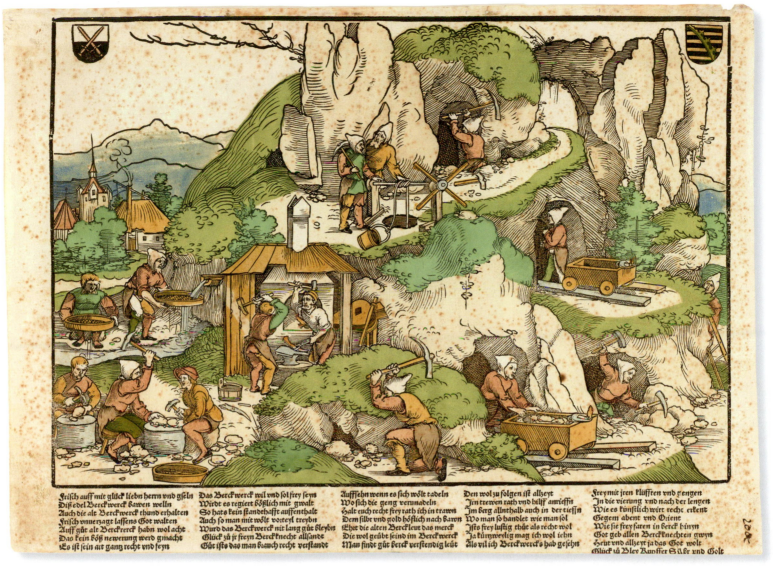

21

21

Hans Sebald Beham
The Saxon Mine

Around 1528
Colored woodcut, typographic text
Sheet cut at the top and bottom, mold stains
Sheet: 28.9 × 39.6 cm; Type area: 28.4 × 36.1 cm;
Image: 25 × 36.1 cm
Foundation Schloss Friedenstein Gotha, G35,24
Minneapolis Exhibition

Inscription:
Frisch auff mit glück liebn herrn und gseln /
Diß edel Berckwerck bawen welln [...]
(Go with luck, dear gentlemen and friends /
who are building this fine mine [...])

Martin Luther grew up in a house where mining was part of the daily routine. Luther's father Hans was the manager of copper shale mines in the Mansfelder Land district, a position which allowed him to amass considerable wealth.

As the influence of *Saigerhutten* (companies that extracted silver out of copper ore) on production and sales in the mining sector expanded in the 1520s, many mine operators had to go into debt to keep pace. This was followed by the merger of work unions in an attempt to cut costs. In addition, efforts were made within the County of Mansfeld to bring the mining industry under the control of the territorial sovereign. It is in this light that this publication by Hans Sebald Beham should be understood, which includes the downright slogan-like demand, "the mine will and should be free." The verses praise the old mines and the work of the old miners. The author believes that the former should be preserved, while the latter should be respected for their expertise. The broadsheet warns against "evil innovations," against mines which are run by force with only profit in mind. To the anonymous author, it is clear that the ability to successfully extract metals comes from God alone.

The large-scale woodcut portrays all of the necessary steps in the mining operation, including the processing stage. In one mine, various miners are at work making holes in the rock with pickaxes. Elsewhere, we can see completed tunnels; a man pulls an empty car into the passageway, while another pushes a loaded car out. Small oil lamps on the cars provide light in the otherwise dark tunnels. On the left side of the picture, ore is being broken down with pickaxes. The stones are then washed by two men in large sifters. The processing of ore in a forge is shown in the middle of the woodcut. A piece of metal is lying on an anvil, where it is worked on by two smiths. The two coats of arms at the upper edges indicate that the mine belongs to the Elector of Saxony, but the precise location of the mine cannot be identified. UE

Literature
Bingener/Bartels/Fessner 2012, pp. 327–329, 349 · Pauli 1974, p. 51, cat. 1444 a · Röttinger 1925, p. 136, no. 170, pl. VI, ill. 8 · Röttinger 1927, pp. 755 f., no. 1219a · p. 790, no. 1444a · Schäfer/Eydinger/Rekow (forthcoming), cat. 329 (ill.)

19

Hans Vischer, workshop(?)

Tomb of Count Hoyer VI of Mansfeld-Vorderort

1541
Brass
35 × 215 × 82 cm
Evangelische Kirchengemeinde
St. Andreas-Nicolai-Petri, Eisleben
Minneapolis Exhibition

Born in Eisleben and raised in Mansfeld, Martin Luther had as his territorial sovereigns the Counts of Mansfeld, who were divided into multiple branches, and who had their seat in Mansfeld. They owned a palace as well as a few townhouses in Eisleben. The members of their family were also laid to rest in that city, which was booming thanks to its flourishing mining industry.

Count Hoyer of Mansfeld-Vorderort, whose gravestone is located in St. Andrew's Church in Eisleben, was in the service of the imperial dynasty and enjoyed considerable esteem from that quarter. In 1516, he became a member of the prestigious Order of the Golden Fleece. Hoyer was the last of the Counts to remain a supporter of the old Church until his death; the Mittelort and Hinterort branches declared in favor of Luther's doctrine as early as 1519 (officially 1525). In the year of Hoyer's death, 1540, the Reformation was introduced throughout the county.

Tombs with recumbent effigies, in the medieval tradition, were considered to be among the most genteel forms of burial in the 16th century, reserved for princes and the high nobility. This tomb, from the year 1541, must therefore be viewed as an expression of the Count's political ambitions. This tomb for a Catholic Count, professing the old faith in a Lutheran environment, is an unusual case for the Reformation era. The tomb, now located in the northern side chapel, once stood in the middle of the church in which Martin Luther gave his final sermons.

The cover plate, which is cast in brass, represents the fully three-dimensional recumbent effigy of the Count in armor, wearing the chain of the Order of the Golden Fleece and the accessories of his rank: with his sword to the left and a plumed helmet at his feet. His face has portrait-like features. This tomb, which is based on that of Cardinal Albert of Brandenburg, is designed to serve as an eternal memorial for the deceased. The artistic tomb and the associated columns can be attributed to the Halle-based sculptor Hans Schlegel and his workshop; however, the person who modeled and cast the recumbent effigy is unknown. It may have come from the famous Vischer workshop in Nuremberg. The tomb represents a high point of Renaissance sculpture in central Germany. IRL

20

Literature
Hauschke 2006, pp. 372–375 (ill.) · Merkel 2004, pp. 202 f. (ill.) · Niehr 2000 (ill.) · Roch-Lemmer 2000, pp. 164 f. (ill.) · Smith 1994, p. 178 (ill.)

20

Gargoyle in the Form of a Dragon

Likely 16th century
Copper, wrought, polychrome and gilded
88 × 53 × 58 cm
Lutherstadt Eisleben, Städtische Sammlungen, V/H 3362 (currently on loan to the Martin Luther Birth House Museum, Eisleben)
Minneapolis Exhibition

In the collections of the City of Eisleben there are currently three gargoyles in the form of dragon heads, one of which can be seen here. They likely came from Seeburg Castle, an impressive structure on Süßer See (Sweet Lake) between Halle (Saale) and Eisleben. The wide open mouth of the dragon, revealing a jagged tongue, once served as a rainwater drain. The sheets which make up the dragon's mane, ears and skin look like large leaves.

Eyelashes cut from strips of metal hang over the large eyes and small metal rosettes adorn the cheeks of the mythical creature. The mouth is painted red, which was perhaps added in the 19th century, and the other raised areas are highlighted with gold.

The Romanesque fortress was built by the Counts of Mansfeld in 1287, and in the 15th and 16th centuries they expanded the fortress using mining revenue. The expansion of the "Widow's Tower," for example, the representative residential quarters, is attributed to the Counts of Mansfeld, who made the sturdy fortress into a magnificent palace combining elements from the late Gothic period and the Renaissance. Today, the fantastic design of the gargoyle conveys an impression of the former richness of the architecture of Seeburg Castle. SKV

Literature
Bartzsch/Schmidt 2006 · Treu 2007, pp. 25–33 (ill.) · Wäscher 1956

Nappian and Neucke, the Legendary Founders of Mansfeld's Copper Shale Mine

Around 1290
Sandstone
Minneapolis Exhibition

22
Nappian

35 × 24.5 × 26 cm
Lutherstadt Eisleben, Städtische Sammlungen,
V/H 1543 (currently on loan to the Martin Luther
Birth House Museum, Eisleben)

23
Neucke

32 × 23 × 26 cm
Lutherstadt Eisleben, Städtische Sammlungen,
V/H 1542 (currently on loan to the Martin Luther
Birth House Museum, Eisleben)

Mansfeld's copper shale mine has a history which goes back more than eight hundred years. According to Cyriakus Spangenberg, the chronicler of the Counts of Mansfeld, two miners, Nappian and Neucke, were the first to engage in the mining and smelting of copper shale at Kupferberg, near Hettstedt, in 1199.

In his 1572 Mansfeld chronicle, he describes the result as follows: "Around this time mining began in the County of Mansfeld not far from Heckstedt when two miners, one Necke or Neuke the other with the last name Nappian leached the first shale. And when they were judged good—their ability and what they sacrificed—and so they began to build the mine and because there was good copper there, the same place was called Kupferberg [copper mountain]."

According to Spangenberg, Welfesholz has traditionally been a place of pilgrimage where "godless idolatry" was practiced. Following the battle of Welfesholz in 1115, a "Jodute," the representation of a Nordic deity, was supposedly created in order to commemorate the victory of the Saxon nobles over Emperor Henry V. This was preceded by the existence of a cult surrounding the symbolization and commemoration of this deity, a kind of wayside shrine that was reputed to possess healing powers.

King Rudolf I of the House of Habsburg sought to eliminate such heathen religious traditions, and in the course of these efforts he had a small chapel built in Welfesholz in 1289. An inscription on the door identified the king as the benefactor. The "Marienkapelle" (chapel of St. Mary) in Welfesholz is first mentioned in the records in 1290. In this document, a visitor to the chapel is granted an abatement of penalty for forty days.

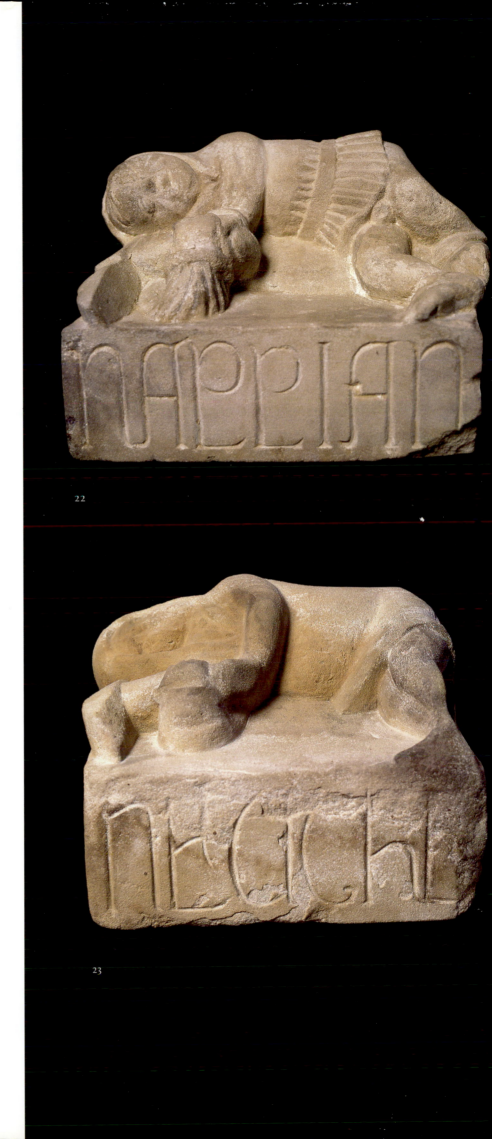

22

23

According to statements made by a contemporary, Pastor Andreas Hoppenrod, the two figures were still on display in the chapel in Welfesholz in the year 1584. While in the chapel, they likely served as corbel figures or beam supports, or were part of a capital. In 1669, they could be found among the possessions of the Eisleben copper shale mining union, where they were displayed in a stairwell. When the building was torn down in 1824, the stone sculptures were relocated to the mining office conference room. Later on, the figures could be found among the possessions of the East German mining company VEB Mansfeld Kombinat "Wilhelm Pieck." Today, they are on display in the permanent exhibition of the Luther Memorials Foundation of Saxony-Anhalt, in the Martin Luther birth house in Eisleben.

The two sandstone sculptures show the founders of Mansfeld's copper shale mine, Nappian and Neucke, at work in the mine. In their hands, they are holding typical mining tools: irons and mallets. Their characteristic miner's clothing is easily recognizable. Their hood-like cloaks, called "Bergkittel" (miner's jackets), are designed to protect their heads and necks from dripping water and falling stones. Miner's aprons, also called "leather backside protectors" because they were worn over the backside, serve to keep water from dripping onto the backs of the miners, who were constantly bent over. They also served to protect the seat of the trousers when sitting or sliding on freezing stone. The miner's apron is the most characteristic form of miner's clothing. KB

Literature
Freydank 1955 · Krühne 1888 · Treu 2007, pp. 36 f., fig. 27

24

Copper Slag

Mansfeld, Luther's parents' home,
Lutherstraße 24–26
Around 1500
State Office of Heritage Management and
Archaeology Saxony-Anhalt, State Museum
of Prehistory, HK 2004:9232q
Minneapolis Exhibition

The region surrounding Mansfeld has a long mining tradition, which was reaching a pinnacle of prosperity in the late 15th century. Martin Luther's father Hans Luder, a prosperous businessman involved in both copper mining and refining, was one of the wealthiest and most respected burghers in town. The Luders could afford an impressive house, which spanned across two properties. Against this background, it is remarkable that excavation of a stairwell used as a refuse pit in the yard of the Luther/Luder household revealed large amounts of glassy copper slags. The reasons for this have a lot to do with the ecological havoc caused by the late medieval mining boom in the Mansfeld region.

Copper shale, which had previously been exploited by surface quarrying, was being systematically deep mined in the later 15th century, exposing rich seams of ore under the supervision of mining entrepreneurs like Hans Luder. Shoring up the mining shafts with timber, but especially refining the ore, which lay in thin seams in a mud stone matrix, was only possible due to the use of enormous amounts of wood and charcoal.

Not surprisingly, historical views of Mansfeld show what are now the wooded hills and mountains around the town in a completely deforested state. Wood, which people needed every day to cook food and heat water and homes, was a luxury item. As early as 1484, the practice of heating water by throwing in glowing hot slag from the refineries is recorded for Mansfeld. This custom was maintained into the 19th century. Glassy slags retain their stability even in the face of drastic temperature changes, whereas heated stones can easily explode. Large amounts of rusty iron nails found in the Luders'/Luthers' yard tell a similar story: they show that recycled, nailed boards were being fired instead of the rare and expensive fresh timber in this mining area. LN

Literature
Fessner 2008 b · Fessner 2014 · Jankowski 2015 · Meller 2008, p. 206, cat. C 92 (ill.) · Schlenker 2008, p. 93, pl. 4

Dawn of a New Era

The period around 1500 marks a turning point in Europe, separating the late Middle Ages from the Early Modern era. Although with its new conception of humankind and its achievements, the Renaissance had renewed the arts, science and technology, the period was still heavily imbued with the Christian faith. The papacy in Rome was a central authority. The Pope, Vicar of Christ on earth, headed the Church and was one of the most politically powerful men in Europe. Secular power was held by major aristocratic dynasties, whose spheres of influence divided the continent into Kingdoms. In their center was the Holy Roman Empire of the German Nation, which extended from the Baltic Sea to the Mediterranean and throughout large parts of central Europe. An Emperor headed the Empire but decentralized power rested in the hands of the secular and religious Electors, rulers of smaller territories and imperial cities.

The majority of people lived in a very straightforward, agrarian world around 1500. Society had been rigidly divided since the early Middle Ages into estates that assigned everyone their social status: There was the nobility that usually had estates in the countryside, the clergy that was responsible for all religious matters, and the estate of the peasantry that was largely dependent on manorial lords.

A new social class of burghers formed as cities developed through the Middle Ages: City dwellers primarily lived off of commerce and craft trades. Increasing prosperity engendered a new assertiveness among burghers. The foundation of universities turned cities into important centers of scholarship. The development of printing laid the cornerstone for new avenues for the dissemination of knowledge. And even though city dwellers only accounted for ten percent of the population, cities increasingly wielded power and political influence. Merchants' ties beyond their home regions expanded the long-distance trade routes that crisscrossed Europe. The search for new trading partners was an important reason for the voyages of discovery from the mid-15th century onward, which opened up new continents. More than just the "discovery" of America by Christopher Columbus opened new worlds for Europe. KH

25

25

Hartmann Schedel
Michael Wolgemut (illustrator)

Liber Chronicarum (Schedel's World Chronicle)

Nuremberg: Anton Koberger, for Sebald Schreyer and Sebastian Kammermeister, July 12, 1493
Printed on paper
45 × 35 cm
Luther Memorials Foundation of Saxony-Anhalt, SS 2154 (Inc. 33)
Atlanta Exhibition

This magnificent Nuremberg Chronicle was compiled by Hartmann Schedel, a Nuremberg bibliophile, humanist scholar and medical doctor. Like many of the world chronicles that preceded it, the *Liber Chronicarum* was as much of an almanac as a history book and contained what seems to us to be a jarring mixture of hard facts intermingled with myth and fancy. All this is loosely sequenced according to the seven ages of the world, that is from the creation to the present day, with a postscript describing the apocalypse which was expected to unfold in the near future.

It contains a wealth of historical information accompanied by geographical descriptions, natural history, scientific speculation, biographical sketches, religious tracts, trivia and even pernicious slander, such as a grisly account of Jewish "ritual murder." The enormous success of this ostentatious book, which was bankrolled by leading Nuremberg patricians, was in part due to the fact that it was illustrated with 1,809 high quality woodcuts which were fashioned in the workshop of Franconia's leading artist, Michael Wolgemut, who trained Albrecht Dürer. These illustrations, which were integrated into the text, show a broad range of images including real and imagined portraits of rulers, scholars, saints and monsters, views of towns, maps of the universe and the world (excluding newly discovered America), religious scenes and icons. Sometimes the woodcuts illustrate the articles, while others are placed randomly in the text, and a great many are even shown multiple times.

The main reason for the success of the book, however, was that Anton Koberger (Dürer's godfather) printed it in exceptionally high quality and in two languages in what at the time was an enormous edition run: 1,500 Latin and 1,000 German copies. Additionally, some illustrated pages were also sold as individual broadsheets.

Despite its lavish illustrations and pioneering printing technology, the *Liber Chronicarum* was more of a monument to the accumulated knowledge of medieval scholarship than a reference book for Germany's educated renaissance burghers. Under the tutelage of humanist scholars such as Conrad Celtis and Erasmus, they had come to expect programmatic and coherent narratives of the real and imagined past. LN/FK

Literature
Joestel 2008, pp. 22 f. (ill.) · Reske: Weltchronik · Wagner 2014

sensum doloris
ficisci ad illum e
tam. pro tenebri
oportet opera d
didit firmauitq̃
lauit montibus.
cit e nihilo. perſp
omes. hunc aud
victores. ac diui
altiſſimũ celum r
ciuiũ atq̃ dei. ma
calipſi ſonãt. in ſ
portas duodecim
Murus ciuitatis
ta muri ciuitatis
ram remigrabim
Quãtopere poſt lo
uentu noſtro gra
Concedat dominu
Et inueniri inter
dominũ noſtrũ. p

II

Worldly Power and Courtly Art

The role that works of art played at the courts of European rulers during Luther's time was both varied and increasingly vital. Art was used to express the representative pretentions of a ruler, was valued as diplomatic gifts, or simply commissioned to meet the personal taste of a patron. Inevitably, art was also used as a medium of political propaganda. A prime example of this is the art policy pursued by the Electors of Saxony. They employed the flourishing workshop of the Cranachs to spread their image as powerful players in the affairs of the Empire and protectors of the Lutheran cause.

Works of art could mirror both the individual preferences of patrons and the prevalent taste of their time. The quality and cost of a real masterpiece would emphasize the wealth of a potentate and thereby indicate the extent of his power. In order to fulfill this demand for ostentation, both lay and clerical princes would enlist court artists to coordinate the various artistic activities at their courts. These included the interior decoration of palaces, the production of portraits, designs for the ornamentation of armor, heraldic devices and feast decorations. An important task was the composition of designs for diverse building projects and public memorials. An artist of renown could even find himself on loan from one court to another or entrusted with important diplomatic missions.

In the Early Modern era, the enthusiasm with which some princes collected art led to the establishment of cabinets of arts and curiosities. These displays, whether they consisted of natural curiosities, measuring instruments or works of art, would be sorted according to principles that reflected the perceived divine order of the world. The wealth and variety of such collections would also serve to impress a contemporary visitor with the erudition and knowledge of its owner. These diverse collections would eventually evolve into specialized collections that concentrated on specific subjects, such as painting, sculpture or natural history. ID

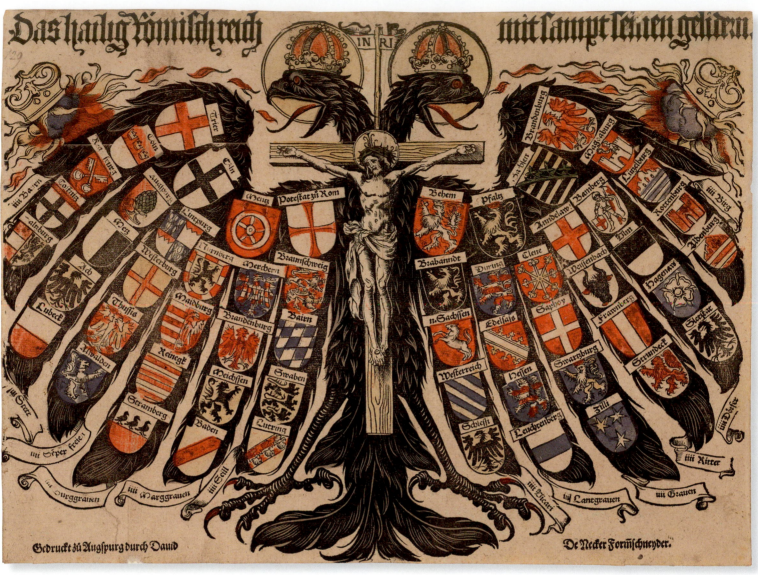

26

26

Hans Burgkmair the Elder
David de Negker
(woodblock cutter and printer)
**The Imperial Eagle with
the Coats of Arms of the Electors
and Quaternions**

Augsburg, before 1564
Colored woodcut and typographic text
28.2 × 37.8 cm
Foundation Schloss Friedenstein Gotha, G15,1
Minneapolis Exhibition

Top: Das hailig Römisch reich mit sampt
seinen gelidern. (The Holy Roman Empire and
all of its member states.)
Below: Gedruckt zů Augspurg durch David
De Necker, Formschneyder. (Printed in Augs-
burg by David De Necker, woodblock cutter.)

From the time that the double-headed eagle was
introduced by Emperor Sigismund in 1433 as the
coat of arms of Germany's Emperors and Kings,
this became the most important symbol of the
Holy Roman Empire as a whole. The eagle wears
the crucifix on its breast as a symbol of Christian
rule and on its wings are the coats of arms of the
quaternions of the Empire (*quattuor* = four): the
electors, princes, imperial estates and cities. The
CAROLVS QVINTVS ROMANORVM IMPERATOR AE-
TATIS SVAE XXXII upper row shows the symbols
of the clerical and secular Electors.

The social and political structure of the Holy Ro-
man Empire has been explained by means of
quaternions ever since the 15th century. In this
system, the various imperial estates are orga-
nized into groups of four, or quaternions. The
number four is supposed to symbolize the divine
creation of the Empire. Because the woodcut ad-
heres to the model, it assigns a group to the "Pre-
fect of Rome," i.e. the papacy, even though there
has never been an electorate there. This also

makes it clear that the division of the Empire into
units of four does not reflect the actual constitu-
tion of the Empire, but rather it is an imaginary
division which became a popular way of seeing
the imperial organization. The representation of
the quaternion system together with the Golden
Bull in manuscripts and early printed works
caused its popularity to grow, as well as the pre-
sumption of its authoritative status, into the
Early Modern period. This popularity is reflected
by the role of the quaternion eagle in woodcuts,
pamphlets and representative glass cups (cat. 27).
BS/RK

Literature
Kroll/Schade 1974, p. 15, cat. 14 · Reformation
1979, p. 241, cat. 271 · Rommé 2000, vol. 1, p. 17 ·
Scheurmann 1994, p. 54 · Scheurmann/Frank
2004, vol. 1, p. 121, cat. 103 · Schubert 1993

Imperial Eagle Beaker

Bohemia(?), around 1615
Glass, enamel painting
H 30.8 cm; D 14.5 cm
Stiftung Deutsches Historisches Museum,
KG 2005/43
Minneapolis Exhibition

Inscription: DAS HEILIGE RÖMISCHE REICH
MIT SAMPT SEINEEN GLIDERN 1615 (The Holy
Roman Empire and its constituent parts 1615)

This drinking vessel with its decoration in the
shape of the imperial eagle nicely represents the
self-perception of the Holy Roman Empire of the
German Nation. The coats of arms of the clerical
and lay electoral princes, the estates of the Em-
pire and the free imperial cities are displayed on
the wings of the crowned and double-headed
imperial eagle. A total of 56 coats of arms, clas-
sified into schematic groups of four, serve as a
heraldic illustration of the hierarchy and struc-
ture of worldly power. The coats of arms of the
Electors who participated in the election of Em-
peror Matthias in 1612—Trier, Cologne, Mainz,
the Palatinate, Saxony and Brandenburg—oc-
cupy the most eminent positions in the top row.
The breast of the eagle is adorned with an impe-
rial orb. Glass beakers that thus displayed the
symbols of an idealized concept of the Empire
were quite popular as vessels for welcoming cer-
emonies or other representative and official oc-
casions. Vessels of this type had been produced
since the 1570s. The motifs were copied from
existing prints and then painted on with enamel
colors. The preferred design came from a wood-
cut made by Hans Burgkmair in 1510 (cat. 26).
In the 17th century, imperial eagle beakers were
produced throughout the Empire in all the re-
gions that possessed a glass industry. During the
second-half of the 17th century, glass painters
were even required to paint this particular sub-
ject as part of their master's examination. LK

Literature
Ottomeyer/Götzmann/Reiß 2006, pp. 89–91
(ill.) · Saldern 1965, pp. 51–67

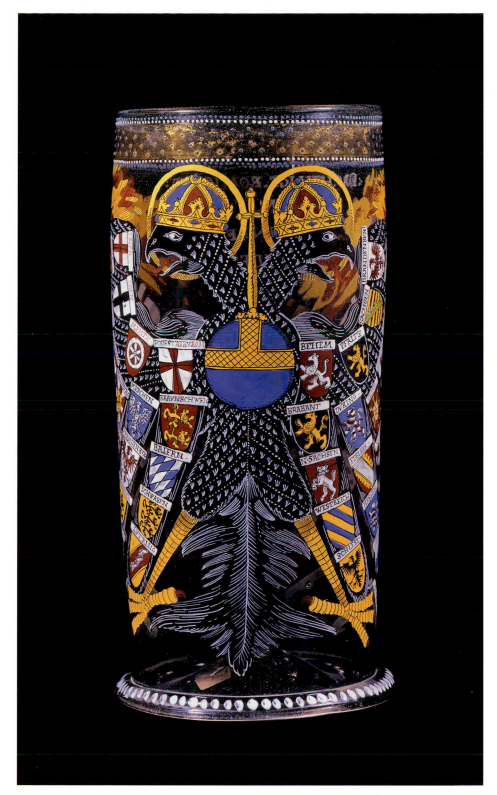

27

28

28

Lucas van Leyden
Emperor Maximilian I

1520
Engraving and etching
26 × 19.4 cm
Minneapolis Institute of Art, Gift of Herschel V.
Jones, 1926, P.10,913
Minneapolis Exhibition

Signed with initial and dated in the upper left
corner

Emperor Maxmilian I was the premier secular
power in Germany during Luther's student years
and when the controversy of the 95 Theses first
erupted. He was a master of propaganda, fash-
ioning himself as the last Christian knight, often
using printed books and large scale prints to re-
inforce his image as a wise, powerful, pious,
magnificent ruler descended from the leaders of
antiquity. His understanding of the power of the
press must be seen as an example for Luther and
his supporters.

Maximilian's awareness of symbols of power is
manifest in this portrait. He wears the elaborate
chain of the Order of the Golden Fleece, founded
in 1430, by Philip the Good, Duke of Burgundy, to
unite and elevate the local rulers of his wide-
spread territories. The cloth of honor draped be-
fore him bears the double-headed eagle of the
House of Habsburg, the dominant family in Ger-
man-speaking lands. On his hat is a badge de-
picting the Madonna and Child, a proclamation
of his piety. In his hand is a small scroll, suggest-
ing the importance of his proclamations.

Maximilian died in 1519. Lucas van Leyden's print
seems to respond to a surge in demand for me-
morial portraits. His strategy for rapidly bringing
the print to market became a landmark in the
history of printmaking. Lucas was a gifted en-
graver. He began as a prodigy and by this time
had extensive experience in producing engrav-
ings on copper. Engraving is a laborious art, re-
quiring patience and an unerring steady hand.
Producing an engraved image as complex and
detailed as this portrait would have taken pre-
cious weeks at a moment when time was of the
essence. Lucas decided to engrave the most im-
portant part of the image—the sitter's head—to
achieve lifelike precision and palpable fleshi-
ness. For Maximilian's clothing and surround-
ings, Lucas turned to etching, a fast chemically-
rather than mechanically-based method of incis-
ing the image into the copper printing plate. This
is believed to be the first instance of an artist
etching on copper rather than on iron, which had
been experimentally used with unsatisfactory
results due to its propensity to rust.

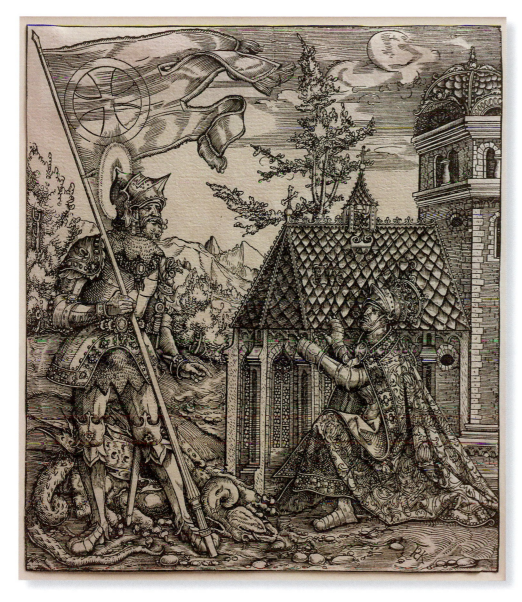

29

This woodcut was apparently part of Emperor Maximilian I's sustained campaign of printed propaganda. No contemporary impressions are known to exist, but the block was reprinted in Vienna in 1799. The Emperor kneels before Saint George who stands over the slain dragon and holds his lance as a pole for his banner. Over his armor Maximilian wears a spectacular brocaded and bejeweled cope, with a clasp bearing George's arms. Surmounting his helmet is the crown of the King of the Romans, a title which had evolved into a preliminary step toward imperial coronation. Maximilian appears to present to George a chapel that is decorated with the flint-and-steel emblem of the Order of the Golden Fleece.

The chapel offered by Maximilian remains un-identified and may never have actually been planned or built. Maximilian was notoriously short on cash, unable to realize many architectural achievements. His propaganda efforts are sometimes likened to paper monuments. Springinklee played an active role in some of Maximilian's greatest projects, such as the *Ehrenpforte* (Triumphal Arch) and the *Triumphzug* (Triumphal Procession) to which he contributed numerous sections prepared under the supervision of his teacher, Albrecht Dürer. TR

Literature
Dodgson 1980, vol. I, pp. 404f., cat. 75 · Hollstein LXXV and LXXVI

Lucas began his project by making a detailed drawing using pens, pencils, and brushes (Foundation Custodia, Paris). He used Albrecht Dürer's woodcut portrait of Maximilian as his model, freely adapting the image, altering the clothing, adding the hands and surroundings. He also added the jester-like figures who cavort around the column and hold the banner bearing Lucas's monogram and the date. These figures may be warnings not to take life too seriously for it is destined to pass away. TR

Literature
Jacobowitz/Stepanek 1983, pp. 199–201, cat. 75

29

Hans Springinklee
Saint George as the Emperor Maximilian's Patron Saint

Around 1516–1518 (printed 1799)
Woodcut
23.6 × 20.8 cm
Minneapolis Institute of Art, Gift of Herschel V. Jones, 1926, P.10,954
Minneapolis Exhibition

Signed in the lower right corner with monogram

The Emperor and the Papacy

The concepts of the offices of both Emperor and Pope had their origins in antiquity. While the bishopric of Rome began as one of five early Christian patriarchies and gradually expanded into the papacy, the office of Emperor (Latin: *imperator*) was legitimized through the assumed continuity of the Roman Empire. Both of these institutions were locked in a complicated relationship throughout the Middle Ages. The fundamental dispute concerned which of the two offices held ultimate religious authority. The Empire was defined as sacred from the 12th century on in order to emphasize the Emperor's claim. The tradition of crowning the Emperor in Rome gave the Pope some leverage, but the Empire dropped this requirement at the start of the Early Modern era. Charles V was the last monarch to be crowned in this fashion. Even though the Empire was in theory an electoral monarchy, the Habsburg family occupied the throne almost continuously from Maximilian I to the end of the Empire in 1806.

The position of the Emperor was traditionally weak. He depended on the collaboration of the greater and lesser princes, which was formalized in the evolution of the original court assemblies into the so-called Imperial Diets. These were held on a regular basis since the Reformation era. The members of the imperial estates sat in three separate colleges. The first of these comprised the Electors, the princes who enjoyed the right of choosing the Emperor. The second consisted of the lesser princes and nobles and church prelates. The third body was composed of the free imperial cities. The Emperor's appearance before this assembly in the company of the Electors was a strong symbol of the unity and plurality of the Empire.

While the Empire took its time in developing institutional structures, the Roman Church saw itself as the guardian of an unbroken tradition reaching back to antiquity. A new Pope was customarily appointed by a conclave of cardinals. In Luther's time, Giovanni de' Medici occupied the post from 1513. It was accepted practice in the Empire for clerical prelates to hold worldly positions of power, but the election of a new church dignitary by the clergy was subject to approval by the Pope. Only then could such a prelate be invested by the Emperor with the insignia of temporal power which entitled him to administrate worldly possessions and rights. RK

30

30

Augustin Hirschvogel
Emperor Charles V

Around 1549
Etching
Plate: 12 × 12 cm
Minneapolis Institute of Art, Bequest
of Herschel V. Jones, 1968, P.68.175
Minneapolis Exhibition

Inscribed round frame: Charles V Emperor of the Romans at the age of 32

Charles V was the most powerful man in Europe during most of Luther's public career. Following the death of his grandfather Maximilian I, Charles was elected King of the Holy Roman Empire in 1519 and named Emperor the next year (cf. cat. 28). In 1530, Pope Clement VII crowned him, thus confirming church assent to his imperial status. Hirschvogel's selection of a profile view similar to an ancient roman imperial coin is no accident.

A descendent of multiple royal lines, Charles inherited vast territories, not just in Europe but with footholds in Asia and America as well. He further increased his lands through military conquest. His Empire was so large and unwieldy that he constantly had to fend off armies of opponents, from invading Ottoman Turks to the forces of French King Francis I (cf. cat. 35). Yet, one of his most formidable opponents stood before him and fought with words at the Diet of Worms in 1521.

Luther's resistance to Charles's entreaties to recant eventually emboldened his followers, including the protestant Duke John Frederick I, Elector of Saxony (cf. cat. 50), to form the Schmalkaldic League in 1531 to fight Charles' army.

Dangling from a ribbon around Charles's neck is the Order of the Golden Fleece, the most exclu-

sive knighthood in Europe. Charles was its leader and actively used the order as a way of staving off the Reformation. He granted greater rights to members of the order and excluded those he considered to be heretics. TR

Literature
Hollstein XXXI, p. 234, no. 134,14

Hans Krafft the Elder, after a design by Albrecht Dürer
Nuremberg Medal of Honor for Emperor Charles V

1521
Silver, cast and minted
Obv: CAROLVS : V : – : RO : IMPER :
Cuirassed bust of the Emperor, wearing the Order of the Golden Fleece and crown to right, girded by border of coats of arms; at top in border of coats of arms frieze containing the motto PLVS – VLTR over the pillars of Hercules
Rev: Double-headed imperial eagle, girded by border of coats of arms. Beside eagle 15 – 21, at bottom of frieze with shields bearing arms N (= Nuremberg)

31
D 70 mm; weight 197 g
Foundation Schloss Friedenstein Gotha,
3./Co 1124
Minneapolis Exhibition

32
D 71.5 mm; weight 195.5 g
Kunstsammlungen der Veste Coburg, 0469,1
New York Exhibition

The magnificent Nuremberg Medal of Honor for Emperor Charles V was commissioned by the city council, and they intended to present him 100 copies as an especially valuable and prestigious gift upon his visit to the city for the Diet in 1521. Extensive planning for this official showpiece had already started one year before because the provisions of the Golden Bull passed in 1356 stipulated that each new king had to convene his first Diet in Nuremberg.

The Nuremberg Council did not want only to impress Charles V with the large number and the material value but also with its quality, excellent artistry and technical craftsmanship. As in the case of the governor medals for Frederick the Wise, the design was provided by a well-known artist of the time, Nuremberg-based Albrecht Dürer, who enjoyed the particular good graces of the Emperor. Nuremberg's Hans Krafft the Elder, who was experienced in coining large silver medals, was commissioned to produce the medals of

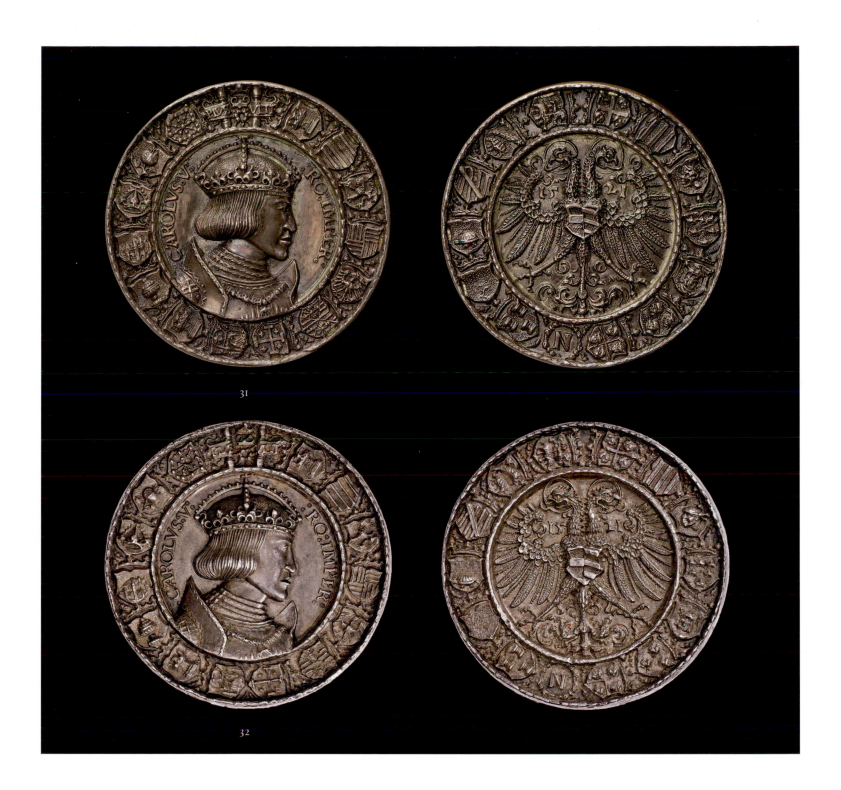

31

32

honor. He had achieved an impressive artistry in using the two-step technique for his governor medals: initially, the planchets and reliefs were cast and then over-stamped to obtain pictorial sharpness.

The medal obverse shows a crowned and cuirassed bust of the youthful Emperor wearing the collar of the Order of the Golden Fleece. His portrait is deeply cut with a raised relief that is harmoniously integrated into the broad pictorial border decorated with coats of arms. The same frieze is found on the reverse where it surrounds the double-headed imperial eagle with the arms of Habsburg and Burgundy. The 27 coats of arms essentially represent domains acquired by the Emperor though his Spanish heritage and thus document his increase in power compared to his predecessor, Emperor Maximilian I. The device PLUS ULTRA on the medal obverse displays Charles's motto in the frieze.

The carefully planned Diet could not be held in Nuremberg because of an outbreak of plague, and was moved to Worms. This is where Luther refused the anticipated revocation of his doctrines and writings. Hence, the medals were never turned over by the Nuremberg Council. The city had many of the 167 medals made by Krafft in 1537. In 1613, there were still 24 medals in Nuremberg, of which only a small number are currently extant. Besides the showpieces in Gotha and Coburg, only ten other original are known to exist. UW

Literature
Cupperi 2013, pp. 201f., cat. 100 · Eberle/ Wallenstein 2012, p. 78, fig. 94 · Habich 1929– 1934, vol. I,1, no. 18 · Maué 1987 · Schade 1983, pp. 178f., cat. C 20.1

33

Both the Cross of Burgundy (a saltire cross made of branches) and the Order of the Golden Fleece (whose collar consisted of links in the shape of the fire-steel badge) were part of the official iconography of the former Burgundian state. This entity, which was located between the Empire and France, was acquired by the Habsburgs in 1477 through marriage, a move which laid the foundation for their near-universal position of power.

In using these symbols, Ferdinand was not only reaffirming the claim of the Austrian branch of the House of Habsburg to the imperial title; he also upheld the claim on Burgundy, which had in fact fallen to the Spanish line at the division of 1521. In doing so, he proclaimed his commitment to the continuing unity of the Habsburg dynasty. SL

Literature
Müller/Kölling 1981, p. 387, cat. 217

34

Desiderius Helmschmid (armorer)
Daniel Hopfer the Elder (engraver?)
A Close Helm Made for Emperor Charles V

Augsburg, around 1536
Steel and iron, etched, fire gilt; brass, chased, rivetted
42.5 × 28.8 × 34.5 cm (including visor)
Stiftung Deutsches Historisches Museum, W618
Minneapolis Exhibition

On February 25, 1500, Charles V was born into the Habsburg dynasty in the Flemish town of Ghent. His place of birth was not accidental. Charles was the son of Duke Philip I the Handsome of Burgundy, to which Flanders belonged, and the Spanish Infanta Joanna. His grandfather, Emperor Maximilian I, had united the rich territory in the Netherlands with his Austrian domains by marrying the heiress of Burgundy. He had also arranged for the betrothal of his son Philip to the Spanish princess, thereby laying the foundation for the universal preeminence of the house of Habsburg.

Maximilian's grandson Charles would eventually rule not only the Habsburg core lands in the Empire and the Burgundian inheritance in the Netherlands, but as King of Spain from 1516, he would also become lord of this nation's newly acquired overseas possessions in Africa, America and Asia. He would go on to become head of the Holy Roman Empire, being elected Roman King in 1519 and Emperor in 1520. Charles would always maintain that he was set above all other rulers, but also had a corresponding responsibility to preserve Christendom in its entirety, especially

33

Pole Arm of the Palace Guard of Emperor Ferdinand I

Southern Germany, 1558
Iron, wood, etched, painted
Overall length: 225 cm; length of blade and socket: 33.5 cm; length of blade: 26.5 cm; width of blade: 8.3 cm
Stiftung Deutsches Historisches Museum, W410
Atlanta Exhibition

Ferdinand I became head of the Holy Roman Empire in 1558 when he succeeded his brother Charles V as Roman Emperor. Ferdinand had already been one of the most powerful rulers in Europe before this date. The division of the Habsburg inheritance in 1521 had given him control over the dynasty's core dominions within the Empire, and in 1525 he acquired the kingdoms of Bohemia, Croatia and Hungary. His election as King of the Romans in 1531 made him the official deputy of his brother within the Empire.
Ferdinand stood in the shadow of his brother for a long time, always supporting him loyally, yet he pursued a different style of policy when he became Emperor. Unlike Charles, Ferdinand was willing to work with the existing coalitions of princes and the traditional opposition in the Imperial Diets in order to find effective compromises. In the end, this made him a more successful ruler than Charles. While he was personally devoted to the Old Church, he realized at an early date that Protestantism had come to stay and needed to be accepted as a political reality. This attitude enabled him to play an important part in bringing about the religious settlement of the Peace of Augsburg in 1555.

As Emperor, Ferdinand was protected by a palace guard equipped with ceremonial pole arms of the type shown here. The broad blades of these weapons bore inscriptions of the date of his election as Emperor ("1558") and his cypher ("KF") on both faces. In addition, one side displayed an array of imperial and Burgundian symbols—the imperial crown, the cross of Burgundy and a fire-steel badge—while the other was decorated with the double-headed imperial eagle bearing a shield with the Austrian coat of arms on his breast, above the collar of the Order of the Golden Fleece.

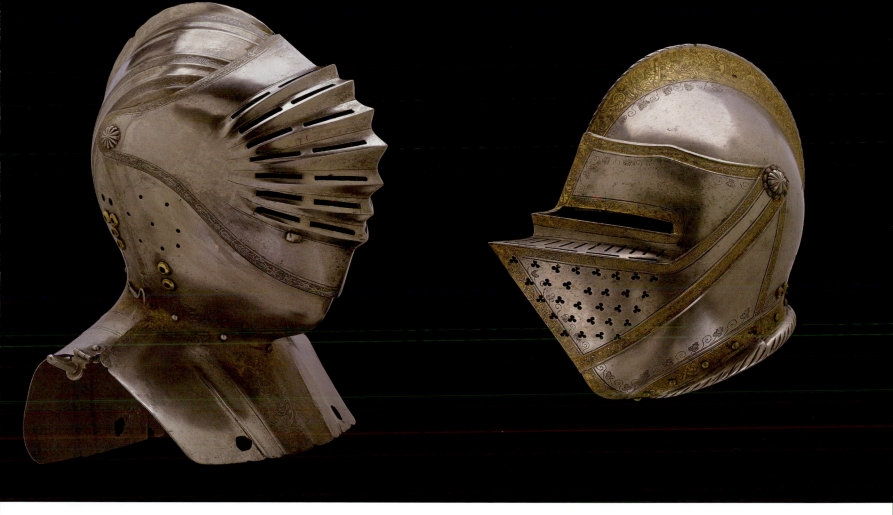

in its struggle with the Ottoman Empire of the Turks. He intended to reorganize the Church through a council to be held under his leadership. This concept of a universal monarchy, however, intensified the already festering conflict with France and its ambitious King Francis I. In the Holy Roman Empire, Charles encountered the opposition of the German imperial estates in his bid to strengthen his position as Emperor. In addition, a new major conflict emerged not long after his election with the rise of Luther's Reformation. This problem would eventually coalesce with the existing political conflicts. After initial attempts to find a peaceful solution for the impending rift, Charles went to war with the Schmalkaldic League, the defensive alliance of the Protestant estates. While Charles won this initial round in 1547, the resulting unrest among the German princes, who became wary of the loss of their liberties and religious freedom, would lead to the decisive defeat of the Emperor in 1551. Worn out by his many struggles, he resigned his offices and retreated to Spain, where he died only three years later.

As a typical Renaissance ruler, Charles would often employ representational art to enhance his position, frequently commissioning works from outstanding Dutch or Italian artists. As a prominent member of the culture of nobility that formed the common background for the elites of contemporary Europe, he was also well acquainted with the world of tournaments and the accompanying trappings. Costly armor was indispensable in this context, and Charles could afford to employ the best armorers of his time to outfit him. The helmet shown here, part of a complete multi-piece suit of armor, was fashioned for Charles by Desiderius Helmschmid of Augsburg and covered with etched ornaments by Daniel Hopfer. This helmet had an additional protective chin-piece (bevor) and neck-guard (tail), and fitted snuggly to the body armor, making it ideal for use in foot combat. SL

Literature
Kruse 2000, p. 180 · Müller 1993, p. 63 · Müller/ Kunter 1984, p. 261 · Schilling 1994

35

Jörg Seusenhofer
Close Helm for a Jousting Suit of Armor Made for King Francis I of France

Innsbruck, 1539/40
Steel and iron, etched and fire gilt
31 × 21.3 cm
Stiftung Deutsches Historisches Museum, W1016
Minneapolis Exhibition

King Francis I of France was the primary rival of Charles V in the political theater of Europe. He was a scion of the Valois dynasty that had worn the French crown throughout centuries of hereditary succession. In contrast to the situation facing their counterparts in Germany, the French Kings had been successful in strengthening the position of the monarchy and concentrating power in their capital of Paris. When he became king in 1515, Francis continued to pursue the foreign policy of his predecessors, which was mainly directed against the House of Habsburg.

Ever since this German dynasty had secured the succession to the thrones of both Burgundy (1493) and Spain (1516), France had been obsessed with the perceived threat of encirclement (cf. cat. 34). Consequently, the youthful King Francis went on the offensive, which initially won him some notable diplomatic and military victories in northern Italy, a traditional theater of conflict between France and the Empire. He even challenged Charles of Habsburg directly by announcing his candidacy for the election as a new Emperor of the Holy Roman Empire in 1519. This attempt was thwarted, however, as Charles had managed to secure the backing of the Fugger bank, which enabled him to pay higher bribes to the Electors and estates.

Francis was rather ambivalent when it came to religious matters. He negotiated a deal with the Pope that gave him substantial control over church institutions and their riches within his domain, basically constituting a state Church for France. On the other hand, he would also form opportunistic alliances with the Sultan of the Muslim Ottoman Empire and the Protestant princes of Germany in his struggle against the Catholic Habsburgs, while at the same time suppressing the Reformation in France itself. Francis also promoted the colonial expansion of France in overseas regions. He saw himself as the ruler of a new age that demanded a new kind of representational art, and he was determined to encourage this art by commissioning magnificent works of architecture and acquiring priceless Italian Renaissance paintings.

Just like his opponent Charles, though, he was also rooted in the universal tradition of European court culture, which still expressed and asserted status through the pageantry of tournaments. The armor associated with this pastime ranked high in the eyes of the nobility, and Francis made sure that he received the finest products in this field as well. It is hardly surprising that even diplomatic gifts to rulers that were intended as signs of peace and goodwill could take the shape of a suit or garniture of armor. Two fine suits of armor which Charles's brother, Archduke and later Emperor Ferdinand I, commissioned from the renowned Innsbruck armorer Jörg Seusenhofer in 1539 for Francis I fall into this category. Seusenhofer actually travelled to Paris to take the measurements of the French King, and he completed the two suits, but a renewal of hostilities prevented him from ever delivering this fine gift. SL

Literature
Kruse 2000, p. 180 · Müller 1993, p. 63 · Müller/Kunter 1984, p. 262 · Schilling 1994

36

A Sabre with an Etched Calendar Blade

Holy Roman Empire, blade before 1535, hilt added around 1700
Iron and steel, etched, ground and polished
Overall length: 93 cm; width of blade: 2.7 cm
Stiftung Deutsches Historisches Museum, W554
Minneapolis Exhibition

The slightly curved blade of this sabre is ornamented with an etched perpetual calendar for the years from 1535 to 1551. It would obviously have been made before 1535. This type of calendar allowed its user to determine the weekday on which a particular future date would fall by cross-referencing the abbreviations for the days of the week and weekend with a given date. The hilt and guard were replaced sometime around 1700.

From the closing years of the Middle Ages, astronomy and astrology had become increasingly popular in Europe, particularly among the political elite, who set great store by "the power of the stars." In this context, sword blades with calendar inscriptions, such as the one shown here, seem to have been a peculiarity of the Holy Roman Empire until well into the 17th century. The surviving inscriptions differ somewhat in the listings of feast and saints' days, a result of differing usages in the different dioceses of the Empire. This attention to detail suggests that a lot of these calendar swords were not produced as curiosity objects for art collections, but were actually intended for practical use.

This makes more sense if one considers that the Church depended on a functioning calendar to a significant degree. Its institutions had long been preoccupied with regulating the annual calculation of fixed and moveable holidays, especially the all-important date of Easter. Yet the ancient Julian calendar that Europe had inherited from the Romans was inherently flawed, being a full 11 minutes longer than the actual solar year. By the 16th century, this deviation had added up to ten days. The need for reform was obvious.

In 1582, a flexible and mathematically sound new version of the calendar (which had actually been under discussion for centuries) was proclaimed through the papal bull, *Inter gravissimas curas,* by Pope Gregory XIII with the full authority of the Catholic Church. As a one-off measure, ten days were to be struck from the calendar in October 1582, and the calculation of subsequent years was to be slightly altered. Today, this Gregorian calendar is in use across the world, with only a few exceptions within the Orthodox Church.

Initially, its acceptance in the Holy Roman Empire was widely opposed. The mere fact that this reform had been authorized by the Pope led to a

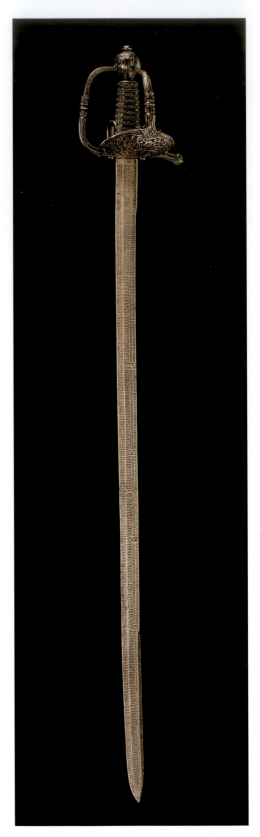

36

rejection of the "new style" and a retention of the Julian calendar by most Protestant countries, not only within the Empire, but also abroad. It took an extremely drawn-out and heated debate until a common usage was reestablished in the Empire on March 1, 1700. Even then, an obstinate core of Protestant states held out until much later.

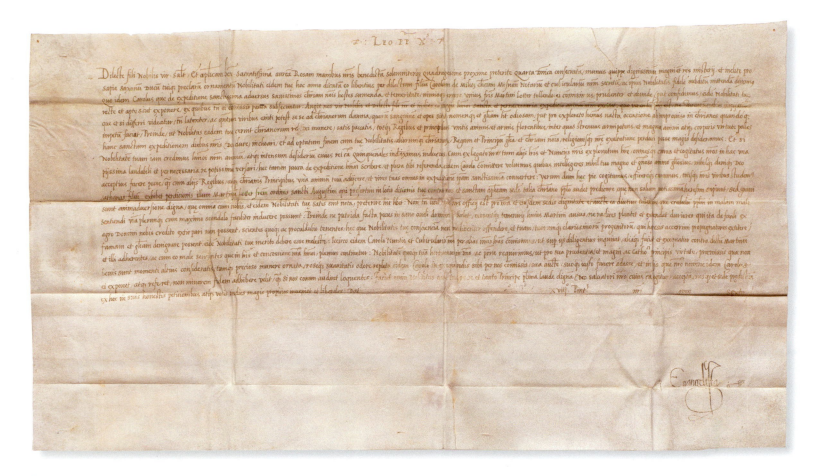

37

37

Pope Leo X

Papal Brief of 1518 to Frederick
the Wise about the Bestowal
of the "Golden Rose"
and Combating Martin Luther

Rome, October 24, 1518
28 × 50 cm
Thüringisches Staatsarchiv Gotha, QQ I Mond
no. 64
New York Exhibition

Until this date one simply had to live with the curious reality that in some regions of the Empire where the territorial structure was particularly fragmented, such as Swabia or Franconia, not only would the religious affiliation change from one village to the next, but the date of the day as well. In these regions, the calendar swords did actually fulfill a practical purpose in day-to-day situations. SL

Literature
Hamel 1999 · Müller/Kölling 1981, p. 69 · Quaas 1997, pp. 25 and 31 (ill.)

Frederick III, called the Wise, ruled from 1486 to 1525 as Elector of Saxony and was among the chief supporters of Martin Luther and the Reformation. He served as imperial vicar following the death of Emperor Maximilian and was offered the imperial crown because of his personal qualifications, as well as the manner in which he exercised his office. However, Frederick recognized that the House of Wettin was not as powerful as the Habsburgs and that this strength would be needed in order to steer the Holy Roman Empire into safe waters in the face of severe threats from the Turks and the French.

Initially, one might have called Frederick the Wise a devout Catholic, as he had made a pilgrimage to the Holy Land in 1493 and assembled a large collection of relics in Wittenberg (cf. cat. 106 and 107). However, he rejected the financial exploitation of his subjects through the excessive sale of indulgences, as practiced by the Elector of Mainz, Albert of Brandenburg, with whom he was also engaged in a dispute concerning Erfurt. Accordingly, his initial support for Luther was motivated not by theological criticism of the Church, but rather the prospect of financial benefits from taking a stand against the sale of indulgences.

At first, the Roman Curia underestimated the impact of Luther's theses on the sale of indulgences. After all, they felt in control and had already been successful in suppressing other he-retical movements. However, once Rome realized that the Reformation posed a considerable threat to the Catholic Church, efforts were made to combat Martin Luther by any means necessary. To this end, Pope Leo X turned to Frederick the Wise, Elector of Saxony, to award him the Golden Rose of Virtue, a distinction which was reserved for those of particular merit in the service of the faith. In return for this distinction, papal emissary Karl von Miltitz was to obtain the Elector's agreement to come out against the Lutheran teachings and arrest the insubordinate monk. The degree to which Martin Luther was hated by the Roman Curia is expressed in his designation as "son of the devil."

Frederick the Wise accepted the Golden Rose but was steadfast in his support for Martin Luther. In 1521, when Luther was in extreme danger on his way back from the Diet of Worms, after the imperial ban had been imposed, the Elector had him brought to Wartburg Castle, where he was placed under the personal protection of the Elector's officer, Hans von Berlepsch, until 1522. StA

Literature
Holzinger 2013

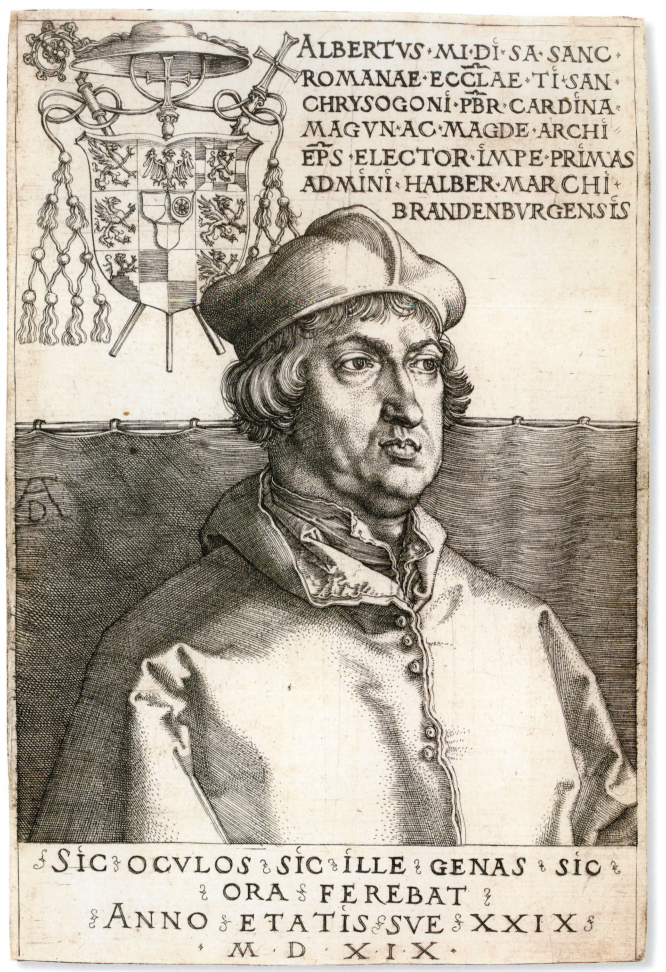

ALBERTVS · MI · DI · SA · SANC ·
ROMANAE · ECCLAE · TI · SAN ·
CHRYSOGONI · PBR · CARDINA ·
MAGVN · AC · MAGDE · ARCHI ·
EPS · ELECTOR · IMPE · PRIMAS ·
ADMINI · HALBER · MAR CHI ·
BRANDENBVRGENSIS

Sic · OCVLOS · Sic · ILLE · GENAS · Sic ·
ORA · FEREBAT ·
ANNO · ETATIS · SVE · XXIX ·
· M · D · XIX ·

The Joint Exercise of Clerical and Worldly Power

Among the great princes of the Holy Roman Empire, the church prelates formed a unique category. They combined high offices in the Catholic Church with worldly powers and positions. This class included archbishops and bishops, abbots and provosts of great convents as well as the grand master of the Teutonic Order. The three Prince-Archbishops of Mainz, Cologne and Trier also held Electoral rank according to the Golden Bull of 1356. This meant that they were entitled to elect a new Roman-German King in conjunction with the four lay Electors. These three prelates were subject only to the king. The boundaries of the territories which they ruled could overlap with the borders of their church provinces, but often deviated significantly.

This dual role had its origins in the High Middle Ages, when the crown had relied heavily on church representatives for its administration. Apart from their clerical authority, they also came to enjoy worldly privileges and possessions. As members of the imperial estates, their power exceeded the authority in their sees and purely clerical affairs. Inevitably, this brought great wealth with it, and a lavish lifestyle of ostentatious representation.

Albert of Brandenburg was a typical representative of this class. As one of his residences was the town of Halle, he became involved in the rise of the Reformation in nearby Wittenberg. Albert had amassed a substantial collection of relics for the cathedral in Halle, in direct competition to the collection of Frederick the Wise in Wittenberg. Albert also demonstrated his power through the lavish endowment of his cathedral with numerous altar paintings created by renowned artists such as Lucas Cranach the Elder and Matthias Grünewald.

When he purchased the post of Archbishop of Mainz in 1514, Albert of Brandenburg also acquired the Electoral dignity and the office of Chancellor of the Empire. His family, the House of Hohenzollern, now held two of the Electoral votes (Mainz and Brandenburg), which made it one of the most powerful dynasties of the Empire. But Albert was forced to substantial amounts of money to achieve this goal, which he tried to recoup by organizing the sale of indulgences in his domains. Unfortunately, his scheme backfired when the theological discussion of these indulgences led to Luther's Reformation. SKV

38

Albrecht Dürer
Cardinal Albert of Brandenburg

1519
Copper engraving
Sheet: 14.8 × 10 cm
Stiftung Deutsches Historisches Museum,
Gr 2005/43
New York Exhibition

Original title: ALBERTVS. MI. DI. SA. SANC. ROMANAE. ECCLAE. TI. SAN. CHRYSOGONI. PBR. CARDINA. MAGVN. AC. MAGDE. ARCHI. EPS. ELECTOR. IMPE. PRIMAS. ADMINI. HALBER. MARCHI. BRANDENBURGENSIS
Original subtitle: SIC OCVLOS SIC ILLE GENAS SIC ORA FEREBAT ANNO ETATIS SVE XXIX. M.D.X.I.X

During the Imperial Diet held in Augsburg in 1518, Albrecht Dürer seized the opportunity to portray Cardinal Albert of Brandenburg. In a letter written to Georg Spalatin in early 1520, the artist remarked that he had sent 200 printed copies of the image and the printing plates themselves to the dignitary, and had been richly rewarded in return. Margrave Albrecht (or Albert) of Brandenburg, the younger brother of the Elector of Brandenburg, Joachim I, had become Archbishop of Magdeburg in 1513 (when he was only 23 years old), and Elector and Archbishop of Mainz in 1514. When he applied for the cardinal's purple in 1517, he was forced to ask the banking house of Fugger for a loan, as he needed a lot of money to pay for both the dispensation from the prohibition on accumulating offices and the required appointment fees to the pontifical Curia. To repay the loan, he had to promise the banking house a cut of the revenues generated by the special sale of indulgences that the Pope had granted to him. This kind of "cross-financing" was one of the reasons why Martin Luther penned his 95 Theses against the sale of indulgences. On August 1, 1518, Albert of Brandenburg finally received the coveted—and dearly bought—purple. The printed portrait of the recently appointed church dignitary was meant for the *Halle Reliquary Book* of 1520. Behind the head of the subject, his coat of arms, with a red cardinal's hat above it, is visible on the left. Right next to it, his complete title takes up seven lines of Latin text. Its translation reads: "Albert, by the grace of God Cardinal priest of the Holy Roman Church, appointed to the titular Church of Saint Chrysogonus, Archbishop of Mainz and Magdeburg, Elector, primate of the realm and administrator of the see of Halberstadt, Margrave of Brandenburg." The caption of the image, which is also in Latin, reads (in translation): "Thus appeared his eyes, cheeks and mouth in the 29th year of his life, 1519." LK

Literature
Anzelewsky 1988, p. 200 (ill.) · Schoch/Mende/Scherbaum 2001, pp. 221–223 (ill.)

39

Golden Chasuble with the Crest of Cardinal Albert of Brandenburg

Central Germany, 1530–1535
Fabric (northern Italy, 1st-third of the 16th century): lampas of red and yellow silk with gilded metal wire; chasuble cross (attributed to Hans Plock, Halle 1530–1535): gold and pearl embroidery (only a few freshwater pearls remaining); flowers formed from metal wires and strips of parchment and wrapped in colored silk; crest: silk fabric, embroidery with various colors of silk, gold and silver strip-thread and metal wire
127 × 93.5 cm
Vereinigte Domstifter zu Merseburg und Naumburg und des Kollegiatstifts Zeitz, Merseburg, Domstift, Gewänderinventar Nr. 3
Minneapolis Exhibition

The original gleaming golden splendor of this vestment can now only be surmised due to the damage, particularly on the back side of the garment. On the front, the luxurious decorative pattern of the fabric is visible, with its fire bowls in abundant tendril work. The representation of these precious materials in paintings from the first-half of the 16th century show that they were used in magnificent garments and elaborate decorations in both the sacred and secular sphere. The main ornament of the chasuble is the broad cross on the back. The frame and the inner fields are covered with embroidered tendril decoration in the forms common to the early Renaissance. The large crest of Albert of Brandenburg is applied in the center of the arms of the cross. This church ruler was intentional about the way he was represented and thus commissioned his own extended crest of 15 fields to be attached to the chasuble. He was first able to use this extended crest from 1530, after an agreement between the House of Electoral Brandenburg and the Dukes of Pomerania. The middle field depicts his three dioceses. Above the shield of the crest is the cardinal's hat, which stands out in three dimensions. The insignia of the cross, crook and sword have been lost.
The once densely packed array of freshwater pearls sewn to the fabric contributed to its particular costliness. Such pearl-embroidered elements on liturgical garments are often portrayed in contemporary paintings of Albert of Brandenburg. The Cardinal employed a pearl and silk embroiderer, Master Hans Plock from Mainz, who

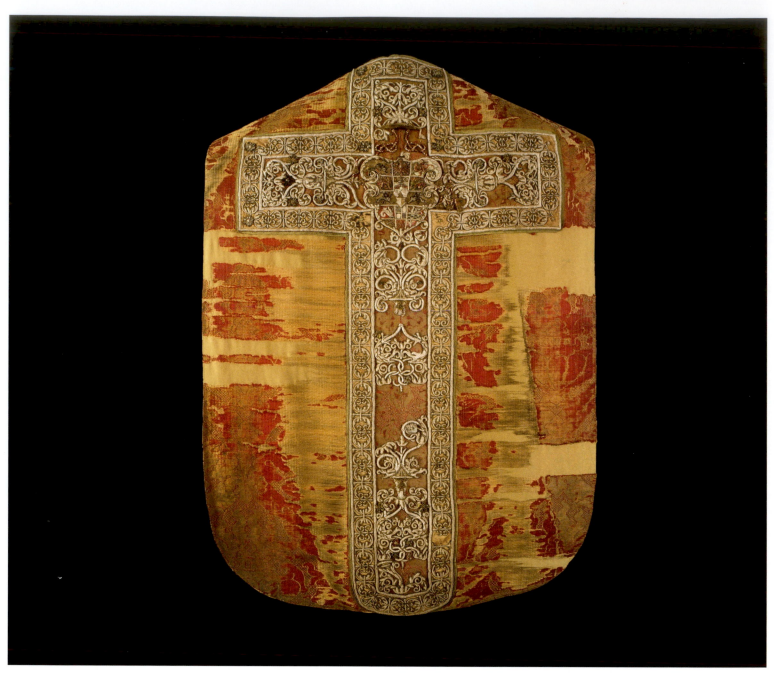

39

was in Albert's service from before 1520 and moved with him to Halle. Plock created embroidery not only for Albert's vestments, but also for the decoration of his collection of relics and the Halle parish church. The elaborate and high quality embroidery of the Merseburg chasuble cross suggest that Hans Plock was indeed the artist of the work. This thesis is supported by a comparison with the only other surviving textile artwork that can be attributed to Plock due to his signature, the Hassenstein-Lobkowitz Pearl Altar (Czech Republic, Castle Nelahozeves).

The valuable chasuble must have come to Merseburg on some special occasion, likely the consecration of Sigismund von Lindenau as Bishop of Merseburg in 1535, which was performed by Albert of Brandenburg himself. BP

Literature
Cottin/Kunde/Kunde 2014, pp. 362–364 (ill.) · Heise/Kunde/Wittmann 2004, pp. 199–201, cat. IV.3 (ill.) · Pregla 2006 · Pregla 2008 (ill.) · Schauerte/Tacke 2006, vol. 1, p. 104, cat. 34 (ill.)

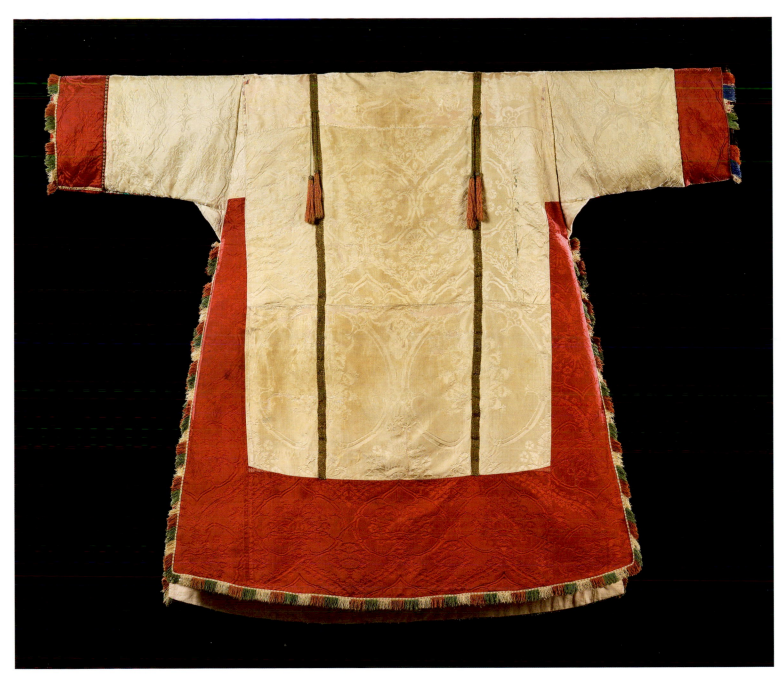

40

40

Dalmatic
with the Crest of Cardinal
Albert of Brandenburg

Probably central Germany
1513 (at the earliest) until the 1520s
Fabric (northern Italy, last-quarter of the 15th/
early-16th century): white and red silk damask
128 × 151 cm (with extended sleeves)
Stiftung Dome und Schlösser in Sachsen-
Anhalt, Domschatz Halberstadt, 201
Minneapolis Exhibition

This festive dalmatic combines and contrasts the basic liturgical color white with red portions, accentuated by narrow gold trimming. On the upper back, sewing holes and breaks in the fabric point to two missing laces. These were probably also made of gold trimming. Thin green braided bands are passed through and lightly tied in three places around the vertical edges. Silver fabric balls with long red or green silk tassels hang from the ends of these bands. On the front side, only two of these decorative elements survive. The missing bands can be reconstructed on the basis of marks on the gold edges. The seam edges of the sleeves, the open sides and the lower edge of the front and back pieces are edged with fringed borders made of colored silk threads. The crest on the back tells us that the garment was a donation from Cardinal Albert of Brandenburg. The dalmatic belongs therefore, like the blue chasuble (cat. 83), to a group of textiles connected to the church ruler and opponent of Martin Luther, who from 1513 was also administrator of the Diocese of Halberstadt. BP

Literature
Pregla 2006, p. 359 (ill.)

The Rulers of Saxony

The Wettin Dynasty is one of the oldest noble families in Europe. Originally the Margraves of Saxony, they had been granted the electorate by the Emperor in 1423 for their help against the Hussites. In 1485, the two brothers Ernst (Ernest) and Albrecht (Albert) divided the family lands and created two dynastic branches. Of these, the elder Ernestine branch ruled Thuringia from their residence in Wittenberg, to which the electoral title was attached. The Albertine lineage acquired the dignity of a dukedom and ruled the March of Meissen and other lands west of Leipzig.

In the following generation, the sons of Ernest, Frederick the Wise and John the Steadfast, became supporters of the Reformation. While Frederick protected Luther from persecution, John introduced the Lutheran creed to the Ernestine lands. Two further brothers held important posts in the Catholic Church, but died before the Reformation began. The son of John, John Frederick I the Magnanimous, became leader of the Schmalkaldic League, but was defeated in 1547 and lost his electoral title to his Albertine cousins.

This branch of the dynasty had been led for a long time by the main adversary of the Reformation, Duke George the Bearded. From his residence in Dresden, he fought to prevent the spread of the Reformation. He had married two of his children to the ruling house of Hesse, unaware that his son-in-law would become one of the leaders of the Schmalkaldic League. George's younger brother, Henry the Pious, supported the Reformation and introduced it to Albertine Saxony after George's death in 1539.

His sons Maurice and Augustus continued this lineage. Maurice pursued a policy aimed at expanding his lands and influence. He sided with the Emperor and gained the electoral title after defeating his Ernestine kin. But when his hopes were disappointed by Charles V, he switched sides again and led a rebellion which drove the Emperor to the brink of defeat in 1522. His successors were unable to maintain such a high profile in European politics, and it would take some 150 years until the Albertine house regained comparable status under Augustus the Strong. The Ernestine branch of the Wettins endured their reduced status until the 19th and 20th century brought them recognition again when several members married advantageously and occupied the thrones of various European monarchies. ASR

41

Hans Krafft the Elder, after Lucas Cranach the Elder

Medal (so-called Statthaltertaler) on the Governor-Generalship Invested in Frederick the Wise in 1507

n. d., made in 1513
Silver, looped and minted
D 50 mm; weight 65.2 g
Foundation Schloss Friedenstein Gotha,
4.1./1150
Minneapolis Exhibition

Obv: FRID · DVX · SAX – ELECT · IMPER – QVE · LOCVM · TI – NES · GENERAL
The obverse legend is interspersed with four coats of arms of the Electorate of Saxony, Duchy of Saxony, Margravate of Meissen and Landgravate of Thuringia. Bearded bust of the Elector with cuirass and wire cowl on hair, intaglio, girded by ornamental wreath of arcs. One cuirass IHS (S retrograde) · MARI
Rev: MAXIMILIANVS · ROMANORVM · REX · SEMPER · AVGVSTVS
Single-headed eagle with head aureole decorated with arcs and imperial (Austrian-Burgundian) escutcheon as breastplate.

Commemorations of the governor-generalship of Frederick the Wise are impressive testimonies of the birth of the art of medal making in Germany, which was one of the earliest and most efficient propaganda tools, used to disseminate images of leading personalities and faith-based ideologies in the Reformation period. Medals like this were made when the Elector was appointed *locum tenens* (temporary deputy) of the then King and later Emperor Maximilian I during the latter's absence from the Empire for the Imperial Diet of Constance on August 8, 1507. The first *Verehrpfennige* ("veneration coins") and medals were made as early as 1508 for the prompt propagation of his high office and the elevated social position granted to him. In order to have his *Contrafeitenmünzen* ("portrayal coins") optimally minted to his personal ideas and requests, in 1507 Frederick the Wise commissioned Lucas Cranach the Elder to create stone-cut models. He also had up to four die-cutters working for him until 1519.
Cranach painted his earliest ceremonial portrait of the Elector for Nuremberg's Dominican church around this same time. The inscription on the painting also refers to the contemporary political situation and Frederick's rise to power.
The use of various pictorial media illustrates the deliberately calculated intensity of dynastic presentation as early as at the beginning of the 16th century.

The original die-cutters for the medal project, Hans Krug the Elder, Lorenz Werder and Ulrich Ursenthaler the Elder, were later replaced by Nuremberg-based goldsmith and die-cutter Hans Krafft the Elder, who used different pairs of stamps to create various imperial governor medals with the typical bust portrait of the Elector between 1513 and 1519.
Frederick the Wise was permitted to keep the title of a governor-general *honoris causa* until the death of Emperor Maximilian I in 1519, although this function was restricted only to the times when the Emperor was absent from the Empire. Wittenberg's court chaplain and close confidant of Frederick, Georg Spalatin, recorded that he had a high demand for *Verehrpfennige* because he gave away "many splendid guilders and silver portrayal coins both during and outside of Imperial Diets." UW

Literature
Bild und Botschaft 2015, pp. 240–246, cat. 79 (ill.) · Cupperi 2013, cf. p. 123, cat. 27 (Year 1519) · Marx/Hollberg 2004, p. 52, cat. 21 (ill.) · Schuttwolf 1994 b, cat. 6,17 (ill.) · Tentzel 1982, p. 19, pl. 2,III

42

Medal of Elector John and Duke John Frederick of Saxony

1530
Ore Mountains Mint
Silver, cast, fire-gilded, double-looped with eyelet
D 42.5 mm; weight 17.22 g
Foundation Schloss Friedenstein Gotha,
4.1./1159
Minneapolis Exhibition

Obv: IOANNIS · E – LECTORIS · D – VCIS · SAXON – IAE · ET · FILI – IOANNIS · – FRIDERICI · – EFFIGIES · – · M · D · XXX ·
Legend with escutcheons of Electorate of Saxony, Landgravate of Thuringia, Duchy of Saxony and Markgravate of Meissen
Bearded busts of John and John Frederick to right with foldable-brim hats, strongly pleated shirts, doublets and fur-trimmed robes
Rev: MONETA · ARGENTEA · DVCVM · SAXONIAE · LAVS · TIBI · DEO
Triple-helmeted escutcheon with major coat of arms of Saxony

John the Steadfast and his brother, Elector Frederick III, had ruled Ernestine Saxony since 1486. John was bestowed with electoral dignity in 1525 and, as a convinced and committed Lutheran, he decreed the introduction of Protestantism into his domains that same year. In 1527, he founded the Evangelical-Lutheran Church of Saxony and became its first regional bishop. He was

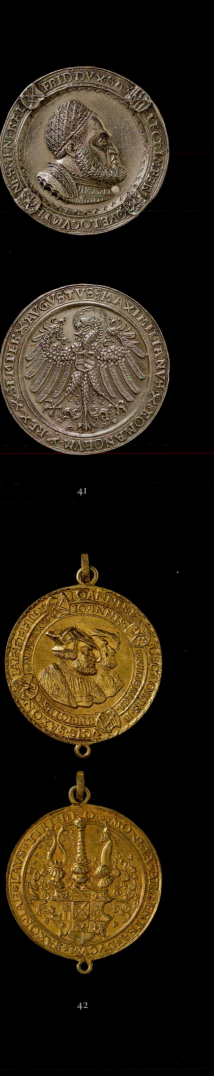

41

42

an active adherent of the Reformation, and on February 27, 1531 he and Landgrave Philip of Hesse, organized the Schmalkaldic League, a defense alliance of the Protestant imperial estates. Additionally, he played a substantial role in supporting the Reformation-influenced Wittenberg University. His unwavering commitment to the Protestant denomination earned John the epithet "the Steadfast" after the Imperial Diet of Augsburg in 1530.

The obverse of the 1530 medal depicts a double portrait of Elector John the Steadfast with his son John Frederick. There are three known variants of the reverse, which include the Saxon major coat of arms and two slightly differing die variants depicting Herod's banquet. There are four more medal types that depict both Ernestine princes together or John the Steadfast alone dating from 1530. Thus, the year of 1530 appeared to be particularly important for the Elector and his son in terms of propaganda on medals.

The double portraits on the medals, grounded in the iconographic tradition of Saxon *Klappmützentaler* (foldable-brim hat Taler), are primarily a display of dynastic power by the depicted persons, also in the spirit of Reformation. Together with his father, John Frederick became politically active after the former's accession to power, was an avid adherent of Luther since around 1520 and, like the Elector John, publicly committed himself to Reformation. Hence, he was substantially involved in the organization and internal structuring of Protestant churches and associated visitations. UW

Literature
Bild und Botschaft 2015, pp. 256 f., cat. 86 (ill.) · Schuttwolf 1994b, pp. 18 f., cat. 4,15 (ill.) · Hortleder 1622, vol. IV, p. 32 · Tentzel 1982, p. 51, pl. 5/I · Habich 1929–1934, vol. II, no. 1911

Portraits of the Electors of Saxony

43
Lucas Cranach the Elder
Frederick the Wise

1525–1527
Oil on ash
40.5 × 25.6 cm
Stiftung Deutsches Historisches Museum,
1988/705
Minneapolis Exhibition

Signed on the left with winged serpent

44
Lucas Cranach the Elder
John the Steadfast

After 1532
Oil on copper beech
36 × 23 cm
Stiftung Deutsches Historisches Museum,
Gm 95/56
Minneapolis Exhibition

45
Lucas Cranach the Elder
Frederick the Wise

1536
Oil on beech
20.2 × 14.6 cm
Foundation Schloss Friedenstein Gotha, SG 8
New York Exhibition

Signed in upper left corner with winged serpent

46
Lucas Cranach the Elder
John the Steadfast

1536
Oil on beech
20.8 × 14 cm
Foundation Schloss Friedenstein Gotha, SG 9
New York Exhibition

Signed in upper right corner with winged serpent

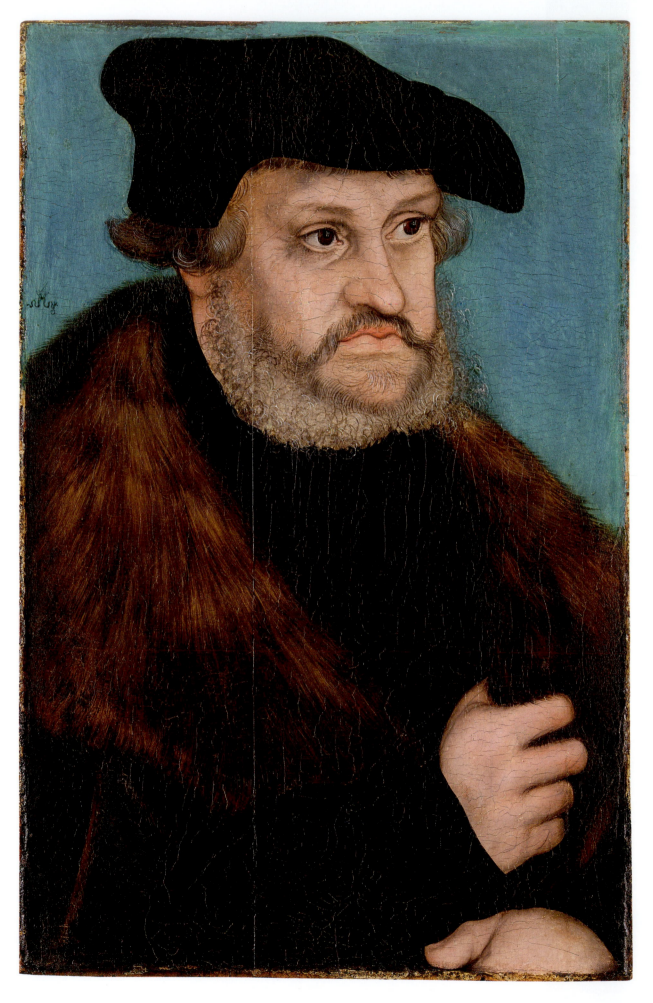

43

47

Lucas Cranach the Elder, workshop
Frederick the Wise

1532
Oil on copper beech
13.2 × 12 cm
Luther Memorials Foundation of Saxony-Anhalt,
G 22
Minneapolis Exhibition

Dated on the left "1532" and signed with
winged serpent

Following the death of Frederick the Wise, his
successor, John the Steadfast, commissioned
numerous portraits of his brother, including sin-
gle portraits, which served to memorialize his
predecessor, as well as double portraits, which
served to legitimize the rule of his successor.
They also served as a declaration of support for
the Reformation.

The portrait of Frederick III (cat. 43) is one of nu-
merous versions of the single portrait and was
presumably made shortly after the Elector's
death on May 5, 1525. The signature on the top
left, a winged snake holding a ring, identifies the
painting as the work of Lucas Cranach the Elder
or of his workshop. The portrait, showing the
subject with a full beard, cap and fur collar before
a blue background, is of a type which dates back
to 1522. In creating this portrait, Cranach pre-
sumably drew upon a study of Frederick that he
had drawn years earlier.

During the period of his rule, from 1486 until his
death, Frederick III endeavored to strengthen the
power of the nobles in the Holy Roman Empire
and to weaken that of the Emperor. While he sup-
ported the election of Charles V as Emperor, the
latter was compelled to sign a capitulation con-
ceding more rights and independence to the no-
bles. He also resisted the financial demands
made by the Pope and his representatives. This
political calculation was likely an important rea-
son for the Elector's decision to support Martin
Luther's efforts at reform. Not only did Frederick
appoint Luther to a position at the University of
Wittenberg, which Frederick had founded in
1502, but he also gave him refuge at Wartburg
Castle following the 1521 Edict of Worms, which
branded Luther an outlaw. Frederick also refused
to follow the resolution of the 1523 Diet of Nurem-
berg prohibiting the printing and dissemination
of Reformationist writings, as it was inconsistent
with his conception of free teaching.

Around 1532/1533, the portrait of John the Stead-
fast (cat. 44), Frederick's successor, was also
posthumously made in the workshop of Lucas
Cranach the Elder. This portrait shows him turned
to the left, wearing a fur coat and biretta, and
dispenses with the Elector's insignia of rule. The
importance of the ruler is made manifest with the
text below the portrait, thus following the tradi-

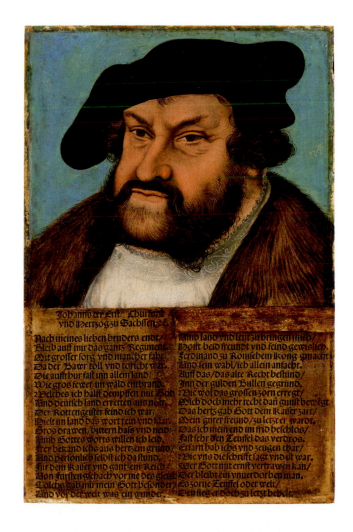

44

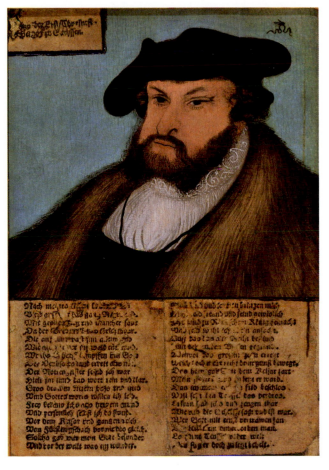

46

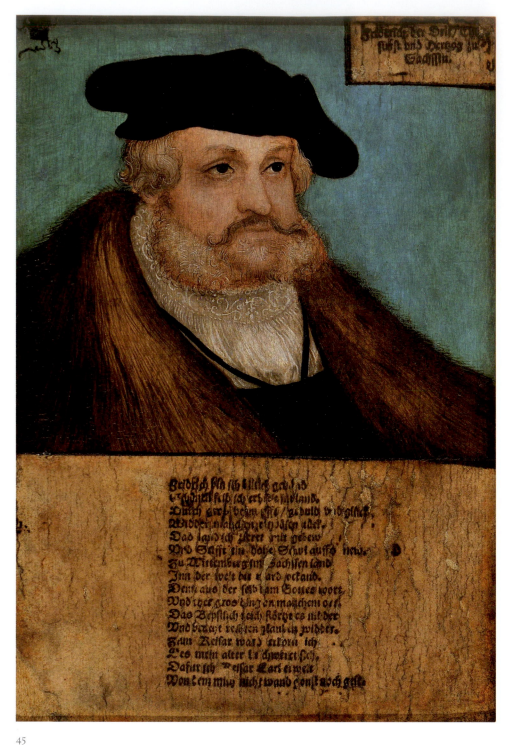

45

tion of the epitaph. It begins with the words "Following the demise of my dear brother," pointing out John's dynastic legitimacy, given that Emperor Charles V had refused to grant him fiefdom over his territory as a feudal lord because of his support for the Reformation. It also justifies his actions, such as his violent suppression of the peasants' uprising in 1525, immediately after he assumed office, and his difficult but ultimately loyal relationship with the Emperor. John the Steadfast took steps to implement the Reformation within the territory under his control and continued his brother Frederick's support for the Reformation, so that his portrait should also be seen as a confession of faith.

John Frederick assumed the office following the death of his father John in 1532, and became one of the leaders of the Schmalkaldic League, which was formed in 1531 as an alliance of Protestant princes under the leadership of Saxony and Hesse. In order to solidify his status as a legitimate Elector upon taking office, John Frederick the Magnanimous, in turn, ordered 60 double portraits of his predecessors, John the Steadfast and Frederick the Wise, for 109 guilders for "happy and praiseworthy remembrance" (invoice of May 10, 1533, Thüringisches Hauptstaatsarchiv Weimar, Ernestine Archive, Reg. Bb 4361, f. 44r), at least the first copies of which were attached by a hinge. The hinges underscore the allusion to the common book format of the time. The small panels are nearly in quarto format of 20.5 × 14.5 cm. The use of a common book format as a template is a further demonstration of the serial character of production in the Cranach workshop, especially since it was engaged in printing books as well. The counterparts in the collections of the Foundation Schloss Friedenstein Gotha are likely not part of this exact series, but might have been based on these portraits (cf. cat. 45 and 46). Because of the lowered wings in Cranach 's signature, which changed in the period after the death of Hans Cranach, it is presumed that these works should be dated after 1537.

Aside from the names inscribed in the upper sections of the portraits, texts printed on paper have been glued to the painted surfaces of both panels. The text under John the Steadfast is identical to that on the Berlin portrait. The text underneath the portrait of Frederick the Wise mainly praises Frederick for founding the University of Wittenberg, at which the ideas of the Reformation were discussed and disseminated. The piece of paper with the inscription attached to the small painting from the Luther Memorials Foundation of Saxony-Anhalt (cat. 47), is torn but nevertheless shows the same inscription. The torn paper fragment at the lower edge of the panel indicates that this copy of the portrait of Frederick the Wise also contained praise for the Elector.

Given the serial production of diptych portraits consisting of text and images, one would have expected an illustrated pamphlet. The Reformation made particularly extensive use of printing, a new technology and the first mass media, helping to spread the ideas of the Reformation widely and quickly (cf. cat. 49). In this case, however, the customer opted instead to commission a painting, thought to be the more valuable medium, since the portrait pairs were to serve as gifts or those well-disposed towards the Reformation. Thus, the combination of painting and pamphlets demonstrates the significance of the new mass media, which is integrated in this case.
BR

Literature
Bild und Botschaft 2015, pp. 248–251, cat. 82 and 83 (ill.) · Habich 1929–1934, vol. II, no. 1911 · Hofmann 1983 b, pp. 204 f., cat. 79 and 80 (ill.) · Holler/Kolb 2015, pp. 110 f., cat. 69 and 70 (ill.) · Hortleder 1622, vol. IV, p. 32 · Kruse 2000, p. 247, cat. 225 (ill.) · Schade 1983, pp. 333–335, cat. E 44 and E 45 (ill.) · Schuttwolf 1994 b, pp. 18 f., cat. 4,15 (ill.) · Tentzel 1982, p. 51, pl. 5/l

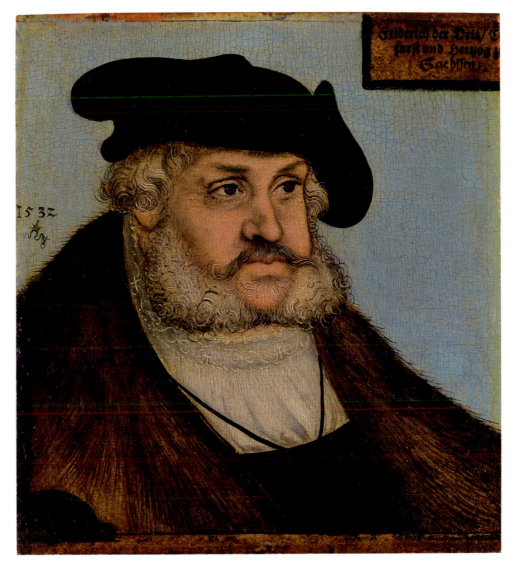

47

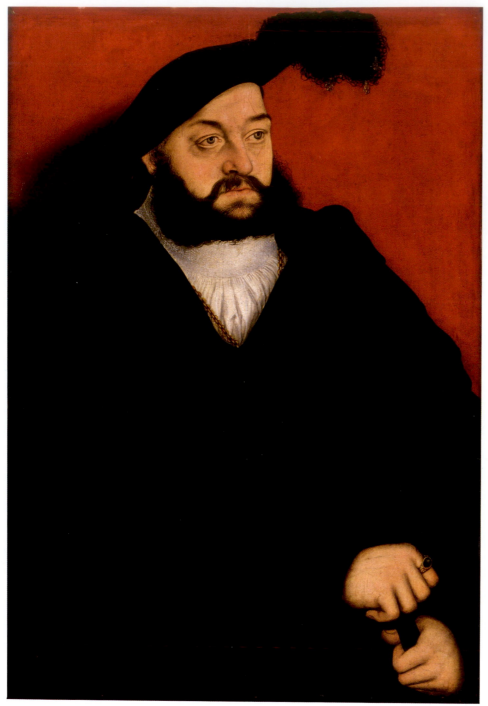

48

48

Lucas Cranach the Elder
John, Duke of Saxony

Around 1534–1537
Oil on beech panel
65.3 × 44 cm
Metropolitan Museum of Art, New York,
Rogers Fund, 1908, 08.19
New York Exhibition

Saxony was divided in 1485 between the two sons of Friedrich II, Ernest and Albrecht, who founded their own respective ducal dynasties. Frederick the Wise inherited the Ernestine branch while his cousin George came to the throne of the Albertine branch. This imposing portrait depicts John, Duke of Saxony, Margrave of Meissen, and Landgrave of Thuringia, the son of Duke George. Although George was initially sympathetic to Luther and supported the Leipzig Disputation in 1519, he turned away from Luther shortly thereafter and remained a vehement supporter of the Roman Church, even sponsoring a German translation of the New Testament to compete with Luther's (cat. 209). In spite of the fact that Lucas Cranach the Elder was the official painter to the Ernestine Saxon court, the dukes who supported the Lutheran cause, as the most famous artist in the region he was still in high demand by the political and religious authorities on the opposite side of the confessional divide. The striking red background, which brings out the black hat and garments of the duke, adds a sense of authority to the portrait. When compared with the portraits of Luther from the 1520s or the Ernestine Saxon dukes of the early 1530s—both of which predate the Albertine portraits and which are generally of a smaller and more personal scale with more subdued color choices—one can more clearly understand the role that the form of an image plays as a creator of a political or social persona. The portrait of John is unsigned by Cranach and the sitter is not identified by an inscription; however, comparisons with other images of Duke John from the Cranach workshop clearly identify the subject, and the overall technique and style of the painting accords with identified Cranach productions. In the mid-1530s Cranach produced several portraits of Duke George which share overall dimensions and figural position with this depiction of his son, and the parallelism of the two portraits suggests that as a pair they were intended to visually represent dynastic continuation (compare to the portraits of Frederick the Wise et al., cat. 43, 44, 47 and 50) and perhaps George's hopes for his son's continued anti-Lutheran stance. Unfortunately this was not to be the case, as John died childless in 1537; two years later his younger brother Frederick died (also childless), as did Duke George. The Alber-

tine opposition to Luther thus ended when George's brother Henry IV, a recent Lutheran convert, inherited the throne. JTM

Literature
Ainsworth/Waterman 2013, cat. 15 · Friedländer/Rosenberg 1979, cat. 424B · Kuhn 1936, cat. 131

49

Lucas Cranach the Elder
Elector John the Steadfast, Duke of Saxony

Around 1525 (cartoon), around 1532/33 (print)
Woodcut, colored, typographic text
Sheet 40.5 × 29.3 cm; print with text:
35.4 × 25 cm; print without text: 27.9 × 25 cm
Foundation Schloss Friedenstein Gotha,
G 38,87
Minneapolis Exhibition

Below the portrait:
Johans der Erst / Churfurst
Vnd Hertzog zu Sachssen.
Nach meines lieben bruders end /
Bleib auff mir das gantz Regiment.
Mit grosser sorg vnd mancher fahr /
Da der bawr toll vnd töricht war.

(John the First/Elector
and Duke of Saxony.
After my dear brother's end/
all of the government rested on me.
With great troubles and some peril/
since the peasant was frenzied and foolhardy.)

Woodcut portraits created by Lucas Cranach the Elder in 1525 were the model for this portrait and the pendant of Frederick the Wise. Both prints in memory of the two deceased Electors can be understood as an exhortation and appeal to the new sovereign, John Frederick the Magnanimous. He commissioned sixty small portraits of his father (John the Steadfast) and his uncle (Frederick the Wise) from Lucas Cranach the Elder in 1533. They were intended as diplomatic gifts for friends and royal relatives. The typographic texts affixed to those are consistent with these broadsheets. The woodcut portraits were surely somewhat more modest gifts.

The Elector is portrayed in a sumptuous fur in half-length, turning slightly to the left. He is wearing a beret on his head, which is slit in the front, revealing its dyed lining. He has curly hair and a full beard, shaved around his chin. Two crests identifying him as the Elector and Duke of Saxony appear in the top left of the print.

Upon the death of his unmarried brother Frederick, the then 57-year-old John assumed rule of

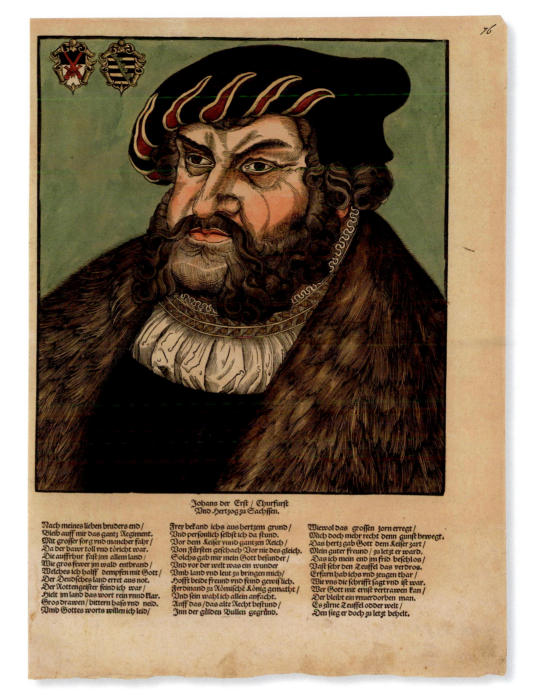

49

electoral Saxony, which he had ruled together with his brother for the preceding 39 years. Whereas Frederick the Wise had merely tolerated Reformation changes, John quickly confessed his faith in the new religious doctrine and refused to be dissuaded by Charles V's pressure and aggression.

Consolidation of the new confession began once the rebellious peasants had been subjugated in 1525. The Protestant estates of northern Germany and the Landgrave of Hesse established a defensive alliance under John's leadership. The Elector appeared at the Diet summoned in Augsburg in 1530 with a "Saxon proposal" formulated by Luther, Bugenhagen and Melanchthon, which he himself had commissioned. He was the chief proponent of the *Augsburg Confession* (cf. cat. 345 and 346), in which the Lutheran confession of faith was formulated for the first time. That same year, the Schmalkaldic League was established under his leadership against possible aggression by the Emperor and his followers. BS

Literature
Bild und Botschaft 2015, pp. 254 f., cat. 85 (ill.) · Brandsch 2001, pp. 14 f. (ill.) · Haag/Lange/ Metzger/Schütz 2011, p. 125, cat. 64 (ill.) · Schäfer/Eydinger/Rekow (forthcoming), cat. 18 (ill.) · Strehle/Kunz 1998, pp. 150–153, 280, cat. 71 (ill.)

Lucas Cranach the Elder
Portraits of the Electoral Couple

1535
Oil on beech wood
New York Exhibition

50

John Frederick the Magnanimous

19.8 × 13.8 cm
Foundation Schloss Friedenstein Gotha, SG 13

51

Sibylle, Wife of the Elector of Saxony

20.2 × 14 cm
Foundation Schloss Friedenstein Gotha, SG 12

Dated in lower right corner "1535" and signed with winged serpent to the left

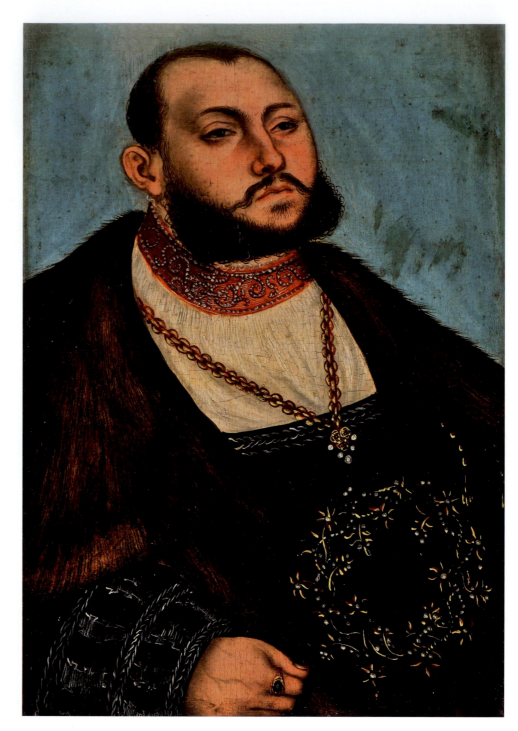

50

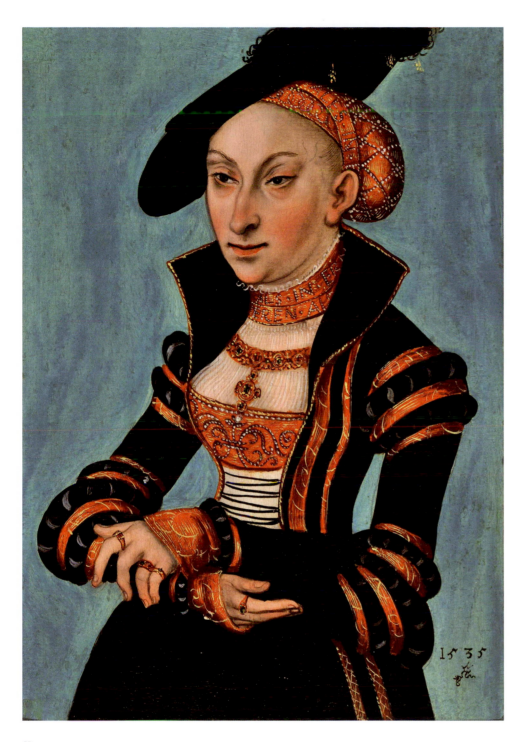

51

In addition to the well-known portrait series of his predecessors, Elector John Frederick the Magnanimous also commissioned portraits of his wife, Sibylle of Cleves, and of himself, from the Cranach workshop after he took office in 1532. Several versions of these portraits have survived, although all of them differ in their level of detail and ornamentation; almost identical counterparts survive at Veste Coburg Castle. The Gotha pair features the winged serpents, the signature of the Cranach workshop, as well as the date of 1535 on the portrait of Sibylle.

Sibylle of Cleves, the daughter of Duke John III of Cleves and Maria of Jülich-Berg, was married to John Frederick of Saxony in 1527. She is shown before a blue background in a very ornate dress, hair net and bonnet. Her device is embroidered on her collar (ALS IN ERN / EREN AL, or "everything in honor") as well as on her hair net (ALES IN E). Similar to the portrait pair of Martin Luther and Katharina von Bora (cf. cat. 227–230), the wife is shown turned towards her husband and occupies a larger section of the picture, which has the effect of making the Elector appear larger, especially since he is on the left side, the heraldically more important side. The Elector himself is dressed in a fur coat and richly decorated clothing, but unlike his predecessors, is shown without a head covering. In another difference from his predecessors, he is shown wearing a ring and chain. He holds in his hands a wreath adorned with gold and pearls, another decorative element.

Following the death of his father in 1533, John Frederick took command of the forces of the Schmalkaldic League, which was formed as a defensive military alliance for the Protestant cities and territories. The Elector continued his father's efforts and the Schmalkaldic League became an important political factor in the Reformation period. However, internal differences as to the goals of the alliance became more and more serious in the 1540s. The effect was to weaken the alliance, which resulted in its defeat at the Battle of Mühlberg in 1547 at the hands of the forces of Emperor Charles V. The Emperor took John Frederick prisoner and removed him from the office of Elector. John Frederick the Magnanimous was released from captivity in 1552 as a duke. Shortly after, he was given the title "Elector by birth," and he died in 1554, just a few days after his wife. BR

Literature

Bild und Botschaft 2015, pp. 258 f., cat. 87 and 88 (ill.) · Brandsch 2001, pp. 43 f., cat. 1.8 and 1.9 (ill.) · Marx/Kluth 2004, pp. 149 f., cat. 203 and 204 (ill.) · Schuttwolf 1994 a, pp. 26 f., cat. 1.8 and 1.9 (ill.)

52

Album of the Wittenberg Scholar Abraham Ulrich and his Son David

Wittenberg and other places, 1549–1623
Manuscript on paper, binding: parchment
over paper boards
15.4 × 10.4 cm
Stiftung Deutsches Historisches Museum,
Do 92/71
Atlanta Exhibition

The Wittenberg scholar's album, a collection of signatures and inscriptions by important contemporary individuals, was started in the year 1549 when the first entries were made for Abraham Ulrich, the future superintendent in Zeitz; from 1580, the album was continued by his son David. It contains 98 entries for Abraham Ulrich from 1549 to 1577 and 218 entries for David between 1580 and 1623. It therefore qualifies as the third-oldest album in existence and towers above the other surviving albums due to the prominence of Abraham and David, important figures from the Wittenberg community of theologians and scholars.

Keeping albums came into fashion in Wittenberg shortly after Martin Luther's death in 1546, and spread quickly throughout Europe. In addition to famous names associated with the Reformation, such as Philip Melanchthon, Johannes Bugenhagen, Johannes Dryander, Joachim Camerarius, Matthias Flacius Illyricus, Justus Jonas, Caspar Peucer, Tileman Heshusen, Cyriacus Spangenberg and Georg Major, the Wittenberg scholar's album also includes numerous entries by well-known scientists, such as the anatomist Andreas Vesalius and the father of mineralogy, Georg Agricola. The entries for David Ulrich, on the other hand, date back in part to his time at the academy in Zerbst and the University of Jena, as well as his extensive travels starting in 1595 as a notary for the Imperial Chamber Court in Speyer.

One of the outstanding episodes in the life of David Ulrich was certainly his November 1581 encounter in Wittenberg with Lucas Cranach the Younger, who entered his name on folios 43v–44r of the album, along with his family coat of arms and Psalm 146:3–4. In the entry, he calls himself "Lucas Cranach the elder [sic] painter in Wittemberg." Lucas Cranach the Younger died on January 25, 1586 in Weimar and was buried in Wittenberg on January 27, 1586. Lucas's sons, Augustin

and Christoph Cranach, who were present at the funeral, also entered their names on the back of folio 44 (which had remained empty) of David Ulrich's album on February 1 and 4, 1586. This indicates that David Ulrich took part in the funeral of Lucas Cranach the Younger and that he took advantage of the opportunity to resume the close relationship between the two families. This inter-familial bond was first formed between Abraham Ulrich and Lucas Cranach the Yonger in Wittenberg. Both were from Kronach and it has been established that Abraham Ulrich also tried to change his last name to Cranach. MM

Literature
Enke/Schneider/Strehle 2015, pp. 156 f. (ill.) ·
Wittenberger Gelehrtenstammbuch 1999 (ill.)

The Cranach Family in Wittenberg

By appointing the Vienna-based Lucas Cranach in 1505 to be his court painter, Elector Frederick the Wise of Saxony laid the cornerstone for the success story of the Cranach workshop in Wittenberg over several generations. At first, the painter Cranach used workrooms in the castle where he also designed furniture and festival and tournament decorations and served as the Elector's artistic advisor. Along with a basic salary, he received separate payments for any work done for the Elector and was also permitted to work for outside clients. After marrying, Cranach ran a workshop of his own in the city, which soon achieved renown beyond the region on account of its high productivity. His efficient division of labor, employment of as many as twelve workers, and repetition of visual themes earned Cranach a reputation as a "fast painter." Following the death of the eldest son Hans, Lucas Cranach the Younger assumed a leading role in the workshop, which produced a body of some 5,000 paintings, numerous drawings, woodcuts and a number of copperplate engravings.

Cranach the Elder demonstrated a talent for business as well: In 1520, the Elector granted him the apothecary privilege, and other privileges followed, which gave the businessman a monopoly in Wittenberg. As he prospered, Cranach purchased several properties and houses in prominent locations in the city and was actively involved in politics. He was a city councilman intermittently for thirty years and was elected city treasurer three times and mayor of the city several times. In 1508, the Elector conferred on him his hereditary coat of arms with a winged serpent, which he had already made his monogram in 1506 and thenceforth used to sign his pictures.

The Cranach workshop in Wittenberg backed the Reformation movement from the start. Lucas Cranach was a friend of Luther's and his early portraits of Luther gave the Reformation a face. He supplied illustrations for Luther's translation of the Bible and intermittently ran a printing press of his own, publishing Luther's translation of the New Testament in 1522. Yet, although he is closely associated with the Reformation, Cranach also worked for Catholic clients. Among other pieces, he created sixteen altars with a total of 142 panel paintings for Halle Cathedral, which were commissioned by Luther's adversary, Albert of Brandenburg. KH

53

53

Tile Fragment with a Depiction of an Angel

Wittenberg, Schlossstraße 1 (Cranachhof)
Late 16th century
Earthenware, green glazing
12.5 × 15 cm
State Office for Heritage Management and Archaeology Saxony-Anhalt, State Museum of Prehistory, 51951259-79
Atlanta Exhibition

The Cranachs, both father and son, regularly depicted God and the risen Christ surrounded by a glittering, golden aura swarming with typical chubby-cheeked putti. Our picture of *Law and Grace* (cat. 186) is a case in point. More harpy than angel, the putti's bodies are usually abbreviated to a fluffy, feathered chest sprouting outstretched wings. Putti, winged infants, above all lusty Cupid, were a mainstay of ancient Roman funerary art. Like so many classical motifs, this image was revived and integrated into Christian iconography in the early Italian Renaissance. They were seen as infant angels joyously proclaiming the glory of God, in many cases with the help of musical instruments. In the 16th century these heavenly children appear in sacred art north of the Alps and the Cranachs wholeheartedly wove them into their imagery of God's glory.

One of these angels, probably inspired by paintings or prints of the Cranach school, decorates this tile of an oven, that once heated a room in the Cranach house. Identical angels decorated an ornate stove dating around 1570 in the Melanchthon House in Wittenberg. These heavenly creatures are quite rightly shown fluttering around the top register. The decoration of a household stove with this self-referencing imagery probably amused the Cranachs. It also shows how profoundly religious iconography was entangled in the daily lives of affluent, Protestant households. LN

Literature
Kluttig-Altmann 2015a, p. 328, fig. 27 · Mendelsohn 1907

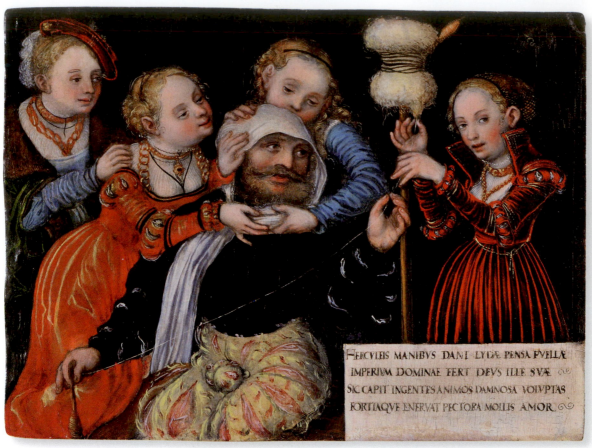

54

54

Lucas Cranach the Elder
Hercules and Omphale

Around 1537
Mixed techniques on beech wood, canvas on back
14.4 × 19.2 cm
Foundation Schloss Friedenstein Gotha, SG 7
Minneapolis Exhibition

Inscription: HERCVLEIS MANIBVS DANT LYDAE PENSA PVELLAE / IMPERIVM DOMINAE FERT DEVS ILLE SVAE / SIC CAPIT INGENTES ANIMOS DAMNOS VOLVPTAS / FORTIAQVE ENERVAT PECTORA MOLLIS AMOR (The Lydian girls give Hercules' hands work; the sovereignty of his mistress tolerates that divinity. Ruinous lust seizes powerful spirits, and even the most capable minds are enfeebled by tender love.)

This small-scale painting depicts Hercules at the center, surrounded by Omphale's servants. While two of them place a woman's bonnet on the Greek hero's head, the third hands him a strand of wool from a spindle. Omphale is looking at Hercules, while he looks at the lady standing on the right. That lady, in turn, is looking right at us, making us into her accomplice. Four Latin verses over a white background comment on the image and warn of blind love, which makes even the strongest among us go soft.

The subject of the painting recalls a theme which is prevalent in ancient times and in biblical stories, that of the power of women. By command of the oracle, Hercules served the Lydian queen, Omphale, for three years as attonement for his murder of Iphitos. Out of love for her, the pampered hero wore women's clothes, spun wool and performed other "women's work" at her behest, while Omphale took his club and lion's skin.

In an interpretation of Psalm 101 dedicated to John Frederick the Magnanimous, in 1534 Martin Luther made reference to this myth in order to warn the Elector of the dangers posed by surrounding oneself with flattering courtiers: "The pagans say of their Hercules (who was their David) that in the end he allowed women to make a fool of him. One put a veil on him, while another gave him her skirt and put a spindle into his hand. And he had to spin because of his great love... and when he had conquered all enemies around him (as Hercules did), in the end he still cannot overcome the house devil, the domestic enemy. That darling lady and beautiful queen Omphale, with her beautiful face and smooth tongue, placed the veil on her dear Hercules and ordered him to spin."

Luther's words seem to refer to Cranach's painting, with which he was clearly familiar. In the 1530s, Cranach's Wittenberg workshop created numerous paintings on this theme, with only slight variations. With its unusual small-scale format, the Gotha painting occupies a special position among the depictions of Hercules and Omphale produced in the Cranach workshop, indicating that it was created for private use. The painting can be traced to the art collection of the Dukes of Gotha as far back as 1764. ID

Literature
Bild und Botschaft 2015, pp. 216 f. (ill.) · Brandsch 2001, p. 46, cat. 1.12 (ill.) · Schade 1974, p. 85, pl. 175 · Schuttwolf 1994, pp. 24 f., cat. 1.12 (ill.)

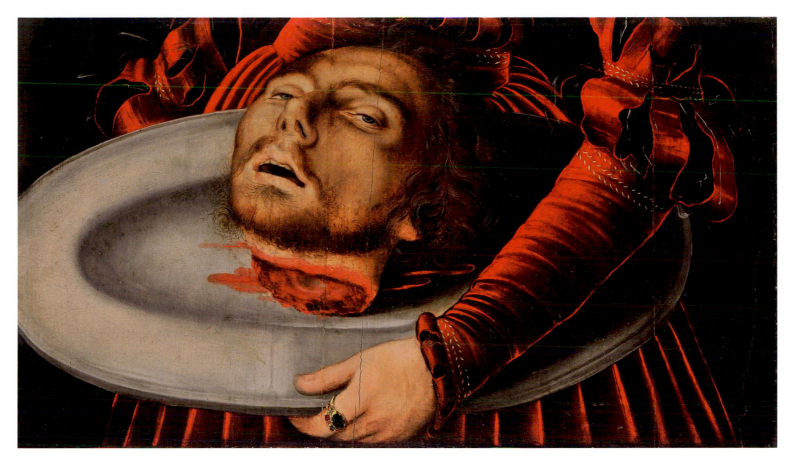

55

55

Lucas Cranach the Elder
Fragment with the Head of John the Baptist

Around 1530
Mixed techniques on fir wood
32.3 × 57 cm
Foundation Schloss Friedenstein Gotha, SG 303
Minneapolis Exhibition

This fragment consists of the lower section of a painting showing Salome with the head of John the Baptist (view of full painting fig. 3). An art dealer broke up the painting, which was sold from the Gotha collection in 1936, in order to more easily sell the woman's portrait. While the head of John the Baptist was returned to the Gotha collection that same year, the whereabouts of the upper section of the panel were unknown. In 1972, it was placed on sale by an art dealer as a portrait by Lucas Cranach the Younger of Sibylle of Saxony, but after that its trail went cold once again.

The severed head of the Baptist is presented to the viewer in a silver bowl. It is meant to evoke fear and revulsion, with its half-opened eyes, open mouth and bloody neck wound. The gruesome fate of John the Baptist is described in the Gospels of Mark (6:21–29) and Matthew (14:1–12). He was taken prisoner after he criticized the marriage of Herod and Herodias because the couple had committed adultery. After Herod watched his wife's daughter Salome perform a dance that so beguiled him that he was prepared to grant his stepdaughter's every wish, Herodias was able to convince her daughter Salome to ask for the head of John the Baptist.

Salome's story was a popular subject for court artists and was meant to be a cautionary tale about the bewitching power of women. Salome

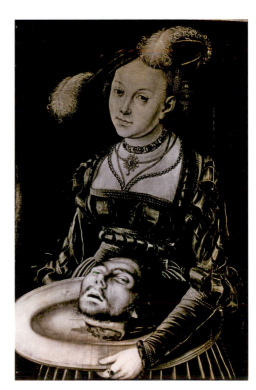

Fig. 3
Lucas Cranach the Elder, Judith with the head of John the Baptist in pre-partition condition. Photo prior to 1936

with the severed head of John the Baptist was a frequent subject for the Cranach workshop as well. She is usually depicted as a half-length figure in a three-quarter view, facing left. Her gaze, looking out at the viewer, conveys a sense of directness, and her contemporary court clothing forms a connection to the then present day. John the Baptist was an exemplary figure for Luther because he heralds the arrival of Jesus Christ, whose death brought salvation for those who believe in him. This led to greater interest in his martyrdom among Protestant nobles, and the production of Salome portraits increased in the 1530s. John the Baptist was also the namesake of John Frederick the Magnanimous, who was considered to be a defender of the true faith and a martyr himself following his loss at the Battle of Mühlberg. ID

Literature
Bild und Botschaft 2015, pp. 278f., cat. 99 (ill.) · Brandsch 2001, p. 49, cat. 1.19 (ill.) · Schuttwolf 1994b, p. 52, cat. 1.21 (ill.) · Schuttwolf 2011, pp. 51f., cat. 68 (ill.)

56

Lucas Cranach the Younger
The Judgment of Paris

Around 1540–1546
Mixed media on limewood panel
121.5 × 82.5 cm
Foundation Schloss Friedenstein Gotha, SG 672
Minneapolis Exhibition

Signed on rock in lower left corner: Serpent with lowered wings

Along with portraits and biblical subjects, scenes from Greek mythology were also part of the established repertoire of the Cranach workshop in Wittenberg. The theme of the Judgment of Paris comes from Homer's *Iliad*. In it, Paris, son of the King of Troy, had been abandoned as an infant since a prophecy foretold that he would bring disaster upon Troy. The beautiful youth leads a simple shepherd's life until Hermes, the messenger of the gods, appoints him judge of a special competition: He is to decide which of three goddesses, Hera, Aphrodite or Athena, is the most beautiful. Hera holds out the prospect of power and Athena the gift of wisdom, while Aphrodite promises him the hand of beautiful Helen. Paris opts for love. His choice proves to be a tragic error of judgment, though: Helen is already married and her abduction sets off the Trojan War and brings about the prophesied fall of Troy.
The Judgment of Paris was a popular theme in the Early Modern era and usually given a moral and didactic interpretation in humanist circles, the choice of one of the three divinities becoming a choice of one of three ways of life for Paris: Hera stands for the active life, and Athena, goddess of wisdom, embodies a life in wise contemplation, whereas Aphrodite promises a life of pleasure. Paris's choice of love ultimately leads to his undoing.
The Cranach workshop met demand for a visualization of this theme with over one dozen paintings. Initially attributed to Lucas Cranach the Elder but now to his son by recent scholarship, the panel in Gotha relocates the mythological scene in northern Europe. Paris is pictured as a knight in contemporaneous armor rather than as a classical shepherd. Above all, the depiction of the three goddesses is novel: For the first time in northern European art, they are completely naked rather than clothed as in the late Gothic artistic tradition. Lucas Cranach the Elder was one of the first artists after Albrecht Dürer to introduce the nude modeled after classical sculpture in painting north of the Alps. The Judgment of Paris enabled the artist to portray the sensuality of the female body three times under the guise of a mythological tale. The combination of moral and intellectual connotations and openly displayed eroticism made the Judgment of Paris a popular theme at the court in Wittenberg, too. Lucas Cranach the Elder was not only commissioned to decorate wall hangings with this theme; John the Steadfast also had him paint his nuptial bed with a Judgment of Paris in 1513. KH

Literature
Bild und Botschaft 2015, pp. 222f., cat. 66 (ill.) · Koepplin/Falk 1976, p. 630 · Schuttwolf 1994a, pp. 31f. and 45, cat. 1.13 (ill.)

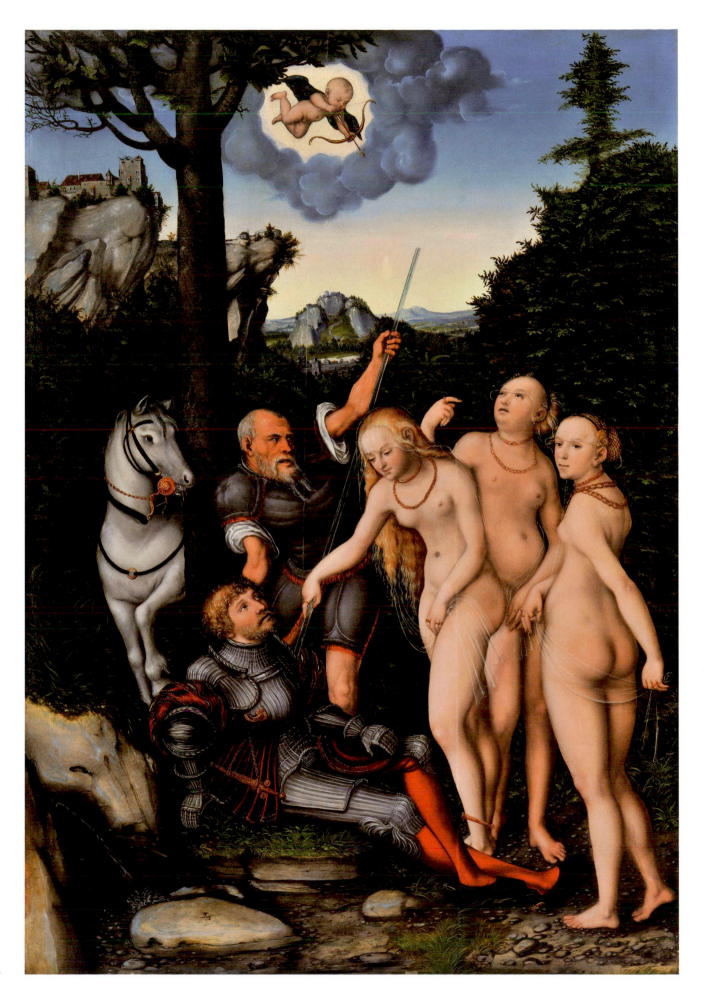

56

57

Lucas Cranach the Elder
Tournament Woodcuts

Signed with monogram and dated
in upper right corner
Minneapolis Exhibition

57

The First Tournament

1506
26 × 37.3 cm
Minneapolis Institute of Art, Bequest
of Herschel V. Jones, 1968, P.68.139

58

The Second Tournament

1509
29.6 × 42 cm
Minneapolis Institute of Art, Bequest
of Herschel V. Jones, 1968, P.68.140

Elector Frederick the Wise staged jousting tournaments on the Wittenberg town square. In addition to offering amusement to the court and the townspeople, these occasions provided opportunities for members of elite families to interact and show off their wealth. Militarily, these staged conflicts were outdated vestiges of an earlier age.

The smaller woodcut of 1506 shows a seeming free-for-all taking place within a heavy wooden barricade. Using pronged lances, combatants attempt to unseat their opponents. The horses' flowing caparisons are decorated with symbols such as lamps, pierced hearts, flowers, horns, and monograms. The elite look on from a late-medieval luxury sky box supported by twisting Gothic brackets and festooned with a tapestry bearing Frederick's arms. The less posh watch from windows or lounge along the rail, gossiping

58

with one another. An equestrian band of musicians plays at the upper left, and a shop offers extravagant wares nearby. At the upper right, more contestants are arriving, with one already waiting at the gate.

The larger, more forcibly drawn scene from 1509 shows a festival known to have taken place in Wittenberg on November 15 and 16, 1508. The level of extravagance seems greater than in the earlier image, and the aesthetic has moved from the Middle Ages to the Renaissance. The architecture has become simpler, more classicizing. A large tapestry, again bearing Frederick's arms, shows the Old Testament hero Samson rending the lion (Judges 14:6). Helmets have sprouted ostrich plumes in profusion, and horses are heavily armored with decorated plates of steel. The emblems on the horses have grown more complex: a woman carrying a cradle on her head,

a pipe-playing centaur, a man visiting a prisoner, a woman with a satyr, a death scene before a burning city. The day's activities include a variety of competitions. Tilters using pointed lances have collided with such impact that a lance shaft has shattered, and a horse and rider have fallen. At the upper left, a battle is taking place between men on horseback wielding batons and armored men on foot armed brandishing swords. If townspeople attended this event, Cranach does not show them. All attention is on the court and its pageantry. TR

Literature
Andersson/Talbot 1983, p. 229, cat. 124 ·
Bartrum 1995, pp. 167–178, cat. 179 · Dodgson 1980, vol. II, pp. 284 and 293, cat. 8 and 54

Heinrich Aldegrever
The Large Wedding Dancers

1538
A set of 12 engravings
Luther Memorials Foundation of Saxony-Anhalt,
fl XX 11660 a – l
Minneapolis Exhibition

Signed with monogram and dated in the top
left/right corner

59

Master of Ceremonies with a Dog

12 × 8 cm
fl XX 11660 a

60

Two Torchbearers

12 × 8 cm
fl XX 11660 b

61

Dancing Couple Turning Left

12 × 8 cm
fl XX 11660 c

62

Dancing Princely Couple Turning
Left

12 × 8 cm
fl XX 11660 d

63

Dancing Couple Turning Left

12 × 8 cm
fl XX 11660 e

64

Dancing Couple with Lady Facing
the Viewer

12 × 8 cm
fl XX 11660 f

65

Dancing Couple Facing Each Other

12 × 8 cm
fl XX 11660 g

66

Dancing Couple Kissing

12 × 8 cm
fl XX 11660 h

67

Dancing Young Couple Turning Left

12 × 8 cm
fl XX 11660 i

68

Dancing Couple Turning Left

12 × 8 cm
fl XX 11660 j

69

Dancing Couple Turning Left

12 × 8 cm
fl XX 11660 k

70

Three Musicians with Sackbuts

11.8 × 7.9 cm
fl XX 11660 l

Pageantry has always been an important means of projecting status and power. Processions provided the opportunity to display wealth and connections—familial, marital, political, and social. Heinrich Aldegrever found such activity so significant that he engraved three sets of prints depicting so-called wedding dancers, the present group being the largest of the three. It appears that the fest is generic, an archetype rather than a reference to any specific historical event.

In plate 1, the master of ceremonies leads this celebratory parade of aristocrats. Though he and his feisty dog move forward, he looks back over his shoulder as if he needs to urge those behind him to quicken their pace. Over his ample mantle, he wears an elaborate chain signifying his office. On it are medallions bearing the arms of his lord, the one to his right clearly showing a rampant lion. A broad sword with a bird's-head pommel hangs from his belt. He holds a staff in his right hand and his many plumed hat in his left. His boots have long, pointed toes, which seem a generation or so out of fashion for 1538. The torchbearers, who follow along in plate 2, are upper class youths. They are richly attired in the latest fashions including breeches with slits that allowed onlookers to see that the clothing was made of multiple layers of sumptuous fabrics. They are shod in trendy low-cut, broad-toed slippers.

The swords worn by the young men, and by nearly all the aristocratic males in the procession, differ from that of the lower-ranked master of ceremonies. While his is broad and without a sheath, theirs are long, elegantly slender and protected by sheaths bearing fittings finely crafted by goldsmiths.

Poking out from beneath the mantles of the torch-bearers are daggers in elaborately decorated sheaths (cat. 71). These striking symbols of wealth and power are also clearly borne by the gentlemen in plates 5, 6, 9, 11. Though less ostentatious, small cutlery sheaths add distinction to some of the women, as in plates 6 and 7. Suspended from their waists by long tethers, each had two compartments that usually would have held a knife and a pricker—a slender spike mounted to a handle. Dining forks had not yet come into common use in Germany. Aldegrever based his dancers on a woodcut series produced not long before by Hans Schäufelein. A notable difference is Aldegrever's addition of the fine daggers and cutlery.

The older couple in plate 3 still seems to be part of the prelude to the most important dignitaries. Compared to those yet to come, the women's headgear is simpler, and the man sports neither slit breeches nor a dagger. They may be high-ranking courtiers rather than actual members of the aristocratic family.

The betrothed appear in plate 4. The bride wears a bejeweled crown and a heavy gold chain. She and the groom both wear fur, hers on the border of her ample mantle and his on the collar of his coat. They are the only couple in the procession with a conspicuous display of fur, and the tufts on hers and specks on his suggest that this may be ermine, a species traditionally reserved for royalty.

Given the age, sumptuous attire, and position in the procession of the next couple, plate 5 appears to show the parents of the bride or groom. They both wear jewels at their busts, and his beard is much more carefully coifed that that of the old courtier in plate 3.

The overt displays of affection in plates 6 and 8 harken back to tapestries and prints of courtly gallantry and gardens of love made in the 15th century. The fullness of the drapery over the women's abdomens might give rise to speculation about whether they are pregnant; yet, the same could be suggested of the women throughout the series. The combination of fashion and high pregnancy rates of the time may require us to leave the question unanswered.

Bringing up the rear are the three musicians of plate 12. They play varying sizes of sackbuts, the valveless trombones of the era. The bearded master of the corps plays the largest of the three and on his mantle wears a medallion similar to those worn by the master of ceremonies.

59

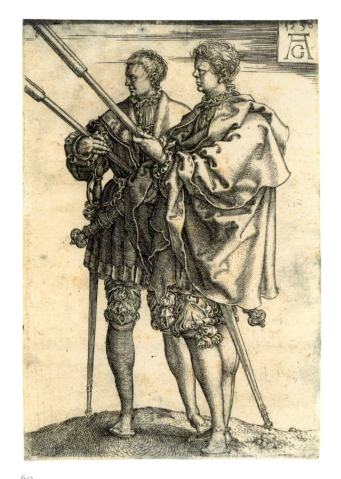

60

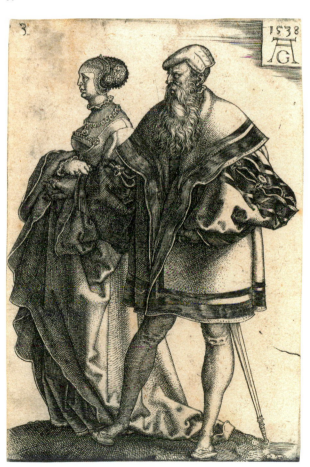

61

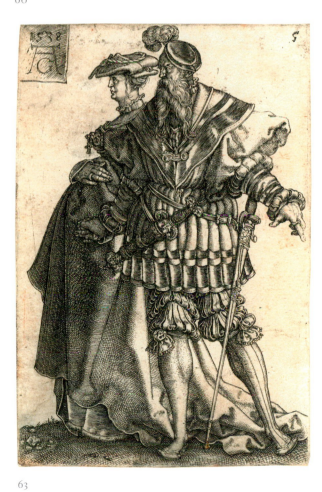

63

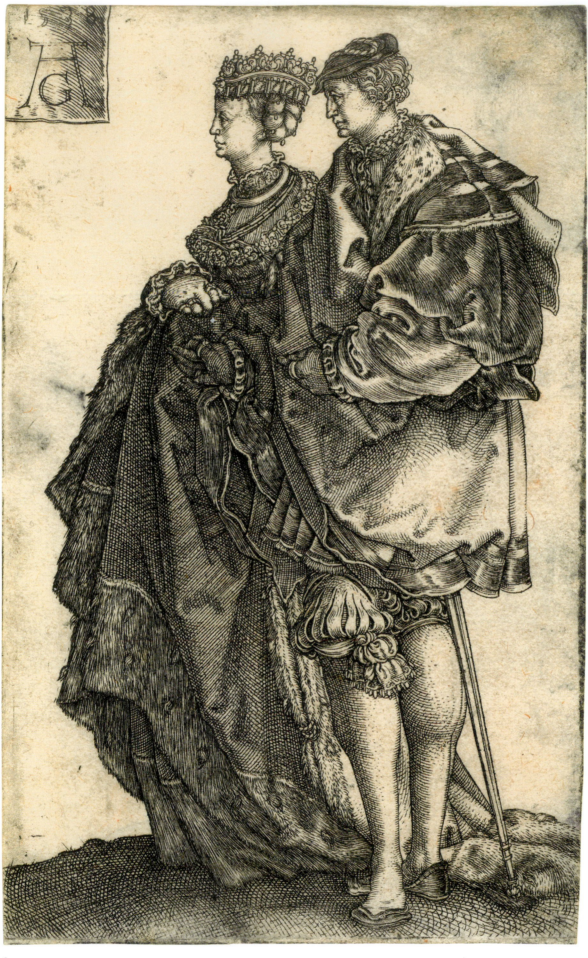

62

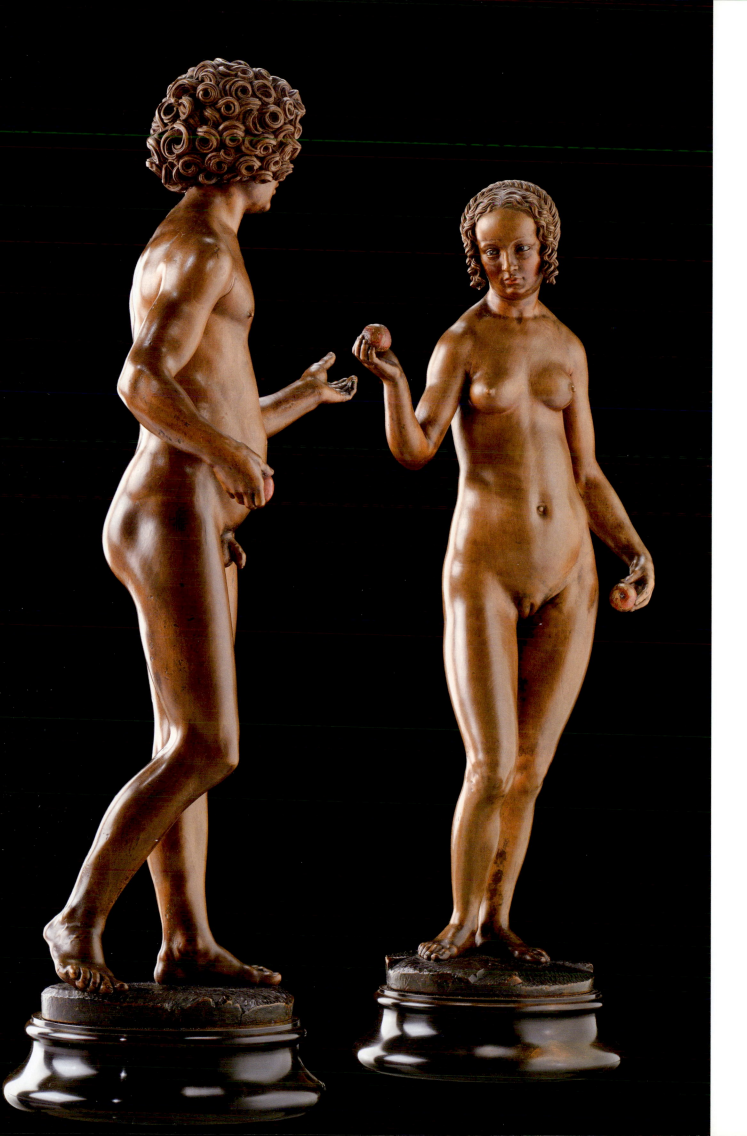

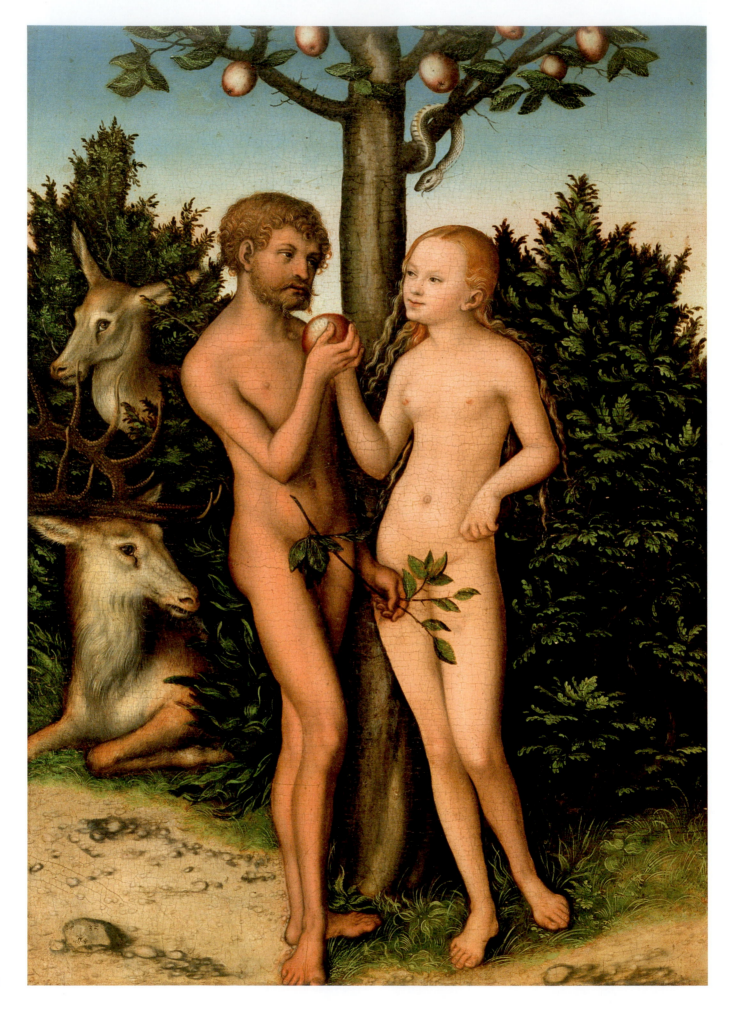

74

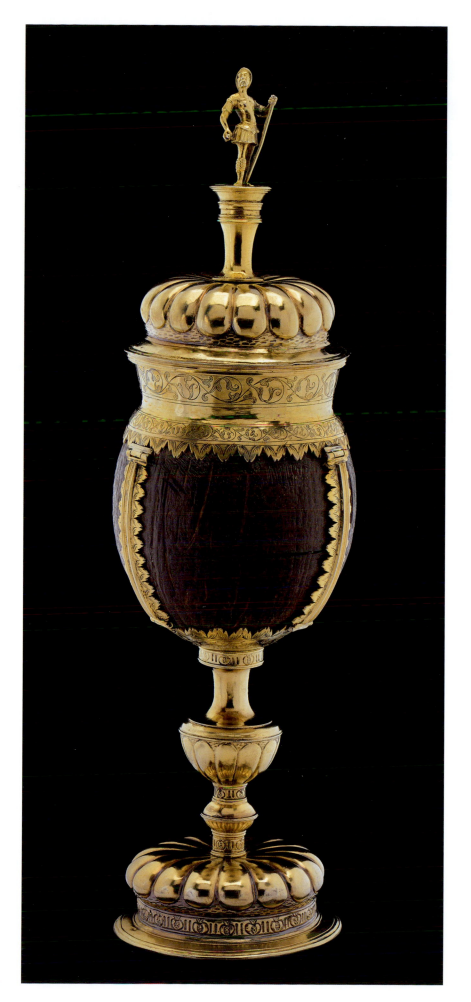

73

three-dimensional figure of a soldier in antique-style armor.

While we do not think of coconuts of having special material value today, for people in the Early Modern period they were especially precious objects. These exotic fruits, imported from a distant land, were extremely expensive to purchase and were therefore most commonly found in the treasure vaults of wealthy princes and patricians. They were also thought to be capable of detecting poison, which made them even more valuable. The south German cities of Augsburg and Nuremberg were centers for the production of such precious objects, and this cup originates there as well. The Saxon princes owned fine vessels like this one and used them as welcome cups, which were offered to special guests on special occasions. SKV

Literature
Fritz 1983 · Onlinesammlung SKD, Deckelpokal · Tebbe 2007 · Treu 2003 b, pp. 49 f. (ill.)

74

Lucas Cranach the Elder
Adam and Eve

Wittenberg, 1532
Oil on copper beech
50 × 35 cm
Kulturhistorisches Museum Magdeburg, G 272
New York Exhibition

Signed at bottom left on the stone: winged serpent (with elevated wings) and dated "1532"

Adam and Eve stand close to each other, their eyes meeting, and hold the forbidden fruit in their hands. With his other hand, Adam is holding a leafy branch, with which he is covering his shame and that of his beloved, who is turned towards him. Lucas Cranach the Elder places Adam and Eve in a central location, in front of the Tree of Knowledge. The cunning serpent, who had promised Adam and Eve that "…when you eat from it your eyes will be opened and you will be like God, knowing good and evil" (Genesis 3:5), slithers down from the apple tree above Eve's head. Cranach chose an idyllic setting to portray the moment of Original Sin, the moment that Adam bit into the forbidden fruit and that Adam and Eve were banished from paradise. While the setting sun casts the sky in an ominous evening hue, a stag and a doe come to join the pair through the green undergrowth, symbolizing harmony and trust between man and woman. Cranach engaged with the subject of Original Sin as early as 1509. More than 30 paintings by the master and his workshop have survived, showing Adam and Eve either in full length in front of a distant background or in the Garden of Eden, as

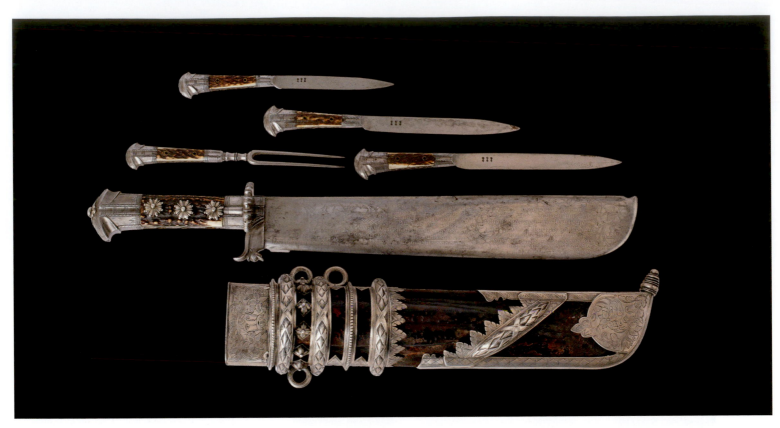

72

in Lochau / His age being 64 years under his rule / The word of God was revealed in / Wittenberg through Doctor Martin Luther).

This five-piece set of hunting implements consists of a large chopping knife (*Praxe*), two smaller by-knives, and a knife and a two-pronged fork for eating. The *Praxe* could be worn and used both as weapon and as a tool to cleave large portions of meat. The pointed smaller knives (*Nicker*) could be used to dispatch wounded quarry with a quick, deliberate stab to the neck. The components of the set could all be stowed in a single scabbard, or *Trousse*, which was made of leather and decorated with silver fittings.

The broad blade of the chopping knife bears etched inscriptions on both sides, which are framed by foliate ornaments. The wording of the inscription on the obverse side is nearly identical to verses that frequently appear on slips of paper that were glued at the bottom of small commemorative portraits of Frederick the Wise painted by the Cranach workshop (cf. cat. 47). These texts laud Frederick's wise reign, his role in furthering the Lutheran doctrine, and they point to the many buildings erected under his patronage, as well as his foundation of the University in Wittenberg. The author of these verses was none less than Luther himself (WA 35, 587).

Interestingly, two lines which did not originate with Luther were added to both the captions of the pictures and the inscriptions on the hunting knife. The paper captions state: "To be chosen for Emperor I was seen fit / Had not my age spoken against it." The engraver of the inscription on the chopping knife went one step further; he has Frederick claim: "To be crowned Emperor I was seen fit." This was certainly not an idle boast for when Emperor Maximilian I died in 1519, Frederick's prospects for being chosen as successor had indeed been very good, as he was the longest-reigning of the Electors.

Frederick, however, declined, considering himself to be too old at 56. Instead, he threw his considerable influence behind the bid of Charles of Habsburg. Waiving his candidacy and the eventual election of Charles V would nevertheless gain him additional power. Frederick was instrumental in drawing up the so-called electoral capitulations, a document in which Charles accepted various demands made by the Electors. These stipulations would weaken central authority and strengthen the imperial estates, of which Frederick was a prominent proponent. GS

Literature
Amme 1994, pp. 158 f. (ill.) · Krauß/Schuchardt 1996, p. 214, cat. 142 (ill.) · Ludolphy 1984, pp. 18 f.

73

Wolff Christoff Ritter
Coconut Cup

Nuremberg
Around 1560
Coconut; silver, cast, wrought, engraved, gold plated
H 30.5 cm; D 9.5 cm
Luther Memorials Foundation of Saxony-Anhalt, K 289
Minneapolis Exhibition

Hallmarked on the shoulder of the vessel: the mark of the City of Nuremberg (Rosenberg 1186) and the master's mark, a tripartite shield with three stars (Rosenberg 1223)

The cup rises from a bell-shaped fluted base with a broad foot rim, and a belt of pomegranates runs around the base. The shaft, the lower part of which is decorated with the same pomegranate pattern, has two nodes: a small lower one that is slightly compressed, and above that a larger hemispherical, fluted one. Above this point, the shaft rises in a biconical fashion, culminating in a border which is also adorned with a pomegranate frieze. The cup itself consists of a polished coconut, held up by three clasps with leaf ornaments. The metal border, with its wide opening, is adorned with engraved floral ornaments. On the knob of the bell-shaped fluted lid is a fully

71

portraits of Anabaptist leaders as well as Luther and Melanchthon. TR

Literature
Andersson/Talbot 1983, pp. 176–177, cat. 56 · Bartrum 1995, pp. 180–182, cat. 183 · Mielke 1998, p. 214, cat. 259 · Stogdon 1989, cat. 27

72

Hunting Knife Set of the Saxon Elector Frederick the Wise

Saxony, 1st-quarter of the 16th century
Iron, silver, antler and leather
Chopping knife: length 45 cm, length of blade 30.5 cm; two by-knives: length 21.8 cm; eating utensils (knife and fork): length 18.5 cm; trousse (scabbard): length 33 cm
Wartburg-Stiftung Eisenach, KB0001
Minneapolis Exhibition

Inscriptions on the broad blade of the chopping knife:
Obverse, in Latin: CHRISTO SACRUM [...] verbo magna putate Propterea dingnus posteritate tali.
Obverse, in German: Friderich bin billich genannt / Schonen frid ich erhilt in lant / Durch groß Vornunfftgeduldvnd gluck / Wider man- chen ertzbosen tuck / Das lant ich ziret mit Gebew / Vndschtifft ein hocheschul aufs neu / Zu wittenberck in sachsenlant / In aller Welt die wart bekannt / Den aus dieselwen kam Gotes Wort / Vnd tat gros Dinck an manchem Ort / das bebstisch reich schtortzt es danider / Vnd bracht den rechten Glauben wider / Zum Keiser wart gekrönet ich / Des mein alder beschweret sich / Dafür ich keiser Karl erwelt / Und nicht vmbgonst oder gelt. (As Frederick I am rightly famed / Who in my land have peace maintained / By wisdom great, patience and luck / Many a vile knave down I struck / Many building projects have I conceived / At Wittenberg in Saxony / Es- tablished a new university / Which became re- nowned universally / From this place forth went God's own word / To great effect throughout the world / To overthrow the popish seat / And rein- state the one true creed / To be chosen for Em- peror I was seen fit / Had not my age spoken against it / So I myself chose Charles for this role / And not for favor, nor for gold).
Reverse, in German: 1525 Am fünften Tag des Meien ist / Geschtorben der Durchlauchtigst / ChurfürstHertzoch Friderich vonn / Sachsen an einem Sonntag auf denn / Abent zur Lochaw umb acht or / Seines Aldersch im 64. Jar bei jm / Kam das Wort Gothes an tack / zu Withen- berck durch Doctor /Martinum Luther. (In 1525, on the fifth day of May / Died our most honor- able / Elector and Duke Frederick of / Saxony on a Sunday towards / Evening at eight o clock

69

70

Aldegrever has made a point of placing the figures outdoors in only roughly groomed terrain. All of the figures are on little mounds, and stones and grass are often under foot. The parade of astonishing affluence, prestige, and might has left the confines of the courtyard and is in the open for all to see. TR

Literature
Dodgson 1980, vol. 2, pp. 50–52, nos. 221–235 · Mielke 1998, pp. 132–136, nos. 160–171

71

Heinrich Aldegrever
Design for a Dagger Sheath with a Nude Couple

1536
Engraving
32.6 × 11.2 cm
Private collection, Minneapolis
Minneapolis Exhibition

Signed with monogram and dated in upper right corner

Elaborate dagger sheaths signified high social status in 16th-century Germany. Few survive because of the precious material used to make them, but many representations of them can be found, perhaps most famously in Hans Holbein the Younger's spectacular painting *The Ambassadors,* 1533 (National Gallery, London), in which Jean de Dinteville holds a gilded sheath in his right hand.

Heinrich Aldegrever, who was trained as both a goldsmith and painter, frequently depicted sheathed daggers as aristocratic accoutrements (cf. cat. 59–70), and he engraved seventeen sheath designs, including three especially large, richly decorated examples that include matching hilts, such as those seen here. The present design is unusual in having supplementary views of the crossguard.

Aldegrever clearly studied the prints of major masters such as Albrecht Dürer, Marcantonio Raimondi, and Lucas van Leyden. From them he drew technical, thematic, and compositional ideas; yet, he could transform them into entirely new creations such as this sheath. The nudes on the smaller compartments meant to contain a knife and pricker suggest that his knowledge of other masters' art may have extended beyond prints. These figures echo Albrecht Dürer's *Adam and Eve* panels of 1507 (Prado, Madrid) in their attenuated sinuous forms as opposed to the weightier figures in his 1504 engraving. Aldegrever was active in Reformation affairs in the town of Soest in Westphalia, where he engraved

66

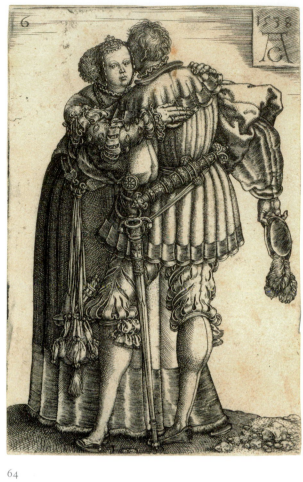

64

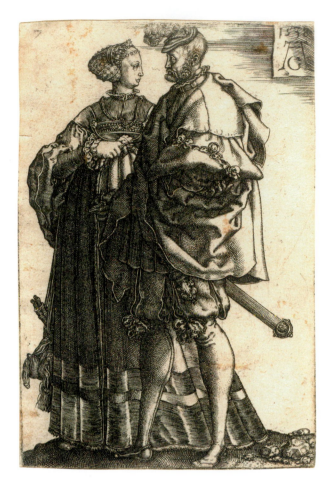

65

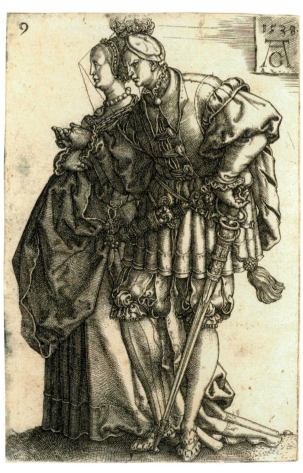

67

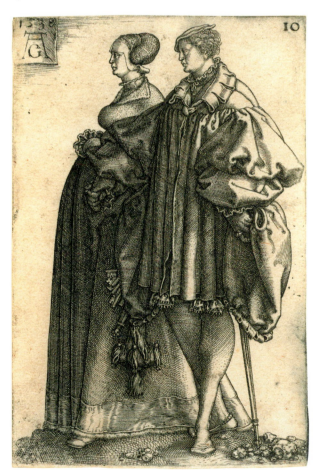

68

75

76

in the case of this painting from Magdeburg. The message and effect of salvation history played a central role for Cranach, especially as a response to Albrecht Dürer's 1504 copper engraving. Man's, and particularly woman's, sensual and lustful disposition is often emphasized in the manner of a cautionary tale, similar to how it is shown in works on themes relating to the "power of women," and is represented in no small number of cases by their unabashed nakedness. Martin Luther and the leaders of the Reformation were engaged in propagating a new understanding of marriage, and viewed Adam and Eve as mankind's first married couple. They held that it was necessary for those bound by marriage to keep lust and sexual urges under control. Cranach took up this interpretation by painting Eve as a sensual Venus in the act of seducing Adam. FK

Literature
Friedländer/Rosenberg 1979, p. 109, cat. 198E · Koepplin/Falk 1976, vol. 2, p. 659, cat. 574a · Schoen 2001, pp. 195–212 · Spielmann 2003, pp. 60 (ill.) and 176, cat. 52 (ill.)

Conrad Meit
Adam and Eve

Around 1510
Boxwood, varnished brown and partially polychromed
New York Exhibition

75
Adam

36 × 15.8 × 9 cm
Foundation Schloss Friedenstein Gotha, P 21

76
Eve

33.7 × 14.5 × 5.3 cm
Foundation Schloss Friedenstein Gotha, P 22

These boxwood sculptures with only a few polychromed details are some of the earliest isolated depictions of Adam and Eve in German Renaissance sculpture. The two unclothed figures holding only three apples from the Tree of Knowledge in their hands as accessories are standing on narrowly confined patches of turf. Adam, holding an apple in his right hand, is turning his head to the left toward Eve and extending his left arm toward her, ready to accept another apple. Eve, inclining her head slightly downward, is gazing toward the fruit she is offering Adam with her right hand. She is holding another apple in her other hand. Both bodies are posed in classical *contrapposto*, indicating a harmonic relationship between movement and tension. The surfaces are modeled extremely delicately and with great detail revealing an exact study of nature, which attests to their great artistic quality. The juxtaposition of smooth skin against three-dimensional hair is masterly.

These statuettes were created by Conrad Meit, who is documented at the court of Frederick the Wise in Wittenberg around 1505—09 and also worked in the workshop of Lucas Cranach the Elder. The figures may have been created for the court in Wittenberg and would thus be evidence of the high artistic standard in Wittenberg shortly before the Reformation. These pieces were solely intended for a cabinet of curiosities and were certainly never placed in an ecclesiastical context. The artist found inspiration in both Dürer's master engraving *Adam and Eve* of 1504 and Cranach's woodcut *Venus Chastising Cupid* (1509, dated to 1506). He nevertheless created an original and independent masterpiece full of sensuality.

The depiction of Adam and Eve and the Fall (Genesis 3) enabled the artist to depict naked human bodies. Therefore, the biblical subject seems to serve only as a cover up for an erotically charged, sensual composition in which the observation of nature and an interest in the human body are emphasized. Meit additionally managed to capture the event with psychological sensitivity, making the anticipation and simultaneous hesitation in the moment of temptation perceptible to the viewer. The impression of this moment when the first couple perceives themselves as man and woman and become aware of their own sexuality varies depending on the two figures' position to each other. TT

Literature
Eikelmann 2006, pp. 68–71 (ill.) · Schuttwolf 1995, pp. 90 f. (ill.)

III

Pre-Reformation Piety

Martin Luther grew up in surroundings that were strongly influenced by religion and religious practice. A town's citizenry and the parish were basically identical, and church services and the hours of prayer provided a framework for everyday life. Churches and chapels were dominant features of the settlement pattern. Their bells would toll not only for divine service, but for all kinds of joyous events, for threatening danger or for an individual's death. The servants of the church, the clerics, were a social class unto themselves, and members of the diverse religious orders were always present on the squares and thoroughfares of towns.

To the people of this era, God was the omnipotent ruler who ordered all things. To please Him was the prime goal of all Christians. Only through this submission could salvation be attained on the day of the Final Judgment and deliverance from the wrath of God be secured during this earthly existence. War, famine, crop failure, disease and pestilence were seen as direct punishments for the transgressions of man. Consequently, the faithful engaged in many different kinds of pious activities to ensure their temporal and ultimate salvation. They would not only diligently attend divine service, praying the hours and recite their rosaries, but also support all kinds of pious foundations as their individual means allowed. Churchgoers could drop their contributions into alms boxes (which were often elaborate works of art), while others might donate wax for making candles or contribute towards the cost of chalices, monstrances or vestments. Still others would bequeath their entire wealth to the church, or at least substantial portions of it. These bequests would sometimes consist of regular incomes from rent or trade profits, and they could be dedicated to the upkeep of particular church buildings or the support of personnel. Last but not least, such contributions could come in the shape of the countless works of art that grace the interiors or facades of church buildings, many of which we can still admire to this day. These artworks include altar images and epitaphs, baptismal fonts, pulpits, murals, as well as innumerable smaller artifacts made of precious metals. SKV

Parochial Churches and Divine Service prior to the Reformation

The often dominant position of parochial churches in German towns stems from their role as a focus of communal life. Life began here with baptism, and it ended here with a burial. While the sacrament of marriage was bestowed mutually by the betrothed, a priest was still required to bless the union. Depending on custom, this ceremony would take place either in front of or inside a church, or under designated "marriage portals." Confession was mandatory once a year, and the faithful were expected to attend Holy Mass in the church to which they belonged on Sundays and holidays. Mass endures to this day as the rite in which bread (or hosts) and wine are transformed into the body and blood of Christ. In the Middle Ages, services were held in Latin. The congregation would only be able to follow what was going on by watching the gestures and actions of the clergy, the ringing of altar bells or the presentation of the body and blood of Christ.

In late medieval times, Mass was a sacrificial ritual through which the faithful attempted to appease God with a view towards the Final Judgment. The requisite sites for holding Mass were altars, which were often furnished with costly works of art such as paintings, sculptures, retables, and products of the goldsmith's craft. Holy Mass had to be conducted properly by an ordained priest, while the attendance of the faithful was of secondary importance.

Masses needed only a single priest to "operate" the altar. This "operator," however, needed various vestments, and the altar had to be furnished with candles, books, and other liturgical equipment. The upkeep of altars was often provided through endowments made by individuals or groups. The remittance of sins which this entailed could be augmented by commissioning additional works of art as contributions for the honor and glory of God.

Altars also needed to be supplied with relics of the saints to which they were dedicated. As the cult of relics expanded in the Middle Ages, these remains would often be displayed in sumptuous shrines. Large collections of relics were assembled by patrons in places such as Wittenberg, and drew crowds of pilgrims. Pilgrimages became mass events which produced enormous revenue not only for the churches but also for the towns which surrounded them. SKV

77

Unknown German artist/workshop
Mass of St. Gregory

Thuringia, 3rd-quarter of the 15th century
Mixed techniques on wood
129 × 127 cm
Foundation Schloss Friedenstein Gotha, SG 1
Minneapolis Exhibition

Signed on the altar cloth: "hoc est factum a d[o]m[ino] et mirabile in" (This is the Lord's doing and it is wonderful in)

The transformation of the Eucharist into the flesh of Christ on the cross—Transubstantiation—reflects the deep devotion to Christian sacraments in the Middle Ages and the great significance of the Mass as an event with the potential to bring salvation. For this reason, portrayals of the vision of Pope Gregory the Great, to whom Christ himself once supposedly appeared on the altar during Mass, are among the most popular subjects in the late Middle Ages.
The panel shown here, with a representation of St. Gregory's Mass, was once part of an altarpiece in the Cistercian monastery in Georgenthal, Thuringia, located south of Gotha.
It shows Christ as the Man of Sorrows leaning on the sarcophagus lid. His entire body is covered with bleeding wounds and, with his left arm around the cross, we can see the wound in his side. He is surrounded by the instruments of the Passion, the *arma Christi* (Weapons of Christ). On the mensa of the altar, we see the chalice, covered by the pall, placed on top of the corporal, which stands on the paten. Christ, enthroned above the chalice and paten, seems to be allowing the blood to flow into the chalice from the wound in his side. Pope Gregory kneels before the altar, his hands folded in prayer, in a devoted posture. Wearing the *signum imperii*, his insignia of rule, the tiara, he appears in his function as spiritual and temporal leader. Holding the shaft of the cross, the bishop on the right side looks straight out of the picture, his hand lightly touching the host on the mensa. Meanwhile, a cardinal standing to the left, his arms folded under his garment, looks down at Gregory with a pious expression on his face.
According to the legend, after Christ appeared to him, Pope Gregory the Great granted the faithful an indulgence for 14,000 years. The *Unigenitus dei filius* ("Only-begotten son of God") bull, issued by Pope Clement VI in 1343, proclaimed the Church's God-given power to grant indulgences to sinners in the name of Christ. Luther's criticism of the sale of indulgences, which by then had become a lucrative business, was a key factor in bringing about the Reformation. As a result, artworks like those showing St. Gregory's Mass

were threatened with extinction in Protestant lands. Artistic representations of the miracle became less common after 1520 as people began to question their value for religious practice. Moreover, Mass was no longer celebrated in the manner depicted by Pope Gregory. FK

Literature
Hecht 2007 · Lehfeldt 1891, pp. 95 f. · Leuschner/Bornschein/Schierz 2015, pp. 51 (ill.) and 55 · Meier 2006 · Steguweit 1990, p. 37, fig. 28

78

Master of the Byzantine Madonna
Altarpiece with Mass of St. Gregory

Leipzig or Merseburg, 1516
Tempera on wood
42 × 104 cm
Vereinigte Domstifter zu Merseburg und Naumburg und des Kollegiatstifts Zeitz Merseburg, Domstift, Deckert no. 35
New York Exhibition

This small altarpiece shows a type of image that was widespread in the late Middle Ages: Jesus, as the Man of Sorrows, along with the instruments of the Passion appear to Pope Gregory I while he is celebrating Mass. As this happens, or so the legend goes, a woman witnessing this scene is cured of her doubt as to Christ's presence in the consecrated host. Pope Gregory I had prayed for the woman and discovered, after the prayer, that a piece of bread had become flesh, in the shape of a finger.
The Man of Sorrows is displayed in Merseburg, as well as in the Roman stational Church of Santa Croce in Gerusalemme, the Basilica of the Holy Cross of Jerusalem. Supposedly, Pope Gregory I himself commissioned this Roman painting after he experienced the miracle.
The representation of the Mass is accompanied on the Merseburg Cathedral altarpiece by portrayals of the Apostle Matthew and John the Evangelist. Kneeling to the left of the beholder is the person who donated the painting, identifiable by his coat of arms as Merseburg Vicar Johannes Hoppe (Hopfen).
Like many other small altarpieces, this one was among the pieces that were newly created for Merseburg Cathedral after its renovation. Work on the cathedral began in 1510, under Bishop Thilo of Trotha with the aim of converting the cathedral into a hall church, and the project was completed under his successor, Adolph of Anhalt, in 1517. Many new altarpieces were created at this time, although their precise location within the cathedral can no longer be determined. MC

77

78

Literature
Cottin/Kunde 2014, cat. VII.4, p. 275 (ill.) · Cottin/
John/Kunde 2008, cat. II.20, p. 289 (ill.) ·
Heise/Kunde/Wittmann 2004, cat. III.43,
pp. 177–179 (ill.)

79

Leipzig workshop(?)

Altarpiece Wings with the Four Archangels, Three Latin Church Fathers and St. Benedict of Nursia

1516
Tempera and gold on wood
192 × 81.5 cm
Vereinigte Domstifter zu Merseburg und
Naumburg und des Kollegiatstifts Zeitz,
Bequest of Carl von Bose,
Minneapolis Exhibition

Inscriptions: scroll in the left hand of the
archangel Gabriel: AVE [MARIA] GRACIA PLENA
D[OMINUS] T[ECUM] (Hail Mary, full of Grace,
the Lord is with thee)

These two wings belong to an altarpiece that is
not fully preserved, and that is closely related to
the Bose family of Frankleben, near Merseburg.
Two other surviving wing panels contain portray-
als of St. Augustine and Benedict of Nursia. The
painting portraying St. Augustine carries the date
1516. The four archangels are portrayed on the
interior of the wings shown here: Michael, the
weigher of souls, below him Uriel with a censer,
on the other side Gabriel with the Annunciation
to St. Mary and below him Raphael with a fish.
The exterior of the panels depict Pope Gregory I

in papal vestments and St. Jerome in cardinal's
garb, with a Bible and accompanied by a lion.
The landscapes in the background of these paint-
ings of the archangels and the Church Fathers are
reminiscent of the Danube School, the style of
which was also adopted in the central German
region by Lucas Cranach the Elder and Georg
Lemberger. The paintings are particularly remi-
niscent of other artworks in Merseburg Cathe-
dral, such as the large enclosed garden in the
Bishop's Chapel, and the altarpiece in Naumburg
Cathedral showing the Conversion of St. Paul.
The panels were presumably made in Leipzig,
which was a major artistic center in the late Mid-
dle Ages.
The portrayals on the wings of the altarpiece in-
dicate a particularly strong veneration of the
archangels (among which Uriel was not consid-
ered canonical) or a particular appreciation of
the Church Fathers, among whom in this case
Ambrose of Milan is replaced by Benedict of Nur-
sia. It should be kept in mind that the middle of
the altarpiece has been lost, so that the altar's
donor is difficult to determine. However, the
provenance of the four panels can help us solve
this mystery: they come from Frankleben, where
the Bose family had maintained its seat since the
Middle Ages. Apparently, the associated altar
was donated by the family, and came back into
their possession after the Reformation.
All of the surviving wings of the altar were expro-
priated by the state in 1945 and 1946 and found
their way into the art collections at the Moritz-
burg in Halle (Saale). In 2008, all four panels
were donated by the Bose family to the United
Cathedral Chapter in Merseburg Cathedral. The
close relationship that the altarpiece has to this
family should give an indication of the original
donation. In the year 1447, Balthasar and Georg
Bose, the brothers of John II Bose, the Bishop of

Merseburg, created a large donation for the ben-
efit of the *Altar of the Four Evangelists* at the
Church of St. Sixti in Merseburg (Merseburg
Cathedral Chapter Archive, St. Sixti Records
Nos. 101, 102). The eldest in each generation was
to have the right to an altar attendant's position.
This position was occupied by Johannes Bornis
and Johannes Junge; both were of illegitimate
birth, although it is certain that Johannes Bornis
was a son of John II Bose, the Bishop of Merse-
burg (RG 5, No. 4965; RG 7, No. 1310). In other
words, the family had apparently sponsored the
altar with the deliberate intent of providing for
the illegitimate son of the bishop. In the 16th
century, that is after the new wings of the altar
were created, the altar was dedicated to the four
Church Fathers along with the four Evangelists
(Merseburg Cathedral Chapter Archive, Record
no. 1049). Based on the figures shown, as well as
the close relationship to the Bose family, this
might be the donation of the Bose family from
the 15th century. In that case, the altarpiece
would be representative not only of religious ob-
servance in the pre-Reformation era, when it was
made, but also of the provision for illegitimate
children by the family of the bishop. MC

Sources and literature
Burkhardt/Küstermann/Otte 1883, p. 42 f. (ill.) ·
Cottin/John/Kunde 2008, cat. II.12, pp. 242–
246 (ill.) · Kunde/Hörsch 2008, cat. I.12,
pp. 32–39 (ill.) · Merseburg Cathedral Chapter
Archive: Record No. 1049 · St. Sixti Records
nos. 101, 102, RG 5 · RG 7

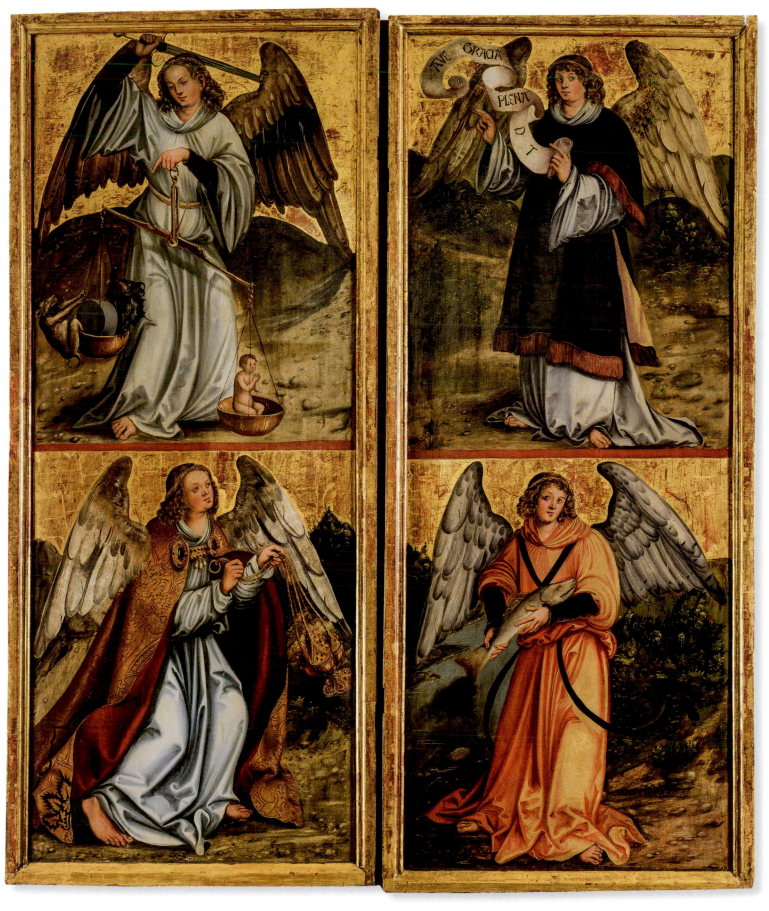

79

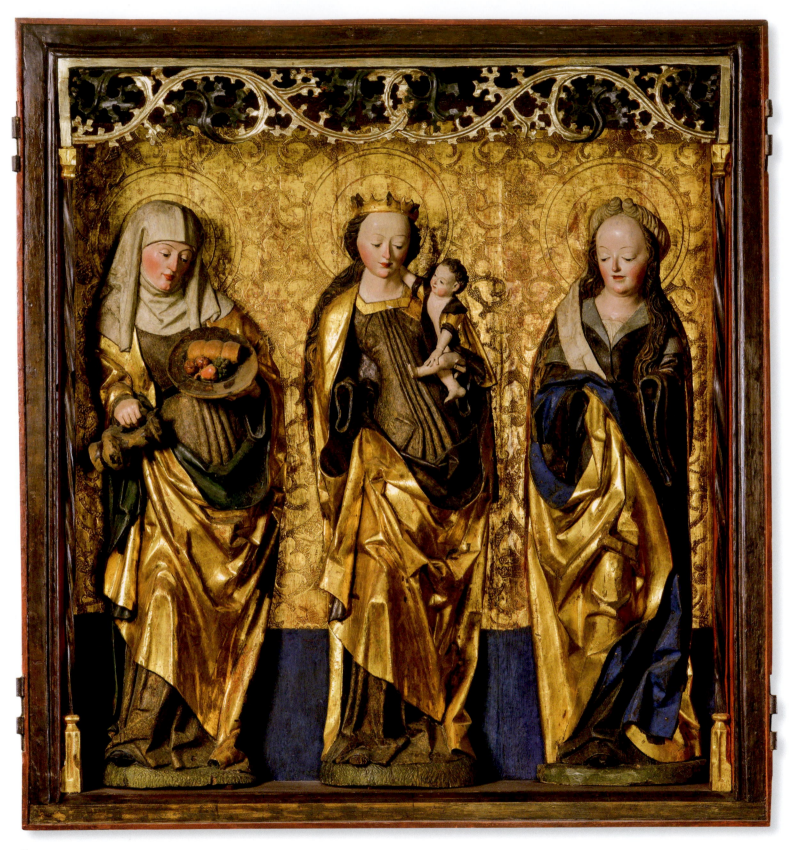

80

Leipzig workshop(?)
Kämmeritz Altarpiece (center shrine) with Three Female Saints (Elisabeth, the Virgin Mary, unidentified Saint)

Around 1500
Limewood, polychrome, partially with metal plating
Center shrine: 125 × 117 × 23.5 cm; St. Elisabeth: 93 × 32 × 8 cm; Virgin with Child: 98 × 28 × 15 cm; unidentified saint: 97.5 × 28 × 13.5 cm
Stiftung Moritzburg Halle (Saale), Kunstmuseum des Landes Sachsen-Anhalt,
MOIII00264 a–c
Minneapolis Exhibition

In the period preceding the Reformation, the faithful hoped for intercession with God from the saints and martyrs already partaking of divine grace and visualized in altar figures. Whenever relics were placed inside altars as well, then a sacred substance was present. *Contemplatio*, meditative veneration of the lives of the saints, increased through mysticism in the 13th century in particular. Different saints were "responsible" for quite different petitions.

Patron saints or donors of a particular church accompanied the Mother of God, who appeared most frequently as the central figure, in altar shrines. Such altars often remained in churches that had turned Protestant, even after the Reformation. The saints' significance declined, however, since their function as mediators of salvation had been repudiated. Altars and figures of saints were removed little by little over the following centuries, during renovations and remodeling or simply because they had become unsightly. In central Germany, the Provinzialmuseum (provincial museum) in Halle gathered the remaining altars and holy figures sold or left by church congregations. From this stock the Moritzburg Museum acquired select pieces in 1917.

The surviving center shrine of the Kämmeritz Altar holds a figure of the Virgin Mary with the Christ Child, which is flanked by St. Elisabeth on the left and by a no longer identifiable youthful saint on the right. She may be Mary Magdalene and might have held an ointment jar in her now missing hands. These women have graceful S-curve postures that embody the medieval ideal of beauty and are attired aristocratically with pointy-toed shoes and sumptuous garments: They are wearing lined brocade mantles over wide-sleeved gowns. The Virgin's gown, for instance, is relief brocade with floral ornaments and the lining of her mantle is silver plated. The Virgin is wearing a crown on her head with her

hair bound at her neck. Its ornamental points have been broken off and lost. She is holding a wriggling infant Jesus in her arm. He has his arm slung around his mother's neck and is wearing a small mantle made of the same material as hers over his naked body—a rare image in central Germany. The blue lining of the unidentified saint's mantle is decorated with golden paper dots. The Virgin and the unidentified saint are depicted as maidens with uncovered hair falling in long locks and highlighted with gold. The youthful saint, whose pleated chemise is visible under the opened collar of her gown, is wearing a piece of cloth wound like a turban around her head and gathered in two twisted points above her forehead, with a broad decorative ribbon falling over her right shoulder and onto her chest and the collar of her gown. Such a coiffure is similar to French tapestries of the Lady and the Unicorn (end of the 15th century, Musée national du Moyen Age, Paris). The other figure accompanying the Madonna, Landgravine Elisabeth of Thuringia, canonized because of her charity and piousness, is rendered as a married, somewhat older woman with thin cheeks, more distinct crow's feet and with covered hair. Her coiffure, consisting of a piece of cloth and a gorget covering her neck, appears in French sculptures of female saints and pious donors between 1280 and 1320. Elisabeth is holding a wine flagon and a plate with bread, walnuts, a pear and grapes in her hands as alms for the poor. The three saints are standing on separate plinths beneath carved tracery that is supported by slender turned columns, all of which is set before a gilded background embossed with a thistle leaf ornament representing a tapestry. The pattern points to a Saxon workshop in the region of Leipzig and the painter Pancratius Grueber, who was active there. The altar is noble and fine work. The painting on one side panel suggests that he had knowledge of Dürer's work. Following exhaustive testing, the altar was fully restored in 2008. CW

Literature
Bergner 1909, p. 132 · Flechsig 1912, p. 49 (ill.) · Schaich 2007, p. 28 (ill.)

Workshop of Franz Geringswalde
Altarpiece from the Cathedral of St. Peter and St. Paul in Naumburg

Altenburg, around 1510
Conifer wood, carved, polychrome and gilded; fragments of tempera paint preserved on the reverse side of the wings
Central shrine: 146 × 132 cm; wings: 146 × 66 cm
Vereinigte Domstifter zu Merseburg und Naumburg und des Kollegiatstifts Zeitz, Naumburg Cathedral
Minneapolis Exhibition

Inscriptions:
Central shrine: in the halo of the Saints:
S. CATHERINE S. MARY S. BARBARA
Left wing: Ecce.ancilla., no longer recognizable with the naked eye today
Right wing: Aue.gracia.plena.dominus..tecum.. (cf. Luke 1:28); on the angel's scroll on the reverse side of the shrine: Johann Carl Schoch / Custos. 1766 [...] RESTORED / 1957/58 / Inst. f. Denkmalpfl.

This altarpiece consists of a central shrine and two wings; the superstructure and the original predella are lost. The panels of the closed altar depicted an Annunciation scene, of which only a fragment of Archangel Gabriel survives on the exterior side of the right wing. When opened, on the insides of the wings we can see the twelve Apostles standing on pedestals in two rows of three figures each. The central shrine depicts in the middle the Virgin Mary standing on the crescent moon, crowned by two angels, with St. Barbara on her left and St. Catherine on her right, who are also wearing crowns. The two Holy Virgins are turned to face the Virgin Mary, whose gaze is, in turn, directed at the Christ Child, who is actively moving around. St. Barbara is holding a chalice in her right hand, and a small tower can be identified to her left. The identifying feature for St. Catherine, presumably a wheel in her right hand, is missing.

The workshop that created this piece, which most likely relied on engravings by Israhel van Meckenem for the inspiration of its commission, intended for the workmanship and effect of the image to increase as the eye moves to the center of the shrine. Almost all of the identifying features of the apostles are lost; only in the upper row of the right wing are Andrew (X-shaped cross), John (chalice) and James the Elder (pilgrim's staff and hat with shells) clearly identifiable.

The three figures on the shrine stand on profiled pedestals in arcades with golden thistles resting on twisted columns. Consistent with the base of the wings, the rear wall of the shrine shows a

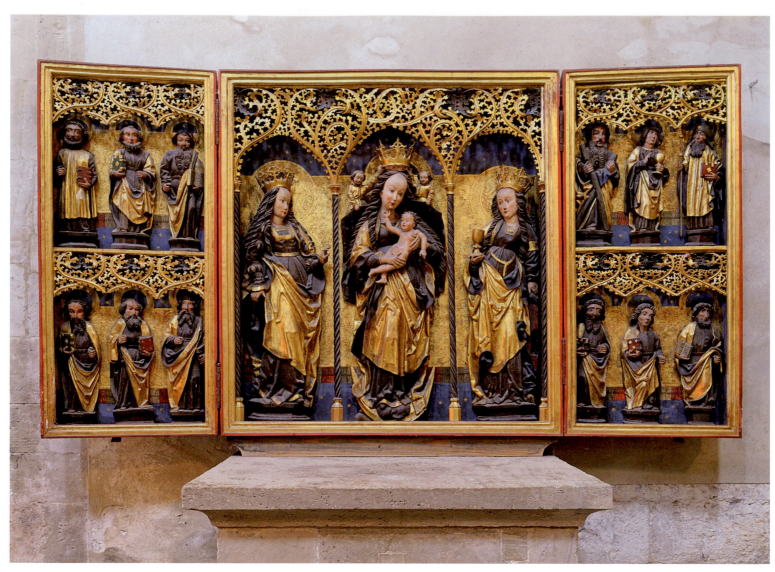

81

golden brocade carpet with fringe painted in different colors before a blue sky with golden stars. The heads of the three female figures feature high foreheads, and their hair is falling in characteristically thick curly wisps to well beyond their shoulders. Their rich clothing is consistent with the court fashion of the time, and St. Catherine's slashed sleeves are especially characteristic.

Before the Reformation, the Cathedral of Saints Peter and Paul in Naumburg had about 40 different altars, and others were located at St. Mary's Church, in the immediate neighborhood of the cathedral. Devotion to St. Mary at Naumburg Cathedral had become steadily stronger since the mid-13th century. A similar trend has been observed at Naumburg Cathedral with regard to the holy martyrs Catherine of Alexandria (died in 287) and St. Barbara (died in 306), who numbered among the Four Holy Virgins. In view of their prominent representation in this altarpiece, it may be assumed that it originally stood on the Altar of Saints Mary, Paul, Catherine and Barbara in St. Mary's Church, which was first mentioned in 1385 (Naumburg Cathedral Chapter Archive, Record No. 513). HK

Sources and literature
Bergner 1903, p. 163 · Kayser 1746, fol. 83r · Kunde 2006, p. 17, fig. p. 12 · Ludwig/Kunde 2011, p. 122 · Schubert/Görlitz 1959, p. 122, no. 122

82

Lucas Cranach the Elder
Virgin with Child and Young John the Baptist Praying

Around 1514
Tempera and oil painting on limewood
67.4 × 45.5 cm
Federal Republic of Germany, on permanent loan to Kunstsammlungen der Veste Coburg, M.337
New York Exhibition

Signed above left with the winged serpent

Born a half year before Jesus Christ, John the Baptist is considered to be his forerunner and the final prophet of the Old Covenant, bridging the gap between the Old and New Testaments as the first person to recognize Christ as the Messiah. While the Gospel of Luke gives an account of Mary and Elizabeth meeting while pregnant with their respective children (Luke 1:39–45), there is no other mention in the Gospels of Christ and John the Baptist meeting as children. The motif of John the Baptist worshipping the Christ Child on the lap of his mother, the Virgin Mary, was a popular subject in Italian painting of the Renaissance pe-

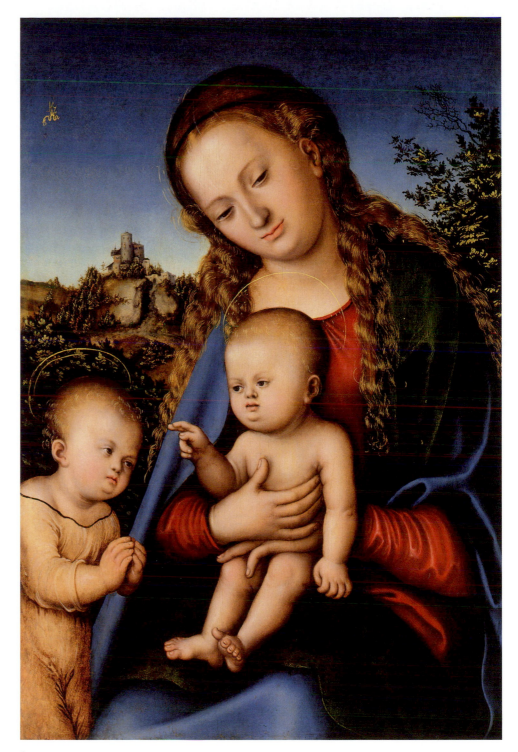

82

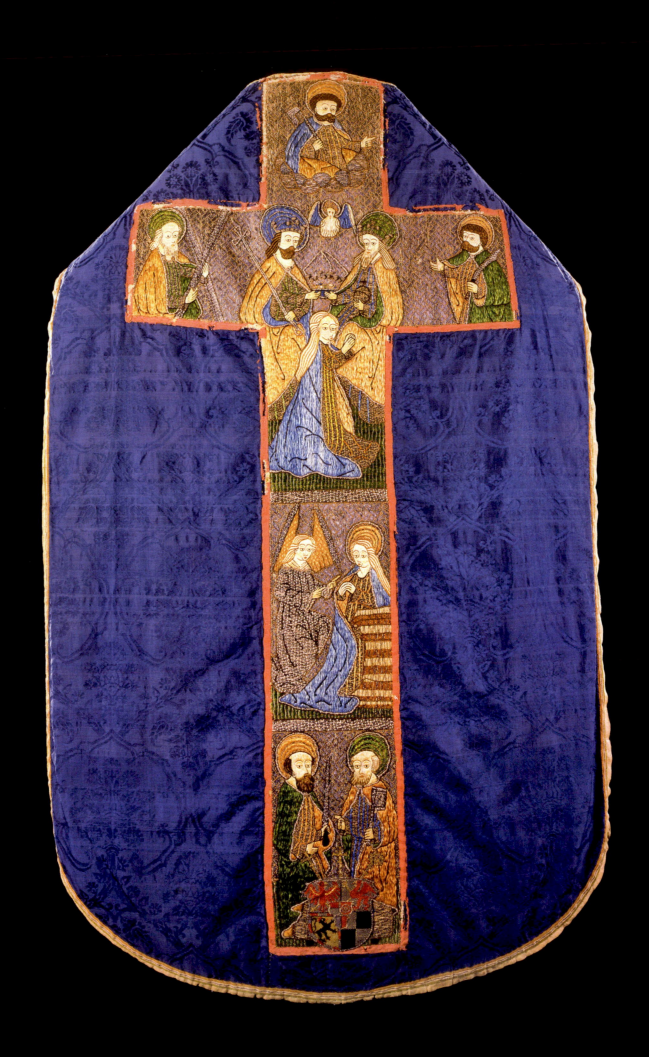

riod (there are well-known examples by Botticelli, Perugino, Raphael and Leonardo), and it is to Cranach's credit that he was able to introduce and spread this subject north of the Alps. This theme engaged the Cranach workshop well into the 1530's, turning out more than 50 versions of this scene over the course of two decades. The Virgin and Child subject first appears in multiple versions dating back to 1514, and the Coburg panel belongs to this group. One of Cranach's assistants/followers produced a less successful version of the Coburg painting; however, it is dated 1512 (sold at Sotheby's in London on July 3, 1996, lot 285a). A version that is very similar to the Coburg panel, and also from the year 1514, had survived in the Carthusian monastery in Galluzo, near Florence (now in the Uffizi). The choice of subject is not the only area where an Italian influence is evident: the manner in which Mary's hand covers the child's genitalia, the arrangement of the figures in front of the landscape and the warm and lush atmosphere also identify the Coburg painting as closely related to the work of Italian artists of the Early and High Renaissance. How this Italian influence found its way into Cranach's work is unclear. His attention may have been drawn to Italian models while at his patron's court in Wittenberg, or perhaps it came during his interactions with the humanist Christoph Scheurl, who had come to the University of Wittenberg from Bologna. Jacopo de' Barbari, Cranach's predecessor as Wittenberg court painter, is another possible link to the Italian artistic tradition. Last but not least, such examples of Cranach developing Italian subject matter serve to fuel speculation that Cranach may have traveled to Italy, as is also reflected in the portrayals of Lucretia that were created at the same time. KW

Literature
Coliva/Aikema 2010, pp. 280 f., cat. 49, fig. 281 · Krischke/Grebe 2015, p. 36 (ill.) · Maedebach 1972, cat. 4 (ill.)

83

Blue Chasuble with Embroidered Cross and the Crest of Albert of Brandenburg

Central Germany, 1513 (at the earliest) until 1520s
Fabric (northern Italy, last quarter of the 15th/ early 16th century): blue silk damask; embroidery (central Germany?, first quarter of 16th century): silver strip-thread, gilded silver strip-thread, different color silk threads
132 × 89 cm
Stiftung Dome und Schlösser in Sachsen-Anhalt, Domschatz Halberstadt, 226
Minneapolis Exhibition

Albert of Brandenburg was the most powerful German church ruler of his time. He united in his person not only the positions of Archbishop of Mainz and Magdeburg, but from 1513 he was also the administrator for the Diocese of Halberstadt. He gave several donations to the Halberstadt Cathedral for the decoration of the services. Several textiles survive from that era. Among them are ten liturgical garments that are recognizable on account of the crests of Albert of Brandenburg applied to each. In all cases the four-field crest of the House of Brandenburg is adorned in the middle with the shields of the three dioceses Magdeburg, Mainz and Halberstadt. In addition, the symbols of his spiritual and worldly power are included: the sword, cross and crook.

The chasuble belongs to an ensemble of garments that belong together, an "Ornat," from which also a dalmatic and the cope (Latin: *pluviale*) survive. The main material for all three garments is blue silk damask with a pomegranate pattern. Such fabrics, produced in northern Italy, were widespread across Europe in the second-half of the 15th and the first decades of the 16th century.

The separately embroidered and applied chasuble cross has a Marian theme. In the center of the cross, emphasizing its significance, is the coronation of Mary. She kneels before the enthroned figures of God the Father and Christ, who together hold a large crown over her head. Above, the dove of the Holy Spirit hovers and completes the representation of the Trinity. Beneath this ensemble there is a further representation from the life of Mary, the Annunciation. At the end of the arms of the cross are the apostles who, assisting as witnesses, create a frame around the Marian scenes: the half-figures of the apostle Matthew (with an axe), Andrew (with the saltire) and Bartholomew (with a knife), and the full figures of Peter and Paul, the princes of the apostles, with the keys and sword, respectively.

The connection of the Annunciation to Mary, the beginning of the event of Christian salvation, with the coronation of Mary being received into heaven creates the shortest form of the story of Mary's life. This chasuble and the set of vestments related to it were therefore probably worn on the occasion of Marian festivals. BP

Literature
Maseberg/Schulze 2004, p. 306, cat. VI.28 (ill.) · Meller/Mundt/Schmuhl 2008, pp. 278–281 (ill.) · Pregla 2006 · Riepertinger/Brockhoff/ Heinemann/Schumann 2002, pp. 225 f., cat. 107 (ill.) · Schauerte/Tacke 2006, p. 64, cat. 5 (ill.)

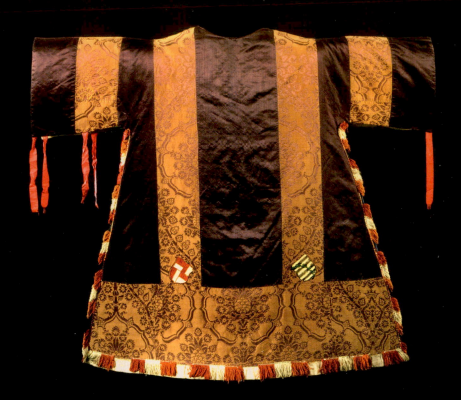

84

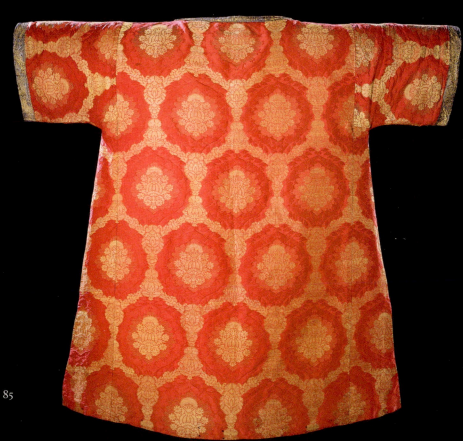

85

84

Dalmatic with the Crest of Archbishop Ernest of Saxony

Central Germany, 1480–1513
Fabric (northern Italy, last quarter of the 15th century): violet silk satin, bicolor silk damask (copper color and violet)
112 × 136 cm (with extended sleeves)
Stiftung Dome und Schlösser in Sachsen-Anhalt, Domschatz Halberstadt, 257
Minneapolis Exhibition

This garment from the treasury of Halberstadt Cathedral, which was worn by a deacon during the liturgy, is remarkably intact and without later changes or major repairs.

The dalmatic is characterized by its contrasting combination of violet satin fabric and the bicolored damask. The violet damask has a pattern of seven-petal rosettes with large-scale petals or fruit in a leaf and flower crown. Due to the combination of violet warp thread and golden-yellow weft thread, the basic color of the damask fabric alternates between a copper color and a golden luster in different lights. The richly detailed pattern suggests that the fabric is a product of an Italian silk weaving mill from the last quarter of the 15th century.

On the back side of the garment two crests are clearly visible. On the left (from the viewer's perspective) is a combination of the crests of the Dioceses of Magdeburg and Halberstadt. The right crest is of the Duchy of Saxony. In this arrangement, the crests clearly point to Ernest II of Saxony (a younger brother of Frederick the Wise, Elector of Saxony). Ernest was made Archbishop of Magdeburg in 1476 and named administrator of the Diocese of Halberstadt in 1479. In both of these positions, he was the immediate predecessor of Cardinal Albert of Brandenburg. The coincidence of two bishoprics in one person was forbidden according to church law; nevertheless, Elector Ernest I of Saxony, the father of the young candidate, managed to arrange a dispensation for his son. In 1480, while on a pilgrimage to Rome, his plea to Pope Sixtus IV was successful, not in the least thanks to the financial donations he made. In 1491, after a period of construction that had lasted over 250 years, the festive consecration of Halberstadt Cathedral was celebrated under Archbishop Ernest of Saxony.

Even if the dalmatic can be clearly identified as an endowment from Ernest of Saxony, it is very unlikely that it was one of his personal pieces of clothing. BP

Literature

Cottin/Kunde/Kunde 2014, pp. 250–253 (ill.) · Maseburg/Schulze 2004, pp. 276 f. (ill.)

85

Silk Brocade Dalmatic

Central Germany(?), 4th-quarter of 15th century/early 16th century
Silk fabric (northern Italy, ca. 1470–1490): red silk damask with brocades of gilded silver strip-thread
121 × 133 cm (with extended sleeves)
Stiftung Dome und Schlösser in Sachsen-Anhalt, Domschatz Halberstadt, 217
Minneapolis Exhibition

The dalmatic made from gold-brocaded silk damask would have only been worn by a deacon for special church services. The relative effect of the garment is essentially a consequence of just how precious the materials are: intensive red-colored silk and shimmering metal threads made of small strips of a gilded silver plate wrapped around a silk core. Over the red base of the fabric there is a golden net of pointed ovals made of branches with leaves and small fruit. In the center of each field within the brocade net is a blooming pomegranate. In addition, a damask pattern, consisting of pointed oval-formed rosettes, is woven into the red silk areas. The design of this pattern is characteristic for many precious fabrics of the second-half of the 15th century. The earliest datable example is silk brocade from the grave of Sigismondo Pandolfo Malatesta in the cathedral in Rimini, Italy. Aside from gold-brocaded fabrics, pure silk damask and, so-called "pomegranate velvet," were also decorated in this fashion between 1470 and 1490. We have no example of a design closely related to the Halberstadt dalmatic, but there are several comparable fabric patterns with a comparable fundamental structure and level of detail. These include a pluviale vestement in Halberstadt Cathedral treasury (Inv.-Nr. 120) and two dalmatics in Riggisberg (Switzerland) (Abegg-Stiftung, Inv.-Nr. 296) and Chicago (The Art Institute, 47.429) made of colored brocaded silk damask.

The amount of material used for the garment is also a testament of lavish wealth. For the desired effect, the dalmatic required a run of the precious fabric about 4.4 meters long. We can assume that the material was donated by a high-ranking personality. For this time period, the most likely candidate is the then Archbishop of Magdeburg and administrator of the Diocese of Halberstadt, Ernest of Saxony, or it might have been another member of the Electoral House of Saxony. The gleaming gold dalmatic fits Ernest of Saxony's heightened need for representation and ceremonial pomp and therefore embodies a general development at the end of the Middle Ages. Inventories of his assets as the archbishop illustrate the quantity and quality of the precious textiles available at his time. BP

Literature

Flemming/Lehmann/Schubert 1990, p. 239 (ill.) · Meller/Mundt/Schmuhl 2008, pp. 268 f. (ill.) · Schade 1983, p. 112

86

Episcopal Glove with the Lamb of God

Central Germany
15th century
White linen yarn knitted in knit stitches; embroidery: silver strip-thread, gilded silver strip-thread, colored silk thread
24 × 12 cm
Stiftung Dome und Schlösser in Sachsen-Anhalt, Domschatz Halberstadt, 139
Minneapolis Exhibition

In addition to their heads being distinctively covered by a miter, since the end of the first millennium, bishops and other high-ranking spiritual dignitaries had the privilege of particular clothing for their hands and feet. Before the Mass, accompanied by a special clothing prayer, a sub-deacon would clothe the celebrating bishop or dignitary in gloves, tights and shoes. The bishop's ring was put on the finger of the fingered glove so as to be very visible. The episcopal gloves, called *chirothecae* in the Middle Ages, were worn only during the Mass until the washing of hands before the Eucharist.

Five single gloves survive in the Halberstadt Cathedral treasury, three left- and two right-hand gloves, of which the matching exemplar in every case is lost. They are all made of fine white linen yarn knitted in knit stitches and decorated additionally with embroideries employing colored silk and metal threads in various techniques.

The left glove displayed here had separately prepared embroidery attached to the back. Twigs emerge from a green branch laden with leaves and flowers in red and blue and form a round medallion. In the middle of the medallion, there is a silver *Agnus dei* (Lamb of God) with a golden flag of victory and a golden chalice, into which the blood of the lamb is being collected. This motif corresponds to what is happening on the altar during the mass, where the sacrifice of Christ takes place. In this context, the leafy twigs sprouting from the branch are an allusion to the tree of life, the cross on which Christ overcame death. BP

Literature

Braun 1907, p. 373, fig. 178 · Meller/Mundt/Schmuhl 2008, pp. 262–265 (ill.)

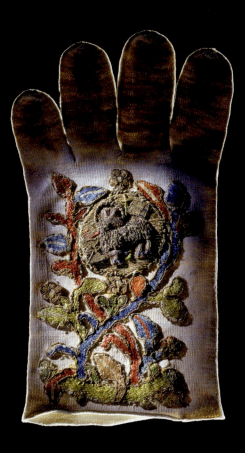

86

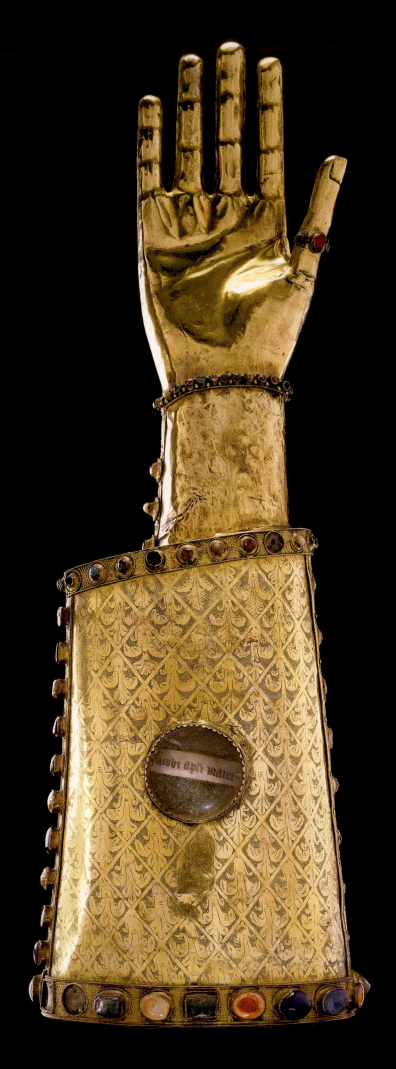

87

Arm Reliquary of the Apostle James the Elder

Lower Saxony (Harz region), 1st-half
of the 14th century
Wood, gilded silver, quartz, amethyst, ruby,
turquois, sapphire, mother-of-pearl, glass
63 × 22 × 14.5 cm
Stiftung Dome und Schlösser in Sachsen-
Anhalt, Domschatz Halberstadt, 70
Minneapolis Exhibition

This shrine serves the sacred protection and pre-
sentation of a piece of bone that is attributed to
the apostle James the Elder. The reliquary is in
the form of a right arm, which protrudes out of
the tightly fitting drapery of a deacon's vestment.
The sleeve of this vestment, called a dalmatic, is
adorned with stately grandiosity. The form of the
container gives away its content: an arm relic.
The inscription *Authentik* (authentic) in the open-
ing for viewing is meant to confirm that the relic
is genuine.

James the Elder counts as one of the first disci-
ples called by Jesus. He was decapitated under
the rule of Herod. According to the legend, his
body was brought to Spain. With the "rediscov-
ery" of his supposed grave in the 9th century,
one of the most famous places of Christian pil-
grimage was created at the place named after
him, Santiago de Compostela. From across Eu-
rope, droves of pilgrims set out on the "Way of St.
James" to the apostle's grave on the Galician
coast. As proof of their journey, they brought
back a St. James's (scallop) shell. The majority of
believers could not afford such a pilgrimage.
Therefore, touring relics, as in the case displayed
here, also gave Luther's compatriots the oppor-
tunity to encounter the venerated companion of
Jesus in their own region.

Luther himself criticized the relic cult, above all
against the background of the proliferation of the
trade in indulgences, by which the amassing of
such relics was financed. For Luther, only the
Word of God counted, and for the communication
of the word, one did not need objects as wit-
nesses: "I praise the relic [of the word] and I do
love it heartily; but a skirt, body, leg, bone, arm
or head of a dead saint I cannot praise at all; for
they are not any use for us" (WA 51, 139). Luther
also doubted the authenticity of James's grave.
AM

Literature
Arens 2012 · Herbers 1990 · Krumhaar 1845 ·
Richter 2008, pp. 106 f. · Tacke 2006 a

88

88

Warming Ball

Meuse region or northern France,
between 1280 and 1300
Copper, chiseled and gilded
D 10 cm (ball)
Stiftung Dome und Schlösser in Sachsen-
Anhalt, Domschatz Halberstadt, 014
Minneapolis Exhibition

Alongside the *vasa sacra* necessary for the liturgy
of the Mass, such as the chalice and paten,
warming balls (known as "warming apples" in
German) were also used on the altar. These
round objects warmed the hands of the priest in
a cold church during the liturgy when he had to
handle the important substances of the Christian
faith: the body and blood of Christ. In the middle
of the warming ball there was a gimbal (a gyro-
scopic device) that could be filled with hot sand
or a glowing piece of metal.

Although warming balls must have been very nu-
merous in Europe, there are only eleven now
known. The exemplar in the treasury of Halber-
stadt Cathedral is the only one with its leather
cover extant. The ball was commissioned by an
unknown canon of the cathedral. The crests of
his family are likely those on the leather mantle,
but these have yet to be identified. The gilded
copper ball is made of two halves. The top half is
divided into eight fields, in which are engraved
medallions depicting the four Evangelists (Mat-
thew, Mark, Luke and John) and their symbols
(the man, lion, bull and eagle). The spaces be-
tween the medallions are adorned with decora-
tive leaves. The iconography of the ball was fit-
ting for the context of the mass. Warming balls
could stand together on the altar with the *vasa
sacra*, the cross and the Gospel book. TL

Literature
Bednarz et al. 2009, pp. 152 f. · Meller/Mundt/
Schmuhl 2008, pp. 138 f., no. 38 (ill.) · Richter
2009, pp. 130 f.

90 and 89

Chalice and Paten

Germany, 1501
Stiftung Dome und Schlösser in Sachsen-
Anhalt, Domschatz Halberstadt, 7 and 7 a
Minneapolis Exhibition

89
Late Gothic Chalice

Silver, forged, cast, gilded; translucent enamel
H 19.9 cm; D (foot) 14.9 cm;
D (cup) 11.5–11.9 cm

Inscriptions: "frater mathias 1501" and "Ihesvs"

90
Late Gothic Paten

Silver, gilded; champlevé enamel
H 1.7 cm; D 15.9 cm

This chalice and paten are a set. They are part of
the *vasa sacra*, those vessels which come into
contact with the transformed elements of the Eu-
charist. The consecrated host was laid upon the
paten; in the chalice is wine. According to the
Roman Catholic faith, both are transformed into
the body and blood of Christ, a process called
Transubstantiation.

The late Gothic paten from Halberstadt Cathedral
treasure is a flat plate whose center is a three-di-
mensional quatrefoil. The corresponding chalice
is most elaborately decorated. Aside from the
finely worked tracery on the stem and nodule,
there are six cast reliefs fastened to the foot of
the chalice. They depict the Crucifixion of Christ,
and Saints Benedict, Lawrence, Mary Magdalene
and Stephen, as well as a crest of the Diocese of
Gardar in Greenland. An engraved inscription on
the foot of the chalice names the donor and the
year of its making: "Tuam deus deposcimus /
pietatem vttribuere / digneris lucidas et quietas
/ mansiones frater mathias / indignus episcopus
gadenis / Anno domini 1501 (Your goodness,
God, we beseech, that you would give them light
and peaceful dwellings. Brother Matthias the Un-
worthy, Bishop of Gada in the year 1501)." While
the first part of the inscription quotes the respon-
sory *Libera me* from the Office of the Dead, the
second part names the donor and the year in
which it was made: Matthias Kanuti became tit-
ular bishop of the Diocese of Gardar in 1492, but
from 1496 was suffragan bishop in Halberstadt
and Magdeburg under Bishop Ernest II of Saxony
(reigned 1475–1513), of whom he was a trusted
friend. TL

Literature
Fuhrmann 2009, pp. 208 f., no. 157, fig. 139 ·
Meller/Mundt/Schmuhl 2008, cat. 44, pp. 152–
155 (ill.)

91

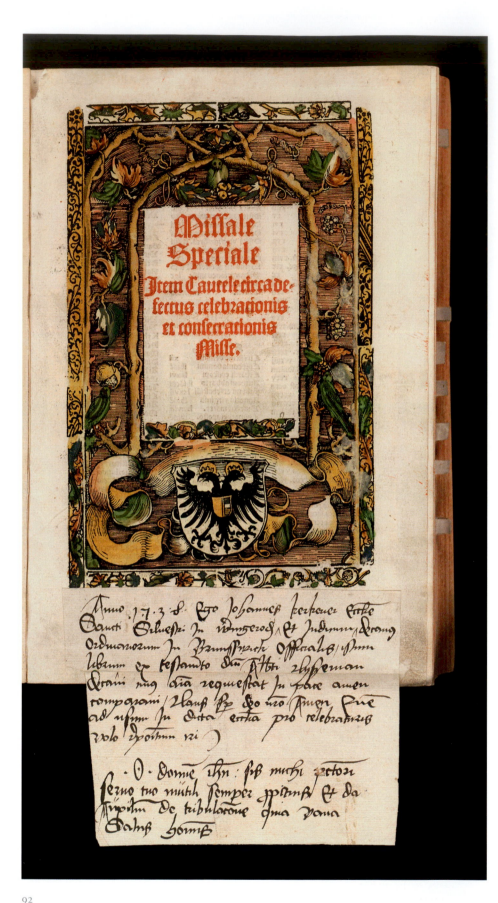

91

Monstrance

Germany, 2nd-quarter of the 15th century
Silver, forged, cast, engraved and gilded
53.4 × 9.2 cm; D (base) 16.6 cm
Stiftung Dome und Schlösser in Sachsen-Anhalt,
Domschatz Halberstadt, 6
Minneapolis Exhibition

Inscription: "Ihesvs"

A monstrance (from the Latin *monstrare*, to show) is a vessel for displaying the consecrated host, which according to Roman Catholic teaching is the body of Christ. It can be placed on the altar for worship and veneration or carried in processions (above all, for the feast day Corpus Christi). This late Gothic monstrance from the Halberstadt Cathedral treasury combines different micro-architectural motifs. Above the bell-bottomed foot and the stem structured by a knop there rises a delicate architectural construction of buttresses, supporting arches and pinnacles. Two silver bells attached to the monstrance are meant to remind the congregation of the sounds of heaven. The spire has graphically rendered roof panels and is crowned by a cast representation of the crucified Christ. The center of the monstrance is the *lunula*, a crescent-shaped bracket in which the host is placed. The cylinder of glass or mountain crystal that both presents and protects the host has been lost. The architectural elements also suggest an understanding of the monstrance as the Church of God, in whose center Christ stands. TL

Literature
Fuhrmann 2009, p. 130, cat. 77 · Meller/Mundt/
Schmuhl 2008, pp. 150 f., cat. 43 (ill.)

92

Missale Speciale (Special Missal)

Strasbourg: Reinhard Beck the Elder, 1518
32 × 23.5 cm
Luther Memorials Foundation of Saxony-Anhalt,
ss 3522
VD16 M 5629
Minneapolis Exhibition

The liturgy of the Eucharist had been codified by the Roman Church in a Mass-book, the missal (Latin: *missale*), in the 8th century. As a kind of script for the priests, it contained Bible texts, prayers and liturgical songs. The exact order of the service, including the smallest actions, such as the 34 signs of the cross performed in the canon of the Mass over the bread and wine, or the clothing of the priests, were fixed. Liturgical actions were indicated in red text. Essentially, the form of the celebration was the prerogative

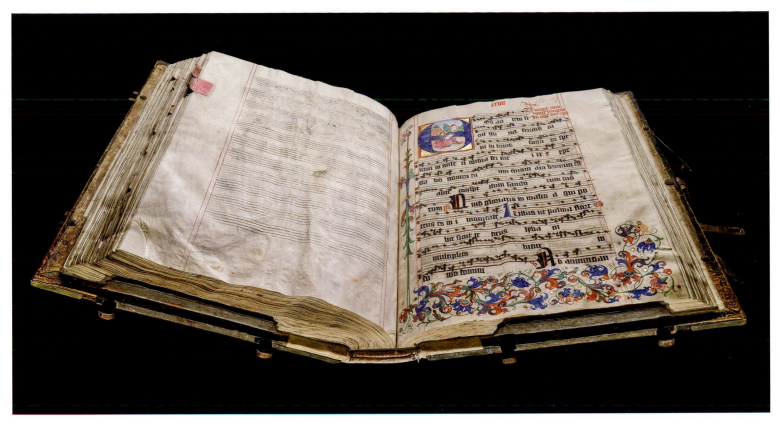

93

of the priest. The participation of the congregation was kept to a minimum in the ritual of the Mass. The *MissaleSpeciale* was first published in Basel in 1473 as a shorter form of the mass for side altars and subsidiary churches.

The *Missale Speciale* of the Luther House in Wittenberg is the fifth edition, printed in Strasbourg by Reinhard Beck the Elder. It was bought from the Duke of Stolberg-Wernigerode in 1931 when his library of 120,000 volumes was sold, through the famous antiquarian bookseller Martin Breslauer and several other dealers.

The Strasbourg *Missale Speciale* belonged to a certain Johann Kerkener, the dean of the Wernigerode monastery (*Chorherrenstift*). As the handwritten note stuck to the title page indicates, Kerkener inherited the missal from his predecessor, Albrecht Liesmann the Younger. Both Liesmann and Kerkener wanted the books of their collection to be given to a public library. Among the first new libraries of the Reformation era, aside from that of St. Andrew's Church in Eisleben, was that of the monastery church of St. Sylvester in Wernigerode.

Johann Kerkener, who got to know Martin Luther personally in Wittenberg in 1520, noted in his accounts book his disappointment following Luther's marriage to Katharina von Bora, using words that actually belong to the Pope's enthronement ceremony: "*Sic transit gloria mundi* (So goes the glory of the world)." FK

Literature
Jacobs 1894, pp. 597 f. · Joestel 2008, p. 78

93
Leipzig missal workshop(?)
Choir Book of Naumburg Cathedral

1504 – after 1506
Parchment, bound in wooden boards
covered in pigskin
80 × 61 cm
Vereinigte Domstifter zu Merseburg und
Naumburg und des Kollegiatstifts Zeitz,
Domstiftsbibliothek Naumburg, Hs VII
Minneapolis Exhibition

A group of eight large codices from the Middle Ages belong to the inventory of the historical cathedral library in Naumburg. They are among the largest surviving manuscripts from the Middle Ages. Originally, these choir books were the foundation for the liturgy of the Divine Office in the choir of Meissen Cathedral. The manuscripts were commissioned by the cathedral chapter, together with Bishop John VI of Salhausen. The eight manuscripts were produced between 1504 and 1506, probably in a Leipzig workshop. The success of the Reformation in the region of Meissen after 1539 led to the elaborate manuscripts losing their liturgical function. They eventually ended up in the possession of the Elector of Saxony, kept safe at the court in Dresden. The Naumburg Cathedral chapter managed, through religious debates, not only to secure its own existence, but also to hold fast to the received practice of sung Daily Offices. Mediated through the

The original stands for the choir books in Naumburg Cathedral

93 (detail)

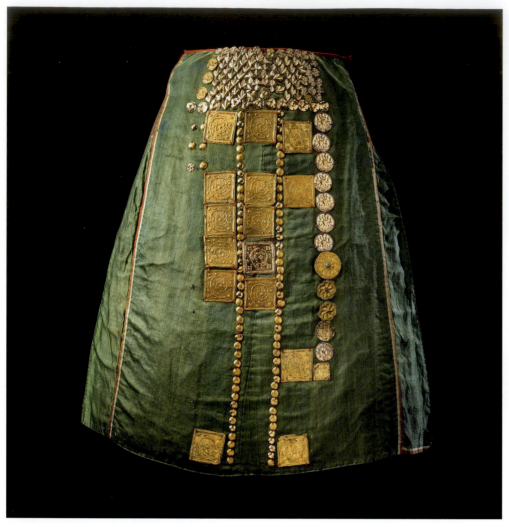

94

Garment with Gilded Ornamental Plates to Adorn a Statue

Central Germany, 2nd-half of the 14th century/
early 15th century
Green silk-satin with brown linen padding;
metal applications: gilded silver, mostly
pressed plates
67 × 69 cm
Stiftung Dome und Schlösser in Sachsen-
Anhalt, Domschatz Halberstadt, 164
Minneapolis Exhibition

The particular attraction of this simple small hanging of green silk-satin is surely the closely spaced precious metal appliqués. The unfurled, spiral vine with small leaves and fruit cannot be clearly recognized as a grapevine, so its interpretation must remain open. But the representations of hearts gripped by burning love on the smaller round appliqués can be understood as belonging to the world of courtly love. Such precious metal ornaments were popular in the courts and among the aspiring middle class, as well as being used to decorate churches. They reached the height of their popularity in the 14th and early 15th century. The gilded plates may therefore have originally been secular jewelry donated by a layperson to adorn the hanging.
Based on its size and form, the small hanging was probably used to clothe a statue. According to common tradition in the Middle Ages, the real presence of a person venerated as holy was present in their pictorial representation. Therefore, the decoration of a work of art was always also a votive offering to the saint. It cannot be said with confidence for which work the green hanging in Halberstadt was intended. One possibility, however, is that it was for a processional figure: a double statue that had St. Stephen, the patron saint of Halberstadt Cathedral, on one side and the Virgin Mary on the other. A similar red hanging for the other side of the sculpture (which was made around or soon after 1400), is still in the cathedral vault today. A clue that the green ornament may have been made for the Madonna could be two pilgrim badges which were sewn on around 1500 (right row, first and third appliqués from the bottom). These badges both come from Marian pilgrimage sites: one from Aachen, the other from Eicha near Leipzig. BP

Literature
Kühne/Bünz/Müller 2013, pp. 294 f. (ill.) ·
Pregla 2015, p. XX (ill.)

Naumburg canon John of Haugwitz, who had also been the last Bishop of Meissen, the Naumburg chapter was able to buy back the former Meissen choir books for its own church in 1580. In the same year, the chapter commissioned two dovecote-like lecterns that are still present in the east choir of the cathedral. The choir books were used there from the late-16th until the middle of the 19th century as a main source for the celebrations of the canonical hours. The clerical employees of Naumburg Cathedral were exclusively of the Evangelical confession from around 1600, and even before that Lutheran services had taken place in the cathedral. However, the old Latin hours continued to form the liturgical nucleus of the cathedral monastery's right to exist. Only when the monastery was changed into a charitable foundation during the 19th century did the liturgy and the choir books fall out of use. The manuscripts (the largest has 337 pages) have an unusually large format of up to 81 × 63 cm (cover) and weigh up to 45 kg. The contemporary bindings have some minor repairs due to damage from their long and intensive use and display. The pigskin leather exhibits the typical design elements of the period, such as embossed lines and blind-stamp ornamentation. The buckle, clasps and catches belong to the functional furnishings of the book, and the attachments on the bottom edge of the back cover fasten the heavy books to the lectern.

A special feature of these manuscripts is the rich collection of high quality miniatures and foliate designs. These are among the highlights of artistic book decoration in the late Middle Ages. At least five different artists produced the opaque paint and gold miniatures that correspond to special high festivals. While the miniatures contain representations of the Virgin Mary and the saints, a rich variety of forms and colors are present in the elaborate vine ornamentation. Alongside motifs from court culture and drolleries (grotesque images), there are remarkably natural representations of flora and fauna, with numerous kinds of birds. ML

Literature
Bachmann/Gröbler/Kunde/Hörsch/Stewing
2006 · Bergner 1903, pp. 193–198 · Eifler 2015,
pp. 343–353 · Wiessner 1997/98, pp. 283 f.

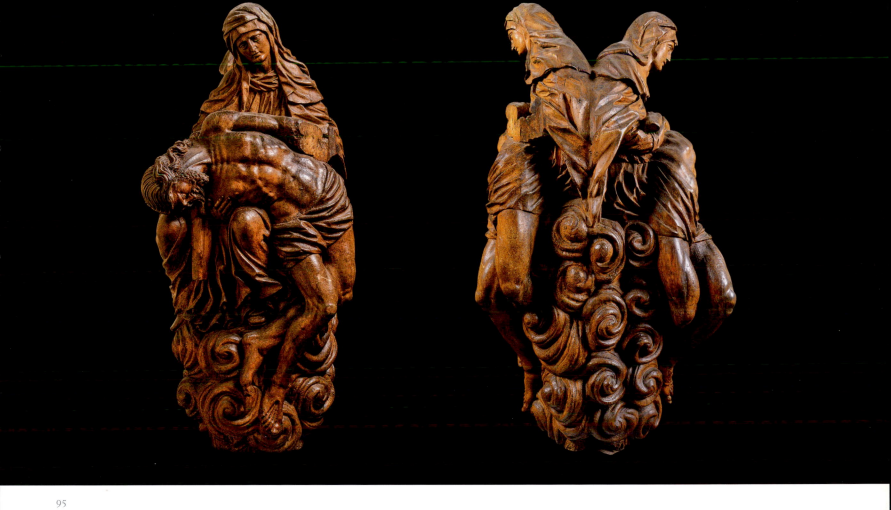

95

95

Unknown artist/workshop
Double Pietà

1st-half of the 16th century
Wood, carved
121 × 52 × 64 cm
Luther Memorials Foundation of Saxony-Anhalt,
P 82a
Minneapolis Exhibition

This wooden sculpture depicts Mary, the Mother of God, enthroned on a cloudy pedestal and cradling the body of Christ on her lap. She is dressed in a gown, a mantle and a headscarf. Even though Mary must have been an elderly woman at the time of the Crucifixion, she is depicted here with youthful features as a sign of her purity and virginity. Her face, however, is marked by both dignity and the anguish caused by the death of her son. The image is composed in an aesthetically pleasing manner, with the vertical axis of Mary's erect posture intersecting with the arch formed by the body of Christ. Mary holds the heavy, limp and lifeless body of her son without any apparent effort. This contrast is especially striking by her hand that easily supports Jesus' body by holding him under the armpit while his arm droops heavily to the ground. This style of depicting Mary as a mother mourning her dead son, which is termed a *Pietà* in art history, was a frequent subject around 1500.

What makes this particular example so remarkable is the repetition of the motif on the reverse side. This allows a contemplation of the image from two different positions. But in order to fit the reverse image into the sculpted outline, it had to be mirrored. This means that Mary gazes to the left on one side and to the right on the other, while similarly supporting the body either on her left or her right knee. Interestingly, the sculptor took this mirroring so seriously that he also placed Christ's side wound on the wrong side in the reverse image in a clear breach of iconographic convention. It is obvious that this sculpture must have been intended for free-standing display.

Comparable examples of double-sided sculptures appear from the late Middle Ages on. They were sometimes placed on columns that were erected by roadsides, so as to be visible when approaching from either direction. Double-sided sculptures of the Virgin were also placed in churches so that they could be contemplated from both the clergy's position and the attendant congregation's side. Some notable examples for this type of image of Mary (which did not necessarily have to be of the *Pietà* type) are preserved in the cathedral of Paderborn (from around 1480), in the Mainfränkisches Museum in Würzburg (around 1515) and in Kiedrich, in the Rheingau region (around 1510). In Wittenberg, a corresponding double-sided image of Mary could be found in the Castle Church during Luther's time. The sculpture, which stood raised on a marble column, was created in the Cranach workshop by Conrad Meit in 1509/10. Without a doubt, the Reformer would have been aware of this conspicuous image. DL

Literature
Bellmann/Harksen/Werner 1979, p. 252 · Treu 2010, pp. 61 f., 109, fig. 45

Piety in the Late Middle Ages

In the Middle Ages, pious endowments, pilgrimages and divine services were manifestations of the importance of the Church as an institution. It is rather more difficult from today's point of view to assess personal religiosity. We can get an idea by looking at the surviving material culture, which includes religious books written either in Latin or German. Their value could be increased by pictorial decoration, even though possession of such tomes would be restricted to the wealthy. Single block prints were popular, and even everyday objects could be decorated with religious motifs. Prayers were important for the devout individual, and were recited several times a day. During the 15th century, piety focused on the Passion of Christ, with the aim of a complete identification with the sufferings of Christ and an inner realization of the Godhead.

The veneration of saints was connected to this endeavor. It encouraged the faithful to develop empathy and a desire to follow in the footsteps of Jesus. Saints were also expected to intercede with God on behalf of the faithful and provide direct assistance. A huge number of saints were identified with specific areas of responsibility covering every aspect of life.

These trends led to new motifs in the visual arts: the Mass of Saint Gregory, the Man of Sorrows and the Pietà. Contemplation of these images and simultaneous prayer were supposed to focus concentration on the sufferings of Christ and man's redemption. By reciting specific prayers before the images of appropriate saints, one could obtain the remittance of sins. Captions beneath the images listed the particular prayers to be said, and commented on the indulgence to be expected. Another motif which became popular in this context was the so-called Veil of Veronica.

Many pilgrimages were established at the end of the Middle Ages. There were thousands of local events which could be made by the faithful without undue hardship. Their destinations were often the tombs of saints, relics and collections, and miraculous artifacts and sites. The major pilgrimages to Santiago de Compostela, Rome or the Holy Land were prestigious, but reserved for the wealthy. The intensification of pious activities around 1500 was probably due to widespread tribulations and dangers which caused apprehension of the coming of the Last Judgment. SKV

96

Daniel Hopfer
The Last Judgment

1520s (printed in the 17th century)
Etching on iron
31 × 45.1 cm
Minneapolis Institute of Art, The William M. Ladd Collection, Gift of Herschel V. Jones, 1916, P.112
Minneapolis Exhibition

God's ultimate judgement of individual human souls and their disposition for eternity were the stakes of the battles between religious factions in Europe. The New Testament provided ample evidence that sooner or later one's time would come. In Matthew 7 and Luke 13, Jesus forewarns that even those who professed their faith might find themselves shut out of the Kingdom of God, left to weep and gnash their teeth. In Matthew 25, Jesus describes the time when all of the nations will be gathered before him so that he can separate them, placing the blessed sheep to his right and the damned goats to his left.

Images of the Last Judgement frequently appeared directly above the doorways of medieval churches, and they often appeared inside on altars or painted on walls. Prints of the Last Judgement circulated widely in Italy, Germany and the Netherlands in the 15th century. Albrecht Dürer rose to international prominence with his 1498 publication of *The Apocalypse,* his illustrated version of the Book of Revelation. Clearly, there was widespread interest in the subject and a market for such images.

Daniel Hopfer, the first artist to specialize in etching printing plates, crams his version of the Last Judgement with countless figures, giving the impression that indeed every person who ever lived will be weighed. At the upper center, Jesus appears as the King of Heaven, enthroned on a rainbow with the world at his feet. Around him angels bear the instruments of the Passion. To his right is Mary, crowned as the Queen of Heaven. Beneath them are twelve apostles, with Peter as the Pope and the others with the instruments of their martyrdoms. At the bottom are empty graves from which the masses flanking the image have risen.

To the left, standing peacefully among clouds, are the saved, including Old Testament figures, such as Moses and King David; saints such as Lawrence, Dorothy, George, Barbara, and Christopher; and figures from all stations in life, including aristocrats and beggars, peasants, knights, and naked children. To the right, amid fire and demons are soldiers, laborers, teachers, tax collectors, mercenaries, prostitutes, beggars, and—more pointedly—rabbis, bishops, cardinals, Popes, and no young children. Hopfer appears to

value much of Catholic tradition while recognizing the corruption of its earthly hierarchy. TR

Literature
Hollstein XV, p. 55, no. 20 · Metzger 2009, pp. 341 f., cat. 23

97

Ars Moriendi (The art of dying)

Leipzig: Konrad Kachelofen, around 1495
Paper, several incunables bound together, modern hardback cover
21 × 17 cm
Evangelische Marktkirchengemeinde Halle (Saale), Marienbibliothek, Q 1.42
Minneapolis Exhibition

The *Ars moriendi*, the art of dying, signifies a genre of popular religious literature in the late Middle Ages concerned with the Christian endeavor to die blessedly, i.e. with penitent repentance and with the expectation of grace through trust in God. The booklet is designed to help people, through mental and spiritual preparation, to retain trust in God and pious confidence in the last hours of one's life. Originally, the *Ars moriendi* served as practical instruction for priests on how to care for the dying. Later, in times of plague, when the number of clerics could not keep up with the need to provide for the dying, the books were also read by laypersons. Thus, epidemics and early mortality, as well as the invention of printing, led to a wide circulation of these books on dying.

The most popular booklets were the *Picture-Ars*, in which the texts were printed opposite full-page woodcut illustrations. The fight for the soul of the dying person is emphasized by devilish beings on one side and saints and angels on the other side of the deathbed. The order of the texts and pictures is uniform in nearly all printed editions. The text begins with the themes of temptation and strengthening of faith. Following that, there is the trial of despair and comfort through hope, the trial of impatience and the exhortation to patience, and the trial of vain fame with the exhortation to humility; the final trial is the temptation of greed and the comfort that comes through the willingness to abstain. The conclusion of the booklet is a perspective of a blessed death with a representation of the soul of the deceased being received by angels and ascending to heaven. The demons that fought for the soul without success remain defeated at the deathbed.

The displayed copy of *Ars moriendi* was printed by Konrad Kachelofen in Leipzig. He probably published five Latin versions between 1495 and 1497/98 and three German editions in 1493,

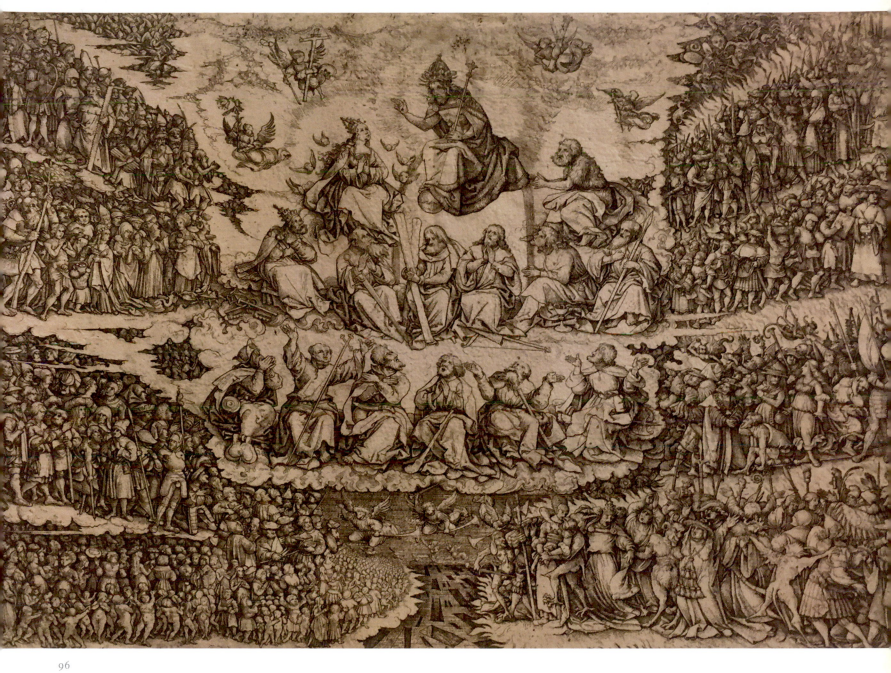

96

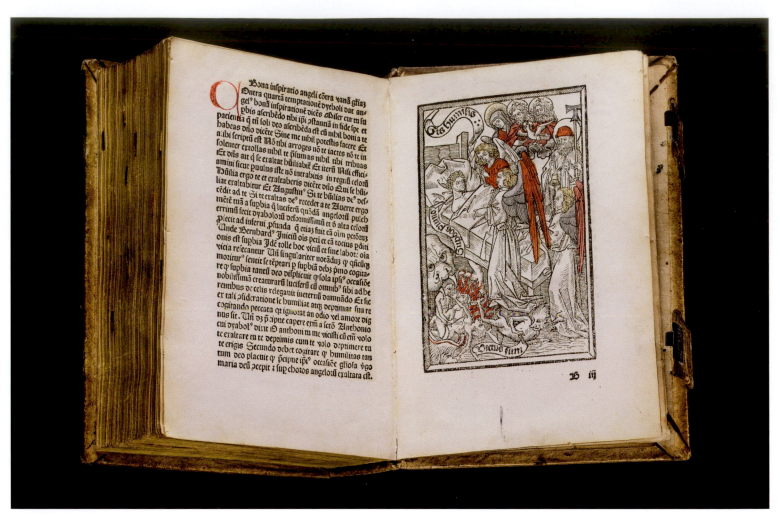

97

1494 and 1498. The artist who created the wood-cut illustrations, inspired by earlier examples, is unknown. The Latin edition from 1495, which is displayed here, contains three further illustrations in addition to the usual eleven: the representation of a confession, the receiving of the Eucharist, and the Final Judgement with the archangel Michael. Michael holds a sword and scales and stands over the jaws of hell. The woodcut illustrations are partly colored and the beginning of every section of text is decorated with a red initial.

The illustration depicted here shows the comfort of the dying person through humility. No less than three angels stand beside him in his final hours. One holds a banner with the motto "*Sis humilis* (stay humble)." In the background one can see the Holy Trinity: God, Jesus Christ and the Holy Spirit in the form of a dove. By their side stands Mary, the mother of Christ. A saint standing to the right of the picture at the foot of the bed typifies the exhorted humility and modesty. The emissaries of hell lie on the floor or creep away under the bed. One of the devilish forms at the bottom of the picture is holding a banner saying "*victus sum* (I have been defeated)." JF

Literature
Birkenmeier 2013 · Cottin/Kunde/Kunde 2014 · Jezler/Altendorf 1994 · Kühne/Bünz/Müller 2013

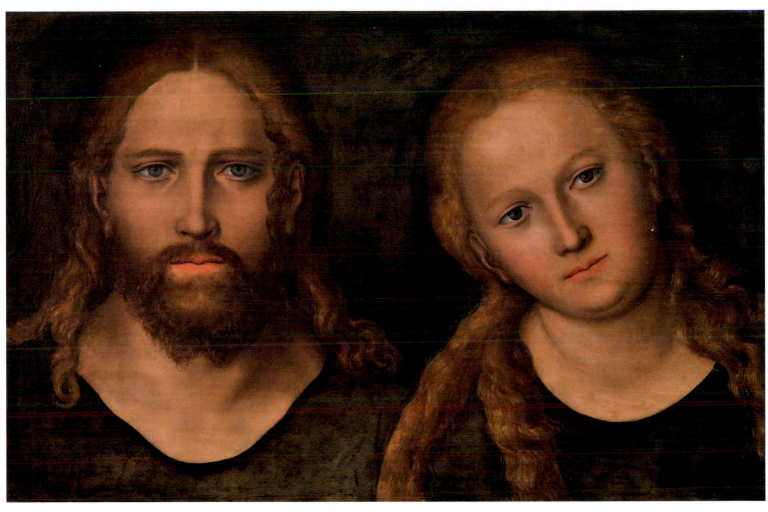

98

98

Lucas Cranach the Elder

Christ and Mary

1516–1520
Oil on parchment on oak
34.2 × 52.7 cm
Foundation Schloss Friedenstein Gotha, SG 14
New York Exhibition

This small painting is a bust portrait of Jesus Christ and Mary. They are looking right out at the observer, with Mary's head tilted slightly at the side of the Messiah. Her shoulder is placed in front of the Christ's torso. The painting is characterized by a dark, almost monochrome coloring. Only the blue eyes and the tender pink-colored lips deviate from the brown tones that dominate the painting. The clothing and the neutral background are entirely black.

This is not the only aspect of this painting that is unusual. The segmented nature of the painting, the absence of an action and the lack of features that would allow us to clearly identify the female figure have resulted in different interpretations of the painting. Mary is portrayed with openly uncovered hair, a form of portrayal which was reserved for unmarried women in Christian iconography. This led to the assumption that the figure might be Mary Magdalene. A counter-argument to this view, however, is the fact that the Virgin Mary was also portrayed in this way when the intent of the artist was to stress her virginity. Cranach also often painted Mary without a veil.

Moreover, the painting is likely a private devotional painting, which supports the notion that the person depicted is the Virgin Mary.
Another unusual feature in Cranach's work is the use of parchment as a painting surface. Aside from book illustrations, parchment was also used in small paintings such as portraits and still lifes; this was atypical for Cranach, but was a very popular practice in Dutch and Italian painting in the 16th century. It is likely that the Gotha painting was commissioned by the Elector's court. It is of high quality and the influence of Albrecht Dürer is clearly recognizable; in fact, the work was originally attributed to him in the 18th century inventories. ID

Literature
Brandsch 2001, p. 40, cat. 1.3 (ill.) · Brinkmann 2007, p. 242, cat. 61 (ill.) · Ritschel 2007, (ill.) · Schade 1983, p. 311, cat. E 22 · Schuttwolf 1994a, pp. 18f., cat. 1.2 (ill.)

Stove Tile with a Depiction of St. Dorothy

Wittenberg, Luther House, Collegienstraße 54
Early 16th century
Earthenware, green and yellow glazing
28 × 19 × 5.5 cm
State Office for Heritage Management and
Archaeology Saxony-Anhalt, State Museum
of Prehistory, HK 667:143:144a
Minneapolis Exhibition

This beautiful stove tile once decorated an ornate, late Gothic oven, which once warmed what must have been a representative room in the Wittenberg Augustinian monastery. It was most likely still in use when the property was given to Martin Luther but was probably demolished during his tenancy. Several fragments of stove tiles were found during excavations in the garden of the Luther house. Most of them are very small, but this example is nearly complete. It depicts St. Dorothy of Caesarea framed by a Gothic arch with floral finials. She is shown emerging from a niche decorated with swirling tendrils. She wears a martyr's crown and holds a chalice-shaped basket in her right hand and a flower in her left. Dorothy, a virgin martyr, is said to have fallen victim to Diocletian's persecution of Christians at Caesarea in Anatolian Cappadocia. She was tried, tortured, and sentenced to death for failing to sacrifice to the Emperor's image. Her execution on a cold winter's day in 311 AD is linked to the miraculous appearance of a basket full of fruit and sweet smelling roses, hence the basket and the flower that she holds. Although her legend is completely unhistorical, she was revered intensely in the Middle Ages, particularly in northern Europe, as one of the *Virgines Capitales*, the most powerful virgin saints. She was a helper saint who could be invoked by the needy, particularly in cases of infertility among humans, animals, and crops. Dorothy was and is the patron saint of gardeners, women in childbed, honeymooners, but also, interestingly for Luther's family history, of miners.

This tile belonged to an ornate stove, which would have had a row of niches with different saints along its top. Identifiable fragments also depict St. Margaret and perhaps St. Anne, and it seems likely that biblical scenes were also on display. Both orange and green tiles were combined, which would have given the stove an eye-catching checkerboard aspect. Such ostentatious stoves would have not only provided a room with a resplendent source of warmth but also have served as a focus for the devotions of the resident monks and their guests. It is unclear when this oven was dismantled but most likely after Luther's Reformation and his transformation of the monastery into his residence. The

99

Fig. 4
Top half of a Gothic polychrome-glazed tiled stove at the Kunstgewerbemuseum Schloss Pillnitz near Dresden

stove's decoration would have been a reminder of an unloved past, and it is likely that a gaudier stove decorated with more worldly themes took its place. LN

Literature
Kluttig-Altmann 2015 a, p. 391, fig. 43 · Kluttig-Altmann 2015 d, p. 267, fig. 44 · Meller 2008, pp. 274 f., cat. E93 (ill.) · Roth Heege 2007 · Schwarz 2008, p. 211 (ill.)

Lucas Cranach the Elder, workshop
Two Panels with Saints
Around 1520
Oil on panel
New York Exhibition

100
Saint Anthony

45.5 × 13.5 cm
Free State of Saxony-Anhalt, G 158 (on permanent loan to the Luther House in Wittenberg)

101
Saint Sebastian

45.5 × 12.7 cm
Free State of Saxony-Anhalt, G 159 (on permanent loan to the Luther House in Wittenberg)

Each of these two paintings, of St. Anthony and St. Sebastian, has a dark blue background. Bright yellow halos can be seen behind their heads, the blurred contours of which make them look like the sun. Anthony the Great, the bearded monastic father, wears the habit of the Order of St. Anthony, and the Roman captain Sebastian is wearing the clothes of a nobleman circa 1500. He is holding a bow and arrows in his hands as symbols of his martyrdom.

These panels likely once formed the wings of a small altarpiece; their narrow upright format indicates such a use. Their size and composition are similar to those of the wings of a private altar of Landgrave William II of Hesse, featuring St. Barbara and St. Catherine. Even larger altarpiece wings, such as those for an altar in the west choir of Naumburg Cathedral and the individual wings showing the Four Holy Virgins which have been found at St. Peter and Alexander Church in Aschaffenburg, show similar compositions.

The representation of the halos in the Wittenberg panels in particular makes them stand out from comparable representations by Cranach and his workshop. While in those works gold paint was used to represent the halos or the halos were left out entirely, they are represented in these panels in a lush yellow, so that, together with the blue of the background, they really seem to shine.

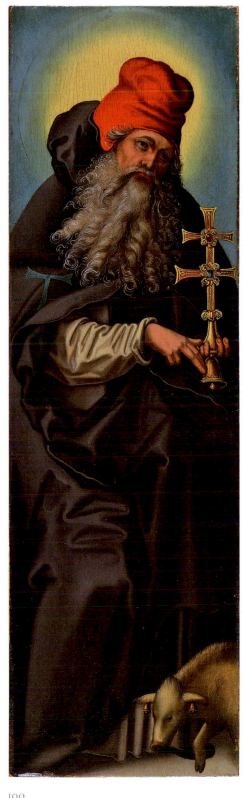

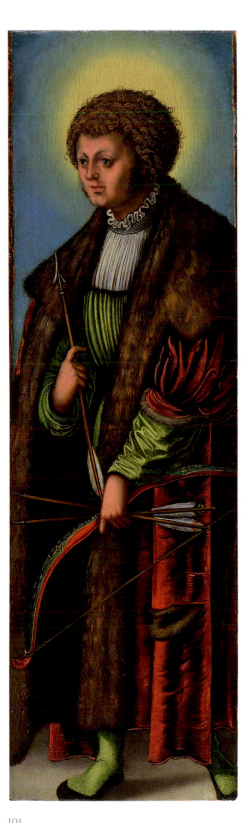

100

101

Extraneous details are limited, so that the eyes of the pious beholder are drawn to the figures of the saints. This minimalist representation is designed to increase the intensity of veneration during prayer. In this way, those engaged in prayer will be able to empathize with the actions and suffering of the persons represented, which in turn will strengthen their own faith.

Anthony and Sebastian belong to the group of saints known as Holy Helpers, who were and are to this day called upon for assistance with a wide variety of troubles. One thing that these two saints have in common is that praying to them is supposed to help against the plague. For this reason, they are frequently represented in altarpieces and in public spaces. People in the time around 1500 perceived the plague, as well as other epidemics, like St. Anthony's Fire, a malady caused by ergot poisoning which is named after St. Anthony, as a constant threat. The Order of St. Anthony, also named after the saint, was devoted to caring for the victims of St. Anthony's Fire and later established itself as a hospital order.

Allusions to the Order in the paintings include Anthony's black habit with blue Tau cross, the bell on the double cross in his hand and the pigs at his feet. The members of the Order would walk through cities ringing handbells while collecting alms for the poor and would keep pigs, who would run around freely to be fed by the general public. Little bells hanging on their necks or, as in our painting, on the ears, identified the animals as belonging to the members of the Order. The Roman Emperor Diocletian sentenced St. Sebastian to death because of his beliefs. He was shot with arrows, but survived. Once he had recovered from his wounds, Sebastian continued to profess the Christian faith, whereupon he was beaten to death with cudgels. People in the late Middle Ages saw the plague as punishment from God, who was raining down poisonous arrows upon the sinners. Accordingly, St. Sebastian's arrow wounds were reminiscent of the boils and open wounds of the plague, which he above all was supposed to defend against.

The veneration and invocation of St. Anthony and St. Sebastian blossomed around 1500, not least because of the deep fear of the Black Death. As of the mid-15th century, the Hospital of St. Anthony in Lichtenburg Palace had a house in relatively nearby Wittenberg. They were part of the Wittenberg townscape and besides provided the chancellor for the University of Wittenberg, which was formed in 1502. As in other cities, Wittenberg's rifle guild chose St. Sebastian as its patron saint. SKV

Literature
Brinkmann 2007, pp. 164 f., cat. 23 (ill.) · Joestel 2008, pp. 80 f. (ill.) · Krentz 2014, pp. 29–31 and 144–147 · Schade 2006, pp. 135–137 · Schlenkrich 2007 · Schlenkrich 2008

102

with additional themes and variations on the traditional iconography. However, the woodcuts are still easily legible due to their clear visual composition and their focus on the main action. The book was meant for devotional purposes and was part of a tradition of interest in the Passion in the late Middle Ages, which inspired a large number of tracts and imagery about Christ's Passion.

Christ's Passion was of central importance in Lutheran theology. With reference to the statements of the apostle Paul, Luther formulated a *Theologia crucis* ("Theology of the Cross") which placed the death of the crucified Christ at the center of the doctrine of justification.

No work of Albrecht Dürer's has been copied as frequently as the *Small Passion*. It was a big seller and influenced artists for generations to come. All printing blocks for this woodcut series, with the exception of the title page, can be found in the British Museum in London. ID

Literature
Hütt 1971, pp. 1590 f. and 1595 (ill.) · Strieder 1989, pp. 278–283 (ill.)

103

Anonymus
(attributed to Jakob Elsner)
Jerusalem and the Holy Sites,
In Commemoration of Frederick
the Wise's Pilgrimage
to the Holy Land in 1493

After 1503
Oil and tempera on canvas-laminated spruce wood
68.8 × 80 cm
Foundation Schloss Friedenstein Gotha, SG 77
Minneapolis Exhibition

Inscription (under Frederick the Wise): Friderich Von gottes gnaden / Hertzog Zu Sachsen und churfürst Zug Zum heyligen grab 1493 (Frederick by the grace of God / Duke of Saxony and Elector visited the Holy Sepulcher in 1493)

The painting gives a panoramic view of the Holy Land from a bird's eye perspective. Miniature figures illustrate scenes from the Bible, as well as pilgrims at various holy sites, which are identified by name. In the left foreground, Frederick the Wise is kneeling in prayer. He is identified by an inscription and by the coat of arms of the Electorate of Saxony. The Elector made his way to Palestine on March 19, 1493, with a large entourage, in order to visit biblical sites in the Holy Land. His route has been recorded in several accounts. The right side of the painting shows

102

Albrecht Dürer
The Annunciation (Small Passion)

Around 1510
Paper, woodcut
Sheet: 13.2 × 10.2 cm
Image: 12.7 × 9.7 cm
Foundation Schloss Friedenstein Gotha, 48,18
Atlanta Exhibition

Signed "AD" on the top right, at the baldaquin

The Annunciation is the fourth woodcut—after the title page, Fall and Expulsion from Paradise—in a series of 37 sheets showing the process of Christian salvation from the Fall through the birth and Passion of Christ to the Last Judgment. The first edition of the woodcut series, known as the *Small Passion*, was printed as a quarto-format book in 1511 by the Nuremberg printer Hieronymus Höltzel. The woodcuts on the right side of the book are accompanied by explanatory text on the left side. The Latin verses were composed by the humanist monk Benedictus Chelidonius, who also wrote the text for Albrecht Dürer's *Great Passion* and *Life of the Virgin*, which appeared the same year. In his *Small Passion*, Dürer expanded upon the typical scenes of the Passion,

103

the Venetian trading galley which took the pilgrims to Jaffa. In the background we see Bethlehem, the Jordan River, Mount Sinai and the Mount of Olives, which features prominently in the painting.

The panorama is based on the map of Palestine from Bernhard von Breidenbach's *Peregrinatio in terram sanctam* (1486). The painter devoted the utmost care to his representation of Jerusalem. Within the city walls, he depicts the various Stations of the Cross leading to the Church of the Holy Sepulcher. These depictions, down to the smallest detail, conform to the printed model in Breidenbach's account. Contemporary views of the city are combined with representations of Christ's Passion, since illustrating the religious

significance of the holy sites was as important as remembering the experiences of the pilgrims.

One of the pilgrims in the Elector's large entourage was Wolf Ketzel. Along with him, seven other members of this wealthy Nuremberg family who undertook this ambitious voyage between 1389 and 1503 are shown on the reverse side of the panel. Both the painter and the person who commissioned the work are unknown. However, there was another Ketzel pilgrimage painting identical to the Gotha panel. It was in the private collection of the Wingfield family but was destroyed by a fire in Powerscourt House (Ireland) in 1974. It is likely that a member of the Ketzel family commissioned both the Gotha and the Powerscourt paintings after Michael Ketzel returned from his

pilgrimage to the Holy Land in 1503. While the Powerscourt panel was intended for the family's private collection, the Gotha painting included the likeness of Frederick the Wise and was presented as a gift to the Elector in memory of the pilgrimage undertaken with Wolf Ketzel. This is likely the reason why the family members are shown on the back of the painting and not on the front side, as in the original panel. This assumption is supported by the fact that the Gotha pilgrimage painting can be found in the collection of the Duke of Saxony, which dates back to the collection of Elector Frederick the Wise. ID

Literature
Bruck 1903, pp. 202 f. · Fey 2007, pp. 152–154 and
324 (ill.) · Holtermann 2013, pp. 46–54 (ill.) ·
Purgold 1937, p. 161 · Schuttwolf 1994 b,
pp. 54 f., cat. 1.25 (ill.) · Syndram/Wirth/Zerbe/
Wagner 2015, p. 243, cat. 167 (ill.)

104

Emperor Maximillian I's Pilgrim's Garment

Iberian Peninsula, late-14th/early-15th century
Linen, silk embroidery
137 × 130 cm
Foundation Schloss Friedenstein Gotha, Eth. 5 T
Minneapolis Exhibition

This linen garment, presumably made at the court of Cordoba in the early-15th century, is adorned with intricate Islamic ornamental embroidery. There are 14 slits with round toggle buttons in the seam, floor-length sleeves and shoulders that can be opened or closed as needed.

This garment was previously held in the vault of the Benedictine Abbey of Echternach in present-day Luxembourg.

Emperor Maximilian I visited Echternach during a pilgrimage in the year 1512. He took part in a procession and in the Divine Office with the Benedictine monks, after which he donated the pilgrim's garment he was wearing to the monks. For almost three centuries, this precious garment was kept in the abbey's vault. In 1794, the monks fled before the advance of the French revolutionary forces, taking with them the most valuable items from the abbey's vault to protect them from plunder.

In 1801, Duke Ernest II of Saxe-Gotha-Altenburg acquired the Codex Aureus of Echternach—the famous 11th-century gospel book now in the Germanisches Nationalmuseum in Nuremberg —as well as the pilgrim's garment of Emperor Maximillian I. The garment was first displayed in the art chamber of Castle Friedenstein, and in 1879 it was placed on public display in the newly built Ducal Museum in Gotha.

As early as the 19th century, this unique object began to attract great interest from art and church historians because of its good condition of preservation. Franz Bock, curator of the Art Museum of the Archdiocese of Cologne and an internationally recognized expert in sacred textiles, published the first detailed description and drawing of the garment in 1858. UD

Literature
Bock 1858, p. 59 · Märchenschloss 2012,
pp. 66–69, cat. 3.2 (ill.)

104

105

Lucas Cranach the Elder
The Virgin and Child Adored by Frederick the Wise of Saxony

Around 1512–1515
Woodcut
36.5 × 22.7 cm
Minneapolis Institute of Art, Bequest
of Herschel V. Jones, 1968, P.68.136
Minneapolis Exhibition

Signed with serpent in the lower right corner

In 1509, Frederick the Wise completed a twenty-year construction project that resulted in a new and enlarged Wittenberg Castle Church complex. He dedicated it to the Virgin Mary and all the saints. It was here that he displayed his fabulous collection of relics (cf. cat. 106–119). As late as 1518, he further demonstrated his devotion to the Virgin by co-sponsoring an altar dedicated to her for his much-beloved castle in Torgau.

The superb quality of the design and carving of this woodcut makes it clear that Lucas Cranach knew the importance of Mary to his main patron. The graceful folds of Mary's robes and the intricate knot in her headcloth are some of the loveliest passages in Cranach's entire production. The slashed sleeves and thick fur of Frederick's clothing clearly speak to his exalted station. The mother's tender attitude toward her energetic son combined with Frederick's reverence produce a quiet yet utterly convincing emotional tenor. The fruited garland and sturdy old oak tree proclaim the blessings of abundance, strength, and endurance that the Virgin bestows on Frederick's picturesque domain, seen in the distance. Despite its beauty and importance, this woodcut is remarkably rare. Probably less than ten copies survive. Unlike many of Cranach's woodcuts, the block for this one was not reprinted in later years. Once Frederick became Luther's most powerful ally, it would have been inappropriate to continue to circulate images of him adoring the Virgin, whose role as God's intermediary was discounted by Reformation theology. TR

Literature
Hollstein, VI, p. 47, no. 72 · Koepplin/Falk 1976, vol. II, p. 492, cat. 341

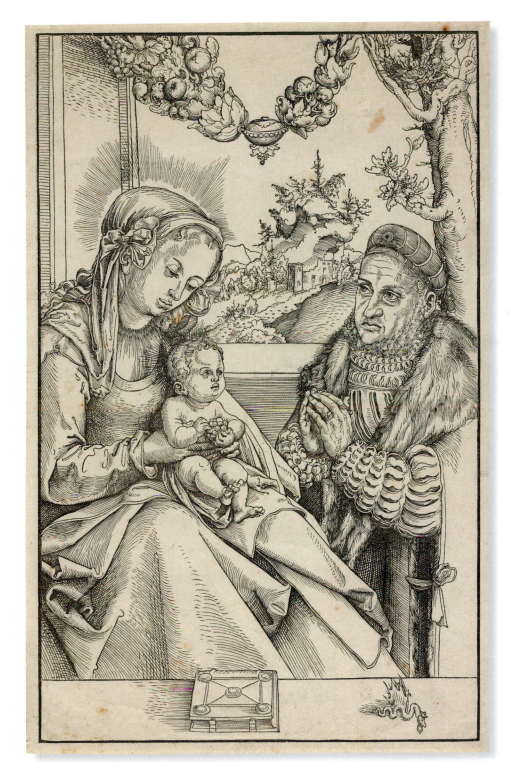

105

107

Georg Spalatin
Lucas Cranach the Elder
(illustrator)
Dye zaigung des hochlobwirdigen
hailigthums der Stifft kirchen
aller hailigen zu wittenburg
(The Wittenberg Relic Book)

Wittenberg: Symphorian Reinhart, 1509
VD16 Z 250

106
20.5 × 31 cm
Luther Memorials Foundation
of Saxony-Anhalt, ss 3579
Minneapolis Exhibition

107
21 × 31 cm
Wittenberg Seminary,
Lutherstadt Wittenberg, A VII.33
New York Exhibition

Wittenberg printer Symphorian Reinhart produced three editions of the *Wittenberg Relic Book* in the years 1509 and 1510. Elector Frederick the Wise probably ordered a small number to be printed on parchment in 1509 as gifts for prominent personalities. Today we know of only five surviving copies, two of which are in Wittenberg. Pilgrims bought such catalogs of relics at pilgrimage sites with extensive relic treasures. The books could serve as a memento of the pilgrimage, as an aid for meditation and prayer, as an explanation of the process whereby the relics were presented and as an advertisement for the presentation of the relics and the place of pilgrimage. Elector Frederick arranged for the *Wittenberg Relic Book* to be prepared by people close to him. Georg Spalatin, who at that time worked at the Wittenberg court, produced the text for the book. We also still have his handwritten list of relics. The book's fame is especially due to the inclusion of the 117 woodcut illustrations by Lucas Cranach the Elder.

The goal of the book is described in the foreword: "So that [...] all believers in Christ may be bidden and moved to the indulgence and blotting out of their sins, even to eternal blessedness. Thus [...] every conceivable praiseworthy relic of the cathedral chapter church listed, depicted and printed with their delicate repositories."

The *Wittenberg Relic Book* was meant to encourage believers to come to the presentation of the relics in Wittenberg. This took place annually on the Monday after Misericordias, the second Sunday after Easter. An additional motivation was information suggesting the possible extent of indulgence through participation in the presentation of the relics. 100 days of indulgence were promised per relic, and by 1509 the treasure had grown to 5005 pieces. These were presented in eight successive groups, and viewing each group of relics promised another 100 days of indulgence. In the year the relic book was produced, believers could gain a half-million days of indulgence.

Two impressions of the book were produced in 1509 after the Castle Church had been completed. The only extant copy of the first edition, with 104 woodcut illustrations, is housed in the British Museum in London. The second edition included many additional illustrations, the very first being a copperplate engraving with a double portrait of the princely brothers, Frederick and John of Saxony. Today only six copies of this edition are known to exist, though very many more must have been printed.

The two versions displayed here do not contain the copperplate engraving. These copies were printed on parchment, which does not appear to have been suited to this printing technique. The costly style points to the function of these books as part of the gift-giving practice of Frederick the Wise. This special characteristic explains the relatively high number of extant copies. The foreword in both copies emphasizes the achievements of the Ernestine brothers. It characterizes Frederick the Wise as a God-given ruler, promoter of science and pious patron of the arts. As a descendent of a long line of important rulers, the text praises him, in the manner of the time, as a broadly educated and wise humanist.

The illustrations by Lucas Cranach the Elder promote above all the recognition of the piety and artistic understanding of Frederick, but also create a lively impression of the sheer number of relics. This plenitude shows the material and intellectual strengths of the Elector, who enabled such an expensive and ambitious way of packaging the often much more valuable relics.

Thus as a whole, the *Wittenberg Relic Book* served to represent the political, religious and intellectual power of Frederick the Wise and his brother and successor, John the Steadfast. SKV

Literature
Cárdenas 2002 · Cordez 2006 · Gößner 2006, p. 151 · Heiser 2006 · Joestel 1993 b · Kunz 1998 · Laube 2006

107

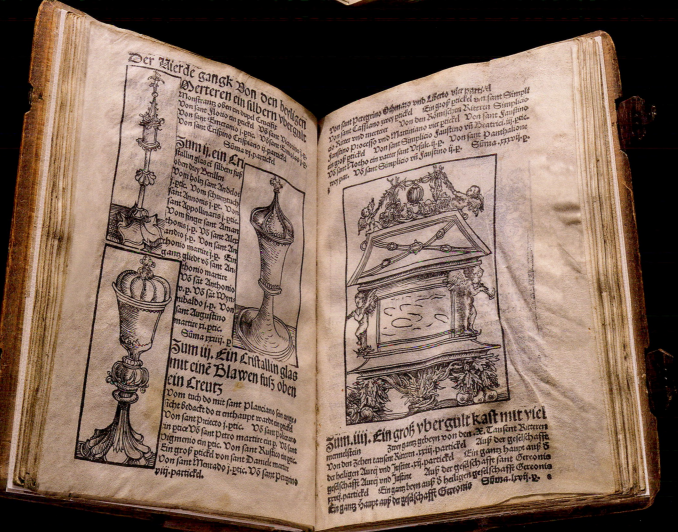

106

108

109

110

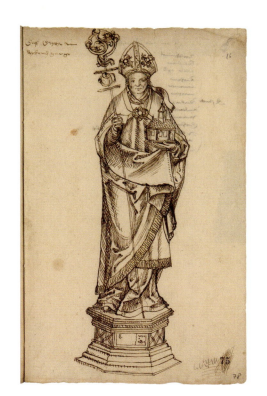

112

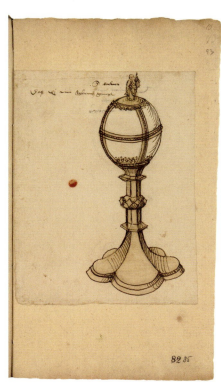

113

Unknown artists
at the Wittenberg court
Drawings of the Relic Collection of Frederick the Wise

Around 1509
Ink over graphite, watercolor on paper
Thüringisches Hauptstaatsarchiv Weimar,
Ernestinisches Gesamtarchiv (EGA)

108
Tower Reliquary

32.7 × 22 cm
EGA, Reg. O 213, Bl. 13
Minneapolis Exhibition

Labeled top right: "Das ander Stuck des || an-
deren gange" (The second piece of the second
row)
below left, crossed through: "In disser uber /
gult[e]n mo[n]stra[n]tz / sindt disse stuck / von
/ dem grabe Christi / tischtuch des abentes-
sens / der krippe unsers hern / der seule
Jhesu" (In this / gilded monstrance / are these
pieces / from / the grave of Christ / tablecloth
of the evening meal / the crib of our Lord / the
Son, Jesus)
verso: "Monstran[cia] nova inqua est magna
pars de clavo quo Χρι[st]us fuit crucifixus et
mag[na] p[ar]s de lingua domi[ni] et c[etera],
[…] de sancto Machiario et Quirico, de s[ancto]
Habundo" (New monstrance in which there is a
large part of a nail with which Christ was
crucified and a large part of the tongue of the
Lord etc, of Saint Macario and Quriaqos, of
Saint Habundo)

109
Gothic Architecture Reliquary

33 × 22 cm
EGA, Reg. O 213, Bl. 51
Minneapolis Exhibition

Labeled top left: "Daß viii diß vierden gang[es]"
[The eighth of the fourth row],
verso: "Monstran[cia] magna et p[rae]ciosa con-
tinens reliquias / Depepulo b[ea]te Ma[r]ie v[ir]
g[inis] de Sangwine Chri[sti] sparso De lintheo
domi[ni], quo in cena p[prae] cintus erat quade
pedes discipulorum lavit" (Monstrance, large
and precious containing the relics of the robe of
the blessed virgin Mary, spotted with the blood
of Christ, and of the sheet of the Lord with
which he was girded when he washed the disci-
ples feet)

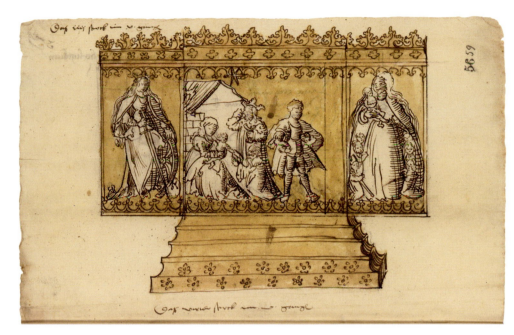

III

110
Arm Reliquary

34.3 × 21 cm
EGA, Reg. O 213, Bl. 55
Minneapolis Exhibition

Labeled top left: "Daß xii stueck deß iiii
gang[es]" (The twelvth piece of the third row)
verso: "In dissem vorsilberten großem arm ist
ein mercklich stück von s[anctae] C[un]enunge,
keyser Heynrichs elich gemall gewest" (In this
silver-plated large arm is a remarkable piece
from Saint Kunigunde, who was Emperor Henry's
former wife)

111
Triptych with the Magi, Virgin of Mercy and Saint Catherine of Alexandria

22 × 32.2 cm
EGA, Reg. O 213, Bl. 59
Minneapolis Exhibition

Labeled top left: "Daß iiii stueck im v. gang[e]"
(The third piece of the fifth row)
below middle: "Das vierde stueck im v. gang"
(The fourth piece of the fifth row)
verso: "In disser taffeln mit den heyligen drey
konigen findet ma[n] ditz heyligthum / Von
s[ancto]Mathia / dem appostell / Luca ewange-
liste / Ottone und Henrico konigen / Felicitate
ju[n]ckfrau." (In these panels with the Holy
Three Kings one finds these relics / of Saint
Matthew the Apostle, Luke the Evangelist, Otto
and Henry, kings, Felicitas the blessed virgin)
"Ditz heyligthum hath hertzog Rudolff mit
bracht von Costewitz, der man gemeyne co[n]
ciliu[m] gehalten habt (!)" (Duke Rudolf brought
this relic from Costewitz, where there was a
general council)

112
Statuette of Saint Wolfgang

33 × 21.8 cm
EGA, Reg. O 213, Bl. 78
Minneapolis Exhibition

Labeled top left: "Daß drytte im sybend[en]
gange" [The third piece of the seventh row]
Verso: "In dem bilde s[ancti] Wolfgangi /
Wolfgangk / Sebastiano / Paulo app[osto]lo /
Anthonio / Laurencio / Martino / De sancto /
Barbare / Ludimilla / Marando / Gothardo /
De lapide inquo stetit Christus in celos asscen-
det" (In the picture of Saint Wolfgang: Wolf-
gang, Sebastian, Paul the Apostle, Anthony,
Lawrence, Martin / Of Saint Barbara, Ludmilla,
Marando, Gothardo, of the stone on which
Christ stood when he ascended)

113
Ostrich Egg Ciborium

34.2 × 21.8 cm
EGA, Reg. O 213, Bl. 85
Minneapolis Exhibition

Labeled top left: "S[anct] Barbara / Daß xi im
sybend[en] gange" (Saint Barbara / the elev-
enth in the seventh row)
verso: "Clementis epi[scopi] / De / s[ancto] Eu-
stachio / Pangaie martiris" (Bishop Clement /
of Saint Eustace / Pangaian martyr)

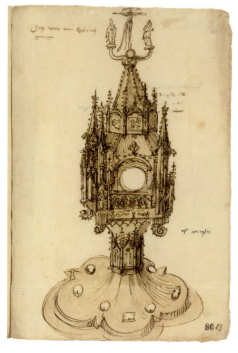

114

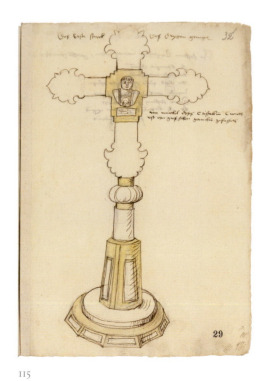

115

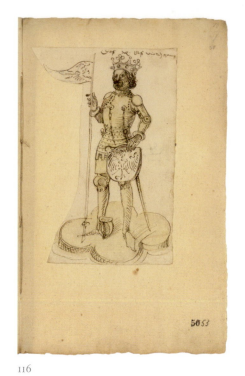

116

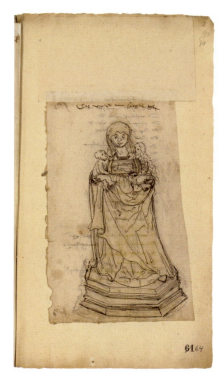

117

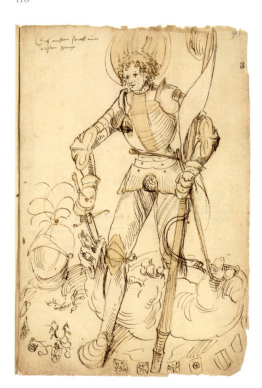

118

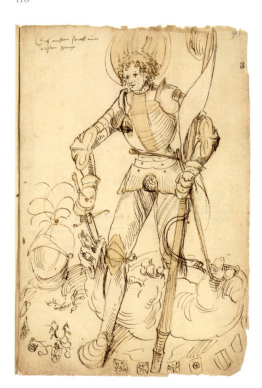

119

114
Monstrance Reliquary

32.8 × 22 cm
EGA, Reg. O 213, Bl. 83
Minneapolis Exhibition

Labeled top left: "Daß viii im sybend[en]gange"
(The eighth in the seventh row)
middle right: "Neben dem Fuß: ist gerissen"
(Next to the foot: torn away)
verso: "In dysser monstrantz vorgult / De sepul-
chra Chri[sti] / Von dem tuch deß obentessenß
Chri[sti] / P[rae]sepe David / De statua
Chri[sti]" (In this gilded monstrance / from the
tomb of Christ / from the cloth of the last sup-
per of Christ / crib of David / of the image of
Christ)

115
Reliquary Cross

32.1 × 22.2 cm
EGA, Reg. O 213, Bl. 29
Minneapolis Exhibition

Labeled above: "Das erste stueck deßdrytten
gang[es]" (The first piece of the third row,
middle, right: "Im mitthel dyses cristallii
creuces ist eyn groß schon gamhie gefasseth"
(In the middle of this crystal cross in large
beautiful gem)
verso: "in dysßem cristallyn creutz mitten i
gross[e]n gammhie ist / de spongea domi[ni] /
de veste inconsutuli / de v[ir]gis quib[us] Cris-
t[us] fuit cesus / in pede eius habent x reliquie
/ sancti Steffanis prothomartiris / et de lapide
sup[ra] quam Chr[ist]us sagweneum sudorem
studavit" (In the middle of this crystal cross is a
large gem / of the sponge of the Lord / of the
seamless garment / from which Christ was
beaten with rods / in the foot ten relics / Saint
Stephen the first martyr / and the stone on
which Christ shed his bloody sweat)

116
Statuette of Saint Wenceslas

32.8 × 22 cm
EGA, Reg. O 213, Bl. 53
Minneapolis Exhibition

Labeled top right: "Daß x deß vierd[en]
gang[es]" (The tenth piece of the fourth row)
Verso: "In dissem ubergulten bilde sancti
Wentzeslay ist vill heylthum seines heylig[e]n
corpers" (In this gilded picture of Saint Wenc-
eslas are many relics of his holy body)

117
Madonna and Child
with Saint Anne

34 × 22 cm
EGA, Reg. O 213, Bl. 64
Minneapolis Exhibition

Labeled top right: "Daß vierde im secgst [en]
g[ange]" (The fourth in the sixth row),
verso: "In dem bilde Anne / Pollic[is] dextre
man[u] s[an]cte Anne / De vestibus Ma[r]ie v[ir]
g[inis] / De cingula Ma[r]ie v[ir]ginis / De sepul-
chro Ma[r]ie v[ir]g[inis] / [...]" (In this picture of
Anne / the right thumb of Saint Anne / the
clothes of Mary the Virgin / the belt of Mary the
Virgin / from the grave of Mary the Virgin [...])

118
Crucifix with Crystals

33.1 × 22 cm
EGA, Reg. O 213, Bl. 14
New York Exhibition

Labeled top right: "Daß drytte ym andern
gange" (The third in the second row)
Verso: "In dysen ubergulten creutz ist heil-
gthum von dem heylig[e]n creutz, von den
geyschel[e]n von dem purpern cleyde unßers
herren" (In this gilded cross is the relic of the
holy cross, of the whip, of the purple clothing
of our Lord)
Crossed out: "In dysem ubergulten creutz hat
man heyligthum vom nagel unßers her[r]n
Eyn stuck von dem heupt s[ancti] secundi mar-
tir[is] undt von s[ancta] gemmaria auch von der
geselschafft s[ancti] Mauricy" (In this gilded
cross there is a relic of the nail of our Lord, a
piece of the head of a second martyr and, also
from the Society of Saint Mauritius)

119
Statuette of Saint George

33.1 × 22 cm
EGA, Reg. O 213, Bl. 3
New York Exhibition

Labeled top right "Das drytte ym andern Gang
(The third in the other row)"

The *Weimar Sketchbook* is a collection of 82 pen
drawings created by various artists for Frederick
the Wise between 1491 and 1509. The pen draw-
ings try to depict the real appearance of the ob-
jects and allow us to understand the contemporary
style of the examples, despite the fact that the
level of detail is limited in some cases. The draw-
ings present reproductions of the gold work that
are faithful to the originals and therefore have a
documentary character. They appear to be a drawn
inventory and not, as previously thought, sketches
for the printed book (cf. cat. 106 and 107). The
book's woodcuts differ significantly from the draw-

ings, having been unified in style and exaggerated
in an illusionistic way in Cranach's workshop typi-
cal for early 16th-century style.
The most important characteristic is surely that
the images in the finished relic book do not nec-
essarily represent relics but rather detached
scenes, objects and pictures of saints. The pre-
sentation of the the glass of Saint Elisabeth (not
in the catalogue) makes this very clear. The draw-
ing portrays a high cut glass from around 1200 in
a very recognizable manner. However, the wood-
cut illustration shows an elaborate silver-mounted
Nuppenbecher (a drinking glass decorated with
prunts) from the 16th century. The figures of Saint
George and Saint Wolfgang are representations
of statuettes in the drawings, while the printed
pages of the book contain lively images of the
saints.
The reliquary statue of Saint Wenceslas can be
dated to the 14th century due to its style. The
figure reminds one even of one from the Parler
Workshop in the Wenceslas Chapel of the St. Vitus
Cathedral in Prague. The reliquary crosses on
which the drawings in the this catalogue are
based can also be more closely identified. The
cross with a late Roman gem or cameo at the
crossing corresponds to a group of Venetian
crystal crosses from the 14th century, which can
still be found in the church treasuries of central
Germany and Bohemia to this day. The crucifix,
with arms ending in trefoils decorated with
symbols of the Evangelists, probably comes
from the same period. The little towers and
crocketed pinnacles of the architectural reliquar-
ies also have tiny angel and saint figures, and
three-dimensional Crucifixion scenes. These as-
pects point to the 15th and 16th century as the
period of manufacture. The triptych, reminding
us typologically of winged altars, also seems to
belong to the group of reliquaries from around
1500.
While Cranach stylistically unified the woodcut
illustrations of the relic book and the images
were not focused on a pure representation of the
objects, the drawings do give an impression of
the accumulated inventory of the relic treasures.
The documented time span in which this collec-
tion was created makes clear that the Wittenberg
relic collection was based on an older inventory
that was expanded through donations and acqui-
sitions from other collections.
The drawings were only later labeled with the
inventory details of the surviving relics. It is strik-
ing that the content of the labels for the drawings
do not always match those in the relic book.
There are differences both in regard to how reli-
quaries were organized in the rows of the relic
presentation as well as which relics were sup-
posed to be included in them. SKV

Literature
Cárdenas 2002 · Cordez 2006 · Holler/Kolb
2015 · Laube 2006

The System of Indulgences in the Catholic Church

Indulgences developed during the Middle Ages in connection with the sacrament of penance as it became a private rite administered by a priest. In its simplest form, an indulgence did not remit sin but set aside part or all of the satisfaction that a penitent was required to perform after confessing and being absolved. Satisfaction consisted of religious acts like giving alms, saying prayers, or fasting, and performing these acts paid the earthly or temporal penalty for the sins committed. The guilt incurred by those sins had already been removed by virtue of the atoning death of Christ. An indulgence, therefore, did not forgive sin or its guilt but exempted the penitent from some or all of the satisfaction that had been imposed by the priest. The notorious indulgence that provoked Martin Luther's Ninety-Five Theses (1517) and ignited the Reformation was advertised as a guarantee both to forgive sins and to shorten the time that sinners would have to spend in Purgatory. The income from that indulgence was designated for the building fund of St. Peter's Basilica; unbeknownst to Luther, part of the revenue would also pay the Roman Curia for the elevation of Albert of Brandenburg to the Archbishopric of Mainz. Pope Leo X authorized the same Albert of Mainz to issue the so-called St. Peter's indulgence. In return for their contributions to the construction of St. Peter's, priests outside Rome were given privileges that enabled them to celebrate Mass in locations under interdict, places where no public religious rites were allowed. Protestant reformers rejected many features of indulgences, but their harshest criticism was reserved for the abusive claim that an indulgence could forgive sins. If that claim were true, then indulgences would be more important than faith, the sacraments, and even the atoning death of Christ. An indulgence, however, did not forgive sin or its guilt but rather only exempted the penitent from some or all of the satisfaction that had been imposed by the priest. It was this misrepresentation of indulgences that led Luther to question the ideas of sin and grace and to write the Ninety-Five Theses.
SH

120

120

Cardinal Albert of Brandenburg
Indulgence for the Construction of St. Peter's Basilica in Rome

Leipzig: Melchior Lotter the Elder, 1515
Printed on parchment
14.5 × 18.9 cm
Luther Memorials Foundation
of Saxony-Anhalt, Urk./3213
New York Exhibition

With the plenary indulgences proclaimed on March 31, 1505 for the building of St. Peter's in Rome, Pope Julius II declared all other indulgences in Germany to be invalid. This was preached from the pulpits. Indulgences increasingly became a source of money for the continually growing financial needs of the Curia. In the era of book printing, it was easy to prepare indulgence forms with spaces for the name, date and place of the purchaser, as well as for an official seal as receipt of the payment.

The blank indulgence displayed here comes from a productive printer, Melchior Lotter, who had the privilege of printing all of the archbishop's indulgence documents. This unsold copy had, along with two other indulgences, been used until 1933 as a book cover in the Mining Office in Halle (Saale), the impressive former residence city of Cardinal Albert of Brandenburg.

Cardinal Albert was Archbishop of Mainz and Magdeburg, administrator of the diocese of Halberstadt, Elector and chief chancellor of the Empire. He ran in his own dioceses the program of indulgences proclaimed by Pope Leo X for the reconstruction of St. Peter's. However, the 24 year-old cardinal had to use part of the income from the indulgences to pay off his own immense debts to the Roman Curia and the house of the Augsburg merchant family Fugger. The double role of Archbishop of Magdeburg and Mainz had cost him 48,000 guilders. The St. Peter's indulgence lasted for eight years and earned a profit of around 73,000 guilders.

Albert sent the Dominican monk Johann Tetzel as an agent to travel through the regions of Magdeburg and Brandenburg (cf. cat. 125). Tetzel, who rewarded himself and his sub-agents with 300 guilders per month, became the most famous preacher of indulgences and proclaimed "full indulgence and forgiveness of all sins." One could even buy indulgences for dead relatives from Tetzel.

However, the Wettin princes like Duke George of Saxony forbade the sale of St. Peter's indulgences in their territories. That, however, did not stop numerous believers from travelling to the Magdeburg region to buy them there.

The small indulgence card for the construction of St. Peter's documents the "out-and-out scandal" (Meissinger 1952, p. 129) of the increasingly irritating connection between faith and money. As

121

the trigger for the critique of the reformers it bears a connection to the events of 1517: The acquired indulgence—penance bought—was contested by Luther's 95 Theses. FK

Literature
Häberlein 2016, p. 51 · Joestel 2008, pp. 36 f. (ill.) · Kühne/Bünz/Müller 2013, pp. 362 f. · Meissinger 1952, p. 129 · Meller 2008, p. 220, cat. D 3 (ill.) · Treu 2010, pp. 28 f. and 105 (ill.)

121

Cardinal Albert of Brandenburg
Indulgence for the Construction of St. Peter's Basilica in Rome

Leipzig: Melchior Lotter the Elder, 1515
30.2 × 20.2 cm
Pitts Theology Library, Candler School of Theology, Emory University, Atlanta, Ms. 85
Atlanta Exhibition

Some of the surviving St. Peter's indulgence letters from the Leipzig printer Melchior Lotter the Elder found their way into book bindings as waste paper. This uncompleted letter of indulgence, which is in the possession of the Pitts Theology Library in Atlanta, was discovered in 1937 by German Reformation historian Fritz Beyer in a bookbinding from 1530.
Melchior Lotter received orders to print the indulgence from Cardinal Albert. As the house and court printer, Lotter printed official and political documents and liturgical works in addition to the indulgence letters, even though Leipzig was not within the cardinal's archbishopric. With this letter of indulgence priests were rewarded for their contribution to building St. Peter's Basilica with permission to celebrate Mass at places that fell under interdict, that is, sites where the celebration of public religious ceremonies was forbidden. FK

Literature
Beyer 1937 · Döring 2006 · Pitts 1999, vol. 1, cat. 86

122

122

Cardinal Albert of Brandenburg
**Indulgence for the Construction
of St. Peter's Basilica in Rome**

Leipzig: Melchior Lotter the Elder, June 12, 1517
Printed on parchment with attached seal
in a wood capsule
14 × 20 cm; D capsule: 6 cm
Mühlhausen Town Archive, O 1322a
Minneapolis Exhibition

This unfilled template for a letter of plenary indulgence from the Pope (cat. 120) was issued on June 12, 1517 by Melchior Lotter in Leipzig for the members of the Dominican priory in the Free Imperial City of Mühlhausen. The prior and the members of the priory are listed by name on the reverse side of the copy. Attached to the letter is the seal of St. Peter's Basilica, printed in red wax. It depicts St. Peter with a key and tiara, along with the circumscription, "S[IGILLUM]. FABRICE. S[ANCTI]. PETRI. DE. URBE (Seal of St. Peter's Basilica)." The papal seal was meant to indicate that the proceeds from the indulgence sales would be used for their intended purpose: the construction of St. Peter's Basilica.

The Mühlhausen Town Archive has an extensive collection of illuminated indulgence letters from the late Middle Ages. A dense network of churches and monasteries in and around Mühlhausen cultivated a deep-seated devotion to indulgences among the city's population starting in the 13th century, relying in no small part on this extraordinary form of indulgence document (see Hrdina/Studničková). FK

Literature
Brüggemeier/Korff/Steiner 1993, p. 177, cat. 4.1/21 · Hessen 1992, p. 267, cat. 506 a · Hrdina/Studničková 2014 · Kühne/Bünz/Müller 2013, pp. 364 f., cat. 7.2.1C

123

123

Monogrammist HCB
(also attributed to Jakob Binck)
Tournament in Belvedere Courtyard

1565
Copper engraving and etching on two plates
44 × 57.8 cm
Luther Memorials Foundation
of Saxony-Anhalt, grfl XIV 8860
New York Exhibition

Inscriptions:
in the cartouche: Monstra della giostra fatta nel
Teatro di Palazzo / ridotto in questa forma dalla
S.tà di N.S. Pio 4° come / si vede nella stampa
della pianta, con le sue mesure
on the balustrade (left): Ant. / Lafreri / formis
on the balustrade (right): HCB / fecit

This engraving, published in Antonio Lafreri's
Speculum Romanae Magnificentiae (The Mirror
of Roman Magnificence) shows a tournament
which was held on March 5, 1565 in the Vati-
can's Belvedere courtyard. The occasion for this
spectacular event was the marriage of papal
standard-bearer Annibale Altemps to Ortensia
Borromeo, the sister of the highly venerated
Archbishop of Milan and church reformer Charles
Borromeo, who was rumored to be destined for
sainthood even during his lifetime. An eyewit-
ness at the tournament, Antonfrancesco Cirni,
expressed the view that the spectacle had propa-
ganda value above and beyond its entertainment
value. He wrote in a letter to Cosimo de' Medici
dated March 14, 1565 that the organizers had
hoped that such an honorable contest would mo-
tivate those in attendance to fight the Turks.
A large audience followed the event from the log-
gia and windows. In the background on the right

edge of the image, we can see the construction
of the new St. Peter's Basilica, the drum of which
was almost complete. The new basilica was built
because of the desire of Pope Julius II for the
erection of his monumental tomb, a project
which he entrusted to Michelangelo in 1505. The
dilapidated state of the thousand-year-old
Constantinian basilica, the difficult terrain and
the desire for an architectural style appropriate
for the importance of the location made it impos-
sible to simply extend the old St. Peter's Basilica.
The burial place of the apostle Peter was the
most important pilgrimage destination in Latin
Christendom, alongside Jerusalem and Santiago
de Compostela.
Bramante was commissioned to make plans for
the new structure, and he supplied the initial
designs. The foundation of the new St. Peter's
Basilica was laid on April 18, 1506. The Pope pro-
claimed the St. Peter's indulgences in 1507 in an

124

effort to finance this ambitious project. The Archbishop of Magdeburg, Albert of Brandenburg (cf. cat. 38), purchased the office of Archbishop of Mainz in 1514, using money he borrowed from the Fuggers. In order to pay off his debts, he obtained approval from Pope Leo X to sell the St. Peter's indulgences in his bishoprics, and was allowed to keep half of the proceeds (cf. cat. 120–122). The unscrupulous methods employed by the person charged with selling these indulgences, Johann Tetzel, prompted Luther to criticize this practice and, ultimately, to turn against the Catholic Church. Four of Luther's 95 Theses attacking the sale of indulgences, which were published in 1517, relate explicitly to the financing of the new St. Peter's Basilica (cf. cat. 145 and 146). ID

Literature
Bury 2001, pp. 162 f. (ill.) · Hollstein IV, p. 112, no. 261 (I) (ill.) · Riepertinger/Brockhoff/Heinemann/Schumann 2002, p. 162, cat. 100 a

124

Indulgence Chest

16th century (padlock from 20th century)
Iron plates studded with straps, forged lid lock with five bolts
42 × 75 × 47 cm
Luther Memorials Foundation of Saxony-Anhalt, K 372
Minneapolis Exhibition

Since the middle of the 12th century, the offertory box was the place where money collected in church services, or the *Denarius Dei,* was kept. Thus it was part of the inventory of churches. When the possibility arose to swap crusade indulgences for an amount of money, these payments were also collected in these locked chests. The indulgence chest from the Luther House in Wittenberg is from the 16th century, while the padlocks are 20th-century additions. The opening for coins is framed by a plate-like iron mounting. Thus, the money could be counted exactly before being placed in the chest without a coin being lost.
The buyers had to put their contributions into the locked chest by themselves. When the chest was opened, a public notary (who kept records of the process and the income) or several witnesses had to be present. Different keys for three or four locks (or in the case of the Wittenberg chest, five) meant that every keeper of the keys had to be present. FK

Literature
Meller 2008, pp. 222 and 224, cat. D 6, Paulus 2000, p. 386 · Treu 2010, pp. 27 and 105

125

125

Indulgence Chest

Early-16th century
Oak wood, iron covering
40.7 × 82.5 × 47.5 cm
Städtisches Museum Braunschweig, B31
New York Exhibition

Robust and secure lockboxes were needed in order to store the money that was collected from the sale of indulgences (cf. cat. 124). Covered in broad iron plates, with two handles on the narrow sides and a reinforced cover which could only be opened using multiple keys at the same time, the chests were subject to the highest level of security. The theft of these well-stocked treasure chests is the subject of many legendary anecdotes, many of which involved Johann Tetzel. The indulgence chest in the Braunschweig Municipal Museum, which was allegedly stolen from the indulgence seller by a butcher, or a knight, on the road to Königslutter, is testament to the creation of these legends. Matthäus Merian's 1654 *Topographia* includes an account of the "money box" of Johann Tetzel, who had supposedly been selling indulgences at St. Peter's Chapel in Süpplingenburg (near Helmstedt; cf. Merian, p. 193), but the spectacular story of the theft had already been spread by Luther's contemporaries before Merian's account was written. There were many stories about preachers engaged in the sale of indulgences who would tell a prospective buyer that, for a low price, he could purchase indulgence for future sins, only to be robbed by the buyer shortly after (cf. cat. 120–122). Even Philip Melanchthon was known to tell some of them around the table. They were part of Reformation propaganda against the construction of St. Peter's Basilica in Rome, which was carried out with funds that were raised from the sale of indulgences by Cardinal Albert of Brandenburg and his subordinate, Johann Tetzel. The Braunschweig "Tetzel chest" dates to this time. FK

Sources and literature
Bott 1983, pp. 166 f., cat. 200 (ill.) · Christiani 1983 · Joestel 2013, pp. 172–175 · Meller 2008, p. 222, cat. D 6 (ill.) · Merian 1654

126

126

Cardinal Albert of Brandenburg

Instructions for Agents, Penitents, and Confessors

Leipzig: Melchior Lotter the Elder, about 1516
Printed on paper
20 × 15 cm
Luther Memorials Foundation
of Saxony-Anhalt, ss 2180
VD16 M 266
New York Exhibition

Original title: Instructio Summaria pro subcommissarijs, penitentiarijs et confessoribus [...] (Summary of Instructions for Agents, Penitents, and Confessors [...])

As the representative of the Pope, Cardinal Albert of Brandenburg issued a summary of instructions for his agents and indulgence preachers consisting of 94 articles. The instructions for the regions of Saxony and Thuringia emphasized how and for what sum the confessing believers could be given a full measure of grace (cf. cat. 120). While kings, princes, rulers or (arch)bishops had to pay 25 guilders, the amount was reduced according to the wealth of the believer. For example, a simple citizen paid 1 to 1 ½ guilders. The poor, i. e. beggars and day laborers, could gain the St. Peter's indulgence through prayer and fasting. However, the *Instructio* laid out explicitly that the agents should first try to get money out of God-fearing people. Apart from this, indulgence could be bought with the same conditions on behalf of the dead. An impression of the hardline negotiating tactics which the agents were encouraged to use is the demand that they should, in the will of a dead person, find "wrongful assets," i. e. bequests to "uncertain churches, holy places, uncertain or absent persons" (Felmberg, p. 67).

On October 31, 1517, Martin Luther demanded of Cardinal Albert that the *Instructio* "should be completely abolished and the indulgence preachers be ordered to preach in another way." Furthermore, he warned of "the disgrace to Your Serene Highness" (Iserloh, p. 53) that the cardinal would face through written responses. Getting to know this document was for Luther a decisive moment: this manual was a positively "scandalous writing of the Church's indulgence-theology" (Felmberg, p. 34). FK

Literature
Felmberg 1998, pp. 34–71 · Iserloh 1962 · Paulus 2000, pp. 385 f.

IV

Luther as a Monk, Scholar and Preacher

When he had joined the convent in Erfurt, Martin Luther, a Master of the Liberal Arts, had abandoned all plans of further professional education. His superiors, however, soon decided to have him ordained as a priest and to let him study theology. Luther prepared for his ordination with serious intent, and applied himself to his studies with great enthusiasm. At the suggestion of Johann von Staupitz, he enrolled at the University of Wittenberg, where he completed his studies by becoming a doctor of theology. Throughout his coming struggles, Luther would always emphasize the fact that he had sworn an oath as a doctor of the sacred scriptures to proclaim and to defend the truth of the faith publicly—even if this meant opposing the official representatives of the established Church.

In addition to his other offices, Luther also assumed a preacher's position in the town church of Wittenberg from about 1513. To this day, the specific reasons that led to this step remain obscure. But it is certain that his closer contact with the ordinary Christians of Wittenberg contributed decisively to the evolution of the Reformer-to-be. The truth that he believed to have found through his studies of scripture now had to prove itself on the pulpit and in the confessional.

When he published his *Disputation on the Power and Efficacy of Indulgences*, Luther finally entered the wider academic world beyond the seclusion of Wittenberg. But it was the printed German edition of these statements in his *Sermon on Indulgences and Grace* that first earned him enormous and widespread popularity among the nobility and burghers. This high profile was to save him from the fate which had befallen Jan Hus in 1415—to be burned at the stake for his doctrines—when he took his stand before the imperial estates and the Emperor in Worms in 1521. Seen in this light, the second portrait of Luther by Cranach seems appropriate: It shows Luther in profile, dressed in the garb of a monk, but with the voluminous cap of a scholar on his head. In Luther's view, scholarly erudition and a public confession of his faith were inextricably connected. MT

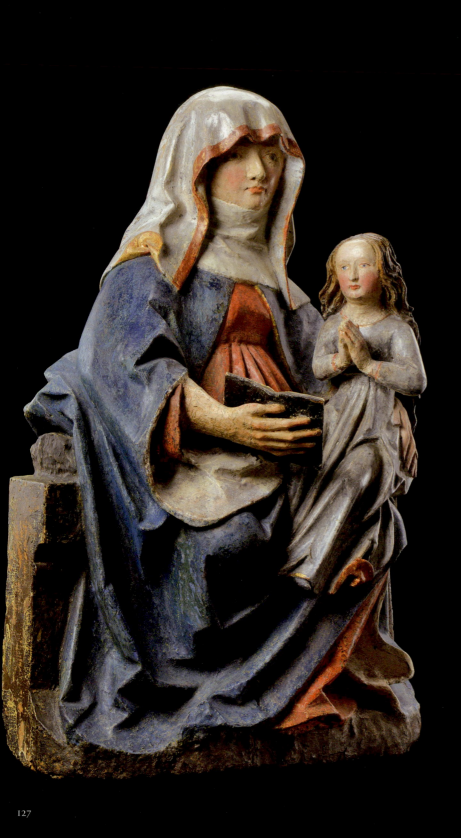

Unknown artist/workshop
St. Anne Instructing Mary

Swabia or southern Germany, around 1500
Limewood, polychrome
57 × 38 × 22 cm
Luther Memorials Foundation
of Saxony-Anhalt, P80
New York Exhibition

"Help me St. Anne, and I will become a monk!"
This pledge was made by the aspiring lawyer
Martin Luder to the mother of the Virgin Mary
when he was nearly struck by lightning on July 2,
1505 near Stotternheim, while on the way from
his parents' house to Erfurt; or at least, so the
legend goes. Then, on July 17, 1505, Luther en-
tered the monastery of the Augustinian Hermits
in Erfurt. He would repeatedly tell people about
the lightning bolt that brought him proverbial
enlightenment.

Although Luther would later distance himself
from the veneration of St. Anne, the young Martin
was typical of pious Christians of his time in his
strong devotion to the saint. Veneration of St.
Anne, the patron saint of women, families, mer-
chants and even miners, was "booming" around
1500. Dukes George the Bearded and Frederick
the Wise of Saxony promoted the cult of St. Anne
by acquiring relics of the saint. George even
named the city of Annaberg in honor of the
mother of Mary.

The considerable popularity of Jesus Christ's
grandmother led to the establishment of numer-
ous pious foundations, which were naturally
equipped with artworks. This sculpture shows St.
Anne in customary widow's garb, with the child
Mary sitting on her lap in a prayerful posture.
Anne is holding an open book, from which she is
instructing her daughter in matters of life and
faith. This representation of the mother of Mary
is highly typical for the period around 1500.
Luther himself surely prayed to her in front of
similar artworks, as is impressively demon-
strated by the representations of Anne on the
main altar and a side altar of St. George's Church
in Mansfeld, as well as Anne's altar in St. Peter's
Church in Eisleben (cf. cat. 7). SKV

Literature
Dörfler-Dierken 1992, pp. 21 f. · Hornemann
2000 · Leppin 2013, pp. 15–17 · Roch-Lemmer
2008, p. 225 · Schilling 2012, p. 78

Late Gothic Chasuble, the "Coat of Martin Luther"

Central Germany, end of 15th century/1st-third of the 16th century
Fabric (Italy?): violet silk satin; chasuble cross (Germany): embroidery of silver strip-thread and gilded silver strip-thread, carnation from light half-silk satin, sculpted padding, with wire enwrapped in brown silk for hair and beard
123.5 × 87 cm
Vereinigte Domstifter zu Merseburg und Naumburg und des Kollegiatstifts Zeitz, Merseburg, Domstift, Gewänderinventar Nr. 5
New York Exhibition

According to local tradition, this late Gothic vestment made from violet silk has a connection with Martin Luther himself. The origin of this tradition is unknown and can be traced back to the early-19th century, but we cannot be sure of its validity. The chasuble is a garment worn by the priest while celebrating Holy Mass. In the process of the Reformation, different positions emerged concerning the use of this kind of liturgical clothing. Luther himself took an open position toward vestments, keen to avoid new rules. When he celebrated the Eucharist, he is said to have continued to wear a chasuble.

The violet silk satin of the garment survives in a very fragmentary condition. The back side is adorned with an embroidered chasuble cross. It follows a design common to the end of the 15th and first-third of the 16th century that was probably disseminated in a graphic form and was replicated in embroidery with varying levels of quality. The crucified Christ hangs on a tree-shaped cross, which suggests a strong connection with the Tree of Life, and thus implies the overcoming of death through Christ's Resurrection.

It is chronologically possible that Martin Luther saw the vestment in Merseburg or even used it. As far as we know, Luther stayed only once in Merseburg in August 1545, where he preached in the cathedral on three days. The context of the tradition, however, may make us doubt the validity of the connection with Luther.

Since the middle of the 18th century, the "Luther Coat" is mentioned in one breath with the "Coat of the Saint Anthony of Padua" and the "Robe of Saint Kunigunde." In the two later cases, the textiles presented are far younger than the people to whom they were supposed to belong. It is far more likely that the legend of Luther's coat arose in an era that loved curiosities and was part of an effort to increase the attraction of Merseburg Cathedral and its treasures. That this calculation was successful can be seen by the surviving

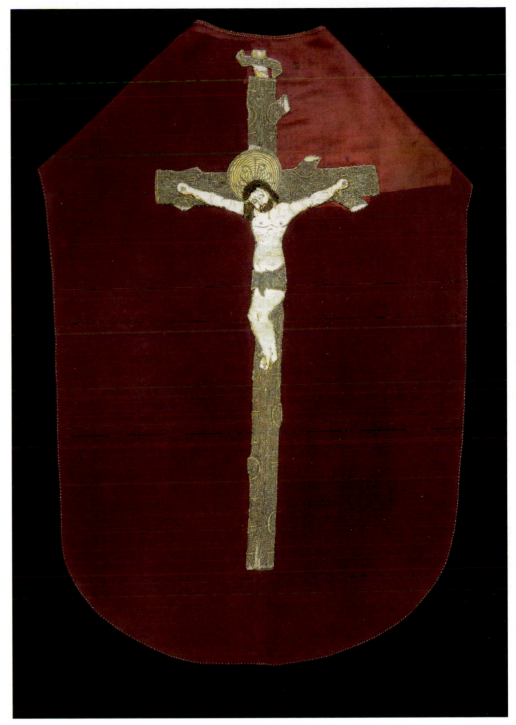

128

"souvenirs" of small pieces of violet silk that were distributed with certificates. Thus, the condition of the chasuble is witness to the excessive Luther veneration in the 19th century. BP

Literature
Bergner 1926, p. 199 · Burkhardt/Küstermann 1883, p. 128 · Cottin/Kunde/Kunde 2014, pp. 280–282 (ill.) · Otto 1834, p. 48 · Schmekel 1858, p. 194

Luther's Academic Background

Martin Luther began his studies in Erfurt in 1501. He completed them after four years by becoming a *magister artium* (Master of Arts). This signified that he was proficient in the seven liberal arts (grammar, rhetoric, logic, arithmetic, geometry, music and astronomy). Luther had also been instructed in the field of medieval scholasticism (which dealt with the philosophies of Aristotle and Thomas Aquinas) by Jodocus Trutfetter, a professor who displayed a particular interest in humanism. Luther would later evolve his own ideas from his teacher's approach, but Trutfetter would never accept his pupil's radical criticism of the Church. Luther was to experience a similar estrangement with another teacher when Bartholomäus Arnoldi, who initially befriended Luther, became an opponent.

After Luther entered a convent in 1505, his confessor, Johann von Staupitz, urged him to take up theological studies at the University of Wittenberg after his ordination. Here, Martin Luther became acquainted with the theology of William of Ockham, with its insistence on God's freedom of choice and the human free will. By studying the *Sentences* of Petrus Lombardus—a systematic compilation of theology—Luther acquired a working knowledge of the teachings of the Church Fathers, especially the writings of Augustine. Luther was strongly influenced by the latter's teachings on double predestination, which assumed that God's grace assigned some people to eternal life and others to damnation. As this view amounted to a negation of man's free will, Luther rejected it in his doctrine of justification, which held that every believer had been redeemed by the grace of God and the death of Christ.

Surrounded by constant scientific debate, Luther became a doctor of theology and a tenured professor in Wittenberg, where he transformed traditional Bible exegesis by focusing on the faith of the individual. His doctrine of the two kingdoms, which was essentially based on Augustine's *City of God,* defined the relationship of the faithful with the worldly authorities. Seen in this light, Luther's earlier studies in Erfurt and Wittenberg can be said to have had a direct influence on his later theology and reformatory work. He was influenced particularly by those concepts which focused their attention on the Holy Scriptures and the free will of the individual. ASR

129

Lucas Cranach the Elder
Martin Luther an as Augustinian Monk with a Doctor's Cap

1521
Copperplate engraving

Inscription: LUCAE OPVS EFFIGIES HAEC EST MORITVRA LVTHERI/ AETHERNAM MENTIS EXPRIMIT IPSE SVAE/ M.D.X.X.I. (This mortal figure of Luther is Cranach's work, he himself fashioned the eternal portrait of his spirit), followed by the signature (winged serpent facing left)

129
1st state
Sheet: 20.4 × 15 cm
Forschungsbibliothek Gotha der Universität Erfurt, Gym.5, Bl. Ir
New York Exhibition

130
2nd state
Sheet: 20.6 × 14.9 cm
Thrivent Financial Collection of Religious Art, 97-01
Minneapolis Exhibition
In addition to the inscription: watermark

Shortly after producing his first two portraits of Luther (cat. 154 and 155), Lucas Cranach created this portrait of the Reformer and his personal friend, which has survived in two versions. The background of the first version, of which only five copies are known, was left empty and therefore appears white. Dark background hatching and accentuated shadows in the second version render the profile portrait far more striking. The eleven known copies of this version make it a rare print of the Reformer, too. The portrait is larger than the preceding copperplate engravings and unusual in several respects: On the one hand, it not only portrays Luther in his habit as a representative of the Augustinian Order but also pictures him in his role as a doctor of theology at the University of Wittenberg. A doctor's cap accentuated by the profile position covers the monk's tonsure. An attribute of his position, it makes this picture primarily an official academic portrait.

The position of the subject in full profile is particularly significant, and not only because it is the sole known portrait of this type from the Cranach workshop. Originally familiar from portraits of rulers on ancient coins, this specific form of representation was applied to portraits of individuals during the early Italian Renaissance. It reappeared primarily in portraits of rulers and was particularly widespread in humanist circles. The first profile portraits north of the Alps did not appear until toward the end of the 15th century. They did not appear in German prints until the time this portrait of Luther was created. At first, they solely served as formulaic portraits honoring rulers and high-ranking public figures.

Cranach was alluding to more than the Reformer's humanist education by portraying him in profile; he was using the close association with portraits of rulers to formulate a claim to power with which he symbolized the political significance of Luther's impact. The doctor's cap is a reference to his academically grounded theological expertise, thus underpinning his authority in doctrinal issues. Cranach shows us the man who had launched a major publishing campaign against his adversary one year earlier with his main Reformation writings (cat. 181–184). Rather than a gaunt Augustinian monk, an influential representative of his estate is now standing before us. KH

Literature
Koepplin/Falk 1976, p. 95, cat. 38 · Lindell 2011, pp. 68 f. (ill.) · Schuchardt 2015, pp. 29 f. and 78–81, cat. 14 and 15 (ill.) · Strehle/Kunz 1998, pp. 146 f. and 149, cat. 4 (ill.) · Warnke 1984, pp. 32 f. and 40–49 (ill.)

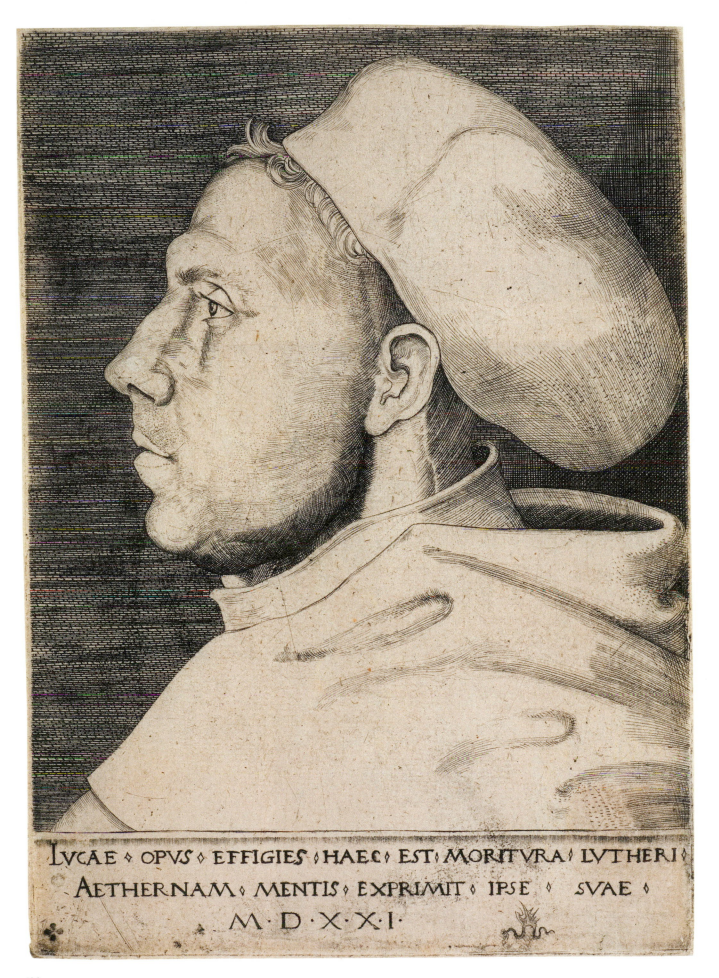

IVCAE ◇ OPVS ◇ EFFIGIES ◇ HAEC ◇ EST ◇ MORITVRA ◇ LVTHERI ◇
AETHERNAM ◇ MENTIS ◇ EXPRIMIT ◇ IPSE ◇ SVAE ◇
· M · D · X · X · I ·

130

Luther's Handwritten Marginalia on St. Jerome

In: Eusebius Sophronius Hieronymus,
Operum Omnium divi Eusebii Hieronymi
Stridonensis, Vol. 3/4
Basel: Johann Froben, 1516
Ink on paper
39.5 × 27.5 cm (W opened 59 cm)
Wittenberg Seminary,
Lutherstadt Wittenberg, HTh 2° 666
VD16 H 3482
Minneapolis Exhibition

Martin Luther was particularly interested in early Christian authors because of their relative temporal and spatial proximity to the Savior's revelation. What is more, their writings were not yet encumbered by later theological disputes. He immersed himself in St. Jerome's translations of the Bible in this book. Luther's handwritten notes on numerous passages in the text reveal how intensely he studied the text. Different inks and other evidence indicate that he picked up this work quite often in order to hone his own theological reflections. The earliest entries are written in red ink and date to 1516–17.

Not just any work, the subject of Luther's study was long the definitive interpretation of the Bible in the Catholic Church, going back to one of the four Western Doctors of the Church of Late Antiquity. Eusebius Sophronius Hieronymus (St. Jerome) translated the original Hebrew and Greek versions of the Bible into the vernacular Latin of his day.

Although Luther cited this Catholic authority with particular frequency, he ultimately considered St. Augustine—another of the early Church Fathers—to be more valuable for his theological studies: "*Hieronymus potest legi propter historias, nam de fide et doctrina verae religionis ne verbum quidem habet* (Hieronymus can be read for the history he relates but he has nothing to say about faith and the teachings of the true religion)" (WA.TR 1, 106, 1–3, [no. 252]).

The Vulgate text on display here was edited by the polymath Erasmus of Rotterdam and printed by the important printer and publisher Johann Froben. This bibliographic treasure unites the work of these three prominent figures of the Early Modern era, with Luther's meticulous notes providing direct insight into the Reformer's own creative process and pursuit of knowledge. AM

Literature
Leppin/Schneider-Ludorff 2014, p. 295,
pp. 356 f.

131

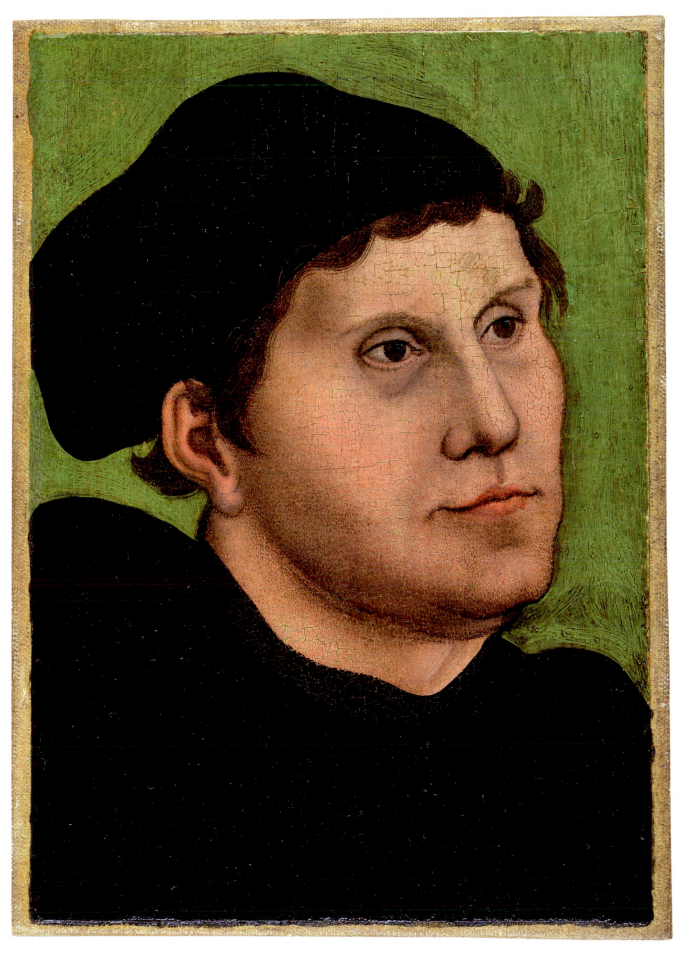

Lucas Cranach the Elder, workshop
Martin Luther with Doctoral Cap

Around 1520
Oil on wood (transferred to canvas)
26 × 18 cm
Free State of Saxony-Anhalt, G 163 (currently
on loan to the Luther House in Wittenberg)
New York Exhibition

This half-profile portrait shows Martin Luther,
turned to the right, as a young Augustinian Her-
mit in a black habit. The doctoral cap on his head
identifies him as a scholar. The young man has
soft and round facial features and is looking
straight ahead to an indeterminate point in the
distance. Six versions of this category of Luther
portraits by the Cranach workshop are known to
exist today, one of which, in a private collection,
is attributed to Cranach himself.
The round proportions shown in this painting
differ from Cranach's earlier portraits of Luther,
which represent him as a gaunt and youthful
scholar who is "so exhausted by worries and his
studies that, if one looks closely, one can count
nearly all of his bones." The depiction of Luther's
physiognomy that comes the closest to this one
is the 1521 copper engraving by Lucas Cranach
the Elder showing Luther in profile as an Augus-
tinian monk with doctoral cap (cat. 129 and 130).
There as well, Cranach showed Luther with some
meat on his bones, a portrayal which has nothing
in common with the haggard ascetic of earlier
portraits (cf. cat. 154, 155 and 159–161). Instead,
this portrait seems to show Luther as a young
scholar at the beginning of his career.
In fact, Luther made a name for himself in his ca-
pacity as a doctor of theology at various disputa-
tions all across the Empire. Although Staupitz had
released him from his oath in 1518 following the
examination before Cajetan in Augsburg, Luther
did not break with the Order for good until his mar-
riage in 1525. This explains why, with the excep-
tion of his portrayal as "Junker Jörg" (cf. cat. 200
and 201), Luther was shown as a member of the
clergy in every case until his wedding portraits.
The dating of these paintings showing Luther as
an Augustinian monk has been a subject of dis-
cussion. Schuchardt opines that all paintings in
this category were made only after Luther's
death, while Friedländer, Schade and Brinkmann
believe that at least this painting, on display in
the Luther House in Wittenberg, and the one in a
private collection in Switzerland, date back to the
period around 1520. This would make them the
earliest known portraits of Martin Luther. SKV

Literature
Brinkmann 2007, pp. 188 f., cat. 38 · Joestel
2008, p. 125 · Schade 2003 · Schuchardt 2015,
pp. 34–38 · Treu 2010, p. 48

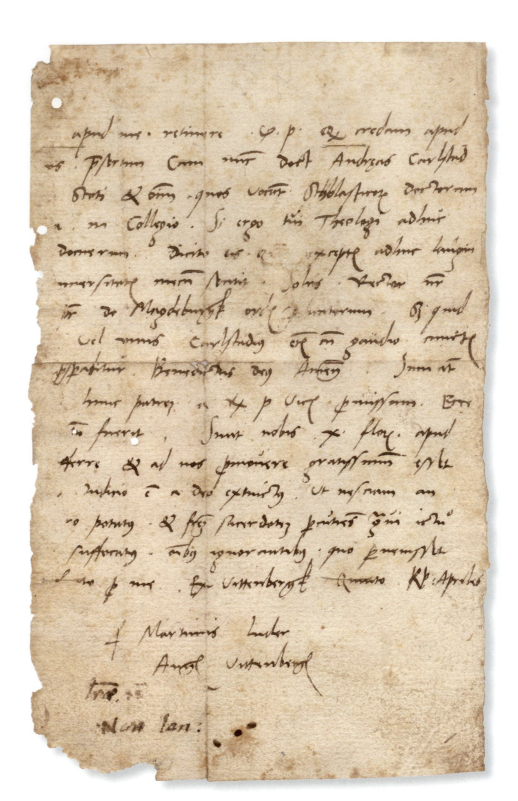

133

133

Martin Luther
Luther's Letter to an Unknown Monk

March 28, 1517
Ink on paper
15.1 × 9.5 cm
Luther Memorials Foundation
of Saxony-Anhalt, s 32/52342
New York Exhibition

Only the right half of this letter in Luther's hand-writing survives. This letter was formerly in the possession of Professor Johann Christoph Beck-mann of the University of Frankfurt/Oder, who apparently had the complete letter, in 1671. Al-legedly, the letter had been addressed to a fellow member of Luther's order, Johannes Lang(e), and was dated "V. Kal Aprilis 1517" (i. e., March 28). The year, which was presumably in the lost half of the letter, seems to be correct, since it is consis-tent with the reconstructed content of the letter, in which Luther reports that Karlstadt (Andreas Bodenstein) has come over to Luther's side. Luther states that he will now be joining the fight against the scholastic theologians and jurists. Karlstadt, who was initially skeptical of Luther's anti-scholastic position, began studying St. Augustine's anti-Pelagian writings in January 1517 with the intention of using them to refute Luther. But instead, his encounter with these texts led him to take Luther's side and break with the tra-ditional doctrine. Ultimately, it led him, on April 26, 1517, to nail 151 theses of his own attacking scholasticism to the door of Castle Church in Wittenberg. The letter appears to allude to this polemic, which Luther later valued very highly.
The text of the letter also deals with monastery affairs, such as a promise by Johannes von Staupitz to send the recipient of the letter a Father, money matters and a disciplinary measure concerning a physical assault by a drunken monk on another member of the order. This letter also reveals Luther acting in his capacity as district vicar, re-sponsible for handling the relatively mundane affairs of the ten central German Augustinian monasteries assigned to him.
Although Beckmann names Johannes Lang as the recipient of this letter, there are some indica-tions that is not the case: for example, Lang is addressed in the letter in the third person and the tone of the letter is far more formal than in Luther's other letters to his trusted friend in this period.
The letter represents an important breakthrough for Luther in early 1517. In the year before, the young professor had proposed a debate on a new doctrine, a debate that was initiated by a dispu-tation by his student, Bartholomäus Bernhardi, "De viribus et voluntate hominis sine gratia," which was based on Luther's lecture on Romans.

However, the Wittenberg professors were slow to adopt Luther's position. But now, in Karlstadt, a senior professor, former Dean of the University and Luther's thesis adviser, he had gained an important ally in his struggle against the scholas-ticism that Luther despised. MG

Sources and literature
Ebeling 1985 · Kähler 1950 · WA.B 18, 143
(no. 4341)

Leucorea

The University of Wittenberg would never have developed such a tremendous attrac-tion—which made it famous throughout 16th century Europe—without the Reforma-tion. When Frederick the Wise founded the *Leucorea*—Greek for Wittenberg, or "white castle"—this development had been quite unforeseeable; he had merely intended to establish the first university in the Ernes-tine-Thuringian territory. The existing uni-versity at Leipzig had served as a model for this venture. Frederick declined to secure legitimation from the Pope, the usual pro-cedure for such a foundation. Instead, he obtained a document directly from Emperor Maximilian I on July 6, 1502. The economic foundation for the venture was to be the huge property of the convent of All Saints. The university was incorporated into this institution economically as well as legally, ensuring a jurisdiction which was indepen-dent of the town of Wittenberg.

Apart from teaching the subjects of law, medicine and theology, the university also provided much-needed specialists for the territorial administration of the Electors. But at the beginning of the 16th century, even this prospect of employment was not enough to draw sufficient numbers of stu-dents to of Wittenberg. Young academics generally preferred the universities of larg-er cities such as Heidelberg, Vienna or Louvain. Only with the rising prominence of Luther and Melanchthon as the major pro-tagonists of the Reformation did the univer-sity experience an unexpected boom. The influx of students led to a rise in the num-ber of inhabitants and benefitted the town's role as an Electoral residence. The reforms that Melanchthon initiated in the university created the framework for a cur-riculum built on humanist principles. Inde-pendent courses in geography or mathe-matics had already been offered before the Reformation, forming a part of the general education in the liberal arts along with the classical fields such as Greek, Latin and Hebrew.

The campus was successively enlarged with the building of the *Collegium Frideri-cianum* (later called Old College), the New College, and the auditorium of the theolog-ical faculty. In addition, the Castle Church, which had been completed in 1506, was in-corporated into the university. It provided a representative venue for academic events, and symbolized the close ties between church, university and residence in Witten-berg. RN

134

134

Emperor Maximilian I

Emperor Maximilian I's Charter of Foundation for the University of Wittenberg

Ulm, July 6, 1502
Parchment with attached wax seal
58.8 × 49.5 cm
Archiv der Martin-Luther-Universität
Halle-Wittenberg, Rep. 1, U 95
Minneapolis Exhibition

The University of Wittenberg was solemnly opened on October 18, 1502, the Feast of St. Luke. The university's founder, Elector Frederick the Wise, and his brother Duke John of Saxony, with whom he shared rule, had made the public aware of this event in a printed text of August 24, 1502. The basis for this announcement, intended to attract as many students as possible to Wittenberg, was King Maximilian I's charter of July 6, 1502, which the royal chancellery in Ulm had issued at the request of the Elector of Saxony. With this charter, the king had acknowledged the dearth of opportunities for an academic education in the region around Wittenberg and approved Frederick the Wise's request to establish a university in the capital of the electorate. Maximilian further approved the establishment of four schools with the usual rights to confer doctorates and authorized the Elector to appoint their faculty members.

The charter is made of lambskin and bears King Maximilian's signature beneath the fold (plica). The issuer's seal is attached on a silk cord and displays the simple imperial eagle of the King of the Germans and the arms of Hungary, Austria, Burgundy, Tyrol and House of Habsburg on red wax in a white skippet. The white and red strands of the seal's cord take up the Austrian tinctures, its blue strands the Burgundian tincture.

135

The charter for Wittenberg became a model for universities founded later on. In a departure from the practice followed for every university founded beforehand, the Elector of Saxony did not first obtain the Pope's approval to establish an academy in Wittenberg. He even made note of this anomaly in his inventory of relics in Wittenberg (cat. 106–119). This made the University of Wittenberg the first to open without a papal charter being issued beforehand. It can nevertheless be assumed that Frederick the Wise anticipated the pontiff's approval. He eventually had King Maximilian's charter of foundation confirmed by the papal legate Reimund Peraudi on February 2, 1503, four months after the university had opened. MR

Literature
Blaschka 1952 (ill.) · Friedensburg 1917, pp. 16 f. · Friedensburg 1926, pp. 1–3, no. 1 · Matthias 2002, p. 149 (ill.) · Speler 1994, pp. 61 and 117 (ill.)

135

Pope Julius II

Pope Julius II's Bull for the University of Wittenberg

Rome, June 20, 1507
Parchment with lead bulla attached on a red and yellow silk cord
63.5 × 65 cm
Archiv der Martin-Luther-Universität Halle-Wittenberg, Rep. 1, U 47
Minneapolis Exhibition

Elector Frederick the Wise had the royal charter of foundation (cf. cat. 134) confirmed by the papal legate Reimund Peraudi after the University of Wittenberg opened. At the same time, he obtained assurances that the University of Wittenberg would be permitted to teach theology and canon law. Frederick probably had reservations about the secular ruler King Maximilian I's absolute right to authorize ecclesiastical subjects. The University of Wittenberg did not receive the Pope's official confirmation until four years after teaching had commenced. With the bull issued in Rome on June 20, 1507, Pope Julius II recognized the legitimacy of the founding of the university and conferred all of the benefits and privileges enjoyed by other universities and their faculties. What is more, the papal document primarily served to secure the finances of the young academy, for which Elector Frederick had set aside the Collegiate Church of All Saints in Wittenberg. Several vicarages there were altered to increase the number of offices of canons to twelve and these clerics were obligated to teach at the university. Frederick himself bestowed 2,000 florins on the Collegiate Church, which served to augment the prebend. Once this charter was issued, the University of Wittenberg enjoyed all necessary privileges from the Pope, Emperor, king, and territorial sovereign. MR

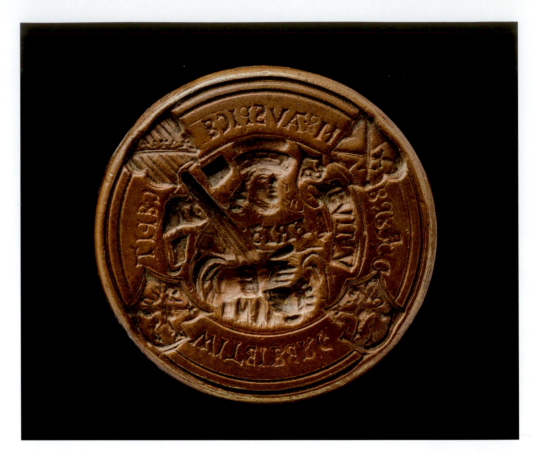

136

Literature
Friedensburg 1917, pp. 21 f. · Matthias 2002, p. 150 (ill.)

136

Lucas Cranach the Elder
(attributed to)
Seal of the Rector of the University of Wittenberg

1514
Bronze
D 4 cm
Zentrale Kustodie der Martin-Luther-Universität Halle-Wittenberg, MLU-Ku 21
Minneapolis Exhibition

The rector's seal was used to authenticate official letters and documents of the University of Wittenberg. It remained in use until the University of Wittenberg's merger with the University of Halle in 1817. The seal's inner field displays a half-length portrait of the university's founder, Elector Frederick the Wise, with his electoral hat and ermine cape and the characters "FRI 3" (Frederick III) visible on the front. His face is framed by long curls and a full beard; his chin and cheeks are shaved. Crossing his arms, the Elector is shouldering the electoral sword. A winding banderole with the inscription "VNIVERSIT. 1502" fills the rest of the space of the seal's field. The circumscription "ME AUSPICE / CEPIT / WITE(N)BERG / DOCERE (Wittenberg began teaching under my aegis)" appears between a pair of circles. It is broken up by four crests arranged in pairs along the sides. The arms on the top right bear the electoral swords, and the Saxon crancelin is on the left; the Thuringian lion is at the bottom right with the lion of Meissen on the left. They stand for the Electorate of Saxony, the Duchy of Saxony, the Landgraviate of Thuringia and the Margravate of Meissen.

A handle decorated with five perforated trefoils is attached to the obverse of the bronze seal. The seal's design is attributed to Lucas Cranach the Elder. The "steward's medal" of the Elector of Saxony designed by Cranach in 1508, which was made by the medalist Hans Krafft the Elder and minted in silver in 1512, is thought to have been the stylistic model for this piece. The design, size and circumscription of the oldest seal of the University of Jena from 1557 indicate that it was modeled after the University of Wittenberg's seal. MR

Literature
Gritzner 1906, pp. 37–39, pl. 32/4 · Matthias 2002, pp. 146 and 152 (ill.) · Speler 1994, p. 119 (ill.) · Treu/Speler/Schellenberger 1990, p. 45 (ill.)

137

Nuremberg goldsmith's work,
Paul Müllner the Elder (attributed to)
Small Scepters of Wittenberg University

Around 1502
Silver, partially fire-gilt, Nuremberg hallmarks
L 66 cm apiece
Zentrale Kustodie der Martin-Luther-Universität Halle-Wittenberg, MLU-Ku 3A and 3B
Minneapolis Exhibition

138

Nuremberg goldsmith's work,
Paul Müllner the Elder (attributed to)
Large Scepters of Wittenberg University

1509
Silver, partially fire-gilt
L 87 cm apiece
Zentrale Kustodie der Martin-Luther-Universität Halle-Wittenberg, MLU-Ku 2A and 2B
Minneapolis Exhibition

137

138

Along with Halle University's scepters, the University of Wittenberg's academic scepters are some of the most valuable art objects in the possession of Martin-Luther-Universität Halle-Wittenberg and have always been prominent among the university's insignia. This is evident from, among other items, a medal minted on the occasion of the university's 200th anniversary in 1702. It pictures six-year-old Electoral Prince Frederick Augustus as newly elected *Rector Magnificentissimus* and reaching with his right hand for the university's scepters and the rector's mantle lying on a table, thus depicting the moment the Electoral Prince of Saxony assumed the venerable position of rector. This symbolic act was also performed every time rectors

changed normally: the departing rector laid down the insignia and the incoming rector picked them up. The scepters had very special significance because whoever wielded them headed and represented the university. They thus symbolized academic authority. Their use was dictated by the university statutes of 1508. The beadles had to carry the scepters at every solemn and public event or at the invitation of university representatives to doctoral defenses. Moreover, students undergoing examination had to place two fingers on one scepter when swearing their oaths.

In keeping with centuries-old tradition, the large Wittenberg scepters were carried on solemn academic occasions as insignia and symbols of office

and the university's prominent legal status. They were used whenever new students were enrolled well into the final third of the 20th century.

The existence of two pairs of scepters is unique to the University of Wittenberg.

The two larger scepters were presumably made by master goldsmith Paul Müllner the Elder in Nuremberg in 1509. The university's founder, Elector Frederick the Wise, commissioned them in 1508, which was also the year when he had the university statutes put down in writing. The scepters measure 87 cm in length and are partially fire-gilt. One bears the date of 1509 engraved above the handle and, next to this, the arms of the Duchy of Saxony and the Grand Marshall of the Holy Roman Empire of the German Nation,

thus identifying the Elector of Saxony as the client. This pair of scepters ranks among a small number of university scepters displaying the founder's arms (e.g. Heidelberg, Freiburg, Königsberg, Leipzig, Basel and Krakow).

Like most German university scepters, the Wittenberg scepters are of the so-called bulb type, which was widespread from the 15th to the 18th century. Each of the heads is made of a knob of abundant acanthus leaves. A polygonal spike on the top indicates that a smaller finial of unknown shape has been lost. The presence of ornamental or figural terminals on nearly every university scepter of this type corroborates this presumption. The "repair" of the scepters in May of 1702 might be evidence of past damage to and loss of the finials.

The artistic quality of the University of Wittenberg's pair of small scepters is similar to that of the large pair. They must have been presented to the university on October 18, 1502, the day it was solemnly opened, because the use of the scepters at academic festivities and ceremonies had already been established in the school and university statutes of 1504 and 1508, long before the large scepters were presented. An invoice for the scepters from 1502 from Hans Unbehau, the Elector of Saxony's agent in Nuremberg, suggests that they are just as old as the university itself. The need for a royal charter of foundation documenting the university's special legal status in order to wield university scepters suggests this as well. The academy in Wittenberg received such a charter in 1502. The small scepters lost their function as the university's central insignia when the pair of large scepters were made and presented in 1509.

The small scepters are also very likely the work of the goldsmith Paul Müllner the Elder, who is documented as a supplier of decorative arts to Frederick the Wise from 1501 onward. An oblate foliate knob terminating with a pomegranate blossom crowns the scepters, which are 66 cm long and partially fire-gilt. The plain handles are framed at the tops by fire-gilt bands on the shafts and at the bottoms by similar knobs, resembling those on the University of Greifswald's pair of small scepters. MR

Literature
Matthias 2002, p. 152 (ill.) · Speler 1987, pp. 8–14 (ill.) · Speler 1997 b, pp. 23 and 32 (ill.) · Treu/Speler/Schellenberger 1990, pp. 46 f. (ill.) · Werner 1961, pp. 1122 f. (ill.)

Various Implements from an Alchemist's Laboratory

Wittenberg, former Franciscan Convent
2nd-half of the 16th century
State Office for Heritage Management and Archaeology Saxony-Anhalt
State Museum of Prehistory,
HK 4900:482:6am to f
Minneapolis Exhibition

139
Alembic and Separate Spout

Green tinted glass
Dimensions (without spouts): H 43 cm, max. D 16 cm, min. D 7.8 cm

140
Partially Melted Fragment of a Retort

Turquoise tinted glass
Max. L 20 cm, D of opening 2 cm, width at base 8 cm

141
Triangular Crucible

Glaze-free ceramic material
H 6.8 cm, max. D 6.3 cm, min. D 2.6 cm

Wittenberg University was founded in 1502 by Frederick III the Wise, Elector of Saxony. The vibrant academic and scientific activity that soon evolved in this small residence town on the Elbe River included not only the classical fields of theology and jurisprudence, but several disciplines that today would be considered natural sciences. One of these "other" disciplines was alchemy, which had not yet been reduced to the status of a para-science by the development of modern chemistry in the 17th and 18th centuries. Several alchemists are known to have pursued their studies in the safe environment of the university, and probably under the direct protection of the Elector. One of these might have been the famous Doctor Faust, whose presence in Wittenberg in the 1530s is, however, only attested by secondary sources. Among others, Luther's own son Paul was active as an alchemist in and around Wittenberg in the 16th century.

A refuse pit containing several implements from an alchemist's laboratory was uncovered during archaeological excavations in 2012, adjacent to the northern outside walls of the Franciscan church in Wittenberg. It can be dated with some certainty to the second-half of the 16th century. The church and the associated convent had been dissolved by the Reformation in 1522, and the buildings had been given over to secular uses. The refuse pit had originally been located in a small room beneath a stairway adjoining the sac-risty to the north. The pit itself was quite small, measuring 100 by 130 cm, with a depth of 80 cm. The artefacts which were found here were mostly fragmented, but it was possible to reconstruct them. For the most part, they can be attributed to alchemical activities. The material includes at least nine different *cucurbits* (distillation vessels) as well as four complete and a few fragmentary *anbiks* (condensation caps) belonging to *alembics* (stills), plus some retorts, several triangular crucibles made from ceramic material, and a couple of glass and ceramic household implements. Some of these vessels displayed traces of *lutum philosophorum* (philosopher's lute). This mixture of clay and other components was used as a protective coating for the glass vessels, to prevent damage by rapid temperature changes or excessive heating, and as a sealant.

There were no indications that this particular equipment might have been employed in attempts to synthesize gold from base substances, one of the popular assumptions usually made in connection with alchemy. Instead, some traces of chemical components such as antimony and mercury compounds seem to indicate a connection with the production of pharmaceuticals. AR

Literature
Curry 2016 · Meller/Reichenberger/Wunderlich (forthcoming) · Reichenberger/Wunderlich 2014 · Reichenberger 2015

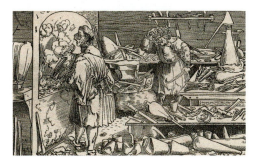

Fig. 5
Hans Weiditz the Younger, Alchemists at Work, around 1520

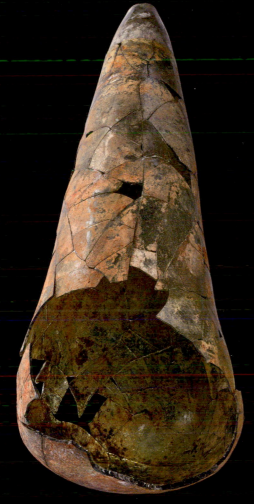

139

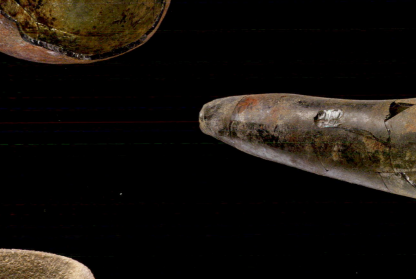

140

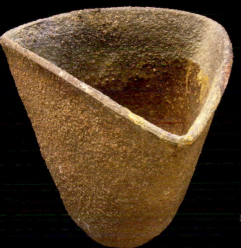

141

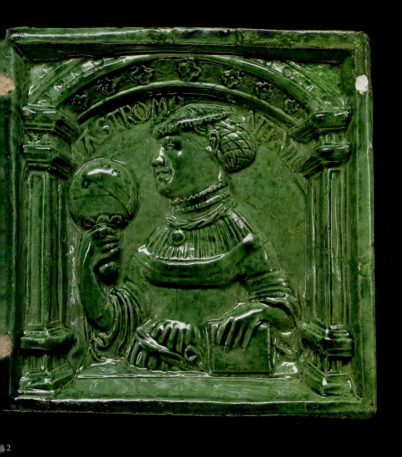

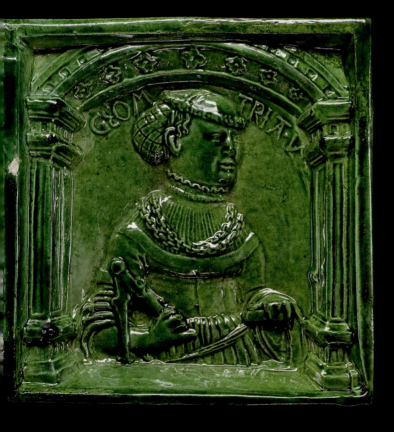

Two Stove Tiles from a Series of the Seven Liberal Arts

Wittenberg, Bürgermeisterstraße 5
2nd-quarter/mid-16th century
Earthenware, green glazing
State Office for Heritage Management
and Archaeology Saxony-Anhalt
Minneapolis Exhibition

142
Stove Tile with the Personification of Astronomy

18.5 × 17.9 × 6.4 cm
State Museum of Prehistory,
HK 98:24:665

143
Stove Tile with Personification of Geometry

18.8 × 17.9 × 7.2 cm
State Museum of Prehistory,
HK 98:24:664

These green glazed stove tiles are part of a series depicting female personifications of the seven liberal arts. Identical tiles have also turned up in Mansfeld. They embody the complex and uneven history of the reception of humanist ideas and the rediscovery of classical antiquity in central Europe. This series of tiles, which would have decorated a shiny green stove in a burgher's home, shows young women dressed in fashionable attire of the 1530s and holding attributes related to the seven liberal arts, as spelled out at the top of the arched frame. Examples found so far represent grammar, rhetoric, philosophy, dialectic, geometry, music, and astronomy.

The figures are framed by two pilasters and a vaulted embossed roof with the inscription, partially hidden by the lady's elaborate headdress. The neck and bodice of Astronomy are draped with a choker, chain, and ruff. The stemmed, ball-shaped object with diagonal bands in her right hand is an armillary sphere or spherical astrolabe. An astrolabe was a highly complex achievement of Renaissance technology made up from a series of concentric spherical rings and hoops representing the movement of stars and planets around the Earth. Not only did this serve to illustrate the Ptolemaic vision of an Earth-centered universe (in which the staunch anti-Copernican Martin Luther firmly believed), it also allowed its user to predict upcoming astronomical events. In her left hand, Astronomy holds what seems to be a book but was probably intended to be a folded map of the stars. Armillary spheres, astrolabes and star charts were, however, not only used to observe and predict the movements of the heavenly bodies, but also to practice astrology and

cast horoscopes. A court astronomer's main business was to interpret heavenly portents, and casting horoscopes was an attractive source of income for humanist scholars who lived precarious existences on the periphery of the noble courts. Much to Luther's distaste, Philip Melanchthon was obsessed with astrology, cast horoscopes (cat. 144), and even tried to plan his friend Martin's trips based on the aspect of the moon and stars. It is interesting to note that interest in astrology, and particularly predictive horoscopes, was awakened with the rise of the Reformation and the collapse of the attendant system of certainties and support provided by the hierarchical structure of Roman Catholic ritual and belief.

The other tile depicts Geometry from the same series. The styles of hair and dress are very similar on both tiles, as is the overall quality of the tiles themselves. Geometry's attributes are the circle and compass.

New research suggests that the Seven Liberal Arts tile series originated in Wittenberg. With the Cranach workshop and other artists working for the Electors, Wittenberg was an important cultural and artistic center for the region, and a number of artistic ideas and styles were created there.

The iconography of these tiles is an appropriate symbol of the new Reformation era. The bevy of helpful saints in Gothic arches that graced 15th century stove tiles was being replaced by a series of allegorical figures, nymphs, and frequently politicians—the patron saints of the new age.
LN/RKA

Literature
Berger/Stieme 2014 b, p. 283, fig. 14 b · Hennen 2013, p. 28, fig. 24–25 · Rosmanitz 2014, pp. 193 f., fig. 1–2 · Vahlhaus 2015, pp. 449 f., fig. 29–30

144

144

Philip Melanchthon
Horoscope for Eusebius Menius

Wittenberg, September 9, 1545
Ink on paper
17.5 × 15.5 cm
Forschungsbibliothek Gotha der Universität Erfurt, Chart. A 384, f. 66r
Minneapolis Exhibition

Despite working to a great extent in unison, Luther and Melanchthon also had their differences. They disagreed sharply with one another, for example, on the usefulness of astrology. Whereas Luther regarded it as "ridiculous speculation (feine lustige fantesey)," Melanchthon had a strong affinity to this age-old astronomy-based discipline, making it an established part of the general curriculum at the University of Wittenberg in the 16th century. With this prognostic science, he opposed philosophies with fatalistic and deterministic tendencies that consequently relieved people of responsibility for their own life and actions. Based on the fundamental assumption that God intervenes in natural events and that the will of man is free in worldly matters, Melanchthon saw in astronomical phenomena signs of divine providence but not the cause for a person's fortune. According to Melanchthon's understanding, the relationship of the stars and planets to each other at a significant moment, such as at one's birth, could indicate personal predispositions and dangers that often admonished one to lead a penitent life.

Melanchthon generated numerous horoscopes in his lifetime for prominent political figures, friends, and family, but very few have survived over the centuries. Melanchthon made the one depicted here when advising the pastor and ecclesiastical supervisor in Eisenach, Justus Menius, on the education of his sons Justinus and Eusebius in 1545. In the interpretation of the horoscope written in his own hand at the bottom of the diagram, Melanchthon confirmed what he had pointed out to Menius a couple months earlier in a letter: whereas Eusebius showed signs of becoming a good academic scholar, Justinus was, because of his affinity to Mars, more suitable for a military career. DG

Sources and literature
Gehrt 2015, pp. 678 f. and 694 f. · Gehrt/Salatowsky 2014, pp. 126 f., cat. 63 · MBW.T, vol. 14, no. 4009, pp. 456 f., here p. 457 (Q 7) · Salatowsky/Lotze 2015, esp. pp. 39–47 and 145–148

The Ninety-Five Theses

In addition to lectures, scientific discussions or disputations were a vital feature of academic teaching in Luther's time. In these sessions, which were a regular part of the curriculum, a given subject would be discussed controversially, according to the strict rules of logic. Another format consisted of disputations for the attainment of academic degrees, in which a candidate had to defend his theses. A third form of disputation was also practiced in Wittenberg: Here, the participants enjoyed more freedom as they debated solutions to actual controversial subjects in an exchange of arguments.

It was for such a debate that Luther had formulated his *95 Theses on the Power of Indulgences*. He had noticed that in spite of all the promises of the indulgence salesmen, an official definition of indulgences did not exist. Luther had uncovered this problem less through academic studies than through his regular contacts as a preacher and confessor with the ordinary faithful of Wittenberg.

His initial criticism of indulgences was actually phrased quite moderately and in a querying tone. The virulence of his theses is not really evident for a modern reader without closer inspection. But when Luther stated that the entire life of a Christian should be one continuous penance, this was actually a revolutionary statement. Previously, Jesus' call for penance in Matthew 4:17 had always been understood as referring to formal confession as a sacrament. But based on his reading of the Greek original text, Luther now argued that Jesus had instead enjoined his followers to change their entire life to one of repentance.

The disputation, to which Luther had also invited external candidates (to participate in writing), never materialized. The reasons are unclear. Luther also sent his theses to other institutions and private individuals, and reprints were published in Leipzig, Nuremberg and Basel. But for all his efforts, he received only a limited reaction—indulgences just did not seem to be a topical subject for contemporary theologians. Unfortunately, the laymen who bought the indulgences with such eagerness would not have been able to read his piece of professional theological literature in Latin. It was only when a German summary was published by Luther in March 1518 (cat. 151) that his arguments would reach a wider public—with tremendous effect. MT

145

Martin Luther
Broadside of the 95 Theses

Leipzig: Jakob Thanner, 1517
Paper, typographic printing
Sheet: 40 × 28 cm; Type area: 36 × 23 cm
Evangelische Kirchengemeinde Zeitz
New York Exhibition

Original title: Amore et studio elucidande veritatis. Hec subscripta disputabuntur Wittenberge Presidente R. P. Martino Luther Eremitas / no Augustiniano Artiū et S. Theologie Magistro. eiusdemque ibidem lectore Ordinario. Quare petit vt qui non / possunt verbis presentes nobiscum disceptare / agant id literis absentes. / In Nomine d[omi]ni nostri Ihesu Christi. Amen. (Out of love for the truth and from desire to elucidate it, the Reverend Father Martin Luther, Master of Arts and Sacred Theology, and ordinary lecturer therein at Wittenberg, intends to defend the following statements and to dispute on them in that place. Therefore he asks that those who cannot be present and dispute with him orally shall do so in their absence by letter. In the name of our Lord Jesus Christ, Amen.)

Luther attached a copy of his theses opposing indulgences and the related abusive practices of high church officials to a letter he wrote to Archbishop Albert of Mainz and Magdeburg. While Albert initially forwarded Luther's concerns only to the Roman Curia and the University of Mainz, the theses, which did not amount by any means to a complete rejection of the practice of indulgences but instead objected merely to the "self-deception of souls," quickly became public. Luther himself sent them out to princes and selected friends.
The Zeitz broadside comes from the Leipzig print shop of Jakob Thanner. Another single-sheet edition from the Nuremberg printing shop of Hieronymus Höltzel exists in only two copies, located in the Staatsbibliothek zu Berlin – Preussischer Kulturbesitz and the British Museum in London.
Similar to pamphlets, which circulated since the early-16th century, single-leaf prints, or broadsides, were a common tool in theological debates. Jakob Thanner was the Leipzig University printer between 1501 and 1519 (cf. Treu 2008). Accordingly, it would not have been unusual for Thanner to be awarded the printing contract. It remains unclear whether the aforementioned broadsides, printed on common laid paper, were intended primarily to be publicly posted on church doors, and therefore served as a call for a debate, or whether they were mailed in letters.
The Zeitz broadside was discovered in 1882 in a book in the library of St. Michael's Church by Hermann Kromphardt, the church's archdeacon at the time. Aware of the fact that he had found a rare copy of the print, Kromphardt took it with him to Schönebeck, where he had recently been appointed pastor. This was the second copy of the print to come to light: until then, only the London copy of the Nuremberg edition was known. The residents of Zeitz found out about this "precious treasure" from the regional press (commentary of the "Zeitzer Zeitung" newspaper, October 31, 1883). At the insistence of the congregation of St. Michael's Church, this rare find was returned to the church, its rightful owner. The city of Zeitz itself has a close connection to Martin Luther: Luther installed Nicholas of Amsdorf as the first Protestant Bishop of Naumburg-Zeitz, and Luther visited the city for the first time in 1542. How the print found its way to Zeitz is not yet known. FK

Literature
Drößler 1995, pp. 21, 24–27 (ill.) · Leppin 2006 · Meller 2008, p. 226, cat. D 10 (ill.) · Moeller 2008 · Thönissen 2014 · Treu 2008 a

Martin Luther
95 Theses

Original title: Disputatio pro declaratione virtutis indulgentiarum (Disputation on the power of indulgences)
Basel: Adam Petri, 1517
VD16 L 4457

146
28 × 15 cm
Luther Memorials Foundation of Saxony-Anhalt, ss 2183
Minneapolis Exhibition

147
19.2 × 15.1 cm
Forschungsbibliothek Gotha der Universität Erfurt, Theol 4° 00224l 11
New York Exhibition

The Reformation began, not only according to Luther, with the posting of the 95 Theses on the Power of Indulgences on October 31, 1517, the evening before the Feast of All Saints. The faith of the traditional Church, that one could attain forgiveness of sins through the payment of money, elicited Luther's critical, but at first measured reaction. The facts of the case seemed unclear to him. So in accordance with his doctoral oath, he sent invitations to an academic debate, which, however, never happened. He sent the theses with an accompanying letter to his superiors in the Church: the Bishop of Brandenburg and Archbishop of Magdeburg, Cardinal Albert of Mainz. Albert quickly forwarded the

¶ Amore et studio elucidande veritatis, hec subscripta disputabuntur Wittenburge Presidente R.P. Martino Luther Eremitano Augustiniano Artiu et S. Theologie Magistro, eiusdemq; ibidem lectore Ordinario. Quare petit vt qui non possunt verbis presentes nobiscum disceptare / agant id literis absentes. In Nomine dñi nostri Ihesu Christi, Amen.

[The remainder of the sheet consists of the numbered theses (1–87 visible) printed in two columns in heavily abbreviated Gothic Latin, which are not reliably legible for transcription.]

1517.

146

AMORE ET STVDIO ELVCIDANDAE

147

documents on to Rome on the suspicion they were heretical. He feared a reduction in profit from the sale of indulgences.

A first printing of the theses from Wittenberg is no longer extant, but this does not mean that it never existed. The theses were reprinted as single-sheet broadsides by Jakob Thanner in Leipzig and Hieronymus Höltzel in Nuremberg. The quarto-format edition by Adam Petri in Basel, copies of which are displayed here, could be more easily preserved between the covers of a book in a library. At the same time, the places of printing show that interest in the topic was present beyond the narrow boundaries of the Wittenberg University. The audience, however, still would

have been limited to the small milieu of academically educated people due to the use of the Latin language and the complexity of the arguments— it is essentially about the intricacies of a late medieval theology of penance. MT

Literature
Joestel 2008, p. 38

Martin Luther

Resolutiones Disputationum de Indulgentiarum Virtute

[Wittenberg: Rhau-Grunenberg], 1518

148
19.2 × 15.4 cm
Forschungsbibliothek Gotha der Universität Erfurt, Theol 4° 00224l 26
VD16 L 5786
Minneapolis Exhibition

149
19.5 × 15 cm
Martin-Luther-Universität Halle-Wittenberg, Universitäts- und Landesbibliothek in Halle (Saale), Ib 3611
VD16 L 5787
New York Exhibition

Luther was shocked at the dissemination of the 95 Theses and at how egregiously they were being misinterpreted. Encouraged by Johann von Staupitz, the Vicar General of the Augustinian Order in Germany, Luther published this point-by-point explanation ostensibly to appease Pope Leo X, to whom Luther was to send a copy along with a letter of apology. He sent a manuscript copy of the *Resolutiones* to Leo X via Staupitz on May 30, 1518; the *Resolutiones* was printed in August of that year. The open letter to Leo X prefacing the work explains that Luther had written the theses to defend the papacy against the abuses of the indulgence sellers and was now doubly defending himself against the lies that were being spread about him. Luther's explanation did not assuage the fears of the authorities but rather enflamed them, and papal proceedings against him continued.

In addition to a thorough explanation of the theses, the *Resolutiones* is an early testament to Luther's developing theology and how his doctrine of justification by faith alone was compelling him to separate from church traditions. Luther was continuing to distance himself from scholastic theology by clearly stating in his opening declaration that he would "refute or accept, according to [his] own judgement, the mere opinions of St. Thomas [Aquinas]..." Luther was turn-

ing ever more towards scripture as the sole source of doctrine.

Four independent editions of the *Resolutiones* appeared in 1518–1519: two from the press of Johann Rhau-Grunenberg in Wittenberg and two from Melchior Lotter the Elder in Leipzig. Rhau-Grunenberg was Luther's first printer, and in spite of the fact that he printed 21 works by Luther in 1518 alone, Luther repeatedly railed against his poor printing. The unevenness of the printed lines is clearly visible on the title page and throughout the text. JTM

Sources and literature
Flood 1998 · WA 1, 523–628

150

Albert of Brandenburg

Letter to His Privy Counselor Count Botho of Stolberg and Other Counselors

Aschaffenburg, December 13, 1517
Ink on paper
22.2 × 32.7 cm
Landesarchiv Sachsen-Anhalt, A2,
Erzstift Magdeburg. Innere Landesverwaltung,
no. 498a, ff. 8r–9v
New York Exhibition

In November of 1517, Cardinal Albert of Brandenburg received a letter from a "presumptuous monk in Wittenberg" criticizing indulgences and the system of indulgences in general. This monk was none other than Martin Luther. Luther—and this was crucial—also enclosed his 95 Theses with his letter. They were a particular thorn in Albert's side since he felt they were causing unrest among the people.

Albert took his time reacting to the letter. He did not inform his counselors in Halle of his response until December 13, 1517, and he never replied to Luther himself. Although Albert did not feel that he had been attacked personally, he wanted his theologians at the University of Mainz to provide an opinion on and to study the theses, which he considered to be presumptuous. Albert also apprised the Pope of events in Wittenberg in the hope that the Pope himself would take action against Luther, as he later did. Albert wanted to avoid open conflict with the Augustinian Order, to which Luther belonged. This document nevertheless provides evidence that the cardinal was considering proceedings of his own against Luther to ban his writings in order to reprimand him and halt the spread of what he considered to be a "pernicious error" among the people.

Albert's own criticism of Johann Tetzel's indulgence practices in his letter is also interesting.

BEATISSIMO PATRI LEONI DECIMO PONT: MAX: FRATER MARTI-NVS LVTHER AVGVSTI-NIANVS AETERNAM SALVTEM.

¶ Audiui audiui de me peßimů, Beatißime pater, quo in telligo, quosdã amicos, secectiße nomen meů, grauißime corã te & tuis, stere, vt qui authoritate & poteſtate claui & ſummi Pontificis minuere moliuntur, inde hęretici, apoſtata, pfidus, & ſexcentis nominibus, imo ignominis accuſor, Horret au-res, & ſtupent oculi, Sed vnicü ſtat fiduciæ pſidium, innocens, & quieta conſcientia, nec nona audio, Talibus em inſignibus & in noſtra regione, me ornauerit, homines iſti hõdiſſimi & veraces, ideſt, peſſime ſibi conſcij, qui ſua poſeõ, mihi co-nantur imponere, & mea ignominia, ſuas ignominias glorifi-care, Sed rë ipam Beatiſſ: pater dignoris audire ex me infante, & inculto, Cœpit apd nos, dieb⁹ pximis, pdicari Iubileus ille indulgentiæ, Apficaæ, pſecitæ adeo, vt precones illius, ſub titi nominis terrore, omnia ſibi licere putares, impijſſima hyre-ticæ, palam auderent docere, in grauiſſimű ſcandalũ & ludi-briũ Eccleſiaſticæ pōtatis, ac ſi decretales d'Abuſiõib⁹ Q vſto æ nihil ad eos pertinerent, Nec contenti, ᵱ liberrimis verbis hęc ſua venena diffunderent, inſuper libellos ediderunt, & in vul-gum ſparſerunt, In quibus, vt racæam inſatiabilem & inauditã auariciam, quã ſinguli pene apices olent craſſiſſime, eadẽ illa impia & hæretica ſtatuerſit, & ita ſtatuerũt, vt Confeſſores iura-mento adigerẽt, quo hęc ipa, fideliſſime, inſtantiſſimeᵱ po-pulo inculcarent, Vera dico, nec eſt, quo ſe abſcondant a ca-lere hoc, Extant libelli, nec poſſunt negare, Agebantur illa proſpere, & exugebant populi faſſis ſpebus, & vt Propheta ait Carnem deſuper oſſibus coɽ tollebant, Ipi vero pinguiſſime & ſuauiſſime interim paſcebantur, Vnũ erat, quo ſcandala ſe dabant, ſcz terror nominis tui, ignis comminatio, & hęretici nominis opprobriũ, Hęc em incredibile eſt, ᵱ ᵱpenſi ſunt in tentare, qñcz etiam ſi in meis opinioſiſcz nugis ſuis contradi-ctioné ſenſerint, Si tamë hoc eſt ſcandala ſedare, ac non potiꝰ

A ij

148

Resolutiones disputationum de Indulgẽtiarum virtute

F. MARTINI LVTHER AVGVSTINIANI VITTENBERG-ENSIS,

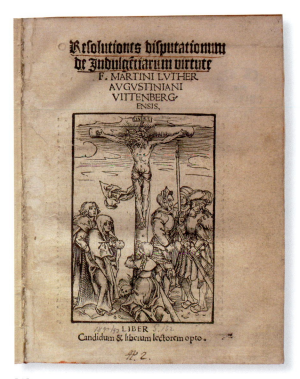

LIBER
Candidum & liberum lectorem opto.

149

Aᵒ 1517.

Ablaßkram

Albrecht von gots gnaden Ertz Magdeburg und Meintz Ertz Bischoff prima und Churfürst, administrator zu Halberstad Marggrave zu Brandenburg ꝛc

150

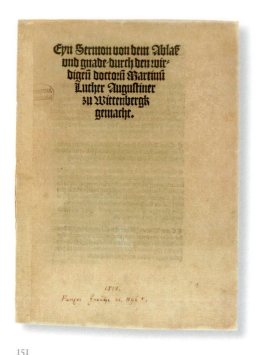

151

His displeasure, however, was directed at his profligacy. Tetzel was to cease with such "pomp" so as not to diminish the income from the indulgence sales. A stop was also to be put to his subagents' misconduct, which included laxness, ineptitude when preaching and even personal gain from the sale of indulgences.

All in all, this letter and the notification of the Pope about Luther's theses set off a fateful turn of events. The initially purely theological debate about indulgences spread through every level of society like wildfire and took on a social and political dimension that later brought about major changes. VR

Literature
Brecht 2013 · Jürgensmeier 1990 · Kaufmann 2012 · Lohse 2012 · Schrader 1972 · Schwarz 2014

151

Martin Luther

Sermon on Indulgences and Grace

Leipzig: Wolfgang Stöckel, 1518
21 × 15.2 cm
Luther Memorials Foundation
of Saxony-Anhalt, Ag 4°185g
VD16 L 6272
New York Exhibition

The publication of the 95 Theses was not a financial success for the printer, since only a few hundred copies were sold (cat. 146 and 147). It was quite different with the *Sermon on Indulgences and Grace*, which appeared in March 1518, but had probably already been sent, handwritten, to Archbishop Albert.

Luther explains the problem for ordinary Christians in just eight pages: If one has money left over, it would be more Christian, and therefore safer, to help one's neighbor than to buy indulgences. The text is especially suited to being spoken aloud, so that the illiterate could be informed at public readings. At the same time, this work was Luther's breakthrough as the most important author in German history. In less than two years, 23 editions of this sermon appeared, and there were also translations into Czech, Danish and Dutch. We should remember that there was no copyright in the modern sense. Printer-publishers produced whatever it seemed would sell well, and the success of this work helped it to spread from place to place. It was not the 95 Theses, with their limited reach, but this sermon that irrevocably thrust the indulgence topic into the public sphere. It was exactly this popular ap-

peal that Luther's opponents objected to, but it was also this which decisively contributed to his success. MT

Literature
Moulin 2014, pl. 10

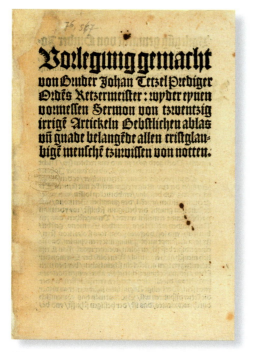

152

152

Johannes Tetzel

Rebuttal to Luther's Sermon on Indulgences and Grace

Leipzig: Melchior Lotter the Elder, 1518
20.2 × 14 cm
Luther Memorials Foundation
of Saxony-Anhalt, Kn A 76/567
VD16 L 6269
New York Exhibition

Original title: Vorlegung gemacht von Bruder Johan Tetzel Prediger Ordens Ketzermeister: wyder eynen vormessen Sermon von tzwentzig irrige[n] Artickeln Bebstlichen ablas vn[d] gnade belange[n]de allen cristglaubige[n] mensche[n] tzuwissen von notten (Rebuttal by Brother Johann Tetzel Domincian and Inquisitor of Heretics against a presumptuous sermon of twenty incorrect articles on papal indulgence and grace, for all Christian believers necessary to know)

On January 22, 1517, Johann Tetzel was placed in charge of the indulgences campaign of Archbishop Albert of Brandenburg for the Archdiocese of Magdeburg and the Diocese of Halberstadt. His sermons were successful and provoked Luther's 95 Theses.

Tetzel, who was not very intellectually accomplished, attempted to defend himself in February 1518 at the University of Frankfurt by contending for 106 counter-theses authored by the rector of the University, Konrad Wimpina. Tetzel answered Luther's *Sermon on Indulgences and Grace* (cat. 151) with this German rebuttal. In the introduction, as in the title, he calls himself Master of Heretics, that is inquisitor with magisterial authority, and reminds his readers of the burning of the Bohemian reformer Jan Hus in 1415 in Constance. This amounted to a clear threat to those who would follow Luther. This is followed by an exact copy of Luther's twenty articles, each with a corresponding refutation. If this publication had any success, it was only that of making Luther's position better known in even wider circles. MT

Literature
Leppin/Schneider-Ludorff 2014, p. 677

Martin Luther
Letter to Georg Spalatin

June 4, 1518
Ink on paper
34.5 × 22 cm
Landeshauptarchiv in Sachsen-Anhalt Dessau,
Z8 Lutherhandschriftensammlung, Nr. 17
New York Exhibition

Luther's letters provide incomparable glimpses into his professional and daily life. His primary correspondent in these early years was Georg Spalatin, private secretary and librarian to the Saxon Electors. Luther kept Spalatin continually apprised of his activities and publications, perhaps always with an eye toward maintaining the critical support of the Elector. He touches upon several topics in this letter, including the possibility of hiring Peter Mosellan from Leipzig University as the Greek professor at Wittenberg (though the position ultimately went to Philip Melanchthon), Luther's delivering books to someone in Heidelberg for Spalatin, and sending Spalatin what might be a proof copy of Luther's *German Theology* (cat. 180). The letter comes in the middle of the indulgence controversy, and Luther records that he is "hammering out" the *Resolutiones disputationum de indulgentiarum virtute* (cat. 148 and 149) to correct the many misconceptions spread about his theses. Luther notifies Spalatin that Johann Tetzel, the Dominican monk who was in charge of selling the St. Peter's indulgence, has written a rebuttal to Luther's published sermon on indulgences and grace (cat. 151). Luther finds Tetzel arrogant and notes that his own work will help shed light on the situation so that all may understand. The indulgence controversy was originally limited to those who could read Latin, but through Luther's sermon and Tetzel's rebuttal, the fight was now being waged in the vernacular for a larger reading population. While Tetzel's rebuttal netted only a single edition, Luther's sermon proved highly influential and was published in a remarkable 23 editions in two years, more than any of his other works arguing against indulgences. JTM

Sources
WA.B 1, 179–181 (no. 80)

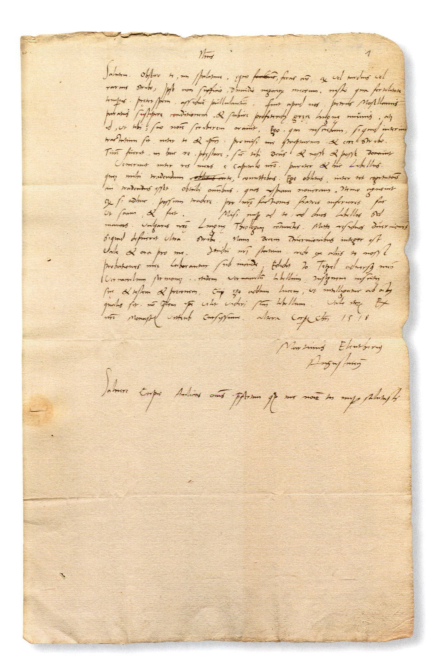

From Likeness to Image: Early Portraits of Luther

Already in his own lifetime, Martin Luther was one of the most popular subjects of portraiture of his day. This was unusual because around 1500, portraiture was usually reserved only for high-ranking individuals from the nobility, clergy and, increasingly, the upper burgher class. But the publication of his Ninety-Five Theses throughout Germany, followed by his major publishing campaign against the Roman Catholic Church, his public appearances, most notably his confrontation with Johannes Eck at their Leipzig Debate, and, finally, his declaration before the Diet of Augsburg made Luther a public figure.

In a letter to Georg Spalatin in 1520, none other than Albrecht Dürer was the first artist to express the desire to create a portrait of Luther and engrave it in copper. Dürer had already produced such a portrait of Luther's adversary, Cardinal Albert of Brandenburg, and published the prints. The Nuremberg artist's wish was not granted, though. Instead, Lucas Cranach the Elder, court painter in Wittenberg, was entrusted with the first portraits that very year. The two first copperplate engravings of Luther as an Augustinian monk were produced in 1520, and followed the next year by a portrait of him in his doctor's cap. The selection of the still relatively new technique of copperplate engraving for these first individual portraits was no coincidence since representation was less important than reproducibility. The Reformer's likeness was to be publicized as widely as possible.

The court in Wittenberg exerted influence over these portraits right from the start. Georg Spalatin, who closely collaborated with Luther and the Cranach workshop as an advisor, played an important role. He may have been the one to have had the first portrait of the Reformer, appearing almost fanatical in his austerity, replaced with the far more conciliatory portrait set within a niche (cf. fig. 6). The Reformer's gentler gaze, the Bible as a compositional point of reference and his hand raised in a rhetorical gesture make him appear more amicable and approachable. Such visual politics were ultimately intended to position Luther as favorably as possible in advance of the Diet of Worms and thus also to create an image aligned with the interests of the court in Wittenberg. KH

Lucas Cranach the Elder
Martin Luther as an Augustinian Monk

1520
Copperplate engraving, 3rd state

Inscribed on the bottom: AETHERNA IPSE SVAE MENTIS SIMVLACHRA LVTHERVS/ EXPRIMIT AT VVLTVS CERA LVCAE OCCIDVOS/ M.D.X.X. (Luther himself creates an eternal image of his spirit, his mortal features are but the wax of Lucas [Cranach])

Signature: winged serpent at center of lower edge

154
Sheet: 14.1 × 9.7 cm
Luther Memorials Foundation of Saxony-Anhalt, fl IIIa 208
New York Exhibition

155
Sheet: 14.3 × 9.8 cm
Thrivent Financial Collection of Religious Art, 85-17
Minneapolis Exhibition

Of all the surviving portraits of Martin Luther, this was the first to picture the Reformer with his individual features. This copperplate engraving was made at a time when Luther had already made a name for himself with his radical theses far outside of Wittenberg's limits. It was the year in which the Pope issued his bull threatening Luther with excommunication and demanding that he recant his 95 Theses. It was also the year in which Luther started a major publishing campaign with his chief Reformation writings (cat. 181–184).

Lucas Cranach the Elder literally shows us the head of the Reformation with this picture: The portrait is fully reduced to Luther's facial features, tonsure and simple habit, identifying him as an Augustinian monk. The classical simplicity of the depiction is dramatized with the aid of clever lighting: The light entering obliquely from above highlights his sharply chiseled features. His modeled brow is just as accentuated as his shaded cheeks, giving the Reformer a somber appearance. Cranach engraved the picture of the man who shook the foundations of the Church by virtue of his faith.

The few surviving copies of this first Luther portrait suggest that the copperplate engraving was never printed in a larger run. Instead, Cranach created a second portrait that very same year, which portrays the Reformer far less radically and was circulated in large numbers (fig. 6). Although the client who commissioned the portrait has never been identified, it is assumed to

155

Fig. 6
Lucas Cranach the Elder, Luther as an Augustinian monk, 1520

have been Elector Frederick the Wise himself, thus influencing the popularization of Luther's image in advance of the Diet of Worms. KH

Literature
Koepplin/Falk 1976, p. 91 · Lindell 2011, pp. 66 f. (ill.) · Schuchardt 2015, pp. 27–29 and 64, cat. 6 (ill.) · Strehle/Kunz 1998, pp. 144 f., cat. 2 (ill.) · Warnke 1984 (ill.)

AETHERNA IPSE SVAE MENTIS SIMVLACHRA LVTHERVS
EXPRIMIT·AT VVLTVS CERA LVCAE OCCIDVOS.

·M·D·XX·

After Lucas Cranach the Elder
Martin Luther as an Augustinian Monk

Woodcuts

Dated in upper right corner "1520"

156
1520
Sheet: 15.6 cm × 12.2 cm
Foundation Schloss Friedenstein Gotha,
G43, 101
Minneapolis Exhibition

157
1520/1521
Woodcut
Sheet: 15.1 × 12.2 cm
Stiftung Deutsches Historisches Museum,
1990/1090
New York Exhibition

In 1520/21, Lucas Cranach the Elder produced three copperplate engravings with slight variations depicting Luther as an Augustinian monk in three-quarter profile. Of these, the third version, which shows the monk in front of an alcove with a book held in his hand, became the most popular image. It was instantly and extensively copied, among others by Hans Baldung Grien. Interestingly, neither Cranach nor the copyists paid any attention to the direction of the gaze and the correct posture of the hands of the depicted. As Luther was right-handed, he would normally have held any piece of writing in his left, leaving the right free to gesture or leaf through the pages. The Cranach prints, however, which show Luther left-handed and gazing to the left, are clearly mirrored images. This was probably the result of the artist simply transferring his sketch directly onto the copper plate without bothering to mirror it in anticipation of the reversal inherent in the printing process. As a result, it was the woodcut prints of the copyists which came to depict the "correct" image of Luther. This was not intentional. The copyists again chose the easiest method of reproduction by copying the existing—incorrect—prints of Cranach onto their wooden printing block, which would then be reversed to the correct appearance during printing. The image of the Augustinian monk standing in front of a niche, looking to the right, thus became the accepted representative portrait type. It was copied extensively and even served as an illustration for Luther's early writings. LK

Literature
Falk/Koepplin 1976, vol. 1, pp. 92 – 94 ·
Schuchardt 2015, p. 68 (ill.)

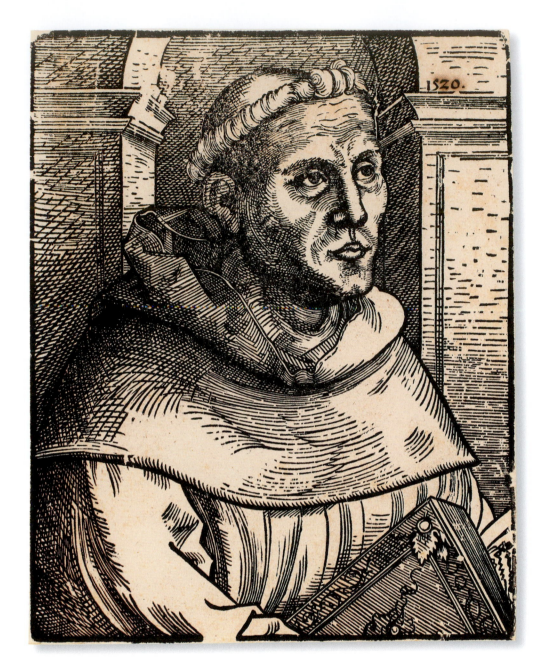

156

158

Monogrammist H.G., based on a
model by Lucas Cranach the Elder
Medal of Martin Luther

1521
Lead, cast, pierced
D 60 mm; weight 29.62 g
Foundation Schloss Friedenstein Gotha,
4.1./3979
Minneapolis Exhibition

Obv: HERESIBVS · SI · DIGNVS · ERIT · LVTHERVS
· IN · VLLIS · ET · CHRISTVS · DIGNVS · CRIMINIS ·
HVIVS · ERIT
Bust of Luther with doctor's cap and monk's
frock to left. In field left: 1521, below bust bor-
der: H.G.

This medal, which exists in a single-sided version
only in the Numismatic Collections of Berlin (sil-
ver) and Gotha (lead), and has various reverse
sides in later designs, is the earliest portrayal of
the Reformer in this artistic genre. The high-qual-
ity picture of Luther as a scholar with doctor's cap
and monk's habit is almost identical with his
portrait in the famous copper engraving by Cra-
nach the Elder, also of 1521 (cat. 129 and 130), of
which two versions were made by the artist.
Frederick the Wise's court painter and his work-
shop portrayed the founder of the Protestant
Reformation in a great variety of graphic prints
and serially-produced oil paintings at various
points in his life, and Cranach was the only artist
to depict Luther as a commoner during his life-
time.

Attributing the medal to an artist is not unprob-
lematic. Some experts presume that Cranach, as
a close friend of Luther, made the model himself,
which is very likely on account of its high quality
and identifiable artistic signature, but unlike the
governor medals of Frederick the Wise, this can-
not be proven. On the other hand, the initials
H.G. below the Luther portrait are interpreted as
the signet of an unknown artist, the monogram-
mist H.G. In 1928, Behrendt Pick even suspected
that the letters could be the abbreviated name of
the author of the text: "If Luther should be guilty
of any heresies then Christ will also be guilty of
such trespassing."

Based on the very precarious circumscription, it
can be assumed that the medal was created im-
mediately after the historic appearance of Luther
before the Imperial Diet in Worm on April 17 and
18, 1521 and his abduction to Wartburg Castle
near Eisenach, that was instigated by Frederick
the Wise as a protective measure for Luther's
own protection. In Worms, the Reformer had
steadfastly refused to revoke his theological writ-
ings before Emperor Charles V, whereupon he

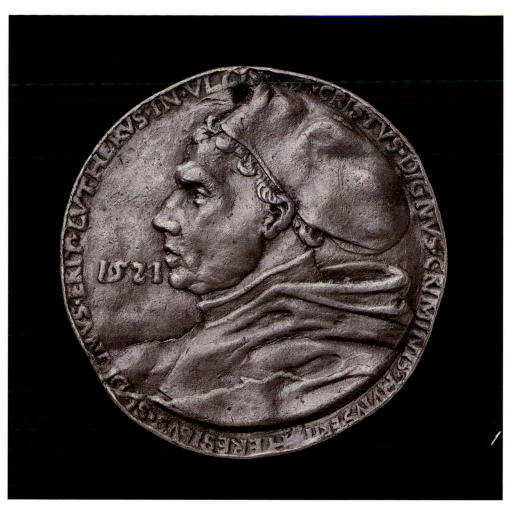

158

was branded a heretic and was put under the
imperial ban with the Worms Edict of May 8, 1521
(cat. 177). The legend is an elegiac distich that
relates to this ban and ostentatiously takes the
side of the Reformer. Thus, this medal is a direct
reaction to a current event and can be seen, in
the same sense, as a broadsheet, and as being
highly political. UW

Literature
Cupperi 2013, p. 190, cat. 88 · Hentschel 2001 ·
Meller 2008, p. 327, cat. F 36 (ill.) · Pick 1928 ·
Schuttwolf 1994 b, pp. 29 f., cat. 4.31 (ill.)

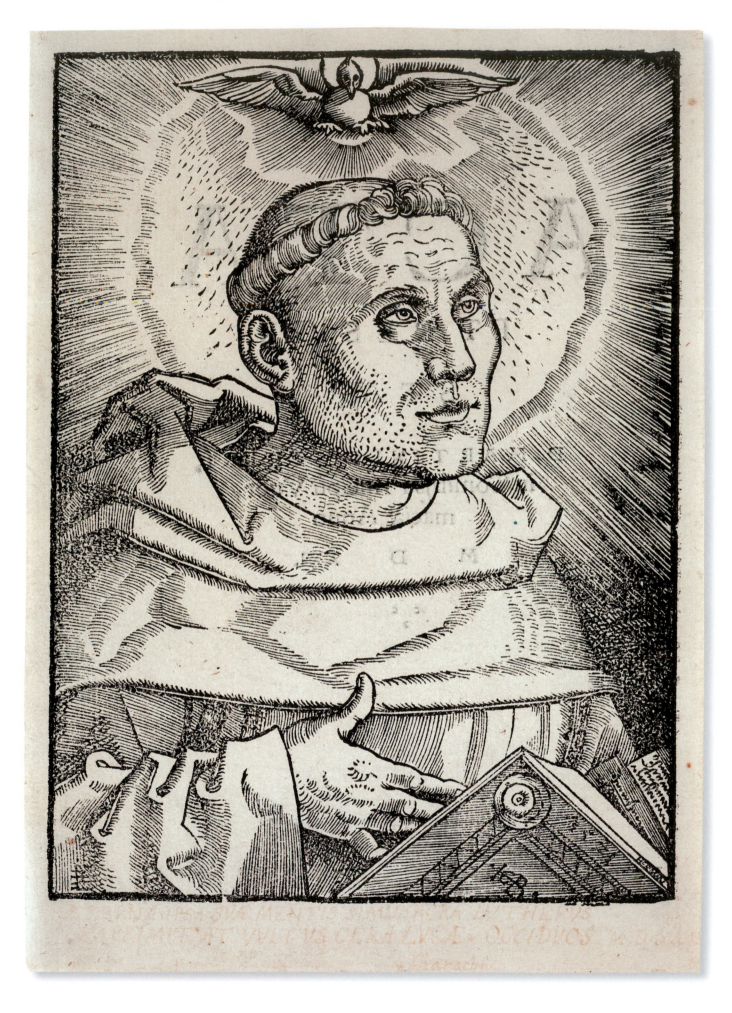

161

Hans Baldung Grien
Martin Luther with a Dove

1521
Woodcut
In: *Acta et res gestae D. Martini Lutheri in comitiis principum Wormaciae anno MDXXI*
Strasbourg: Johann Schott, 1521
VD16 ZV 62

159
Folio a1v
20 × 15 cm
Wittenberg Seminary, Lutherstadt Wittenberg,
EKU 203
New York Exhibition

160
20 × 15 cm
Pitts Theology Library, Emory University,
1521 LUTH DDD
Atlanta Exhibition

161
15.6 × 11.5 cm
Thrivent Financial Collection of
Religious Art, Minneapolis, 90-03
Minneapolis Exhibition

Hans Baldung Grien took up the theme of the second portrait version of Luther created by Lucas Cranach the Elder shortly before the Diet of Worms (fig. 6) in a new woodcut, but he altered the original composition. As in Cranach's portrait, the Reformer appears as an Augustinian monk with his habit and tonsure; he is holding an opened Bible in his hand. Rather than the secular background, however, a nimbus with an aureole filling the image now appears behind his head. A dove symbolizing the Holy Spirit and additionally bathing Luther's head with divine light has been added at the top edge of the picture.
Hans Baldung Grien, himself an adherent of the Reformation, turned the secular portrait into a portrait of a saint. This and similar images of Luther as a saint were published for the first time against the backdrop of the Diet of Worms, where they caused a stir. Catholics were as utterly disconcerted by the depiction of Luther as a saint as by his adherents' veneration of his image. Dispatches from the papal legate Aleander reveal that Luther's followers purchased portraits for personal use, kissed them and carried them with them.
The papal bull against Luther, his appearance at the Diet of Worms and his sudden disappearance, construed by many as proof that he had been slain, turned the Reformer into a Protestant martyr. Textual and visual depictions of Luther as a saint flourished. A publication entitled *Ain schöner neuer Passion*, which equated Luther's journey to Worms with the Passion of Christ, appeared that same year. Moreover, the image of Luther with the dove of the Holy Spirit became such a popular broadsheet that the Nuremberg city council issued a decree prohibiting its sale in 1522.
This woodcut created by Hans Baldung Grien subsequently found its way into publications devoted to Luther's work and impact. One example of this is the account of the "Handlungen und Umstände, die Martin Luther auf dem Reichstag zu Worms widerfuhren" (Acts and Situations that Befell Martin Luther at the Diet of Worms) of 1521 published under the title *Acta et Res Gestae* [...], in which the portrait of Luther with the dove serves as the title woodcut preceding the text by Justus Jonas. Any such image of Luther as a saint was inherently self-contradictory in a way, since Luther and his fellow reformers vehemently rejected the veneration of images. KH

Literature
Bott 1983, pp. 222 f., cat. 280 (ill.) · Hofmann 1983 b, pp. 152–154, cat. 27 (ill.) · Lindell 2011, pp. 71 f. · Strauß 1978 · Warnke 1984, pp. 16 and 30–36 (ill.)

The Imperial Diet of Worms

The Imperial Diet of Worms and the ban that declared Luther an outlaw were the dramatic culmination of a confrontational process that had started with the election of Albert of Brandenburg as Archbishop of Mainz. This position had been bought in an act of blatant simony, financed by a loan from the Fugger bank. Pope Leo X had granted Albert permission to sell letters of indulgence in his dominion in order to pay off this debt. The sale was to be organized by a Dominican friar Johannes Tetzel and half of the proceeds were to be set aside for Albert's use, with the other half to be used for the construction of St. Peter's Basilica in Rome.

After Martin Luther published his 95 Theses and his first treatises, the Church tried to silence him by taking "appropriate" measures. He was challenged to public disputations in Heidelberg in 1518 and in Leipzig in 1519. But the Curia's representatives could not convince Luther to recant, and he was now considered a heretic. When Luther burned the papal bull threatening his excommunication on December 10th, 1520, Pope Leo X responded by excommunicating him. The Reformer's break with the Church had now become official. Emperor Charles V also reacted to the growing success of the reformatory movement in his domains: He summoned Luther to appear before the Imperial Diet of Worms in 1521. Those princes of the Empire who had already sided with the Reformer saw this as a chance to reduce the influence of Rome in the realm and weaken the Emperor. They were opposed by a faction which was keen to disprove the heretic and his positions.

After his triumphal arrival in Worms, the accused appeared before the Emperor on two occasions. He was asked to recant his writings and his theses, but in Luther's view, the arguments of his opponents were anything but convincing. Consequently, he refused to retract his statements even in the face of the most powerful princes of the Empire. At this point, only arguments derived from Holy Scripture itself would have been able to budge him. Luther had been assured of 21 day's safe conduct with his departure, but in order to protect him, Frederick the Wise organized a staged abduction to Wartburg Castle. When the imperial ban was imposed on May 8th, 1521, with the so-called Edict of Worms, the Reformer's breach with the Pope was reinforced by his breach with the Emperor. RN

Wolf Milicz
Medal of Martin Luther

1537
Silver, cast, fire-gilded, looped
D 45 mm; weight 28.23 g
Foundation Schloss Friedenstein Gotha,
4.1./3978
Minneapolis Exhibition

Obv: DOCTOR · MARTINVS · LVTHERVS ·
PROPHETA · GERMANIAE · MDXXXVII
Half-figure picture of Luther from right front with
gown and cap, holding a Bible in his hands.
Rev: IN · SILENTIO · ET · SPE · ERIT · FORTITVDO ·
VESTRA · MDXXXVII
Two angels holding a shield with Luther's
emblem, a five-petal rose, inlaid with heart and
cross.

This 1537 medal depicts Luther in his cap and
cassock, holding the Bible in the style of a
preacher. The legend accordingly addresses him
as "Prophet of Germania."
An iconographic model for this portrait can again
be found in the artistic oeuvre of Cranach the El-
der, who had represented the Reformer in this
manner since 1532. The Wittenberg-based court
painter created significant portraits of leading
Reformation personalities that made them pop-
ular reference models for other artistic genres.
These portraits, which were serially produced
and served to propagate a certain "image," were
conceived by Cranach almost as visual represen-
tations of the divine (*Merkbilder*), with the func-
tion of identifying the subject. This is why the
portraits have monochrome backgrounds and a
deliberate trend towards two-dimensional repre-
sentation.
The exhibited medal type, "Luther as a scholar"
by the die-cutter Wolf Milicz of St. Joachimsthal,
goes back to the fifth version of Cranach's depic-
tions of Luther, which was rendered as a printed
portrait by a minor Nuremberg master, the mono-
grammist IB, in 1532.
The first method of representing the Reformer
dates back to 1520, and depicts him as a monk
or in the style of a saint. In 1521, Cranach por-
trayed him as a young scholar in a doctor's cap
and monk's habit, which was followed in 1522 by
Luther as Junker Jörg (Knight George) and then by
the wedding portrait with Katharina von Bora in
1525–29. Starting in 1532, Luther was portrayed
as middle-aged scholar, and from that point on,
Luther's image was propagated as a preacher-
scholar, the dignified head of a family, and Father
of the Church.

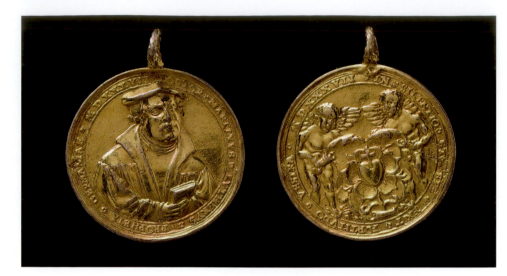

162

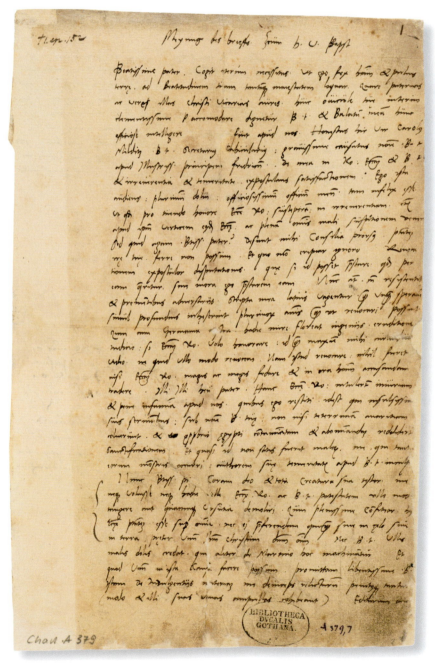

163

This iconography, besides the 1521 portrait of the Reformer and his portrait in old age, was to leave a decisive mark on the Luther image in the centuries to come, and was repeatedly copied, e.g. on baptismal medals.

Luther's emblem on the reverse side of the medal, the so-called Luther Rose, is an ideograph of his doctrine. He himself called it "*my Compendium Theologiae*" (summary of theology). The white rose symbolizes the idea that faith gives joy, comfort and love. The cross stands for Christ's sacrificial death and is a token of faith in Christ. The heart represents the overcoming of death and stands for new life. The Luther Rose was first depicted in 1533 on a medal with a picture of the Reformer. The biblical verse "In quietness and in confidence shall be your strength" (Jes 30:15), the legend on the reverse side, is Luther's personal motto. UW

Literature
Cupperi 2013, p. 261, cat. 172 · Doerk 2014, p. 22, cat. 4 (note), pp. 52 and 143, cat. 4 · Meller 2008, p. 327, cat. F 37 · Schuttwolf 1994 b, pp. 13 f., cat. 4.9 (ill.)

163

Martin Luther
Letter to Pope Leo X

[Altenburg, January 5 or 6, 1519], Latin
Ink on paper
33.5 × 21.5 cm
Forschungsbibliothek Gotha der Universität
Erfurt, Chart. A 379, ff. 1r–v
New York Exhibition

Accusing Luther of heretical opinions, Pope Leo X sent Karl von Miltitz as nuncio to Saxony in the fall of 1518. He was to urge Elector Frederick the Wise to hand over the rebellious Augustinian monk to the papal authorities for trial. As part of the strategy to win the sympathy of Frederick, Miltitz was instructed to present the prince with a prestigious papal distinction of virtue and piety, the Golden Rose (cat. 37). Connected with this gift was a papal bull increasing the indulgence value of the prince's renowned relic collection in the Castle Church in Wittenberg. During negotiations with Miltitz on January 5 and 6, 1519, at the house of the prince's secretary and confidential advisor Georg Spalatin in Altenburg, Luther wrote this letter to the Pope. In it he expresses his resoluteness to defend his critical opinions on indulgences, refusing to recant. He declares, however, his willingness to alleviate the conflict by refraining from printing further controversial writings on the subject if his opponents were willing to do the same. In the end,

Miltitz was not able to silence Luther or to successfully mediate between the papacy and the Saxon monk.

The letter was never sent to Rome, but it did not remain among Luther's own private papers. After the negotiations with Miltitz, it was preserved in the electoral court archive, underscoring that in this precarious state of affairs Luther did not act fully autonomously, but rather that his response to the situation was discussed with and hence pre-censored by the court. During the 200th anniversary of the publication of Luther's 95 Theses in 1717, the letter was bound together with other original writings by prominent reformers and humanists to form a commemorative manuscript volume on the Reformation. This object of princely representation was commissioned by Duke Frederick II of Saxe-Gotha-Altenburg, who together with his predecessors, built up an exceptional collection of manuscripts and prints on the Reformation at Friedenstein Castle in Gotha. DG

Sources and literature
Brecht 1986, vol. 1, pp. 255–264 · Gehrt 2015, pp. 666–670 · Gehrt/Salatowsky 2014, pp. 29 and 133 · Höss 1989, pp. 143–149 · WA.B 1, 291–293 (no. 129)

164

Martin Luther
Epistola Lutheriana ad Leonem decimum (Letter of Luther to Leo X)

Wittenberg: Johann Rhau-Grunenberg, 1520
20.6 × 15.7 cm
Luther Memorials Foundation
of Saxony-Anhalt, Ag 4°192q
VD16 L 4630
New York Exhibition

In September 1520, as a reaction to the attempts at mediation by Karl von Miltitz, Luther agreed to write a personal and (up to a point) conciliatory letter to the Pope. In the letter, he assured Leo X that he had never wanted to attack him personally, but remained insistent that he saw himself as bound by God's Word. At the same time, he attached his *Tractatus de libertate Christiana*, which seems to have been based on a previous German version of the *Sermon on the Freedom of a Christian*. The relationship between the two versions is not entirely clear. What is certain is that the letter and the tract form a single composition.

A paradox is introduced: "A Christian is a perfectly free lord of all, subject to none. A Christian is a perfectly dutiful servant of all, subject to all." This paradox is just as famous as it is misunder-

stood. It is important to note that Luther speaks of a Christian freedom which in his view had nothing to do with political or economic freedom. Faith in justification through grace alone frees the Christian from all earthly obligations, laws and works. However, the love of one's neighbor which necessarily emerges from faith, when it is authentic, turns the free lord into a servant toward his neighbor. With regard to the salvation of redemption, the Christian is free. With regard to the well-being of the neighbor in this world, the Christian is bound to every service. But this obligation is also freedom because it grows out of the freedom of faith, because it cannot be perceived as coercion. "In the voluntariness of love, faith's freedom from worry about oneself and fulfilling divine and human laws is lived out actively" (Berndt Hamm, in: Leppin/Schneider-Ludorff 2014). Luther's dialectic concept of freedom was already misunderstood in his lifetime. Its nuance was not suited for simplified campaigns. MT

Sources and literature
Leppin/Schneider-Ludorff 2014, pp. 227 f. · WA 7, 20–38 [LW 31, 334–343]

Bulla contra errores
Martini Lutheri
ז sequacium.

165

BVLLA
Decimi Leonis, contra errores Martini
Lutheri, & sequacium.

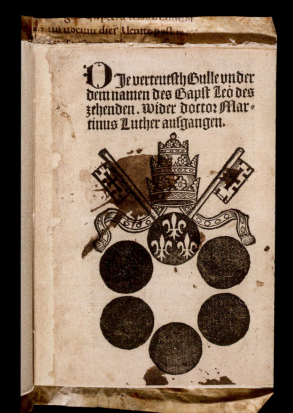

Astitit Bulla à dextris eius, in vestitu deaurato, circumamicta varietatibus.

Vide lector, opereprecium est. Adscieris, Cognosces qualis pastor sit Leo.

167

Bulla contra errores
Martini Lutheri
ז sequacium.

Oje verteutscht Bulle vnder
dem namen des Bapst Leo des
zehenden. Wider doctor Mar=
tinus Luther ausgangen.

Pope Leo X

Exsurge Domine. Papal Bull against Martin Luther in Various Editions

165

Bulla Contra Errores Martini Lutheri et Sequacium

Rome: Giacomo Mazzocchi, 1520
Printed on paper, binding: modern
19.5 × 14 cm
Stiftung Deutsches Historisches Museum,
R 55/803
EDIT 16 CNCE 40438
Minneapolis Exhibition

166

Bulla Contra Errores Martini Lutheri et Sequacium

Rome: Giacomo Mazzocchi, 1520
Printed on paper, binding: modern
20.5 × 15.5 cm
Luther Memorials Foundation
of Saxony-Anhalt, ss 3519
EDIT 16 CNCE 40438
New York Exhibition

167

Ulrich von Hutten, Editor

Bulla Decimi Leonis, Contra Errores Martini Lutheri, & Sequacium

Strasbourg: Johann Schott, 1520
Printed on paper, binding: modern
19.5 × 14.5 cm
Stiftung Deutsches Historisches Museum,
R 53/1871‹b›
VD16 K 277
Minneapolis Exhibition

168

First German Edition of the Papal Bull against Martin Luther

Cologne: Peter Quentel, 1520
Printed on paper, binding: parchment
manuscript
18.4 × 13.3 cm
Stiftung Deutsches Historisches Museum,
R 13/102
VD16 K 282
Minneapolis Exhibition

Pope Leo X was slow to respond to the revolutionary events in Wittenberg. After Luther published his 95 Theses in late October 1517, it was not until the summer of 1518 that the Dominican Silvestro Mazzolini da Prierio, the Pope's representative in matters of faith, and papal magistrate Girolamo Ghinucci first addressed the text. They recommended inviting Luther to Rome so that he could recant his theses in the presence of the Pope. However, the death of Emperor Maximilian I in 1519 delayed matters, as the Pope now had more important concerns with regard to the question of the imperial succession: preventing the election of Duke Charles of Burgundy as Holy Roman Emperor. The high-level political maneuvering played into the hands of Luther and his reformationist efforts. Luther's sovereign, Elector Frederick of Saxony, happened to be the only eligible Elector whom the Pope was able to draw to his side. In order to avoid antagonizing Frederick, Pope Leo X chose not to pursue the "Luther affair" for the time being. It was not until the summer of 1520 that a group of German theologians led by Johannes Eck were able to revive the effort to excommunicate Luther. Eck and Cardinal Thomas Cajetan laid before the Pope a text which cited 41 propositions from Luther's previously published writings and branded them heretical. The resulting papal bull, which began with the words *"Exsurge Domine* (Arise, Oh Lord)*"* from Psalm 74:22, calls upon Luther to recant those 41 propositions within 60 days. Otherwise, Luther was to face excommunication.

This bull arrived in Germany by several routes and, interestingly, in different versions. As papal emissaries, Johannes Eck and Girolamo Aleandro, the Vatican librarian, took three manuscript copies with them, one of which was delivered to Duke George of Saxony (and is now in Dresden) and another was given to the members of the Imperial Diet (now in Stuttgart). The third copy found its way to Vienna. The two papal legates also carried with them certified copies, as well as the first Roman imprints, which they handed out to various bishops and princes. The University of Wittenberg also received a printed copy from the Roman printer Giacomo Mazzocchi. The bull was distributed as quickly as possible through many German dioceses, to be read from the pulpits. The Deutsches Historisches Museum's Mazzocchi copy is the one which was sent to the papal nuncio in England, Girolamo Ghinucci, the very man who had passed judgment on Luther's 95 Theses back in 1518.

The bull found a very eager audience in Germany. In the year of its publication alone, it was reprinted twelve times in Latin and three times in German. It appeared five more times in 1521, both in Latin and German. Assuming that there were 500 copies per edition, this means that there were about 10,000 copies of the papal bull in circulation. However, the effect of the bull on the public was limited, since German bishops generally did not bring their own copies of the bull into circulation until 1521. Moreover, Luther in the meantime had personally ensured a final break with the Catholic Church when he not only refused to recant the 41 propositions censured by the bull, but proceeded on December 10, 1520 to publicly burn a copy of the bull and other works of canon law in front of Elster Gate in Wittenberg. MM

Literature
Fabisch/Iserloh 1991, pp. 338 – 412 · Krentz 2014, pp. 125 – 139 · Marx/Kluth 2004, p. 106, cat. 122 · Schottenloher 1918, pp. 197 – 208, nos. 1, 9, 13 and 17 · Staatliche Archivverwaltung 1983, p. 84 (ill.)

169

Martin Luther

Adversus Execrabilem Antichristi Bullam (Against the Execrable Bull of the Antichrist)

Wittenberg: Melchior Lotter the Younger, 1520
20 × 15.1 cm
Luther Memorials Foundation
of Saxony-Anhalt, Kn D65
VD16 L 3723
New York Exhibition

After the papal bull threatening him with excommunication was delivered to Martin Luther on October 3, 1520, Luther immediately drafted a rebuttal. The central theme of this rejoinder, which was written in Latin, is Luther's realization that the papal chair is occupied by the Antichrist. The papal bull contained a list of 41 errors and heresies of which Luther had been accused by the Church. Among them are the decisive insights through which Luther said he "became a Christian." Confronted with the Church's rejection of his insights, Luther's theological conclusion was to designate the Pope as the Antichrist. The use of the term "Antichrist" in this context should not be understood as merely polemical, but rather as part of Lutheran theology: if the Church is holding back Christian truth, it cannot be the institution charged with upholding truth. In fact, if it is trying to suppress Christian truth, then the Church must be anti-Christian, i.e. the opposite of Christ. In other words, Luther is not attacking Pope Leo X personally, but rather the institution of the papacy.

Luther had a growing realization that the Antichrist was ruling in Rome during the disputes in connection with the sale of indulgences. He formulated this suspicion in a letter as early as late 1518. He became certain of this in the summer of 1520, and he made it public in his *To the Christian Nobility of the German Nation*. Finally, his *Against the Execrable Bull of the Antichrist* makes this realization part of the title.

In Christian apocalypse literature, the figure of the Antichrist is a sign that the end of days is

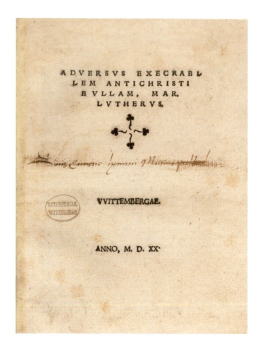

169

coming. Luther applies this term to the Church within the context of his theological views because the church hierarchy, legitimized by the Pope, was taking a stand against the free propagation of the Gospel. He accuses the Pope of being a double tyrant. First, Luther charges that the Pope places himself above the authority of God's word and puts himself in the place of Christ. This act tyrannizes the conscience of many believers and is the reason for the loss of Christian freedom. The results of this tyranny include the separation of clerics and laymen, priestly celibacy, mandatory confessions and the prohibition of the lay chalice. At the same time, the Pope places himself above Emperors and kings, Luther says, even though the Donation of Constantine had already been debunked as a forgery. At the end of his polemic, Luther, together with all other free Christians, excommunicates the Pope and all of his cardinals. RK

Literature
Bornkamm 1998 · Jörgensen 2014 · Maurer 1976 · Seebaß 1978

170

Martin Luther

Opening of a Manuscript for a Speech to be Held in German at the Second Hearing Before the Imperial Diet in Worms

Worms, April 17/18, 1521
Ink on paper
28.2 × 21.5 cm
Thüringisches Hauptstaatsarchiv Weimar,
Ernestinisches Gesamtarchiv, Reg. E 81, f. 1
New York Exhibition

The document has been registered as part of the UNESCO world documentary heritage "Memory of the World" in 2015

The agenda for the Imperial Diet, the assembly that Charles V had ordered to convene at Worms on January 6, 1521, was truly staggering: it included the enforcement of law and order, questions of peace and the constitution, the arrangement of governmental affairs in the Emperor's absence, the Emperor's coronation and the support for the journey to Rome by the Estates of the Empire that traditionally followed the Diet: these were all matters of the greatest importance concerning the very future of the Holy Roman Empire. Compared to this lineup, the *causa Lutheri*—the Luther case—was considered but a minor affair, a purely formal matter that would probably be resolved quickly. As it turned out, the Diet of Worms, which was solemnly opened on January 27, 1521, was to be remembered chiefly for Martin Luther's defiant stand.
The summoning of this Bible-thumping professor from Wittenberg to the Diet was in itself a novelty. Ever since 1220, when Emperor Frederick II had concluded an arrangement with the ecclesiastical princes of the Empire (the so called *Ketzerkonstitution* or Constitution on Heretics), any church ban was to be automatically followed by an imperial condemnation and vice versa. Girolamo Aleander, the papal nuncio, referred to this usage when he followed the Pope's instructions in demanding that Charles V should enforce Luther's excommunication with a ban according to imperial law (cf. cat. 177). The *causa Lutheri* had thus become a concern of the Empire.
For Luther's territorial sovereign, Frederick the Wise of Saxony, the legal situation, however, was anything but obvious. He did not see a violation of an ecclesiastic dogma in the controversy, but merely an ordinary dispute with the Roman Curia. According to this view of the affair, the Diet was free to decide on a possible ban once the assembled estates of the Empire had questioned Luther one more time. Consequently, Luther was presented by the assembly with two questions on April 17, 1521: did he admit to his authorship of the books published under his name, and did he intend to recant any part of what was written therein. Luther answered "yes" without hesitation to the first question. For his reply to the second question, he requested an adjournment. Luther must have started writing this draft for a speech (to be held in German the following day) on the very same evening. The text ends abruptly, however, after describing the events of his hearing before the Emperor. On April 18, 1521, Luther informed the assembled Diet that he saw no reason to recant his writings "unless I am convinced by the testimony of the Scriptures or by clear reason." DB

Literature
Blaha 2014, pp. 140–144 and 270 f. (ill.) · Blaha: Beginn · Borth 1970 · Staatliche Archivverwaltung, pp. 97 and 342 (ill.)

171

Central Germany

Habit of an Augustinian Hermit, as Luther would have worn

Around 1st-quarter of the 16th century
Black woolen twill
138 × 62 cm
Luther Memorials Foundation
of Saxony-Anhalt, K 373
Minneapolis Exhibition

On July 17, 1505, only a few days after his vow in the storm near Stotternheim, Luther asked to be received as candidate in the Order of Augustinian Hermits at Erfurt. Luther was accepted as a novice in September 1505. He was given the monastic name Augustine, received the tonsure and was clothed in a monk's habit.
The clothing of the Augustinian Hermits followed strict rules. Nearly all the pieces of clothing had to be made of wool. On top of a white tunic, girded around the middle with black leather straps, the brothers wore a white scapular and a long white cape. On top of this the rules demanded that, during daily prayers, church services and in public, the black gown—the famous habit of the order—had to be worn. The large garment was then completed with a leather belt and broad shoulder collars, as well as a pointed hood.
Looking back, Luther said that he once thought he pleased God in his monk's habit (WA 21, 519, 5). He was portrayed as a monk many times, and the copperplate engraving *Martin Luther as an Augustinian Monk* by Lucas Cranach the Elder from 1520 is considered to be the earliest depiction of Luther (cat. 154 and 155). The engraving became the model for further representations,

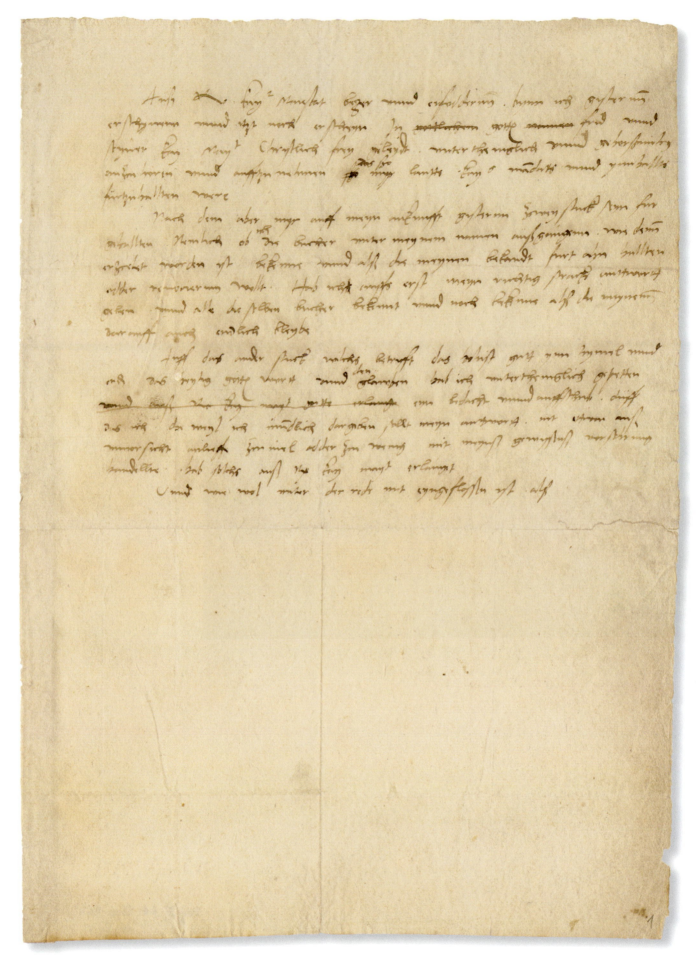

171

including those of Hans Baldung Grien, Albrecht Altdorfer and Hans Sebald Beham.

In his *Table Talk*, Luther claims to have had his gowns repaired many times and worn them until they were no longer wearable ("*usque ad extremum*"). Apparently he was repeatedly pressured to have new clothes made. In 1524, he finally abandoned his monk's habit (LW 54, 337–339 [no. 4414], WA.TR 4,624 [no. 5034]; WA.TR 5,657 [no. 6430]). From then on, he dressed in the clothing of a secular academic.

The surviving gown in the Luther House in Wittenberg is made out of black-brown woolen twill woven with a rough but tight texture. The garment is tailored in the style of a coat that is wider at the bottom and with a banded collar and long arms. There is no evidence as to who wore it or when it was made. However, there is no reason to doubt that the material and finishing of the much-repaired garment correspond to a date in the first quarter of the 16th century. This is supported by an entry in a historical inventory stating that in the 16th century the gown was already kept in the black monastery, i. e. in the monastery of the Wittenberg Augustinian Hermits, today known as the Luther House. BP

Literature
Brecht 1983, pp. 70 f. · Treu 1991, pp. 30 f. (ill.)

172

Martin Luther
Letter to Georg Spalatin

Wittenberg, August 28, 1518
Ink on paper
21.6 × 34.5 cm
Landesarchiv Sachsen-Anhalt, Z8 Lutherhandschriftensammlung, no. 19
New York Exhibition

The year 1518 was a very dramatic period in Luther's life. His theses against indulgences had been widely circulated and had met with widespread response since their publication. Apart from the theological dispute, Luther anxiously awaited the Pope's response after Cardinal Albert of Brandenburg reported him to the Holy See in December of 1517. The Pope eventually initiated official proceedings against Luther in the summer of 1518, investigating him on suspicion of heresy and defamation and for allegedly challenging the Pope's authority. This resulted in Luther receiving a summons to Rome where he was to appear within 60 days. It threatened him with excommunication, that is, exclusion from the Church and thus from society as well, if he failed to comply.

Luther was aware that the proceedings could take a bad turn. His existential conflict and fear of imprisonment, banishment or even death are also palpable in this letter, especially since Luther knew from hearsay alone that Cardinal Cajetan, the Pope's envoy in Augsburg, was supposed to turn "the sentiments of the Emperor and the princes with everything in his power" against him. Given the situation, even Luther was unable to foresee whether his sovereign, Elector Frederick the Wise, would back him in a potential trial. He therefore asked Georg Spalatin, his confidant and the Elector's counselor, for help on August 28, 1518. He inquired whether Frederick might be able to deny him his request for an escort from the Elector for his journey so that he would have grounds to stay away from Rome. The Elector rejected this course of action but was willing to aid him in another way: by expediting the negotiations to have Luther's trial held on imperial soil. Luther was in fact interrogated by Cardinal Cajetan in Augsburg in October of 1518. Luther's tremendous self-confidence and trust in God during these events is astonishing. He was convinced that scripture alone, not the Pope, can be the decisive standard for and final authority on any action. As Luther saw it, he could never be a heretic with this knowledge. The events of 1518 thus helped Luther's views steadily mature into the revolutionary ideas that would later be identified as his "Reformation discovery." VR

Literature
Brecht 2013 · Lohse 1995 · Schilling 2013

Luther as a Monk, Scholar and Preacher 173

173

Martin Luther
Letter to Georg Spalatin

March 30, 1522
Ink on paper
29 × 21 cm
Landeshauptarchiv in Sachsen-Anhalt,
Abt. Dessau, Z8 Lutherhandschriftensammlung,
Nr. 143
Minneapolis Exhibition

The town council had to ask Luther to leave the security of the Wartburg and return to Wittenberg to quell the rebellious and fanatical atmosphere incited by Andreas Karlstadt and the Zwickau prophets. Upon returning to town, Luther preached his famous Lent sermons, known as the eight Wittenberg or *Invocavit* sermons, on March 9–16, and after only a few days of preaching, the populace was calmed and order restored. Now Luther could turn to the business at hand: polishing up his New Testament translation and promoting his ideas of proper religious devotion so as to avoid future dissident outbursts.

In this letter to Spalatin, Luther requests his friend's help to find the correct names for the precious stones mentioned in Apocalypse 21. Luther was concerned that the language of the New Testament remains clear and simple and warns Spalatin against using lofty court language. Luther opens and closes the letter, however, with references to current controversy regarding the ways of receiving the sacrament—the body and blood of Christ. Karlstadt argued that the sacrament could only be in both forms, and he set the chalice and bread in the hands of the laity. At this point, Luther was writing *Receiving Both Kinds in the Sacrament*, wherein he cites biblical precedent that both Christ's blood and body were offered, and it is not for men (that is, the Roman Church) to restrict the sacrament to only one form. In Luther's view, Karlstadt had placed the physical embodiments of the sacrament above their spiritual essence. Karlstadt had pushed this necessary reform on the people but too hastily and with harm to their consciences, whereas in this letter and in subsequent publication Luther insists on a restrained implementation and only by those thoroughly qualified to offer the sacrament to parishioners. JTM

Sources
WA.B 2, 489–490 (no. 470) [LW 49, 3–4 (no. 120)]

173

174

174

Martin Luther

Autograph Letter to Emperor Charles V

Friedberg, April 28, 1521
Ink on paper
29.2 × 42.6 cm
Luther Memorials Foundation
of Saxony-Anhalt, I5/1387
New York Exhibition

The document has been registered as part of the UNESCO world documentary heritage "Memory of the World" in 2015

Luther's refusal to revoke his writings before the Emperor and the Electors at the Diet of Worms ensured he would certainly become an exceptional figure in German history. At that point in time, he stood at the height of his popularity. On the journey back home, which would in fact end with his "kidnapping" to the Wartburg Castle, he wrote a letter to Charles V in which he thanked him for the safe conduct but also reaffirmed his standpoint: "because my conscience is constrained by the divine scriptures I quote in my little books, I can in no way recant without being better instructed." The confident letter, which is rather rambling for Luther's typical style, had certainly been written in consultation with Georg Spalatin, privy secretary of the Elector of Saxony. Spalatin soon had it printed (cat. 176), along with a German translation aimed at the princes. A comment on the back of the original letter reveals that it never reached the Emperor because no one on the Saxon side dared give it to him.

The inclusion of the letter in the Wittenberg collection has a remarkable history. The manuscript was put up for auction by an antiquarian book dealer in Leipzig in May 1911 and assigned

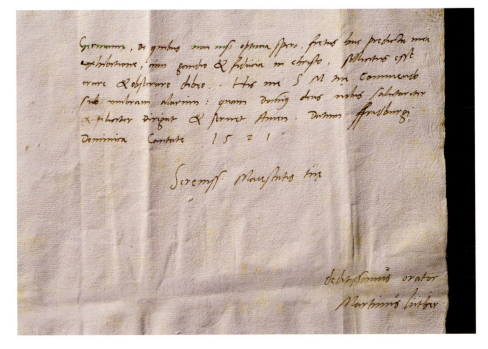

175

176

a value of 10,000 Reichsmark. The American financier Pierpont Morgan, who had been looking for a spectacular gift for the German Kaiser, Wilhelm II, sent two separate agents (who knew nothing of each other) to bid for the item. The letter was ultimately purchased for 102,000 Reichsmark. The Kaiser then gave the letter to the Luther House Museum and honored Pierpont Morgan with the Order of the Red Eagle (cat. 175). MT

Literature
Joestel 1993 a, pp. 110 f. · Joestel 2008, p. 52 · Rhein 2014 a, pp. 145–159, pl. 18

175

Order of the Red Eagle, First Class, Cross Pendant and Breast Star

Prussia, early-20th century
Gold, silver, enamel, and silk
5.7 × 5.7 cm (pendant) and 9.2 × 9.2 cm (star)
The Morgan Library & Museum, given to Pierpont Morgan, 1911, ARC 1157.042
New York Exhibition

Kaiser Wilhelm II conferred the Order of the Red Eagle, First Class, on Pierpont Morgan on June 26, 1911 after Morgan presented the Kaiser with Martin Luther's autograph letter to Charles V from 1521, perhaps the most important letter Luther ever wrote (cat. 174). Morgan had just purchased the letter at auction at the exorbitant price of 102,000 Marks (or $25,500; approximately €614,000/$680,000 today). He paid more for it than any other manuscript letter ever to sell at auction, and in the process he outbid the Prussian government and Lutherhalle (today's Luther House) in Wittenberg. The elevated price might have been a ruse by Morgan to increase the perceived value of the gift (an out-of-character act by the shrewd collector) by using two agents to bid on the letter but without either of them knowing that they were working for the same man. The purchase and later presentation of the letter as a gift to the Kaiser made headlines around the world. Morgan's gift of the letter to the people of Germany was the most historically significant gift that he made to any state, organization, or institution.

The Order of the Red Eagle was a chivalric order in the Kingdom of Prussia established in 1792 to honor military personnel and civilians for service to the state. The order included six distinctions: the Grand Cross, in four classes (First through Fourth), and the Medal of Honor. While the Grand Cross was reserved for royalty, the First Class distinction could be awarded to foreign heads of state, which in this case included the international financier Pierpont Morgan. JTM

Literature
Breslauer 1997, p. 263 · Strouse 1999, p. 636

176

Martin Luther
Letter to Emperor Charles V, April 28, 1521 (Ad Domino Nostro Carolum V.)

[Haguenau: Thomas Anshelm], 1521
18.7 × 14 cm
VD16 L 3673
The Morgan Library & Museum, gift of Lathrop C. Harper, Inc., 1958, PML 49060
New York Exhibition

The letter that Luther wrote to the Emperor after leaving Worms never made it to its recipient (cat. 174). Whether Spalatin's note that no one was brave enough to deliver Luther's missive to Charles V is true or not, a copy of the letter and its counterpart addressed to the German Electors were dispatched to Thomas Anshelm's printing press in Haguenau, a short distance up the Rhine River from Worms. Anshelm was predominantly an academic printer, specializing in works on rhetoric and linguistics. In his first press at Pforzheim, he published the works of Johannes Reuchlin, the eminent Greek and Hebrew linguist, who was something of a father figure to Philip Melanchthon, and he recommended Melanchthon for the professorship at Wittenberg. After moving his press to Haguenau, which was on the river and better suited for international trade, Anshelm printed predominantly classical Greek and Latin authors, as well as a large number of works on Greek grammar, including those by Luther's colleagues Petrus Mosellanus from the University of Leipzig, and Melanchthon. Prior to this letter, Anshelm printed only one Lutheran work, his *Von den guten Werken* (On Good Works) of 1520 (VD16 L 7138), but in 1521, four pro-Lutheran texts, all concerning Luther's trial at Worms, were issued from his press (VD 16 L 3648, S 7415–7416, and ZV 60). Anshelm's name does not appear in any of the 1521 Lutheran works, perhaps due to fear of imperial reaction, but the type and typographic ornaments used to print the texts appear in other works wherein he is identified as the printer. While the letter to Charles V was printed in only this single edition, Anshelm printed several editions of a popular work summarizing the events of Luther's trial, and two editions of Luther's letter to the German Electors (of which about 15 editions were printed in 1521 alone). Luther made printers money, and Anshelm's proximity to the news coming out of Worms helped him capitalize on the media storm surrounding Lu-

ther. It is perhaps not surprising that Luther's Latin letter was not the marketing success that the German version was, since the vernacular text would have been the more commercially marketable to a wider audience. We do not know how many copies of the letter to Charles V Anshelm originally printed, but the Morgan Library's copy is one of only five copies that exist today.
JTM

Sources and literature
Benzing 1966, p. 1027 · WA.B 2, 306–310 (no. 402) [LW 48, 203–209 (no. 74)]

177

Emperor Charles V

Imperial Edict of Worms, imposing an Imperial Ban on Martin Luther

Vienna?: Johann Singriener?, May 8, 1521
Printed on paper (4 sheets pasted together)
115.5 × 44.2 cm
Stiftung Deutsches Historisches Museum, 1988/808
New York Exhibition

After Luther was excommunicated by Pope Leo X on January 3, 1521, Emperor Charles V invited the great Reformer to the Diet of Worms for a final interview. It took place on April 17 and 18, 1521 before a small group of princes and councilors in the imperial residence.

The edict that was drafted after this interview lays out the reasons for inviting Luther to Worms and the circumstances of the hearing. The text is based on a draft by Papal Nuncio Girolamo Aleandro, who had already taken part in disseminating the papal bull threatening Luther with excommunication, *Exsurge Domine* (cat. 165–168), in Germany. The edict announces the imperial ban and prohibits anyone from giving Luther shelter or other assistance. It ends with a call to take Luther prisoner and deliver him to the Emperor. Aleandro recognized that the development of printing in particular had given an enormous lift to the Protestant Reformation. As a result, the final section of the Edict of Worms prohibits anyone from printing, buying, selling or owning Luther's works, or from using them for teaching. It also contains censorship provisions that relate not only to the publishing of books but also to works of fine art that are also subjected to imperial censorship. These articles are the direct predecessors of the *Index librorum prohibitorum*, the list of books prohibited by the Catholic Church, which was first published in 1559.

The dissemination of the Edict of Worms is a curious story. Aleandro presented the Latin draft of his text to the Imperial Privy Councilor on May 2,

Anno a reconaliata diuinitate octauo suṗ
Millesimuq̃ quingentesimuq̃ In festo diui luce
Egregius vir dñs Nicolaus Viridimotan⁹
Arcuũ et phie mgr̃ Sacre theologie pfessor ac
ecclie Lignicen Canonicus oĩm patruũ suffragi
is h⁹ almi study Vittbergen designat⁹ fuit
rector atq̃ moderator magnific⁹ Sub c⁹ sco
lastica prefectura subscripti studetes cõputati st̃



Dñs Johañes Teuschleyn de frickenhausen
 Arcuũ mgr̃ sacre theologie pfessor h⁹ study
Dñs Thomas Molitoris Iuris pontificii licẽ
 ciatus pastor in Torgaw
Nobilis dñs Cristoferus de klenow decem
 grossos dedit
Valentinus Rothembuꝛgk viridimotan⁹
Georius emmen de Bruck
Henrigus wese de Browne
Marianus Gotfryd de Soraua
Donatus wyllen de Crossen
Pancracius vochs de Staffelsteyn
Gregorius hoendorff de witembg
Stephanus de Heldrith
Caspar erle de grymis
Gregorius Schrode de Nymick
Joannes Tulis de Erssenach
Andreas probanth de Seltz
Joannes watter de feltkirchen
Wulffgangus heyntzel de Nyssa
Fulinus tyl de Swtspach
Andreas kaufnan de domytz
Martinus Netter de Wittembergk
Dñs hinric⁹ Vogt de warburg Mgr̃ freydebuꝛ
Mathias tabernatoris de kirchhain
Joannes pauonis de Zwickaua
Nicolaus Cappuß de molhausen psbr̃
Baccalari⁹ frowps de feltkyrchen
Laurenci⁹ Bencko de Leppyn
Stephanus molitoris de Brunssfeld
Joannes Bruckmeister de kam
Joannes kunyg de kam
Egidius penygk
Petrus hyraw de Jutterbogk
Valentin⁹ ylten de Zwickaua



ludewicus domitz de Torgaw
Symon falkenbg de Mittenwaldiß psbr̃
Matheus mersebergk de Czyrbusch
Symon falkenbg de Mittenwaldiß
frat Cristofer⁹ fencke de Esue
frat Jolies bethel de Spangenbg
frat Erkardus tham de hoimbg Augustiniani
fr̃ Martin⁹ luder de Mansfelt
frat Joañes tinctoris de haynis
frat ludewic⁹ kuberyt de dresden
frat leonardus de Monacho
Joannes oder de Namslaua
Benedictus Czange de Czauh
fridericus pistoris de Berkestel
Petrus popphinger de Protzel
Johañes kaufman de Mergeten
Gregorius klungenstein de Masfeld
Philippus engelbrecht de engsse
Valentin⁹ molitoris de meller stat
Cristoferus Beler de Pausa
Matheus wheuer de Possem
Johannes lindfrund de Brytznaw
Anthonius kocheler de luckaw
Joannes pauli de Nawinstadt
Joannes scheffe de hämelburg
Joannes scholtz de Magdeburch
Michael gottengast de Jutterbock
Joannes holstet magdeburgen
Joannes haecke studensis
Bñdictus Groß de Czorbick psbr̃
Georgius lubeck de Slussen
Augustin⁹ haueman de Jutterbock
Andreas Bernhardt de Jutterbock
Hinricus wesener de Erssezel
Hilebrandus Ersengarth de Munden
Michael Smesterpensis
Eberhardus hagen de lomberga

MARTINVS
LVTHER

1521. The final version was translated into German on May 7. On May 8, Aleandro received permission to issue the edict in both languages, which he did on May 10. Immediately after, the Worms printer Hans von Erfurt was assigned to print the German version of the text. However, the Emperor hesitated when it came to signing the original (manuscript) copies, deciding ultimately to notify the imperial estates in a plenary session. The first public reading of the edict did not take place until May 25, which is why the Emperor's signature on the original copies is dated May 26. However, the text of the original copies differs substantially from that of the first printed edition. Accordingly, the authentic version of the Edict of Worms is not the two original manuscript copies but the version printed by Hans von Erfurt, certainly a unique situation for such an important event in the history of the Church and the Empire. The broadside displayed here was designed to publicly proclaim the edict in the churches of the Empire. MM

Literature
Anderlik/Kaiser 2009, pp. 91 f., cat. 2.18 (ill.) · Borth 1970, pp. 99–143 · Bott 1983, pp. 199–204, esp. 203, cat. 258 · Fabisch/Iserloh 1991, pp. 484–545 · Koschnick 1997, p. 45 (ill.)

178

Matriculation Register of Wittenberg University with Luther's Entry

1502–1552
Manuscript on parchment
32 × 24 cm
Universitäts- und Landesbibliothek
Sachsen-Anhalt, Yo (1)
Minneapolis Exhibition

The first volume of the matriculation registers of the University of Wittenberg, called the *Matricula prima 1502–1552,* is one of a set of ten such books of parchment pages bound between large wooden boards covered in pigskin and is lavishly embossed with ornaments. This decoration was applied with rollers, single-motif stamps and larger blocks. The copy displayed here is furnished with brass clasps and corner mountings, as are most of the other volumes. After the University of Wittenberg was merged with the University of Halle in 1817, the registers were entrusted to the university library in Halle in 1823. Like all the other volumes, the *Matricula prima* is richly furnished with colored miniature illustrations as the title pages for each semester. The volume contains a catalogue of the elected rectors and lists of the matriculated students that were compiled by a scribe after the actual act of matriculation. The inside of the front cover was decorated by Lucas Cranach the Elder with a colored pen drawing of the Final Judgment. A comparison of this drawing with other (dated) works by Cranach permits the assumption that it was made in the early years of the artist's time in Wittenberg.

The image shows Christ in Judgement, enthroned on a circular rainbow of red, yellow and green, which surrounds a globe on which some landscape features can be vaguely discerned. A lily and the tip of a sword blade touch the head of Jesus on the left and right. On the left side of the rainbow, the figure of Mary is depicted kneeling in supplication. A male figure to the right is partly obscured by damage, leaving only his head and a hand to indicate what was probably Saint John the Baptist. Below the rainbow, we find a caption consisting of the first three lines of the Gospel of Saint John (in the Vulgate): "*In principio erat verbum et Verbum erat apud Deum et Deus erat verbum* (In the beginning was the Word, and the Word was with God, and the Word was God)". The lower part of the image depicts the resurrection of the dead. While the blessed are welcomed by angels on the left side, the damned are taken into custody by the devils waiting on the right.

The composition is surrounded at the top and sides by small cupid-like angels seated on a wreath of clouds. One of these is blowing his trumpet. The globe and the section below it were inscribed at a later date with some letters and the date 1563. Folio 19 verso is marked by a framed polychrome historiated initial "*A*". Here, we find the entry recording Luther's matriculation in the year 1508.

Two of the miniature illustrations are particularly noteworthy: A semester title page on fol. 10 recto is ornamented in gouache showing the coat of arms of Vincentius Ravenna from 1504, and a depiction of the investiture of a newly-elected rector with his rod of office. A second semester title page on fol. 107 recto, this time for the winter semester of 1531/32, bears another gouache displaying the family coat of arms of the new rector, one Hans Ulrich Schilling von Cannstadt. His device is surrounded by ornamental paraphernalia, including a crown or a heraldic crest. Four medallions are placed around the coat of arms, painted by Lucas Cranach the Elder, showing portraits of personalities of the Reformation period. The portraits in the top row depict the famed reformers Martin Luther and Philip Melanchthon, while those below show the famous humanists Rodolphus Agricola and Erasmus of Rotterdam. MvC

Literature
Förstemann 1841 · Meller 2008, pp. 226 and 229, cat. D12 (ill.) · Rübesame 1981

V

Luther's Theology

...eologia est scientia practica — Theology is a practical science — was Luther's fundamental conviction. The statement was actually aimed at his opponents from two different angles. On the one hand, it targeted traditional scholastic theology, which modern standards would define as a kind of religious philosophy. This focus relegated any scientific interpretation of the Sacred Scriptures to a minor role. This meant that a university degree in theology was actually irrelevant for the majority of priests in relation to the daily exercise of their calling. On the other hand, the quote was also aimed at those opponents whom Luther termed "*Schwärmer.*" These "enthusiasts" erred, in his opinion, by believing that the proclamation of the Gospel needed no scientific assistance, or worse, that erudition was an actual impediment to the free operation of the Holy Ghost.

The point of departure for Luther's theological work lay in his personal experience that it was practically impossible, despite the best of efforts, to comply with the requirement of the law to practice a perfect charity and love of God. His thorough reading of Paul's Epistle to the Romans made him realize that man is not justified in the eyes of God by his works, but only by his acceptance of God's merciful promise. Luther termed this concept "Justification through Faith." His train of thought, which at first glance might seem somewhat abstract, was to have a multitude of practical consequences.

If God had revealed himself solely through the Sacred Scriptures, then all human tradition, however old and venerable it might be, was irrelevant. Only baptism and the rite of the Last Supper had any foundation as sacraments in the New Testament. Even a distinct order of priests that was set apart from the laity could not be deduced from this source. It was the duty of each Christian to accept the sole care of and responsibility for his own faith. The only sure means to further this end, according to Luther's conception, was to provide each lay Christian with a version of the Bible that he could read in his mother tongue and thus understand. In this light, the translation of the Bible from Latin into German must truly be considered Luther's greatest achievement. MT

Eyn deutsch Theologia. das ist

Eyn edles Buchleyn/von rechtem vorstand/was
Adam vnd Christus sey/vnd wie Adam yn
vns sterben/vnd Christus ersteen sall.

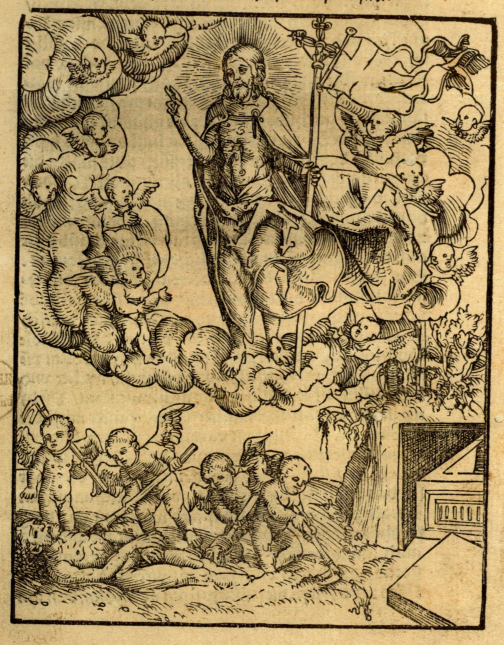

1518

Panzers Annalen V. 1. S. 414. n 898.

179

180

Martin Luther
Lucas Cranach the Elder (illustrator)
Eyn deutsch Theologia
(A German Theology)

Wittenberg: Johann Rhau-Grunenberg, 1518

179
20 × 15 cm
Luther Memorials Foundation
of Saxony-Anhalt, Ag 4° 1850
Atlanta Exhibition

180
19.2 × 15.4 cm
Forschungsbibliothek Gotha der Universität
Erfurt, Theol 4° 00224l (27)
VD16 T 896
New York Exhibition

Original title: Eyn deutsch Theologia. das ist/
Eyn edles Buchleyn, von rechtem vorstand,
was/Adam und Christus sey, und wie Adam yn/
uns sterben, und Christus ersteen sall.
(A German Theology, that is, a noble little book
from the correct understanding, what Adam and
Christ are, and how Adam must die in us and
Christ arise.)

Luther considered this text, also known as
the *Theologia Germanica*, a spiritual work of the
utmost importance, surpassed only by the Bible
and the works of St. Augustine. The original au-
thor is unknown, but in the introduction he states
that he is a priest of the Teutonic Order in Frank-
furt am Main. For this reason, the author and text
are sometimes referred to simply as "The Frank-

furter." The *Theologia* comes out of the tradition
of German mysticism, a spiritual movement that
flourished in the 14th century when the Pope,
trying to weaken the power of the Holy Roman
Emperor, forbade priests in imperial territories to
perform certain religious rites. German mystical
writers, such as Meister Eckhart and Johann
Tauler, advocated an increased focus on the laity,
including vernacular instruction, and placed a
stronger emphasis Christ's humanity and less
reliance on church sacraments. This was a defi-
nite break from traditional church practice and
led some mystical theologians, like Meister Eck-
hart, to be accused of heresy.

Luther likely came to know the *Theologia* through
his superior Johann von Staupitz, whose ser-
mons reiterate some themes popular in German
mysticism. The text itself is something of a man-
ual for spiritual practice, and Luther praised its
clear, unadorned language and focus on the Gos-
pel—two characteristics that had profound influ-
ence upon his own spiritual development. Luther
first published an incomplete version of the text
in 1516 (VD16 T 890) and called it *Eyn geystlich
edles Buchleynn* (A Noble Little Spiritual Book).
After finding a complete manuscript of the text,
he edited this full version in 1518, providing it
with a version of the title it would retain. For this
new edition, Lucas Cranach the Elder provided a
woodcut depicting the resurrected Christ over
the burial of Adam, an evocation of the book's
subtitle, "how Adam must die in us and Christ
arise." The themes of the *Theologia* so naturally
fitted with Luther's own spiritual ideas that the
text remained incredibly popular during the early
days of the Reformation and appeared in 20
printed editions during Luther's lifetime. JTM

Sources and literature
Balmires 2003 · Ruh 1980, vol. II, column 802–
808 · WA 1, 152–153 and 375–379

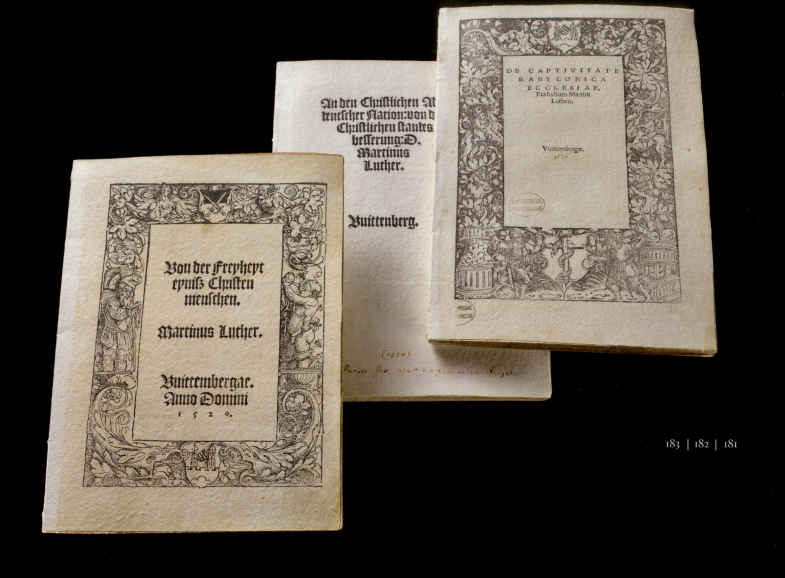

183 | 182 | 181

181

Martin Luther

De Captivitate Babylonica Ecclesiae
Praeludium (On the Babylonian
Captivity of the Church, a Prelude)

Wittenberg: Melchior Lotter the Younger, 1520
21.2 × 15.4 cm
Luther Memorials Foundation
of Saxony-Anhalt, Ag 4° 191 c
VD16 L 4189
New York Exhibition

The Latin essay *On the Babylonian Captivity of the Church, a Prelude* (cf. cat. 184) was an attack on the papacy and opposed above all the traditional number of the sacraments. Of the seven sacraments, Luther retained only those he deemed to have a biblical foundation: the Eucharist, baptism and penance. Penance, understood as a reminder of Baptism at the end of the book, was however no longer to constitute a sacrament in its own right. Following in the steps of Augustine, Luther understood a sacrament as an explicit divine promise which is bound to a visible element. Therefore, he saw himself forced to polemicize against the Roman custom of withholding the wine from the laity in the Eucharist. At the same time, he criticized the confusing and unbiblical doctrine of Transubstantiation: he found the notion of changing the divine gift into a human sacrifice completely unbearable. Thus,

he emphasized that it is not the sacrament as such that brings salvation to humanity, but rather it is faith in the sacrament that justifies it. Therefore, the notion of an "automatic" effect of the sacrament was denied and the faith of the believer was made central.

This new concept of the sacrament had profound consequences for traditional church life. Fewer sacraments meant lower income for the lower clerics. The rejection of the sacramentality of marriage led to a new ethical stance which, under certain circumstances, also made legitimate divorce possible. MT

Sources and literature
Leppin/Schneider-Ludorff 2014, pp. 153 f. ·
WA 6, 497–573 [LW 36, 5–126]

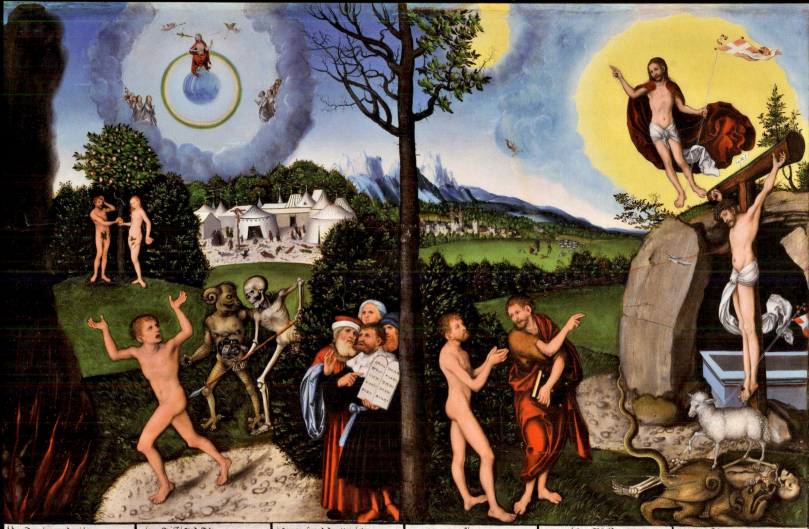

185

Lucas Cranach the Elder
Law and Grace

1529
Mixed techniques on limewood
82.2 × 118 cm
Foundation Schloss Friedenstein Gotha, SG 676
Minneapolis Exhibition

Signed and dated at the tree trunk: winged
serpent facing right, 1529
Caption: Vom Regenbogen und gericht / Ess
wird Gottes zorn offenbart vom himmel uber
aller menschen Gottloss [...] (Of rainbow and
judgment / For the wrath of God is revealed
from heaven against all ungodliness [...])

Lucas Cranach the Elder first explored the Law
and Grace motif in 1528, in a woodcut that
adorned the title page of Luther's *Exposition of
the Epistles and Gospels from Advent to Easter*.
The year after that, he created his first paintings
on the subject: the Gotha panel and a version
that is similar to the woodcut and now in the
Prague National Gallery. The fundamental com-
positional schemes of the Law and Grace images
are classified based on these two paintings: the
Gotha-type and the Prague-type.
Divided into two halves by a half-barren and
half-blooming tree, the painting compares indi-
vidual scenes from the Old and New Testaments.
Unlike the Old Testament, in which people are
obliged to follow God's law in order to save their
souls, the New Testament promises salvation in
the form of God's grace, which is revealed in
Christ. To illustrate this point, the painting de-
picts Moses, surrounded by other prophets, re-
ferring the naked sinner to the Ten Command-
ments. The sinner, however, is unable to comply
with the laws on his own and is driven into the
fires of hell by death and the devil. The reason for
the damnation of mankind is the Original Sin of
Adam and Eve, which is depicted in the center of
the painting. Above them, the Pantocrator, sur-
rounded by a rainbow, sits in judgment on a
globe. In the background, however, the brazen
serpent is lifted up in the camp of the Israelites
as an allusion to God's grace. This scene prefig-
ures the Crucifixion, which John the Baptist
points out to the sinner. The latter is sprayed with
blood from the wound in Christ's side, allowing
him to share in salvation. At the foot of the cross,
the Lamb of God triumphs over death and the
devil. Behind the cross is Christ's tomb and
empty coffin, and above that is the Risen Christ
holding a victory banner. In the background we
can see shepherds hearing about the birth of the
Lord from an angel. This event brings salvation
into the world, which the people had been lack-
ing since Original Sin. The interlocking of the Old
and New Testaments is also evident from the

quotations from the Gospels underneath the im-
age. These quotations refer to the individual
themes depicted in the painting and support
Luther's interpretation of Holy Scripture in terms
of his doctrine of justification. ID

Literature
Bild und Botschaft 2015, pp. 170 f., cat. 42 (ill.) ·
Brandsch 2001, pp. 41 f., cat. 1.4 (ill.) · Fleck
2010, pp. 17 f., 44–57 and 485 f. (ill.) · Reinitzer
2006, vol. 2, p. 250, fig. 169 · Schuttwolf 1994 b,
pp. 20 f., cat. 1.3 (ill.) ·

186

Lucas Cranach the Younger
Law and Grace

Around 1550
Oil on wood
19 × 25.5 cm
Free State of Saxony-Anhalt (on permanent
loan to the Luther House in Wittenberg), G 156
Atlanta Exhibition

Signature on tree trunk: winged serpent
facing left

The composition of this small-scale painting, cre-
ated by Lucas Cranach the Younger around 1550,
follows that of the Gotha panel of Cranach the
Elder (cf. cat. 185). The Wittenberg painting is
also divided in two parts, showing the antitheti-
cal relationship of law and the gospel, of the Old
and New Testaments, as interpreted based on
Lutheran doctrine. The themes from the Old
Testament, which are portrayed on the left side
of the painting, illustrate that man is lost under
the law, as transgression results in his damna-
tion. By contrast, the right side of the painting
shows God's grace, which is afforded to man be-
cause of Christ's sacrifice. In other words, grace
cannot be obtained through our own actions. In
Luther's view, faith alone can justify man before
God.
The Wittenberg painting deviates from the Gotha
panel in some respects. For example, the resur-
rected Christ is shown twice in this painting. He
appears as the victor, trampling over death and
the devil, whom he stabs with the banner of the
cross. At the same time, the feet of Christ are vis-
ible above the grave as he ascends to heaven in
a gloriole. Also, the conception of the cross-bear-
ing Christ Child by Mary on Mount Zion has been
added as a typological counter-image to the Fall.
This theme is referenced by the Latin inscription
above this image, which cites Isaiah 7:14 and
prophesizes the virgin birth of Christ. However,
the inscription (Romans 1:18) next to the judge of
the world warns the sinner of God's wrath.
The biblical quotes which can be found in six col-
umns underneath the image are also composed

in Latin, leading us to presume that this small
painting was made for a well-educated buyer.
However, the selection of the quotes is consis-
tent with that of the other *Law and Grace* paint-
ings from the Cranach workshop, all of which are
presented in German. Seven of these panels are
known to exist in all, of which the Wittenberg
panel is the smallest. Except for the painting in
the Prague National Gallery (1529), all of them
conform to the Gotha-type, featuring the selec-
tion of biblical themes which can be found in the
Wittenberg panel as well. Only here and in the
Gotha and Prague paintings is the brazen ser-
pent represented on the "law" side. It was in-
cluded on the right side of the *Law and Grace*
panels painted by the Cranach workshop in the
1530s as an allusion to God's grace, which is ful-
filled by the death of Christ. ID

Literature
Bild und Botschaft 2015, pp. 180 f., cat. 47 (ill.) ·
Enke/Schneider/Strehle 2015, p. 366, cat. 3/37
(ill.) · Fleck 2010, pp. 507 f. (ill.) · Reinitzer
2006, vol.1, pp. 54, 451–452, cat. 779 and
vol. 2, p. 255, fig. 174

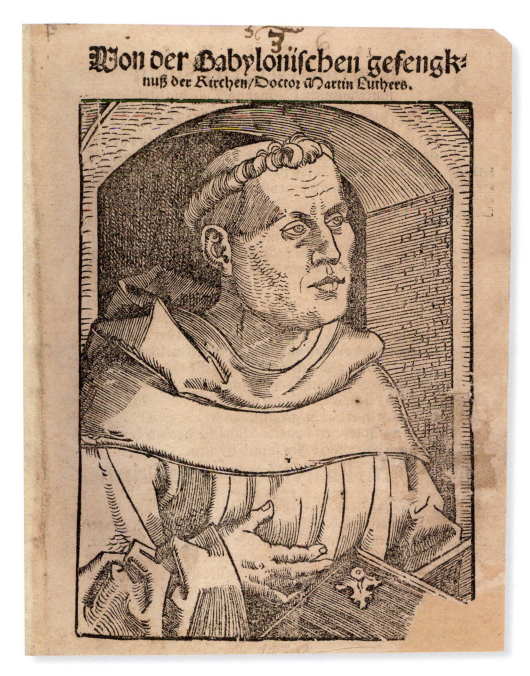

Won der Babyloniſchen gefengk=
nuß der Kirchen/Doctor Martin Luthers.

184

Law and Grace – A Pictorial Subject of the Reformation

When a painting is titled *Law and Grace*, one may safely assume that it is an allegory of Martin Luther's doctrine of justification. Lucas Cranach the Elder created this type of theological image at the end of the 1520s, probably with the assistance of Luther or Melanchthon (cf. cat. 185 and 186). It was designed to be a striking and memorable instrument for propagating the concept of Justification by Faith as the basic assumption of the Reformation.

Martin Luther himself was convinced that people did not, as a rule, think in abstract concepts but rather in images. As a consequence, contemplative images and paintings ("*andechtig bilder und gemelde*") were thought to be a useful tool for generating faith. Appropriate images could give solace or admonish, and they could strengthen and improve an understanding of the Gospel in the beholder. Cranach's painting *Law and Grace* is a prime example of such an image, and we can assume that it corresponded fully to the Reformer's taste.

This subject is probably the only original Lutheran creation in the entire field of visual art. Its antithetical juxtaposition of biblical motifs was not unusual as such. But Cranach's composition for *Law and Grace* is unique in its conclusive combination of simple pictorial devices. These enabled a viewer to grasp the content of the image with minimum effort. The Old Testament scenes on the left side of the painting illustrate the fundamental sense of loss that man suffered under the Law of God, which he was bidden to observe lest he be damned. In contrast, the right side depicts the Grace of God, given to mankind without consideration of merit through the sacrificial death of Christ.

There are two variant compositions of *Law and Grace* in the Reformation period. They appear widely in diverse media, such as prints, altar paintings and epitaphs, and even on everyday functional objects. The two versions are generally termed the Gotha-type and the Prague-type, according to the present-day locations of the earliest known painted examples (from 1529), which are now housed in the collections of the Foundation Schloss Friedenstein Gotha and in the National Gallery in Prague. ID

182

Martin Luther

An den christlichen Adel
deutscher Nation (To the Christian
Nobility of the German Nation)

Wittenberg: Melchior Lotter the Younger, 1520
21 × 15.7 cm
Luther Memorials Foundation
of Saxony-Anhalt, Ag 4° 189f
VD16 L 3758
New York Exhibition

The letter to the Christian nobility opens Luther's
series of four main Reformation writings from the
year of 1520. The title is misleading because
Luther not only addresses the lower nobility but
all who have political responsibility in Germany,
including the Emperor. The tract consists of two
parts that were written at different times. The first
part, finished around June, advocates for a
church council. The second part contains a set of
28 concrete suggestions for reform. The central
theological concern of the work is Luther's doc-
trine of the priesthood of all baptized persons.
According to this, every Christian is called to con-
cern themselves with a godly life in the Church.
Thus the powerful division between clerics and
laity is dissolved. Therefore, Luther concludes
that the traditional claims of the Roman Church
have fallen (Luther speaks of three walls): the
Church's expectation of control of worldly rulers,
the monopoly on normative interpretation of
scripture and the superiority of the Pope over an
Ecumenical Council, thus removing from the pa-
pacy the Power of the Keys. For Luther, it is now
entirely clear: the Pope in Rome is, as an institu-
tion, the Antichrist.
The final catalogue of demands for reform comes
from various sources. Luther demands among
other things the curtailing of religious orders, the
abolition of celibacy for ordinary priests, the re-
form of theological education on a biblical foun-
dation, but also reconciliation with the Hussites
in Bohemia and the abolition of public brothels.
Most of the suggestions were not new but were
given new impetus by Luther's authority. The first
edition of 4,000 copies demonstrates the suc-
cess of the tract, which would soon become one
of the most-read in the German realm and be-
yond. MT

Sources and literature
Leppin/Schneider-Ludorff 2014, pp. 42 f. · WA 6,
404–469 [LW 44, 117–219]

183

Martin Luther

Von der Freiheit eines Christen-
menschen (On the Freedom
of a Christian)

Wittenberg: Johann Rhau-Grunenberg, 1520
19.8 × 15 cm
Luther Memorials Foundation of Saxony-Anhalt,
Kn D 69
VD16 L 7194
New York Exhibition

In these 30 theses, Luther explains his concep-
tion of Christian freedom. He begins as follows:
"A Christian is a perfectly free lord of all, subject
to none. A Christian is a perfectly dutiful servant
of all, subject to all" (cf. cat. 164). Luther resolves
this contradiction by distinguishing the internal
man from the external man, identifying the exter-
nal man by his corporeality and the internal man
by his soul. The further arguments presented in
this work are based on this dichotomy: theses
3–18 deal with the internal man and 19–30
address the external man.
The separation of internal and external is re-
flected in the separation of the New and Old Tes-
taments. Luther argues that the Old Testament
proclaims the law, which is superseded by the
appearance of Jesus. Basing his views on Ro-
mans 13 and Galatians 4, Luther concludes that
the law is no longer sufficient for Christian justi-
fication. The law is merely the necessary venue
for man to become conscious of the truth. In this
way, man could "learn his own incapacity for
good."
As Luther argues: The word of God can save us
from the consciousness of sin. Faith in Christ
would make us spiritually free. That the revela-
tion of Christ and human faith are possible at all,
Luther attributes to God's grace. Luther illus-
trates this through the metaphor of Christ as a
pious and sinless groom marrying a mean harlot,
where the harlot represents sinful man. The
Christian who would be freed by faith would rec-
ognize the other, externally, as Christ. By follow-
ing Christ, he would become a good person who
performs good works for his neighbor. Thus spir-
itually freed by his faith, he would now perform
good works externally as well. This is how Luther
interprets St. Paul's commandment of love.
Throughout the work, we find arguments against
the doctrine of justification by works. His central
argument is in opposition to a formulaic practice
which is directed not towards internal repen-
tance, but rather towards good appearances. In
this respect, the freedom of a Christian, to Lu-
ther, is freedom *from* the law. In 1520, Luther was
not aware that there was also a Greek and Jewish
tradition of freedom *for* or *through* the law.

This has been considered one of Luther's princi-
pal works since the 19th century. It underwent
18 editions in the 16th century and was quickly
translated into Low German. RK

Literature
Graf 2006 · Linde 2011 · Rieger 2007

184

Martin Luther

Von der Babylonischen Gefangen-
schaft der Kirche (The Babylonian
Captivity of the Church)

Strasbourg: Johann Schott, 1520
18.4 × 14.5 cm
Luther Memorials Foundation
of Saxony-Anhalt, Ag 4° 191f
VD16 L 4196
New York Exhbition

The German version of the Latin tract *De captivi-
tate Babylonica ecclesiae praeludium* (cat. 181)
was written by Luther himself around the same
time as the Latin version. However, in the Ger-
man title, the term *prelude* (*praeludium*), which
had already puzzled people, was missing. Luther
most probably intended it as a threat: if he did
not succeed with his suggestions for reform he
would publish more, and in a stronger tone.
The title page of the edition employs a full-page
version of the first woodcut Luther portrait cre-
ated by Lucas Cranach the Elder in 1520. The
woodcutter was probably Hans Weiditz. Obvi-
ously, it had been recognized that a pictorial
representation of Luther increased profits. The
trained printer Johann Schott had already made
a name for himself as an editor of humanistic
publications. Most of all, he disseminated the
pamphlets of Ulrich von Hutten, who in the early
phase of the Reformation furthered Luther's
cause and had an exceptional influence with his
sharp critique of Rome. MT

Sources and literature
ADB 32, 1891, pp. 402–404 · Leppin/Schnei-
der-Ludorff 2014, pp. 153 f. · WA 6, 497–573
[LW 36, 3–126]

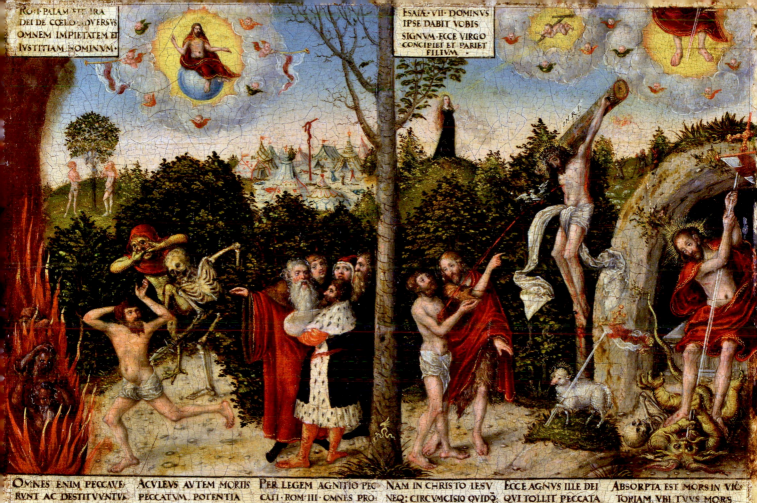

RO · I · PALAM EST IRA
DEI DE COELO ADVERSVS
OMNEM IMPIETATEM ET
IVSTITIAM HOMINVM·

ESAIAE · VII · DOMINVS
IPSE DABIT VOBIS
SIGNVM · ECCE VIRGO
CONCIPIET ET PARIET
FILIVM·

OMNES ENIM PECCAVE RVNT AC DESTITVVNTVR GLORIA DEI · ROM · III ·	ACVLEVS AVTEM MORTIS PECCATVM · POTENTIA VERO PECCATI LEX I · COR · X V · LEX IRAM OPERATVR · ROM · IIII ·	PER LEGEM AGNITIO PEC CATI · ROM · III · OMNES PRO PHETÆ ET IPSA LEX VS QVE AD IOANNEM PRO PHETAVERVNT · MATTHÆI · XI ·	NAM IN CHRISTO IESV NEQ: CIRCVMCISIO QVID Q: VALET, NEQ: PREPVTIVM SED FIDES OPERANS P: DILECTIONEM AD GAL · V ·	ECCE AGNVS ILLE DEI QVI TOLLIT PECCATA MVNDI IO · I · PER SANG TIFICATIONEM SPIRITVS IN OBEDIENTIAM ET AS PERSIONEM SANGVINIS	ABSORPTA EST MORS IN VIC TORIAM. VBI TVVS MORS ACVLEVS · VBI TVA INFERNE VICTORIA' SED DEO GRATIA QVI DEDIT NOBIS VICTORIA PER DOMINVM NOSTR·

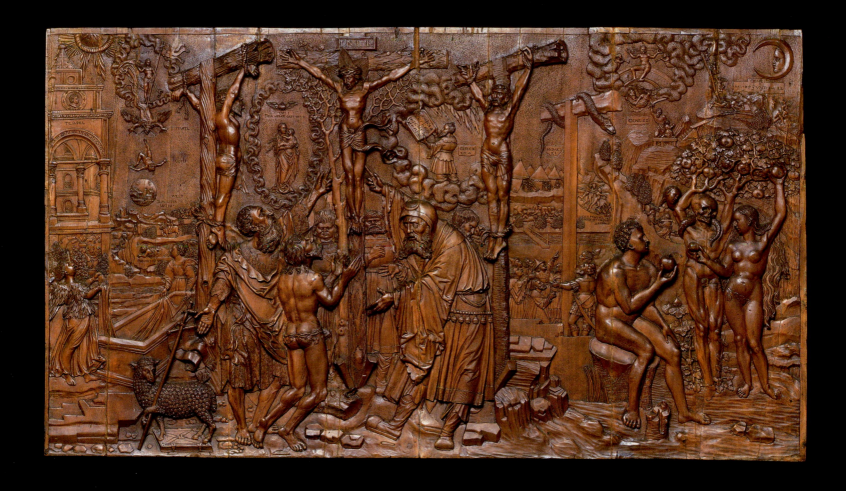

187

187

Peter Dell the Elder
Allegory to the Old and New Testament

1530–1534
Pear wood, brown varnish, applied with glue to
a conifer wood panel
43 × 75.8 × 2 cm
Foundation Schloss Friedenstein Gotha, P 20
New York Exhibition

This relief, including a portrayal of the Protestant *Law and Grace* theme, was created by the Würzburg sculptor Peter Dell the Elder, a student of Tilman Riemenschneider. From 1528 until about 1533/34, Dell worked at the court of Duke Henry the Pious of Saxony in Freiberg, for whom he created several wood reliefs with religious and allegorical subjects. The Gotha panel was likely commissioned by the court in the early 1530s. Dell based his work on the *Law and Grace* images created by Lucas Cranach the Elder (cf. cat. 185) and on themes from contemporary prints.

However, unlike in Cranach's *Law and Grace* portrayals, the side of the "law" is on the right here, while "grace" is on the left, which can be attributed to the position of the cross, which serves to divide the picture into two parts. After all, according to Christian tradition, the redeemed are to be shown on the right side of Jesus. The relief is distinguished by its intricate detail, as even the smallest elements of the image have been carved with utmost care. The individual motifs are supplemented by inscriptions which either identify the images ("death," "world") or interpret them by citing a biblical passage ("The sting of death is sin, 1 Corinthians 15").

The scene of the Fall, prominently displayed in the right foreground, is given more space than in other *Law and Grace* portrayals. Dell also artistically enhanced this theme. A woodcut of the same theme by Lucas Cranach the Elder from 1509 served as the model for portraying Adam and Eve. Jutta Reinisch has also identified the influence of the "little masters" of Nuremberg in this group of figures. Specifically, the seated Adam is based on the work of Hans Sebald Beham, while the Tree of Knowledge, which takes on the human form of death, can be traced back to the copper engraving *Adam and Eve* by Barthel Beham.

The architecture shown on the left edge of the relief might also be based on a pre-existing model. After all, the tondo showing a head in profile was primarily an element of architectural design in northern Italy in the late 15th and early

16th centuries, and was based on adoption of the designs shown in ancient coins.

With great creativity, Dell varied the predefined image composition of the Cranach workshop and enriched its imagery by inserting additional biblical motifs. These images can be interpreted christologically and in terms of Luther's doctrine of grace. Perhaps the appearance of Martin Luther's first complete Bible induced Dell to include more scenes from the Old Testament. In that case, it is conceivable that the panel was created in the year 1534. ID

Literature
Fleck 2010, p. 550, cat. 186 (ill.) · Reinisch 2015, fig. 1 · Reinitzer 2006, vol. 2, pp. 66, 104 (ill.) · Schuttwolf 1994 b, pp. 67 f., cat. 1.36 (ill.) · Schuttwolf 1995, pp. 94 f., cat. 29 (ill.)

188

Tile Fragment Depicting Law and Grace

Wittenberg, Schlosshof
1st-half of the 16th century
Earthenware, green glazing
32 × 16 cm
State Office for Heritage Management and Archaeology Saxony-Anhalt, State Museum of Prehistory, HK 3500:9:27h
Atlanta Exhibition

Although it is badly damaged, the main elements of the imagery of this stove tile have survived. It was formed from the same mold as the wall fountain (cat. 236) and shows an abbreviated version of Cranach's visual exegesis of Martin Luther's hope for human salvation, *Law and Grace*. In fact, it includes a detail of Cranach's Prague variation on this theme, which focuses on the personalized dichotomy between the exponent of the law of the old covenant, as personified by Moses, and the Savior's promise of grace, embodied by John the Baptist. Yet interestingly, although Lucas Cranach and the Cranach workshop were all but mass-producing this imagery in Wittenberg, there are certain details on this stove tile, which was probably crafted in nearby Bad Schmiedeberg, which deviate fundamentally from Cranach's iconography. Importantly, the sinner is shown as kneeling in prayer, facing the crucified Christ. He has made his choice and is saved. John takes him by the arm and Moses fades into the background. The triangular composition of the figures on this tile focuses on the Crucifixion of Christ with John's pointing arm binding the sinner to the Savior. Cranach's original work focuses on the sinner's choice, where he sits on a stone in the center of the picture between Moses and John and is in the

process of making his decision. Our tile shows a saved soul that has made this crucial choice. Another important deviation is Adam's skull, which is shown at the bottom of the tile tilted upwards waiting to be washed free of sin by the Savior's blood. This traditional, comforting image signals God's all-embracing will to save errant humanity. This image in fact diametrically contradicts the message of Cranach's work and Luther's message, which rejects blanket salvation of humanity and focuses on the vital importance of the individual sinner's belief in Christ's gift of salvation (*sola fide*). Interestingly, similar deviations can be seen in the carved, high-relief, wooden panels of Peter Dell the Elder (cat. 187). It is likely that tile makers were more easily inspired by, or took casts, of wooden panels, rather than paintings and engravings. However, there were probably deeper reasons as to why stoves and fountains were decorated with this divergent iconography. Cranach's iconography was intellectually demanding, concentrating on agreements and decisions, while our tile maker celebrates the prospect of sure salvation. The courtier in the palace who ordered this stove must have had similar feelings. LN

Literature
Fleck 2010 · Stephan 2014

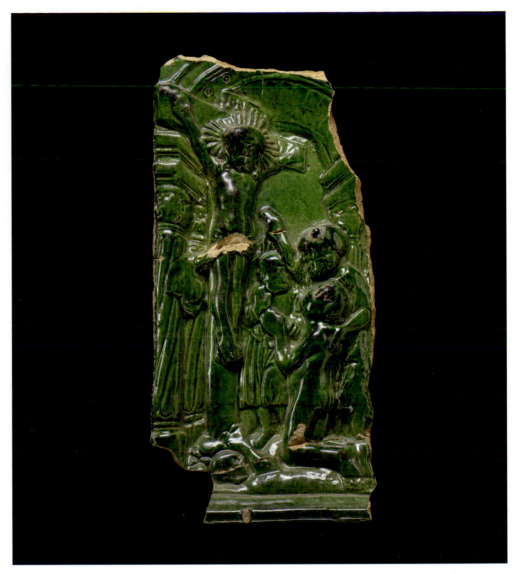

188

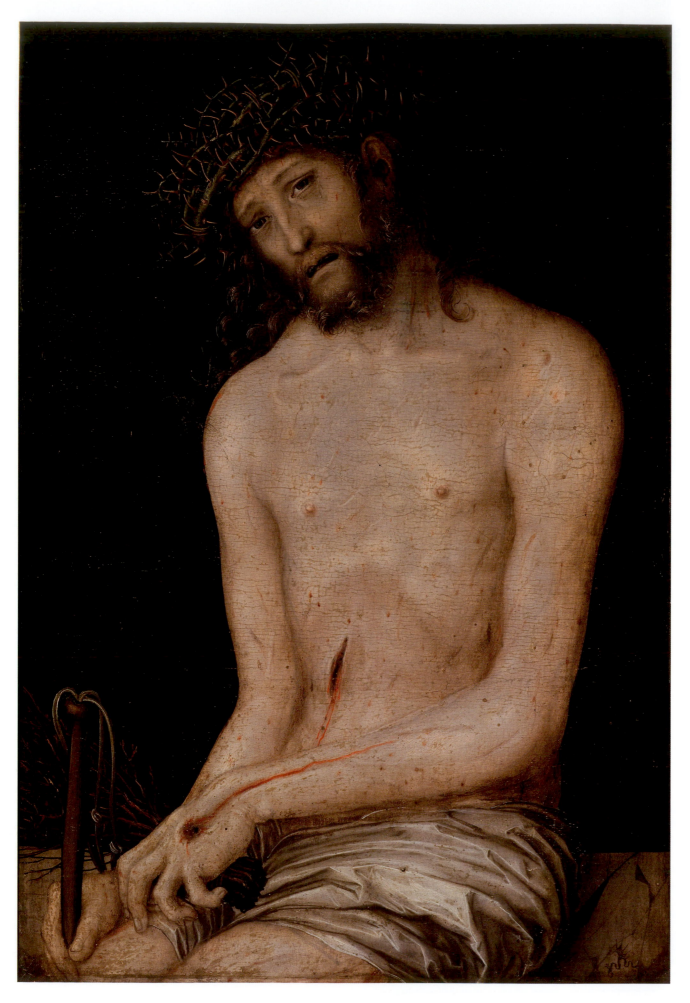

189

189

Lucas Cranach the Elder
Man of Sorrows

Around 1530
Oil on panel
55.5 × 38 cm
Evangelische Kirchengemeinde St. Petri Wörlitz
der Evangelischen Landeskirche Anhalts in
Deutschland (Gotisches Haus, permanent loan
to the Dessau-Wörlitz Cultural Foundation)
New York Exhibition

Signed on the bottom right with the winged
serpent

Jesus Christ sits on a rocky bench, clad in a loin-
cloth and with the crown of thorns on his head. In
his hands, he holds the whips and rods with which
he was tortured. With his head inclined to the left,
he is looking straight out of the picture, and his
mouth open slightly in an expression of suffering.
Drops of blood and sweat cover his whole body, and
his face is wet with tears. The wound on his side
and the stigmata on his hands reveal that Jesus
has already died, but he is alive in this painting.
The motif of Christ as the Man of Sorrows was a
typical theme in devotional paintings of the late
Middle Ages. When used as an altarpiece, it
served as a reminder of Christ's suffering in the
form of flesh and blood, the Eucharist. It served
to remind the sinner that Jesus, the conqueror of
death, suffered and eventually died on the cross
so as to take all of mankind's sins upon himself
and to bring salvation. The copious wounds,
sweat and tears are meant to symbolize the
transgressions and evil of mankind.
The extremely realistic representation of Christ's
wounds and the natural appearance of his face
and body were more than just a demonstration
of the artistic mastery of Cranach the Elder.
Rather, the realism of the painting was calcu-
lated to induce the beholder to empathize with
the suffering of Christ, so that he too could share
in the emotional experience of the Passion.
This motif was frequently used in paintings and
sculptures of the early Reformation period. Many
of these representations have survived in the
Lutheran world. At this time, the focus shifted to
Jesus Christ himself, who suffered for the sins of
mankind and who alone can bring salvation.
Luther himself recommended that paintings of the
Crucifixion should show Christ's wounds, consis-
tent with the tradition of the late Middle Ages, so
as to remind the beholder of the Passion. For this
reason, it comes as no surprise that this painting
of Christ as the Man of Sorrows, which formerly
belonged to the sacristy of St. Peter's Church in
Wörlitz, had been preserved there. SKV

Literature
Marx/Mössinger 2005, pp. 56 f. (ill.) · Melzer
2015, p. 159 (ill.) · Schmidt-Hannisa 2005, p. 71

190

190

Lucas Cranach the Elder, workshop
(attributed)

**Sermon of John the Baptist. In: Ur-
banus Rhegius, Vom hochwürdigen
Sacrament des altars […] (On the
Blessed Sacrament of the Altar […])**

Leipzig: Jakob Thanner, 1525
woodcut
Paper size: 15 × 10.5 cm
Luther Memorials Foundation of Saxony-Anhalt,
Ag 8° 633 e
VD16 ZV 13191
Atlanta Exhibition

This woodcut illustrates the third chapter of a
pamphlet by the theologian Urbanus Rhegius
(Urban Rieger, 1489–1541). Rhegius was known
as the Reformer of the Duchy of Lüneburg. In the
foreground, a large-scale John the Baptist gives
a sermon to a small group to his left. The inscrip-
tion on the ground to the right of the prophet
says he is "*Anczeiger Cristi* (he who points to
Christ)". His outstretched arm points clearly to a
crucifix and emphasizes again this function. A
panel at the foot of the cross marks the crucified
one, surrounded by rays of light, as "*Vnser Recht-
eertigvng* (our justification)." In the background
of the scene rises a tall, rocky mountain. On the
peak stands the Virgin Mary with her arms reach-
ing toward the Christ child. The unclothed boy
carries his cross on his shoulder and hovers on a
ray of light, surrounded by angels facing the

191

awaiting Virgin. In an inscription over her head she is given the title "*Gnad* (grace)" and the child is given the name "*Emanuel* (God is with us)". The text fields and especially the inscription point to Italian art of the Renaissance. The symbols, influenced by humanism, point to the world of the author Rhegius. The sermon of John the Baptist—a theme from the art of the late Middle Ages—stands in the center of the picture. The topics of his sermons appear behind him: redemption through the sacrifice of Christ on the cross and the beginning of the work of salvation through the conception of Jesus. The right side of the Prague panel of *Law and Grace* derives almost completely from the presentation of the woodcut. Scholars therefore think it is the earliest example of the "law and gospel" theme, even if only one half of the entire theme—the theme of grace—is portrayed.

Some scholars believe that the woodcut sermon of John the Baptist was not conceived as an illustration for the pamphlet because it seems thematically incongruous. However, the third article of the work, next to which the woodcut appears, is about the redemption of the sinner through Christ's death on the cross "[...] when the sinner gains displeasure over his sin and brings about judgment and justification, then I will no longer remember his sins. When the body is given and the blood is poured out in forgiveness of sin." Spira rightly notes that the woodcut fits well with the others in the pamphlet (cf. Bild und Botschaft 2015). The comparison with the text proves, in fact, that the woodcut was chosen to illustrate the text. SKV

Literature
Bild und Botschaft 2015, pp. 166 f., cat. 40 (ill.) · Fleck 2010, pp. 28–32, 442 f., cat. 6 · Hendrix 1996 · Hollstein XXII, no. 163 · Reinitzer 2006, p. 39

191

Annaberg Mint

Triple Thaler, so-called Plague Thaler

n. d. (after 1527)
Silver, minted
D 48.5 mm; weight 86.7 g
Foundation Schloss Friedenstein Gotha, Münzkabinett, 4.1./5732 Atlanta Exhibition

Obv: DER · HER · SPRAC · ZV · MOSE · MAC · DIR · EIN · ERNE · SLANG · VNT · RICT · SI · ZVM / · ZEIGEN · AVF · WER · GEPISN · IST · VND · SICT · SI · AN · DER · SOI · IE
Mint Hallmark: winged head (Annaberg)
Below cross arms: NVM – RI · ZI
At center upright the brazen serpent. Below cross kneeling persons on either side looking upwards at cross pole and partially hold snakes in hands. Four dead bodies at foot of cross.
Rev: GLEIC · WI · DI · SLANG · SO · MVS · DES · – MENSEN · SON · ERHOET · WERDEN · / · AVF · DZ – AL · DI · AN · IN · GI – BEN · HABN · DZ · EB – IC · LEB
Mint hallmark: winged head (Annaberg) below cross arms: · IOAN – NES · 3 ·

At center Christ on the cross; below cross kneeling persons on either side looking upwards at the Son of God

Besides large-scale works of Reformation art, medallions and medals, due to their easy reproducibility and material durability, played a decisive role in the dissemination of Lutheran doctrine and contemporary theological disputes and conflicts. The increasing demand for religious showpieces sparked a significant upturn in biblical and allegorical medals, which were struck starting in 1528 in mints in the Ore Mountains, and because of their popularity, they were often recast or copied well into the 17th century.

Plague thalers minted there are considered an early form of biblical "exhibition coins" (*Schaugroschen*). They exist in a large variety and derive their designation from their amuletic function during plagues. They represent a transitional stage between the large silver coins from the Ore Mountains and religious stamped medals that have been known since 1525; from 1527 they are known with double-row circumscriptions. The close relationship between the plague thaler and a coin is evidenced by its edition with the weight of one thaler, as well as partial and multiple denomination and very flat relief.

The depiction of the brazen serpent of Moses on the observe side and the Crucifixion on the reverse side is a known reference to the sacrificial death of the Son of God that will reappear in the central pictorial theme of the "Law and Gospel" in various Reformation artistic media and representation variations. The brazen serpent was

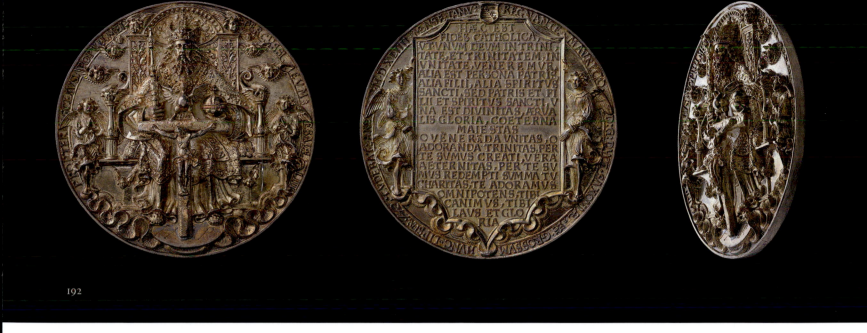

192

considered a prophecy of Christ's sacrificial death and the salvation of mankind from death and evil. It can be identified as an image motif from the 12th century, and as a typological model of the crucified Christ, and its roots date back to the early Christian period. It is regarded as an Old Testament reference to the unconditional grace of God, which was solely based on the faith of man and which was elevated to a central dogma in Luther's Protestant doctrine of justification. According to the Old Testament, the Israelites were healed by simply looking at the brazen serpent, which is parallel to the salvation granted the faithful when they gaze upon the elevated, crucified Christ. It is also found in the spirit of their profession of faith: "And as Moses lifted up the serpent in the wilderness so must the Son of Man be lifted up, that whoever believes in him may have eternal life" (John 3:14–15). UW

Literature

Bild und Botschaft 2015, pp. 164 f., cat. 39 (ill.) ·
Brozatus/Opitz 2015, vol. I,1, p. 426, cat. 607 ·
Schuttwolf 1994 b, p. 10, cat. 4.2. (ill.)

192

Hans Reinhart the Elder
Trinity Medal

1544
Silver, cast with solderings
D 103 mm; weight 269 g
Foundation Schloss Friedenstein Gotha,
3./Co 639
Minneapolis Exhibition

Obv: PROPTER. – SCELVS – POPV – LI.MEI – PERCV – SSI – EVM – ESSAIAE . – LIII
The obverse depicts God the Father sitting on a richly ornamented throne of grace with crown, insignia (scepter and globe), and in sumptuous vestments. Christ on the Cross is depicted in front of him in the bottom half of the medal. At the center of the arms of the cross, the dove with outspread wings as symbol of the Holy Spirit. One standing, praying angel and several cherub heads on either side of the throne. On base panel: H – R
Rev: The reverse depicts angels holding a tablet inscribed with verses from the Athanasian Creed.
HAEC EST / FIDES CATHOLICA, / VT . VNVM DEVM IN TRINI, / TATE,ET TRINITATEM,IN / VNI-TATE,VENEREMVR, / ALIA EST PERSONA PATRIS, / ALIA FILII,ALIA SPIRITVS / SANCTI,SED PATRIS ET FI / LII ET SPIRITVS SANCTI,V / NA EST DIVINI-TAS,AEQVA LIS GLORIA, COETERNA / MAIESTAS / O VENERADA VNITAS,O / ADORANDA TRINI-TAS,PER / TE SV / MVS REDEMPTI / SVMMA TV / CHARITAS,TE ADORAMVS / OMNIPOTENS,TIBI /

CANIMVS,TIBI / LAVS ET GLO /RIA; Legend: REG-NANTE MAVRITIO – D : G : DVCE SAXONIAE,ZC : GROSSVM – HVNC ~ LIPSIAE HR CVDEBAT : AN o – M D . XLIIII - MENSE IANV :

The Trinity Medal, made in 1544, constitutes the zenith in the oeuvre of Leipzig-based artist Hans Reinhart the Elder and is a highlight of German Renaissance art. Its unparalleled mastery and unique finesse show a design combination of casting and artful goldsmith soldering, in some cases even producing fully three-dimensional miniature sculptures and decorations. Reinhart, a skilled goldsmith, was a master of his art and in his image compositions he drew inspiration from his artistic experiences in wood-carving. The throne of grace motif follows pre-Reforma-tion models from the early 16th century that can be found in Saxon architectural sculpture as well as the graphic work of Cranach the Elder. In addition to its outstanding quality, the medal is of enormous religious and political signifi-cance. It expresses the contemporary yearning for unity between the Catholic and Protestant Churches and documents relevant endeavors towards reconciliation between the religious fac-tions. The legend on its reverse side and the de-piction of the Saxon ducal escutcheon make it highly likely that the medal was commissioned by the later Elector, Maurice of Saxony. Before the outbreak of the Schmalkaldic War, young Duke Maurice, who had converted to Protestant-ism in 1539, tried to mediate between Emperor Charles V and the Protestant members of the Schmalkaldic League. His efforts at reconcilia-

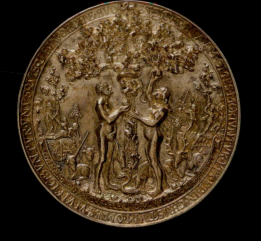
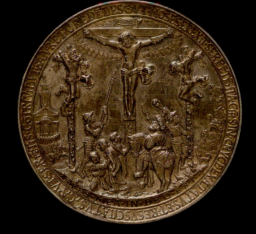

193

tion began about 1542 and are reflected in the iconographic statement of the medal, the theological theme of which is the Trinity. Both the motif of the throne of grace and the inscription on the reverse side, consisting of extracts from the creed of Athanasius, a 4th-century Doctor of the Church, were recognized by Roman Catholics and Protestants alike. The Athanasian Creed formed the theoretical basis of the Trinity doctrine in both Churches and was also mentioned in the Schmalkaldic Articles. Thus, the medal conveyed a clearly unifying religious message.

The tremendous importance of the medal prompted Reinhart and his works to remake the medal with subtle variations in 1556, 1561, 1566, 1569 and 1574. UW

Literature
Cupperi 2013, pp. 264 f., cat. 179 · Eberle/ Wallenstein 2012, p. 80, fig. 96 (ill.) · Habich 1929–1934, vol. II, 1, no. 1962 · Kuhn 1942, p. 16, fig. 15 · Schuttwolf 1994 b, pp. 26 f., cat. 4.26 (ill.) · Steguweit 12/2012, fig. 3 (ill.)

Hans Reinhart the Elder
Two Medals with the Fall of Man and Salvation

Obverse: Adam and Eve underneath the Tree of Knowledge, surrounded by Paradise animals and a unicorn. In the background on the left, the creation of Eve from one of Adam's ribs, on the right: their expulsion from paradise. At the bottom rim on the left: the shield of the Elector of Saxony, on the right: the escutcheon of the Duke of Saxony. Reverse: Christ on the cross, on each side one thief. At foot of cross John supporting Mary, Mary Magdalene, two soldiers and a captain on horseback. In background on left: depiction of a church, on right the sepulchral cave, above the risen Christ with victory banner.

193
1536
Silver, cast with soldering
D 67 mm; weight 71.17 g
Foundation Schloss Friedenstein Gotha,
3./Co 659
Minneapolis Exhibition

Obv: ET · SICVT · IN . ADAM (AD ligated) · OMNES (MNE ligated) · MORIVNTVR · ITA · ET · IN · CHRISTVM (HR ligated) · OMNES (MNE ligated) . VIVIFICABVNTVR (AB ligated) . VNVSQVISQVE · IN · ORDINE (NE ligated) · SVO - bottom: IOANN[e]S · FRIDERICVS · ELECTOR · DVX · SAXONIE · FIERI · FECIT
Rev: · VT · MOSES · EREXIT . SERPE [n]TE[m], ITA · CHR[i]S[tus] (HR ligated) · IN . CRVCE · EXALTATVS (AL ligated) ET · RESVSCITATVS, CAPVT (AP ligated) . SERPE[n]TIS . CO[n]TRIVIT, VT SALVARET (AL and VAR ligated) · CREDE[n]TES – bottom: · SPES · MEA · IN · DEO · EST ·, at top of

cross: INRI, at bottom of cross: H[ans] R[einhart] (ligated) /1 5 3 6 (depressed)

194
n. d., around 1536
Silver, cast with soldering, looped
D 56 mm; weight 34.32 g
Foundation Schloss Friedenstein Gotha,
4.1./2300
Atlanta Exhibition

Obv: in field: MVLIER DE - DIT · MIHI . / ET · COME . DI . GE – Z ·
Rev: in field: MIS – ERERF · NO - BIS · DOMI – NE

The medals made by Saxon goldsmith and medalist Hans Reinhart the Elder in 1536 with the "Law and Gospel" motif take up a central theme of the Reformation that received its decisive pictorial rendition in the work of Lucas Cranach the Elder in 1528/29 (cf. cat. 185f.). Cranach configured various iconographic scenes, some of which had been known since the early Christian period, and recent artistic precursors from the first-half of the 1520s into this new conceptual motif, which is deemed by some to be the only Lutheran innovation in the field of fine arts.

The theological background for "Law and Gospel" was Luther's doctrine of justification, in which he, with reference to Paul's Epistle to the Romans 3:28, proclaimed that men will find justice before God alone through their faith in Jesus Christ (righteousness of faith), who through his death on the cross took up all the sins of the world. According to Luther's newly-won theological conviction regarding God's grace, His mercifulness and righteousness could not be acquired through a sinless life or good works and, hence, could not be actively obtained—an attitude that

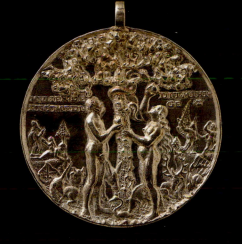
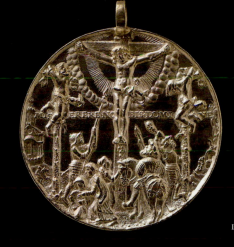

194

was also directed against the sale of indulgences and the penitential concept of the Roman Church. He regarded these gifts rather as attributes of God, which He grants to man through forgiveness.

Along similar lines as the depictions of the Fall of Man and salvation in the visual arts, where the composition strictly separates aspects of the Old and New Testaments, Hans Reinhart portrays condensed theological images on his elaborate medals with the Fall of Man on the obverse and Crucifixion on the reverse. The art of medal making thus follows the same Protestant teaching found in other visual arts.

The circumscription on the obverse of the dated medal indicates that this was a work commissioned by Saxon Elector John Frederick the Magnanimous in the spirt of a Protestant confession. This is why the reverse carries his personal motto "My hope is in God," which was derived from one of Luther's mottoes. Another version of the medal was also made in 1536 (cat. 194). The theme of damnation and salvation was taken up for the last time by Reinhart the Elder in a medal commissioned by Elector John Frederick in 1547, the year of the decisive Battle of Mühlberg. UW

Literature
Bild und Botschaft 2015, pp. 186 f., cat. 50 (ill.) · Cupperi 2013, pp. 263 f., cat. 178 · Doerk 2014, pp. 54 f., fig. 7 · Kuhn 1942, p. 15, fig. 10 · Tentzel 1982, pp. 98–105, pl. 8,I,II

195

Stove Tile Depicting the Baptism of Christ in the River Jordan

Wittenberg, Luther House, Collegienstraße 54
Mid- to late-16th century
Earthenware, green glazing
29 × 17.7 cm
State Office for Heritage Management
and Archaeology Saxony-Anhalt
State Museum of Prehistory, HK 592:45:1c0
Atlanta Exhibition

This rectangular stove tile depicts the baptism of Christ in the River Jordan by John the Baptist. Apart from the unmistakable content of the image, this information is also provided by the caption at the bottom of the tile, "DR.IVRDAN" in relief letters. The fact that the letter "N" is inverted may indicate that the maker of a mold may not necessarily have been literate. In addition, the captions on these tiles were not just meant strictly to convey information. They were also perceived as part of the decorative scheme. This could lead to a certain tolerance for inaccuracies that might in turn result in more mistakes as motifs were passed on and further altered, sometimes to the point of mutilation.

The columns that frame the central image on both sides bear the initials "V" and "T" on their bases. The same initials, and others which are similar to them, appear on a variety of tiles across a substantial area of distribution. The letters could be the initials of the mold maker, of the potter who made the tile, or even of a merchant specializing in the tile trade. For example, a series of tile finds from Stralsund and Anklam that date to the middle of the 16th century and bear the images of princes (including some of the Saxon Electors) are marked with a "V" and "F". Another example that can be compared to the Wittenberg baptism tile, but which combines the initials "VT" with a depiction of Elector John Frederick of Saxony, was found as far away as Copenhagen.

The tile from the Luther House is particularly remarkable for its finely executed and particularly deep-cut relief. Another peculiarity is the way in which God the Father is represented: this figure, which is shown watching from behind a jagged cloud, occupies the upper part of the picture, and even extends beyond it to cover part of the frame in a manner that is definitely unusual for the tiles of this period.

The baptism scene, the submerging of Christ in the waters of the Jordan and his emergence, as well as the opening of the heavens, have been interpreted as a foreshadowing of the death and resurrection of Christ. By extension, any Christian could participate in this act of salvation through baptism, which Luther continued to regard as a sacrament. That the very same type of tile was also available in an even more luxurious polychrome version is confirmed by a fragment depicting God the Father and his cloud that was recovered in 2012 during excavations on the site of the Golden Ring, the former inn across from Luther's parental home in Mansfeld. RKA

Literature
Hoffmann 2008, p. 205 · Hoffmann 2009, p. 307 · Schäfer 2008, pp. 289 f. · Schwarz 2008, p. 219, fig. 8 · Vahlhaus 2015, pp. 435–451

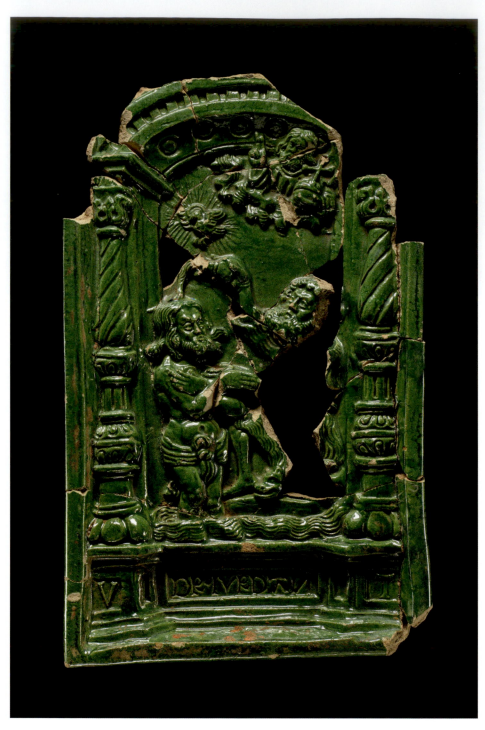

195

The Eucharist

As part of divine services or Mass, Christian churches observe the tradition of distributing bread—and, depending on the denomination, also wine—among the faithful in a rite known as the Eucharist, Communion or Lord's Supper. This is generally preceded by Christ's words of institution as passed down in the Gospels. The exact theological meaning of the ceremony, however, is a matter of controversy.

The doctrine of Transubstantiation had been accepted within the Latin Church since the High Middle Ages. The transformation of bread and wine into the body and blood of Christ was defined in 1215 by drawing a scholastic distinction between matter and appearance, meaning that the indistinguishable essence or substance was altered, while the visible aspect of the bread and the wine remained unchanged. This doctrine was declared orthodox by the 4th Council of the Lateran in 1215, and confirmed by the Council of Trent 1563 in reaction to the rise of the Reformation.

In a Catholic Mass, the priest acts as a representative of Christ, while the transubstantiation occurs through the grace of God. This change remains permanent beyond the Eucharist, so that the host and wine need to be stored in a tabernacle behind the altar. There is no lay chalice in the Catholic Church; only the priest is allowed to partake of the wine.

Luther insisted on the actual presence of Christ in the Eucharist. For him, the transformation of bread and wine into the body and blood of Christ was real. The Lutheran Church practices the lay chalice as ordained by Christ's words of institution, permitting the congregation as well as the the priest to partake of the wine. The transformation of bread and wine is only effective while the Eucharist is being celebrated. The host and the wine do not have to be locked away afterwards, but become ordinary food again.

The Swiss reformer Huldrych Zwingli viewed the Eucharist as a memorial meal: the sharing of bread and wine is meant to strengthen the congregation in its remembrance of the resurrection of Christ. The essential aspect, however, is the faith of the congregation, which needs to fully understand and believe the words of institution. The congregation gathers around a table and partakes of both bread and wine. In the tradition of the Reformed Churches, the Eucharist is celebrated not with a host, but with normal bread. RK

196

Unknown artist, monogram "MB"
Evangelical Eucharistic Chalice

Southern Germany(?), 2nd-half
of the 15th century, and 1636
Silver cast, embossed and engraved,
gold-plated
H 21.8 cm; D 12.5 cm
Luther Memorials Foundation of
Saxony-Anhalt, K 275
Minneapolis Exhibition

Inscription on cup: "DAS . BLVT . IESV . CHRISTI .
GOTTES . SOHNS . MACH . VNS . REIN . VON .
ALEN . VNSERN . SVNDEN [flower] . I . IOHAN . I"
(The blood of Jesus Christ, God's Son makes us
clean from all our sins [flower] 1 John 1)
on the heads of the rotuli: "I H E S V S",
Underside of the base: "G. V. B. COL. 1636 ||
GEORG. MATHESIVS . P."
Hallmarked on the rim of the base with city
mark (not known) and maker's mark "MB" (not
known) ligated in an oval.

The foot of the chalice is a sexfoil, and the
straight sides are decorated with pierced tracery.
The profiled six-sided stem has a node with rot-
uli. On top is the relatively large cup with a flared
rim.
The distribution of the Eucharist in both forms
(bread and wine) to all adult members of the
Church brought with it changes in the Eucharistic
vessels. For example, jugs were bought to hold a
greater volume of Mass wine. The acquisition of
chalices with greater volume is also evident.
Georg Mathesius donated this chalice in 1636.
We can assume that he only financed the fitting
of a larger cup for the chalice, for chalices in the
Middle Ages were considerably smaller. This
chalice is a good example of common practice in
the Lutheran churches. The skillfully rendered
Gothic bases and stems seem to have been
highly prized and were therefore preserved, such
that we repeatedly find pre-Reformation chalices
with large cups added later.
The engraved inscription below the rim of the cup
commemorates the saving sacrifice of Christ. It is
very appropriately Lutheran to include a direct
reference to the scriptures in the liturgical act of
the distribution of the Eucharist. The dated in-
scription of the donor's name on the underside
of the base shows that donations of material
goods continued after the Reformation. However,
they no longer functioned as good works to guar-
antee the salvation of the soul. Instead they
should serve the worship and praise of God and
of His Church. SKV

Literature
Brademann 2014 · Seyderhelm 2001 · Treu
2003 b, pp. 64 f. (ill.)

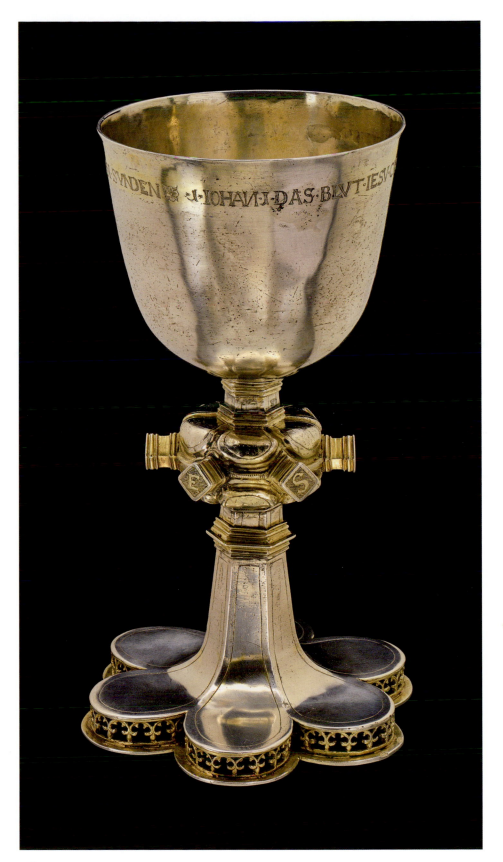

196

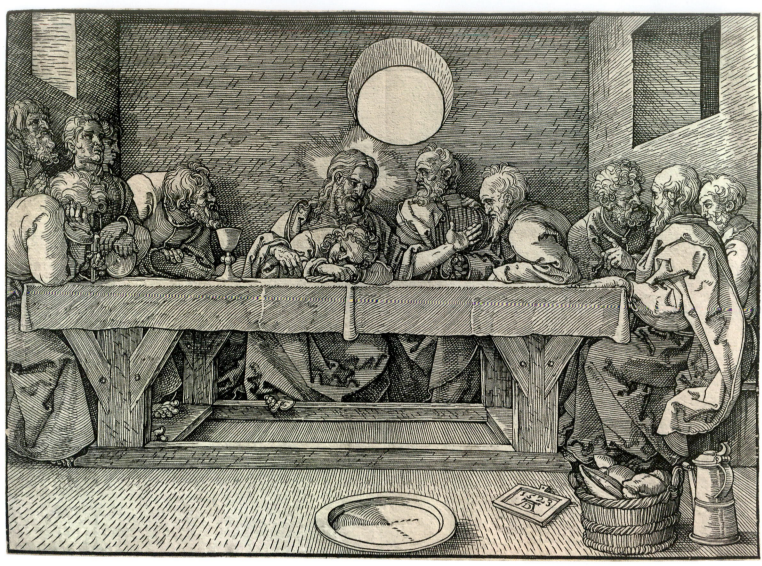

197

Albrecht Dürer
The Last Supper

1523
Woodcut
21.2 × 29.8 cm
Private collection, Minneapolis
Minneapolis Exhibition

Signed with monogram and dated "1523"
on little tablet on the floor

Albrecht Dürer published this image of the Last
Supper at a time of great social, political, and
religious tension. Pope Leo X had excommuni-
cated Luther. Luther had stood up to Charles V
and Johannes von Eck at the Diet of Worms.
Luther had recently emerged from his seclusion
at the Wartburg Castle and returned to a Witten-
berg that to him seemed out of control. Three
radicals, known as the Zwickau prophets, had
built a following, including Luther's early ally

Andreas Karlstadt, for their teaching that direct
revelation from the Holy Spirit held greater au-
thority than scripture. Karlstadt was successfully
promoting iconoclasm. He also held forth against
infant baptism and church music as he broke
away from state sanctioned theology to become
the prototypical congregationalist preacher.
Luther found himself in the position of having to
be a conservative force within the Reformation.
The Peasant Wars had not yet broken out, but the
potential for upheaval was palpable.

A significant theological question that provoked
infighting had to do with the nature and proper
administration of the Eucharist. Was the body
and blood of Jesus physically as well as spiritu-
ally present in the bread and wine? Was the Eu-
charist a sacrament or a sacrifice? Should the
wine be reserved for the clergy or made available
to the laity? Dürer seems to have taken an active
interest in the subject. In this version of *The Last
Supper*, he placed a breadbasket and a wine jug
in the foreground, seemingly within reach of the
viewer. The charger that held the paschal lamb

lies empty in the foreground as if to emphasize
the physical absence of the body—to emphasize
that the Eucharist is a sacrament, not a sacrifice.
Amazingly, in 1521, Karlstadt, who would go on
to become an outspoken advocate of icono-
clasm, dedicated to Dürer, Germany's greatest
artist, a pamphlet arguing his position on the
Eucharist: *Von anbetung vnd eer erbietung der
zaychen des newen Testaments* (The Adoration
and Veneration of the Signs of the New Testa-
ment). Karlstadt made the point that the bread
and wine should not be adored but should be
consumed. Dürer presents us with an empty
plate and a chalice which has been pushed aside
and is not the center of attention.

Dürer shows only eleven apostles present. The
only gospel that gives an account of Judas's de-
parture is the Book of John, specifically chapter
13: 34–35 in which Jesus says to his followers: "A
new command I give you: Love one another. As I
have loved you, so you must love one another. By
this everyone will know that you are my disciples,
if you love one another." He goes on to remind

them of the difficulty in following his teachings, predicting that even Peter will deny him three times before the cock crows. Dürer seems to have been well aware of the problems faced by a community setting out to redefine its religion. An irony of the image is Dürer's use of formal concepts of space, proportion, and balance developed by Italian Renaissance artists to make an anti-Roman, Reformation statement. TR

Literature
Burnett 2011 · Panofsky 1948, pp. 222 f. · Talbot 1971, pp. 194 f., cat. 206

198

Cranach circle
Luther and Hus Giving Communion

Around 1554
Paper, woodcut
22.7 × 24.1 cm
Luther Memorials Foundation
of Saxony-Anhalt, fl VIII 1105
Minneapolis Exhibition

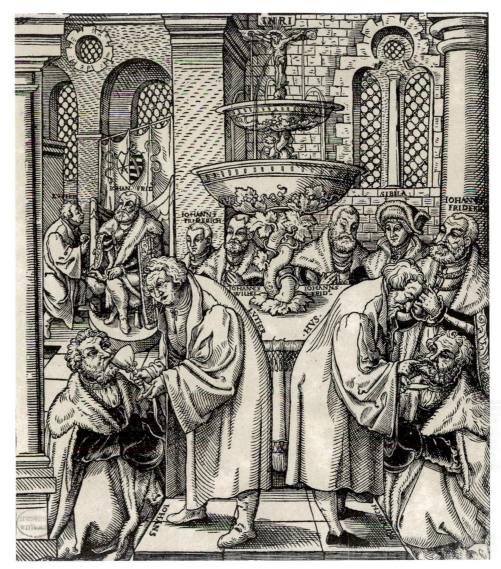

198

The woodcut depicts Martin Luther and Jan Hus giving communion to the princes of the House of Saxony. The movement led by Hus, who had demanded the lay chalice, was considered to be a forerunner of the Reformation. Depicting the last three Ernestine Electors, all of whom supported the Reformation, this woodcut belongs to the category of memorial and confessional images which became increasingly widespread starting in the mid-16th century. In front of the altar, Luther hands the chalice to John the Steadfast, while Frederick the Wise receives communion from Hus. John Frederick the Magnanimous, his wife Sibylle of Cleves and his sons, John Frederick the Middle One, John William and John Frederick the Younger, are watching the action. On the altar is a fountain crowned with a crucifix, the bowls of which are supported by a vine. Building on the motif of *Fons pietatis* ("fountain of mercy"), the fountain flows with the salvific blood from the wounds of the crucified Christ.

In Protestant art, the salvation of humanity through the blood of Christ was interpreted as the symbol of God's grace in terms of the doctrine of justification. The presence of the fountain of mercy on the altar serves not only to propagate the idea of Communion in two forms but to stress the actual presence of Christ in the bread and wine. Thus, the scene taking place in the background, which is typically interpreted as showing John Frederick the Magnanimous in the act of confession, is more likely intended to portray Luther, who is shown in a speaking posture, explaining his understanding of Communion to his sovereign, who is seated on a throne. Hanging above the duke is the coat of arms of Saxony, with the crossed swords of the Elector. However, we can clearly see the scar on the face of John Frederick, which he had received at the lost Battle of Mühlberg in 1547. That military defeat resulted in the captivity of the Ernestine Duke, the loss of substantial parts of his territory and the loss of his status as an Elector. However, shortly before his death (in 1554), John Frederick the Magnanimous was granted the title "Elector by birth," which may be an important frame of reference in dating this artwork. ID

Literature
Hofmann 1983 b, p. 229, cat. 102 (ill.) · Marx/Hollberg 2004, p. 211, cat. 331 · Schade 1983, pp. 421 f., cat. F42 (ill.) · Schäfer/Eydinger/Rekow (forthcoming) (ill.) · Schulze 2004, pp. 101 and 103 (ill.)

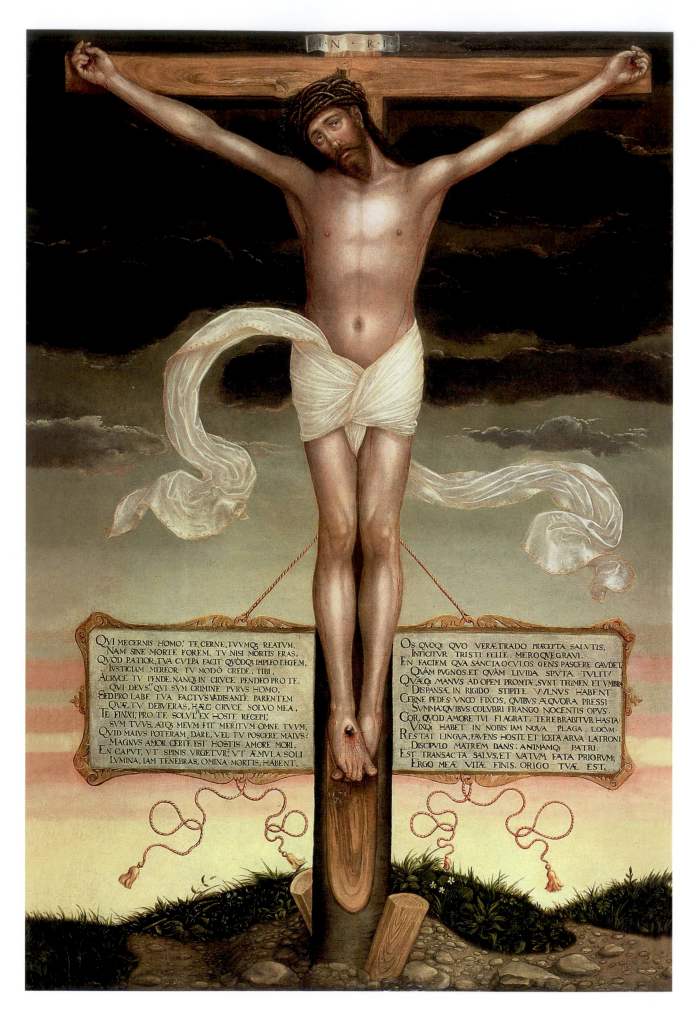

199

199

Lucas Cranach the Younger
Christ on the Cross

1571
Oil on canvas
251 × 158 cm
Wittenberg Seminary, Lutherstadt Wittenberg, 5
Minneapolis Exhibition

Dated and signed with the winged serpent at
the base of the cross
Inscription on the panels on the side of the
base of the cross: left: "qvi me cernis homo: Te
cerne, tvvmq Reatvm / Nam sine morte forem,
Tv nisi mortis eras, / [...]"
right: "Os qvoq, qvo verae trado praecepta salv-
tis, / Inficitvr tristi felle, meroqve gravi. / [...]"

In 1571, Lucas Cranach the Younger created a
monumental painting of the Crucifixion. It shows
Jesus Christ, still alive, with his head inclined to
the side, his mouth open to speak and his eyes
looking upward. Tender drops of his blood are
coming out of the wounds in his hands, feet and
underneath the crown of thorns. The beams of
the cross consist of roughly cut tree trunks. They
are reminiscent of the Tree of Life. Behind him,
the reddish sky is overcast with dark clouds. The
site of the Crucifixion in this painting does not
show the surface of Golgotha (Calvary) where
Adam's bones lie scattered. Rather, this cross is
set in a stony terrain, although the ground has an
almost pleasant appearance, with tender plants
growing out of it. Jesus Christ's long loincloth,
blowing in the wind, breaks up the otherwise
static composition of the painting. Two plaques
to the left and right of the shaft are attached to
the cross with golden cords.
Johannes Maior, a professor of poetry in Witten-
berg, composed the poem that is shown here
and which was published in 1584 as "Christ's
Lament." In the text on the left plaque, Jesus
Christ turns directly to the beholder and calls
upon him to examine the scene closely so that
he can understand the Passion. On the right
plaque is an account of the death of Christ, allow-
ing the beholder to internalize and empathize
with the sufferings of Christ. Written and visual
representations of the Passion were a constant
fixture of Lutheran religious observance dating
back to Luther, but especially to Melanchthon.
They were meant to constantly remind the faith-
ful of their own sins and of the suffering of Christ.
Both the text and the visual representation
served as meditation aids. The humanistic man-
ner of the mediation of salvation is clearly evi-
dent in this Crucifixion scene, and it is probable
that the painting was created for display at the
University of Wittenberg.
As early as his 1519 *Sermon on Preparing to Die*,
Luther spoke of Jesus Christ on the cross and his
Saints as a "picture of grace." Luther saw the

Crucifixion as a comforting scene, and Cranach
the Younger also staged it in this way. The fact
that Christ's blood is hardly visible, in contrast to
the customary depiction in the late Middle Ages,
the limited background and the widespread light
make this representation only symbolically rem-
iniscent of the sufferings of Christ. The sparse
details allow the beholder to reflect on the prin-
cipal message of the painting in pious venera-
tion. At the same time, Cranach included ele-
ments which make the representation more true
to life, as the fineness of the brushwork and the
high level of detail give the work an illusionary
realism. SKV

Sources and literature
Heal 2013 · Schulze 2004, pp. 203–206 ·
Slenczka 2015, p. 378, cat. 3/43 (ill.) · Wimböck
2010 · WA 2, 689, 18 f.

Luther's Translation of the Bible

Luther's translation of the Bible, which
took many years to complete, could not
have been accomplished by a single per-
son. It is the joint achievement of a group
of scholars of Wittenberg University. The
essence of their effort was its humanistic
precept to base the new German Bible on
the original Greek and Hebrew sources.
This was a complete departure from the
previous translations that were based
exclusively on the Latin Vulgate version.
Luther also excelled at developing a fluid
style, punctuated by figurative expres-
sions, which conveyed the actual meaning
of the text and made the Gospel easier to
understand for average folk.

Encouraged by Philip Melanchthon, Luther
started to translate the New Testament
from the Greek original between December
1521 and February 1522. At the time, he
was hiding as "Junker Jörg" (Knight George)
in Wartburg Castle under the protection of
Elector Frederick the Wise (cf. cat. 205–
208). After the first editions had been re-
leased in Wittenberg in September and
December 1522, the year 1523 witnessed
twelve reprints, published in Leipzig,
Grimma, Augsburg and Basel. Another 14
authorized editions and some 66 addi-
tional prints soon flooded the market, so
that Luther began to fear a distortion of
his own translation. In 1524, he ordered
authorized editions to be clearly marked
with his personal signet, the Luther Rose,
and a depiction of the Lamb of God.

Even while the September Testament was
undergoing final preparations for printing,
Luther had begun a translation of the Old
Testament. This laborious task was to last
for more than twelve years, due not only to
the larger amount of text, but also to the
greater difficulty of translating from Hebrew.
In order to arrive at a text that was both
accessible and appropriate, Luther and his
colleagues would sometimes polish their
expressions for weeks. To complicate mat-
ters, Luther fell ill in the early 1530s, leav-
ing Justus Jonas and Philip Melanchthon
to translate several portions of the Old
Testament on their own.

From 1523 on, the individual books of the
Old Testament were published in separate
editions. The complete Bible, including the
New Testament, was only published in 1534
by Hans Lufft of Wittenberg. Ever since, the
original and catchy expressions that were
coined by the Reformer have had a major
influence on the German language. ID

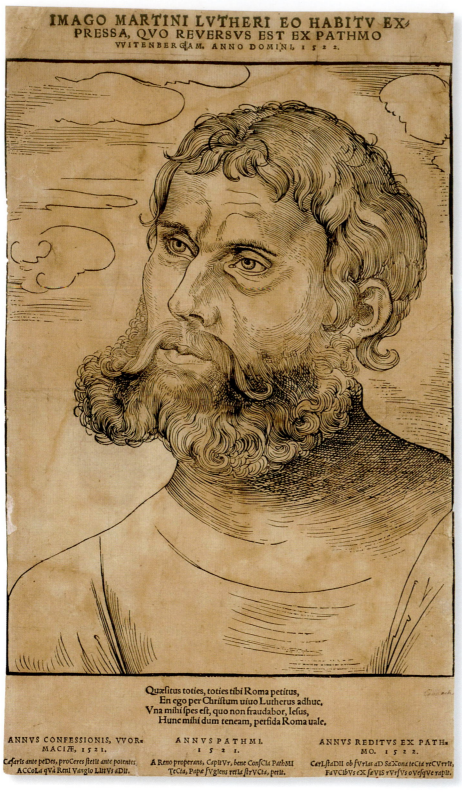

IMAGO MARTINI LVTHERI EO HABITV EX‑
PRESSA, QVO REVERSVS EST EX PATHMO
WITENBERGAM. ANNO DOMINI. 1 5 2 2.

Quæſitus toties, toties tibi Roma petitus,
En ego per Chriſtum uiuo Lutherus adhuc,
Vna mihi ſpes eſt, quo non fraudabor, Ieſus,
Hunc mihi dum teneam, perfida Roma uale.

ANNVS CONFESSIONIS, VVOR‑
MACIÆ, 1521.
Cæſaris ante peDes, proCeres ſtetit ante potentes,
ACCoLa qVá Renl Vanglo LIItVs aDIt.

ANNVS PATHMI.
1 5 2 1.
A Reno properans, CapiuVr, bene ConſCIa PathMI
TeCta, Papæ ſVglens retIa ſtrVCta, petit.

ANNVS REDITVS EX PATH‑
MO. 1 5 2 2.
CarLſtaDII ob ſVrIas aD SaXonateCta reCVrrIt,
FaVCIbVs eX ſeVIS rVrſVs oVeſqVe rapIt.

200

Lucas Cranach the Elder
Martin Luther as Junker Jörg

1521/22
Woodcut
Image: 28.3 × 24.4 cm
Klassik Stiftung Weimar, DK 181/83
New York Exhibition

Inscription on the upper edge: "IMAGO MARTINI LUTHERI EO HABITU EXPRESSA, QUO REVERSUS EST EX PATHMO WITENBERGAM ANNO DOMINI, 1522" (Portrait of Martin Luther showing how he appeared when he returned from Patmos to Wittenberg, 1522 A.D.)

This woodcut, which is highly rare to find in this state, is no doubt based on a drawing by Cranach himself that is lost today. Cranach also likely worked as the "drawer," that is he transferred the preliminary drawing to the wood block himself. The actual cutting of the wood block was performed by a professional block cutter, and then the work was handed over to the printer.
The design of the sheet follows an emblematic structure, with image and text closely intertwined. However, the work lacks the enigmatic character typical of an emblem. We see the core message above, in the sense of a lemma (premise): "Portrait of Martin Luther showing how he appeared when he returned from his Patmos to Wittenberg in the year 1522." Behind these words is a biblical allusion: the Greek island of Patmos was the place where John wrote the Book of Revelation during his exile. Luther, too, was compelled to go into involuntary exile at Wartburg Castle for a period of around ten months after the Diet of Worms, where he worked on his translation of the New Testament while in hiding. Below the text is the icon (picture), the portrait of the person who was reported to have appeared in March 1522. This portrait was meant in no small part as proof that Luther was still alive, and that the rumors which had been circulating at the time, some of which were reported by Albrecht Dürer, were untrue.
Another written explanation, the epigram (subscript), follows below the image: "As much as I have been sought and pursued by you, Rome, see that I, Luther, still live through Christ. Jesus is my hope, and has not deceived me. As long as I have this, fare thee well, false Rome." In these words, the person depicted speaks directly to us and emphatically conveys his message of faith. Beneath this confessional statement are three short columns, one next to the other, which serve to place this scene within the historical record and create a narrative setting with dramatic accents. On the left we read: "Year of the Confession at Worms, 1521: At the Emperor's feet, be‑

fore the mighty he stood, where Worms lies on the banks of the Rhine." The middle the text reads: "The year on Patmos, 1521: hurrying away from the Rhine, he is seized; avoiding the outstretched nets of the Pope, he seeks the welcoming roofs of Patmos." Finally, on the right, we read: "year of the return from Patmos, 1522: because of Karlstadt's fury he hurries back to Saxony and rips the sheep out of the raging throat." This woodcut combines features of a memorial with those of a pamphlet, which was designed for widespread distribution. WH

Literature
Holler 2016

201

Heinrich Göding the Elder
Luther as Junker Jörg

1598
Etching
26.3 × 18.5 cm
Luther Memorials Foundation
of Saxony-Anhalt, fl III 467
Minneapolis Exhibition

This etching is part of an extensive cycle of illustrations by Heinrich Göding for the *Geschichte des Volkes der Sachsen* (History of the Saxon Peoples), published in 1597–98. This also explains the image's narrative nature. It presents Luther in full length in his arguably most unconventional role: Rather than as a tonsured monk, he appears with a full head of hair and a thick beard and is outfitted with a breastplate, sword and dagger. This portrait alludes to Luther's identity as "Junker Jörg" (Knight George), which he had to assume during his sojourn in Wartburg Castle in order to remain incognito there. After the Diet of Worms, Frederick the Wise had provided safe haven in Wartburg Castle to the Reformer on whom not only the interdict but also the imperial ban had been imposed. Luther used this time in hiding to work on his German translation of the New Testament.

Göding's etching combines these different episodes in a visual homage to the great Reformer. The cityscape of the imperial city of Worms, where Luther had publicly stood his ground against state and Church, is recognizable in the background. The sword on which Luther is leaning can be understood as a symbol of his combativeness. The two folios to the bottom right of the picture allude to the Reformer's epochal translation. Each of the two opened leaves contain the openings of the Gospels of Matthew, Mark and John. The fourth Bible passage is also a verse from the Gospel of St. John: "For God so

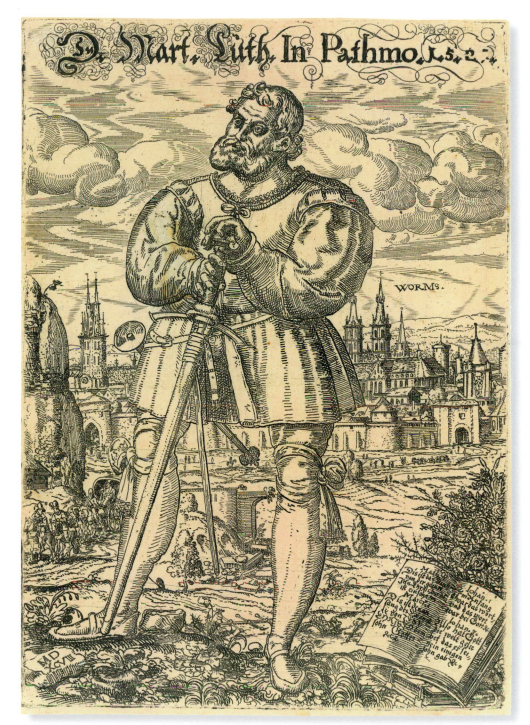

201

loved the world that He gave His only begotten Son" (John 3:16). This manifestation of God's unconditional love is framed by a bush with Luther roses.

In his etching, Heinrich Göding referenced a visual theme created by his teacher Lucas Cranach, first as a drawing and later as a woodcut (cat. 200), when in 1521 Luther had traveled incognito from Wartburg Castle to Wittenberg for a few days. Cranach had also drawn parallels to John of Patmos in his portrait, thus turning his friend living in exile into a new evangelist. Göding incorporated these parallels with the caption "In Pathmo 1521" above Luther's head. He enhanced the half-length portrait created by Cranach by adding anecdotal details to it. His portrait of Luther is a commemorative image that, in retrospect, clearly shows us the evolution of reverence for Luther into a romanticization of Luther. KH

Sources and literature
Albinus/Göding 1597/98, vol. II (ill.) · Andresen 1864, p. 93 · Hollstein X, p. 171 (ill)

202

Monogrammist W. S. (Wolfgang Stuber)
Luther as Saint Jerome in His Study

Around 1580
Copperplate engraving
Sheet: 13.6 × 12.6 cm
Luther Memorials Foundation
of Saxony-Anhalt, 4° IV 469
Minneapolis Exhibition

Inscription on the bottom edge of the image: "PESTIS ERAM VIVVS/ MORIENS TVA MORS ERO PAPA" (Living I was a plague to you, O Pope, dying I will be your death.)

With this posthumous portrayal of Luther—the engraving was made some thirty years after his death—Wolfgang Stuber took up a visual theme created by Albrecht Dürer in one of his master engravings in 1514. His *St. Jerome in His Study* (cat. 204) depicts the Church Father writing a text in an old German study, a scene alluding to the later canonized monk and scholar's chief work, his translation of most of the original Bible texts into Latin. Depictions of Jerome were widespread in 16th century humanist circles precisely because of his erudition. They also included portraits in which historical figures slipped into the role of the saint, thus surrounding themselves with the great Church Father's aura. Luther's adversary Cardinal Albert of Brandenburg had himself portrayed in this role several times by Cranach.

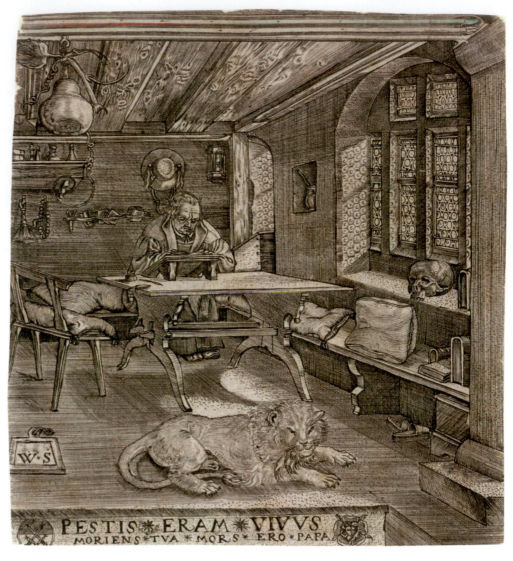

202

Stuber placed Luther in the saint's stead in his version of Dürer's engraving, reversed by the printing process. Apart from that, he quotes the theme down to the minutest of details. Even Jerome's attributes—the lion and the large cardinal's hat on the wall—have been included to render the visual quote recognizable. By adopting this theme, Stuber was conveying to viewers the parallels between the Reformer and the Church Father in his picture. Both of them set theological standards with their translations of the Bible: Jerome, by creating the Vulgate, which became the Roman Catholic Church's Bible text in the centuries thereafter, and Luther, by translating the Bible into German, thus making it accessible to large segments of the population.

Portraits that made a saint out of Luther were already in circulation in the Reformer's own lifetime (cat. 159–161). Ironically, however, Luther himself vehemently rejected such personal exaltation in pictures. Stuber demonstrated his respect for this fact with his variation on the theme:

He dispensed with the halo that emanates from Jerome's head in Dürer's engraving. Instead, Luther appears as a secular scholar whose deeply furrowed intellectual brow is a reference to the feat of erudition and earthly fame of his epochal work. KH

Literature
Bott 1983, p. 224, cat. 282 · Hofmann 1983 b, p. 208, cat. 82 (ill.) · Holsing 2004, pp. 51 f., fig. 26 · Schuchardt 2015, p. 128, cat. 55 (ill.) and p. 146 (ill.) · Warnke 1984, pp. 57–59

203

Monogrammist W. S.
(Wolfgang Stuber)
Luther as Saint Jerome in his Study

Around 1580
Copperplate engraving, colored
Sheet: 14.2 × 12.7 cm, trimmed on all sides
Kunstsammlungen der Veste Coburg, Print
Room, I,335,3d
New York Exhibition

Inscription on the bottom edge of the image:
"PESTIS ERAM VIVVS/ MORIENS TVA MORS
ERO PAPA (Living I was a plague to you, O Pope,
dying I will be your death)"

Basing his work on Dürer's composition of *Saint Jerome in His Study* (cat. 204), the engraver of this sheet set out to place the subject in a decidedly Reformation context. Due to the copying process, the representation is reversed, as if in a mirror. The Church Father who translated the Bible into the Latin Vulgate becomes the Great Reformer, who made the Holy Book accessible to the broader German-speaking public. The translation of the Bible into the common tongue is what unites the two.

In his engraving, Stuber notably decided to retain many elements of the original composition. After all, the lion in the foreground is an identifying feature of St. Jerome, and the cardinal's hat stands for the Catholic Church. But without these details, the equation of Luther with Jerome would not have been as clear. The dig at the 1525 painting by Cranach that transformed Dürer's composition and presented Albert of Brandenburg as Jerome, would also have been hardly obvious. As Tacke has shown, Albert was likewise interested in presenting himself as a translator of the Bible through obvious references to St. Jerome (Tacke 2006, p. 122).

At the lower edge of the image, Stuber takes advantage of the step that was in Dürer's work for the inclusion of an inscription. Between the crossed swords of the Elector of Saxony and the Luther Rose, we find the following Luther quote, in Latin: "Living I was a plague to you, O Pope, dying I will be your death." In the earlier prints, there is an error in the inscription: the word "FIFVS", which can be found here, was later corrected to read "VIVVS."

Mende has argued that "such an elevation to the heights of the saints of the early Church is easiest to imagine in the year of Luther's death" (Schoch/Mende/Scherbaum 2001, No. 70, p. 177). Since the inscription also seems to refer to the year of his death, Mende assigns the engraving a date of c. 1546. It is not presently clear whether this date falls within the artist's own lifetime. The initials "W.S." are commonly interpreted as the

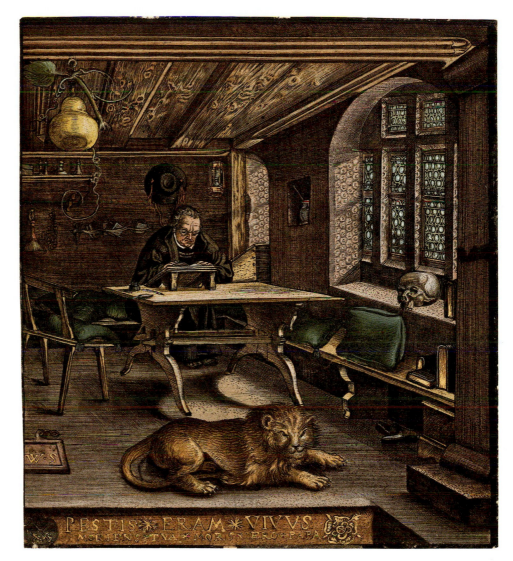

203

monogram of the Nuremberg artist Wolfgang Stuber. The few dated works from Stuber's hand known today have the dates 1587 and 1588. Since this quote from Luther became a motto of the Protestant movement after his death, nothing can be derived from it other than that the engraving was created after 1546.

The Veste Coburg Art Collections hold a version of the early print (with the word "FIFVS") as well as a colored version of the later copy of this composition (with the corrected inscription). Muted yellow-brown hues predominate in this copy, with only sparse use of shell gold; this color scheme seems more indicative of a 17th-century style. SK

Literature
Andresen 1874, vol. 4, pp. 14–21 · Bott 1983,
p. 224, cat. 282 · Nagler 1919, vol. 5, pp. 380 f. ·
Schoch/Mende/Scherbaum 2001 · Tacke 2006 b

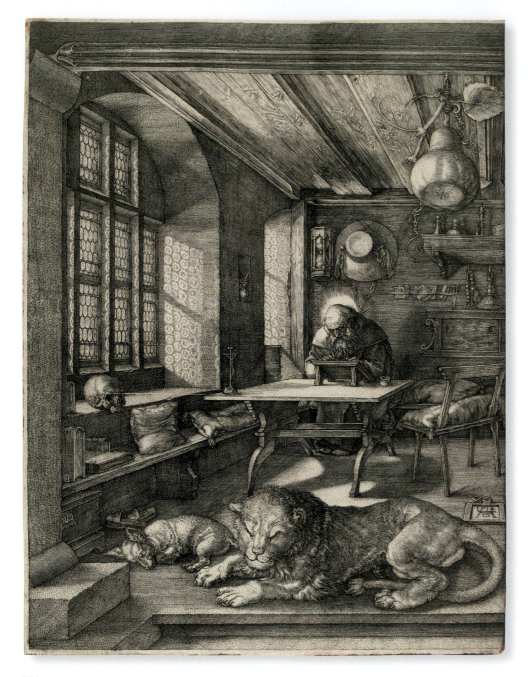

204

hat and lion. According to the legend, Jerome once pulled a thorn out of a lion's paw, after which the erstwhile wild animal became his companion. There are also some elements in the composition that allude to death, as well as to salvation and resurrection. The hourglass on the wall and the skull lying on the window sill serve as reminders of the mortality of all earthly beings. On the other hand, the crucifix on the table alludes to Jesus Christ's act of redemption. The dried gourd hanging from the ceiling is a reference to the resurrection, since it alludes to the story of Jonah, who enjoyed the shade of a gourd vine after three days in the belly of the whale (Andersson/Talbot 1983, Cat. 155–156, p. 281). On the right edge of the picture we see a tablet which, as the string indicates, was probably intended to hang on the wall. Dürer uses this tablet to insert his monogram and the date.

Dürer made a total of six prints on the subject of Jerome. A 1496 copper engraving shows the Church Father not as a learned translator of the Bible, but as a repentant hermit in the desert. Devotion to St. Jerome increased over the course of the 15th century. The learned translator of the Bible was highly respected, especially among 16th century humanists. For Albert of Brandenburg, who in 1525 commissioned Lucas Cranach the Elder to create a portrait of himself as Jerome, based on Dürer's engraving, the office of cardinal was something which drew him together with his great predecessor. SK

Literature
Andersson/Talbot 1983 · Sander 2013, pp. 260 f., cat. 10.2 · Schoch/Mende/Scherbaum 2001 · Tacke 2006 b

204

Albrecht Dürer
Saint Jerome in his Study

Copperplate engraving
1514
Sheet: 24.9 × 18.9 cm,
cut along the edge of the plate
Kunstsammlungen der Veste Coburg,
Print Room, I,17,66
New York Exhibition

Saint Jerome in his Study has always been ascribed great significance as one of Dürer's three engraving masterpieces; the others are *Melencolia I* and *Knight, Death and the Devil*.

In a room with central perspective, an old, bald man with a long beard sits at a table. The eye of the beholder has to overcome a few obstacles before it can reach St. Jerome: to enter the room physically, one would have to first go up a step and then get past two animals, a lion and a dog, before reaching the Church Father, who is sitting behind a barricade comprised of a desk and a bench.

He is at work translating the Greek text of the Bible into Latin. His significance is accentuated by the halo around his head, and he is also recognizable by his identifying features: the cardinal's

205

Martin Luther,
Lucas Cranach the Elder (illustrator)
Das Newe Testament Deutzsch
(The New Testament in German)
"September Testament"

Wittenberg: Melchior Lotter the Younger,
September 21, 1522

205
30.8 × 21.5 cm
Luther Memorials Foundation
of Saxony-Anhalt, Kn K 1
VD 16 B 4318
New York Exhibition

206
30 × 21 cm
Scheide Library, Princeton University Library,
Sign. S2.29
VD 16 B 4318
Minneapolis Exhibition

Martin Luther,
Lucas Cranach the Elder (illustrator)
Das Newe Testament Deutzsch
(The New Testament in German)
"December Testament"

Wittenberg: Melchior Lotter the Younger,
December 1522

207
30.5 × 20.5 cm
Luther Memorials Foundation
of Saxony-Anhalt, ss 3590
VD16 B 4319
New York Exhibition

208
29 × 21 cm
Scheide Library, Princeton University Library,
Sign. 8.3.3
VD16 B 4319
Minneapolis Exhibition

Luther took advantage of his stay in Wartburg
Castle in 1521–22 to translate the New Testament
into German. For his translation, he used the
original Greek text, which was printed for the first
time in 1516, together with a Latin translation by
Erasmus of Rotterdam. His reliance on the origi-
nal language for a coherent and generally com-
prehensible translation resulted from his convic-
tion that the Bible alone is decisive in matters of
faith.

The entire translation of the New Testament was
completed in just eleven weeks. For the transla-
tion, Luther obtained advice from friends of his
who were familiar with the language. The first
edition was printed in September 1522 by Lucas
Cranach the Elder and Christian Döring in Witten-
berg, featuring a cycle of 21 full-page woodcuts
from the Cranach workshop illustrating the Rev-
elation to John. The work quickly became known
as the September Testament, after its date of
publication, and was followed in December by a
second edition, the December Testament.

This edition included numerous changes to both
the text and the images. Some of the woodcuts

207

in the *September Testament* have a very pronounced anti-papal polemical character, associating the end of times foreseen in the Apocalypse with the end of the Roman Church. However, this provocative imagery encountered considerable resistance, so that on the intervention of Duke George of Saxony, Frederick the Wise decreed that, in the second edition, the papal tiara would be removed from the head of the dragon in the temple (Revelation 11), the beast from Chapter 16 and the Whore of Babylon (Revelation 17). Dürer's *Apocalypse*, printed in 1498, served as a model for Cranach's cycle in terms of both motifs and composition. However, the simplicity of Cranach's woodcuts made them easier to understand, which was consistent with the goal of Luther's translation of the New Testament: making the gospels more accessible to the people. ID

Literature
Bild und Botschaft 2015, pp. 118 f., cat. 14 and 15 (ill.) · Füssel 2012 · Hofmann 1983 b, p. 172, cat. 44 · Reinitzer 1983 · Volz 1978, pp. 111 f. · Widmann 1972/73

209

Martin Luther
Hieronymus Emser (editor)
Neues Testament (New Testament)

Dresden: Wolfgang Stöckel, 1527
31.5 × 37 cm
Luther Memorials Foundation
of Saxony-Anhalt, ss 3589
VD16 B 4374
New York Exhibition

Hieronymus Emser was from the south of Germany and became one of the most prolific opponents of Luther. Duke George banned Luther's translation of the New Testament in his region of Saxony the same year it was published; however, the ban had little success.

Emser justified this ban in a pamphlet of 1523, arguing that Luther's translation contained mistakes and heresies. In 1527, his own posthumous edition of the New Testament, which was chiefly based on the Latin Vulgate Bible but also followed Luther's translation to a large extent, appeared. The elaborate woodcut illustration on the title page portrayed the baptism of Christ in the Jordan (Mark 1:11) and the encounter of Jesus with his disciples, whereby Peter is distinguished by keys and Paul with a sword. An addendum reads "Whoever hears you, hears me…" (Luke 10:16). The presentation embodies Emser's fundamental conviction that the traditional Church remains in the immediate succession of the apostles.

Luther reacted to Emser's work with scorn and mocking in his *Letter on Translation* from 1529. But he could not stop the Bible translation from having great success in regions where the old faith still held sway. In 1532, the Dominican monk Johann Dietenberger edited a second version that was printed in Tübingen and Cologne. Emser's translation was an important step on the way to a German Catholic Bible. MT

Sources and literature
Leppin/Schneider-Ludorff 2014, p. 191 · WA 30 II, 632–646, esp. 633–634 [LW 35, 181–202, esp. 182–185]

209

210

Martin Luther
Autograph Fragments of
Martin Luther's German translation
of Ecclesiasticus
(Ecclus. 33:13−34:4, 36:9−37:5)

1531
21.5 × 16.5 cm
Forschungsbibliothek Gotha der Universität
Erfurt, Chart. A 121, ff. 20r–21v
Minneapolis Exhibition

Luther did not exclude the non-canonical or apocryphal books from his Herculean task of translating the Bible from the original Hebrew, Aramaic, and Greek into colloquial, yet elegant German. He cherished the book of Ecclesiasticus, also called the Wisdom of Sirach, as a valuable writing for teaching spiritual ethics at church, school, and home. Translating this seemingly random and easily misinterpreted compilation of proverbs from diverse sources proved to be an extraordinary challenge, as Luther commented in the preface. In his own opinion, the fruits of his efforts surpassed all previous Greek, Latin, and German translations of the book. Luther vividly compared his work on Ecclesiasticus to reassembling and cleansing the scattered pieces of a torn up and trampled on letter. Today, the final draft of the translation is in a fragmentary state due in part to the common practice of dismembering manuscripts at the printing presses in order to facilitate the typesetting. The single leaves that still exist are preserved in Gotha, Germany, and Lubań, Poland. DG

Sources and literature
Gehrt 2015, pp. 480 f. · Koch 1990 · 2, 198–200 ·
WA.DB 2, XIX (no. VIII)

211

Martin Luther

Manuscript of Luther's Translation of the Old Testament, 2 Samuel 23

Before 1534
Ink on paper
22 × 33.5 cm
Landesarchiv Sachsen-Anhalt, Z8 Lutherhandschriftensammlung, no. 473, ff. 110v–111r
New York Exhibition

Luther did not limit his efforts in the dissemination of the Holy Scriptures to the New Testament. In several stages, he translated the Old Testament into German as well. The displayed exhibit comes from this period.

Both the German original manuscript and the later editorial changes (partly in Hebrew) come from the pen of Martin Luther. It is a translation of the second book of Samuel from the Old Testament. The added corrections show the Reformer's effort in striving for the ideal exposition of the biblical texts. He wanted to optimize his own work.

In order to understand the original meaning of the biblical text with utmost precision, Luther consulted not just Latin versions but also the Greek and Hebrew sources. Although he had only a limited grasp of Hebrew and had to seek expert assistance, Luther appreciated the sources written in this language not only because of the strength of expression but also because of their temporal proximity to the Holy Scriptures. The Hebrew texts seemed to him to be the most authentic: "The Hebrews drink out of the spring source; the Greeks from the waterline; the Latin out of puddles" (WA.TR 1, 524, 21f., 525, 15–20; cf. also WA.TR [nr. 6805]). On the other hand, he was of the opinion that the rabbinic exposition of the texts did not preserve the original meaning.

The goal of all of Luther's efforts was a Bible translation in the best possible German that could also be understood by simple people. Therefore, he did not translate literally but tried to give the gist of what was intended, often in popular language. AM

Sources and literature
Hermle: Luther · Leppin/Schneider-Ludorff 2014, pp. 108–112 · WA.TR 1, 524, 21f., 525, 15–20 · WA.TR 6, (no. 6805)

Georg Rörer (editor)

Der Erste Teil aller Bücher und Schrifften Martin Luthers (The Complete Books and Writings of Martin Luther, Part I)

Jena: Christian Rödinger the Elder, 1555
33.9 × 22.9 cm
Forschungsbibliothek Gotha der Universität
Erfurt, Theol 4° 3071 (1)
VD16 L 3323
Exhibition Minneapolis

As a result of the Protestant defeat in the Schmalkaldic War (cat. 356 and 359), John Frederick of Saxony lost authority over electoral Saxony, including Wittenberg and its university. In an effort to reclaim cultural, political, and religious prestige, he sponsored another complete edition of Luther's works to compete with the existing Wittenberg edition. He also founded a new university at Jena, which he intended to be the premier school of Lutheran theology, outstripping Wittenberg. In 1553, Georg Rörer, who had helped to initiate the Wittenberg edition, was summoned to Jena to lead the new editorial project. Rörer had been a student of Luther's and recorded a considerable portion of Luther's lectures, sermons, and his statements and comments that formed the basis of the *Table Talk*, as well as playing the critical role in preparing many of Luther's texts for printing and correcting proofs. Rörer's personal library contained more than 40 volumes of manuscript material relating to Luther and 442 individual printed works by Luther and his contemporaries. Few people were as well-equipped to edit Luther's works.

The Jena edition, completed in 1558, contained eight volumes of German material and four of Latin. Unlike the Wittenberg edition, where Luther's writings were arranged thematically, the Jena edition organized the texts chronologically, which placed the focus on the historical development of Luther's theology. The edition also included related material from Luther's colleagues and opponents, to provide a more holistic view of Lutheran theology; however, the promise to print previously unpublished material of Luther's was not fulfilled, and some existing publications were edited to remove specific comments. The first German volume, covering material from 1517–1522, came out in 1555 in a print run of 1,500 copies, and although about half of those had sold by the following year, subsequent volumes did not fare so well. JTM

Literature
Koch 1999 · Michael 2014

Carlstads schreiben. Anno M.D.XIX. 161

Concilium / dieweil sie noch waren vnter dem gehorsam der andern zweier Bepste Gregorij xij. vnd Benedicti xiij. Darumb ist kein Concilium noch nicht gewesen zu der selbige zeit. Sie haben wol gezweiuelt / ob dis ein recht Concilium doch sey oder nicht / wie das nach der lenge möchte erzelet werden. Darumb redet D. Ludder gantz lesterlich von den Concilien / das sie geirrt haben / jtzt das / jtzt jenes gesetzt / vnd die Christen jrrig gemacht / das kein fromer Christ reden sol. Derhalb aus allem vorgehenden leichtlich vermerckt wird / wie D. Ludder böslich verwirfft / als möcht ich kein bestendig Argument aus den heiligen Conciljs nemen / Denn ein Christ sol nicht reden von den heiligen Concilien / das sie wanckelbar seien / vnd parteische Wendel determiniren / Denn also hette Gott den Christlichen glauben in zweiuel gelassen.

SO etwas fürfiele aus der heiligen Schrifft / das Doctor Ludder so verstünde / vnd ich anders / Jglicher vermeint / der Text were für jn / So wil D. Ludder sich nicht keren an Bepstliche entschied / So sey das Concilium wanckelbar vnd jrrig / Vnd also müssen wir bleiben in einem zweiuel / das nicht sol von vnsern WErrn Jhesu Christo gesagt werden / das er sie also hülfflos in den stücken des glaubens gelassen hette. Also würden sich alle Ketzer beheiffen / mit anzeigung / Die Concilia vnd die Bepst hetten geirret.

GNEdigster Werr / wie kan E. Ch. F. G. das gestatten / das Doctor Ludder noch bleibt auff seiner jrrigen / falschen / ketzerischen meinung / das etliche Artikel des Wussen vom heiligen Concilio zu Costentz verdampt / seien Christenlich vnd warhafftig / die er wider mich wol erhalten wölle. Es were / was mein Person belanget / mir nicht viel dran gelegen / das er die wider das heilig Concilium erhalten wil / Höret aber doch / das E. Ch. F. G. Nachbawren die Behemische Ketzer sagen / Denn von stund an sagen sie / Man hab jren Meister vmb Christliche vnd warhafftige Artikel verbrennet.

ES erzelet Doctor Ludder etliche Artikel / vnd bringt wider herfür das Concilium Nicenum / da vongnugsam gesagt ist / wie er das felschlich einfüret / er hats auch nie gesehen. Es ist auch das Concilij gantz wider jn. E. Ch. F. G. sehe doch / wie gar vppisch bruder Ludder sich gibt / indem er spricht / Ich hab das Nüsslin nicht mögen beissen. Ich setze das zu E. Ch. F. G. erkentnus / ob ich nicht mit der warheit recht angezeigt habe / wie das Concilium zu Nicea nicht mit jm / sondern wider jn / ist.

SOlch falscheit hat er auch gebraucht / mit dem Concilio in Aphrica gehalten / welchs er auch allegirt für sich / so doch solche Allegata nirgend in dem Concilio stehen / denn er hat keins gesehen / wie ich gesagt hab / Aber also ist er betrogen worden. Denn c. primæ sedis. 99. distinc. ist ein Regel desselbigen Concilij / vnd nach dem sie kurtz ist / hat er die nachfolgende wort / die

E E Gratiam

Martin Luther
Biblia / das ist die gantze Heilige
Schrifft Deudsch
(Bible / this is the Complete Holy
Scripture in German)

Wittenberg: Hans Lufft, 1534
32 × 23 cm
Luther Memorials Foundation
of Saxony-Anhalt, Ag 2° 86
VD16 B 2694
Minneapolis Exhibition

After the publication of the New Testament in
1522, Luther was fully aware that the translation
of the Old Testament could only be completed by
a team and would have to be published in sev-
eral volumes on account of its size and linguistic
complexity. The Reformer was especially worried
by difficulties with the texts in the Books of the
Prophets, first made fully available in 1529, and
the Book of Job. However, the edition was a great
success and was reprinted outside of Saxony. By
1546, 253 full or partial editions of Luther's Bible
were available.

Despite the collaboration of Luther's compan-
ions like Philip Melanchthon and Justus Jonas, he
took the leading role in this translation, as
demonstrated in its singular identification as the
Luther Bible. Other vernacular language editions
are named after the place where they were pub-
lished, like the Zurich Bible, or after the ruler who
commissioned the translation, like the King
James Version.

The German language is shaped to this day by
Luther's translation of the Bible. Even more than
his hymns and catechisms, Luther's translation
of the Bible keeps his memory alive in everyday
language. MT

Literature
Leppin/Schneider-Ludorff 2014, pp. 108–112
and 709–711

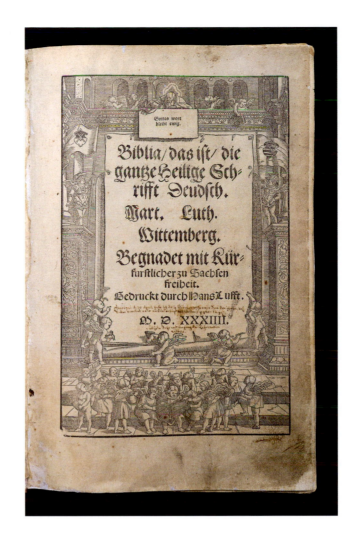

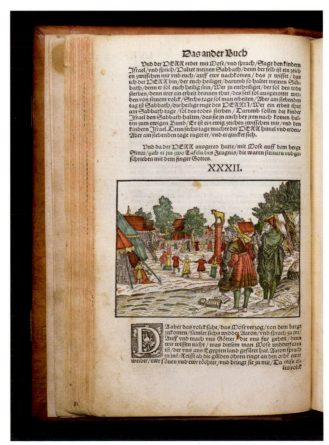

214 a

Martin Luther
Lucas Cranach the Elder, workshop
(illustrator)

The Zerbst "Cranach Bible"
(Volumes 1 and 3)

Wittenberg: Hans Lufft, 1541
Parchment, colored woodcuts, gold leaf
Each volume: 40 × 27.5 cm
VD16 B 2712
Minneapolis Exhibition

214 a
Volume 1
City of Zerbst/Anhalt, So 546 a

Original title vol. I: Biblia: das ist die gantze
Heilige Schrift Deutdsch, Auffs neuw zugericht.
D. Mart. Luth (Bible: This is the complete Holy
Scripture in German)

214 b
Volume 3
City of Zerbst/Anhalt, So 546 c

Vol. III: Die Propheten / alle Deudsch. /
D. Mart. Luth (The Book of Prophets, German)

This three-volume Zerbst "Cranach Bible" was printed on parchment in autumn of 1541 for the Prince of Anhalt-Dessau. Prince George III of Anhalt-Dessau, called "the Blessed," was given a strict Catholic education by his mother, Margaret of Münsterberg. By 1518, he became canon in Merseburg, after which he was consecrated as a priest and appointed provost of the cathedral in Magdeburg. In 1530, he became one of the ruling Princes of Anhalt, together with his two brothers, Joachim I and John IV, due to the complex nature of succession in Anhalt. With the partition of 1544, the territory of the three brothers was divided into three sections: Anhalt-Plötzkau, Anhalt-Dessau and Anhalt-Zerbst.

Martin Luther had been preaching in Zerbst in 1522, but it was not until 1534 that George, the last Prince of Anhalt-Dessau, was able to introduce the Lutheran faith into his realm; it was not until the death of his fervently Catholic mother that he could adopt the Lutheran faith himself. In 1545, he assumed the office of the first and last Bishop of Merseburg. Martin Luther, with whom he maintained a close and friendly relationship for years, ordained him personally. George was the only prince to hold office as a Lutheran cleric.

The intricately designed Zerbst Bible was produced at this time. Lucas Cranach the Elder was responsible for the richly illustrated volumes, highlighted with gold in this copy. A total of 100 woodcuts adorn the large-format Bible.

The princes would stock their libraries with Luther Bibles featuring extraordinarily intricate decorations, complete with a separate title page bearing the coat of arms of their territory. The representative character of this now authoritative version was a symbol of the new politics.

George had the bundle of parchment sheets divided into three volumes and then bound in wood covers wrapped in velvet. In the summer of 1544, the volumes were brought to Wittenberg so that Martin Luther, Philip Melanchthon, Johannes Bugenhagen and Caspar Cruciger could inscribe them. They proceeded to "dedicate" the volumes in the spirit of the Reformation with brief remarks in German, Latin and Greek.

The pages at the end of the volumes also contain punched gold plates with portraits of Elector Frederick of Saxony and Emperor Charles V, as well as Martin Luther. They were presumably crafted by the goldsmith Jobst Kammerer and added to the volumes in 1548 and 1558.

The provenance of the Zerbst Bible is no less significant, but can be mentioned here only in passing. Two volumes of the "biblical triptych" (volumes 1 and 2) were presumed lost after World War II, but in the last 20 years they were reunited with the third volume. The three volumes are a cultural artifact of the 16th century with vital importance for the history of Anhalt and the Reformation. FK

Literature
Brüggemeier/Korff/Steiner 1993, p. 183, cat. 4.1/41 (ill.) · Cranach-Bibel 1997 (ill.) · Hoernes: Krimi · Reformation in Anhalt 1997, pp. 9 f. and 26, fig. 12 (ill.) · Wahl 1935

215

Martin Luther
Luther Bible of George of Selmenitz

Wittenberg: Hans Lufft, 1541
44 × 27.5 cm
Evangelische Marktkirchengemeinde Halle (Saale), Marienbibliothek zu Halle, B I. 20
VD16 ZV 1473
New York Exhibition

Original title: Biblia: Das ist: / Die gantze Heilige / Schrifft. Deudsch / Auffs New zugericht. / D. Mart. Luth. (Bible: This is the complete Holy Scripture in German, newly prepared by Dr. Martin Luther.)
On the inner side of the front cover: Prouerb. 8. / Ich Liebe die mich Lieben, vnd die mich frue suchen, finden mich / Wer an mir sündiget, der verletzt seine seele. Alle die mich hassen, / Lieben den todt / Die weisheit ist das wort Gottes, durch welches alles geschaffen ist. / Gen. 1. Gott sprach: Es werde etc. Eben die selbig weisheit oder Wort / Gottes ists, das mit vns menschen ynn der heiligen schrifft vnd durch / aller heiligen mund redet. Vnd gibt eitel leben allen die / es suchen vnd gerne hören. Denn es lest sich gerne finden vnd / ist gerne bey Menschen, yhnen zu raten vnd zu helffen. Wie man / spricht: Gott grußt manchen. Wer yhm danken kündte. Aber / der hauffe hat den tod lieber vnd wil den tod lieber denn das leben. /
[rot:] Johannis 16 / Warlich Warlich, sage ich euch, So yhr den Vater etwas bitten / werdet ynn meinem namen, So wird ers euch geben. / Johannis 15 / So yhr ynn mir bleibet, vnd Meine Wort ynn euch bleiben, Werdet / yhr bitten, was yhr wollet, vnd es wird euch widerfaren.
[schwarz:] Martinus Luther D. 1543.
(Proverbs 8. I love those who love me, and those who seek me early, find me. Whoever sins on account of me, harms his soul. All who hate me love death. Wisdom is the word of God through which everything is made.

214 a

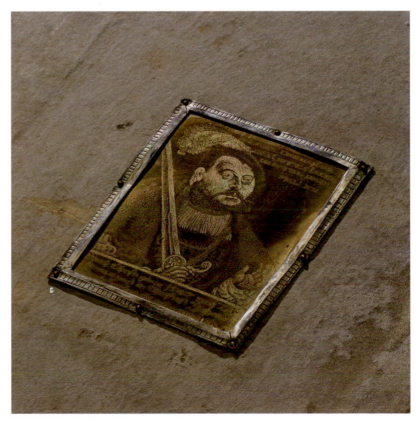

214 b

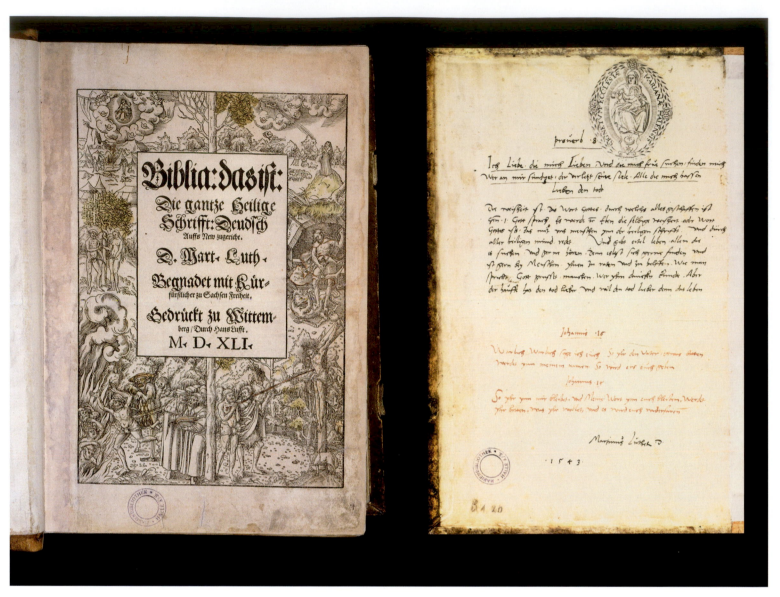

Genesis 1. God spoke: Let there be etc. Just the same wisdom or word of God it that speaks with us humans in the holy scripture and through every holy mouth. And gives vain life to all who seek and love to hear it. For it likes to let itself be found and likes to be with the people, to advise and help them. As one says: God greets some. Whoever thanks him. But the crowd likes death better and wants death more than life. [red:] John 16. Truly, truly I say to you. When you ask the Father for something in my name, so he will give it to you. John 15 When you remain in me and my word remains in you, then you will ask what you want and it will happen. [black:] Martinus Luther D. 1543.)
On the last front fly leaf:
Psalm 130 / Expectat Dominum mea mens, Anima aegra requirit, / ipsius in verbo spes mihi tota manet / 1545 / Hoffnung Altzeydt meyn Trosst / Georg vonn Selmenitz (Psalm 130 / I wait for the Lord, my whole being waits, and

in his word I put my hope / 1545 / Hope is at all times my comfort / Georg von Selmenitz)
Single leaf print (pages LI and LII):
IMAGO ECCLESIAE / MOSES STANS IN CAVERNA EVPIS, AC / videns tergum Die [...] (by Philip Melanchthon)
On the last rear fly leaf: Announcement of the opening of the Wittenberg University on October 18, 1502 by Elector Frederick the Wise, August 24, 1502.

In 1522, Felicitas of Selmenitz confessed the new faith and received the Eucharist in both forms. This widow was then banished from the Diocese of Magdeburg by Cardinal Albert of Brandenburg in 1528. She moved with her son George to Wittenberg.
Numerous reading marks—underlining, handwritten repetitions of parts of the text and picture symbols—in the margins of the books in St. Mary's Library impressively reflect the reading

practice of Felicitas and her son. Following the principle of *sola scriptura*, she had thoroughly studied Luther's translations of the Bible. The many dedications of leading reformers, such as Martin Luther, Philip Melanchthon, Justus Jonas and Johannes Bugenhagen, clearly show that both of the book's users belonged to the Reformation movement.
Felicitas's 1534 Luther Bible (Sign. I.19) carries a personal dedication by Luther and was displayed unprotected in front of the "*Lutherschreck*" (a wax figure of Luther) in Halle from 1663 (cf. cat. 406). However, the second revised edition displayed here is no less significant. It was printed in 1541 and comes from the collection of George of Selmenitz. Here, too, we find Luther's signature under several handwritten Bible verses. In addition to this, on the last page of the book of Genesis, the Bible contains a colored pen and ink drawing of a carriage ride across the country. It is thought that George added this il-

lustration of one of Luther's journeys from Halle to Wittenberg. On the last page, above the family motto, there is an extremely rare example of an attached flyer. The printing is dated August 24, 1502 and is an invitation from Elector Frederick III of Saxony and his brother John to the opening of the University of Wittenberg on October 18, 1502. George, who taught his mother to read and write, must have archived this announcement in the thankful knowledge that the new university would offer him and his mother new opportunities. In 1547, Felicitas and her son returned to Halle, which had in the meantime become Lutheran. In 1578, the St. Mary's Library in Halle received the book and pamphlet collection of the Selmenitz family through a bequest of the descendants of Felicitas and George. FK

Literature
Bibliothek Selmenitz 2014, pp. 33 f. (ill.) · Hendgen 2002 · Kuschel 2014, pp. 34 f. · Luther und Halle 1996, pp. 22–28 (ill.) · Nickel 2002, p. 225, cat. 47 · Wendel 1908

Martin Luther
Lucas Cranach the Younger (illustrator)
Lukas Furtenagel (painter)
Bible of the Town Council of the City of Halle

Wittenberg: Hans Lufft, 1541
Paper and parchment, illustrated
39 × 28 cm each
New York Exhibition

Original title: Biblia: Das ist die gantze Heilige Schrift Deudsch [...] (Bible: This is the complete Holy Scripture in German [...])

216 a
Volume I
Stadtarchiv Halle (Saale), H A A 89,1

216 b
Volume II
Stadtarchiv Halle (Saale), H A A 89,2

This two-volume Bible was created in the workshop of the most significant Lutheran Bible printer, Hans Lufft in Wittenberg. The reformed community already had him to thank for the first complete Luther Bible in 1534. The title page includes an illustrated frame by Lucas Cranach the Younger, consisting of six individual images with allusions to original sin and salvation, as well as elements from the "Law and Gospel." The volumes are illustrated throughout with woodcuts from this workshop. The 129 biblical scenes in the Halle Town Council Bible are all decorated with water-soluble paint and gold leaf. Decorative woodcut initials, also painted, adorn the beginning of each chapter. The wooden covers of the bindings are clad in dark brown leather. Unlike other Reformation era texts in Halle's Town Council Library, which feature Renaissance ornaments and medallions of Luther, Melanchthon or Erasmus of Rotterdam, these volumes were rebound in the 18th century and are adorned with simple lines and enclosed with vine decorations.

The sentimental value of this Bible for the history of the Reformation in Halle lies above all in the handwritten inserts by Luther and the city's first Reformation preacher, Justus Jonas, that start in April 1541. Inside the first volume Luther wrote a four-line undated dedication that begins: "The Ten Commandments, the highest teaching..." and ends with his signature. In this copy of the first volume, Luther's dedication is followed by a two-page inserted inscription on parchment by Justus Jonas from 1544. He discusses a verse from the Gospel of John 4, "Children, you are from God," in German, and adds a Latin commentary on John 17:3. A two-and-a-half-page letter from Martin Luther to the Halle Town Council from 1545 is added at the end of the volume. In the letter, he expresses his confidence in the Town Council with regard to the cause of the Reformation and praises the role of his ally, Justus Jonas, in that struggle.

The second volume contains a sheet of parchment, bound before the flyleaf, containing four inscriptions from major Reformation figures, each one page long. It begins with an inscription by Johannes Bugenhagen, on the back of which is a 21-line dedication by Martin Luther. Opposite this dedication, the Council asked Philip Melanchthon to write something. The final inscription is from Caspar Cruciger the Elder, the preacher at Wittenberg's Castle Church, who played a decisive role in bringing the Reformation to Leipzig. On the reverse side of the paper flyleaf, the Council had its scribe insert a well-known Luther quote: "Oh Halle, you worthy city! May merciful God keep you so that you do not sink; you have always loved God's word, and for that God will preserve you."

The value attached to the Council Bible at the time of its acquisition is demonstrated by the bookplates produced by the painter Lukas Furtenagel in opaque paint and gold on parchment. Furtenagel was from Augsburg and was employed in Cranach's workshop in Wittenberg before moving to Halle in 1538. In the middle of each page is the coat of arms of the City of Halle, the red moon accompanied by two stars of different sizes in front of a magnificent gate. Both works are signed by him, on the lower edge, as "Lucas/L. Furtenagel of Augsburg" and dated "MDXLII," or 1542.

Both volumes were among the outstanding treasures of Halle's former Town Council Library,

216 a

which was founded in 1535 and was merged into the City Archive in the first-third of the 20th century. RJ

Literature
Krauß/Schuchardt 1996 · Neuß 1930 · Speler 1997 a, pp. 19 and 41 (ill.) · p. 83, cat. II.3 · Volz 1978

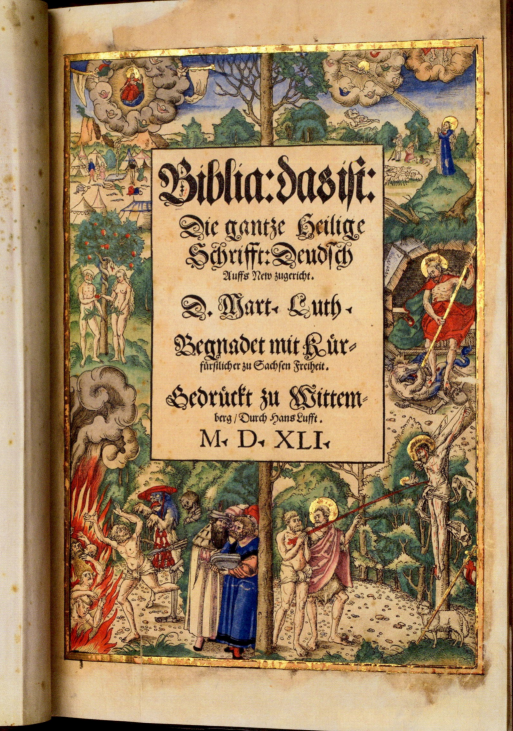

Biblia: das ist:

Die gantze Heilige Schrifft: Deudsch

Auffs New zugericht.

D. Mart. Luth.

Begnadet mit Kur-
fürstlicher zu Sachsen Freiheit.

Gedruckt zu Wittem-
berg / Durch Hans Lufft.

M. D. XLI.

Joh: 6: spricht Christus

Das ist Gotes werck, das ir an den
gleübt den er gesand hat.

Die welt, da sie voll frou~ und seelig sein
schreyet alls der verm~fft on Gotes
wort, Gutte werck Gutte werck,
und ertichtt ir selbs gute werck,
Gotesdienst, heiligen, ablas, orden ec~
gelu~, damit sie gu~tig~~e fur die
su~nd, Gotes gnad erwerbe und das e~
wig lebe~ verdie~ das achtet also
an, isst gute wercke oder Gotesdienst,
sondern eitel abgotterey, den solche
werckheyligen saget Christus, nicht
alleine Ir su~n rede~ ni ec, sondern
auch, descedite a me omnes qui ope~
ramini iniquitatem, id est, Ir ido
lolatres, non dei religiosi ne fidryste~
ec. Aber an dieser Gotes werck oder
gute werck wil mir~ aud, das wir~t
gleuben sollen an de~ so~ Gotes, welchey
der vater uns gesand und gegebe~
hat, die~ aud wil an de~ vilan der
da heysset Jesus Christus, durch welche~
thue~ alles geschaffe~ ist, durch welche~
blut das verlore~ erlöset ist, on welche~
keine seligkeit ist, on welche~ kein
gut werck fur Gott ist, dru~mb
so die Capernaiter, wie die ganche welt
spreche~, Was sollen wir thu~n, das wir
Gotes werck wercke~, antwortt Jesus
das ist Gotes werck, da weyset euch
hin ~ein vater mit drey Euangelie~
da hin weyset euch die ganche heilige
schrifft, da fragt er de~ heyligen Geist
da weiset er hynder Gotes gute beume,
das er kom~et gute früchte bringe~, das
ist Gotte gehorsame hyndere werde zu
thu~n gute werche, die Gott in seine~ Zehe~
gebotten ~v~ gebotten hat. Gli das wird~
~chts draus.

217

217

Heinrich Füllmaurer, workshop
Gotha Altar

1539–1541
Mixed media on fir panel
Center: 201 × 210 cm, outer wings: ca. 98 × 105,
inner wings: 96 × 48 cm
Foundation Schloss Friedenstein Gotha, SG 5
Minneapolis Exhibition

The *Gotha Altar* presents the most extensive cycle of Reformation-era imagery on fourteen hinged wings and a stationary center panel. It comprises three scenes from the Creation and 157 panels with scenes from the life of Christ. Two stationary wings with the genealogy of Jesus went missing in 1945 and are now in the Pushkin Museum in Moscow. This monumental work of art was created by Heinrich Füllmaurer's workshop in Herrenberg in southern Germany and was presumably commissioned by the ducal house of Württemberg. A comparable piece, the so-called *Mömpelgarder Altar* (Kunsthistorisches Museum Vienna), is closely related to the *Gotha Altar* both compositionally and formally.

The polyptych's formal design, which dates back to medieval winged altars, allows for five different views, each of which reveals the individual scenes in chronological order read from top left to bottom right. Attention is always focused on the presence of Christ, who is depicted, for instance, as a teacher, a teller of parables, a preacher, a healer of the sick and a miracle worker. The climax of the narrative follows on the final panel with Christ's arrest, passion and resurrection. The contemporary clothing, the absence of halos among all of the saints and the intensive visual polemics against monasticism and the papal Church are striking.

The upper third of every single panel is filled by a text cartouche framed with golden scrollwork, in which the respective passage from the German New Testament provides a written explanation of the scene depicted. Medallions noting references and cross-references to the texts cited from the four Gospels are attached to every text field. Additionally, two-line rhyming proverbs, written in the style of doggerel verse, appear on the molding of the frame. Disks in the four corners of the frame bear quotes from the Gospels. The Gospel Harmony by Jakob Beringer, which was published in Strasbourg in 1527 and based on Luther's translation of the Bible, has been identified as the source of the texts on the altar. Formally, the *Gotha Altar*'s striking combination of texts and images is consistent with different contemporary printed matter and Reformation-era didactic images. Lutheran picture Bibles for lay use, which combine texts and images, are comparable examples. In his writing, Luther explicitly encouraged the use of images for instructional purposes. As he saw it, rather than allowing them to be enticements to veneration and idolatry on their own, their instructional function was to be emphasized.

The *Gotha Altar* is named for its present-day location, where it was mentioned for the first time in 1648 but remained disassembled. The altar was not reassembled and convincingly reconstructed until the 20th century. Its intention is very consistent with the interests of the Dukes of Gotha, who long viewed and promoted themselves as guardians of the true Lutheran faith, predominantly in collecting works influenced by the Reformation. The extent to which the term "altar" also correctly describes the object's original site of installation and function, however, is uncertain. More likely, it was intended for private use as a monumental Reformation teaching tool, providing religious instruction much like a contemporary picture Bible for princely consumption. TT

Literature
Hintzenstern 1964 (ill.) · Kieser 1939 · Packeiser 2004 (ill.) · Schaumburg 1997 (ill.)

◄ 217 Right interior wing with the Passion
after restoration

VI

Luther in Wittenberg

Wittenberg was the birthplace of the Lutheran Reformation. It had already been a thriving university town and a residence of the Saxon Electors when Luther studied there. It became the base to which he returned after his stay in Wartburg Castle, where he had been taken for his own protection after the Diet of Worms. Until his death (which occurred in his birthplace, Eisleben), the center of his work and his private life remained in the former Augustinian convent in Wittenberg. He lived here before the Reformation, as a member of the Augustine order. After he had married former nun Katharina von Bora in 1525, the complex became the home of his family and a hive of economic activity. It was Katharina who, with a number of enterprises, managed to supplement the salary that her husband received as a professor of theology at the university.

In addition to the preserved Luther House itself, recent archaeological finds from the site allow a glimpse of the daily life of the Reformer and his family. They also expand our knowledge of this aspect with several new and interesting facets. This material is complemented by archaeological finds from other sites in the town that enable us to understand the general cultural and historical background of the Reformation period even better.

In the Luther House itself, the wood-paneled sitting room in the upper story from Luther's time is still extant. The large wooden table in the room is a memorial to the famous table talks the Reformer would deliver in the convivial company of his students and friends. These fellow supporters included theologians such as town pastor Johannes Bugenhagen or Justus Jonas, as well as professor of Greek Philip Melanchthon: men with whom he collaborated closely in his translation of the Bible and the subsequent revised editions. Aside from this major undertaking, the Reformer was also working on a multitude of other projects at this time, including the drafting of regulations for services and the composition of new hymns and sermons, which he considered the core of any service. TE

218

218

View of Wittenberg

1536–1546
Woodcut comprised of three blocks
26.5 × 109.5 cm
Luther Memorials Foundation of Saxony-Anhalt,
CGH 497
Minneapolis Exhibition

This woodcut shows the city of Wittenberg, located on the northern bank of the Elbe River, from east to west. Our view sweeps over the slightly hilly landscape, from the wooden bridge on the left edge of the image, which was built by 1490, into the city, the residence of the Elector of Saxony, which extends over the entire width of the page. The city's rapid development following the 1485 Leipzig partition as the residence of Frederick the Wise can be discerned based on the number of buildings. The cityscape also reflects the history of the early Reformation. Just two years after the partition of the Wettin lands, construction began on the new Renaissance palace. It was built at the southwestern edge of the city as a three-wing structure, and included the Castle Church, on whose door Luther is said to have nailed his 95 Theses.

Among the personalities who found their way to the city was Lucas Cranach the Elder, who worked as a painter at the court of the Electors of Saxony starting in 1505 and opened his workshop, including a print shop, right in the center of town. East of the marketplace, St. Mary's Church towers over the other buildings. The pulpit from which Luther held his sermons is currently on display in the Luther House.

Further up the river in the eastern part of the city we can see the buildings of Leucorea University, which was founded in 1502. The first functional university building, the *Collegium Fridericianum* (Frederick's College), was built as early as 1503. With the addition from 1509 to 1511 of the New College and the use of the Castle Church as the university church, the educational institution grew steadily. The building on the eastern edge of the page is the house where Luther lived. Between that building and the university complex is Melanchthon's house, recognizable by its striking round gables, which was built in 1536 at the expense of Elector John Frederick I.

All of the aforementioned institutions in this city were combined into a single complex, which allowed the Reformation to spread rapidly. By the time Luther became a professor of theology at the university here in 1512, and then proclaimed his 95 Theses in 1517, the economic and intellec-

tual conditions necessary for the growth of the city and, above all, the university, had already been created: Wittenberg developed into a center of the Reformation, making it one of the most important places in the Empire in the 16th century. RN

Literature
von Gaisberg 2011 · Hennen 2015 a · Hennen 2015 b · Joestel 2008, pp. 98 f. · Treu 2010, pp. 13 f.

219

The Wittenberg Executioner's
Sword

1st-quarter of the 16th century
Iron, forged
105.5 × 29 cm
Lutherstadt Wittenberg, Städtische
Sammlungen, KMH 220
Minneapolis Exhibition

219

The executioner's sword of the City of Wittenberg dates back to the 15th century. Its maker has not been identified, as the mark on the blade is otherwise unknown. The blade has also been cut down from the original length. The guard is formed by a twisted iron bar, and the ribbed pommel of the weapon was forged from a massive piece of iron. The tang is encased in a wooden grip consisting of two halves and was probably added at a later date. In 1441, Elector Frederick the Meek transferred local administration of justice to the mayor, council and people of Wittenberg for a sum of 1000 Rhenish guilders on condition of intended repayment (that never materialized).

It was probably at this time that the city acquired an executioner's sword. A written source in the council archives of the city collections refers to this transaction: The municipal account book of 1532 has an entry showing that a certain Veit Messerschmied received 5 groats for the adaption of a sword and the fashioning of a new scabbard. According to the record, this scabbard was lined with fustian, a textile made of either wool or linen. In addition, a new chape was attached to the tip of the scabbard by Messerschmied. Such evidence makes it likely that this was also the occasion when the blade was shortened and its tip rounded, as this would have made a new scabbard with a different chape a necessity.

When not in use, the executioner's sword was kept in a cabinet by the city council. This cabinet is mentioned in the city accounts of 1553 on the occasion of a carpenter receiving 12 groats and nine pennies for fixing it. According to Treu, Luther himself considered the executioner's sword of Wittenberg a symbol of temporal authority (Treu 2003, p. 69). An example of this significance is the record of a woman sentenced by municipal judges to be beheaded in 1525—she is said to have "aborted the fruit of her womb."

An inventory was made in 1690 of the city courts, which resided in the town hall. This list shows that both the cabinet and the sword were still in the town hall at this date. When the magistracy chambers in the town hall were refurbished in 1865, it was made possible for curious citizens of Wittenberg and visitors to view several objects pertaining to the history of the city. These tours would be conducted by a city employee, and they would definitely include the executioner's sword. In 1905, participants of the ninth district athletics festival were officially encouraged to visit the town hall and view the sword.

A society for local history and self-defense (!) was founded in 1910. It struck a deal with the municipal authorities in 1928 concerning the loan of several objects of historic relevance, among them the executioner's sword. The blade was henceforth displayed in the society's museum in Wittenberg Castle. When the society was dissolved in 1945, the loaned objects were returned to the care of the city. When a museum for local history and culture was founded in 1954, the sword was put on display along with an antique leather scabbard. In 2005, it was once again returned to the municipal collections. The executioner's sword is now part of a permanent exhibition in the former municipal arsenal of Wittenberg at *Arsenalplatz* square. An exact replica is on display in the Luther House. AW

Sources and literature
Kreis-Turnfest des Turnkreises IIIe der Deutschen Turnerschaft (Provinz Sachsen und Herzogtum Anhalt) am 8., 9. und 10. Juli 1905 zu Wittenberg, Wittenberg 1905 · Kühne 1994 · RatsA WB: Ln. Urbar (alt) 2; Ln. 2254; KR 1525; KR 1532 · Schild 1892 · Treu 2003 b · WA 11, 258, 21; WA 11, 260,30–261,8

Hitched with Luther: The Marriage between Katharina von Bora and Martin Luther

"But under these circumstances [...] I shall not take a wife; my mind could not be further from the subject of marriage, for I expect to meet death and the just deserts of a heretic any day" (Luther to Spalatin, November 30th, 1524; WA.B 3, 394 [no. 800]). When Martin Luther wrote this, he was already acquainted with the former nun Katharina von Bora. In April 1523, twelve nuns had escaped from the convent of Nimbschen to Wittenberg, where the reformers arranged for their marriage to suitable men as a way of reintegrating them into lay society. This solution was risky, but it was their only real chance of a new life.

For most of the former nuns, the scheme worked. But in the case of Katharina, who came from a destitute family, the situation was not so easy. She had been rejected by the family of her chosen, Hieronymus Baumgartner of Nuremberg, and she was now biding her time in the Cranach household. She had informed Luther's friend Nikolaus von Amsdorf that she would marry either him or Luther. Luther, on the other hand, who had publicly rejected the celibate life of the priesthood and encouraged monks and nuns to enter into matrimony, was egged on by his friend Argula von Grumbach to follow up his statements with actions. Luther finally gave in, and on June 13th, 1525, the 42-year old Reformer married the 26-year old Katharina in Wittenberg.

For the opponents of Luther, this marriage was a confirmation of his "base" instincts. One of these critics, King Henry VIII of England, accused him of instigating the Reformation out of sheer lust. Incidentally, this was the same man who was to leave his own mark on history through his peculiar understanding of marriage. More seriously, Luther was also criticized by like-minded people. In spite of this, the marriage of the runaway nun and the former monk was to become an avowed model.

A vast number of portraits of the couple were produced by the Cranach workshop in small and medium formats. These images symbolized a new era, which brought with it a different—Protestant—view of marriage and family and the relationship between husband, wife and children. It encompassed an increased appreciation of matrimony as opposed to celibacy, and a more functional understanding of the roles of wife and husband as the core of Christian society. FK

Johann Eberlin von Günzburg
How Dangerous it is when a Priest has no Wife

Augsburg: Melchior Ramminger, 1522
Printed on paper
19.5 × 14.5 cm
Luther Memorials Foundation
of Saxony-Anhalt, Slg. Ag 4° 242 d
VD16 E 156
Minneapolis Exhibition

Original title: Wie gar gfarlich sey. So / Ain Priester kain Eeweyb hat. Wye Vn / christlich, vnd schedlich aim gmainen / Nutz Die men-schen seynd. Welche / hindern die Pfaffen Am Ee / lichen stand. Durch / Johan Eberlin Von Güntzburg. Anno. / 1522 (How dangerous it is when a priest has no wife. How un-Christian and harmful for the common good are those people who hinder the priests from the state of marriage. By Johann Eberlin von Günzburg in the year 1522)

The theologian Johann Eberlin von Günzburg joined the Franciscan monastery in Tübingen as a preacher in 1519. Confronted with the abuses in monastic orders, Eberlin found himself at log-gerheads with the University of Tübingen through the various theological positions that he held. After moving to a Franciscan monastery in Ulm, from at least 1521 he had contact with a group of humanists and with several followers of Luther in Basel.

Eberlin gradually began to preach like Luther and therefore attracted the animosity of the brothers of his order. He became notorious to the Curia as the "Franciscan of Ulm." But the town, influenced through Eberlin's Reformation views, stood up for him. When the Edict of Worms and the asso-ciated imperial ban on Luther and his followers was published, Eberlin was forced to leave the order. In 1522, he stayed in Wittenberg, where he sought contact with Luther and the other reform-ers and matriculated at the University of Witten-berg.

On the way to Wittenberg he wrote the first pam-phlet in his name. The edition was reprinted three times by 1523 and was translated into Low German and Latin. In *How dangerous it is when a priest has no wife,* Eberlin appeals to "good-hearted Christians" and attacks compulsory celi-bacy for priests. He calls on all unwed priests to enter into a marriage in order to express their solidarity with married priests.

220

He writes that priests should recognize the "dev-ilish cunning" in the rule against the pastor's marriage because it also harms society at large. The priest who is not allowed to have a normal marriage and gives himself over to prostitutes cannot function as a role model for ordinary peasants. Eberlin says that chastity, according to Christ, is a purity of heart, towards which Chris-tian marriage aims.

Eberlin's arguments had their origin in the writ-ings of Luther and Andreas Karlstadt. The critique of celibacy was an important theme for all the reformers and their followers. Eberlin's pamphlet proved to be very marketable. His zealous per-sonal contribution toward the Reformation is shown in the colloquial form of expression and not least the striking design of the title page of the original Augsburg print edition on which the marriage of clerics is represented.

In 1524, the rebellious monk Johann Eberlin von Günzburg married Martha von Aurach, with whom he had four children. FK

Literature
Dipple 1996, pp. 94–121 · Heger 1965 · Peters 1994 · Wolf 1959, pp. 247 f.

221

221

Martin Luther
Letter to Georg Spalatin

Wittenberg, April 10, 1523
Ink on paper
21.4 × 15.4 cm
Landesarchiv Sachsen-Anhalt, Z8 Lutherhand-
schriftensammlung, no. 197
Minneapolis Exhibition

Martin Luther formulated his critique of monastic vows very early on with his tract *De votis monasticis* of 1521, which induced monks and nuns to flee their abbeys. As Luther saw it, their vows contravened Holy Scripture and God's creation. This especially pertained to women, "who [were] far too weak in and of themselves and bound to men by nature, even by God," as Luther wrote in this letter, but they were nevertheless sent by relatives to abbeys against their will.
Katharina von Bora's flight from her abbey was certainly one of the most widely known escapes. Aided by Leonhard Koppe from Torgau, she escaped the Cistercian abbey in Nimbschen near Grimma together with eight other nuns in the night before Easter Sunday in 1523. They fled to Wittenberg for a variety of reasons: firstly, the nuns were hoping for aid and counsel from Luther himself. After all, his writings were one of the reasons they had run away from their abbey. Secondly, they wanted to evade the severe punishments imposed by canon and secular law for flight from an abbey.
What was to be done with former residents of abbeys, and these nuns in particular? They first had to be cared for and housed. That is why Luther requested in this letter to Spalatin that money be collected at the electoral court, since he was unable to care for them from his own pocket.
The issue of their future also had to be clarified. Very few options remained for women to lead a "chaste" and "respectable" life after fleeing an abbey. They could return to their families, provided they desired to do so or would be taken back by them in the first place. Another option was for them to start working for themselves (as seamstresses or teachers at girls' schools), although in actuality this choice was made only in rare cases. Most opted for the final option, marriage. Luther assured Spalatin that he also intended to do his part by arranging marriages with former clergymen and professors. The situation of most of the nuns from Nimbschen was resolved quite quickly. A solution was only left wanting for Katharina von Bora. Her future was not secured according to the thinking of the day until she married Luther himself. VR

Literature
Bünz 2004 · Köhler 2003 · Ranft 2002 · Schilling 2013

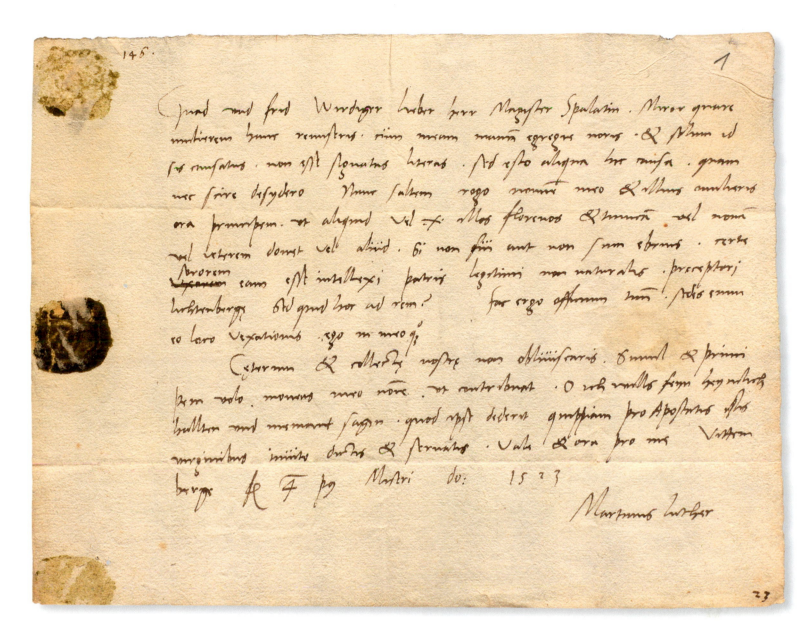

222

222

Martin Luther

Letter to Georg Spalatin

Wittenberg, April 22, 1523
16 × 21 cm
Landesarchiv Sachsen-Anhalt, Dessau,
Z8 Lutherhandschriftensammlung, no. 202
New York Exhibition

This is Luther's second letter to Spalatin requesting assistance for various women. Luther is clearly frustrated that he has to repeat these requests, and Spalatin faces the brunt of Luther's sharp pen. A previous introduction of a woman to Spalatin failed because he had doubts as to her identity. Luther rather curtly reprimands him for not accepting the woman's letter of introduction, and yet even in this letter Luther has strangely changed the woman's status from "*sororem*," sister, to "*uxorem*," wife—a not insignificant difference—and a change which did not accord with the truth. Nonetheless, in no uncertain terms he berates Spalatin, "do your job." Luther also had written previously to him on April 10 (cat. 221) requesting help for the nine nuns who had fled from the convent of Nimbschen and sought refuge in Wittenberg. Nearly two weeks later, Luther has to repeat his request as Spalatin

had apparently not organized help according to Luther's desires. Ultimately the women were housed individually around Wittenberg and one by one married off, the last one to Luther himself. The letter is not the typical message Luther sent to Spalatin, but rather, in both language and format seems like a quick note sent off in annoyance that Luther must remind him of these matters. JTM

Sources
WA.B 3, 64 (no. 608)

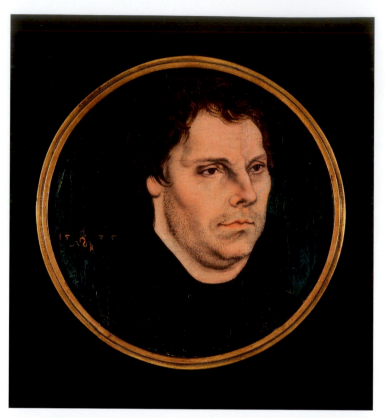

223

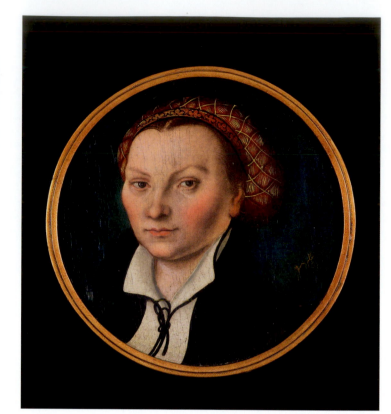

223

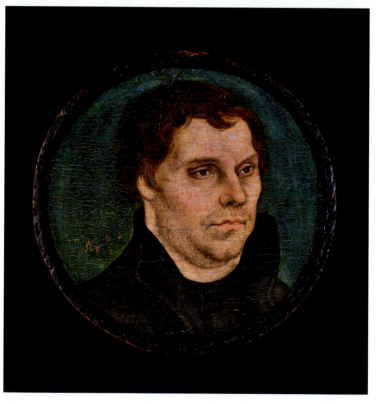

224

223

Lucas Cranach the Elder
and workshop
Martin Luther and
Katharina von Bora

1525
Oil on wood
D (unframed) 10.3 cm and 10.1 cm
The Morgan Library & Museum, purchased
by Pierpont Morgan, 1909, AZ038
New York Exhibition

Signed with Cranach's winged serpent and
dated at left of Luther panel, 1525, and signed
with Cranach's winged serpent at right
of Katharina panel

224

Lucas Cranach the Elder
Martin Luther

1525
Oil on parchment/paper on wood
D (unframed) 14 cm
Luther Memorials Foundation
of Saxony-Anhalt, G 11
Minneapolis Exhibition

Signed with Cranach's winged serpent and
dated at left Luther panel, 1525

Lucas Cranach painted a double portrait of Luther
and Katharina von Bora as a gift for their wedding
on June 13, 1525. The small, round format was
intended to be housed in frames that fit together
face-to-face to form a compact capsule. The pair
of paintings in the Basel Art Museum retain their
original interlocking frames, but both the pair at
the Morgan Library and the Luther House paint-
ing show a circular abrasion inside their current
frames (most clearly visible at the lower edge)
that likely derives from their original, connecting
frames. Both the Morgan and Luther House
Luther portraits are dated 1525 and signed with
Cranach's winged serpent; the Morgan's Katharina
bears only the winged serpent facing in the op-
posite direction of its counterpart. Cranach and
his workshop produced numerous copies of the
wedding portraits around 1525–1526, in both the
small round format as well as the more tradi-
tional rectangular wooden panel. The round pair,
intended for close relatives and friends of the
couple, would have been held in the viewer's
hands and interacted with on a rather intimate
level, while the rectangular panels were likely
hinged as a diptych that could be displayed free-
standing on a table or cabinet. In this marriage
portrait, Luther's eyes look toward his new wife
while Katharina's engage the viewer. As the dot-
ing husband, Luther looks to his wife as the driv-
ing force in their marriage, and it is through her
that the viewer is introduced to the couple. This
portrait pairing portents the partnership that the
Luthers would come to know, wherein Katharina
took the lead in running the household and es-
tate, including various farmlands and a brewery,
as well as managing the coterie of students
drawn to Luther's side.

The second Lutheran portrait type, produced in
1528–1529, reverses the pair's gaze, with Kath-
arina focusing on her husband while he looks out
at the viewer (cat. 225–230). The black cap that
Luther wears in this second portrait type identi-
fies him as theologian and preacher, the *pater
familias* of the Reformation, to whom Katharina
defers. This same depiction of Luther in the black
jacket and cap is also found in the 1530s paired
with portraits of Philip Melanchthon (cat. 289),
where this portrait pairing articulates the politi-
cal and theological unity of the Reformation after
the Diet of Augsburg and the publication of the
Augsburg Confession (cat. 345). The double
portrait was a common artistic format effectively
used to represent marriage and political alliances
as well as serving as friendship gifts. The Cranach
workshop placed the practice in the service of
the Reformation through the painted and printed
depictions of Luther and Katharina, Luther and
Melanchthon, and the Saxon Dukes Frederick the
Wise, John the Steadfast, and John Frederick
(cat. 43, 44, 47 and 50), to represent and
promote the social and political unity of new
Reformation movement. JTM

Literature
Friedländer/Rosenberg 1932, nos. 189–190 E
and 189 B · Heydenreich 2007, pp. 77–80 ·
Koepplin/Falk 1974, vol. I, p. 295 · Kuhn 1936,
cat. 142 · Silver 2003, p. 7

Lucas Cranach the Elder,
workshop
Portraits of Martin Luther
and Katharina von Bora

225

Martin Luther

1528
Oil on copper beech
35.8 × 26 cm
Luther Memorials Foundation
of Saxony-Anhalt, G 16
Minneapolis Exhibition

226

Katharina von Bora

1528 or later
Oil on beech
36 × 26 cm
Luther Memorials Foundation
of Saxony-Anhalt, G 17
Minneapolis Exhibition

227

Martin Luther

1529
Mixed techniques on beech
37.9 × 24.4 cm
Foundation Schloss Friedenstein Gotha, SG 18
New York Exhibition

228

Katharina von Bora

1529
Mixed techniques on beech
38.2 × 24.9 cm
Foundation Schloss Friedenstein Gotha, SG 17
New York Exhibition

229

Martin Luther

1529
Oil on copper beech
51.5 × 36.3 cm
Stiftung Deutsches Historisches Museum,
1989/1547.1
Minneapolis Exhibition

230

Katharina von Bora

1529
Oil on copper beech
51.8 × 34.6 cm
Stiftung Deutsches Historisches Museum,
1989/1547.2
Minneapolis Exhibition

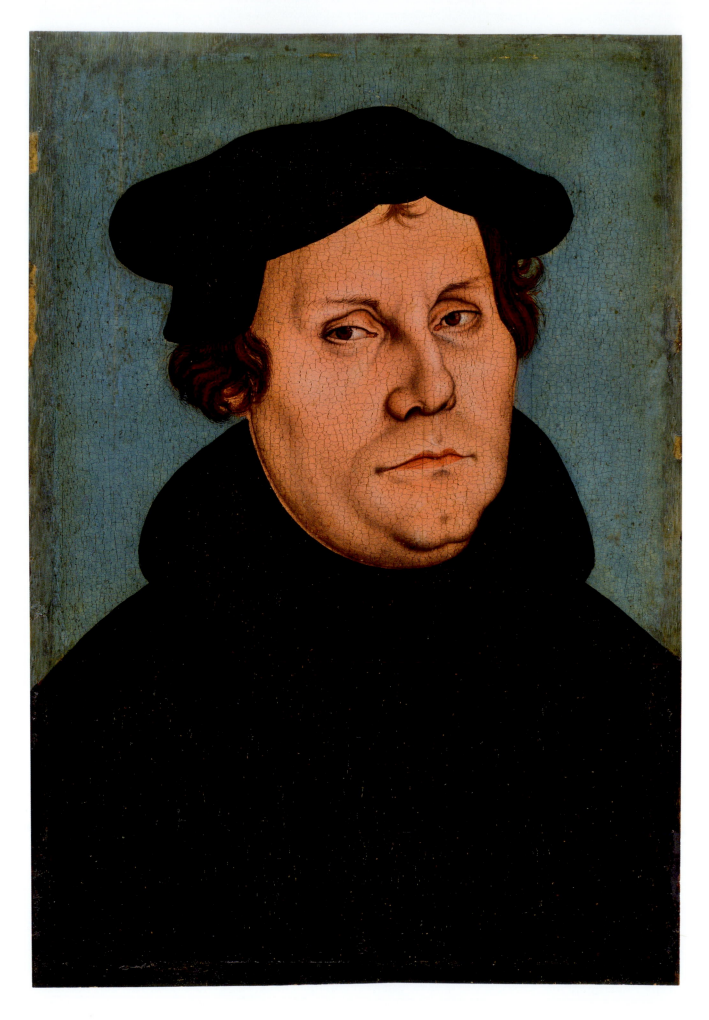

225

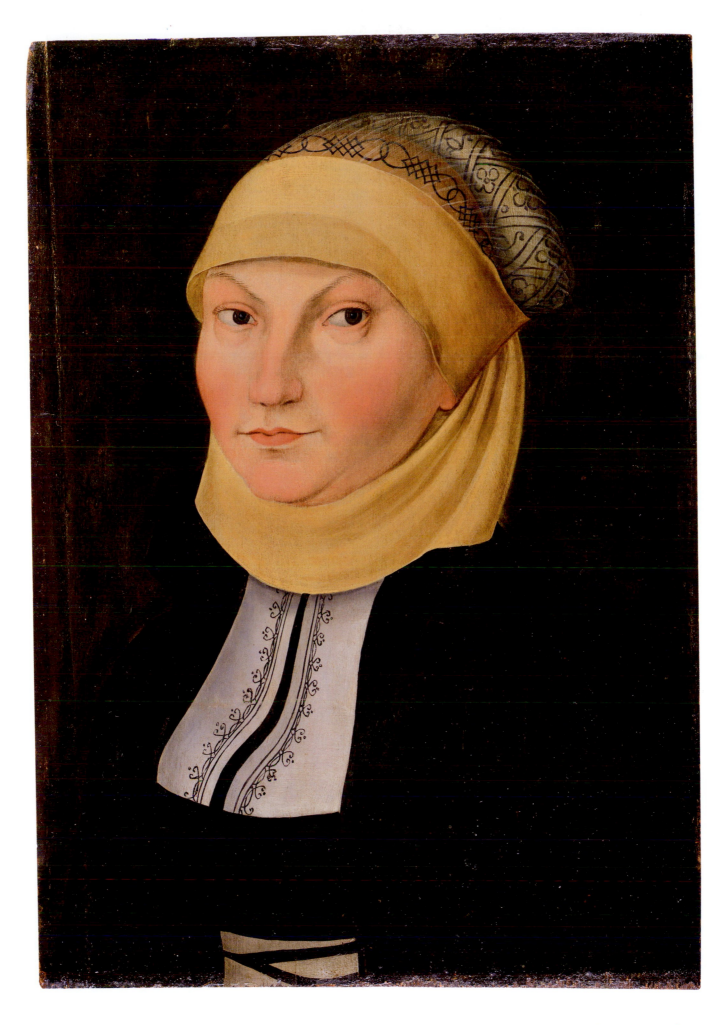

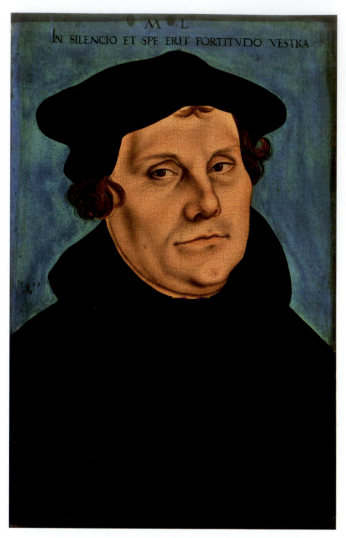

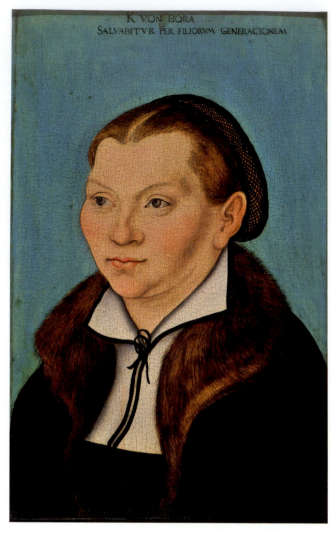

227

228

As early as 1520, in his *To the Christian Nobility of the German Nation,* Martin Luther called for abolishing the requirement of celibacy. In the same year, his companion Philip Melanchthon got married. From that point on there is more and more evidence of priests getting married. For example, Strasbourg reformer Martin Bucer got married in 1522, as did Johannes Bugenhagen, also a companion of Luther. In the following year, the reformer Matthäus Zell was married by Bucer. Zurich reformer Ulrich Zwingli acknowledged his wife, with whom he had been living since 1522, in 1524. In 1525, finally, the former Augustinian monk Martin Luther married the former nun Katharina von Bora, who fled her convent in 1523 and found refuge in the house of Lucas Cranach the Elder. Due the theologian's widespread fame, this essentially private event took on a political dimension, which was reflected in the long line of portraits of the married couple that immediately began to emerge from the Cranach workshop.

No portraits of "die Lutherin," as Katharina von Bora was sometimes called after her marriage, have survived from the time before the wedding. Apparently, she was not deemed to be a worthy subject of portraiture prior to her wedding. The surviving paintings of the couple testify to their public and political role: Martin Luther's marriage to an escaped nun was a clear statement against the doctrine of priestly celibacy. Accordingly, the portraits were utilized in such a way as to influence public opinion. In particular, these portraits were mass produced in order to ensure that the Luthers' status as a Protestant married couple was widely known.

Lucas Cranach the Elder, who was also a witness at the wedding, and his workshop created the large number of double portraits needed for this purpose. Two round portraits from 1525 (Basel Art Museum), the year of the wedding, are considered to be the original version of these portraits. In the ensuing years, large numbers of these portraits were created by the master himself and by his numerous collaborators, often with slight variations in clothing and pose, and then sent to the new Protestant communities in order to promote acceptance of priestly marriage. This may be one reason why the composition conforms to the widely known tradition of the "alliance portrait," which since the late Middle Ages had become an established practice not just for portraying political alliances but for announcing weddings in noble houses. In such upper-class wedding portraits, the husband invariably is placed on the higher-ranking left side, i. e. the heraldic right side, and this is also the case in the diptychs of the Luther couple.

The first series of diptychs, which appeared the year of the wedding, shows Luther bare-headed and withdrawn and is modeled on a series of individual portraits developed as early as 1520 portraying Luther in three-quarter profile and without a head covering. Katharina von Bora, meanwhile, is portrayed in the Basel version in a gray dress with a black collar, an embroidered bodice and a tight-laced white blouse. Her hair is arranged under an embroidered bonnet. Unlike her husband, she looks directly out at the viewer. Luther, on the other hand, appears withdrawn. This form of portrayal is especially common in highly rectangular formats, with both figures typically shown before a monochrome blue or green background.

Starting in 1528, a second series of double portraits appeared, in which the portrayal of Luther

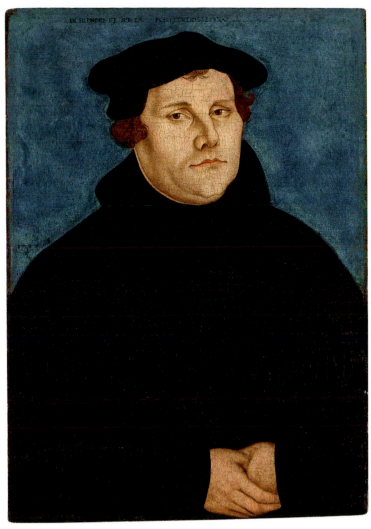

229

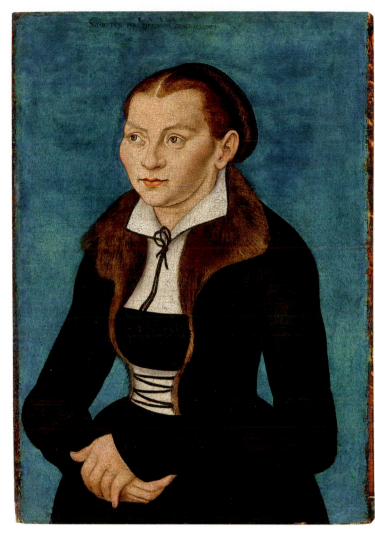

230

underwent a fundamental change, which has been retained ever since. From this point on, Luther appears with a biretta and a black coat. When this line of Luther portraits came out, this coat, an item of secular everyday clothing, became more characteristic than the long praying gown of the pastor. Now, Luther presents a monumental figure, filling the frame with his bulky garb. Katharina's status as Luther's wife is given greater stress than in the earlier portrait: her entire head is now covered by an ornate bonnet, and her face is framed by the bonnet's strings (cf. cat. 225 and 226). Both spouses are looking right out at the viewer.

At this point, when the third series of these portraits appears, a significant change takes place: Katharina von Bora is once again portrayed as she was in the first series, with a hairnet and fur collar, and is now placed in a larger section of the painting, making her appear smaller than her husband. In contrast to the earlier series from 1525 to 1528, in which the two are portrayed as equals, Luther's wife is now portrayed as withdrawn, an impression which is reinforced by the change in the direction of her gaze, which is now directed towards her husband. He, in turn, is gazing right out at the viewer, forming a connection with the space outside the painting.

In the Gotha and Berlin versions (cf. cat. 227–230), moreover, the inscriptions focus on the public roles of the protagonists: the Latin inscription above Luther, M L/IN SILENCIO ET SPE ERIT FORTITVDO VESTRA, "In quietness and trust is your strength" (Isaiah 30:15), stresses trust in God's grace as a theological principle of Protestantism. At the upper edge of the painting above Katharina von Bora, on the other hand, can be found a verse from 1 Timothy 2:15: K VON BORA/ SALVABITVR PER FILIORVM GENERACIONEM, "[But] women will be saved through childbearing," stressing her role as a mother, even though this limitation in her role was not entirely consistent with the actual reality of the married couple. In fact, von Bora managed the finances and acted as the provider for the household, so that Luther addressed her as "Mr. Katie," i. e. as the head of the household.

Despite the many variations, one can say that these portraits of Protestantism's leading couple were mass produced by the Cranach workshop, making them into icons, as it were. It is hardly possible to distinguish the master's hand from those of his numerous collaborators. Scratches and stitches on the surface of the painting indicate the use of stencils to trace the contours. This production of portraits, a process which can be called an example of mass production in the Early Modern period, had the effect of disseminating portraits of Luther and his wife on an enormous scale, which in turn led to higher acceptance for Protestant clerical marriage. BR

Literature
Brandsch 2001, p. 47, cat. 1.14 and 1.15 (ill.) · Brinkmann 2007, pp. 194 f., cat. 41 (ill.) · Eissenhauer 1992 · Schuttwolf 1994 a, p. 50, cat. 1.17 and 1.18 (ill.) · Seebaß 1983

Katharina von Bora
(1499–1552)

On the night of Easter Sunday 1523, twelve nuns fled the Cistercian convent of Marienthron in Nimbschen, near the town of Grimma (Saxony), in the wagon of a convent supplier, and escaped to Wittenberg. One of them was Katharina von Bora. Her father, an impoverished nobleman who struggled to make a living in agriculture, packed her off to a convent in Brehna at the age of five. As a Bride of Christ, she would have learned, among other things, to read, write and manage household affairs, yet upon her arrival in Wittenberg, her prospects as a penniless apostate nun were anything but promising. Nevertheless, her patience and perseverance would bring handsome dividends. On June 13, 1525, Johannes Bugenhagen married Katharina von Bora and Martin Luther in the former Augustinian convent (or *Schwarzes Kloster*) of Wittenberg.

At his death, when the extent of Luther's debts to Wittenberg merchants became known, Katharina was left to repay them. While she had increased the property and possessions of the family over the years, even acquiring farmland, she now had no choice but to pawn luxury items from the household. By the outbreak of the Schmalkaldic War in 1546, her financial existence as a widow seemed secure. The aftermath of this conflict again plunged her into a catastrophic situation, and she was forced to sell the family residence. In 1552, as she fled the plague in Wittenberg, she was injured in a road accident on her way to Torgau and died soon thereafter.

For her pains, Katharina von Bora was later celebrated as a model pastor's wife and Luther's loyal companion, both in the history of the Lutheran Church and in world history in general. As the ideal image of a Reformation wife and mother, "Herr Käthe" became a prime example for a new vision of marriage and family that was celebrated in numerous visual media, especially in the 19th century. Only recently has this perception been confronted with sources regarding her life in an attempt to reconstruct a more factual picture of Katharina. One of the less positive aspects that has come to light is her influence on Luther's anti-Semitic attitude. On his way to Eisleben, Luther wrote to her that the cold wind had turned "his brain into ice." He then added (probably echoing previous derogatory utterances by his wife), "had you been here, you surely would have remarked that this was the fault of the Jews and their God." FK

Hans Brosamer,
after Lucas Cranach the Elder
Wolfgang Resch
(block cutter and printer)
**Portraits of Martin Luther
and Katharina Luther**

Nuremberg, 1530
Woodcut, colored, typographic text
Minneapolis Exhibition

231
Katharina Luther, née von Bora

Sheet dimensions: 40.5 × 30 cm; image dimensions with text: 34.7 × 28.1 cm; image dimensions without text: 32.2 × 21 cm
Foundation Schloss Friedenstein Gotha, 38,2

Above the portrait: Katherina. Martinus. Eelicher gemahel:
(Katherina. Martin's married wife.)
Beneath the portrait: W: Resch Formschneider zu Nürmberg 1530
(W. Resch block cutter in Nuremberg 1530)

232
Martin Luther

Sheet dimensions: 40.5 × 29.7 cm; image dimensions with text: 31.9 × 27.9 cm; image dimensions without text: 31.9 × 18.5 cm
Foundation Schloss Friedenstein Gotha, 38,3

Above the portrait: Martinus Luther
Beneath the portrait: W: Resch Formschneider zu Nürmberg 1530 (W. Resch block cutter in Nuremberg 1530)

Like many of his works, these two woodcuts by Hans Brosamer are heavily influenced by Lucas Cranach the Elder. The pair of portraits of Martin Luther and his wife Katharina von Bora created by Lucas Cranach the Elder in 1529 served as the model for these single-leaf woodcuts (cat. 227 and 228). Exceptionally impressive because of their coloring, these woodcut portraits satisfied demand for faster, more numerous and less expensive images better than painted portraits. Given its widespread circulation, the medium of printing was particularly suited to swaying public opinion in favor of the controversial marriage of clergy. The Reformer is portrayed here in a short coat and beret as the famous professor of theology from Wittenberg. Katharina is wearing a fur-trimmed dress and a mesh cap, identifying her as a married woman. An inscribed plaque above her head further identifies her as "Martin's married wife." The portrait of Katharina thus references the pendant to this single-leaf woodcut, which merely bears the Reformer's name above his head. The portrait of Katharina

is unconventionally on the left side and the portrait of her husband on the right, something accounted for by the technique of printing, which rendered this version, which was modeled after Cranach's original, in reverse. BS

Literature
Andersson/Talbot 1983, p. 40 (ill.) · Schäfer 2010, pp. 62 f. · Schäfer/Eydinger/Rekow (forthcoming), cat. 122 and 123 (ill.) · Syndram/Wirth/Zerbe/Wagner 2015, pp. 288 f., cat. 215 a and 215 b (ill.)

233

Hans Brosamer
Hans Guldenmund (publisher)
Martin Luther

Nuremberg, around 1530–1540
Hand-colored woodcut
35.9 × 25.4 cm
Thrivent Financial Collection of Religious Art, Minneapolis, 01-02
Minneapolis Exhibition

Inscribed at top: In silentio et spe erit fortitudo vestra./ Martinus Luther abconterfect. (In silence and hope shall be your strength./ Martin Luther portrayed.)

This vivid woodcut is one of many portraits of Luther that derive from Lucas Cranach the Elder's direct personal observations. Produced in Luther's lifetime, the portrait demonstrates how quickly information is lost, for the colorist has given the Reformer blue eyes, rather than the brown found in Cranach's paintings.
The woodcut's design appears to stem from a drawing made in Cranach's workshop. Two very similar drawings, in Berlin and Weimar, resemble the woodcut in design and scale. Details such as the loop at Luther's lapel were transformed in the course of the multiple series of copies leading to the woodcut. The Berlin Kupferstichkabinett version (inv. no. 4794), showing both the date 1528 and Cranach's serpent emblem in reverse, has the appearance of a drawing. The shading on the face is extremely schematic. The sheet is pricked with tiny holes along the outlines to facilitate transfer of the image to another surface. The Weimar version is also dated 1528 and pricked for transfer. Given the clear intent to mass produce this likeness of Luther, it is ironic that Brosamer's print is remarkably rare today.
The first line of the Latin inscription surmounting the image comes from Isaiah 30:15 and also appears on a painted portrait of Luther from Cranach's studio and now in the Saint Ulrich Church in Augsburg. Luther alluded to the passage in his lectures on the book of Romans, de-

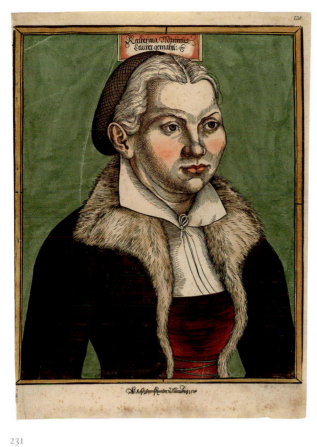

231

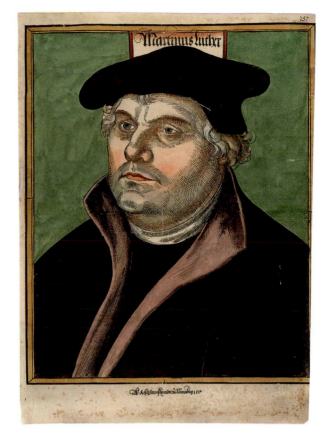

232

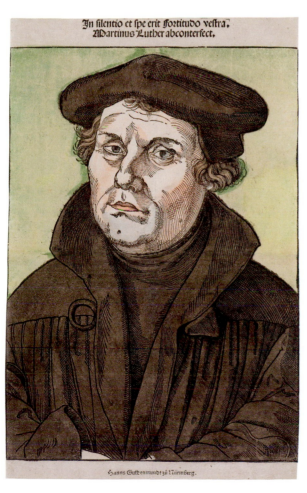

233

livered in Wittenberg, 1515–16: one who believes in Christ does not hasten or flee; he is not frightened, because he fears nothing; he stands quiet and secure, founded upon a firm rock, according to the teaching of the Lord.

Apart from his surviving art, little is known about Hans Brosamer. He worked as a painter, engraver, and designer of woodcuts in the town of Fulda, in Hesse, from about 1520 until the mid-1540s, when he moved to Erfurt. He made several portraits of Reformation leaders, plus the illustrations for Luther's Bible, printed by Hans Lufft. Even though he occasionally portrayed opponents of the Reformation, it seems curious that a biting satirical image of Luther as a seven-headed monster has been attributed to Brosamer, although this attribution is disputed (cat. 315 and 316). TR

Literature
Hollstein IV, p. 259, no. 595 · Lindell 2011, pp. 78 f.

234

Golden Ring

Wittenberg, Luther House, Collegienstraße 54
1st-half of the 16th century
Gold, cast and embossed
H 2.4 cm; D 1.9 cm
State Office for Heritage Management and Archaeology Saxony-Anhalt, State Museum of Prehistory, HK 667:130:1
Minneapolis Exhibition

This gold ring originally sported a gem mounted in a claw-like, serrated setting. Renaissance gemstones were ground and polished to a hemispherical cabochon shape and did not sparkle as faceted gems do now. This was an unusual discovery to make among the rubble in Luther's garden, and if it came from Luther's household it must have graced the finger of a distinguished lady, most probably Katharina von Bora herself. Indeed, she is shown wearing a nearly identical ring with a blue stone in Cranach's portrait of her from 1526.

It is very tempting to relate this find to a small domestic drama related by Martin Luther to a onetime ally, the theologian Wolfgang Capito from Strasbourg, who was trying to resolve the escalating disputes between Luther and the western European reformers. The golden ring Capito had sent to Katharina during negotiations in 1536 had gone missing, and, on July 9, 1537 an aggravated Luther wrote to Capito: "I never saw her [Katie] so vexed than she was when she found out that it had been stolen, or (as she constantly accused herself) that she herself had lost it out of carelessness." He finally advised Capito

234

to abstain from such lavish gift-giving to his wife in the future in order to prevent similar disappointments, and besides, Christ's blessing was enough wealth for both of them.

Obviously there is more to this episode than an exceptional, somewhat jealous flare-up in what was universally considered to have been a harmonious and successful marriage. On the one hand, it reflects the personal nature of the discord between Luther's Central and Northern European Reformation and the much more radical Western European paths to reform, which by that time had already sown ruinous schism within the Reformation movement and would continue to do so. On the other hand, it shows Martin and Katharina enjoying the status of a princely pair, receiving lavish personal gifts in order to facilitate diplomacy. Yet the fact that the stone is missing from the ring makes this identification difficult, as there seems to be no easy explanation about how the stone could have disappeared before or after Katharina misplaced the ring. LN

Sources and literature
Gutjahr 2001, p. 7, fig. 1 (ill.) · Meller 2008, pp. 238 f., cat. E 10 (ill.) · Stephan 2008 b, p. 20, fig. 5 · WA.B 8, 99 f. (no. 3162)/ LW 50, 171 f. (no. 282)

235

Rosary, probably owned by Katharina von Bora

16th century(?)
L 46 cm
Turned wood, cord
Luther Memorials Foundation of Saxony-Anhalt, K 2
Minneapolis Exhibition

This Paternoster, or prayer beads, reputedly belonged to Luther's wife, Katharina, although this cannot be proven. Such an item, used for the formulaic repetition of prayers, would not necessarily be expected to have been in the Reformer's household. Luther had little regard for such religious practices, which were considered to be in the category of works, since he did not feel they were consistent with reasonable faith. These beads, though, might be a relic of Katharina's time as a nun. Katharina, from the von Bora family of impoverished rural nobility, had been committed to a monastic community for her education and care, from which she was able to flee in 1523 thanks to Luther's active assistance.

The beads were used to count off the set sequence of prayers of the Our Father (*Paternoster*), Hail Mary (*Ave Maria*) and Glory Be (*Gloria*)—hence the names Paternoster or rosary, the latter being an allusion to Marian iconography of the rose. This devotional aid reflects the veneration of the Virgin Mary and Christological piety in Catholic religious practice and in female orders in particular. This rosary might have been a memento of her escape from the abbey, recalling a crucial episode in one person's life in the Luther home. Its structure, however, is puzzling. A Catholic rosary usually has 59 beads of two sizes arranged in a symmetrical circle, but Katharina's rosary consists of a total of 118 beads in four sizes. Although half of this number would constitute a double rosary, the irregular arrangement of the beads does not follow any recognizable structure and thus fails to reveal any pattern of prayers. AM

Literature
Joestel 2008, pp. 20 f. (ill.) · Meller 2008, pp. 238–240, cat. E 11 (ill.) · Treu 2010, p. 76

235

Wall Fountain with Bronze Spigot

Wittenberg, Luther House, Collegienstraße 54
1st-half of the 16th century
State Office for Heritage Management and
Archaeology Saxony-Anhalt
Minneapolis Exhibition

236
Wall Fountain

Earthenware, green glazing (with additions)
28 × 18.5 × 9.5 cm
State Museum of Prehistory, HK 667:207:197p

237
Bronze Spigot with Trefoil Grip

Bronze
6.2 × 1.2 × 11.7 cm
State Museum of Prehistory, HK 667:106:2g

Fragments of 22 green-glazed, ceramic wall foun-
tains were found during excavations in the court-
yard of the Luther House. Among these is an
almost completely extant, green-glazed, box-
shaped example with a water tank in the back, a
tap-hole in the front, and with two hooks on each
side to fix it onto pegs on the wall or oven. With
a bowl lying beneath them, they were used for
hand washing before and after meals, but also to
mix ink for writing. The box-shaped cistern fitted
with a removable, pitched roof would be filled
with water, which on festive occasions could
even be scented. A cast bronze spigot plugged
into the tap-hole regulated the water flow. To-
gether with other objects like the inkstands or
pen knife (cf. cat. 239–241), the wall fountains
are physical evidence for the crucial importance
of writing in Luther's household.

The decoration on this fountain shows a crowded
scene framed by two double pilasters and
spanned by a scalloped vault. It is all but obliter-
ated by the figures of the scene it encloses. On
the left, Christ is crucified. His radiant halo
partially obscures the INRI (*Iesus Nazarenus Rex
Iudaeorum*) inscription over his head. Adam's
skull emerges from the earth heap at the foot of
the cross and will be sprinkled with the Savior's
blood. A nude kneeling youth (a sinner) gazes at
the crucified Christ and holds up his folded
hands in prayer. John the Baptist, the bearded
man in penitential garb, looks down at him, with
his left hand resting on the youth's shoulder and
his right pointing to the crucified Christ. In the
background, Moses stands clutching a tablet of
the Commandments in his left and holding up his
right hand in admonition.

Identical compositions are known from Lower
Saxony, but also Nuremberg, where they were
used on stove tiles. This composition, an abbre-
viated version of *Law and Grace* (cat. 185 and

237

186), is of course ideally suited for a water fountain in a Protestant household. A guest washing their hands was confronted with the image of the blood of the martyred Savior washing Adam's bones clean of sin, while simultaneously cleansing her or his own hands. Similarly, metaphorically mixed with the Savior's blood, the resulting ink produced with this water would be well suited to write, translate, and interpret the Gospel.

Up to the first-half of the 19th century, miniscule brass spigots or faucets with conical locking mechanisms were used to regulate the flow of liquids from barrels, tubs, distilling flasks and even water-pipe systems. The shape of their handles varies from zoomorphic to geometric shapes. Two spigots which were most likely used to regulate the water flow from wall fountains were among the finds made in the garden of the Luther House in Wittenberg. This faucet's grip is composed of three rings, a common design at the time. LN

Literature
Kluttig-Altmann 2015 a, pp. 396 f., fig. 50–52 (ill.) · König 2008 · Meller 2008, pp. 284 f., cat. E 114 and 115 (ill.) · Schmitt/Gutjahr 2008, p. 136, fig. 81 (ill.) · Stephan 2008 b, p. 22, fig. 7 (right) and pp. 30 f. fig. 39 a, c (ill.)

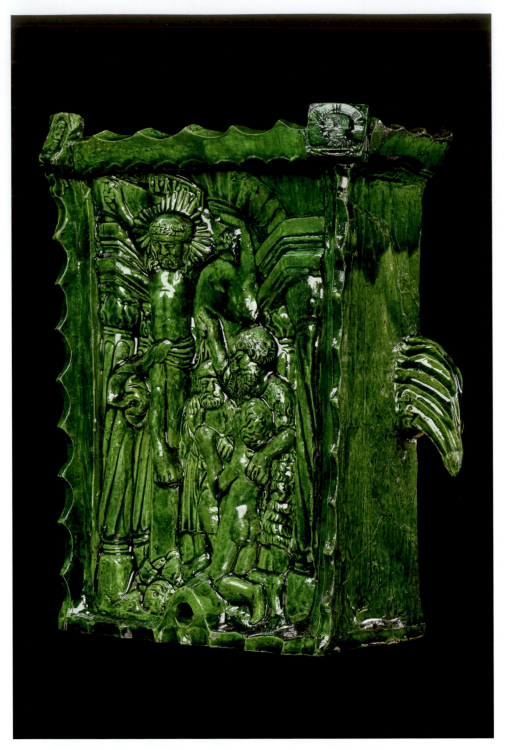

236

Front of a Box-Shaped Wall Fountain with a Depiction of the Crucifixion with the Virgin Mary and John the Evangelist

Wittenberg, Luther House, Collegienstraße 54
1st-half of the 16th century
Earthenware, (interior/exterior) yellow-green glazing
27 × 19 cm
State Office for Heritage Management and Archaeology Saxony-Anhalt
State Museum of Prehistory, HK 592:45:1dx
Atlanta Exhibition

The decoration on the front of this green-glazed wall fountain (cf. cat. 236) shows a Crucifixion scene. Jesus is flanked by his distraught mother and St. John the Evangelist. The sign bearing the mocking inscription INRI (*Iesus Nazarenus Rex Iudaeorum*), or Jesus of Nazareth, King of the Jews fixed to the top of the cross is easily legible. Unfortunately, the panels to the right and left of the Savior, which would have quoted scripture in Luther's German, are all but illegible. The mold that this fountain was cast from was well worn, blurring many details in the design. Quoting scripture reflects the Protestant belief in the importance of the written Gospel, particularly as translated into German by Luther. An important part of the fountain's imagery involves its missing bottom, which would have shown Adam's skull at the base of the cross, just above the tap-hole. The clear message of the picture is that not only were Adam's bones washed clean of original sin by the blood flowing down from the Savior's wounds, but that the grace of Jesus would also cleanse a sinner's hands or flow into the inkwell to inspire a pious author. LN

Literature
König 2008, p. 102, fig. 2 (ill.), Stephan 2008 b, p. 38, fig. 39b (ill)

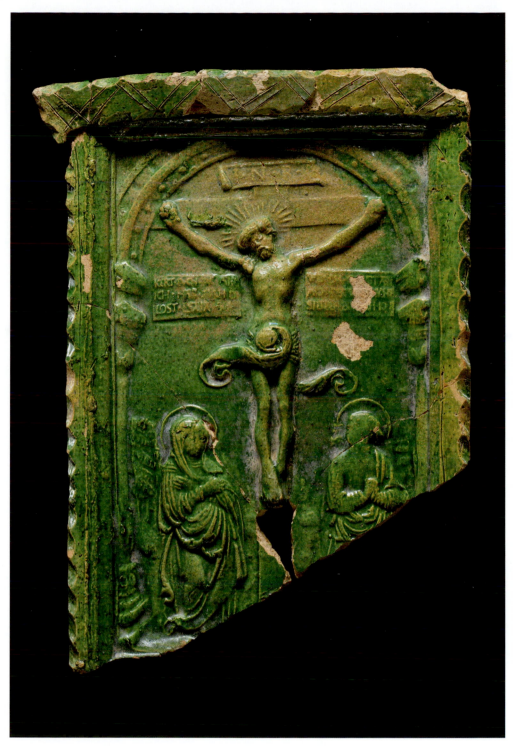

238

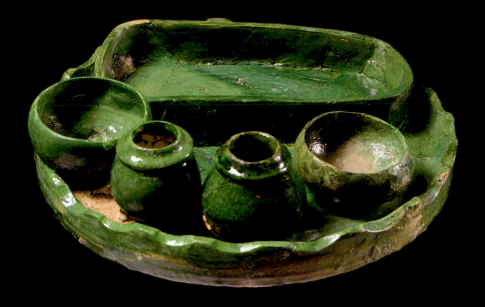

239

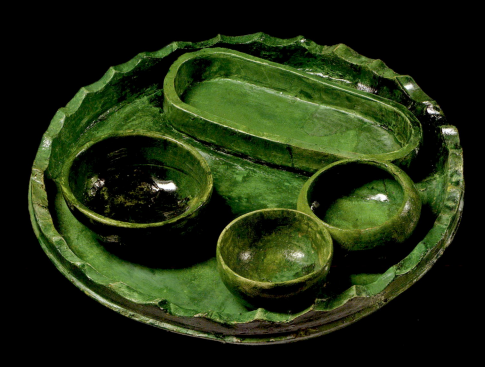

240

241

Two Ceramic Inkstands

Wittenberg, Luther House, Collegienstraße 54
1st-half of the 16th century
Earthenware, green glazing (with additions)
State Office for Heritage Management and
Archaeology Saxony-Anhalt, State Museum
of Prehistory, HK 667:106:57a

239
Plate: H 4 cm, D 22.8 cm
Minneapolis Exhibition

240
Plate: H 2.8 cm, D 23 cm
New York Exhibition

This green-glazed ceramic inkstand includes the
inkwell itself, a small bowl for the fine sand used
to soak up excess ink and to prevent smearing
when the writer's sleeve inevitably brushed up
against the freshly written page, as well as an
oval tub to hold the quills. All are mounted onto
a broad circular tray to keep them from tipping,
spilling, or dripping. Many fragments of such
writing sets survived from the rubbish pit in Lu-
ther's garden, including these well-preserved
examples. They may well have been used by the
Reformer himself. These inkstands were made by
a local potter and sold for a pittance in the mar-
ketplace. In Wittenberg, fragments of such writ-
ing sets were found at various sites, including
places where the Cranach family lived, but most
of them were recovered from Luther's house. To-
gether with finds of wall fountains and pen
knives (cf. cat. 236, 238 and 241), they are
evidence of the enormous written output by the
Reformer and his associates.
The considerable size of these sets makes a col-
orful Luther legend all the more dramatic. The
devil is said to have molested Martin Luther
while he was translating the Bible during his sur-
reptitious stay at Wartburg Castle in 1521. A furi-
ous Luther hurled his ink pot squarely into the
devil's mocking face. The demon disappeared,
and the inkwell crashed against the study's wall,
leaving a gigantic ink stain next to the corner
stove. The dark stain, which was said to be the
result of this encounter, had to be continually
refreshed as it was an enormous tourist attrac-
tion and was constantly chipped away at for sou-
venirs. Today, a crater in back of the oven in Lu-
ther's study in Wartburg Castle marks the spot.
Obviously, this is a thinly disguised parable
about the effect Luther's written polemics had
when he hurled them at his satanic foes. How-
ever, should the ink pot thrown at the demon
have been a substantial inkstand such as the
ones found in the Wittenberg excavations, one
can see why the devil ducked. LN

Literature
Kluttig-Altmann 2015 a, p. 367, fig. 4 · Meller
2008, pp. 296 and 298, cat. E143 (ill.) ·
Schmitt/Gutjahr 2008, p. 138, fig. 83 · Stephan
2008 b, p. 37, fig. 37

241
Handle of a Penknife

Wittenberg, Luther House, Collegienstraße 54
1st-half of the 16th century
Bone
L 10.1 cm; B 0.6 cm
State Office for Heritage Management
and Archaeology Saxony-Anhalt
State Museum of Prehistory, HK 667:106:76a
Minneapolis Exhibition

This find from a pit in the yard of the Luther
House in Wittenberg is most likely the handle of
a penknife. The object is made of bone. It is lan-
ceolate in shape with an almost square cross-sec-
tion and broadens towards one end. At this
thicker end, a small, oval hole has been drilled.
Originally, a metal component would have been
attached here. This component is unfortunately
not extant, but the oval shape of the hole indi-
cates that the object was indeed a penknife. The
knife blade would have been straight, short, and
single-edged in comparison to a kitchen or table
knife.
This type of knife was used, as the name sug-
gests, to cut pens, which could be made from
large feather quills, reeds, and other organic ma-
terials. It is the early modern equivalent of a pen-
cil sharpener, so to speak. The many scratches
on the surface of this handle indicate that this
knife was frequently used, most likely until it
broke. This penknife handle and several others,
all found in the course of the excavations at the
Luther House, as well as the various writing sets
(cat. 239 and 240) and the wall fountain (cat.
238), are only a few of many indications as to the
frequency of writing in the Luther household.
LMcL

Literature
Eule 1955 · Gnaedig/Marquart 2012 · Krüger
2002 · Meller 2008, pp. 296 f., cat. E 142 (ill.) ·
Stephan 2008 b, p. 26, fig. 17 (center)

A Convent Turned Reformer's Home: How did Martin Luther Live?

For more than 30 years, the Luther House, the
former Augustinian convent in Wittenberg,
was the home and headquarters of Martin
Luther. Construction began in 1503/04 at the
command of Frederick the Wise but was never
actually completed. When Luther returned
from his stay at Wartburg Castle in 1522, he
found that the convent had been sacked in
the turmoil of the early Reformation. In spite
of this, he chose to continue living there, as
he would after he married Katharina von Bora
in 1525. The complex became the home of the
couple and their six children (of which four
would live to adulthood). It was gradually
converted into a manor, as Katharina as-
sumed responsibility not only for the kitchen
but also the fields and gardens, the fishery,
the brewery, and eventually the most sub-
stantial herd of livestock in Wittenberg. The
family income was supplemented by Luther's
professor's salary, provided by the electoral
administration since 1525.

The domestic circumstances of the Reformer
can be reconstructed from the impression
given by the preserved wood-paneled sit-
ting room on the first story, as well as the
archaeological finds uncovered on the
grounds of the Luther House. Numerous
stove tiles testify that the house was amply
equipped with tiled stoves, which included
at least one ostentatious example decorat-
ed with polychrome glazed tiles. The re-
mains of some 100 drinking glasses can be
linked to textual mentions of Luther's col-
lection, which was valued (together with
some jewelry) at 1,000 guilders in his will.
Among the most remarkable finds are some
costly faience vessels and filigree glass *à la
façon de Venise*. Such luxury items were
likely brought to Luther as gifts by patrons
or students.

Bones of venison, likely contributed to
Luther's table by his noble supporters, were
found in the archaeological excavations.
Other bones, including the remains of hare,
cow, pig and goat, as well as various kinds
of fish and fowl, allow glimpses of the more
regular eating habits in the Luther House.
The convivial groups who regularly gathered
at the table of the Reformer for his famous
table talks would include his friends, com-
panions and students. The notes recorded
by some participants—often published—are
an important source on the everyday life of
the Reformer, although they need to be ap-
praised critically as they were subsequently
edited. TE

Furniture from the Luther Room

Since Luther's time, the Luther Room, located on the upper floor of the Luther House in Wittenberg, has been a major attraction for visitors from all over the world since it offers an opportunity to come as close as possible to the Great Reformer's world. While the rest of the building has undergone various alterations, this room and its furnishings have been left largely unchanged for centuries as a memorial. The addition of wooden plank walls between 1535 and 1538 created a space that was nearly square-shaped. The present room decor dates back to the early 17th century; in Luther's time, the wood paneling was likely still unpainted. The present coffered ceiling was also presumably added in the early 17th century, at which time the original tiled stove was replaced by the black-glazed tiled stove we see today.

The furniture of the Luther Room has been in its current configuration since at least the early 19th century, although it cannot be ruled out that the items came from different parts of the house. Lithographs of the Luther Room dating back to 1815 depict the room's furnishings in their current positions.

242

242

Door from the Luther Room

16th century
Pine, stained and cut; iron, wrought and engraved; chalk, glass
Chalk inscription: 1712;
glass covering: 19th century
187.5 × 91 × 12 cm
Luther Memorials Foundation
of Saxony-Anhalt, K 6c
Minneapolis Exhibition

The doors and the associated door frames are among the most intricate carvings in the Luther Room. The upper arches, with their carved palmettes and the curved iron hinges terminating in dragon heads, allude to the repertoire of Renaissance-era ornamentation. The door to the eastern vestibule of the Luther Room bears a chalk inscription that was protected at first by a grate and, since the 19th century, by a glass covering. It records the name "Peter" in Cyrillic letters. Reportedly, Czar Peter the Great immortalized himself by writing his name here during a visit in 1712, encouraged by the numerous chalk inscriptions that had already been made. The precise course of events is described by Jacob Stählin, who later worked at the Russian Academy of the Sciences: "The monarch noticed that this wall [featuring an ink blot from Luther's legendary inkwell] was almost covered with names, from top to bottom, and when he was told, in response to his question about the significance of these names, that these were the names of random

strangers who had visited the former residence of Dr. Luther and had written their names as a sign that they had been there, the Czar said, 'Well, then I must write my name as well,' he took a piece of chalk out of his pocket and wrote the name Peter in Russian letters next to the aforementioned ink blot." However, the inscription must have been traced over later on, thus sharing the same fate as the alleged ink blot in the Luther Room as well as at Wartburg Castle, which has also been "refreshed" numerous times. As the Czar himself remarked during a visit, "could be, but the ink is fresh." MG

243

Table from the Luther Room

16th century, additions in 19th century
Pine, partially carved, table top: pine, coated with birch
83 × 136 × 124 cm
Luther Memorials Foundation
of Saxony-Anhalt, K 6a
Minneapolis Exhibition

The heavy table is certainly the most prominent piece of furniture in the Luther Room, and is, after all, associated with Luther's famous gatherings and table talks, which were reflected in the *Colloquia* published by Aurifaber in 1566. Whether the table and chair are in their original positions in the Luther Room, however, remains uncertain. The form and design of the table are typical of Renaissance furniture, as was especially popular in southern Germany and in the Alpine region. A retractable table top covers a

broad and simple cabinet with inner compartments for drawers, which have since been lost. This cabinet is supported by a pinewood frame whose legs are connected by two wedged bars. The two baseboards lying on the legs were either added later or, at least, have been replaced with later models. Both on the sides and in the interior of the cabinet (where it is written upside down), some chalk graffiti has survived, which was otherwise almost entirely eliminated when the Luther Room was transformed into a museum in the 19th century. The dates accompanying the names range from the second-half of the 18th century to the mid-19th century. The table surface also shows signs of earlier visits to the museum: the many notches and incisions there testify to the tradition of obtaining permanent souvenirs of the Reformer's residence by taking home slivers of Luther's furniture. MG

244

Window Seat from the Luther Room

16th century, with significant modifications in the 19th century
Pine, carved and turned
120 × 118 × 52 cm
Luther Memorials Foundation
of Saxony-Anhalt, K 6b
Minneapolis Exhibition

The window seat which is now placed near the eastern bay of the Luther Room was presumably located elsewhere in the Luther House and only moved to its current position when the room was

transformed into a museum. This is indicated by its dimensions, which do not fit the much broader bays of the Luther Room. Made of pine wood, the double seat with a curved double volute as its right backrest presumably served as a place to work by the window, so as to take advantage of the meager sunlight, e. g. for needlework. However, with its side compartments underneath the two opposite seating surfaces, it also allowed for the storage of small household objects. The doors to both opened to the outside, via a set of two curved and wrought hinges. The double pitch-faced surface of the two doors, separated by a horizontal bar, is mirrored in the wrought iron knobs and in the decorative pegs, featuring heads that are likewise pitch-faced. The latter can also be found on the two armrest fragments. In both sections, the armrests, which are decorated with a frieze, are supported by turned round moldings (two on the left; originally three on the right, of which only two survive). Here as well, chalk graffiti from the 19th century survives.
MG

Literature
Joestel 1993 b, pp. 240–245 · Laube 2003, pp. 93–99 and 108–111 · Neser 2005 · Treu 2010, pp. 85–87, fig. 4

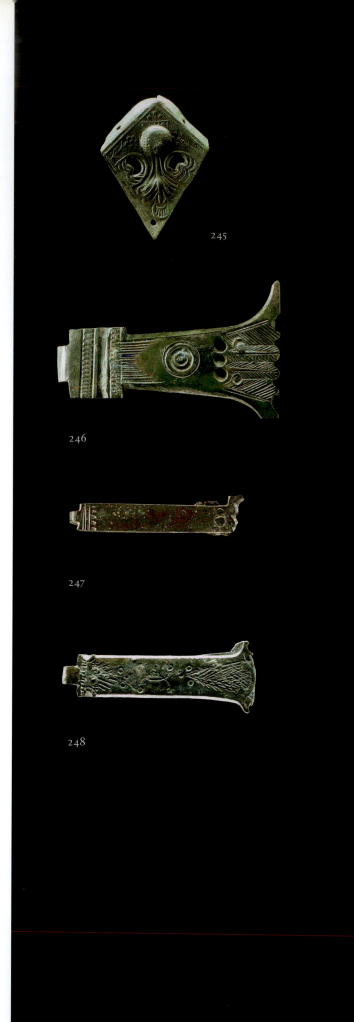

245

246

247

248

Fittings and Clasps from Book Covers

Wittenberg, Luther House, Collegienstraße 54
1st-half of the 16th century
Copper alloy (bronze), partially engraved
State Office for Heritage Management and
Archaeology Saxony-Anhalt
Minneapolis Exhibition

245
Corner Fitting from a Book Cover

L 3.4 cm; width 2.7 cm
State Museum of Prehistory, HK 667:106:2a

Three Clasps from a Book Cover (fragments)

246
L 5.5 cm, max. width 4 cm; H 0.5 cm
State Museum of Prehistory, HK 667:106:2e

247
L 4 cm; width 0.7–1 cm
State Museum of Prehistory, HK 667:106:241b

248
L 4.5 cm; width 1.5 cm; H 0.4 cm
State Museum of Prehistory, HK 667:106:71f

Books continued to be regarded as objects of great value in the decades following the invention of printing with moveable type, in spite of the much larger quantity of editions that had then become possible. The production of books was still a laborious and expensive process, and thus the requirement to make each individual volume as durable as possible to withstand the rigors of long-term use persisted.

Purely by coincidence, Wittenberg had evolved into the foremost printing center of Germany with the emerging Reformation movement. Books produced in Wittenberg in the 16th century were usually protected by metal clasps and fittings, as was traditional in the Medieval and Early Modern periods. Flat diamond-shaped fittings were fixed to the corners of the book's leather-wrapped wooden covers with the help of small holes and nails that pierced the tips and the small flanges at the side of the fitting (cat. 245). The clasps were made of metal hooks and eyes that were riveted onto leather straps. These helped to keep the books, which were often large, heavy and tightly bound, from opening under pressure or by accident (cat. 246–248).

Images from the 15th and 16th centuries show that books were not always stored according to our modern practice, with the spine facing a user standing in front of the bookcase. Instead, they were often stacked horizontally, or stood on their fore edge with the spine facing up. Small embossed projections on the corner fittings would help keep the book raised off of potentially dirty tabletops or other surfaces during reading. Frequent use would often abrade these bosses so that until only circular holes in the fittings would remain. This kind of wear is observed in the Wittenberg finds. In general, the fittings and clasps, which are often decorated in a geometrical or floral relief patterns, tend to be remarkably similar across a wide area of distribution. Research has yet to determine the locations where they were actually produced. Finds of such fittings from archaeological excavations tend to be quite rare, even in a printing town such as Wittenberg, which was already home to several private and public libraries in the 16th century. This is mostly due to the fact that books seldom ended up in refuse dumps like other mundane items, such as crockery. In addition, metal objects were generally recycled for their material value. Nevertheless, the numerous fittings and clasps that have been found in Wittenberg are still a rare find considering the large amount of books that must have been in circulation in this literate community. The finds were discovered in several locations, including the Luther House, the site of the *Collegium Fridericianum* (Frederick's College), the home of the Cranachs at Schloßstraße 1, the municipal school of 1564 at Jüdenstraße 38, and several homes of private citizens. RKA

Literature
Adler 2010 · Adler/Ansorge 2006 · Fuchs 2014 · Kluttig-Altmann 2015 a, p. 367, fig. 5 · Lang 2014 a · Meller 2008, pp. 298–300, cat. E 144 (ill.) · Stephan 2008 b, p. 21, fig. 6

Fig. 7
For similar clasps from a book cover cf. cat. 366

Unguentaria

Wittenberg, Luther House, Collegienstraße 54
1st-half of the 16th century
Stoneware
State Office for Heritage Management
and Archaeology Saxony-Anhalt
Minneapolis Exhibition

249
H 4.8 cm; D max. 3.2 cm
State Museum of Prehistory, HK 667:62:18

250
H 5.3 cm; D 3.1 cm
State Museum of Prehistory, HK 667:207:197c

251
H 6.5 cm; D 5.4 cm
State Museum of Prehistory, HK 667:207:197d

252
H 5.3 cm; D 3.1 cm
State Museum of Prehistory, HK 667:207:197e

253
H 7.1 cm; D 5.2 cm
State Museum of Prehistory,
HK 2005:22040 (667:106:50)

These five small vessels were found in the yard of the Luther House in Wittenberg. They are very well preserved, most of them almost completely extant or with only a few fragments missing. The vessels have a very small holding capacity. This indicates that their content was only dispensed in very small quantities, as it was either perishable or very costly and was only produced in very small quantities. The vessels were mass-produced products, made on a pottery wheel.

Among the vessels here two types can be differentiated: a slightly conical to bag-shaped type with a wide mouth, and a flask-shaped type with a narrow mouth. The conical to bag-shaped type increases in width to a pronounced foot and the mouth of the vessel has a curved lip. The flask-shaped type is only represented here by one object. The mouth of the vessel has a thickened lip, a high transition from neck to shoulder (forming the widest part of the vessel), and tapers down to a flat bottom. The pronounced lips of the vessels assist in covering the mouths of the vessel. To cover the container, a piece of parchment was placed over the mouth of the vessel und then tied down with thread below the lip. The lip thus prevented the thread from slipping. This method of covering vessels was also used with larger stoneware vessels and was continued up to the modern age for certain types of vessels.

249

250

251

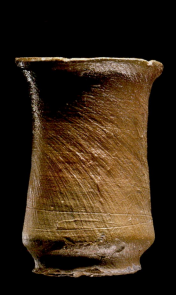

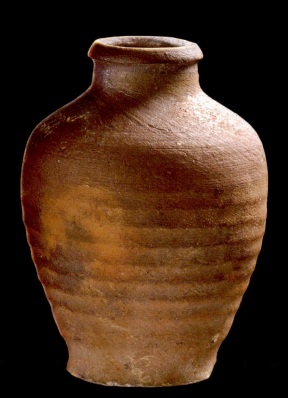

252

253

The technical terms for these small vessels, which are referred to as (apothecary) dispensing vessels or unguentaria, give an indication as to their function, usage and possible place of issue. Medicinal products such as pastes, salves, oils, or healing powders were sold to customers at the apothecary in these vessels, and they held their contents in these vessels. The different shapes of the vessel potentially indicate that oils and other liquid products were kept in the flask-shaped vessels and pastes, salves and powders were kept in the conical to bag-shaped ones. Due to the medicinal nature of the contents it is possible that the vessels were not re-used. This would be a possible explanation for the high incidence of finds of these objects, making them an early modern example of throw-away packaging. Another explanation for the high incidence of finds of these vessels at the Luther House could be a high consumption of apothecary products. Perhaps this is a reflection of Martin Luther's many illnesses and frequently being unwell. It is possible that the Luther household purchased these dispensary vessels at the Cranach apothecary at Schloßstraße 1 in Wittenberg, which had been owned by Lucas Cranach the Elder since 1520. LMcL

Literature
Hennen 2015 a · Kranzfelder 1982 · Meller 2008, pp. 302 f., cat. E 147 · Neumann 1995 · Scheidemantel/Schifer 2005

254 255 256

Fragments of Glass Goblets (*Nodi*)

Wittenberg, Luther House, Collegienstraße 54
1st-half of the 16th century
Colored and discolored glass
State Office for Heritage Management
and Archaeology Saxony-Anhalt
Minneapolis Exhibition

254
L 3.7 cm; D 2.4 cm
State Museum for Prehistory, HK 667:105:19f

255
L 3.5 cm; D 2.8 cm
State Museum for Prehistory, HK 667:106:73b

256
L 3.4 cm; D 2.0 cm
State Museum for Prehistory, HK 667:106:73b

These three fragments are from the stems of several colored glass goblets, two blue goblets and one discolored goblet. Due to their knot-like appearance, these fragments are called "nodi" (knots, in Latin). They decorated the stems of elaborate glass goblets (cat. 257 and fig. 8). The uncolored fragment has an additional s-shaped decoration on the lower of its two coils. One of the blue fragments still retains a small portion of what may have been part of a bell-shaped foot or a portion of the cup.

All three fragments were found in the course of the excavations at the Luther House in Wittenberg. The multi-colored shimmering of these fragments is due to their deposition in the soil. Unfortunately, it is not possible to reconstruct the appearance of the original goblets from the fragments. Their presence among the finds of the Luther House does, however, allow for some general statements: It is unlikely that these fragments originally belonged to goblets produced in Venice or made *à la façon de Venise* (in the Venetian style). The coloration and craftsmanship indicates that they were the products of local glass workshops. As early as the twelfth century, flourishing regional glass production had been established north of the Alps. At the same time, the presence of such regional glass in the Luther household is significant. Glass tableware and the imitations of Venetian glasses were expensive and thus precious. Regionally produced glass was much more affordable, but it is unlikely that these goblets of blue and discolored glass were used as everyday tableware. Their presence in the Luther house thus remains an indicator of a certain level of wealth in the household of Martin Luther. LMcL

Literature
Dreier 1989 · Meller 2008, pp. 266 f., cat. E 79 · Ring 2003 · Stephan 2008 b, p. 69, fig. 84 (2nd from bottom) · Steppuhn 2008

Fig. 8
Glass goblet with a round, knobbed stem,
mid-/2nd-half of the 16th century

257

Latticino Goblet

Venetian, around 1530
Glass
H 26 cm
Glass, colorless, with filigree ornament
Minneapolis Institute of Art, gift of Chichi
Steiner and Tom Rassieur in memory of Mary
Orear Terry, 2013.39.2
Minneapolis Exhibition

Excavations at Luther's Wittenberg home turned
up many bits of broken glass. In some of the
pieces, white lines are apparent within clear, col-
orless glass (cat. 258). Those are fragments of
valuable imported luxury vessels similar to this
rare surviving item, a goblet made in Murano
around 1530. In 1291, as a fire safety precaution,
the glassmakers of Venice were ordered to move
to Murano, a small cluster of islands about a mile
north of the city's main body. In this confined
space, their craftsmanship flourished, and their
products were in demand even in distant lands.
The *latticino* (referring to the milky white color)
decoration at the knob and the foot was newly
introduced and became a cutting-edge fashion
in Luther's lifetime. Rods of opaque white glass
were fused with the clear glass, twisted and
formed into complex shapes such as this goblet.
It took specialized knowledge, skilled hands,

257

plenty of fuel for lamps and furnaces, considerable time, and very careful handling to get such objects into clients' hands. One suspects that Luther received his best glassware as ceremonial gifts and that some blasphemous words crossed lips on the days such wares were reduced to shards.

Although this glass has long been regarded as a goblet, the closest comparison to its shape and decoration is a *Reliquary Vase and Cover* at the Museo Vetrario in Murano. This raises questions, such as whether this vessel is a reliquary that has lost its lid and whether certain shapes were used for multiple purposes. TR

Literature
Dorigato 1986, p. 82 · Mariacher 1963, p. 95, pl. A · Theuerkauff-Liederwald, Glas, p. 279, cat. 267

258

Seven Fragments of Filigree Glass
à la façon de Venise

Wittenberg, Luther House, Collegienstraße 54
1st-half of the 16th century
Glass, colorless, with filigree ornament
D. base: 8.7 cm
L max. 5.4 cm; W max. 3.1 cm
State Office for Heritage Management and Archaeology Saxony-Anhalt
State Museum of Prehistory, HK 667:106:73k
Minneapolis Exhibition

Unlike ceramic vessels, which were basic household goods, glass vessels were indicators of their owner's wealth in the Early Modern era. Three different varieties of glass can be identified in the period. Rustic forest glass, whose simpler production process resulted in a more or less green hue, was used for everyday vessels such as bottles, simple drinking glasses, leech cups and alchemical implements (cat. 139 and 140). Colorless glass demanded a more controlled production process and was mainly reserved for tableware or window panes (cat. 9 and 10). The pinnacle of glass production was so-called filigree glass, which consisted of glass threads of various colors sandwiched between layers of clear glass. In a complex process, a body of colorless glass was made first onto which filaments of white or colored glass were laid and which were then covered with another layer of clear glass. In the end, the entire package was fused together.

At the beginning of the Early Modern era, the production this particular kind of glass was centered on the Venetian island of Murano, from where it was traded far and wide as a luxury product. This monopoly was soon undermined

258

when Venetian artisans escaped the tight control on their production and took their knowledge to other European localities. The successful establishment of filigree glass production is first documented in France and the Netherlands, but it had spread to Bohemia, the Ore Mountains (Erzgebirge) region and many other places in Central Europe by the end of the 16th century. While this wave of imitations swamped the Venetian production, these copies soon became accepted as luxury vessels in their own right. Because of their exceptional quality, these glasses (*latticino*) *à la façon de Venise* (in the Venetian style) were much esteemed as representative drinking or serving vessels. Typical shapes were cylindrical beakers or covered goblets.

The fragments of such glass vessels from Wittenberg, which are shown here (and for which a provenance from Luther's household may be

assumed), are early examples of high quality filigree glass made using the canework technique. Considering the early date and the high quality of some pieces, they may even have been imported originally from Venice or northern Italy. The fragments can be reconstructed as belonging to several tall beakers, from which quantities of beer or wine would have been quaffed. RKA

Literature
Eichhorn 2014 b · Henkes 1994 · Meller 2008, pp. 270 and 272, cat. E 86 (ill.) · Ring 2003 · Stephan 2008 b, p. 70, fig. 86 (ill.) · Steppuhn 2008, p. 131–142

Faience Bowl

Wittenberg, Luther House, Collegienstraße 54
1st-half of the 16th century
Faience, bright fragments, cobalt blue decoration (added)
H 4.1 cm; Opening: 10.5 cm
State Office for Heritage Management
and Archaeology, Saxony-Anhalt
State Museum of Prehistory, HK 667:106:42
Minneapolis Exhibition

Faience pottery, originally produced in Faenza, Italy, is tin-glazed pottery richly painted with underglaze colors, and it was part of the standard equipment of well-to-do upper middle class households in the 16th century. However, there have been virtually no archaeological discoveries of this kind of pottery north of the Alps. This makes it all the more remarkable that a small faience bowl was found at the Luther House in Wittenberg. With its white glaze, blue paint and stylized plant decoration consisting of simplified leaves and vines with double circle (*alla-porcellana*-decoration), this piece is similar to the large plates decorated with alliance coats of arms owned by patrician families in southern Germany, who purchased these pieces from workshops in northern Italy between 1510 and 1540. However, the form, decoration and style of the Luther House faience bowl are ultimately modeled on the blue and white Chinese porcelain of the Ming Dynasty period, the influence of which extended beyond the Ottoman Empire to pottery workshops in northern Italy. This vessel likely came to the Luther household as a valuable gift, together with the faience jug from Iznik, Turkey (cat. 260). The Reformer may have received this pottery, like he did many other unique pieces before it, from his friend of many years, Wenzeslaus Link. For example, Luther expressed his thanks to Link in August 1528 for sending him "samia vasa" (vessels from Samos), a term first used early in the 2nd century BC by Plautus to refer to a type of pottery which is unknown today, and which Luther may have used here as a learned allusion to these vessels that seemed exotic to him. MG

259

Sources and literature
Meller 2008, pp. 258–260, cat. E 67 · Stephan 2008 b, p. 27, fig. 19 · WA.B 4, 538 (no. 1308)

Neck of Vessel Reconstructed from Fragments of a Faience Jug from Iznik

Wittenberg, Luther House, Collegienstraße 54
1st-half of the 16th century
Faience, painted/glazed (reconstructed)
8.2 × 8.5 cm
State Office for Heritage Management
and Archaeology Saxony-Anhalt
State Museum of Prehistory, HK 667:106:45
Atlanta Exhibition

260

One of the most surprising discoveries made in the rubble in the backyard of Luther's house were these colorful yet seemingly nondescript sherds from the neck of a polychrome jug, decorated with a floral pattern. They belong to a little jug made in Iznik, Turkey, which produced exquisite Chinese- and Persian-inspired pottery for the ruling class of the Ottoman Empire between the 15th and 18th century. This jug, which is the first of its kind found in an archaeological excavation in Germany, dates to the early-16th century and was probably given to the Reformer as a precious gift from one of his many wealthy supporters.

One wonders whether Luther was aware of the origins of this piece, as it might have evoked highly ambiguous reactions in him had he done so. On the one hand, Luther was writing highly polemic diatribes against the Turks, their Muslim religion and their Empire. He was particularly alarmed by the seemingly unstoppable westward expansion of the Ottoman Empire. On the other hand, he would, as a humanist scholar and theologian, have been aware that Iznik was ancient Nicaea in whose basilica the Nicene Creed was promulgated in 325 AD. Luther saw this creed as a crucial early witness to the Christian faith and approved it for use in Protestant Church liturgy. Whether Luther was aware of their origins or not, this handful of sherds does much to highlight the crises faced by Europe in Luther's day, and the entanglements between the past and present which helped form the consciousness of the Renaissance. LN

Literature
Carswell 1998 · Meller 2008, p. 260, cat.
E 69 (ill.) · Stephan 2008 b, p. 28, fig. 21

Fig. 9
Jug from Iznik, Faience, mid-16th century

Polychrome Stove Tile with the Palatinate's Coat of Arms

Wittenberg, Luther House, Collegienstraße 54
1st-half of the 16th century
Earthenware green, blue, white and brown glazing
19 × 16 × 3.4 cm
State Office for Heritage Management and Archaeology Saxony-Anhalt
State Museum of Prehistory, HK 667:106:63k
Minneapolis Exhibition

The motif on this polychrome tile, an escutcheon with blue and white rhombus fields quartered by rampant lions, is the coat of arms of the Electoral Palatinate (Kurpfalz). It is framed by a Renaissance-style architectural frame with square columns, a low vault, and a tapering tiled floor. Perhaps the polychrome stove in Luther's house once displayed the coats of arms of all seven electorates, but the more likely possibility is that the oven was donated by a patron from the Palatinate's princely house of Wittelsbach, Otto Henry, Elector of the Palatinate (1502–1559). In fact, Otto Henry was in Wittenberg in 1536, where he became interested in the Reformation. He converted to Lutheranism in 1542, and upon becoming Elector of the Palatinate in 1556, he introduced Lutheranism to his domains. This intellectual Elector headed a brilliant court from his capital in Heidelberg, but unfortunately he died only three short years later. His coat of arms may simply have been chosen by the Luthers to commemorate the affiliation of this potentially, vitally important prince to the Protestant cause. These hopes, however, were misplaced. The prince, while a gifted scholar and patron of the arts, was a spendthrift glutton, who failed miserably in his attempt to halt the resurgence of imperial power and Counter-Reformation in the mid-16th century. The presence of his coat of arms on Luther's polychrome stove demonstrates both the highly political nature of the Reformation and the surprising fact that imagery reflecting profoundly political events were integrated into the Reformer's domestic environment.
LN

Literature
Meller 2008, pp. 277 and 279, cat. Nr. E 101 (ill.) ·
Schwarz 2008, p. 216, fig. 5

261

262

Polychrome Stove Tile Depicting Eve

Wittenberg, Luther House, Collegienstraße 54
1st-half of the 16th century
Earthenware, green, blue, white and brown glazing
18.8 × 15.9 × 4.2 cm
State Office for Heritage Management and Archaeology Saxony-Anhalt
State Museum of Prehistory, HK 667:106:63f
Minneapolis Exhibition

This polychrome tile shows the bust of a colorfully dressed young woman. It is strangely inscribed with the name "Eva" and an enigmatic "H" and framed by an elaborate arch. The tile was part of the décor of an ostentatious stove that included portraits of biblical rulers, coats of arms, and a sculptured crest. Fragments inscribed with the year 1536 help to date the construction of this masterpiece, which must have featured prominently in Luther's household. Interestingly, identical tiles were found in the palace of one of Luther's most powerful opponents, Cardinal Albert of Brandenburg, in Halle (cat. 263 and 264).

While in some cases the origins of the motifs on these polychrome oven tiles are obscure, this particular Eve is copied almost exactly from the print *Twelve Women of the Old Testament* by the prolific Nuremberg woodcutter and printer Erhard Schön (1491–1592) around 1530. In fact, since

Fig. 10
Eve, detail from: Erhard Schön, Zwölf Frauen des Alten Testaments (12 Women of the Old Testament), around 1530

the printed image was traced directly onto the mold, the image on the tile produced is thus a mirror image of Schön's Eve.

The Eve in Schön's woodcut and on the Luther House stove tile is a beautiful young woman with long tousled hair. She is, unusually, shown fully clothed. Her rustic costume, an animal hide with a shaggy collar gathered together by the sticky tendrils of a hop vine, demonstrates her unkempt, wild state after the expulsion from paradise. In her right hand she holds an apple, her sad attribute and the agent of man's fall, which the tile maker has reduced to a golden ball. Eve is shown contemplating Adam's pearly white skull, which she cradles in her left hand and eyes with a rueful gaze, which is a detail that would have evoked more complex associations in the minds of those warming their hands on this magnificent stove. On the one hand, by bringing sin into the world, Eve has subjected mankind to the dominion of death, symbolized by the skull. Thus her beauty will be transient, as she will also die. On the other hand, Adam's skull will come to lie beneath Jesus' cross and be washed clean of sin by the Savior's blood. Thus, this depiction of Eve symbolizes both humanity's doom and salvation. LN/SKV

Literature
Crowther 2010 · Geisberg 1974 · Meller 2008, p. 277, cat. E 100 and p. 283, cat. E 109 · Schwarz 2008, p. 213, fig. 2

Two Polychrome Stove Tiles with Depictions of Women of the Old Testament

Bad Schmiedeberg
Around 1530 to 1540
Earthenware, polychrome lead and tin glaze

263
"Eve" Tile

18.5 × 15.7 × 2.5 cm
Stiftung Dome und Schlösser in Sachsen-Anhalt, Kunstmuseum Moritzburg Halle (Saale), MOKHWKE00128
New York Exhibition

264
"Rebecca" Tile

18.5 × 15.9 × 5.5 cm
Stiftung Dome und Schlösser in Sachsen-Anhalt, Kunstmuseum Moritzburg Halle (Saale), MOKHWKE00231
Minneapolis Exhibition

263

264

The two tiles shown here belong to a group of twelve such half-portraits that were based on series of graphic images from 1530. The *Twelve Women of the Old Testament* were created by Erhard Schön. Each of the female figures is depicted facing left and furnished with various attributes. The women are also surrounded by lavish architectural frames of an early Renaissance style. The columns to each side of the portrait are made up of three different colored zones, and they support a low coffered arch or vault and a denticulated frieze. This frame differs slightly on both of the tiles, but the construction of the central image and the color schemes are identical. While the outer frame of each tile is glazed green and the background honey-yellow, the architectural parts are glazed in medium blue, white or honey-yellow glaze. The clothing in the portraits is cobalt blue with honey-yellow trimmings and accessories.

Captions below the portraits identify the subjects. The half-figure portrait of the biblical Eve, clearly marked by the caption "EVA H," is described in detail elsewhere (see the identical tile find from the Luther House, cat. 262). With regard to its style and technical features, this tile can be compared with another example in the catalogue (cat. 265), which depicts a prince holding an arrow. It has an architectural frame that is basically identical to that of our Eve, differing only in the color scheme of the glazes. The second female portrait on display wears a typical contemporary Renaissance dress of the 1520s and 1530s. She is identified as another heroine of the Old Testament by the caption "REBECA." The sleeves of her dress are slit and puffed, her bodice tightly laced and her collar stiffened. On her head, she wears a white headdress. Rebecca's left arm rests lightly on a bannister; while her right holds a handled jar conspicuous for is antique shape and decoration. This pose is a compromise between the full portraits of Schön's original pictures, where Eve and Rebecca hold their respective apple and jar at knee height, and the constraints of the reduced half-portraits on the tiles. Magnificent tiled stoves once formed a part of the lavish furnishings of Moritzburg Castle, the seat of the Archbishops of Magdeburg in Halle. Even though this residence was destroyed during the Thirty Years' War, recent construction work on the site has turned up some fine examples of these masterful tiles. They can likely be attributed to the refurbishing measures that Cardinal Albert of Brandenburg ordered to increase the representative splendor of his residence. Without a doubt, the sumptuous colors and the picturesque effect of the relief on these tiles testify to the high standards that this prince demanded.

A pottery center was recently documented in Bad Schmiedeberg, and its find material includes fragments of this very same type of tile, albeit with different motifs. Ironically, the excavations in Luther's home in Wittenberg have also turned up such tiles, indicating that the Reformer and the cardinal had at least one thing in common: their taste in interior decoration. Further examples of this type of tile have also been found at other sites in central Germany, so that we can safely assume their motifs to have been universally popular. PJ/RKA

Literature
Kluttig-Altmann 2015 d · Meller 2008, p. 282, cat. E 109 (ill.) · Schauerte/Tacke 2006, pp. 258–261, cat. 147 (A and B) (ill.) · Stephan 2008 b, p. 58, fig. 67

265

Polychrome Stove Tile Depicting a Prince

Wittenberg, Luther House, Collegienstraße 54
2nd-quarter of the 16th century
Earthenware, polychrome glazed
(with additions)
19 × 16 × 6.4 cm
State Office for Heritage Management and Archaeology Saxony-Anhalt
State Museum of Prehistory, HK 667:106:63d
New York Exhibition

It is difficult to identify the person depicted on this stove tile from the second-quarter of the 16th century, as the usual scroll on the lower part which would have borne the caption is missing. Several different interpretations are possible for this image of a man dressed in a noble's garb, with an arrow or crossbow quarrel held in his hand. There is the comparable depiction of King Ahab in an illustrated series published by Erhard Schön in 1531, *A Tableau of Infamy: The Twelve Tyrants of the Old Testament*. An identical ornamental border has turned up on a tile from the very same find site, but this example frames a portrait of the biblical Eve (cat. 262 and 263). The fragments of other tiles, of similar make but with different frames, are adorned with portraits of other "tyrants" such as Abimelech and Adoni-Bezek. All things considered, an interpretation of the piece shown here as a (fictional) portrait of Ahab would fit in nicely with the find context of the site.

Alternatively, it is possible to see a contemporary personage in the tile, perhaps the imperial archmaster of the hunt, the Margrave of Meissen. This interpretation is supported by the man's cap and chain of office, which denote a princely status, while the arrow or quarrel was often used in comparable images either as a symbol for a hunter or a ceremonial attribute of a commander. Hunting was taken very seriously at the court of the Electors of Saxony, scions of the Wettin dynasty who had held the office of imperial archmaster of the hunt since 1350. As this particular style of cap was also used as a symbol of judicative power, the depicted might also be Elector John Frederick I in his role as the supreme judge within his domains.

Polychrome tiles were manufactured in central Germany from before 1500 to around 1550. The bulk of the tiles were glazed in green, both before and after this period and in parallel with the polychrome versions. Polychrome tiles were considered a luxury, and have been found on only a few sites in Wittenberg, particularly in the Luther House, in the vicinity of the castle, and in a few houses of wealthy citizens, such as the Cranach family. Series of tiles with figures from the Old Testament seem to have been preferred initially, but as Reformation and Renaissance ideas spread, subjects from the New Testament and humanist allegories also became popular.

By a happy coincidence, one of the polychrome tiles found in Luther's house bears the date 1536, confirming the written information we have for a refurbishing of Luther's parlor in the very same year. As stoves of a similar quality were also found in the castle at Wittenberg, and as the Electors of Saxony are known to have supported the Reformer with material donations, it is conceivable that John Frederick the Magnanimous ordered one of these stoves to be set up in Luther's home. The tile shown here may have been a part of this friendly gift. RKA

Literature
Böckem 2013 · Kluttig-Altmann 2015 d · Meller 2008, pp. 278 f., cat. E 102 (ill.) · Schmitt/Gutjahr 2008 · Stephan 2008 b, p. 57, fig. 66

266

Polychrome Stove Tile Depicting a Dancing Couple

Bad Schmiedeberg, "Alte Gärtnerei"
After 1535
Earthenware, glazed
28.5 × 18 × 4.3 cm
State Office for Heritage Management and Archaeology Saxony-Anhalt
State Museum of Prehistory, HK 802:123:1146
Minneapolis Exhibition

The 16th century was, of course, not only a period of religious fervor and armed conflict: people also had fun, like this fancy couple depicted on a stove tile, who are probably shown attending a formal dance. The potter would have been familiar with popular prints of dancing dandies and their sumptuously dressed consorts, such as those engraved by Hans Schäufelin in 1535 (Reetz 2014, p. 214 fig. 12), when he fashioned this pretty tile. With others like it, it would have embellished the upper registers of an ostenta-

265

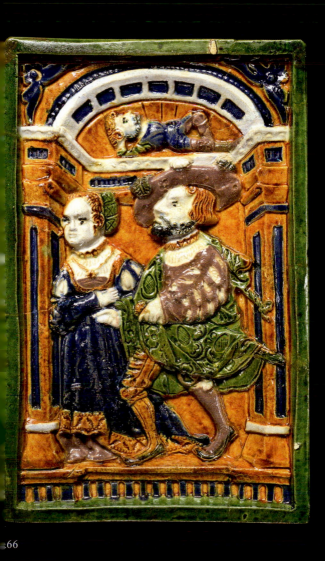

266

tious stove in a wealthy burgher's or nobleman's living room. Less fortunate customers had to settle for the more basic, green-glazed versions.

Unlike many other reformers, Luther had nothing against dancing and loved music as well as good food and drink; his followers would not have felt any pangs of conscience about enjoying festive occasions.

The gentleman's sword and the lady's jewelry suggest that the merry couple on this stove tile is of noble social status. Both are dressed in the typical, multi-layered, heavy costumes of the time. A period of well-below normal temperatures known as the Little Ice Age reached its peak during this period, making warm clothing and effective stoves a must.

This tile was found with other potter's waste in a refilled sandpit during an excavation in 2005 by the State Office for Heritage Management and Archaeology Saxony-Anhalt on the outskirts of Bad Schmiedeberg. This small town lies 25 kilometers south of Wittenberg, surrounded by the heavily forested, sand- and clay-rich hills of the Düben Heath. Bad Schmiedeberg is now a quiet resort town in the midst of idyllic woodland. Between the late-14th and early-16th centuries, however, it was a bustling industrial potters' and brick-makers' town. Its kilns supplied much of central Saxony, and in particular Wittenberg, with pottery, stoneware, and bricks. Like Renaissance glass makers, potters were forced to live on marginal land in order to quarry for clay and sand and harvest endless amounts of firewood to feed their roaring kilns. They then travelled long distances to hawk their wares in the bustling market squares of Saxon towns.

The Luthers, who were fortunate enough to own a prestigious polychrome stove, would have seen the oily brown smoke plumes of the Schmiedeberg kilns billowing above the hilltops when they looked southeast across the Elbe valley from the upper floors of their stately Wittenberg home. Moreover, they would have heard the raucous cries of the potters' wives hawking their wares when they crossed the market square to visit the Elector's palace or the town church. LN

Literature
Kluttig-Altmann 2015 d, p. 286, fig. 83 · Reetz 2014, pp. 205–215, fig. 12

267

duction of tools and technical instruments was a flourishing business in the 16th century.

In taking up a craft, Luther was following the fashion that was spreading through the princely houses of Europe and was apparently initiated by royal paragons like Duke Philip the Good of Burgundy and Emperor Maximilian I. Certain kinds of crafts were considered to be socially acceptable pursuits for members of court, including rather ordinary activities like metalworking, smithery and turnery, especially if they involved expensive new equipment and valuable materials. For sovereigns, these activities served as a means of depicting their mastery over nature and representing princely power. Turning tools, as well as self-made pieces, were frequently given by sovereigns as valued gifts. Luther's overlord, Frederick the Wise, is said to have given handmade crossbows, quarrels (square arrows for crossbows) and rosaries as gifts for his friends and favorites. MG

Sources and literature
Meller 2008, p. 236 cat. E6 · Paravicini 2005 · Stephan 2008 b, p. 24, fig. 14 · WA.B 4, 149 (no. 1065)

268

268

Strap Buckle

Wittenberg, Luther House, Collegienstraße 54
1st-half of the 16th century
Brass
5 × 7 cm, D 1.6 cm (buckle)
State Office for Heritage Management and
Archaeology Saxony-Anhalt
State Museum of Prehistory, HK 667:24:4ag
Minneapolis Exhibition

This beautiful clothing accessory was cut out of a larger brass sheet, which had been stamped with floral ornaments. After being wrapped around the buckle it was bent back and riveted on to a leather strap that could have been used as a belt or shoe strap. Elegant, thin belts with the thin strap ends, sometimes sporting tassels, slipping over the hips, and with elaborate buckles were used to gather the high-waisted, girthed dresses of the late-15th century. In the 16th century, the heavy brocade robes of the times were held together by a laced bodice. Decorative straps were only sporadically used, for instance to tie a purse around a woman's waist. Elegant clothing accessories like this are a reminder that Luther's family household was indeed different from the frugal, male, monastic society into which he moved. Moreover, the women of Luther's household were clearly part of the town's high society, and although Luther himself might rail against female laziness and luxury, he had no problems with ladies getting dressed up

267

Drill

Wittenberg, Luther House, Collegienstraße 54
1st-half of the 16th century
Iron, wrought
L (arm, individual): 10 cm, 10 cm, 11 cm;
width (arm end to arm end): 16 cm
State Office for Heritage Management and
Archaeology, Saxony-Anhalt
State Museum of Prehistory, HK 667:106:2i
Minneapolis Exhibition

"Since no artists or skilled craftsmen are to be found among us barbarians, I have begun the turnery work with Wolfgang, my servant. I have a gold guilder for you if you would please, when you get the opportunity, send me some cutting and turning tools, as well as two or three devices called 'screws,' which a turner would gladly provide you with information about. We have tools here, but we're looking for finer ones, like those in your artistic Nuremberg."

A turning tool like the one Luther ordered from his old friend Wenzeslaus Link was, in fact, found in the excavations in the area to the south of the Luther House. The iron drill has three arms, each of which ends in a different drilling head, so that two of the arms can serve as handles whichever way the drill is turned. It is likely that this instrument originated in Nuremberg, where the pro-

for a wedding dance. The archaeological finds made in the garden of the Luther House confirm that the women of his household probably did just that. LN

Literature
Krabath 2001 · Meller 2008, p. 291, cat. E 126 (ill.) · Stephan 2008 b, p. 22, fig. 8 · Stephan 2014

269

Fragments of a Polychrome Jug with Applied Relief Decoration

Wittenberg, Luther House, Collegienstraße 54
1st-half of the 16th century
Earthenware, polychrome glazing
Largest fragment: around 5 × 5 cm; smallest fragment: around 2 × 1 cm (H of reconstructed vessel: around 20 cm)
State Office for Heritage Management and Archaeology Saxony-Anhalt
State Museum of Prehistory, HK 667:106:52
New York Exhibition

Ceramic vessels have always been a cheap and practical choice for household crockery. They would often be preferred even if certain types were available in more expensive materials, such as glass or metal. But some ceramic vessels were also produced to higher standards, distinguished from the mass of everyday wares by the special design of their surfaces and superior ornamentation. The methods of decoration which were increasingly employed in the Renaissance included polychrome glazes and applied relief ornaments (cf. cat. 270).

The high status of such vessels is mirrored in the rarity of corresponding finds among the archaeological material of central Germany. It would appear that not every pottery workshop was capable of producing such luxury vessels. Ceramic vessels of this type, with their lavish polychrome and relief decoration, are usually found in the former homes of wealthy 16th-century burghers of both smaller and larger towns such as Dresden, Leipzig, Görlitz, Freiberg and, of course, Wittenberg.

Apart from the larger cities of the region, the possible production centers of this time include Kohren-Sahlis (south of Leipzig), Annaberg (in the Erzgebirge, or Ore Mountains, region) and Schmiedeberg.

The fragments unearthed at the Luther House can be reconstructed as one or two beehive-shaped jugs or pitchers with slightly tapering tops. This kind of vessel, whose shape was typical for the Saxon region, would have a yellow glaze on the upper and lower zones, while the middle would be ornamented with fields of green and black-brown glaze. The applied polychrome relief orna-

269

ment, some of which would have been prefabricated using special molds, consists of vines, blossoms and berries, and it even includes a fish tail, which might have belonged to a mermaid. This vessel is a bold combination of the applied relief decoration adapted from stoneware models with the polychrome exuberance shown in the contemporary tile craze. Fragments of the kind of Waldenburg stoneware with relief decoration that might have served as an inspiration for this jug were also found in Luther's home.

The particular vessel to which the fragments displayed here belonged was probably made in Schmiedeberg, close to Wittenberg. The local potters here also made brilliant polychrome tiles. The possibility cannot be ruled out, however, that the vessel was produced in Nuremberg. A renowned workshop for polychrome vessels is recorded in this Renaissance metropolis, and Luther is believed to have received, among other supplies, some ceramic vessels from Nuremberg.
RKA

Literature
Kluttig-Altmann 2006, pl. 3.3 · Krabath 2012 · Meller 2008, pp. 258 f., cat. E 64 (ill.) · Stephan 2008 b, pp. 30 f. (ill.)

270

Round-Bodied Pitcher

Southern Germany(?), 2nd-half of the
16th century
Earthenware, polychrome glaze
H 16 cm; D of mouth 6.4 cm; max. D 8.8 cm
Bayerisches Nationalmuseum München, 13/81
New York Exhibition

The fragments of a vessel identical to this were found in the Luther House in Wittenberg (cat. 269). The decoration on these pieces is quite unusual, but there is a small ewer in the Bavarian National Museum to which they can be compared. The identifiable shape of this object allows the reconstruction of the Wittenberg vessel. Horizontal white-glazed ridges divide the ewer's body into distinct zones (foot, belly and neck), which are covered in dark brown, yellow, green and blue glaze. This background is overlaid with blossoms and leaves that were shaped in separate molds. The same ornaments appear on the Wittenberg fragments, but the main motif of the intact piece in the Bavarian National Museum, a leaping stag, is missing.

The ewer has a handle made from two twisted clay strands attached to one side, while the opposite side is decorated with a superimposed rosette. This ornament is only attached to the body of the ewer at its top and bottom, and thus the sharply recessed neck spans between the

270

shoulder and mouth of the vessel. There may have been an inlay in this rosette that is now lost. There is a close parallel for this particular ornament on a larger pitcher from the Munich collection, whose overall decoration scheme is also quite similar. This vessel is attributed to the 16th-century Nuremberg workshop of Paul Preuning. The figural scenes on this larger pitcher include the Crucifixion, a feature that makes a connection to archival sources possible: Preuning had to justify his production of this very type of vessel and motif when he was arrested as a Protestant in 1548. However, these polychrome, relief-ornamented vessels hardly had any religious or liturgical function. It is much more likely that they were conceived and sold as luxury tableware. Besides, Preuning's workshop was not the only one that produced such vessels.

There are indications that several production centers in southern Germany and Upper Austria were also involved in this particular trade. The specific function of the smaller ewer is suggested by the position of the handle, which is placed high on the body: It would have been used as a prestigious vessel for serving beverages. Minor traces of repeated use—evidence of only occasional practical employment—would tend to support this interpretation. The lack of a spout or lip on vessels of this type is a typical feature which may simply have resulted from the prominent placement of the rosette ornament on the front of the rim. SW

Literature

Bauer 2004, pp. 109–114 and 117 f. (ill.) · Meller 2008, p. 258, cat. E65. (ill.) · Stephan 1987, pp. 25–35 and 311 (ill.)

271

Unknown artist/workshop
Luther Cup

Southern or central Germany, June 25, 1530
Turned pearwood, gilt and engraved silver mount
27 × 4.5 cm; weight 660.9 g
HMB, Historisches Museum Basel, 1922.195
Minneapolis Exhibition

Martin Luther's household boasted a number of exquisite items, which he had received as gifts from wealthy benefactors and admirers and which were venerated like relics soon after his death. The "cup collection," as Luther himself called it, with an estimated value of around 1,000 florins, included this masterpiece of the turner's art. The engraved dedication on the gilt knob of the lid states that Elector John the Steadfast of Saxony gave this ceremonial cup to Luther as a

271

272

gift on June 25, 1530 as a token of recognition for his famous subject on the occasion of the presentation of the *Confessio Augustana* (cat. 345 and 346). June 25 is the day on which the Lutheran imperial estates had confessed their faith before Emperor Charles V at the Diet of Augsburg. The knob of the lid is a detachable papal tiara. In combination with the inscription *post nubila Phoebus* ("sunshine follows rain"), it is an allusion to the defeat of "papism."

This commemorative object landed in the hands of Colonel de Graaf, commander of an Alsatian regiment during the occupation of Wittenberg by Napoleon's troops in 1806 and, through bequests, ended up in Basel before 1846 and finally, into the possession of the municipal museum in 1923.

This type of cup—consisting of two bowls that fit into each other when inverted—is also called a "double cup." They were popular from the 13th century to 17th century, but only in German-speaking regions. Such drinking vessels made from the dense root wood of hardwood trees were used as loving cups in wedding parties. The libation allegedly worked miracles, that is, it strengthened men, made women more beautiful, and, above all, rendered poisons harmless. AM

Literature

Meller 2008, pp. 313 f., cat. F 13 (ill.) · Schefzik 2008 · Sdunnus 1994, p. 178, cat. 270 (ill.) · Treu 2008 c, pp. 365 – 367

272

House Clock

1st-half of the 16th century
Iron
48 × 22 × 22 cm
Luther Memorials Foundation
of Saxony-Anhalt, K 305
Minneapolis Exhibition

In his 1321 poem, *The Divine Comedy*, Dante Alighieri makes the first known reference to the wheel clock, the innovative technology of which would revolutionize conventional timekeeping. The invention of mechanical escapement around 1300 made it possible to design precision clocks. Clocks were made with a 24-hour dial, two twelve-hour dials and even four six-hour dials. Starting in the 16th century, clocks also came with an hour and a minute hand. The intricate technique that these clocks required made them expensive, so that at first they tended to be owned only by cities and wealthy nobles. Through the end of the 15th century, almost every mid-sized European city had a public and highly visible square wheel clock, bringing innovation into city life as a symbol of the city's wealth.

273

As the art of clockmaking began to develop at a faster pace and clockmaker guilds formed, mechanical timepieces found their way into the household of many city dwellers.

Martin Luther also appreciated this development: "The invention of the clock is a truly outstanding thing because it keeps time so precisely that one cannot even express it in words. It is clearly one of the most important human inventions." There is evidence that he received clocks from Nuremberg as gifts in 1527 and 1529. Whether one of those is the object depicted is unclear. But somehow, Luther also came into possession of one of the pocket watches which were being made largely in Nuremberg and elsewhere in the southern part of the Empire. The clock shown here, from the Luther House in Wittenberg, is an example of the late Gothic type which was increasingly used as a wall or console clock in the early-16th century. Framed by four square iron pillars connected by crossbars, the clockwork is exposed to view so that the observer can see what is going on in the interior of the clock. Consistent with the Gothic architecture of the time, the pillars are adorned with two perforated cusps each and three crabs at the tip. The movement and striking mechanism consist of two four-spoke iron wheels, one behind the other. On the face of the clock, one has to imagine the dial and the hands of the clock, which are no longer present today. RN

Literature
König 1991, pp. 91–95 · Maurice 1976 · Treu 2010, pp. 82 f. and 111 (ill.)

273

Ceramic Fanfare Horn

Wittenberg, Collegienstraße 90/91
16th century
Yellowish white earthenware, red slip glaze painting
L 41.3 cm; weight 0.714 kg
State Office for Heritage Management and Archaeology Saxony-Anhalt
State Museum of Prehistory, HK 98:7075
Minneapolis Exhibition

This ceramic fanfare horn is an object of particular rarity, the significance of which extends beyond the archaeology of Wittenberg. It is made of yellowish-white earthenware, with ornaments painted in red slip glaze. The mouthpiece is missing, but drops of glaze adhering to the body suggest that it would have been covered with green glaze for a more convenient use. In spite of the interesting overall shape, the object is certainly not a piece of art but merely a commonplace pottery product. The rough quality of the object indicates an unsophisticated production process. The considerable overall length of the coiled tube, some 2.15 m, was achieved by combining separate prefabricated segments of 25 to 50 cm length. Traces of this process can easily be recognized in the thickened transitions distributed along the horn's length.

Perhaps surprisingly, tests with replica ceramic instruments have shown that they are quite capable of producing strong and loud notes. However, as the horn lacks any valves or features to control note modulation, its user would only have been able to produce simple melodies by varying lip tension. As professional musicians, military trumpeters and lookouts of the era are known to have preferred metal instruments, ceramic pieces may conceivably have been used in a less formal, civilian context. The frequent mentions of horns used by pilgrims (so called *Aachhörner*) refer to a much smaller instrument than the piece shown here but also of a different shape (cat. 6).

It is highly unlikely that a wind instrument such as our Wittenberg example, with its length of 41 cm and weight of 0.8 kg, would have been lugged around as a souvenir on a pilgrimage journey of any distance. The possibility remains that the horn was actually made in Wittenberg itself, either as a toy (less likely because of its size and weight), for use for some kind of signal by the citizens, or most likely, as an instrument for making noise on the occasion of gatherings or pageants.

Objects comparable to this kind of wind instrument, whether coiled or in the shape of a straight tube, are rarely found in an adequate state of preservation. One rare example was found in Dresden. Fragments, however, have also be found at other sites such as Leipzig, Lübeck and Wismar. Nearly half of the fanfare horn finds documented in Germany were discovered in an urban context, while a third were recovered directly from pottery sites. Examples from convents or castles are extremely rare. In Wittenberg itself, at least two more fragments of similar instruments were found at other sites in the center of the town. RKA

Literature
Falk 2001 · Haasis-Berner 1994 · Kluttig-Altmann 2015 b, p. 97, fig. 8 and p. 100, fig. 10–11 · Krabath 2012 · Lang 2014 b

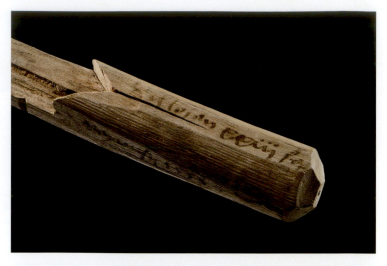

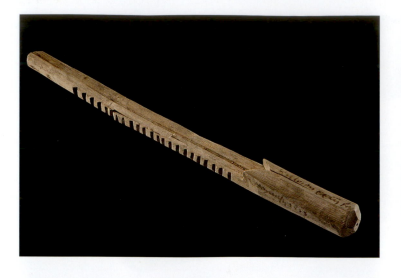

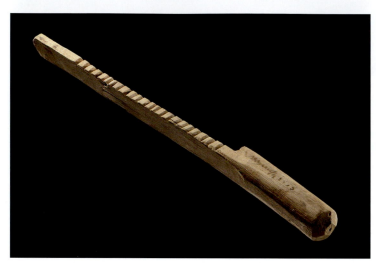

274

274

Tally Stick

Wittenberg, Arsenalplatz
1558
Carved wood, writing
21.5 × 1.8 cm
State Office for Heritage and Archaeology
Saxony-Anhalt
State Museum of Prehistory, HK 4100:338:1x
Minneapolis Exhibition

A substantial debt of 23 guilders was recorded on this tally stick, a piece of wood found during the excavation of a former latrine at *Arsenalplatz* (Arsenal Square) in Wittenberg. The stick has an overall length of 21.5 cm. The named sum was recorded by carved markings on its surfaces, not only in the shape of numerals, but with a series of 23 notches as well. The numerical information is followed by the conventional sign for guilders, "fl" (an abbreviation derived from the Italian florin or *Fiorino d'oro*). The date of the transaction is given on the reverse side, 1558. There is also a

recess here into which the usual counter-piece of the stick (not preserved) would have been slotted to authenticate it.

The fine state of preservation of this wooden artifact is the result of its prolonged rest in waterlogged soil. The tally stick was found in a latrine, a shaft with sandstone walls, along with other organic and non-organic waste material. With a diameter of 2.80 m and a depth of more than 6 m, this structure was extraordinarily capacious for its purpose. The range of artifacts recovered from the infill provides a fascinating glimpse of everyday life in the Reformation period and particularly of the social and economic situation of Wittenberg shortly after the death of Martin Luther and the end of the Schmalkaldic War.

While only a handful of finds of tally sticks have been recorded in Germany to this date, comparisons may be made with the much larger number preserved in England. Here, the custom of recording debts on sticks was normal and accepted until 1826. In English practice, the larger part of the stick (the stock) would remain with the creditor, while the smaller piece (the foil) was held by the debtor. In 16th-century central Germany, debts

would more usually be documented in writing, especially where larger sums were concerned. Where tally sticks were used, it was the normal practice upon repayment of the debt to break the sticks and throw them away. The find from Wittenberg appears to have been at least partially broken, although the parts are still connected.

Apart from the fact that the 23 guilders noted on the stick constitute quite a sum, it would obviously be interesting to know more about the persons behind the transaction. Consistent English practice, the Wittenberg find should be the larger piece which had remained with the creditor. A likely scenario would have the wealthy owner of the site on which the latrine and the stick were found—a large corner lot—lend a substantial amount of money to a second person, whose name might originally have been noted on the upper surface of the stick, in the space before the sum. Regrettably, the find gives no information on the interest to be paid on this sum. HR

Literature
Le Goff 2005 · Le Goff 2011

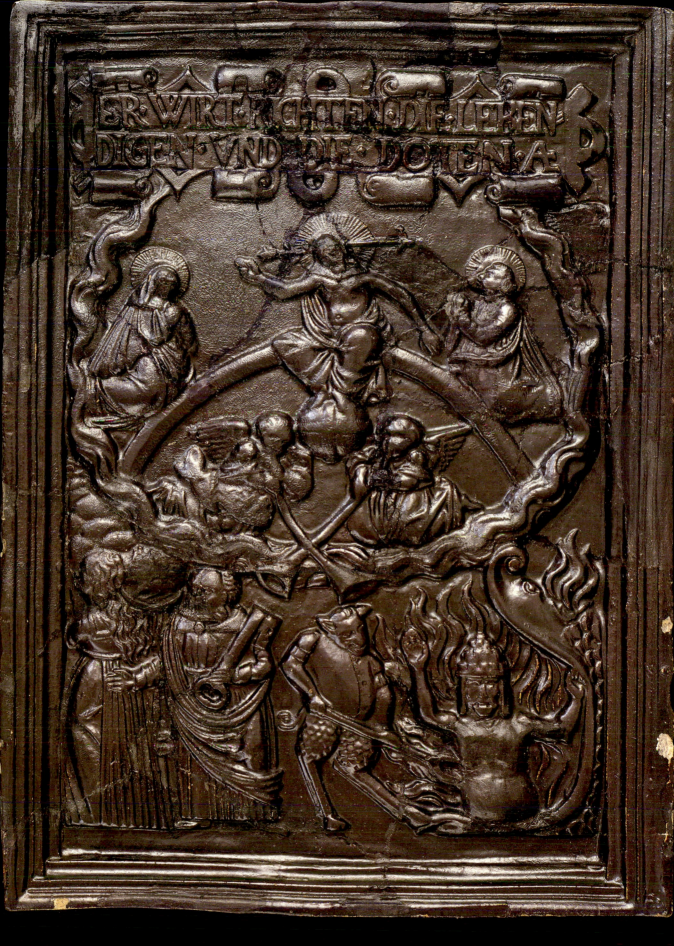

ER·WIRT·RICHTEN·DIE·LEBEN
DIGEN·VND·DIE·DOTEN·A⸱

276

Stove Tiles with Depictions of the Last Judgment

Wittenberg, Arsenalplatz
End of 16th century
Earthenware, black-brown glazing
State office for Heritage Management
and Archaeology Saxony-Anhalt

275
44.5 × 32 × 6.8 cm
State Museum of Prehistory, HK 4100:749:1
Minneapolis Exhibition

276
21 × 30 × 6.8 cm
State Museum of Prehistory, HK 4100:749:314k
Atlanta Exhibition

These large-format relief tiles, one nearly complete example and a large fragment, are adorned with an interesting depiction of the Last Judgment. At the center, Christ is shown enthroned on a rainbow, in his role as ultimate arbiter of the world. His feet are resting on a globe, and his right hand is raised in a gesture of blessing. To the left of his head there is a lily, the symbol of mercy, and to the right a sword, representing justice. He is flanked by the Virgin Mary and Saint John the Baptist, kneeling in supplication. Below them, two angels are blowing their trumpets underneath the rainbow.

This scene in the upper part of the tile is separated by a band of clouds, which denotes the boundary between the celestial and earthly spheres in early modern artistic convention, from the lower part of the picture. Here, we find a scene depicting the devil using a trident to torment the Pope—unmistakably identified by his tiara. Surrounded by flames, the figure of the Pope raises his arms in hopeless supplication. In contrast, the scene to the left depicts Saint Peter

(identified by his keys) as he admits a woman to Paradise. The three scenes are surmounted by an ornamented scroll unfolding across the upper edge of the tile that bears an abbreviated line from the Apostles' Creed: "*Er wird richten die Lebenden und Toten* (He shall judge the quick and the dead)." The depictions on the tile are not framed by the usual architectural border. Instead, the border is reminiscent of a stepped picture frame. It is likely that the figure of the Pope in the lower right hand corner was intentionally smashed when the stove to which the tile belonged was dismantled. The damage to the object could hardly be explained otherwise.

Fragments of similar tiles have been found throughout Wittenberg. One such fragment, covered with green glazing, was recovered from Lot 1 on Schloßstraße, where the Cranachs had their workshop. Interestingly, this very workshop had produced an image sometime between 1548 and 1550 meant to illustrate Luther's anti-papal hymn "*Erhalt uns Herr bei Deinem Wort* (Lord, Keep Us Steadfast in Your

Word)." This image depicted the Pope and a Turk being swallowed by hell, with Christ presiding above the scene as judge.

Of the handful of stove tiles which can be compared with the above pieces, one good example was found in the old town center of Brunswick. It repeats the motif of the final judgment with the Pope roasting in Hell. The Wittenberg example, however, is remarkable for its reinforced expression of Protestant sentiment, which combines the quote from the Apostles' Creed with the image of the Pope in hell. JR

Literature
Hallenkamp-Lumpe 2007, p. 328, fig. 7 · Oelke 1992, p. 298, fig. 25

277

Stoneware Canteen

Wittenberg, so-called Cranachhöfe, Markt 4
Waldenburg, 16th century
Stoneware (with additions)
H max. 18 cm; D max. 21.5 cm
State Office for Heritage Management
and Archaeology Saxony-Anhalt
State Museum of Prehistory, HK 738:65:142
Minneapolis Exhibition

Canteens or pilgrims' flasks were a popular type of stoneware vessel in the Early Modern era, and they turn up frequently in archaeological excavations in the centers of towns all over central Germany. The large example shown here, with its four lugs, was probably made in Waldenburg. While Wittenberg lay closer to Schmiedeberg, another important center for the production of stoneware, it is not unusual that the town obtained its supply of ceramic vessels from several different sources.

Stoneware vessels were popular for the storage of a variety of liquids, as the non-porous, glass-like surface provided a neutral container. In contrast, normal earthenware vessels would often become odorous after prolonged use. For similar reasons, stoneware was also useful for containing acids or other chemical fluids. Consequently, we frequently find alchemical vessels and technical containers made of stoneware, and in central Germany these would often have been produced in Waldenburg.

The exhibited flask would have been suspended from a strap running around its circumference and through the four lugs. In this way, it could be either carried, or hung from a wall, a stand or wagon's frame. With its considerable height of 21 cm, it may not have been intended for carrying around by an individual for any length of time. Such a use would have been more likely with the similarly shaped but smaller types of pilgrims'

277

278

flasks, which were approximately 10 cm in height and had only two carrying lugs. These vessels could be worn comfortably attached to a belt. The light-colored blotch on the mouth of the bottle is not an ornament, it occurred accidentally during the firing process. Another vessel had probably covered the flask's mouth when a load of vessels was stacked for firing, and had protected this particular part from the direct effect of the fire. The reverse side of the bottle is flat, as it would have rested on this side while lying on the potter's wheel. The spout was only added after the body had been completed.

This large pilgrims' flask from an archaeological excavation at a site called Markt 4 once formed part of an inventory that included several large-format stoneware household vessels used for the storage or transport of liquids. As Cranach the Elder is known to have owned and lived at this address from about 1512 to 1517/18, and as the house reverted back to his family when his son-in-law Caspar Pfreundt and his successors bought it in 1550, it is quite plausible that this inventory was once used by to the famous painter's family. Several vessels of similar size and shape were also found among the material salvaged from Luther's house. RKA

Literature
Hennen 2015 a · Holesch 2014, p. 191, fig. 14 and pl. 5–7 · Kluttig-Altmann 2006 · Scheidemantel/Schifer 2005

278

Bellarmine Jug

Wernigerode, Klinthügel
1st-half of the 16th century
Stoneware
15 × 11 × 6.8 cm
State Office for Heritage Management and Archaeology Saxony-Anhalt
State Museum of Prehistory, HK 2003:1093c
Minneapolis Exhibition

This vessel is also referred to as a Bartman (bearded man) jug, due to its decoration with a bearded face. This example is almost complete with the exception of the handle and the lid. This typical stoneware product of Rhineland pottery centers in the early-16th century has a molded, stern, male mask with wild eyes and an unkempt beard with vines sporting oak leaves and acorns swirling around its body. The rough–hewn, disheveled face on the jug's neck is derived from the medieval iconography of the wild or green men, conceived as hirsute, uncivilized inhabitants of the forest. Mummers disguised as wild men were a standard feature of late medieval carnival processions and burlesque entertain-

ments. Moreover, this motif also evoked the humanist, classically-inspired notions of Bacchus' untamed satyrs. They stood for the wild side of the feasting and were the embodiment of drunken mirth. Appropriately enough, these jugs were used to store, transport, and serve beer and wine. Bellarmine jugs were enormously popular, not only in Germany but elsewhere as well during the 16th and 17th centuries. Interestingly, they reached the New World and have been discovered both in colonial settlements, such as Jamestown and Williamsburg, and also in Native American contexts.

Their English name is a result of the fierce anti-Catholic invective during the Counter-Reformation. Cardinal Robert Bellarmine (1542–1621), an Italian Jesuit who was canonized in 1930, was the intellectual hub of the early Counter-Reformation's ideological assault on Protestantism. The popular Protestant answer was to heap scorn on this stern teetotalling ascetic by giving these portly, wild embodiments of mindless drunkenness his name. LN

Literature
Gaimster 1997 · Meller 2008, pp. 250–253

279

Stove Tile with a Portrait of Philip I of Pomerania

Wittenberg, Neustraße/Mittelstraße
2nd-half of the 16th century
Earthenware, green glazing
20 × 17 cm
State Office for Heritage Management and Archaeology Saxony-Anhalt
State Museum of Prehistory, HK 3220:116:46aq
New York Exhibition

This extremely fine example of a tile from the wall of a tile stove depicts a man wearing a triple-jewelled collar around his neck, sumptuous clothing, and a flat beret with a feather. The architectural frame of the tile consists of decorated columns that support a richly ornamented arch. The lower border of the frame is formed by an ornamental zone constructed of square tiles with floral ornaments. There is no caption, but an identification of the subject as Philip I of Pomerania is possible as the graphic model for the tile is known. The image was copied from Johannes Agricola's work *Warhaffte Bildnis etlicher Hochlöblicher Fürsten und Herren* (True Depictions of Several Most Honorable Princes and Lords), which was published in Wittenberg in 1562 by Gabriel Schnellboltz. The woodcuts for this portrait series were made either by Lucas Cranach the Younger or his workshop.

The tile itself belongs to a series that was recovered during the excavation of a pit on Neustraße in Wittenberg. All of these tiles feature an identical architectural frame, the ornaments of which were painstakingly applied to the model of the tile with individual stamps. This laborious method would have resulted in a high price that would have guaranteed the exclusivity of the finished tiles. We can identify the portraits of Judith (the Old Testament heroine), the Emperor, and two lay gentlemen and a lady as the central motifs that graced these stove tiles.

While it is likely that all of the excavated tiles would have been used in building and decorating a single stove, the complete decorative scheme must have included many more images. The tiles were most likely produced in the nearby town of Schmiedeberg, where a large-format tile depicting the Judgment of Solomon was found in the refuse dump of a pottery workshop. This interesting piece possesses several features which have close parallels in the Wittenberg tile series. JR

Literature
Kluttig-Altmann 2015 d, pp. 278 f. and 285, fig. 82 · Reetz 2014, pp. 211 f., fig. 9a and 10 (ill.) · Reske 2007, p. 1003 · Rode 2005

280

Stove Tile with a Portrait of Mary of Saxony

Wittenberg, Neustraße/Mittelstraße
2nd-half of the 16th century
Earthenware, green glazing
19.5 × 16.5 cm
State Office for Heritage Management and Archaeology Saxony-Anhalt
State Museum of Prehistory, HK 3220:116:46ag
New York Exhibition

This half-portrait of a lady wearing Renaissance clothing and an ornamented headdress belongs to the same series as the Philip I of Pomerania tile (cat. 279). The woman is depicted with a pair of gloves held in her right hand, a common pose in portraits of the time. The graphic model for this tile was once again taken from the portrait collection of Johannes Agricola. The portrait is of Mary of Saxony, the wife of Duke Philip I of Pomerania and daughter of Saxon Elector John the Steadfast. It is quite remarkable how closely the tile manages to convey the characteristic facial expression and slender figure of the portrayed woman, traits which are also alluded to in the caption in Agricola's book.

The Ernestine and Pomeranian dynasties became closely connected through the marriage of

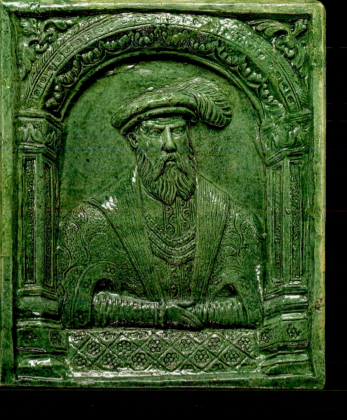

279

Philip I and Mary of Saxony, which was celebrated in Torgau in 1536. Philip I had the event recorded in the so called Croÿ Tapestry in 1554. The tapestry depicts the members of the two princely houses and the reformers Luther, Melanchthon and Bugenhagen. The designs for the individual portraits are based on sketches made by Lucas Cranach the Younger. With nearly 31 square meters, the tapestry is quite a remarkable demonstration of dynastic power and status—considering that it was made after the defeat of the Lutherans in the Battle of Mühlberg! It is also a conspicuous affirmation of Lutheran identity, proclaiming the determination of Pomerania and Ernestine Saxony to uphold their shared Protestant faith and dynastic ties. A similar intent must have lain behind the collection of graphic portraits published by Schnellboltz (cat. 279), in which an assorted selection of rulers was depicted alongside memorable personalities such as Luther, Bugenhagen and Jan Hus. Considering the role that tile stoves played in the early modern age as a medium of communication and propagation, it may safely be assumed that the owner of the stove to which this particular example belonged did indeed intend the images to proclaim his personal views and stance. In this context, portraits of members of the Pomeranian ruling house must surely be seen as testimony of an adherence to the Protestant creed. JR

Literature
Reetz 2014, p. 211, fig. 9 b · Reinitzer 2012, p. 11

281

Relief Tile with a Depiction of the Elector Maurice of Saxony(?)

Wittenberg, Neustraße/Mittelstraße
Between 1550 and 1570
Earthenware, green glazing
19.8 × 18.6 × 6.2 cm
State Office for Heritage Management and Archaeology Saxony-Anhalt
State Museum of Prehistory, HK 3220:116:46aj
Atlanta Exhibition

This relief tile was found during excavations on Neustraße in Wittenberg and dates to the period between the first-half and the middle of the 16th century. It shows the image of a noble man, probably Maurice, Margrave of Meissen (hence Meissen's crest with the crossed swords) who is depicted with his characteristic double pointed beard. His costume, as well as the hand grasping his sword, mirrors a portrait of Maurice by Lucas Cranach, which is on display in the municipal museum in Meissen. Together with other portraits of past and present rulers, the tile decorated a stove, whose imagery celebrated the

lineage of the Saxon ruling house of Wettin. To many burghers of the 16th century, and particularly to Martin Luther, worldly authority was ordained by God to uphold law and justice. Moreover, Luther was very aware that without the patronage of the Saxon princes, his Reformation would have been mercilessly squashed and he himself would have faced burning at the stake. This stove also illustrates the phenomenon of emulating the mighty, which was a typical phenomenon of the time. Increasing literacy, the circulation of printed imagery, and patriotic sentiment had burghers collecting images that celebrated the local reigning lineage. This practice was once a prerogative of the rulers themselves. It is interesting to see the image of Margrave Maurice, who was a highly controversial figure at the time, on this Wittenberg oven. While he was a devout Protestant, he sided with the Empire in the struggle between it and the other Protestant princes, since he was an embittered rival of his relatives, the Prince-Electors of Saxony, Luther's patrons and the rulers of Wittenberg. After the disastrous defeat of the Protestants at Mühlberg in 1547 he became the new Saxon Prince-Elector. This was a major factor in securing a permanent future for Protestantism in Europe, but it also led to Maurice's residence Dresden replacing Wittenberg as the capital of Saxony. Perhaps this stove was erected by a Wittenberg burgher who included Maurice's portrait on it because, like many others at the time, he hoped for reconciliation between the Holy Roman Empire and their new faith. LN

Literature
Reetz 2014, p. 209, fig. 7 · Rudolph 2009

Luther's Fellow Reformers

Martin Luther may have started the Reformation and worked tirelessly to further it, but the movement really flourished because of the united efforts of his companions. Aside from Philip Melanchthon, his circle included notable theologians from Wittenberg: Johannes Bugenhagen, Justus Jonas and Caspar Cruciger. These men were bound together not only by their mission but also genuine friendship.

Bugenhagen (also known as Pomeranus) was approximately the same age as Luther. He stood by the Reformer in his frequent crises and became both his pastor and confessor. He was also deputized in Luther's absence as a preacher in the Church of Saint Mary. Consequently, he was appointed Wittenberg's first town priest in 1523. Through his church regulations and visitations, he became the true founder of the Lutheran Church in northern Germany and Denmark.

Philip Melanchthon, a humanist scholar, came to Wittenberg in 1518 to teach Greek. His acute intellect soon made him one the most important protagonists of the Reformation, second only to Luther, whom he assisted in the translation of the Bible. Melanchthon also authored the *Augsburg Confession*, the confessional statement of the Lutheran members of the imperial estates, which was presented to Charles V at the Diet of Augsburg. This document remains the fundamental creed of Lutheran churches to this day. Melanchthon was keen on maintaining harmony and frequently mediated in Reformation conflicts.

Justus Jonas was provost of the convent attached to Wittenberg's All Saints' Church as well as a professor at the university. He translated many of Luther's and Melanchthon's writings into German, a vital step in disseminating the ideas of the Reformation. As one of Luther's closest confidants, he was at the Reformer's side when he died and delivered the memorial sermon in the Church of Saint Andrew in Eisleben on February 19, 1546.

Significantly younger than the others, Caspar Cruciger witnessed the Disputation of Leipzig in 1519 that pitted Luther and Karlstadt against Johannes Eck. After this experience, he decided to continue his studies in Wittenberg and eventually became a preacher at the Castle Church. In 1533, he was appointed a professor of theology at the Leucorea. He assisted Luther in the translation of the Bible and, with other reformers, edited treatises on diverse subjects, such as theology, church policy and social issues. ID

Albrecht Dürer
Portrait of Philip Melanchthon, Engraving and Plate

1526
Minneapolis Exhibition

Signed and dated on the inscription panel:
1526 Viventis potuit Durerius ora Philipi
mentem non potuit pingere docta manus AD

282
Copper engraving
19.1 × 14.6 cm
Foundation Schloss Friedenstein Gotha, 8,25

283
Copper plate
Dimensions: 17.3 × 12.6 cm
Foundation Schloss Friedenstein Gotha, 8,24a

When Philip Melanchthon was appointed to the newly created professorship in Greek language at the University of Wittenberg in 1518, on the recommendation of Johannes Reuchlin, he initially encountered a great deal of skepticism because of his slight build and minor speech defect. But his first lecture, which he held on August 28, 1518 on a fundamental reform of the educational system, met with utmost appreciation from the audience. He taught Greek grammar, engaging himself with ancient authors and the original texts of the Bible. Melanchthon combined a deep-rooted humanistic education with a reformist theology, making him one of the leading figures of the Reformation alongside Martin Luther. As early as 1521, he formulated his first work on Evangelical dogmatics, *Loci communes*. Aside from his work systematizing Lutheran doctrine, Melanchthon was primarily engaged in reorganizing the Lutheran churches in Saxony. Called *Praeceptor Germaniae* (Germany's teacher) by his contemporaries, Melanchthon reformed the educational system according to humanistic principles and introduced the three-tiered educational system.

In November 1525, Philip Melanchthon stayed in Nuremberg in order to open a new grammar school in that city. From November 12–26, he was the guest of Willibald Pirckheimer, a humanist and friend of Albrecht Dürer. It may be that his portrait was drawn by Dürer at this time. A pen and ink drawing that served as the model for the copper engraving has been among the possessions of the Horn Foundation in Florence since 1904.

The engraving is a bust of Melanchthon turned to the right, with his face shown almost in profile. Dürer's creation is more than just a realistic portrait of the gaunt scholar. With the high forehead of the subject, the artist was also able to convey the sharp intellect of this extremely capable humanist. The epigram on the inscription panel,

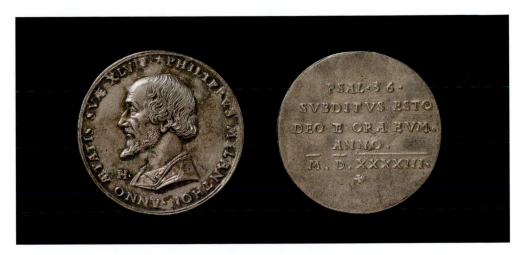

284

"With a skilled hand, Dürer was able to draw Philip's features, but not his spirit," is an expression of the high respect which Dürer had for Melanchthon. This portrait is one of the last copper engravings from the hand of Albrecht Dürer. The plate containing the portrait of Melanchthon was purchased by Duke Ernest II of Saxe-Gotha-Altenburg; the first time it is recorded among the print collection inventory is 1843. ID

Literature
Enke/Schneider/Strehle 2015, pp. 314 f.,
cat. 240 b (ill.) · Fastert 2004, pp. 247–255 (ill.) ·
Hofmann 1983 a, pp. 19 and 162 f., cat. 66 (ill.) ·
Schuttwolf 1994 b, p. 174, cat. 2.67 (ill.)

284
Friedrich Hagenauer
Medal of Philip Melanchthon

1543
Silver, cast
D 39.5 mm; weight 16.19 g
Foundation Schloss Friedenstein Gotha,
4.1./5740
Minneapolis Exhibition

Obv: PHILIPPVS MELANTHON · ANNO AETATIS
SVAE XLVII ·*
Bearded bust of Philip Melanchthon to left.
In field at bottom left FH
Rev: PSAL · 36 · / SVBDITVS ESTO /
DEO E ORA EVM · / ANNO · / M.D.XXXXIII (Be still before the LORD, and wait patiently for him)

Philip Melanchthon, who taught Greek at Wittenberg University from 1518/19, was Luther's friend and most important associate and is regarded as the second reformer. He not only provided Luther with substantial assistance in the translation of the Bible, but also authored writings essential for Protestantism. His central theological works include *Loci communes* (published in 1521), the first summary of reformed theology, and above all, the *Confessio Augustana* which was read out at the 1530 Diet of Augsburg, and today is considered to be the most important confessional writing of the Lutheran Reformation.

Melanchthon also defended the Lutheran Reformation during the Marburg Colloquy in 1529 and in other theological disputations, and he thus made an essential contribution to strengthening the new faith. He rendered great service with regard to developing a Protestant school system, contributing school regulations and textbooks. His comprehensive knowledge of the classical languages made Melanchthon, alongside Erasmus of Rotterdam and Johann Reuchlin, one of the most eminent philologists of his time.

Melanchthon's key characteristic features were impressively recorded by the medalist Friedrich Hagenauer, who worked in Cologne from 1536 to 1544. His face appears to be sensitive and cerebral, his body thin. Georg Habich aptly described Hagenauer's Melanchthon portraits as the "archetype of a scholar ennobled by thought." Hagenauer met Melanchthon in Bonn during preparations for the Cologne Reformation. He designed two variants of the portrait, with and without the cap. This portrait type goes back to the Cranach workshop, which was mass producing small Melanchthon portraits paired with images of Luther as early as 1532. The wooden model for the medal with cap has been preserved at the Numismatic Collection of the Berlin State Museums.

The psalm on the reverse side, "Be still before the LORD, and wait patiently for him," was adapted by Melanchthon into his motto as "Be subject to God and worship Him." UW

Literature
Brozatus/Opitz 2015, vol. I,1, pp. 337 and 339,
cat. 490 · Habich 1929–1934, vol. I,1, no. 651 ·
Schade 1983, p. 381, cat. F 17. · Schuttwolf
1994 b, p. 29, cat. 4.30 (ill.)

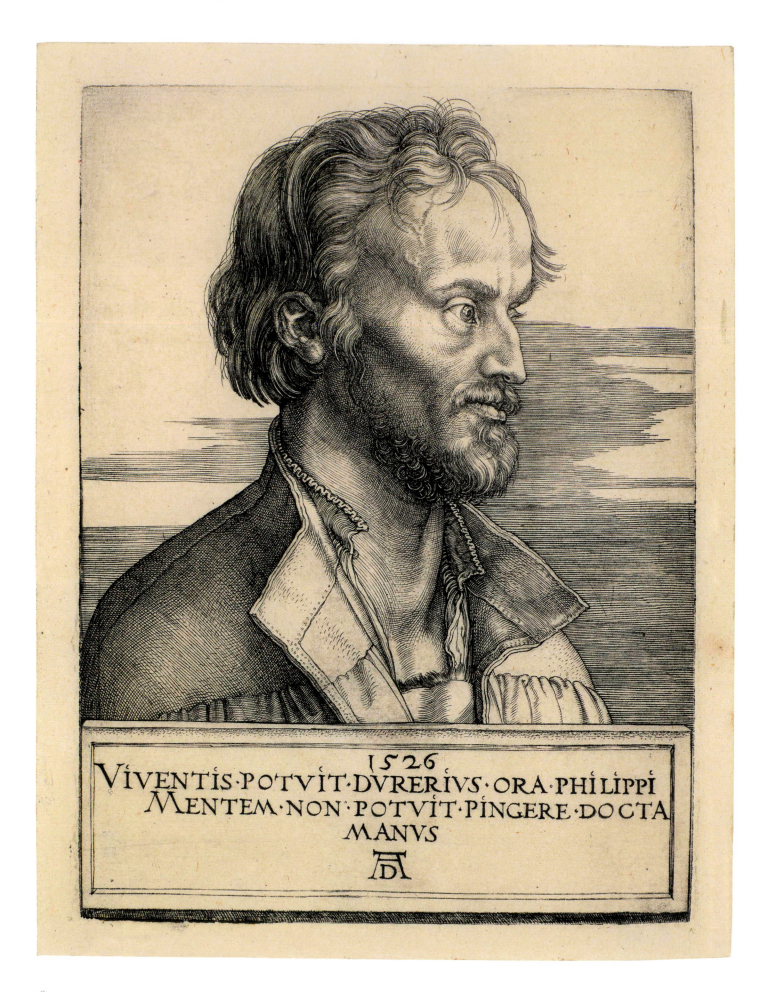

1526
VIVENTIS·POTVIT·DVRERIVS·ORA·PHILIPPI
MENTEM·NON·POTVIT·PINGERE·DOCTA
MANVS

282

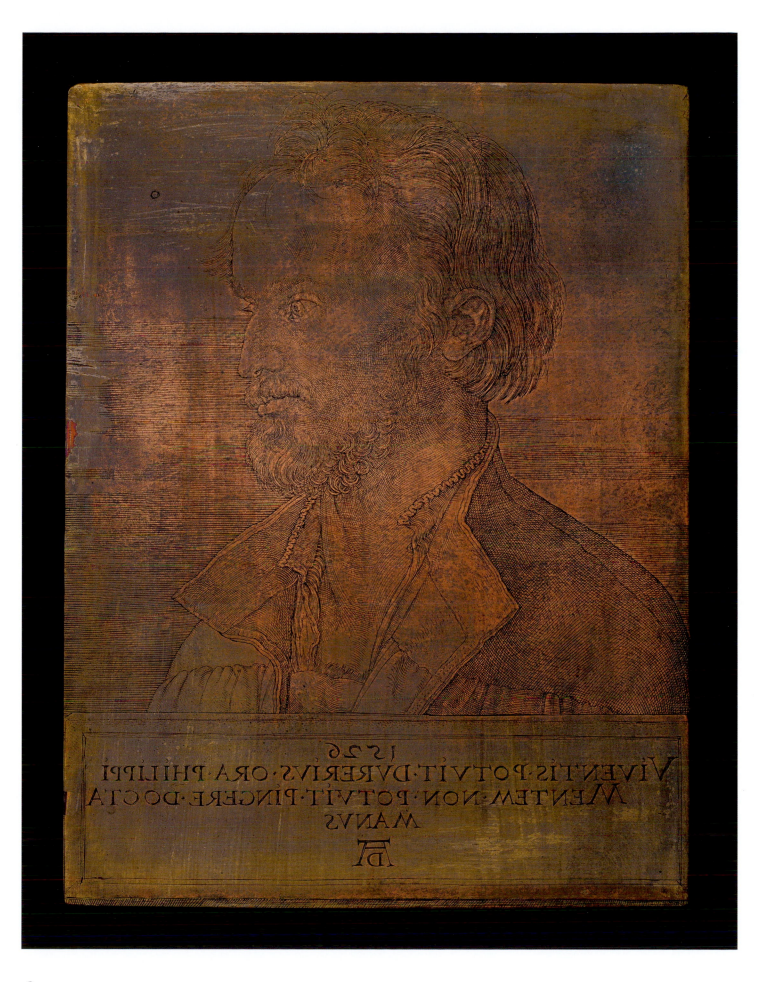

283

Martin Luther

Luther's Testament, with Annotations in Philip Melanchthon's Own Hand (transcription)

January 6, 1542
31.5 × 21.4 cm
Thüringisches Hauptstaatsarchiv Weimar,
EGA, Reg. N 182, ff. 10–14
Minneapolis Exhibition

Martin Luther considered the practice of law a profoundly wicked art, and he harbored a particular dislike for some of the regulations concerning inheritances. After barely surviving a renal colic, the Reformer lived in constant anticipation of his own death. As a consequence, he penned his last will with his own hand in 1542. This document took the shape of a personal bequest to his wife. According to the prevalent legal opinion of the time, she would only have been entitled to the so-called morning gift—the things she had received as a gift from her husband after their wedding night—and the furnishings of their household. All other possessions would have passed (in equal portions) to the surviving four of the six children of Martin Luther and Katharina von Bora.

However, Luther was adamant that his wife—whom he had married in 1525, who had given birth to their six children, and whom he tenderly called "*Herr Käthe* (Mr. Katie)"—should remain head of the household after his death. This position was to entail full control over all possessions and sources of income. In his will, Luther expresses the greatest respect for this woman who had "held him dear, worthy and fine as his devout and faithful marital spouse throughout his lifetime." He signed his entire property over to her, including the manor of Zülsdorf, which he had acquired from her brother Hans, a house, some pieces of jewelry and a sum of money amounting to 8,000 guilders. In effect, he appointed his wife his sole heir.

It was also his intention that Katharina should be the sole legal guardian of their children, as he believed that the natural mother was the person best suited to this role. With these provisions, Luther deliberately ignored the legal customs of this time. As a safeguard, he asked John Frederick, the Elector of Saxony, and his friends to enforce the implementation of his last will and testament. In addition, he had these provisos entered into the official court records of the town of Wittenberg a year before his death.

On April 11, 1546, Elector John Frederick confirmed Martin Luther's testament, which had previously been signed by his allies and companions Philip Melanchthon, Caspar Cruciger and Johannes Bugenhagen. Through this official act,

285

the testament became valid. The one copy of this will by Luther's own hand (which bears his personal seal) eventually found its way into the possession of the scholar Carpzov, whose inheritance ended up in the collection of the Evangelical Lutheran Church in Hungary in the 19th century. The version displayed in the exhibition is a contemporary transcription which was preserved in the electoral records. DB

Literature
Bornkamm 1996, p. 82 · Fabiny 1983 · Scherer:
Luthers Testament

286

Lucas Cranach the Elder
Johannes Bugenhagen

1537
Oil on copper beech
31.6 × 23.5 cm
Wittenberg Seminary, Lutherstadt Wittenberg, 2
Minneapolis Exhibition

Inscription: "EFFIGIES IOH. BUGENHAGII POMERANI. / LUCA CRONACHIO PICTORE. / M. D. XXXVII."

The inscription along the bottom of this picture tells the viewer who was portrayed here and by whom in 1537: Johannes Bugenhagen, an elder of the Protestant movement and longtime follower of the Reformer Martin Luther. He was also called "Doctor Pomeranus" because of his origins in Pomerania and his epochal work of history about that Duchy. He was painted by Lucas Cranach the Elder, already a master of wide renown in his own day. The sitter and the artist himself were some of the most esteemed burghers of the growing university city of Wittenberg at the time the picture was produced.
After earning his degree in the seven liberal arts, Bugenhagen devoted himself to the study of theology through independent study and practical work. The humanist scholar embraced Luther's conception of faith and followed him to Wittenberg in 1521 in order to study Reformation ideas directly from the source. Witty, eloquent and prolific, Bugenhagen subsequently went on to become a popular minister, a highly esteemed university instructor, an effective translator of the Bible and an organizer of the Church with a lasting impact. He reorganized church life in central Germany and especially in the southern and western Baltic Sea region.
Johannes Bugenhagen was close friends with Martin Luther and also his confessor. He performed Luther's wedding, baptized his children and paid his last respects at his friend and mentor's funeral by preaching the sermon. Naturally, he was a regular and welcome guest in Luther's

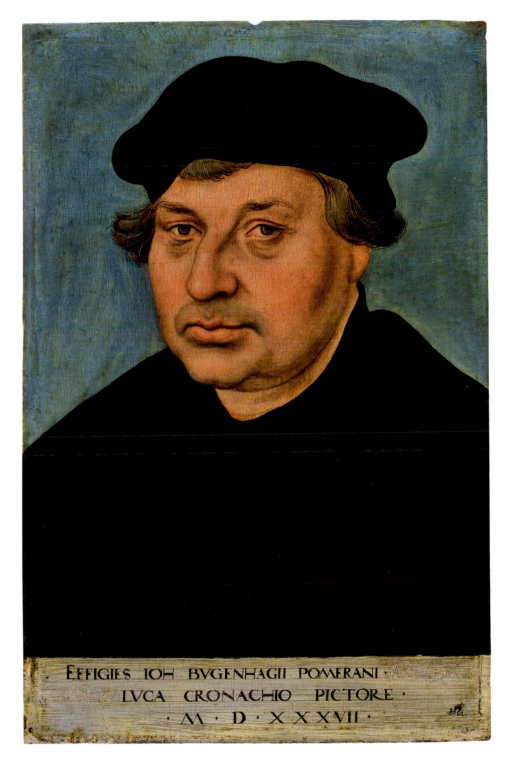

286

home as well. The depth of the friendship between the two reformers can be inferred from a little joke with which Luther alluded to his friend's notorious loquaciousness: "Every priest has to have his personal sacrifice. Ergo Pomeranus sacrifices his listeners through his long sermons. That is to say, we are his sacrifices. And today he sacrificed us inordinately." AM

Literature
Buske 2010 · Garbe/Kröger 2010 · Leder 2002 · Treu 2010, pp. 89, 91 and 142

287

Heinrich Aldegrever
Martin Luther

1540
Engraving
18 × 13 cm
Thrivent Financial Collection of Religious Art, Minneapolis, 97-13
Minneapolis Exhibition

Inscribed at the top: Iacta cvram tvam in dominvm et ipse te envtriet (Cast thy burden upon the Lord, and he shall sustain thee.)
Inscribed at the bottom: Asservit christvm divina vose lvthervs/ cvltibvs oppressam restitvitqve fidem./ Illivs absentis vvltvm haec depingit imago/ praesentem melivs cernere nemo potest/ Martinvs Lvthervs/ m d xxxx (Luther protected the divine word Christ and restored the faith of those oppressed by cult customs. This portrait describes his face while he is absent; were he here, no one could see him better. Martin Luther 1540)

Like many portraits of Luther, Heinrich Aldegrever's appears to be based on one by Lucas Cranach from about 1528, perhaps by way of a Hans Brosamer woodcut (cat. 232). Regardless of his source, Aldegrever skillfully modeled the face and expression to produce an animated, convincing likeness. His composition, which shows a bust-length three-quarter view of the sitter behind a stone tablet bearing a Latin inscription, recalls Albrecht Dürer's engravings of Philip Melanchthon (cat. 282) and Frederick the Wise. Aldegrever engraved a portrait of Melanchthon as a pendent to the present image. The inscription on the stone tablet attests to the veracity of the likeness, which was already about twelve years out of date.
The inscription above Luther's head comes from the Latin (Vulgate) Bible, Psalm 54, verse 23. In the King James Version of the Bible, this is Psalm 55:22. The Psalms of David were seminal in Luther's career. As the subject of his first series of lectures at the University of Wittenberg, they

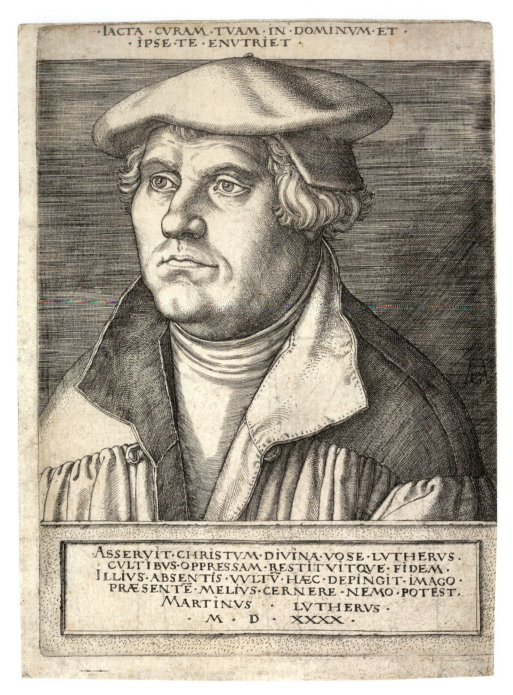

287

proved quite popular. They are so widely regarded as the starting point of Luther's theology that they have been called *initia theologiae Lutheri*. Luther's interpretations placed Christ at the center of the Old Testament Psalms. The verse inscribed on the Aldegrever portrait has strong resonance with I Peter 5:7, "Casting all your care upon him; for he careth for you." TR

Literature
Lindell 2011, p. 79 · Luckhardt 1985, pp. 56f., cat. 10 · Mielke 1998, pp. 156–157, no. 184

Portraits of Martin Luther and Philip Melanchthon

Lucas Cranach the Elder
and workshop

288
Martin Luther

1540
Oil on copper beech
20 × 14.5 cm
Luther Memorials Foundation
of Saxony-Anhalt, G 70
Minneapolis Exhibition

289
Philip Melanchthon

1540
Oil on copper beech
20 × 14.5 cm
Luther Memorials Foundation
of Saxony-Anhalt, G 71
Minneapolis Exhibition

290
Martin Luther

Around 1541
Oil on copper beech
35.5 × 23 cm
Luther Memorials Foundation
of Saxony-Anhalt, G 72
Minneapolis Exhibition

291
Philip Melanchthon

1532
Mixed media on beech
19 × 15.1 cm
Foundation Schloss Friedenstein Gotha, SG 10
New York Exhibition

These two small portraits of Martin Luther and Philip Melanchthon form a pair which originally actually may have been attached (cat. 288 and 289) to form a diptych, a hinged tablet which could be folded over while traveling. On the edge of the image, above the shoulders of the portraits, which were turned to face each other, is the signature of the Cranach workshop, where a first series of diptych portraits of the two Reformation figures was created starting in 1532.

John Frederick the Magnanimous, who was a supporter of the Reformation in Saxony, may have commissioned Cranach to create double portraits of this kind when he took office as Elector of Saxony in 1532. This first series underscores the importance of both theologians for Lutheranism and the implementation of Luther's ideas. They are shown with young-looking facial features, dressed in Reformation-era preaching gowns, before a bright monochrome background. Luther is also depicted with a biretta and a book, while Melanchthon is typically shown with hands folded. In the later second series, which appeared starting in 1539 and are considered to be old-age portraits, Luther appears aged, bareheaded with thin graying hair, holding either a closed book or a Bible which is opened to a legible passage. Melanchthon is also holding either an open Bible or a scroll, as in the Wittenberg version here. In a third series, in production starting in 1543, he is portrayed with a biretta and pointed beard next to Luther, who continues to be shown bare-headed. In all three series, the heraldic right side is occupied by Martin Luther, as is the case in the double portraits with Katharina von Bora (cf. cat. 227–230). The image detail of the two portraits is identical, indicating a certain equality between the two subjects. However, Luther comes across as far more substantial next to the rather dainty Melanchthon and therefore appears as the more significant personality. The workshop of Lucas Cranach the Elder disseminated such "friendship portraits," a category of portraiture which was developed based on portraits of humanists from the early 16th century, as quickly and as widely as the portraits of Luther with his wife, Katharina von Bora. Lucas Cranach the Younger took over production of these portraits and continued to disseminate them on a massive scale; to this day, these portraits define our image of the two reformers, bonded in friendship. The portraits of Melanchthon, for which a companion has not been found (cf. cat. 291), can nevertheless be identified as part of a pair of portraits based on their composition. In the 16th century, Melanchthon was likely perceived as being worthy of protraiture specifically because of his connection with Martin Luther.

Philip Melanchthon, who in 1518 became a Greek language professor at the University of Wittenberg, which had been founded in 1502 by Frederick the Wise, supported Luther's theological ideas on the reform of the Church, and from the moment his theses were proclaimed in 1517, he became Luther's most important ally and companion. Melanchthon drafted the *Augsburg Confession*, the fundamental confessional statement of the Lutheran imperial estates (cf. cat. 345 and 346). It was delivered to the Emperor at the Diet of Augsburg in 1530, in which Luther could not take part because of the imperial ban. In this situation, the dissemination of portraits showing Luther and Melanchthon as friends served to portray the unbreakable alliance between the two. The political dimension of this portrait series is evident, as is that of the double portraits of Luther and Katharina as a married couple. Martin Luther and Philip Melanchthon remained lifelong friends despite a few theological differences. Both were laid to rest in Wittenberg's Castle Church. BR

Literature
Bild und Botschaft 2015, pp. 154–161, cat. 34–38 (ill.) · Friedländer/Rosenberg (1989), p. 131, cat. 314 and 315 (ill.) · Joestel 1993, p. 204 · Marx/Kluth 2004, pp. 150f., cat. 205 and 206 (ill.) · Schuttwolf 1994a, p. 48, cat. 1.14 and 1.15 (ill.)

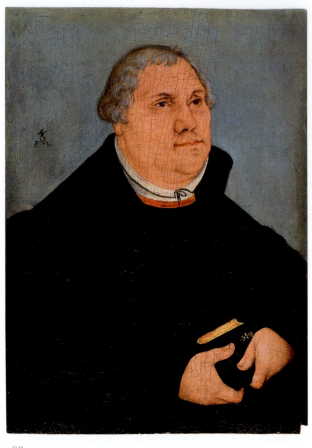

288

289

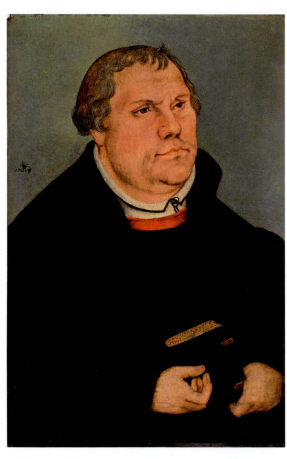

290

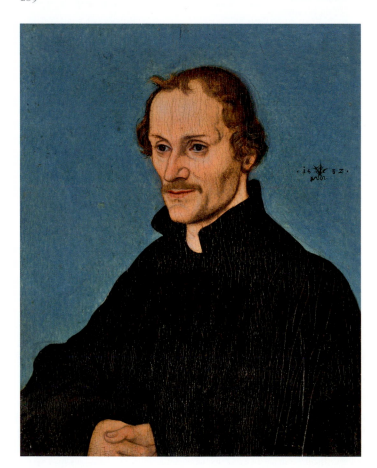

291

Printing in Wittenberg

The small town of Wittenberg was in no way set up to have book printing as a dominant industry, and yet in the 16th century it grew to rank with Paris, London, and Venice as one of the largest producers of books in Europe. Frederick the Wise founded the University in Wittenberg in 1502, and by design, that same year the first printing press in the city opened. Nicolaus Marschalk, professor of Greek, operated the press, and most of the books produced were closely related to the university's curriculum. Print-runs remained small, with simple typography, and limited circulation. In its first year, the Wittenberg press printed only two works; it would not be until 1518 that Wittenberg ever produced more than 15 works in a year. The reason for the change, of course, was Martin Luther. In 1518, following the distribution of Luther's theses against indulgences, 29 books issued from the city's press, nearly six times as many as the previous year. Luther repeatedly complained about the quality of printing coming from the Wittenberg press, now run by Johann Rhau-Grunenberg, but the university print shop was not prepared to match the demands of this most prolific of authors or compete with the aesthetics and distribution of more experienced presses. From 1516, Lucas Cranach's woodcuts frequently adorned the title pages of Wittenberg imprints, yet even this visual augmentation by the renowned artist could not elevate local work to match the quality printing coming from other cities. However, the mid-1520s proved a landmark time for both Luther and the Wittenberg printing industry. The publication of the New Testament in 1522 inaugurated a period of consolidation and substantial growth for the Lutheran movement, which coincided with three new printers—Joseph Klug, Hans Lufft, and Georg Rhau—operating shops in Wittenberg. Luther and his colleagues produced a continuous flow of written material for the printers, who employed modern typographic materials and elaborate new woodcuts by Lucas Cranach. By the time of Luther's death, Wittenberg was the primary center for book printing in the German Empire. The Wittenberg printing industry developed in tandem with the Reformation, where each one helped to ensure the success of the other. JTM

292

Moveable Lead Printing Types

Wittenberg, Bürgermeisterstraße 5
4th-quarter of the 16th century
Alloy of lead, tin, antimony, bismuth
(292 pieces)
L 2–2.5 cm; width 0.2–1.5 cm;
depth 0.1–1.2 cm
State Office for Heritage and Archaeology
Saxony-Anhalt
State Museum of Prehistory, HK 98:24665
Minneapolis Exhibition

Martin Luther strove hard to bring his call for reform to the attention of a larger audience, and books were certainly his most important medium for this. Once Johann Gutenberg had perfected his method of printing with moveable type in the middle of the 15th century, it became possible to produce books both in large numbers and in short time. Not least because of Luther's tireless activity, Wittenberg was soon to become one of the leading printing centers in Europe during the 16th century. This position is attested not only by the large number of works that were printed here (of which many survive to this day), but also by more immediate—albeit rarer—traces of the printers' daily work.

The huge number of lead types unearthed during archaeological excavations in Wittenberg surpasses the comparable material from any other European city. The find complex shown here consists of more than 500 pieces of type, which were found in 1997 in a former latrine on Lot 5 on Bürgermeisterstraße. The refuse pit had originally belonged to a house in which a succession of printers plied their trade during the 2nd-half of the 16th century. Various artefacts found in the latrine infill suggest a deposit date in the last-quarter of the 16th century, and some peculiarities of the lead types themselves confirm this date. A comparison with written sources allows us to connect these finds to the Krafft family, onetime inhabitants of the house who are known to have printed, among others, the works of Luther and Melanchthon.

The alloy from which the letters were made is basically characteristic for the period of the Reformation. Its composition consists mainly of lead, to which a fixed amount of tin and antimony was added to increase durability and strength. The finds from Wittenberg are remarkable, however, in containing bismuth, which was not used in other printing centers of the time. This component was obviously added to improve the casting properties. The types, however, also include letter shapes and symbols in various sizes that were not peculiar to Wittenberg.

The type fonts discovered include Renaissance Antiqua (Roman), which was only used for printing in Latin or other foreign languages, as well as Fraktur (Gothic) and Schwabacher fonts, which were mainly used for German texts—and which are still considered quintessentially German scripts to this day. Some finds of Greek and Hebrew types (cf. cat. 365) add to the impression that the find complex of the Bürgermeisterstraße 5 represents a very broad cross-section of the art of printing in the Age of Reformation. DBe

Literature
Berger 2015 · Berger/Stieme 2014 a, p. 243, fig. 3 · Berger/Stieme 2014 b, p. 281, fig. 12, p. 285, fig. 18, p. 289, fig. 24, p. 306, p. 37 (ill.) · Claus 2002 · Pelgen 1996

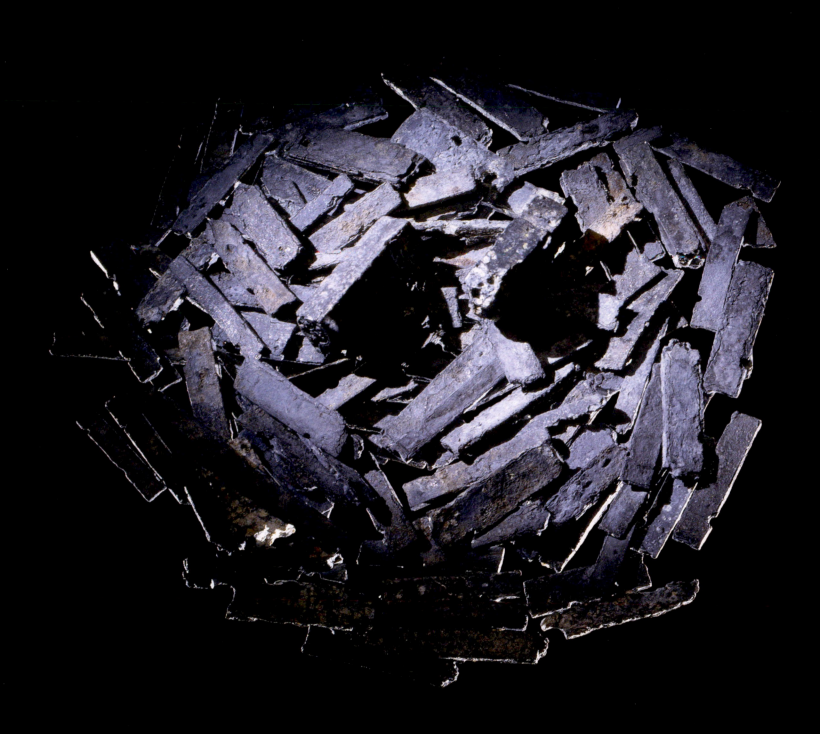

Martin Luther

Deudsche Messe und ordnung Gottis dienst (The German Mass and Order of Service)

Wittenberg: Michael Lotter, 1526
20.3 × 14.7 cm
Luther Memorials Foundation of Saxony-Anhalt,
Ag 4° 207 n
VD16 M 4919
New York Exhibition

When Martin Luther returned to Wittenberg in March 1522, he reversed the changes to the liturgy that Karlstadt and others had introduced. Apart from the words of institution, the liturgy was once again sung in Latin, and the laity no longer received the Eucharist bread in their hands. Within two years, there were German orders of service for nearly all Protestant regions. Luther was concerned for the preservation of evangelical freedom, and he hesitated to provide a universally binding formula for all territories and towns. Upon the insistence of his friends, but also the Elector, in 1526 he finally published an order of service valid for Wittenberg, expressly as an example and not an obligation. For the liturgical singing, Johann Walter and Konrad Rupsch served as advisors.

In the foreword to the edition, Luther emphasizes that he is holding on to the Latin Mass for the sake of the education of the youth. At the same time he dreams of the introduction of a very simple form of church service for all "who want to be Christians in earnest." He says, however, that there are not such people in Wittenberg. A peculiarity of his liturgy, emerging from the literal interpretation of the Bible text, was that the words of institution for the bread were followed immediately by the distribution of the bread, before the words of institution for the wine. This idea of Luther's, however, did not catch on. MT

Sources and literature
Leppin/Schneider-Ludorff 2014, pp. 273–275 ·
Ott 2014 · WA 19, 44, 70–113 [LW 53, 53–90]

Martin Luther

Deudsch Catechismus (German Catechism, also known as Large Catechism)

Wittenberg: Georg Rhau, 1529
20.6 × 15.5 cm
Luther Memorials Foundation
of Saxony-Anhalt, Ag 4° 210 b
VD16 L 4339
New York Exhibition

Alongside his Bible translation and hymns, the catechisms are among Luther's most influential works. The *Large Catechism* was designed for pastors, above all rural pastors, while the *Small Catechism* was for the laity. Both contained the Ten Commandments, the Lord's Prayer and the Apostolic Confession of Faith, accompanied by Luther's pithy explanations. The *Large Catechism* was meant to serve as the foundation for extended sermons, since visitations of the churches had shown there were shocking gaps in knowledge of basic Christian doctrine. The father of a household was to teach his family and servants out of the *Small Catechism*. As Luther stated, "The catechism is the layperson's Bible, for the whole content of Christian doctrine is found within which is necessary for every Christian for blessedness." Luther expected every Christian to learn the catechism by heart. For those who refused, he suggested banishment from the region. He could not achieve this level of compliance, but the *Small Catechism* was still being learned in many places until the end of the 20th century. MT

Literature
Joestel 2008, p. 94

293

294

Poverty and Charity in the Age of Reformation

Luther's fundamental rejection of a justification through works changed the perception of poverty. Whereas the poor had been an important part of the theological system—good deeds to help them were a path to salvation—they now became an object of organized communal care. In the late Middle Ages, townsfolk developed a widespread sentiment against the ostentatious poverty of certain religious orders, which was thought hypocritical, as the orders themselves were obviously wealthy, even if the individual monks appeared not to be.

In To the Christian Nobility of the German Nation of 1520, Luther argued, despite being a member of a poor order himself, that monetary donations were better placed directly in the hands of the needy than in the intermediary hands of monks. This demand gained popularity in the debate over communal charity. Henceforth, poverty was to be addressed at an individual level in all Protestant communities. The neediness of a poor person would no longer depend on an individual's whims, eagerness to donate alms or establish foundations; it would be determined by administrative regulations, and appropriate provisions would be made from a communal chest.

In Catholic territories, the poor continued to be regarded as a visible symbol and reminder of Christ. In Reformed territories, on the other hand, it was seen as desirable to eradicate poverty as a phenomenon and convert the poor into valuable members of society. As attention shifted from the donor to the recipient of alms, the charity practiced by individual Christians inevitably decreased. One could now rely on the authorities to take care of poverty, and consequently, to reduce personal alms-giving without any qualms about neglecting basic Christian duties.

The question of whether the Reformation and Luther's writings were really the decisive factor for innovations in organized charity in the 16th century has been the subject of lengthy debate. The specific effect is now generally held to be doubtful. Attempts to communalize charity in towns were underway before the Reformation. The process was merely codified in the form of "poor ordinances" during the Reformation. Even the basic arguments on the nature of poverty were previously expounded by humanists. Current opinion, therefore, tends to limit the Reformation's influence to a catalyst that focused and accelerated preexisting processes. RK

295

Common Chest of the City of Wittenberg

Around 1520
Iron
59 × 120 × 64 cm
Luther Memorials Foundation
of Saxony-Anhalt, K 364
Minneapolis Exhibition

Opening this sturdy iron chest would require three different keys. This was done to prevent unauthorized persons from opening it. After all, as of January 1521, it was placed in a highly visible position in Wittenberg's parish church. The chest held valuable objects and money. The three keys were entrusted to three different Wittenberg officeholders.

Money was kept in this central location for various purposes: it was used to pay school and church workers, to fund church construction projects and to cover the costs of the city's hospitals and health care services. Anyone who wanted could borrow money from the Common Chest. It was with such a loan that Martin Luther was able to obtain the money he needed to buy a property in 1532. Last but not least, the money was used to provide financial assistance to the poor in Wittenberg. The Common Chest was more than just an iron box; it was an institution, part of the administrative structure of the municipal welfare system.

In Wittenberg in the late medieval period, the welfare system was based on three pillars: the hospitals, the brotherhoods and private donations. This system was in need of reform given the increasing numbers of the poor, sick and beggars, as well as the decentralized organization and the more frequent appearance of beggars from outside the city. The city's 1521 "Common Purse Ordinance" centralized the allocation of funds from the Common Chest. In addition, the Reformation opened up new sources of revenue. At first, the secularization of property caused funds to flow into the Common Chest. These funds came from the sale of confiscated church assets and equipment and vestments that were no longer needed, as well as land. Money also came from collections, plates or "purses" that were passed around from hand to hand.

The receipt of these funds was subject to certain conditions. For example, residents of Wittenberg's poorhouses and orphanages, which were financed from the Common Chest, had to satisfy strict work requirements. When allocating funds to the poor, a distinction was made between those who were able to work and those who were unable to work. Luther demanded that each individual should be required to demonstrate his or her poverty before a right to alms could be established. The grants which were made from the Common Chest were so small that recipients who were able to work were compelled to seek gainful employment. The practice of granting alms had the effect of regulating the municipal job market and was designed to allow beggars to participate in the city's economy. RK

Literature
Fischer 1979 · Grell 1997 · Joestel 2008, pp. 90 f. (ill.) · Jütte 1984 · Oehmig 1988 · Oehmig 1989

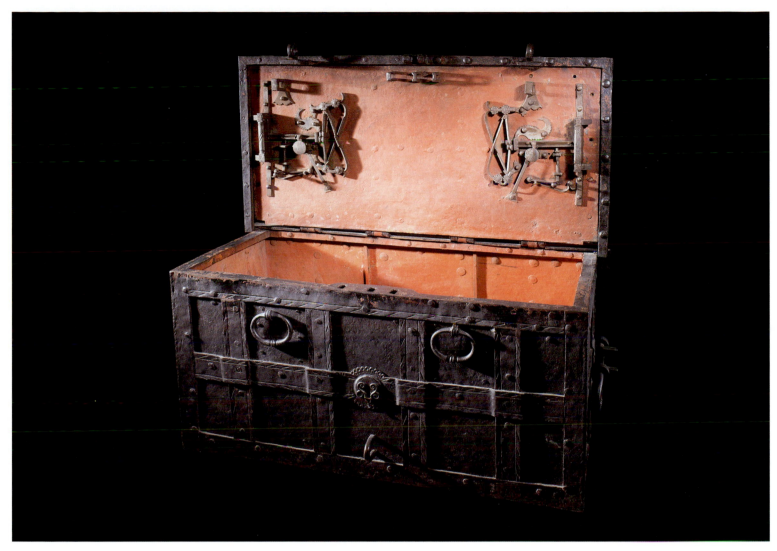

295

296

Martin Luther

A Request Submitted to Elector
Frederick III of Saxony for
the Confirmation of the Regulations
made by the Town of Leisnig
for their Common Chest

August 11, 1523
32.2 × 21.9 cm
Thüringisches Hauptstaatsarchiv Weimar,
EGA, Reg. Ii 114, f. 19
Minneapolis Exhibition

Leisnig was one of the first towns in which the
ideas of the Reformation took hold. Since 1520,
the town council and the church elders had
clashed with the convent of Buch over the right
to appointment the town's priest. At the same
time, a reform of congregational life and church
services began to be debated. The citizens of
Leisnig were supported in this endeavor by
Martin Luther, and he made sure that the con-

flict between townsfolk and convent was de-
cided in favor of the congregation. He also
encouraged them in their intention to organize
their services according to Reformation ideas.
The most pressing problems were actually social
issues. These included an adequate income for
the clergy, the upkeep of church buildings, the
support of the needy poor and the education of
the parish youth. Following the lead of Witten-
berg, the citizens of Leisnig set about arranging
the affairs of their congregation. They took spe-
cial care to establish provisions for adequate fi-
nancing, which they laid down in a document
they submitted to Luther for approval in early
1523. The stated intent was to collect in a com-
mon endowment fund all the revenues and rents,
possessions and furnishings of the four existing
altar benefices, plus those of two lay brother-
hood associations, as well as the income from
donations and testaments.

This Common Chest (*gemeiner Kasten*) was to be
used for the support of the poor and the sick as
well as the upkeep of the clergy and church build-
ings (cf. cat. 295). A committee of ten church

wardens was to oversee these arrangements and
give regular account before the assembled con-
gregation. They were also to appoint a sexton, a
schoolmaster to teach the boys and an "elderly
female person" to instruct the girls. Begging was
to be forbidden, as was blaspheming and other
sins and vices contrary to the laws of God.

Luther was so impressed with these regulations
that he contributed a preface of his own and
wasted no time in having it printed, thereby en-
suring its rapid dissemination. Unfortunately,
this edition lacked official permission on the
town's (and Luther's) territorial sovereign. Real-
izing this oversight, the town council of Leisnig
delayed the intended merger of the various foun-
dations and donations under its authority in the
Common Chest. Inevitably, this delay endan-
gered the planned regular payment of the priests
and other church officers. The letter shown here
was therefore penned by Luther in a belated at-
tempt to secure the permission of the Elector.
Frederick the Wise declined to respond to the
request. This in turn led to a dispute between the
town council and congregation which was to drag

296

Literature
Beyer 1989 · Bornkamm 1979 · Junghans 1982 · Scherer: Luther bittet · Staatliche Archivverwaltung 1983, pp. 148 and 352 f. (ill.)

297

Daniel Hopfer

Illustrations to Proverbs II: The Hoarders of Grain

1684 (first copy: 1534)
Etching
plate: 20.7 × 28.4/28.2 cm, print: 20.1 × 27.6 cm
Luther Memorials Foundation of Saxony-Anhalt, fl XX 8816
Minneapolis Exhibition

Designated in the top middle D. H. [in between Hopfendolde]
dated, under the inscription: MDXXXIIII (in the present Funck copy, later changed to MD-CLXXXIIII [1684]; in the plate on the bottom left, 29, shaved in the present copy)
Inscription above: DIE SPRICH SALOMO DAS XI CAPITEL / WER KORN INHELT DEM FLVCHEN DIE LEIT / AVER SEGEN KOMPT VBER DEN SO ES VERKAFFT / M DXXXIIII (PROVERBS CHAPTER XIL / PEOPLE CURSE THE ONE WHO HOARDS GRAIN / BUT THEY PRAY GOD'S BLESSING ON THE ONE WHO IS WILLING TO SELL / M DXXXIIII)

The image shows the good and the bad grain merchant. The quote at the top of the page comes from Proverbs 11 and tells of God's curse that will be visited on those who hoard grain instead of selling it. This is illustrated on the left side by the depiction of a fat merchant sitting with pleasure on his sacks of grain, hoarding them rather than selling them. A nobleman on his knees is complaining that his sack is only half-full. The fat seller has black dragons sitting on his head and shoulders, while furious citizens try to drive away the dragons. Contemporary legends describe this very event: demons such as these would help their masters steal grain, and only he who can drive away the dragons with harsh words will be able to drive out the profiteers as well. In times of crisis, this was surely a helpful story for explaining distress and justifying curses.
The seller on the right side of the image (in both senses of the word), acts the correct way. The good seller leaves his sacks open in the market-place and, in return, he is crowned by the dove

.D. H.

DIE SPRICH SALOMO DAS XI CAPITEL 26. vers:
WER KORN INHELT DEM FLVCHEN DIE LEIT
ABER SEGEN KOMPT VBER DEN SO ES VERKAFFT
M DLXXXIIII

297

of the Holy Spirit and the hand of God. His grain sales, and we see coins changing hands, are bringing heavenly blessings. Instead of hunger and strife, there is enough to eat; a man in the lower right edge of the illustration is filling a wooden tub with grain.

A crown is hanging on the sacks of the seller on the right-hand side. This is an allusion to the ruling class, as the body responsible for looking ahead and making wise plans to prevent famines by maintaining stores of food. In his 1523 Leisnig Chest Ordinance (cat. 296), Martin Luther had called for the city to build up food stores in order to prevent famines. When in 1525/26 Wittenberg experienced a crisis of supply, which was triggered by the Peasants' War, the city purchased grain using funds from the Common Chest (cat. 295) in order to stimulate the market. RK

Literature
Hollstein XV, no. 6 · Koch et al. 1981, p. 101, cat. 23 · Kuder/Luckow 2004, p. 134, cat. 55 · Metzger 2009, p. 322, cat. 6 · Seifert 2005, p. 180 · Unverfehrt 2001, p. 132, cat. 57

The Role of Music in the Reformation

Without a doubt, Martin Luther is the theological originator and the most famous personality of the Reformation. Yet among the powerful currents that have shaped the Protestant Church to this day, his love and enthusiasm for music stands out. According to Luther, music was second only to theology among the liberal arts. He believed that music had the power to anchor the Gospel in the hearts of people and to attract the young to the faith. He believed that through "singing" and "saying" both the intellect and the emotions could be addressed in equal measure. According to him, it is a vital aspect of liturgy that singing is an integral part of the promulgation, not just an atmospheric ornament: *"Sicut praedicavit Deum evangelium etiam per Musicam"* (God preached the Gospel through music; Arnold 2014, p. 25). Music was seen as a gift of the creator and a deeply human art. Consequently, the Reformation was to thrive as a decidedly musical movement. The new creed was spread through domestic music and prayer and through music in schools and churches. Gradually a new kind of piety began to evolve.

This process created a huge demand for original music with Protestant content and lyrics. All in all, Luther wrote some 40 songs, and for about half of these, he was also the composer of the melody. On the other hand, Luther also commissioned numerous compositions by musicians who supported the Reformation or else these musicians placed their music at his disposal. These were fresh and original tunes that had real musical merit and were in accordance with the prevalent taste of the time. Luther's demands were concordant with a new appreciation of music in the 16th century. The practice of music, the *ars canendi*, which had hitherto been less esteemed, and the theory of music as taught at the universities, the *ars musica*, were beginning to converge. This new concept leads to our idea of "music" by the merging of the separate fields of *musica theoretica, practica* and *poetica* (music theory, performance and composition). Practical music was now given a new prominence and dignity.

Thanks to the advances made in the art of printing, the musical compositions and manuals of the Reformation movement were disseminated rapidly and widely alongside other writings and treatises. Georg Rhau, a printer from Wittenberg, was to play a key role in this process.

To this day, preaching and music form an indissoluble union in Protestant churches. MGr

298

Martin Luther and Paul Speratus

Etlich Cristlich lider Lobgesang, von Psalm, dem rainen wort Gottes gemeß (Book of Eight Songs)

[Nuremberg: Jobst Gutknecht], 1524
21 × 15.5 cm
Forschungsbibliothek Gotha der Universität
Erfurt, Cant. spir 8° 959 (1)
VD16 L 4699
Minneapolis Exhibition

Lyrics set to popular melodies helped many people to more readily accept the messages of the Reformation. This small hymnal, published by Jobst Gutknecht in Nuremberg at the end of 1523 or the beginning of 1524 and referred to in German as the *Achtliederbuch* (Book of Eight Songs), is regarded as the earliest prototype of the modern Lutheran hymnal. It contains songs by Martin Luther and his follower Paul Speratus that had previously circulated individually as broadsheets and that had been introduced into the liturgy in Wittenberg. Printing this and other early collections of Evangelical songs was neither commissioned nor authorized by the authors, but rather a profit-oriented undertaking of publishers and booksellers. The lyrics conveyed fundamental messages of Luther's theology. Central themes of the songs in the *Achtliederbuch* include grace and justification, law and Gospel, and the creed. Underscoring the *sola scriptura* principle, Speratus' lyrics are provided with appendices verifying the biblical foundation of each verse. The book also contains poetically paraphrased Psalms in German. In this way, the Psalter, a primary source of Christian prayer traditionally read or sung in Latin, was introduced into the liturgy in the vernacular language.

The *Achtliederbuch* was a rarity already 300 years ago. The Arnstadt preacher Johann Christian Olearius (1669–1747), regarded as the founding father of hymnology, searched several years before he was able to acquire this copy for his extensive hymnal collection comprised of more than 15,000 songs. Duke Ernest II of Saxe-Gotha-Altenburg purchased this prestigious collection in 1793 for the ducal library at Friedenstein Castle in Gotha. Today, it forms the foundation of one of the largest and most significant hymnal collections in Germany, with more than 3,000 titles from the 16th to 20th century. DG

Literature
Ameln 1956 · Berger/Greb/Rode 2015 · Paasch 2012, pp. 72–77, nos. 1.3, pp. 79 f. · Stalmann 2011

299

Martin Luther

Geistliche Lieder, aufs neue gebessert zu Wittenberg (Sacred Hymns Revised in Wittenberg)

The "Klug Hymnal"
Wittenberg: Joseph Klug, 1533
10 × 16.5 cm
Luther Memorials Foundations
of Saxony-Anhalt, ss 1009
VD16 ZV 6453
Minneapolis Exhibition

including: *A Mighty Fortress is our God*

The second edition of Joseph Klug's hymnal, the oldest surviving edition of his compilation, was published in 1533. It contains Martin Luther's famous hymn, *Ein feste Burg ist unser Gott* (A Mighty Fortress is Our God), under the title *Deus noster refugium et virtus* (God is our Refuge and our Strength), on fol. 42v, adapted from Psalm 46.

The Klug hymnal is considered to be the first illustrated hymnal for the Evangelical community. The woodcuts featuring scenes from the Bible, some of which come from the woodcut workshop of Georg Lemberger, as well as the hymns, prayers and introductions, form a systematic theological compendium for life and faith in multiple parts, the order of which was canonical for some decades: liturgical year, catechism, Psalms and liturgical hymns.

With the publication of this book—and it is extremely likely that he was directly involved in compiling it—Luther sent a clear signal with regard to the order to be followed by this still relatively young denomination and its principles. Twenty-eight of his hymns precede the other compositions, and Luther records himself as their author for the first time. The Luther Rose on the title page signifies the official status of this hymnal and prayer book. The book contains two forewords by Luther pointing out the great importance which music has in raising children, as well as the need to give Evangelical Christians clear guidance in these times of upheaval.

The lost 1529 first edition appeared about the same time as the two catechisms (1529), the expanded new edition of the prayer books (1529) and the new complete Bible translation (New Testament, 1522, complete edition, 1534). In these works, Martin Luther lays the foundation for a distinctive Evangelical religious observance. MGr

Literature
Ameln 1954 (ill.) · Herbst/Seibt 2012, p. 63 · Rößler 2015

Top book (open spread)

Left page

Ein Christenlichs lied Doctois
Martini Luthers/ die vnaussprechliche
gnaden Gottes vnd des rechten
Glaubens begreyffendt.

Nun frewt euch lieben christen gmeyn.

¶Nun frewt euch lieben Christen gmein/Vnd last vns frölich springen/Das wir getrost vnd all in ein/Mit lust vnd liebe singen/Was got an vns gewendet hat/Vnd seine süsse wunder that/Gar theur hat ers erworben.

¶Dem Teüffel ich gefangen lag/Im todt war ich verloren/Mein sünd mich quellet nacht vnd tag/Darinn ich war geboren/Ich viel auch ymmer tieffer drein/Es war kain güts am leben mein/Die sünd hat mich besessen.

¶Mein güte werck die golten nicht/Es war mit jn verdorben/Der frey will hasset gots gericht/Er war zum güt erstorben/Die angst mich zü verzweyfeln treyb/Das nichts dann sterben bey mir bleyb/Zur hellen müst ich sincken.

Right page

Do jammert Got in ewigkait/Mein elend vber massen/Er dacht an sein barmhertzigkait/Er wolt mir helffen lassen/Er wandt zü mir das vater hertz/Es war bey jm fürwar kain scherz/Er ließ sein bestes kosten.

¶Er sprach zü seinem lieben son/Die zeyt ist hie zur barmen/Far hyn meins hertzen werde kron/Vnd sey das hayl dem armen/Vnd hilff jm auß der sünden not/Erwürge für jn den pittern todt/Vnd laß jn mit dir leben.

¶Der sün dem vater gehorsam wardt/Er kam zü mir auff erden/Von einer junckfraw rain vn zart/Er solt mein brüder werden/Gar haimlich fürt er sein gewalt/Er gieng in meiner armen gestalt/Den teüffel wolt er fangen.

¶Er sprach zü mir halt dich an mich/Es sol dir yzt gelingen/Ich geb mich selber gantz für dich/Da wil ich für dich ringen/Dan ich bin dein vn du bist mein/Vnd wo ich bleyb soltu sein/Vns sol der feind nicht scheyden.

¶Vergiessen wirdt er mir mein plüt/Darzü mein leben rauben/Das leyde ich alls dir zü güt/Das halt mit festem glauben/Den todt verschlingt das leben mein/Mein vnschuldt tregt die sünden dein/Da bistu selig worden.

¶Gen hymel zü dem vater mein/Far ich von disem leben/Da wil ich sein der maister dein/Den geyst wil ich dir gebn/Der dich in trübtnuß trösten sol/Vnd lernen mich erkennen wol/Vnd in der warhait leytten.

Bottom book (open spread)

Left page

Der xlvi. Psalm/ Deus noster refugium et virtus/ rc.

Martinus Luther.

Ein feste burg ist vnser Gott Ein gut
Er hilfft vns frey aus aller not/ die vns

te wehr vnd waffen/ Der alt bö-
ist hat be troffen. se feind/

Right page

se feind/ mit ernst ers jtzt meint / gros (macht vnd

viel list/ sein grausam rüstung ist/ auff
erd ist

nicht seins gleychen.

Mit vnser macht ist nichts gethan/ wir sind gar bald verloren/ Es streit für vns der rechte man/ den Gott hat
G ij selbs

300

301

Johann Walter (composer)
Martin Luther (author)

Wittembergisch deudsch Geistlich Gesangbüchlein (Wittenberg German Sacred Songbook)

Wittenberg: heirs of Georg Rhau, 1551
21 × 16 cm
New York Exhibition

300

Part Book: Tenor

Evangelische Marktkirchengemeinde Halle,
Marienbibliothek,
V 1.71 a

301

Part Book: Discant

Evangelische Marktkirchengemeinde Halle,
Marienbibliothek,
V 1.71 b

With the *Sacred Songbook*, the history of independent Evangelical church music begins, and continues to this day. Under this title, Johann Walter (who served as a composer for the court orchestra of the Elector of Saxony) first published choral songs for multiple voices in 1524, in five part books. In the ensuing decades, this hymnal was revised three times and, in some cases, expanded substantially. This edition, the final edition from 1551, contains 125 settings (78 in German and 47 in Latin), as opposed to the first edition, which contained only 43 settings (38 in German and 5 in Latin). Across all the editions, one can find a total of 141 high-quality compositions in the *Sacred Songbook*. As Luther would have wished, they provide suitable material for school choirs, court orchestras and the urban church choirs of later days. Accordingly, it is a collection of material that can be used in order to win over young people and establish an independent Evangelical—religiousness, as Martin Luther states in his foreword to the hymnal.

By 1544, at the latest, the manuscript of the "Walter hymnal" found its way to the music theory scholar, musician and printer Georg Rhau, where it has remained with his heirs. Georg Rhau is the music printer of the Reformation, publishing a large repertoire of liturgical music for school and home. Appearing at the same time as the *Sacred Songbook* was Rhau's hymn collection, *New German Sacred Songs*, a work which was, next to Walter's hymnal, the most important arrangement of new Evangelical hymns for multiple voices in the Reformation period. Between these two publications, Rhau's workshop was responsible for nearly all of the early Protestant hymn settings.

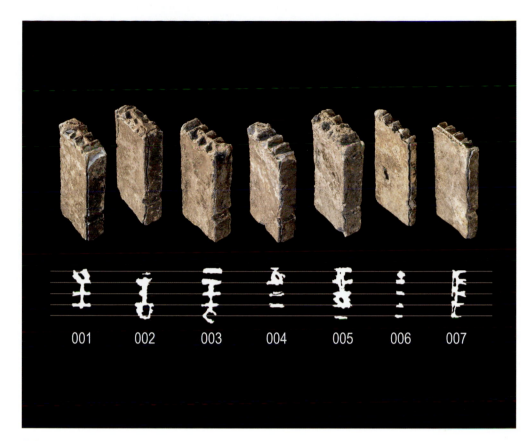

302

Both existing part books are printed with movable type using the single-pull method. Eight type sorts (the eighth object is missing its face, the part that prints the note), which were found in Wittenberg only in 2012—one-of-a-kind technical artifacts of Georg Rhau's early printing workshop—are found in the catalogue under cat. 302. MGr

Sources and literature

Bartsch 2013 · Berger/Greb/Rode 2015 · Blankenburg 1991 · Walter, Gesangbüchlein

302

Seven Musical Notation Printing Types

Wittenberg, Franciscan convent
Between 1538 and 1566
Alloy of lead, tin and antimony
L 2.6–2.7 cm; width 1.1–1.2 cm;
depth 0.2–0.5 cm
State Office for Heritage and Archaeology
Saxony-Anhalt – State Museum of Prehistory,
HK 4900:1141:001–007
New York Exhibition

A mere one hundred meters from the substantial find of lead types at Bürgermeisterstraße 5 (cat. 292 and 365), another group of printing types turned up in Wittenberg in excavations in 2012 on the site of the former Franciscan convent. These types, some 38 pieces in all, had probably been lost during use or shortly afterwards, and had then been trampled into the floor layer of the building where they were found. The finds include printing types for letters from different fonts, such as Renaissance Antiqua (Roman), Fraktur (Gothic) and Schwabacher, but also eight lead types for musical notes of various pitch and length as well as the staff lines. A selection of seven types is shown here. The types from the convent site consist of a lead alloy that is basically comparable with that used for the Bürgermeisterstraße finds but lacks the bismuth component.

The finds from the convent are particularly rare evidence for the early evolution of the moveable type printing process invented by Johann Gutenberg. To this day, no comparable examples of musical notation types have been found in a reliable archaeological context. Furthermore, the finds also document a seminal change in the printing of musical notes. The types could be used to print both lines and notes in a single step. This revolutionary method was flexible and fast, and it permitted substantial print-runs and works of a greater number of pages. Previously, musical works were printed in a much more laborious process, either using woodcuts for single-block printing, or in separate steps for the staves and notes.

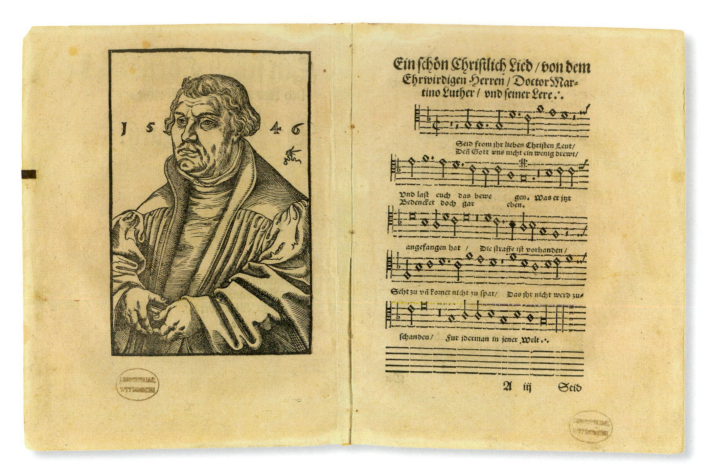

303

A rough date for the type finds is indicated by a few accompanying ceramic fragments from the 1st-half of the 16th century. However, the types can be more precisely dated by themselves, as the earliest production and use of this kind of type is reliably documented in Nuremberg from 1534. In Wittenberg, their first appearance can be dated to 1538, when they appear in the books of Georg Rhau, without doubt the most important printer of musical material during the Reformation. His workshop produced works both for one and for several voices, such as the *Waltersches Gesangbuch* (the Walter Hymnal) and *Ein schön Christlich Lied* (cf. cat. 300, 301 and 303), and works on musical theory as well.

A comparison of surviving original imprints with details of the type finds from the convent site strongly suggests Rhau and his successors as the likely owners of the types. This connection is confirmed by written documentation that definitely places their workshop on the grounds of the former convent. As this workshop is known to have closed around 1566, the finds must have been lost sometime before or around this date. DBe

Literature
Berger/Greb/Rode 2015, p. 142, fig. 11, p. 150, fig. 23 · Gieseking 2001 · Krummel 1985 · Schlüter 2010

303

Johann Friedrich Petsch
Ein schön Christlich Lied von dem Ehrwirdigen Herren Doctor Martino Luther und seiner Lere (A Fine Christian Song on the Worthy Dr. Martin Luther and his Teaching)

Wittenberg: Georg Rhau, 1546
16.5 × 14 cm
Luther Memorials Foundation
of Saxony-Anhalt, Kn A 159/909
VD16 P 1942
Minneapolis Exhibition

Johann Friedrich Petsch published this monophonic song in 1546, shortly after Luther's death. The music as well as the lyrics represent an attempt to sum up and acknowledge the teachings as well as the significance of Martin Luther for the Christian world.

The highlights of the Reformation, according to the poet, are mentioned in rhyme: the "Roman poison" of the Catholic Church, the Pope's sale of indulgences, Luther's refusal to recant at the Diet of Augsburg (1518) and the Antinomian conflict (as of 1537). He also cites a few key points

from Lutheran doctrine, Luther's publication of the two catechisms and the salvation of all mankind through grace alone as the central point of the Evangelical understanding of faith.

To Petsch, Luther is a prophet, and has prepared the way for Christians to attain salvation: "Therefore you, dear Christendom [...] Stay on the true path / Which Luther has shown. Thus you will not go to ruin." The song calls upon us to follow Luther's teachings. The final lines read as follows: "His work is near at hand. And you should diligently read it. It will show the way to the Promised Land. For he was a prophet. / Look to it / Neglect not his teachings."

Aside from this edition, not much is known about the author. He is probably the same person that Elector John Frederick of Saxony recommended for a position in a church office in a letter to Luther and Melanchthon on December 14, 1545; Petsch had previously received the Elector's assistance for his studies.

The work was published by the musician, music theorist and printer Georg Rhau. The notes are printed in white mensural notation with movable type of the same kind as that cited in the catalogue under cat. 302. MGr

Sources and literature
ADB 25, 1887, p. 540 · Berger/Greb/Rode 2015 · Petsch, Christlich Lied

VII

Polemics
and Conflicts

With the invention of the printing process with moveable type by Johann Gutenberg, new professions and a distinctive trade began to evolve. Sales figures of printed media from the turn of the 16th century indicate that the general population was becoming increasingly eager to participate in and be informed about processes of social and cultural change in this era of Humanism. Martin Luther's reformatory treatises were destined to become bestsellers in this atmosphere. While only educated burghers could participate in the debate through the medium of the printed word, those segments of society that had not learned to read would still become involved through the popular medium of woodcut or copperplate prints. The highly expressive depictions of biblical scenes that were widespread in church contexts had made even illiterate contemporaries accustomed to interpreting pictures on their own.

The major protagonists on both the Protestant and the Catholic side of the emerging conflict were quick to realize the possibilities of pictorial propaganda. Soon, derogatory and disparaging images of major opponents were being circulated widely. Conversely, both camps also resorted to censoring objectionable material, which could go as far as public burnings of writings and images. A veritable "war of pictures" erupted, with both sides vying for supremacy in the interpretation of images and the support of the masses. One way to avoid censorship was to print pamphlets for rapid distribution. These would usually contain a brief statement of position presented in a satirical guise. A printer of such broadsheets had to be wary, however, because if he was identified as the source, his printing blocks would be confiscated by authorities.

The conflict between Protestant and Catholic positions was fueled to a large degree by the extreme satires and polemics that were published by the workshop of Lucas Cranach the Elder. One of his favorite ploys was to depict opponents in the guise of an animal with feminine features. The poisoned atmosphere that permeated all levels of society pushed Europe to the brink of all-out religious war again and again. The numerous conflicts of this era follow one another like beads on a string: the Pack Affair, the conflict over the Duke of Brunswick-Wolfenbüttel, the Schmalkaldic War and the unrest of the Peasants' Uprisings, the iconoclast movement and the rebellion of the Netherlands. Mutual animosity was deeply entrenched, not least because of the constant confirmation of negative stereotypes through a continuing stream of propagandistic material. Under these circumstances, a single misunderstanding was enough to ignite a war. Not until the Thirty Years' War had exhausted all participants with its drawn-out and excessive violence would a peace of compromise have any chance of succeeding. ASR

The Peasants' Uprising in Germany

The peasant class predominantly shouldered the burden of supplying medieval society's basic needs. The nobility and clergy lived off the peasants' harvest. This did not mean that all peasants lived in poverty, as some prospered and could confidently resist their lords' demands. The farmers' legal and economic situation could vary widely by region. In the late Middle Ages, however, the nobles increasingly forced them into dependency. By the 15th century, German princes and aristocrats were maximizing their revenues at the peasants' expense.

This exploitation and oppression led to widespread agitation for a return to traditional structures (the "Old Law") by the peasants in the early-16th century. The situation was rapidly deteriorating, especially in Swabia, where open revolt erupted in 1524. Townsfolk and the odd knight sometimes joined the peasants' movement. All of southwestern Germany arose against oppression by the princes, nobility and clergy.

Southwestern German members of the imperial estates reacted by forming the Swabian League to maintain peace. In opposition, the peasants presented a list of core grievances: the *Twelve Articles*. These demands concerned servitude and the feudal system, disputed rights on woodland and common land usage, and desirable church reforms. Many peasants understood Luther's *On the Freedom of a Christian* as encouragement to voice their grievances. Luther's work was seen to address the diverse evils that had accumulated in rural church affairs. As a consequence, the peasants referred to him and other reformers as moral authorities.

When the peasants began to lay waste to monasteries and castles—symbols of the feudal system—and resorted to personal violence against aristocrats, Luther announced his uncompromising opposition to the peasants' cause. He went even further to justify the nobility's determined resistance in his treatise *Against the Plundering and Murderous Hordes of the Peasants*. Ultimately, it was mostly the fast and ruthless action of the professional men-at-arms hired by the princes, that brought the rebellion to an end. By September 1525, the bloody punitive actions had achieved their goal. For the Church founded by Martin Luther, the German Peasants' Revolt marked the beginning of an alliance with the elites (the "authorities") the consequences of which endure to this day. SL

304

Martin Luther
Letter to the Christians in the Netherlands

Wittenberg, the end of July/the beginning of August 1523
25.5 × 18.5 cm
Forschungsbibliothek Gotha der Universität Erfurt, Chart. A 122, ff. 46r/v
Minneapolis Exhibition

Luther's theology and reform ideas tackling prevalent grievances in the Church spread rapidly beyond the Holy Roman Empire into the Low Countries. Their precipitation was facilitated by Luther's connections to members of his monastic order in the harbor town of Antwerp, who had studied at the University of Wittenberg between 1516 and 1520. These Augustinians promoted the distribution of Luther's writings in spite of the condemnation of his teachings by the Faculty of Theology in Leuven in 1519 and efforts of the Habsburgs to suppress the movement. The Governor of the Spanish Netherlands, Margaret of Parma, had all of the members of the cloister imprisoned in the fall of 1522. Two of them, Hendrik Voes and Jan van Esschen, were declared heretics and were burned at the stake on July 1, 1523 at the Grand Place in Brussels. The supporters of the Protestant movement in Antwerp were consequently forced underground.

Luther and other critics of this course of action quickly identified the young Augustinians as early martyrs to the Protestant cause. He addressed their persecution in a song (WA 35, 411–415 [no. 1]) in which he praises the steadfastness of the executed monks and ridicules his opponents in Leuven by pejoratively referring to them as "sophists" and thereby denouncing their arguments as petty and frivolous. Luther ends the song with spring-related imagery and picks up this theme at the beginning of his public letter of comfort to the supporters of the Protestant movement in the Low Countries, published in 1523. Although condemning the execution, Luther maintains a positive tone, thanking and praising God for sending the first martyrs and interpreting this event as an honor to the Christians in the Low Countries. In one passage near the end, however, the criticism is more pronounced. In it, Luther describes the executions explicitly as acts of murder and those responsible as adversaries who will attempt to justify their judgement by labeling the condemned as "Hussitian," "Wycliffite," and "Lutheran sectarians." This passage is missing in the original draft that was written by Luther in his own hand, on which the published version is based (VD16 L 4137–4141). It was bound in a collection of letters and documents owned by the confidential advisor and secretary of Elector Frederick the

304

305

Wise, Georg Spalatin, indicating that the letter was pre-censored at the court. Luther apparently added the harsher words afterwards when the type was set in Wittenberg. This was not the first time that Luther had undermined the efforts of the court to restrict his polemical provocations that strained the diplomatic relations of the prince with the Emperor, the Pope and the King of England. DG

Sources and literature
Berger/Greb/Rode, p. 164 · Beutel 2005, pp. 208 f. · Brecht 1986, vol. 2, pp. 105–108 · Gehrt 2015, pp. 481–484 · Paasch 2012, pp. 78 f., cat. 1.2 · WA 12, 73–80

305

Archduke Ferdinand of Austria
Mandate against the Propagation of the Lutheran Doctrine

1527
83 × 43 cm
Thüringisches Hauptstaatsarchiv Weimar,
Ernestinisches Gesamtarchiv, Reg. H 4, f. 11
Minneapolis Exhibition

"The Turk is the salvation of the Lutherans" was a common saying among Catholics at the time of the Reformation. The Turkish threat to southeastern Europe did indeed bind the hands of many Catholic rulers, foremost among them Emperor Charles V and his brother Ferdinand. This allowed the estates of the Empire to secure concessions in matters of religion. The Reformation began to thrive under these favorable circumstances, in spite of the edict issued in Worms in 1521, which demanded Luther's surrender to the Pope and threatened dire consequences for those who spread his new teachings.
This posed a huge problem for Archduke Ferdinand of Austria, the man who had taken on the government of the hereditary lands of the Habsburg dynasty in 1521. In an attempt to overcome the deepening rift in the Church, he issued this fundamental decree in the Hungarian city of Ofen (or Buda) in 1527. It threatened punishment to any who would "print, offer, buy, sell, read or possess reformatory books and other unseemly images and letters (*sambt andern unziemlichen Gemälden und Briefen zu drucken, feil zu haben, zu kaufen, zu verkaufen, zu lesen und zu behalten*)."
Those who dared to agitate against the Apostolic Creed and the seven sacraments of the Christian Church were declared heretics, to be punished by life and limb according to the extent of their transgression and the magnitude of their blasphemy and heresy. The penalties ranged from imprisonment for eating meat during fasting periods and the loss of honorific rights for harbor-

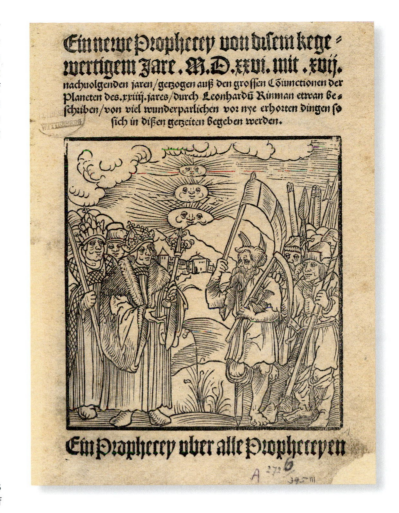

306

ing a heretic, to death at the stake for those who denied or abused the godhead or the humanity of Christ, his birth, passion, resurrection and ascension or any comparable dogmatic article through blasphemous speeches, sermons or writings. DB

Literature
Schneider 1967 · Staatliche Archivverwaltung, pp. 257 and 381 f. (ill.)

306

Leonhard Reynmann
Ein newe Prophecey von diesem kegewertigem Jare. M.D.xxvi. mit xvij.
(A New Prophecy of this Present Year)

Leipzig: Wolfgang Stöckel, 1526
18.2 × 14 cm
Luther Memorials Foundation
of Saxony-Anhalt, Kn A 395/2726
VD16 R 1622
Minneapolis Exhibition

Reynmann's pamphlet belongs to the genre of widely-read astrological prediction books known as *Prognostica*. The woodcut title page by Eberhard Schön shows the Emperor, who here still has the characteristics of Maximilian I (who died in 1518), and the Pope. They are portrayed facing off against Saturn, identified by the scythe and flag, behind whom a group of peasants have gathered. Next to this there are three so-called sun dogs (phantom suns), phenomena which are dealt with multiple times in astrological literature. Under the woodcut illustration is the truly self-confident claim: "A prophecy over all prophecies." Reynmann emphasizes many times his Christian conviction that astrological predictions do not have to come true but only reveal a tendency. This was compatible with the teachings of the old Church. Consistent with the title, the predictions concern the years up to 1543. Reynmann assigns signs of the zodiac to countries in Europe in a way which is not entirely transparent to us now. In contrast to his earlier *Prognostication*, which seemed to have already predicted the Peasants' War in 1524, this work was only published once. It was also the last print by Wolfgang Stöckel's Leipzig workshop before he moved to Dresden. MT

Literature
Leppin/Schneider-Ludorff 2014, pp. 80 f.

307

307

Albrecht Dürer

Peasants' War Memorial

in: Lehrbuch für Messung
und Perspektive
Nuremberg: Hieronymus Andreae, 1525
29.5 × 21 cm
Stiftung Deutsches Historisches Museum,
RA 96/793
VD16 D 2857
Minneapolis Exhibition

Original title: VNderweysung der messung/ mit
dem zirckel vñ richt||scheyt/ in Linien ebnen
vnnd gantzen corporen/|| durch Albrecht Duerer
zů samen getzogē/|| vnd ... || mit zů gehoerigen
figuren/ in || truck gebracht

Dürer's memorial to the peasants killed in the
Peasants' War appears to have been designed on
a whim. Dürer writes that he designed this and
three other pillars as an "adventure:" "Someone
who wishes to erect a victory monument for van-
quishing the rebellious peasants should use
such items." The pillar is built from the bottom
up of many different objects from peasant life,
including a basket of oats, a kettle, a bowl of
cheese, a butter churn, a sheaf with a hoe, flail
and pitchfork and a basket of chickens. At the
very top, sitting on an overturned tub of lard, is a
grieving peasant, whose body is pierced by a
sword. The peasant's positioning is strikingly
similar to that of the "resting Christ" (or the cor-
responding topos, "the suffering of Job") and
that of the Ecce Homo on the title page of Dürer's
Great Passion. It is not entirely clear whether the
work is meant to express that the peasants were
merely stopping to rest or to show the despera-
tion of the peasants and the final defeat of their
revolt. Nevertheless, the Peasants' War Memorial
reflects sympathy and understanding for the
peasants and their goals during the 1525 upris-
ing. MM

Literature
Bott 1983, pp. 262–263, cat. 338 (ill.) ·
Fraengler 1953 · Seipel 2000, pp. 257 f.,
cat. 244 (ill.) · Staatliche Archivverwaltung
1983, p. 162 (ill.)

Weapons of the Peasants' Revolt

Minneapolis Exhibition

308

Large Knife ("Bauernwehr")

Holy Roman Empire, around 1500
Iron, forged
Overall length: 39.5 cm; length of blade: 27 cm;
width of blade: 4.5 cm
Stiftung Deutsches Historisches Museum
Berlin, W3472

309

Morning Star

Holy Roman Empire, 16th century
Wood; iron, forged
Length: 200 cm
Stiftung Deutsches Historisches Museum Berlin,
W72/82

310

Morning Star with Grappling Hook

Holy Roman Empire, 16th century
Wood; iron, forged
Length: 198 cm; width of hook: 21.5 cm
Stiftung Deutsches Historisches Museum
Berlin, W72/79

311

Fishing Spear

Holy Roman Empire, 16th –18th century
Wood; iron, forged
Overall length: 249 cm; length of tines and
socket: 59 cm
Stiftung Deutsches Historisches Museum
Berlin, W1273

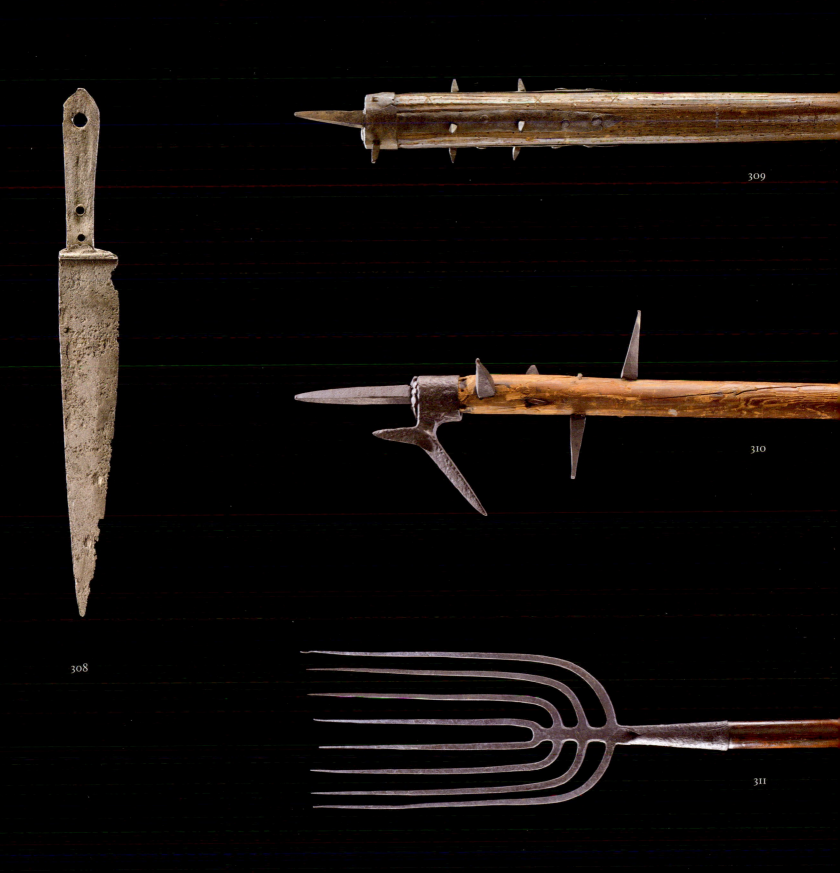

308

309

310

311

Starting at the end of the 15th century, the Empire was repeatedly shaken by peasants' uprisings of varying scale. Yet another outbreak occurred in the summer of 1524, but this time it began simultaneously in several locations in Thuringia, Franconia and on the shores of Lake Constance. Thence, it continued to spread to the central Rhine valley and Swabia. In bands numbering several thousand men, the peasants stormed and destroyed castles and monasteries, the perceived headquarters of their oppression. It took the German nobility until the beginning of 1525 to organize an effective reaction. The Swabian League and other alliances of rulers then embarked on a ruthless suppression of the rebels. In several pitched battles, the separate hosts of the peasants, which were numerically superior, but undrilled and inexperienced, were defeated and destroyed. The Battle of Frankenhausen on May 15, 1525, was the most significant, but by no means the final engagement that the rebels lost. In some cases, the peasants even had modern weaponry at their disposal, such as cannon and smaller firearms which they had plundered from the arsenals of cities and nobles. In addition, they also had the help of some experienced military leaders, knights such as Götz von Berlichingen and Florian Geyer von Giebelstadt. But overall, the lack of discipline and professionalism, combined with a preponderance of improvised weapons, often adapted from everyday tools, proved inadequate.

The equipment, tactics and weapons drills of the peasants could not hope to stand up to the brutal and ruthless approach of the mercenary men-at-arms fielded by the nobility. Ultimately, while the different bands agreed on some demands, this never amounted to a common goal that alone might have turned this rebellion into a true revolution. SL

Literature
Blickle 2012 · Franz 1984 · Müller/Kölling 1981, pp. 88–90 and 394 · Schilling 1994, pp. 140–161

312

Jörg Gastel

Die Gründlichen und Rechten Hauptartikel aller Bauernschaft (The Fundamental and Correct Chief Articles of all the Peasants)

Zwickau: Johann Schönsperger the Younger, 1525
20 × 15.4 cm
Luther Memorials Foundation of Saxony-Anhalt, Kn A 341/2404
VD16 G 3563
Minneapolis Exhibition

312

313

Original title: Dye Grundtlichen Vnd rech= / ten haupt Artitkl/ aller Baur= / schafft vnd Hynder- sessen der / Gaistlichen vnd Weltli= / chen oberkaytē von / wo̊lchen sy sich / beschwert ver= / mainen.

The Peasants' War represented the continuation of the Reformation as a lay movement. The peasants' demands were published in the *Chief Articles of all the Peasants*, generally known as the *Twelve Articles*. This text represents the binding element of the highly diverse uprising of 1524–1525. The *Chief Articles* were drafted by an assembly of Upper Swabian peasants in Memmingen in March 1525 and appeared anonymously; however, it is presumed that the Memmingen furrier's assistant Sebastian Lotzer and the Memmingen predicant Christoph Schappeler were the ones behind the printing of this text.

The *Twelve Articles* calls for the election of preachers, use of the tithe for the payment of preachers, the abolition of serfdom, the freedom to hunt and catch fish, the return of municipal forests, meadows and fields, a reduction in unpaid labor, observance of the contractual terms of fiefdom, a reassessment of the productiveness of their fields, the abolition of arbitrary judgment and abolition of the death tax—a tax which became payable upon the death of a serf. The *Twelve Articles* disseminated the ideas of the Reformation; theologically, they are based on Luther and Zwingli. What was new about them, however, was the justification of the uprising. Unlike prior peasant revolts, which called for the restoration of old laws, the drafters of the *Twelve Articles* make an appeal to "divine law." This religious aspect was important for the further course of the Peasants' War, so that the uprising was associated with a new fundamental principle. The Lutheran Reformation had given the peasants the "opportunity to obtain a new perspective" (Maron 1980) of their circumstances and their position within the society of the Early Modern period. Once the peasants justified their demands on religious grounds, their demands were adopted by public supporters of the Reformation. This text was widely disseminated, with an estimated 25,000 copies in 28 editions. RK

Literature
Blickle 2011 · Blickle 2015 · Maron 1980, pp. 319–339 · Reinhard 1980

313

Martin Luther
Ermahnung zum Frieden auf die Zwölf Artikel der Bauernschaft in Schwaben. Wider die räuberischen Rotten der Bauern (Admonition to Peace on the Twelve Articles of the Peasants of Swabia. Against the Thieving Hordes of Peasants)

Wittenberg: Josef Klug, 1525
20 × 15 cm
Luther Memorials Foundation of Saxony-Anhalt, Ag 4° 206r
VD16 L 4692
Minneapolis Exhibition

These texts were written in the context of the Peasants' War. They represented Luther's response to the demands of the peasants, which they had set down in the *Twelve Articles* (cat. 312). Luther's argumentation remains the same in both texts: rebellion is contrary to the divinely ordained order. What changes between them is the assignment of blame for the rebellion and the method of conflict resolution that Luther demands. In his *Admonition,* for example, which appeared somewhat earlier, he assigned part of the blame for the rebellion to the "tyranny" of the ruling class. But by far the largest share of the blame is laid at the feet of the peasants: he argues that the tyranny of the nobles does not justify rebellion and that even the demand for equality is an act of rebellion, rejecting the abolition of serfdom. He contends that the peasants want to "make all people equal [...], which is impossible" (WA 18, 327, 21–23). Luther concedes that peasants must suffer to remain Christian, but insists that resistance is generally not permitted.

The other text, *Against the Thieving Hordes,* which appeared somewhat later, does not add anything to this argument, but places the blame for the unrest entirely on the peasants. Because of their refusal to listen to Luther, he accuses the peasants of exhibiting three deadly sins: disobedience, rebellion and blasphemy. He recommends that the nobles should first pray and beseech God to drive away the devil. If prayer does not help, Luther says that they should "take action" (WA 18, 360, 13). If a noble is killed as a result, he will become "a true martyr in the eyes of God," (WA 18, 360, 29) while only hell awaits the slain peasants. (WA 18, 360, 31–32).

Following the publication of this text and the simultaneous crushing of the uprising, in which about 75,000 peasants lost their lives, Luther's remarks drew criticism. Erasmus of Rotterdam charged that Luther had called for rebellion, only to take the side of the nobles later on. Luther's friends took exception to the notion that nobles could achieve martyrdom in their fight against the godless peasants. Luther never made any public expressions of regret with regard to the gruesome actions of the nobles, and he later defended the arguments he made on this occasion. The bloody suppression of the uprising with Luther's approval represented a break in the history of the Reformation. The Reformation became less spontaneous, and an "authoritarian streak" (Maron 1980) took root. The crime of breach of the peace, originally conceived as a law precluding the right of nobles to carry o n feuds, was now extended to the criminalization of alliances and organizations. Luther's text established the interpretation of the Peasants' War as "disobedience." RK

Literature
Arnal 1980 · Bischoff 2010 · Blickle 2011 · Blickle 2015 · Maron 1980, pp. 319–338 · Porter 1981

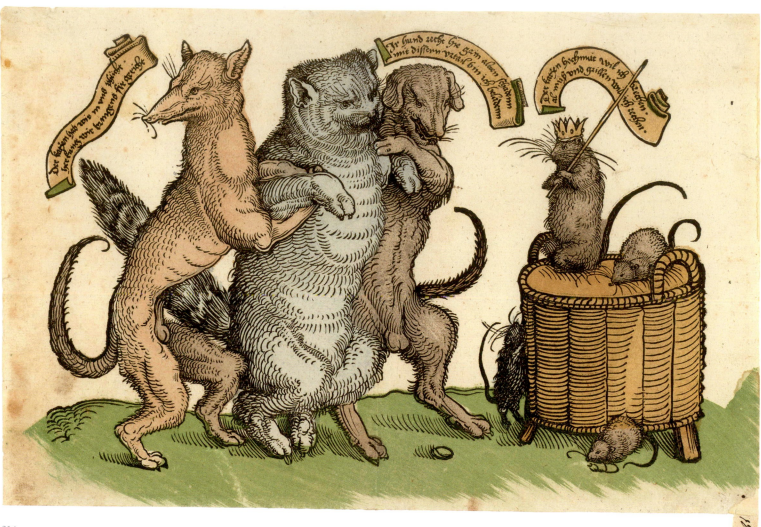

314

314

Hans Weiditz the Younger
(illustrator)
Cat before the Mouse King

Augsburg(?), around 1522
Colored woodcut
Right bottom corner torn out, old shading,
pagination attached specially
Sheet: 26.7 × 39.7 cm; Type area: 23.6 × 34.6 cm;
Image: 23.6 × 34.6 cm
Foundation Schloss Friedenstein Gotha, 40,40
Atlanta Exhibition

Text on banner:
Der katzen hab wir in vns phlicht. / her küng wir
bringens fir gericht [...]
(We have the cat in custody / we are bringing
him to the king for trial [...])

The Augsburg artist Hans Weiditz the Younger
made a name for himself in the early 1520s with
a series of satirical single-leaf woodcuts featur-
ing caricatures of contemporary figures and fa-
ble-like stories including animals with human
characteristics and abilities. This sheet shows a
plump cat between two slender dogs, who are
taking the cat to the mouse king. The king, who
can be recognized by his golden crown and scep-
ter, sits high on a wicker basket. The various
characters comment on the situation by means
of rhyming couplets, which are shown in banners
next to and above the heads of the protagonists.
The dogs are informing the king that they are
bringing the cat to face trial. The cat, however,
warns the dogs not to avenge prior wrongs, stat-
ing that he will, after all, have to bear the judg-
ment of the court. In other words, the cat is al-
ready aware of his guilt and expects the presid-
ing judge, the mouse king, to impose a penalty.
He is upset that the dogs have brought him into
this vexing situation. He believes that their ac-
tions represent retribution for things that were
done long ago, an allusion to the legend as to the
cause of the enmity between dogs and cats
(Schäfer/Eydinger/Rekow [forthcoming], cat. 376

and 377). The mouse king, however, is primarily
interested in breaking the cat's pride, which is
representative of all cats. He pronounces his
judgment in the name of the mice and crickets,
who have suffered at the hands of the cats.
The theme of this single-leaf woodcut addresses
the reversal of power structure, a subject explored
in pictorial inventions since ancient times. An
especially popular theme in this regard was the
triumph of the mice over the cats, since the
power imbalance between those two classes of
animals is immediately apparent. Representa-
tions of the reversal of traditional power struc-
tures are at once humorous and provocative. The
presentation of such scenarios became more
common in print culture once Luther came out
publicly in favor of the Reformation. The explo-
sive potential of these ideas is illustrated by the
revolt of the peasants, which led to military con-
frontations with the ruling class in 1525. UE

Literature
Geisberg 1974, IV, p. 1483, no. G.1521 (ill.) ·
Neumeister 1976, pp. 23 and 96, cat. B 28 (ill.) ·
Röttinger 1911, p. 51, no. 15 (ill.) · Schäfer/
Eydinger/Rekow (forthcoming), cat. 374 (ill.)

Satirical and Polemical Woodcuts

The Reformation triggered the first boom in mass-media political cartooning. Woodcut prints had served religious, political, humanistic, and artistic needs for about one hundred years, but the 1520s and 1530s saw them deployed for satire and polemical purposes with unprecedented intensity. Carving blocks for relief printing—that is, printing from raised surfaces as we have all done with rubber stamps—was the perfect choice for quick dissemination. The materials were inexpensive and the system of production perfected. An artist would draw on the block, then a specialized block cutter, called a *Formschneider,* would excise the spaces between the lines. Printing was done with screw presses of the sort used to print books. The blocks could produce big, bold lines visible from a distance. Simple outline compositions could be colored by hand, often with the aid of stencils, to make them extra vivid. Some woodcuts were used to illustrate books and pamphlets, but they were also cheap enough to post in public places. They could be relatively sober, didactic affairs, or they could be raucous, shocking, crude, offensive, and funny. Regardless of tone, woodcuts communicated directly even to audiences of limited literacy. They clearly came forth in great numbers, as evidenced by the many imitative copies that appeared. Yet today, examples of individual prints tend to survive in small numbers, for they were subject to censorship, vandalism, and forces of nature—from the elements to hungry insects. Many are probably lost altogether.

Catholics and Lutherans unleashed woodcut fusillades. Lutherans depicted cardinals morphing into jesters, the devil selling indulgences, peasants defecating into papal tiaras, demons playing bagpipes in the form of monks' heads, and Popes as the Antichrist. Catholics showed Luther as a tree sprouting heretics or as a seven-headed apocalyptic monster. Sometimes elaborate explanatory texts accompanied the images, but the viewer was frequently left to tease out the meaning without assistance, often a tricky proposition. These low-tech forerunners of tabloid newspapers and the internet retain their fascination and piquancy as they reveal the bared teeth of Europe's most divisive rift of the millennium. TR

Johannes Cochlaeus
The Seven Heads of Martin Luther

Leipzig: Valentin Schumann, 1529
Printed on paper, woodcut
VD 16 C 4391

315
20 × 15 cm
Binding: modern
Stiftung Deutsches Historisches Museum, R 98/1813
Minneapolis Exhibition

316
19.8 × 15.5 cm
Luther Memorials Foundation
of Saxony-Anhalt, Kn A 268/1772
New York Exhibition

Original title: Sieben Koepffe Martini Luthers / Vom Hochwirdigen Sacrament des Altars

Johannes Cochlaeus, a conservative theologican who expressed vehement opposition to Luther in several of his writings and, above all to Philip Melanchthon following the publication of the *Augsburg Confession* in 1530, launched a direct assault on the Reformation movement in his diatribe, *The Seven Heads of Martin Luther*, first printed in 1529. The title page, with a woodcut by Hans Brosamer, reflects the subject of the work and depicts Martin Luther as a creature with seven different heads on an oversized body.

Each of the seven heads has a meaning of its own: first, Luther appears as a scholar (*Doctor*), after which he made his way to the church and became a monk (*Martin*). The third head characterizes Luther as a heathen in a turban (*Luther*). The head in the middle depicts him as a preacher (*Ecclesiast*). The depiction of Luther surrounded by a swarm of hornets (*Schwirmer*, "fanatic") assigns his statements to the realm of the swarming fanatics, a term that Luther himself had coined for the radical, spiritualistic forms of the Reformation movement that he rejected. In the sixth head, Luther is shown as a visitor to churches who sees himself as equal to the Pope. The seventh head depicts Luther as Barrabas. In the Passion narrative, Barrabas was a murderer who was pardoned in place of Christ. The representation of a spiked mace is meant to brand Luther as the instigator of the peasant wars, although Luther had spoken out against the rebellious peasants in several of his writings.

The seven heads are meant to show Luther's transformation from theologian to criminal, from good and pious servant of God to firebrand: a metamorphosis that is shown using biblical numerical symbolism. The people were to learn to recognize and fear Luther as the apocalyptic

315

seven-headed beast (Rev. 12:3 and 13:1–10). He and his teachings should be understood as the path to perdition and therefore as false and senseless. Cochlaeus drafted his work in the form of a dialogue in order to show the contradictions in Luther's theories and in his person. In Cochlaeus' view, the seven phases of Lutheran development shown by the seven heads deserved to be refuted and relegated to the realm of heresy. CO/MM

Literature
Belting 2006, pp. 199–201 (ill.) · Clemen 1939, pp. 32–42 · Cochlaeus 2000, vol. 2, pp. 989–1021 · Moeller 2000 · Müller/Kipf 2008, columns 453 f.

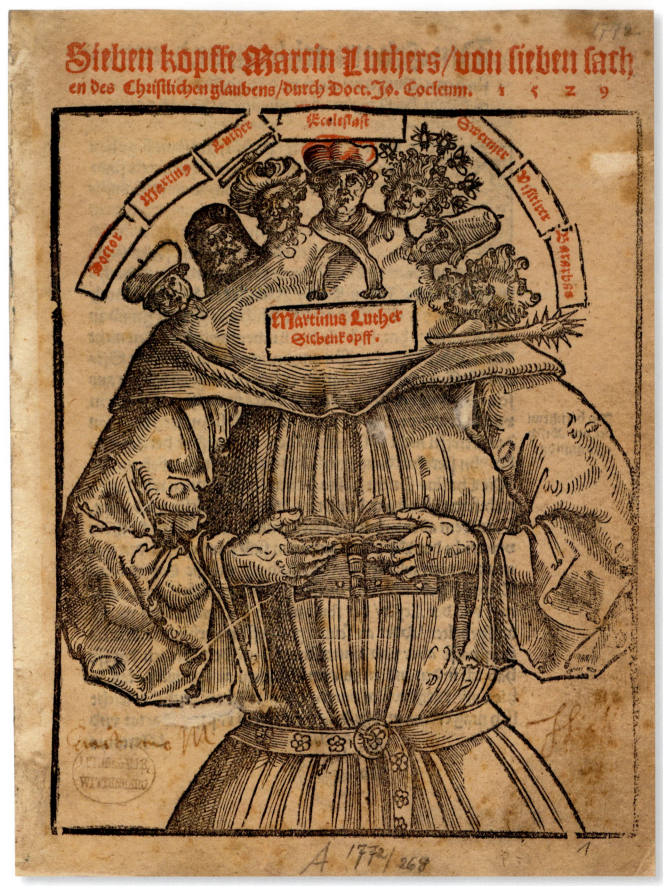

317

Unknown German artist

Birth of a Deformed Calf in Freiberg in the Year 1522 (Monk Calf)

Around 1522
Colored woodcut, typographic text
Sheet trimmed, pagination attached specially
Sheet: 30.7 × 20.5 cm; Type area: 28.5 × 13.4 cm;
Image: 26.4 × 12.5 cm
Foundation Schloss Friedenstein Gotha, 37,3
Minneapolis Exhibition

Inscription below:
Dis wunderlich Thier hat man auß einer Kůhe genōmen zu Freyberg jn Meyssen / am dornstag nach cōcepcionis marie jm M.CCCCC. xxij. jar Aigentlich abcontra / fett. Das thier ist nit rauch aber glatt hat kein har
(This strange animal was born from a cow at Freiberg in Meissen / on Thursday after the feast of the Conception of Mary in the year 1522 A.D., actual / depiction. The animal is not rough, but smooth, with no hair.)

In December 1522, a deformed calf was born in Freiberg, Saxony, whose appearance attracted such attention that broadsheets were printed about it. This is one of them, produced by an unknown artist. The large woodcut shows the animal with blotchy hair forming a bald patch with two boils on the back of its head resembling a clerical tonsure. On its back is a pointy fold of skin, and the creature is standing on its hind legs, which looks unnatural for a calf and makes it appear almost human. By placing the text underneath the animal's hind legs, the printer dictated the reading direction of the calf image, which is otherwise rendered without spatiality. The calf seems to be standing on two feet and therefore appears rather humanized, facilitating the later comparison to a standing monk with a tonsure and cowl over his back. It would develop into one of the most successful polemical figures of the Reformation period: the "monk calf." After it was initially used by Luther's opponents in the print war against the Reformation, similar to the double-head optical illusions (cf. cat. 343), it was Luther himself who made the monk calf into a successful polemical image to be used against the old Church through his own description and interpretation (cat. 343). Lucas Cranach the Elder provided a woodcut for Luther's publication, which was presumably modeled on this broadsheet.

317

The text on this sheet gave no indication of its polemical use. It simply provides information about the time and place of the calf's birth and states that its smooth hairless skin was unusual. As for the other unusual aspects of the calf, the picture speaks for itself. UE

Literature
Bild und Botschaft 2015, pp. 120 f., cat. 16 (ill.) · Faust 2001, III, pp. 162 f., cat. 418 (ill.) · Hase 1935 · Schäfer/Eydinger/Rekow (forthcoming), cat. 239 (ill.) · Zimmermann 1925 (ill.)

318

Martin Luther and
Philip Melanchthon
Lucas Cranach the Elder (illustrator)
Deuttung der zwo grewlichen Figuren Bapstesels zu Rom und Munchkalbs zu Freyberg in Meyssen funden (Interpretation of the Two Dreadful Figures of the Pope Donkey in Rome and the Monk Calf, Found at Freiberg in Meissen)

Wittenberg: Johann Rhau-Grunenberg, 1523
20.5 × 15.5 cm
Luther Memorials Foundation, Ag 4° 200 p
VD16 M 2989
New York Exhibition

In his woodcuts illustrating this work by Martin Luther and Philip Melanchthon, a best-seller in the field of anti-papal polemics, Lucas Cranach the Elder relies on two motifs that were already known to a broad audience. The satirical presentation of the Pope as a grotesque, donkey-like creature was first published in 1496. The so-called "monk calf" was born in December 1522 in Freiberg (Saxony) and very quickly found its way into widely disseminated woodcuts because of its noticeable deformities (cat. 317); these may have served as the model for the Cranach woodcut.

Melanchthon's interpretation of the "Pope donkey" and Luther's commentary on the monk calf had the same objective: interpreting these grotesque figures as signs from God and as warnings to the representatives of the Roman Church. Melanchthon interprets the deformities of the Pope donkey as allegories for the abuses of the papacy and the Roman Church, as well as of the worldly power which protects them. For example, he equates the donkey head with the Pope, who has unjustly made himself into the head of the

318

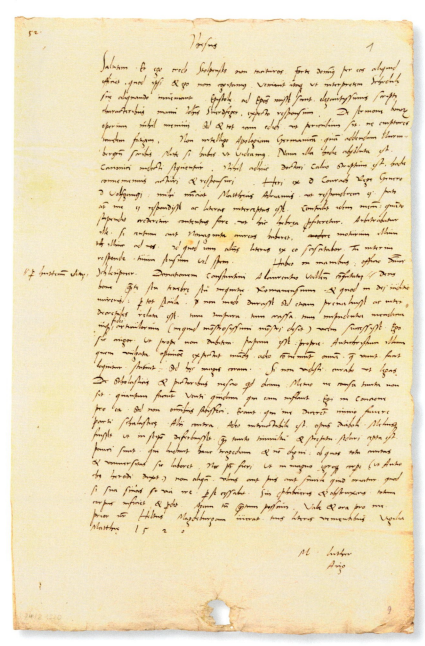

319

Church, a position which only Christ himself can assume. The point he is making is that the Pope as the head of the Church is as ill-suited a match as a donkey head on a human body. Especially in view of the fact that the creature was found in Rome, Melanchthon interprets the Pope donkey as a warning from God about the Antichrist, and at the same time a statement heralding the end of the papacy.

In very similar fashion, Luther also interprets various features of the monk calf as allegories for clerical abuses and misconduct. For example, he reads the stained coloring of the calf, which was reminiscent of a torn habit, as a symbol of the disunity of the various religious orders.

This joint work by Luther and Melanchthon was published in over 10 editions in 1523 alone and numbers among the most successful polemical publications of the Reformation period. TE

Sources and literature
Bild und Botschaft 2015, p. 122 (ill.) · Bott 1983, p. 235 · Bott/Ebeling/Moeller 1983, p. 212 (ill.) · Hofmann 1983 b, pp. 177 f. (ill.) · Strehle/Kunz 1998, pp. 232–235 (ill.) · WA 11, 357–385

319

Martin Luther
Letter to Georg Spalatin

Wittenberg, February 24, 1520
Ink on paper
21.6 × 33.6 cm
Landesarchiv Sachsen-Anhalt, Z8 Lutherhandschriftensammlung, no. 75
Minneapolis Exhibition

Throughout his years of activity in Wittenberg, Martin Luther maintained extremely active correspondence with his friend and advisor Georg Spalatin. They exchanged thoughts on publications and the latest works and projects, discussed decisions about appointments at the university and church institutions, and kept each other up to date about the latest events in the city and environs as well as their circles of colleagues.

Apart from public identification of the Pope as the Antichrist, this letter particularly focuses on the student unrest in Wittenberg in February of 1520, which threatened to disrupt order in the city permanently. Clashes had primarily occurred between university students and the students, journeyman and workers from the workshop of Lucas Cranach the Elder, called "painters" here, the concrete reason no longer being clear. The rapid spread of the Reformation, however, can be regarded as a chief cause of the conflict. Students at the University of Wittenberg, who

demonstrated an increasing willingness to resort to violence, particularly numbered among its early exponents. Moreover, the largest number of students ever had been enrolled at the University of Wittenberg in 1520. This simply packed too many people in the city's limited space in very short time, thus sparking great discontent and putting a significant strain on peace in the city. Luther's classification of the emerging unrest as the devil's work was typical of his argumentation. Elector Frederick the Wise responded to the clashes with a ban on weapons that applied to both students and burghers. His decree threatened violators with fines and imposed a curfew that everyone had to observe. Luther criticized this course of action since he felt that the Elector's provisions to impose peace were doing more to further inflame the situation rather than resolve it peacefully. And he was proven right: The conflict embroiled growing numbers of burghers and reached its height in the summer of 1520. VR

Literature
Berbig 1906 · Bubenheimer 2012 · Kaufmann 2012 · Schmalz: Spalatin

322

Philip Melanchthon and Johannes Schwertfeger
Lucas Cranach the Elder (illustrator)
Passional Christi und Antichristi (Passional of Christ and of Antichrist)

320
Wittenberg: Johann Rhau-Grunenberg, 1521
Woodcut illustrations
19.9 × 15.6 cm
Luther Memorials Foundation of Saxony-Anhalt, ss 40
VD16 L 5585
Minneapolis Exhibition

321
Erfurt: Matthes Maler, 1521
Woodcut illustrations
19.9 × 15.6 cm
Luther Memorials Foundation of Saxony-Anhalt, ss 3173
VD16 L 5579
New York Exhibition

322
Wittenberg: Johann Rhau-Grunenberg, 1521
Woodcut illustrations
Sheets 20.4 × 15 cm
Thrivent Financial Collection of Religious Art, 14-01
VD16 L 5586
Minneapolis Exhibition

Paſſional Chꝛiſti vnd

In yꝛen anſehen iſt er auffgehaben vnd die wolcken haben yn
hinwegk genommen võ yꝛen ougen. Diſer Jeſus der võ euch
yn hꝛimmel auffgenommen iſt / wirdt alſo wyder komme wie
yr yn geſehen habt zu hꝛimmel faren. Act .1. Seyn reych hat
keyn ende Luce. 1. Wer do mir dient der wird mir nach vol geꝛ
vñ wu ich bin do wirt meyn diener auch ſeyn Johã. 12.

Antichꝛiſti.

Wir loſſen auff alle eyde die die geyſtlichen zu gefengknis gelo
bet haben vnnd gebieten das mann nit allein mit geyſtlichem /
ſonder auch mit dem weldelichem ſchwerdt Jꝛe güter be
ſchutzenſall ſo lang biß das yꝛ etrwande güt widder haben
15. q .6. c. Auctoritate vñ d yꝛn dieſem krieck ſtirb adir voꝛ
dürbe wirde erlangen das ewig leben 23. q .5. c. oĩni et q. 8.
c. oĩni das heyſt ſeyns güts gewiß ſein das mans auch voꝛ
güt acht ab ſchön Chꝛiſtenn blüt do mir voꝛgoſſen wirdt .

Paſſional Chꝛiſti vnd

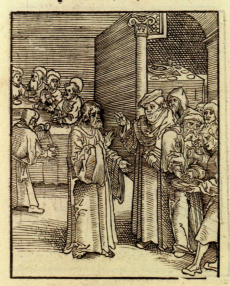

Chꝛiſtus.

Das reich gots iſt nit / yn euſſerlichen gebaden / ſyehie / aber do
iſt Chꝛiſtus / Beſonder das reich gots iſt innerlich yn euch . Lu.
17. Warumb habt ir das gebott gots vbirtretten von menſchen
geſetz wegen / Alle ehꝛen mich voꝛgeblich / die do menſchen lar
vnd gebot halten. Mat.15. Eſaie. 21.

Antichꝛiſti .

Es iſt ergꝛiffen die Beſtia vñ mit yꝛ d falſch pꝛophet der durch
ſie zeychen than hat do mit er voꝛfürdt hat / die ſo ſeyn zeychẽ
von yme genommen / vnd ſein bilde angebet ſeynt verſenckt yn
die teuſſe des fewirs vnd ſchweffels vnd ſeynd getodt mit dem
ſchwerde der do reydt vffm weyſſen pfardt / das auß ſeynẽ
mauel gehet. Apocal. 19. Danne wirde offenbar werden der
ſchalckhafftige dann wirde der herꝛ Jeſus todten mit dem atem
ſeyns mundes vnd wirdt yn ſturzen durch die gloꝛi ſeyner zu
kunfft. 2. ad Teſſa. 2.

322

Since the Middle Ages, a *Passional* has been understood as a presentation of the story of the suffering of Jesus compiled from the four Gospels. Most German texts were aimed at pious lay people and were often illustrated.

After Luther had come to the settled conviction that the papacy in Rome, not the person who is the Pope, is the Antichrist of the New Testament, the idea was in the air to produce a booklet juxtaposing the conduct and teaching of Christ with that of the incumbent of the Roman See. Lucas Cranach's workshop created thirteen pairs of pictures that contrasted certain antithetical situations. Below the illustrations from the life of Jesus are corresponding texts from the New Testament, while under those of the Pope there are quotations from the decrees of canonical law. Philip Melanchthon provided the selection of the biblical texts, while Johann Schwertfeger, who taught canon law at the University of Wittenberg, provided the legal texts. The result must have been impressive for the uneducated laity, such as when the expulsion of the money changers from the temple stands opposite the banking business of the Pope—here obviously intending Leo X of the House of Medici. The set of pictures ends with the ascension of Christ, which is strikingly contrasted with the Pope descending to hell. It is unknown who had the idea for the booklet, but it is possible that it was Lucas Cranach's initiative. Since only two editions of the work were published, its effect on readers was probably limited. The illustrations would have considerably increased the price of the pamphlet in comparison with other textual leaflets. Nonetheless, Luther saw the *Passional* as "a good book for the laity." Some of the woodcuts, and copies of them, however, were still in use at the end of the 16th century. MT

Sources and literature
Leppin/Schneider-Ludorff 2014, pp. 534 f. ·
Staatliche Archivverwaltung 1983, p. 118 · WA 9,
701–715 and Supplement 1

323

Monogrammist IW
(illustrator and woodblock cutter)
Jörg Scheller (printer)
Christ and the Two Thieves on the Cross

Magdeburg, around 1545
Colored woodcut on waste paper, typographic text
Woodcut on reverse side portraying the right side of the representation of the surrender of Duke Henry of Brunswick in 1545 to Duke Maurice of Saxony and Landgrave Philip of Hesse
Sheet: 40.7 × 31.2 cm; Type area: 38.9 × 30.7 cm; Image: 27.3 × 17.2 cm
Foundation Schloss Friedenstein Gotha, 37,33a
New York Exhibition

Inscription above:
In diesem Bilde des gecreützigsten vnsers lieben Herrn / Jhesu vnd der beyden Schecher [...] (In this picture of the Crucifixion of our beloved Lord Jesus and the two thieves [...])
Inscription in the image
INRI / IW (monogram of the artist)

The broadsheet by Jörg Scheller shows the Crucifixion of Jesus between the two thieves. As described in the text, this scene reflects the division of humanity into two groups: the God-fearing and the godless. The artist, known by the initials IW, whom Ingeburg Neumeister sought to identify as Johann Wyssenbach, based this depiction on the iconography of the good and bad thief, the one a positive example for the faithful and the other a cautionary tale. However, he altered the familiar iconography of these figures so that the bad thief, on the left of Jesus, is wearing a tiara on his head, identifying him as the Pope. While the soul of the good thief, in the form of a child, leaves his mouth and is received by an angel, on the other side a diabolical creature receives the bad thief's soul. Meanwhile, a demonic figure is taking an ax to the base of the Pope's cross, which is surrounded by flames.

The columns of text are arranged to match clearly the composition of the image. The text above the woodcut speaks of the death of Jesus, who took upon himself the sins of mankind with his death. The columns to the left and right of the woodcut describe the sinful man, who may be the recipient of God's grace depending on his recognition of his own fallibility. While God takes mercy on those who atone for their sins, the godless and stubborn will be damned; the unknown author ascribes the Jews and the clerics to the latter group because of their false form of worship. The warning to follow the true (i.e. Protestant) faith is made clear in polemical fashion in both image and text. UE

Literature
Bild und Botschaft 2015, pp. 134 f., cat. 23 (ill.) ·
Marx/Hollberg 2004, p. 172, cat. 243 (ill.) ·
Neumeister 1976, pp. 110 f., cat. B 49 (ill.) ·
Schäfer/Eydinger/Rekow (forthcoming),
cat. 237 (ill.) · Scribner 1981, pp. 100 f., fig. 73

324

Niclas Stör (attributed, woodblock cutter and illustrator)
Hans Sachs (author)
Friedrich Peypus (printer)
Wolfgang Resch (publisher)
The Treasure and the Heart

Nuremberg, around 1530
Colored woodcut, typographic text
Sheet: 28.3 × 39.7 cm; Type area: 25.1 × 38.4 cm; Image: 20.3 × 31.2 cm
Foundation Schloss Friedenstein Gotha, 37,16
New York Exhibition

Inscription above:
Wo ewer Schatz ist/do ist ewer hertz. Matth. vi. Hans Sachs.
(Where your treasure is / there is your heart, Matthew VI. Hans Sachs.)
First Column:
Christus im Evangelio / Matthei spricht er klerlich also [...]
(Christ in the Gospel/ Matthew speaks as follows [...])

In Matthew 6:19–21 Jesus warns the faithful against collecting earthly treasures, which are vulnerable to moths, rust and thieves. Instead, they should collect treasures in heaven: "for where your treasure is, there your heart will be also." Based on these verses, in 1528, Meistersinger Hans Sachs composed a lyric poem about the senseless accumulation of worldly objects, which Wolfgang Resch arranged to be printed by Friedrich Peypus with a woodcut by Niclas Stör. The poem states that the root of all sin is avarice, which leads to theft, murder, pillaging, fraud, gambling and envy, as well as to "selling brass, confessions, grace and pilgrimages," which are identified as immoral acts. Since this avarice already controls the entire world, Sachs expresses the pious wish that Christ will fill all men with His spirit. He asks Christ to keep men from being fixated on temporal, ephemeral things, since He alone nourishes men both here and in eternity.

Stör's illustration shows a hall in which two chests are standing next to their owners. The heart of the grim-looking man on the right is filled with avarice, made clear by the string that runs from his heart to the closed chest containing his earthly treasures. In addition, the devil has placed his

In diesem Bilde des geereützigsten vnsers lieben Herrn

Ihesu vnd der beyden Schecher/wirt die gantze Welt abgemahlet/wie
es dem Godtfürchtigen vnd Godtlosen gehen wirdt.
Das ist Gottes Lamb/Das der Welt Sünde tregt.

Diss Bilde Christi am Creutze fron
Be deut wie der wahr Gottes Son
Zwischen zweyen Mördern henget recht
Gleich vnter dem gantz menschlichin gschlecht
Vmb welcher Sünd vnd missethat
Er sich selbst auff geopffert hat
Am stam des Creuz genug gethon
Vor alle Sünd der Wellet schon
Im Geist gelitten angst vnd node
Vnd auswendig des Creutzes todt
Ein fluch fur vns geworden sein
Vns zu erlösen vom fluch vnd peyn
Vormaledeyet ist er in quahl
Das wir wurden gesegnet all
Erhöhet ist am Creutz der Grecht
Mitten vnter Mnschlichem gslecht

Wie die Schlang in der wüstung wart
Auffgehenget zum Spiegel zart
Zum trost das wir nicht stürben gar
Sunder lebten wenn wir gantz klar
Gleuben das er vns hab erlöst
Durch seinen Todt vns alln zu trost
Vnd wie die Mörder mit jm sein
Gecreuziget darauss er scheint
Das alle Welt wie jn auch ist
Gecreüziget zu aller frist
Vmb vnser sünd vnd missethat
Die yder von natur empfangen hat
Vorurteyl seint zum ewigen Tode
Wo er vns nicht auss solcher nodt

Erlöst vom gesetz sünd todt vnd pein
Durch den todt des Creutzes sein
Sunst wern wir doch all vorloren
Aber er stilt des Vaters zorn
Welchs widerfert auch allen dar
Die jhre sünde bekennen klar
Vnd halten Christum auch darbey
Vor jren Heylandt also frey
Vnd rümen sich seins Creuz gantz fein
Vnd auch der welt geereuzige sein
Wie jm der sünd absterben gar
Der grechtigkeit auch leben dar
Wie vns das Petrus melden thut
Das wir erlöst seint dorch sein blut.

Der gerecht Schecher.

Dieser Mörder zur rechtern handt
Deut die gemein Gottes allsandt
Das eine theil der menschen secht
Die gfess der Barmhertzigkeit schlecht
Welche doch auch gantz schüldig ist
Am todt des Herren Jhesu Christ
Von wegen jrer grossen sünde
Die sich im hertzen baldt anzündt
Mit Rew vnd Leidt in schwerer pein
Vnd hat zuflucht zu Christo rein
Vnd gleubt das er vorgebung hot
Durch Christum vormittelst sein todt
Erkent in der armen Figur
Christum ein Herrn vnd König pur
Vber Himel Tode Erde vnd Hell
Der von vns nympt all vngefell
Hanget am Creutz mit Christo klar
Leidet den Todt gedültig gar
Auff das es auch gleichförmig werde
Dem Bild des Son Gottes auff Erde
Darnach gieng jm zur Herligkeit
Erhoben werdt in ewig zeit

Vnd ob schon Christum alle Welte
Vor ein vordampten menschen helt
So bekent doch dieses theil vorwar
Das Christus sey vnschüldig gar
Vnd Bitt vorgebung seiner sünd
Durch ware Rew das hertz entzündt
Der ware glaub an Christum fron
Das der sey warer Gottes Son
Ein König vber Tode vnd Leben
Der vns gewislich kan geben
Aus gnad seine grechtigkeit
Das ewig leben allezeit

Wer nu diesem Exempel sein
Volget bekent die sünde sein
Vnd scheid sich von den Lesterern
Christi vnd straffet sie allzeit gern
Vnd bekent Christum allzeit frey
Das er allein der Heylandt sey
Der ist von der gemein vorwar
Gottes vnd der gerechten schar
Denn Gott keinen gefallen hot
An der elenden Sünder todt
Sunder das er sich baldt beker
Vnd leb allzeit nach Gottes lehr
Denn wer allzeit anruffen thue
De nam des Herrn der wirt behut
Vnd ob die sünd wer gleich blut roth
So wirt sie weiss durch Christi Todt
Denn als sünd vnd böse tück
Wirffet Gott allzeit zu rück
Sein angesicht nicht von vns went
Er ist barmhertzig biss ans ende
Wenn wir erkennen nur die sünd
Warhafftig vns das leben günt
Denn das ist auch gewislich war
Ein tewer werdes wort so klar
Das Christus darzu komen ist
Die sünde zu tilgen alle frist
Wer das nu gleubet allezeit
Der ist selig in ewigkeit.

Der vngerecht Schecher.

Dieser Mörder zur lincken handt
Wirt vor die gemein erkande
Der bößhafftigen Godtloß schar
Die gfess des zorn Gottes vorwar
Welche Christum vorachten gantz
Halten sein Lehr für alefantz
Schenden vnd lestern die alzeit
Veruolgen die mit hass vnd neide
Wie dieser Schecher thut furwar
Mit seiner Rott der Jüden schar
Vnd ob wol diese Gottlos gemein
Am Creuz henget bey Christo rein
Von wegen jrer sünde so schwer
So ist sie doch vorblendt so seer
Das sie jr sünd erkennet nicht
Das macht dieweil sie füle vnd sicht
Das Christus vnd sein gleubig schar
Hangen mit jn am Creuz furwar
Vnd künnen sich selbst helffen nicht
Das ergert jre zuuorsicht
Sie können vnter der armen gestalt
Des Creuz nicht kenne Christi gewalt

Vnd wie die Jüden all zu gleich
Hofften auff ein weltlich Königreich
Vnd auff ein König der do solt
Gewaltig sein in Silber vnd Golde
Ihr Reich auffrichten der gestalt
Iren falschē Godtsdienst mit gewalt
Vorteydigen vnd sie darzu
Bringen in endelich fried vnd ruw
Also vormeinen yzundt all
Babst Bischoffe vnd Cardinal
Pfaffen vnd Münch sampt jrer Rott
Das Christlicher glaub on spot
Müssen in eusserlichem pracht
Stehen zu schützen jre macht
Weil aber solchs Christi Lehr
Nicht thut sunder straffe viel mehr
Iren falsche Gotteedienst gantz klar
Vnd jre laster offenbar
So muss die Lehr auffrürisch sein
Voruolgen die mit schwerer pein
Tödten vnd würgen die all frist
Aber weil Christus erstanden ist
Vom todt vnd ist ein König fron
Vber Himel vnd Erd gantz schon
So wirt er solche Bösewiche
Vmbringen all in sein gerichte
Denn welcher baum nicht tragen thut
Gudt frucht/der wirt ins fewrs glut
Geworffen in ewige pein
Do wirt heulen vnd zenklappen sein
Dafür vns der Herr Jhesu Christ
Behüten wol zu aller frist/Amen.

Jörg Schaller Fort
schneider.

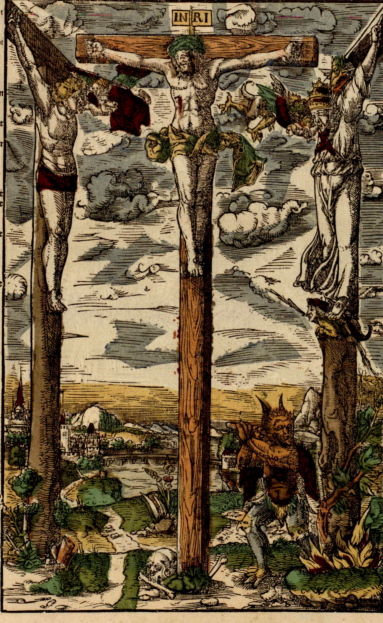

323

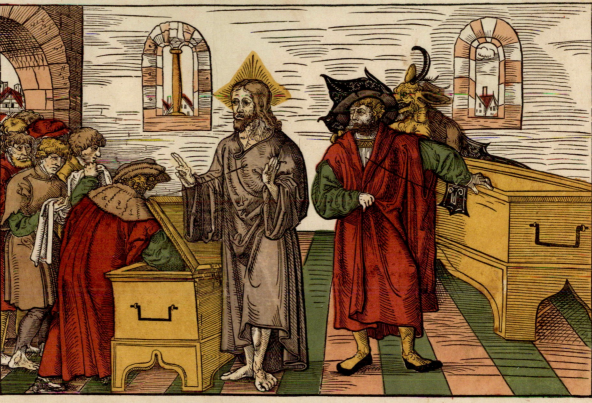

324

paw on the sinner's shoulder. The chest on the left, on the other hand, is open, and its owner is handing out alms to the needy, who are coming into the hall from the left. This man is carrying Jesus, who stands next to him in a benedictional posture, in his heart; they are also symbolically connected by a string. This attitude leads the man to love his neighbor, while the loneliness of the man on the other side is striking.

This print is one of a series of publications which subtly criticize the machinations of the old Church. The corruption that spread in parts of the Church as a result of avarice was among the allegations made by the Protestants and is underscored here by biblical quotes. UE

Literature

Eydinger/Rekow (forthcoming), cat. 361 (ill.) ·
Geisberg 1974, IV, p. 1305, cat. G.1351 (ill.) ·
Neumeister 1976, pp. 93f., cat. B 25 (ill.) ·
Röttinger 1927, p. 47, cat. 213 · Welt 1976,
pp. 69, 75 and 90, cat. 4 (ill.)

Two Anti-Papal Double-Obverse Satirical Medals

325
Wolf Milicz

1543
Silver, minted
D 39.5 mm; weight 15.44 g
Foundation Schloss Friedenstein Gotha,
4.1./5734
Exhibition Minneapolis

Obv: DES · PAPST · GEBOT · IST · WIDER · GOT ·
M · DXLIII ·
Double-obverse: Cardinal to right – Fool to left.
Rev: FALSCHE · LERE · GILT · NICHT · MEHR ·
MDXLIII ·
To right sitting bishop with chalice above female personification sitting wrong way round (Whore of Babylon) with book and sword.

326
Hans Reinhart the Elder

1544
Silver, cast, looped
D 28 mm; weight 7.96 g
Foundation Schloss Friedenstein Gotha,
4.1./5735
Exhibition Minneapolis

Obv: EFFIGIES · CARDINVM · MVNDI ·
Double-obverse: Cardinal to right – Fool to left.
Bottom signature HR (Hans Reinhart) Rev:
EFFE= / MINATI / DOMINA= / BVNTVR / · EIS · /
1544

327
Peter Flötner

Anti-Papal Satirical Medal

Nuremberg, 1540s
Lead, cast
D 60 mm; weight 63.7 g
Luther Memorials Foundation
of Saxony-Anhalt, M 1754
Exhibition Minneapolis

Obv: Holy Spirit as a dove on a band of clouds, below · CHRIS – TVS ·
In field: Bust of Christ to right with epigraph on either side, left: ICH BIN / DAS LEM / LEIN DAS / DER WE / LT SVND / TREGT · IO / HANES · / AM ·; right: I · CAPT / NIMANT / KVMPT / ZV DEM / VATER D / AN DVRCH / MICH · IO / AM XIIII, below signature PF. (Peter Flötner).
Rev: Bust of Pope to left with donkey's ears. The devil clutches a tiara from behind. In field epigraph on either side, links: SO · BIN / ICH · DAS / KINDT DER · VE / RDERB NVS / VND / DER · SV / NDEN / SAGT / SANT; right: PAVLI / IN · DER / Z EPISTEL / AN · DIE · T / ESSALO / NICH · ER.

Broadsheets, lampoons and satirical medals with strong polemic and poignant sarcasm were very popular in religious confrontations in the Reformation period and were used by both denominations against the other confession. Well-known broadsheets include Lucas Cranach the Elder's *The Pope Donkey* of 1523 or the picture puzzle by an unknown artist, *Narr und Voppart*, from around 1525 (cat. 343). The Lutheran side extensively used such propaganda, but the Roman Catholics countered anti-Catholic statements with texts and images. The increasing hardening of denominational fronts was reflected also in the art of medal making.

The first anti-papal medal is believed to have been created by Concz Welcz in 1537. It depicts Christ and the Pope as opposing allegories of Christ and Antichrist on the obverse and reverse sides, very similar to a medal made by Peter Flötner in the 1540s (cat. 327).

Both medals reflect early works of the Reformation, such as Luther's *Passional Christi und Antichristi* of 1521 with illustrations by Cranach the Elder (cat. 327). The equation of the Pope with the devilish Antichrist by Luther is frequently found in his table talks and polemical treatises, for example in *Contra Papatum a Diabolo Fundatum*, which is based on a passage in the New Testament (2 Thess. 2:4) where Apostle Paul warns against the Antichrist. Regarding the Pope, Luther said: "He was the real Anti-Christ of whom all Scripture speaks."

The text on the obverse of Flötner's is taken from the Gospel of John 1:29 and 14:6, with the text on the reverse from the Second Letter of Paul to the Thessalonians, verses 2–4. The appropriation of the papacy by evil is drastically symbolized by devils sitting on the back of the Pope's head and snatching his tiara.

A special, ideologically punchy group is formed among satirical editions by the so-called double-obverse medals, also known as "reversible medals" or "puzzle medals." They were frequently made and were so popular that they were re-cast or copied for long periods—in some cases till well into the 19th century. Their motifs make them clearly distinguishable into anti-papal and anti-Reformation species.

The anti-Roman double-obverse medals, the oldest of which date from 1543/4 in more than 100 types, depict a blended Pope and devil or cardinal and fool that are visible when the medal is rotated, as a polemical accusation against the Catholic Church. Such satirical medals are rarely signed and almost exclusively undated. Some of them were made by major medalists, such as Hans Reinhart the Elder, who signed his small looped medal from 1544 (cat. 326) with the initials HR.

Double-obverse medals often expressed general criticism or grievances against the Roman Church but often also depict specific societal and ecclesio-political events. The conflict surrounding the nomination of Nicholas of Amsdorf as bishop in Naumburg in 1543 is deemed to have prompted this genre. The dispute flared up after Nicholas of Amsdorf was installed as the first Protestant bishop in Naumburg by Saxon Elector John Frederick in 1542. Amsdorf was a supporter of the Reformation and a close friend Luther.

The cardinal-fool depiction on the obverse of the Milicz medal of 1543 (cat. 325) points to the sanctimoniousness of the Catholic hierarchy, that is unveiled as folly. The reverse side of the medal refers to the interpretation of the Holy Communion. The bishop, with chalice raised during transubstantiation, stands for the Catholic Eucharist celebration as a re-enactment of the sacrifice of Christ, a view that was vehemently opposed by Luther. The female personification with sword and book facing the wrong way can be interpreted as the Whore of Babylon, which is deemed as a biblical allegory for false religions and, in Reformation understanding, as a symbol of the Roman Catholic Church. Hence, the sword would stand for wars and bloodshed and the book would symbolize false doctrines.

The fool's image has been a standing term in the literature of the same name since the late 15th century. The trailblazer was Sebastian Brant with his *Narrenschiff* (Ship of Fools) of 1494, which was illustrated by Dürer. The fool served to expose human behaviors, vicious habits and simple-mindedness; the fool's cap became a symbol of the critique of society and morality.

Interestingly enough, the fool's image had been first used by the Catholics to polemicize against the Lutherans during the denominational disputes of the time. A broadsheet of 1520/2, for instance, shows Luther with cap and a fool with

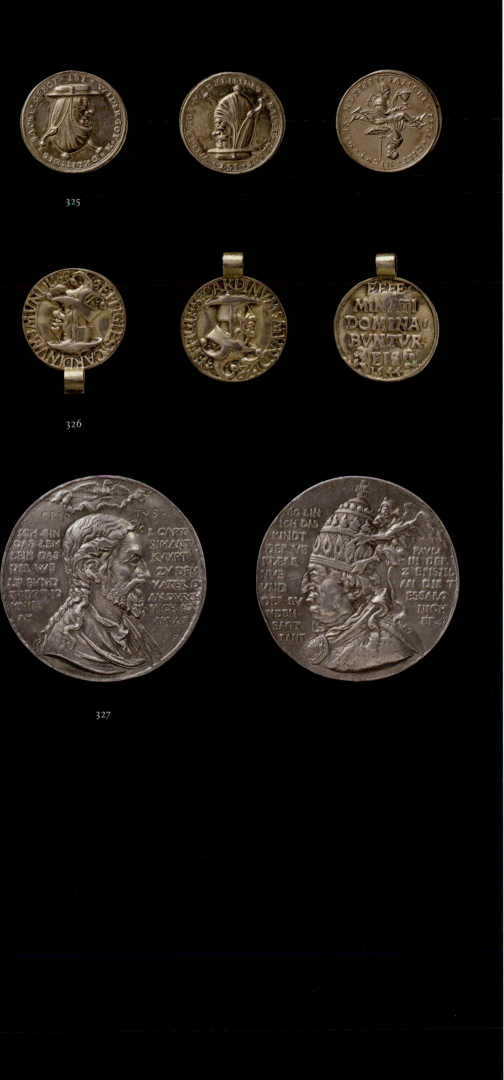

325

326

327

fool's cap as double-obverse. At the same time, Thomas Murner called the Reformer a corpulent fool who should be brought to his senses in his publication *Von dem großen Lutherischen Narren* (On the Great Lutheran Fool). UW

Literature
Brozatus/Opitz 2015, vol. I,1, pp. 435 f., no. 619 (ill.), p. 438, no. 623 (lead, variant) · Cupperi 2013, pp. 69 f., fig. 36 · Habich 1929–1934, vol. I,1, no. 701 · Habich 1929–1934, vol. II, 1, no. 1829, 1979 · Schnell 1983, pp. 44–46 and 125–127, nos. 30, 31, 33 · Schuttwolf 1994 b, pp. 14 f., cat. 4.10 (ill.), pp. 25 f., cat. 4.25 (ill.)

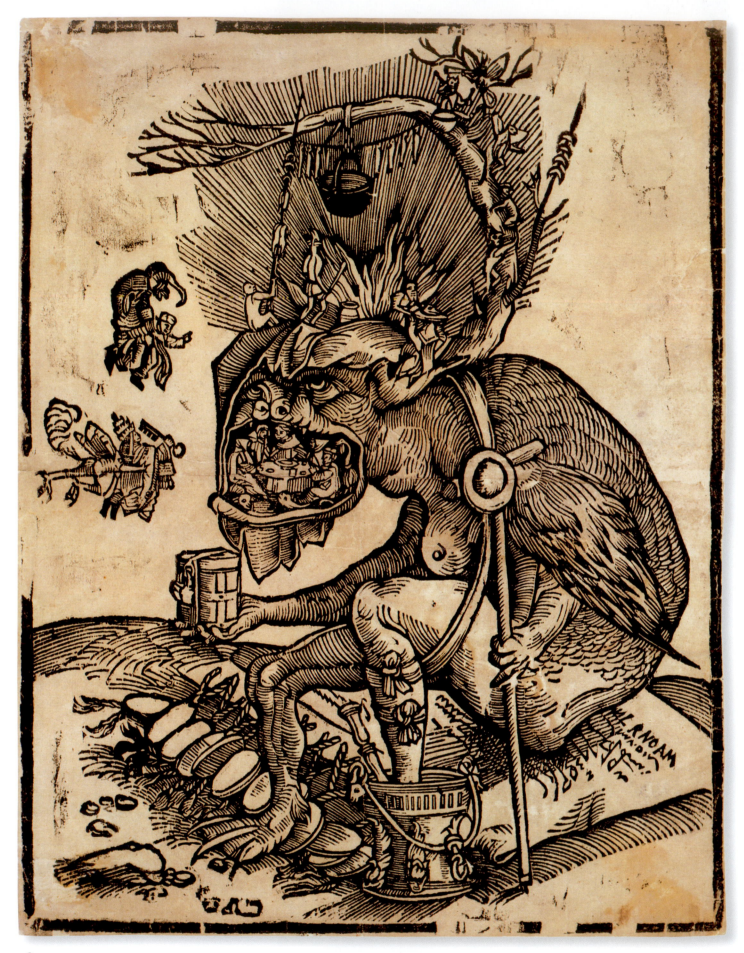

328

Matthias Gerung (attributed)

A Broadsheet Decrying the Sale
of Indulgences

Around 1520
Woodcut
Sheet: 30.9 × 24 cm
Stiftung Deutsches Historisches Museum,
1989/2583
Minneapolis Exhibition

The print depicts a truly devilish figure which
sports the legs of a ram, the feet of a bird and a
woman's breasts. It is shown squatting on a let-
ter of indulgence. In its left hand, it holds a bish-
op's crozier, while its right clutches a strongbox
for the profits from the sale of indulgences. Its
huge, gaping mouth is occupied by five clerics
sitting around a table. On the top of its head, a
purgatory fire burns, with a cauldron hanging
over it from a branch. Humanoid creatures with
the heads of birds surround this strange fire. Two
smaller devils approach in flight, one of them
holding a figure resembling the Pope, while the
second one bears another cleric in his talons.
The broadsheet obviously decries the sale of in-
dulgences by the clergy, who are accused of re-
lieving the common people of their money by
claiming that they could thereby divest them-
selves of their sins. This woodcut had long been
thought to be the creation of Hans Weidnitz, but
has since been attributed to a painter and carver
of woodcuts from southern Germany, Matthias
Gerung. LK

Literature
Krauß 2010, pp. 150 f. · Ottomeyer/Czech 2007,
p. 50 (ill.) · Piltz 1983

329

Martin Luther
Lucas Cranach the Elder (illustrator)

Wider das Bapstum zu Rom
von Teuffel gestifft
(Against the Papacy at Rome,
Founded by the Devil)

Wittenberg: Hans Lufft, 1545
17.9 × 13.5 cm
Luther Memorials Foundation
of Saxony-Anhalt, Kn E113
VD16 L7395
New York Exhibition

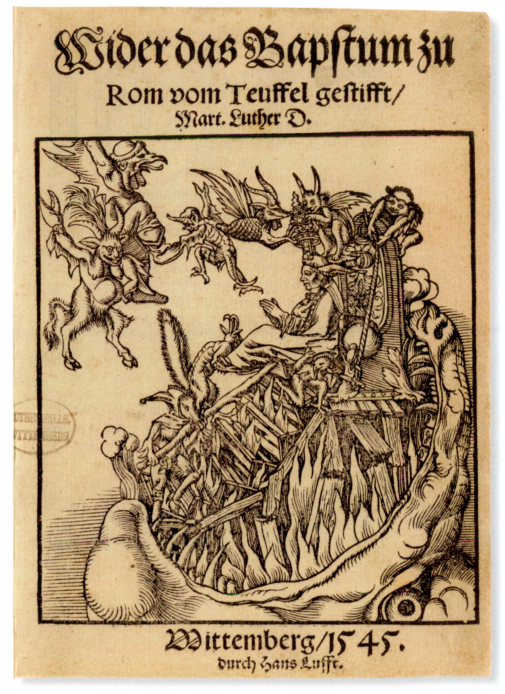

329

In his *Wider das Bapstum zu Rom von Teuffel gestifft* (Against the Papacy at Rome, Founded by the Devil), published in Wittenberg in 1545, Luther undertook one of his fiercest attacks on the papacy. The occasion for this harsh polemic was the convocation of the Council of Trent by Pope Paul III. This council was called together in order to prepare an effective response to the challenges posed by the Protestant teachings and to institute a reform in the Church.

With his harsh disparagement and demonization of the Pope, Luther expresses his full contempt for this project. Luther had already expressed the view that councils could err in his Leipzig Disputation of 1519. For him, the holy scripture alone was decisive (*sola scriptura*). However, this rough abuse against the head of the Church, whom Luther calls *"Ewer Hellischeit* (Your Hellishness),"* did not find approval among all supporters of the new doctrine.

Even the title page of the pamphlet, designed by Lucas Cranach the Elder, leaves no doubt that the Pope is a creature of hell in Luther's eyes and is bound to return there. The Pope, depicted with donkey ears, sits on a frail wooden throne threatening to fall into hell's abyss. Strange demonic creatures prop up the Chair of St. Peter, which threatens to fall apart, and place a tiara topped by a pile of feces upon the head of the Church.

In the same year, Luther continued his polemical attacks against the papacy with a series of images from the Cranach workshop. Ten individual woodcuts appeared under the title *Illustration of the Papacy*, for which Luther composed brief texts (cf. cat. 332–334 and 337). One of them reuses the motif of the pamphlet's title page, *Against the Papacy*. With the Latin title *Regnum Satanae et Papae* (The Reign of Satan and the Pope), below the illustration we see Luther's words: "In the name of all devils here sits the Pope: it has been revealed that he is the true Antichrist as promulgated in the scripture." In this text, Luther refers to 2 Thessalonians 2:4, which reads: "He will oppose and exalt himself over everything that is called God or is worshiped, so that he sets himself up in God's temple, proclaiming himself to be God." Luther sees this as biblical confirmation that the Pope is the Antichrist. ID

Literature
Bild und Botschaft 2015, pp. 124 f., no. 18 (ill.) · Hofmann 1983 b, p. 169, cat. 41 (ill.) · WA 54, 198–299

Martin Luther
Lucas Cranach the Elder, workshop (illustrator)
Series of Anti-Papal Broadsheets

1545
Woodcut, manuscript
Minneapolis Exhibition

330

The Birth of the Pope and the Cardinals (Sheet 1)

Sheet: 30 × 17.9 cm
Stiftung Deutsches Historisches Museum, 1988/708.6

Original title: Nativitas Papae et Cardinalivm
Caption: Hie wird geborn der Widerchrist, Megera seine Seugamm ist, Alecto sein Kindermeidlin, Tisiphone die gengelt jn. Mart. Luth. D. 1545 (Here the Antichrist is born; his wetnurse is Megera, and his nanny Alecto, while Tisiphone leads him on)

The announcement of the Council of Trent by Pope Paul III in March 1545 prompted Martin Luther to once more summarize his prior accusations and invectives against the Pope in writing. Only shortly afterwards, still in March 1545, he published his treatise *Wider das Papsttum zu Rom, vom Teufel gestiftet* (Against the Papacy at Rome, Founded by the Devil) (Kat. 329) in Wittenberg. Lucas Cranach the Elder contributed the appropriate woodcut for the title page, *Der Papst im Höllenrachen* (The Pope in the Maws of Hell). Parallel to this, Luther collaborated with the Cranach workshop in creating another nine anti-papal illustrated pamphlets. These were printed in several editions, of which only a few examples have survived. Within these editions, some further differences are discernible in details of the separate subjects. This is probably a result of trial print runs which occurred at the various stages of the production process of the pamphlets.

The eight prints which are preserved in the collections of the Stiftung Deutsches Historisches Museum (German Historical Museum) are each printed with a different image. The Latin captions above the printed illustrations and the German verses below are written in ink in a neat handwriting. The line breaks of these handwritten parts generally resemble those which appear in the later, completed prints. It can therefore be concluded with some certainty that the handwritten texts on the woodcuts served as patterns for the later, printed pamphlets. The name of the author is not given. The first drafts which pre-

ceded these designs, however, were certainly produced by Luther himself. One trial print run at least is documented. On this surviving print, the Reformer noted, in his own handwriting, the appropriate verse to be used for the image's caption (Sächsische Landesbibliothek, Sign.: Mscr. Dresd.R.307).

The image, titled *Nativitas Papae et Cardinalium* (The Birth of the Pope and the Cardinals), shows a somewhat drastic birthing scene. On the left side, a monstrous, squatting female fury squeezes the figures of the Pope and five cardinals out of her behind; all of them wearing their full vestments. One of the cardinals is shown wearing a beret instead of the appropriate cardinal's hat, and he resembles the Archbishop of Mainz, Albert of Brandenburg. Meanwhile, three smaller furies are busying themselves with caring for the Pope, who is now depicted as a mere toddler.

To the right, Alecto, with her hair of snakes, is rocking the swaddled baby in its crib. Behind her, Megera, likewise snake-haired and quite naked, sits on the ground breast-feeding the infant. And in the background, Tisiphone, who wears nothing save her head scarf, is teaching the little boy to walk. In all of these scenes, the Pope is instantly recognizable by his tiara crown.

Luther explained expansively what he intended to express with this caricature in a Latin letter he wrote to Nicholas of Amsdorf on May 8, 1545. He affirmed his opinion that the Pope and his cardinals were indeed creatures of the devil, who had bestowed all of his envy, hate and greed, along with everything else in the way of evil, upon them as a birthright. LK

Sources and literature
Grisar/Heege 1923, pp. 31–34, fig. 9 · Grüber 1997, Kat. 329, p. 49 (ill.) · WA 54, 343–373, fig. 10

331

The Papal Ass, a Monstrosity Found in the Tiber at Rome in 1496 (Sheet 2)

Sheet: 30 × 17.9 cm
Stiftung Deutsches Historisches Museum, 1988/708.5

Original title: PAPASINUS, MONSTRUM, ROMÆ INVENTUM IN TIBERI. A. 1496

Satirical portrayals of the Pope, in which the head of the Church was depicted as a fabulous beast with the features of a donkey, were first published in Italy in 1496. The background for these fanciful images was provided by an incident which had allegedly occurred in January of the same year. When the high waters receded after a flood of the Tiber River, a hideous mon-

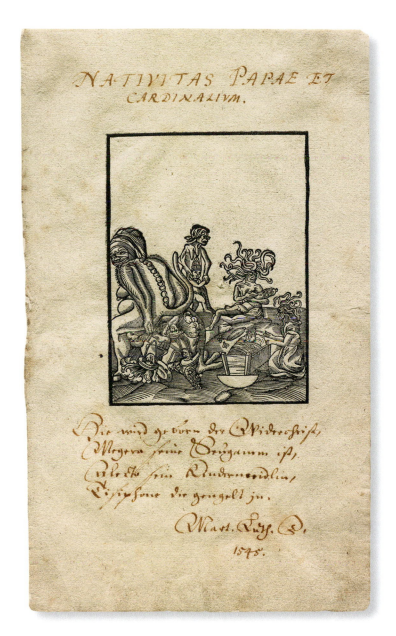

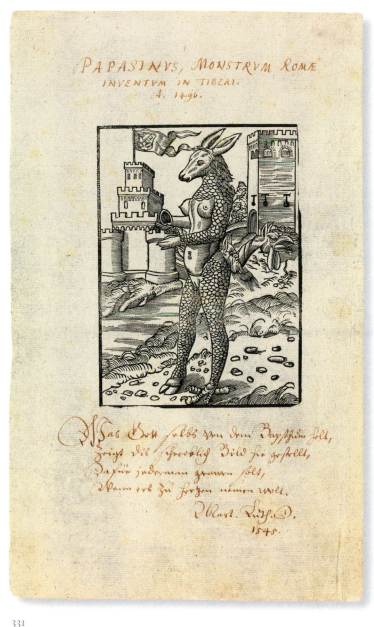

strosity was found on its banks. It was described as a woman with the head of a donkey and animal extremities. This piece of news spread quickly, and the Bohemian engraver Wenzel von Olmütz was able to publish a pamphlet referring to it in the very same year. His caricature on the reign of Pope Alexander VI bore the title "*Roma caput mundi* (Rome, Capital of the World)". It was to become so popular that the workshop of Lucas Cranach eventually published a woodcut version in 1523. The accompanying comment was written by none less than Philip Melanchthon (cat. 318). A version of the print with only minimal alterations was included in the series of anti-papist pamphlets published in 1545.

In the foreground of the image, a naked female figure with generally human proportions is shown standing on the banks of the Tiber. Its

breast and belly are shown bare, and its neck, arms and legs are covered in scales. While the right foot looks like the hoof of a cow, the left resembles the talons of a bird of prey. The right hand is replaced by a rather delicate-looking elephant's foot, and only the left hand seems to be human. The scaly neck is topped by the head of a donkey. These rather incongruous features result in an appearance which is really more quaint than terrifying. If there is anything frightening about the apparition, it is its posterior, from which the head of a dragon seems to grow on a long neck alongside the hairy head of a devil. Above a castle on the opposite bank of the Tiber River waves a flag which displays the pontifical coat of arms with the symbol of the crossed keys. Below the image, a verse by Luther explains the scene: "*Was Gott selbs von dem Bapsthum helt,*

Zeigt dis schrecklich Bild hie gestellt, Dafür jedermann grawen solt, Wenn ers zu Hertzen nemen wolt. Mart. Luth. D. 1545 (How God himself thinks of the papacy is shown by the terrible image displayed here, which should cause all men to recoil in horror, if they would only take it to their hearts)." LK

Sources and literature
Falk/Koepplin 1976, vol. 2, pp. 361–371 · Grisar/Heege 1923, pp. 17–19, fig. 2 · Grüber 1997, vol. 1, p. 49 (ill.) · Saxl 1957, vol. 1, pp. 255–266, and vol. 2, pl. 179 · WA 54, 350, fig. 2

The Pope's Feet About to be Kissed (Sheet 3)

Sheet: 30 × 17.9 cm
Stiftung Deutsches Historisches Museum, 1988/708.7

Original title: HIC OSCVLA PEDIBVS PAPÆ FIGVNTVR.

Caption in the illustration: PAPA. Sententiæ nostræ, etiam iniustæ metuendæ sunt. RESP. Aspice nudatas barbara terra nates. Ecco qui Papa el mio bel vedere.

Under a magnificent canopy decorated with lilies, Pope Paul III of the House of Farnese is shown sitting on his throne. To his right stands Cardinal Otto Truchsess von Waldburg, recognizable by his prominent goatee, and on his left Cardinal Albert of Brandenburg, depicted with the customary beret on his head. Luther nurtured a particular distrust of Albert, as he felt deceived by him. Pope Paul III holds a papal bull in his right hand, which spews forth flames, rocks and rays. This document is clearly meant to be the *Lætare Jerusalem*, a bull or edict drawn up on November 19, 1544, in which Paul III formally announced the Council of Trent. This convention was originally scheduled to begin on March 15, 1545, but the first session did not take place until May 31, while the official opening was delayed until December 13, 1545. Luther was strictly opposed to this council. Even though the demands of the reformers were scheduled to be the central issue of the debate, the Pope had already signaled that he was resolved to condemn the Protestant doctrine in the end. In the depiction in the pamphlet, Paul III presents his outstretched left foot on the platform of his throne, as if expecting it to be kissed in submission. The two rustic figures in front of his throne, however, have turned their backs on him, with mocking grins on their faces. They are, in turn, presenting their exposed backsides, which emit unmistakable clouds of gas. Luther further expresses the peasants' derision against the papal ban and the proffered foot with the following verses: "*Nicht Bapst, nicht schreck uns mit deim Bann, Und bis nicht so zorniger Man, Wir thun sonst ein gegenwehre, Und weisen dir das Belvedere*. Mart. Luth. D. 1545 (Do not, Pope, attempt to scare us with your ban, and be not such an angry man, lest we turn to take up the fight, by showing you a pretty sight)."
LK

Sources and literature
Grisar/Heege 1923, pp. 22–24, fig. 4 · WA 54, 351, fig. 10

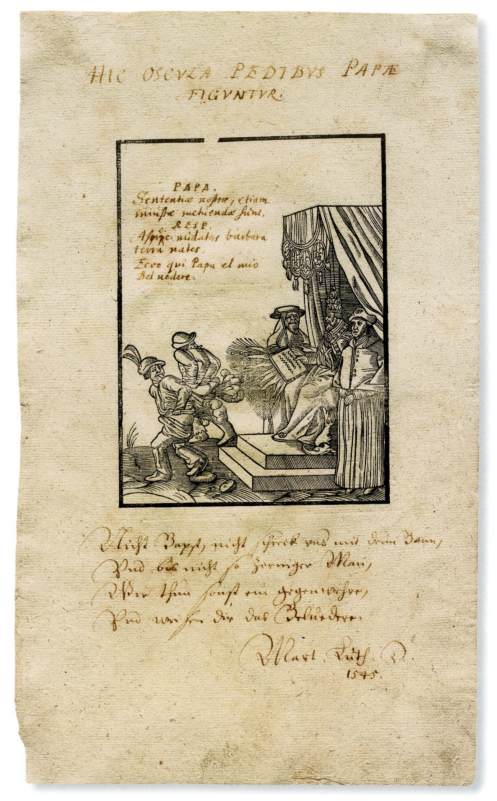

332

333

The Pope – Doctor of Theology and Master of the Faith (Sheet 4)

Sheet: 30 × 17.9 cm
Stiftung Deutsches Historisches Museum, 1988/708.3

Original title: PAPA DOCTOR THEOLOGIAE / ET MAGISTER FIDEI

A donkey wearing a tiara and a cope is shown sitting enthroned beneath a canopy, playing bagpipes with the help of his front hooves. This odd portrayal is immediately explained by Luther's verse below: "Der Bapst kan allein auslegen / Die Schrift, und Irrthum ausfegen, / Wie der Esel allein pfeiffen / Kan, und die Noten recht greiffen. // Mart. Luth. D. / 1545 (The Pope alone can construe / Scripture and eradicate all untruth / just as the donkey alone can play the pipes / and hit every single note just right)." What is criticized here in so drastic a fashion is the power of the Pope to interpret the Gospel of God in a false way. As in the second woodcut of the series, the Pope is depicted in the guise of a donkey. He is, however, clearly identified as Pope Paul III by the heraldic device on his tiara, the fleur-de-lis of the House of Farnese. LK

Sources and literature
Grisar/Heege 1923, pp. 29–32, fig. 8 · Grüber 1997, p. 49 (ill.) · WA 54, 350–354, fig. 4

334

The Adoration of the Pope as God on Earth (Sheet 5)

Sheet: 30 × 17.9 cm
Stiftung Deutsches Historisches Museum, 1988/708.8

Original title: ADORATVR PAPA DEVS TERRENVS

Caption: Bapst hat dem Reich Christi gethon / Wie man hie handelt seine Kron, / Machts jr zweifeltig, spricht der Geist, / Schenckt getrost ein, Gott ists, ders heist. // Mart. Luth. D. / 1545

Three men, possibly peasants or mercenaries, are depicted using the papal tiara, which is mounted upside-down on a block-shaped pedestal, as a lavatory. While the first man, a youngster with his trousers down, is relieving himself into the opening of the tiara, his older companions look on. One of them is already waiting on the pedestal for his turn, while the other is leaning against it, fumbling with the points tying his trousers. The pedestal is ornamented with a large

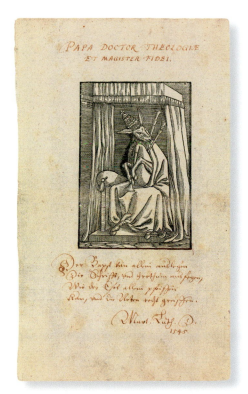

333

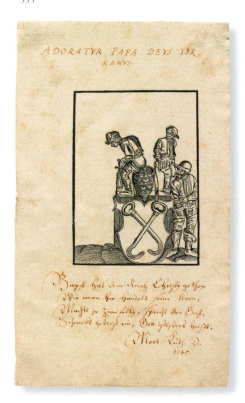

334

coat of arms displaying the two crossed keys of the Pope, but in this case their ends have been altered to resemble lock picks or thieves' hooks. The whole scene derides the Pope as a thief and miscreant, as does the accompanying text by Martin Luther, which accuses him of abusing the kingdom of Christ now and in the past, and of soiling it with his refuse. For this, he will now receive a similar treatment. In the years following Luther's death, several editions of the entire series of anti-papal pamphlets were reprinted. At first, these were made using the original woodcut printing blocks, but from the beginning of the 17th century on, new blocks were used, which incorporated additional ornamental borders. LK

Sources and literature
Grisar/Heege 1923, p. 24–26, fig. 5 · WA 54, 343–373, fig. 11

335

The Pope Granting a Council to Germany (Sheet 6)

Sheet: 30 × 17.9 cm
Stiftung Deutsches Historisches Museum, 1988/708.1

Original title: PAPA DAT CONSILIVM / IN GERMANIA

Caption: Saw du must dich lassen reiten, / Und wol sporen zu beiden seiten, / Du wilt han ein Consilium. / Ja dafür hab dir mein merdrum. // Mart. Luther. D. / 1545 (Sow, you will have to let yourself be ridden / and be spurred on both sides / if you want a council. / In that case you will have to accept my dung)

The Pope, recognizable by his tiara, is depicted riding a sow. His right hand is extended in a gesture of blessing, while his left offers a pile of steaming excrement to the swine, which is eagerly sniffing the fumes. The scene refers to an event in the spring of 1545: the sow represents the representatives of the Imperial and Christian German Nation who had been invited by the Pope to attend a clerical council in the city of Trent. Luther had described the alleged scene to which this image referred in his treatise of March 1545, *Wider das Papsttum* ... (cat. 329). Pope Paul III was said to have threatened Emperor Charles V: "*Wir wollen dich lehren, wie du sollst mit deinen deutschen Säuen ein Konzil begehren von dem römischen Stuhl* (We will teach you and your German sows better than to demand a council of the Holy Roman See)." The print illustrates this trial of strength, but it also offers an ironic piece of advice to the Pope: If the Pope would indeed ride a sow, and not risk being bitten by her, he

should feed her with a bit of excrement, or rather grant her the requested council. LK

Sources and literature
Grisar/Heege 1923, pp. 28–32, fig. 7 · WA 54, 350–354, fig. 3

336
The Pope Repaying the Temporal Rulers their Manifold Kindness (Sheet 7)

Sheet: 30 × 17.9 cm
Stiftung Deutsches Historisches Museum, 1988/708.2

Original title: PAPA DAT MERCEDEM CAESARIBVS / PRO INNVMERIS BENEFICIIS

Caption: Gros gut die Keiser han gethan / Dem Bapst, und ubel gelegt an, / Dafür ihn der Bapst gedanckt hat, / Wie das Bild dir die Warheit sagt. // Mart. Luth. D. / 1545 (Much kindness have the Emperors shown / to the Pope, but this was badly misplaced/ for which the Pope has given them thanks / just as this image shows you in truth).

The second to last of Luther's anti-papal series of pamphlets depicts the Pope in the role of an executioner, dealing out a fate he would suffer himself in the very last of the illustrated pamphlets. The Pope, on the left side, is wearing an alb and a cope as well as his tiara, which is topped by a small devil who observes from within a halo of rays. The head of the Church is wielding a sword with both hands, raising it to deliver the fatal blow to his victim, who kneels in prayer in front of him. This unfortunate is himself wearing a king's vestments. On later versions of the woodcut, we are even given his name: it is Konradin, the last of the Hohenstaufen Kings, who had briefly reigned in the middle of the 13th century and was executed at the instigation of a Pope. The prototype for this pamphlet was a trial print on which Luther had added the above verse in his own handwriting. It is preserved in the Saxon State Library (Sign.: Mscr. Dresd. R. 307), albeit much damaged by water during World War II. LK

Sources and literature
Grisar/Heege 1923, pp. 27–29, fig. 6 · WA 54, 350, fig. 5, 6

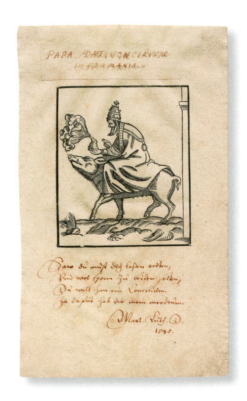

335

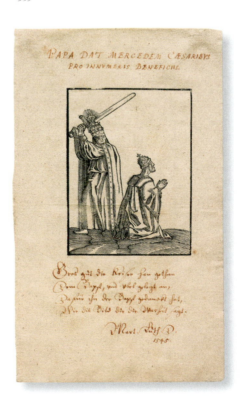

336

337
The Just Reward for the Satanic Pope and his Cardinals (Sheet 8)

1545
Woodcut, manuscript
Sheet: 30 × 17.9 cm
Stiftung Deutsches Historisches Museum, 1988/708.4
Minneapolis Exhibition

Original title: DIGNA MERCES PAPE SATANISSIMI ET CARDINALIVM SVORVM

From a modern perspective, the execution scene depicted on this pamphlet seems particularly repulsive and callous. The image is much more realistic, and certainly less quaint, than the illustrations of the other anti-papal caricatures. Four people are seen hanging by their necks from a triangular gallows, which consists of three horizontal beams supported by three posts. Their tongues have been cut out and nailed to the beams behind their heads. The verse below the image explains this procedure: *"Wenn zeitlich gestrafft solt werden Bapst und Cardinal auff Erden, Ir Lesterzung verdienet hett, Wie ir Recht hie gemalet steht.* Mart. Luth. D. 1545 (If the Pope and his cardinals were to receive an earthly punishment in our time, their blasphemous tongues would truly deserve the fate you see depicted here)." On the right hand, the executioner is shown standing on a ladder in the act of nailing the tongue of the Pope, who is instantly recognizable by the crown on his head. To the left, three more clergymen have already been dealt with. One of them has a pointed beard, identifying him as the Cardinal and Bishop of Augsburg, Otto Truchsess von Waldburg. The cardinal on the left, with a beret on his head and a cardinal's hat dangling from his wrist, is Albert of Brandenburg, Archbishop of Mainz. Luther bore a particular grudge against Albert, who was the younger brother of the Elector of Brandenburg, Joachim I. In a speech made previously at his table, he had insisted: *"Wenn man Diebe hängen sollte, sollte man für allen Dingen den Bischof von Mainz hängen an einen Galgen, der siebenmal höher ist, als der Giebenstein* (If all thieves were to be hanged, then the gallows for the Bishop of Mainz ought to be built seven times higher than the rock of Giebenstein)" (cited after: Grisar/Heege, p. 26). Luther's Giebenstein is the rocky outcrop of the castle of Giebichenstein, north of the city of Halle. Luther explained this harsh attitude in *Wider Hans Worst*, a treatise written in 1541: *"Und ich mag das auch sagen, das mir kein Herr [...] so gnedig allzeit geantwortet, und so viel zu gut gehalten haben, als eben der Bischoff Albrecht. Ich dachte fur war, Er were ein Engel. Er hat den rechten Meister Teufel, der sich so schön*

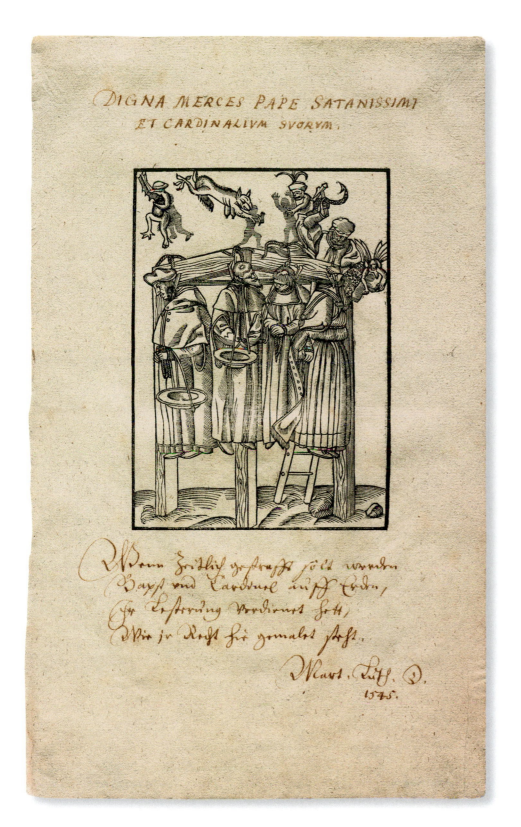

337

putzen kan, und doch darunter uns Lutherische Buben schalt, und, was er wider diese Lere vermocht zu thun, nicht unterlassen hat. Ich meine ja, ich sei auch beschissen in meinem hohen vertrawen auff solchen bösen menschen. Wolan, hin ist hin, er sol und mus auch da hin (And I would also like to say that no lord has ever replied to me so kindly and condescendingly as Bishop Albert. I truly believed him to be an angel, but he is possessed by master of a devil, who, while he appeared most pleasing on the outside, spoke against us Lutheran knaves under this cover, and omitted nothing in his power in acting against our teaching. I verily believe I have been duped in my deep faith in this evil man. But, no matter, what is gone is gone, and he himself must go that way too)" (Cited after: WA 51, 538). LK

Sources and literature
Grisar/Heege 1923, pp. 26 f., pl. 1 · Grüber 1997, vol. 1, p. 49 (ill.) · WA 51, 538 · WA 54, 351 fig. 8

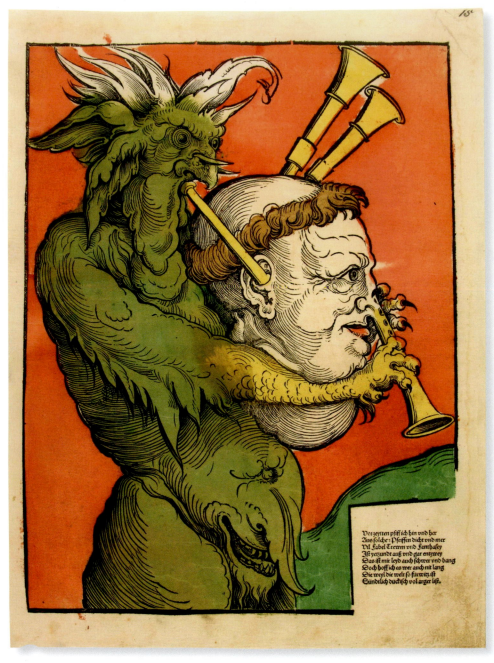

338

Erhard Schön (attributed)
The Devil's Bagpipe

Around 1530–1535
Colored woodcut, typographic text
Sheet: 36.5 × 27.2 cm; Type area: 32.4 × 24.6 cm;
Image: 32.4 × 24.6 cm
Foundation Schloss Friedenstein Gotha, 37,2
Minneapolis Exhibition

Inscription:
Vor zeytten pfiff ich hin vnd her
Aus solchen Pfeiffen dicht vnd mer
Vil Fabel Trewm vnd Fanthasey
Ist yetzundt auß vnd gar entzwey
Das ist mir leyd auch schwer vnd bang
Doch hoff ich es wer auch nit lang
DIe weyl die well so fürwitz ist
Sündtlich dückisch vol arger list.
(In times past I would blow here and there
On pipes like these and more, without a care
Much fable, dream and fantasy
Is now asunder, no more to see
This hard news brings me sorrow and grief
But I hope it will be brief
Because the world is so enamored
With sin, treachery and a malicious manner.)

In this woodcut by Erhard Schön, a greenish yellow and shaggy diabolic creature with pointy ears, circular eyes and a snarling stomach is playing a bagpipe shaped like the head of a monk, with double chin and tonsure. The extended nose of the cleric forms the chanter on which the devil is playing. The mouthpiece through which he is blowing is attached to the monk's ear. This detail is meant to illustrate that the devil is whispering his cunning tricks and evil directly into the ears of the clergy. In light of the confessional disputes taking place at the time, the clergy appears here in a satirical exaggeration as the tool of the devil, while the broadsheet takes the Protestant position. In the eight verses in letterpress that can be found on the lower right corner, the devil laments the fact that he can no longer play much "fable, dream and fantasy" on these pipes like he could before; those days are over. This is an allusion to the dawning of a new era, which was heralded by Luther and his criticism for the machinations of the old Church. But still, the devil hopes that the world is so sinful and malicious that this condition will not last for long. In addition to the polemical content, the final words are to be understood as a warning never again to veer off the right path. UE

Literature
Bild und Botschaft 2015, pp. 130 f., cat. 21 (ill.) ·
Bott 1983, p. 239, no. 301 (ill.) · Hollstein XLVII,
pp. 118–120, no. 80 (ill.) · Schäfer/Eydinger/
Rekow (forthcoming), cat. 238 (ill.) · Scribner
1981, pp. 133 f., fig. 100 (with false location, the
Gotha copy is the one shown)

339

Sebald Beham
Protestant Satire on the Eucharist

Early 1520s
Ink on paper
D 9.9 cm
Thrivent Financial Collection of Religious Art,
84-15
Minneapolis Exhibition

This small sketch appears to be an idea for a
satirical work of art, probably a print. A goat in
priestly garb enters a room where three men
surround a table. The goat carries a plate seem-
ingly heaped with food. The man in the fore-
ground turns to him, wielding a pair of shears.
The figure behind him gesticulates and points
to the third man, whose left hand is raised, per-
haps signaling astonishment or rejection of the
offering.

The image may focus on one of Luther's promi-
nent and tenacious detractors, Hieronymus Emser
(1477–1527), whose family crest featured the
bust of a goat. Emser was personal secretary to
Duke George of Saxony (cat. 349). The duke and
Emser initially sympathized with Luther, but
when they realized the doctrinal implications of
his teaching, they became his ardent opponents
and strong defenders of the Roman Church. In
1519, they arranged the Leipzig Disputation,
which led to Luther's denial of divine papal au-
thority. When Luther burned Pope Leo X's bull of
excommunication (cat. 165, 167 and 168), he also
tossed Emser's books on the pyre. Emser replied
with a succession of books attacking Luther, and
Luther fought back with unbridled invective.
Luther taunted his nemesis as "Bock Emser"—
Emser the goat—and assigned him a beard,
snout, and horns.

Luther wrote that Emser's writings were lies and
poison. This may be the point of the present
drawing. One man wants the goat to pass him by
and, alarmed by the prospect of what the goat
has to offer, the other raises his hand to refuse.
The shears may be intended to lay bare the goat
and his lies. A more specific interpretation might
focus on Emser's position that during Commu-
nion, priests offered Christ *in persona ecclesia*,

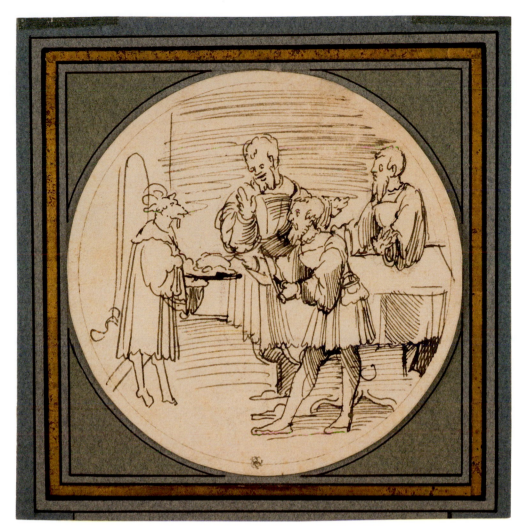

339

(in the person of the Church), which in the pres-
ent satire would place goat meat on the paten.
Attribution of this drawing to Sebald Beham is
plausible but uncertain. Most drawings assigned
to his hand are more finished. Even the sketchier
ones are tighter in execution than this sheet.
Nevertheless, traits such as casual foreshorten-
ing, abundant hatching of varying intensities,
and hair with scalloped edges all have echoes in
known Beham drawings. Initially working in
Nuremberg, Beham, his brother Barthel, and
Georg Pencz were expelled from the city in 1525,
when they were convicted of blasphemy, heresy,
and contempt for the city council. Later the same
year, the city flipped to the reformers' side, and
"the three godless painters" were allowed to re-
turn. TR

Literature
Bagchi, Bagchi 1991 · Lindell 2011, pp. 76–77

340

Abraham Nagel
The Heresy Tree

1589
Woodcut
Plate: 36 × 24.1 cm; sheet 40.7 × 24.3 cm
Luther Memorials Foundation
of Saxony-Anhalt, grfl VI 1071
Minneapolis Exhibition

Inscription above: Delineatio malae arboris Lutheranae: das ist E. eygentliche Entwerffung, und Fürstellung deß bösen unfruchtbaren Luther oder Ketzerbaums, darauß zuvernemen, was deß Baums Wurtzel, Stammen und Näst, ja wie auch der gantz vermeynt Christenbaum beschaffen [...]
(Delineation of the evil Lutheran tree: this is the true make-up and conception of the evil and unfruitful Luther or heresy tree, deriving from this what makes up the tree's roots, trunk and branches, and the entire supposedly Christian tree [...])

In the middle of the image we can read the words *SOROR MEA SPONSA* (my sister, my bride). This allusion to the medieval imagery of the *hortus conclusus,* or enclosed garden, is meant to mock the Protestants. Instead of a fenced-in paradise with the Virgin Mary sitting peacefully in the middle, this garden contains a sprawling and prickly tree, the heresy tree.
The tree is divided into roots, trunk and branches. Because the roots are made up of old heretics, such as Marcion, Jan Hus and Nestorius, the tree has no strength. They are emitting poison, bile and grief. The trunk is comprised of the seven-headed Luther, in an allusion to the seven-headed apocalyptic beast in Revelations. However, the one who is really holding the trunk together is the devil, who can be seen below Luther brewing the poison of heresy and handing it upwards. The result is division and confusion. For this reason, the trunk is not healthy and green, but "mangy," as the author Abraham Nagel writes in his book, *Schüttlung deß vermeinten Christenbaums* (Shaking the Supposedly Christian Tree).
The branches and twigs are barren. The fruits of the tree consist of caterpillars and other "monstrosities." The men sitting on the branches represent the various strands of Protestantism, and they are fighting each other with swords.
This woodcut is rare today. Only one other copy is known to exist, in the Herzog August Library in Wolfenbüttel; that copy is completely preserved, unlike the present one. The author, Abraham Nagel, was a priest who became a canon of the Neumünster abbey in Würzburg in 1584. In 1589, he published *Shaking the Supposedly Christian*

Fig. 11
The Heresy Tree from the Bible of Ernest I, Duke of Saxe-Gotha, 1641

Tree in the midst of the Flacian controversy (cf. cat. 342). Nagel's work explains the letters which can be seen in the woodcut.
There are both Protestant and Catholic heresy trees. Their growth and implicitly sequential expansion are meant to symbolize controversial theological viewpoints from the history of Christianity. They suggest historical chains of causation which serve to legitimize the author's own view of the history of Christendom and demonize the other confession. A Protestant equivalent can be found, for example, in the Bible of Ernest the Pious from the year 1641. The first three editions of that work show a heresy tree from the Protestant perspective. The plant draws its roots from Simon the Sorcerer (Acts 8: 9–24), who is considered to be the first heretic in the history of Christendom because of his Gnostic ideas. The flowers growing from the plant are Islam and the papacy, as visible harbingers of Judgment Day (Fig. 11). RK

Literature
Joestel 2008, pp. 174 f. · Koch 2002 · Marten 2010 · Nagel 1589 · Treu 2003 a, pp. 12 f.

341

Unknown artist
Luther Triumphant (Broadside)

Wittenberg, around 1568
Woodcut
23 × 35 cm
Emory University, Pitts Theology Library,
1568 EHRW
Atlanta Exhibition

342

Unknown artist
Luther Triumphant (Broadside)

After 1568
Etching
Plate: 34 × 27.5 cm; sheet: 36.3 × 29.3 cm
Luther Memorials Foundation
of Saxony-Anhalt, fl XI 1035
Minneapolis Exhibition

The pamphlet *Lutherus Triumphans* (Luther Triumphant) is the Lutheran response to the Catholic accusation of disunity. Two groups stand opposed in the image: on the right side is the Pope with his supporters, and on the other is a closed phalanx of Protestants, led by Philip Melanchthon. The Catholic clergy appears in a disjointed crowd, which is divided into three parts. The sacred objects they carry, such as relics, icons and monstrances, convey the false way to God, as symbolized by the placement of a fox's tail on a spear. The torches and swords of the Dominican monks are a clear allusion to the Inquisition carried out by that order. The monks of the Jesuit order dip their feathers into the hindquarters of a three-part beast, making it clear from where they get their theology. On the other side, Melanchthon raises his pen towards Luther, symbolizing the redemptive quality of Luther and his teachings. Luther, with both legs firmly planted on the ground, holds the Bible open in his hands. In the open Bible we can see Romans 1:17 and Galatians 3:7, two passages which are important for his theology. By contrast, the authoritative books lying under the Pope's chair are falling away. Even the papal insignia, the key to heaven and the double-edged sword, which is supposed to protect the helpless and punish the enemies of the Church, are falling apart in the hands of Pope Leo X. His chair is wobbling dangerously and only the long rods of the Jesuits are propping him up. The Pope and his Church are doomed.
The sheet originally appeared in 1568 as a woodcut (cat. 341). An etching was later made, in which the two sides were reversed. The central figure in the middle of the sheet, derided as

LVTHERVS TRIVMPHANS.

341

"Judas," was renamed in the copy. In the original woodcut, the person depicted here was the converted theologian Friedrich Staphylus, who interpreted Luther's theology in three parts and described it as confused and diabolical. This is why the figure is dragging behind him a three-part chimera. In the subsequent copy (cat. 342), Staphylus becomes Matthias Flacius Illyricus, who is described as the conscience of the Lutherans personified (Stopp 1965). That Gnesio-Lutheran had accused Luther's supporters of deviating from Luther's true teachings. This dispute was grist for the mill of the Catholics, who thoroughly exploited the disunity in the Lutheran ranks. The sheet, on the other hand, portrays the Lutherans in closed ranks and decries supposed traitors as "Judas." RK

Literature
Harms 1983, pp. 36 f., cat. 18 · Harms/Schilling/ Wang 1997, pp. 28 f., cat. 14 · Hofmann 1983 b, p. 156, cat. 30 · Klug 2012 · Niemetz 2008 · Spinks 2015, pp. 109−111 · Stopp 1965 · Treu 2003 a, pp. 10−12

LVTHERVS. TRIVMPHANS.

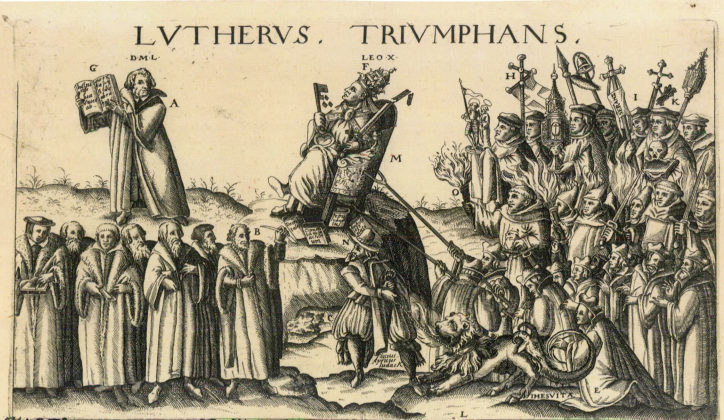

A Als ich Martin Luther hab gesagt/
Im Leben mein vnd offt beklagt/
Das find sich im werck vnd that
Wie der Sathan mit seinem Raht/
Jetzund in Kirchen vnd Schulen Rumiordt/
Durch sein listig vnd lugen-Mordt/
Wider die heilsame reine Lehr/
Welche Christus vnser trewer Herr/
Durch mich in Deutschland mit macht/
lauter vnd rein herfür gebracht/
B Vnd den werthen Gehülffen mein/
Philippum Melanthon ich meyn/
Daß wir beyde in ein Corpus gar/
Brachten mit Gott die Lehre klar/
Solch einigkeit der Reinen Lehr/
Der Teuffel nicht kundt leyden mehr/
Erweckt derwegen der Schwermer viel/
Rotten vnd Secten ohne ziel/
Die schreyen/schreiben vnd schmeissen wol
Alle Kirchen/Schulen vnd Stätte vol/
Auß Gelt/Ehrgeitz/Hoffart vnd Neyd/
Zum Zancken/Hadern/Begirigkeit/
Auch engen Raht/falschen wohn/
Der grossen luft vnd heiligkeit schon/
Vnter welchen Stiffter vnd anfangen gar/
Ist solcher Sect vnd böser Schaar/
C Der Verähter Flacius Apricus/
Der sich behilfft mit Judas Kuß/
Ein Gottloser vnd Christi feind/
Was glaubens er sey vnd was er meint/
Das weist sich auß sein Comment/
Das er Clavem Scripturæ nennt/
Zu diesem ist gar schnell auch fand/
Der trewloß Staphylus genannt/
Ein falsches Hertz vnd roter Hut/
Kurtz Kleyd/schnell gantz nach Judas art/
Ob er wol vor mein Junger war/
In meiner Schul erzogen gar/
Doch gefiel ihm deß Bapstes gut/
Vnd der roht Cardinalisch Hut/
Darumb verleugnet er die Warheit/
Bekam doch nit die gehoffte Beut/

E Drauff folgt die vngehewre Rott/
Die der Andechrist gezeuget hat/
Mit seiner Babilonischen Braut/
Die Rohr Hur ein böß Römische haut/
Welchs ist ein seltsam gstickts Gesind/
Auß allerley Mutter Kind/
Erzogen in dem Höllischen Pful/
Studirt in der Mönchen Schul/
Bringen den alten Thandt herein/
Schmücken sich mit dem Namen sein/
Das die JESVITER seyn/
Ja JESV zu wider ich menn/
Im mund führen sie Christum den HErrn/
Im Hertzen sie ihren Abgott ehren/
Auff einem Stul vor Helffenbein/
Geschmückt geziert mit edlen Gestein/
F Sitzt der Bapst hie/der sich gar fest/
Als einen Gott anbern vnd küssen lest/
Auch sich anruffen daß er ist/
Ein Statthalter deß HErren Christ/
Ist doch voller Laster allerhandt/ (schandt/
Mord/ lügen/ Geitz/ Vnzucht/ Blut
Trewloß meineydig/was er will/
Das muß recht sein/ohn alles ziel/
Sein Recht/ Gesetz soll gelten mehr/
Denn Gottes Wort vnd Christi Lehr/
Was er ordnet/schafft thut vnd lehrt/
Das soll gut sein/trotz der's ihm werht/
Er setzet ab/ er setzet ein/
Keyser/vnd König nach dem willen sein/
Verkaufft den Himmel vmb das Gelt/
Betreugt also die schnöde Welt.
Ein Fegfewer/für die Seelen arm/
Er thut/ er machts ihn sehr Warm/
Wer Reich ist der kriegt Ablaß frey/
Wer kein Gelt hat ist nicht darbey/
Solche grosse macht der Antechrist/
Auff diesem Stul ihm selbst zumißt/
Derhalben bin ich jetzt auff der Bahn/
Mit dem frommen getrewen Mann/
Philippus Melanthon offt genandt/
Den ich in allen trewen erfandt/

Den mir auß sonder grossen gnad/
GOtt zum Gehülffen geben hat/
Dein Bubenstück vnd falsche Lährn/
Deß Antichrist zu offenbahrn/
Die reinen Lehr vnd Göttlich Wort/
Ans liecht zubringen an allen ort/
Ich stehe hie auff dem Berge schlecht/
Für dir/O Bapst du Teuffels Knecht/
G Das ist das Buch/damit ich hab/
Dein Tück endeck/das ist mein Stab/
Damit hab ich die dreyfache Kron/
Mit Edelgestein vnd Golde gar schon/
Dir abgeworffen vnd Abconterfeyt/
Dich selbst hiemit in dieser zeit/
Denn dasselbige die Kräffte hat/
Das es kan vmbstossen in der that/
Den Vatter Bapst mit seinen Pfaffen/
Die Jesuiter sampt Mönchischen affen/
Welche mit der Monstrans vnd fahne vil/
H Sampt andern Heiligthumb ohne ziel/
Mit eusserlichem Schwerdt vnd Feiwer/
Auffgetretten kommen Vngeheuwer/
I Bringen auch mit sich Frans Pluderhose/
Welcher wolt mit der Nonnen kosen/
K Desgleichen mit Creutz vnd Todtenkopff/
Weil der Pfaff ein loser Tropff/
Verthädigen sollen seinen Abgott/
Vnd wolten helffen auß aller Noht/
Da doch die eusserlichn Werck helffen nicht
Vnd erlösen von Gottes Gericht/
Sonder der glaub macht allein Gerecht/
Daran man sich soll halten schlecht/
Wil man hie wol leben zeitlich/
Vnd den Todt nicht sehen ewiglich.
Es wil zwar einr den Pfaffen zhülff kommen/
Dieweil er von ihren Rott vernomen/
Daß nichts mehr hülfft ihr Lift vnd Tück/
Daß ihr Anschläg gehn zu rück/
L Darumb er mit sich das grewlich Thier/
Bringt auß der Höllischen glut herfür/
Welchs in ein Leib hat drey gestalt/
Gantz wundersam/ vnd Mannigfalt/

Forn ist ein Löw hinden ein Drach/
Mitten ein Genß mit Hörnern Flach/
Das nennt die dreyfach Theologi/
Lutheri/vnd nicht ein spötterey/
Darinn er mein Lehr veracht/
Macht sie in aller Welt verdacht/
Dazu machn sich die Jesuiter auff/
Verstossen den Ersamen einen lauff/
Stehen mit ihr Schreibfedern klein/
Dem Thier in dem hindern nein.
Trabens fort gantz vngestüm/
Daß es zuhülff den Stulherrn küm/
M Welcher schon hangt gefehrlich sehr/
Vnd sencket sich je lenger je mehr/
Als wolt er gehn zu boden gar/
Daß auch der Jesuiter Schaar/
Mit Krück vnd Gablen eylen herzu/
Daß er nicht gäntzlich fallen thu/
Aber es hat ein schlecht Fundament/
Sondern es wird nemen ein endt/
N Dann es ist vnterstützt Pilato vn Aristoteles/
Die Pfaffen haben ihren Decretales/
O Petrus Lambertus mit seiner Philosophey/
Vnd die gesetz der Möncherey/
Aber sie können damit die Lehre mein/
Welche stimpt mit Gottes wort überein/
Nicht vmbstossen gantz vnd gar/
Dann sie hat zum pfeiler der Engel schar/
Welche allen Gläubigen stehen bey/
In allen Anfechtungen frey/
Daß sie nit versincken in ihrer Noht/
Sondern durch den zeitlichen Todt/
Können wandlen in das Himmelreich/
Zur ewigen freud allzugleich/
Dazu wolle vns helffen Gottes Sohn/
JEsus Christus der gnaden thron/
Denn sampt Vatter vnd heiligem Geist/
Alle Welt soll ehren allermeist/
Vnd mit Geistreichen Hertzen allesamen/
Soll frölich singen vnd sagen/Amen.

342

343

Unknown German artist
Picture puzzle: Fool and Voppart

Around 1525
Colored woodcut, typographic text
Sheet: 40 × 28.2 cm; Type area: 29.2 × 27 cm;
Image: 27.1 × 27 cm
Foundation Schloss Friedenstein Gotha, 37,1
Minneapolis Exhibition

Inscription : Uoppart/Narr (Fool)

This picture puzzle shows a two-headed creature whose two heads are connected so that they share a mouth. Of these figures, one can be seen right side up and wearing a red cardinal's hat, while the other is upside down. His head, in turn, is covered by a bright dunce cap with donkey ears over which can be read, if the sheet is turned over, the word "fool." His counterpart's title is not cardinal, as one might think at first, but rather "Uoppart."

This is a play on the German word "fopper," a deceiver who leads other people around by the nose, similar to a fool. This single word above the cardinal emphasizes the joke in the image: that the words "fool" and "cardinal" are spoken from a single mouth. The cardinal is unmasked as a fraud, as a fool, and thus belongs to a category of polemical images and ideas in which the actual meaning is *reversed* and the *reversed* meaning is challenged. The print allows the reader to literally turn the page, by which action the truth of the cardinal's speech is revealed.

The motif of the double-head was used starting in the 1540's by the Protestant side in polemical disputes, predominantly through the medium of coins (cf. cat. 342). However, the presumed predecessor of this satirical device is a broadsheet appearing around 1520/22 which is stored today in the Worms City Library. It shows a two-headed creature with a bonnet and fool's cap. The figures can be identified as Luther and a fool speaking the text that is printed above and below the image. Thus, the first use of this device was on the Catholic side, but the Protestants proved cleverer in reusing this device, virtually transforming the motif into an anti-Church symbol by having the polemical message delivered almost entirely by the image itself. The double-headed cardinal and fool, or Pope and devil, later appears not only on coins and medals, but on stove tiles and household items as well. UE

Literature
Bild und Botschaft 2015, pp. 128 f., cat. 20 (ill.) · Krauß 2010, p. 175, fig. 100 (with incorrect inv. no.) (ill.) · Satō/Schäfer 1995, pp. 45 and 139, cat. 37 (ill.) · Schäfer/Eydinger/Rekow (forthcoming), cat. 411 (ill.) · Scribner 1981, pp. 165 f., fig. 134

343

Iconoclasm in Wittenberg: a Myth?

Several important questions confronted the nascent Reformation. These concerned the content of Mass, the character and form of the Eucharist and the future role of monasteries. All of these matters were the subject of heated debates. In this context, the use of images in religious practice was one aspect that was frequently touched upon. A radical criticism of the traditional reading of the first two commandments was exemplified by Andreas Bodenstein known as Karlstadt in his treatise *On the Rejection of Images*. According to his interpretation, God had revealed himself solely through Scripture and the incarnation of Jesus. Any man-made image could therefore depict "nothing but pure naked flesh."

When he returned from his stay in Wartburg Castle, Luther had to calm the heated atmosphere in Wittenberg with his Lenten sermons. He also managed to set Karlstadt's strict demands in a broader perspective and proclaimed the question of images to be of lesser importance. By pointing out that it was only man's frailty that turned an image into an idol, and by insisting that it was faith alone that mattered, he was able to take the edge off Karlstadt's radical thrust. In spite of the tense situation in Wittenberg and the aspirations of Karlstadt, there were no serious attempts to forcibly remove objects from the inventory of the church. The only recorded instance of actual iconoclasm in the town occurred when the Augustinian monks removed the pictorial contents from their church and burned them in the courtyard.

While drastic actions of this kind were the exception in central Germany, Karlstadt's interpretation was accepted in other places. In southern Germany, Alsace and Switzerland, people began to turn their back on the formal use of religious images. This led to a particularly thorough removal of church artworks in the region, which was championed by Hyldrich Zwingli and Jean Calvin. Whether spontaneous or planned, the destruction or removal of images, sculptures and altars from churches was usually carried out by activist gangs, who recruited members from the lower or middle classes. These outbursts of vandalism were often tolerated by the authorities, who sometimes even initiated them. For the most part, this iconoclasm was an urban phenomenon, as the majority of religious images had accumulated within town walls through the numerous donations made by wealthy citizens RN

344 a

Martin Luther
The Ortenburg Bible

Augsburg: Heinrich Steiner for Peter Aprell, 1535
Printed on vellum, binding: calf over wooden boards with brass cornerpieces and clasps
VD16 B 2696
Minneapolis Exhibition

Original title: Biblia: Das ist die gantze heilige Schrifft Deudsch. D. Mart. Luth. (Bible: This is the Complete Holy Scripture in German, Dr. Martin Luther)

344 a
Vol. 1
31 × 21.5 cm
Stiftung Deutsches Historisches Museum,
RA 92/2968-1

344 b
Vol. 2
33.5 × 24 cm
Stiftung Deutsches Historisches Museum,
RA 92/2968-2

Once Luther and his colleagues had completed the translation of the Old Testament, the first complete Luther Bible was printed in 1534 by Hans Lufft in Wittenberg. The Augsburg printer Heinrich Steiner recognized the significance of this text and created the first reprint of the Luther Bible in just a few weeks. His edition appeared on February 16, 1535 and is remarkable for its size alone: its two volumes comprise a total of 1,366 pages of 52 lines each, printed in two columns, for a grand total of around 142,000 lines. The Bible was richly illustrated with three title pages, two full-page woodcuts and 70 column-width woodcuts spread throughout the text. The woodcuts were produced by an unknown artist based upon the work of Hans Holbein the Younger, Lucas Cranach the Elder and Melchior Schwarzenberg from the 1534 Lufft Bible. Most of the copies were printed on paper; a small number were printed on parchment, which was provided by the Augsburg parchment maker Peter Aprell, who was responsible for publishing and marketing this select group of luxurious copies. The parchment copies of the Bible, which likely numbered less than ten, cost the lives of over

344 a

1,000 sheep. We do not know who underwrote the entire publishing project, but we may presume that the money came from wealthy patricians in the city of Augsburg. There are 16 known copies of the Steiner Bible in existence today, four of which are printed on parchment and can be found in Berlin, Stuttgart, Rome and Wolfenbüttel.

In 1561, Count Joachim of Ortenburg entered his name into the first volume of this Bible, together with his device, *"Eile mit Weile* (Make haste slowly)."* There has been much speculation as to how the two volumes of the Steiner Bible found their way to Joachim of Ortenburg. The likeliest explanation is that Joachim received this beautiful 1560 edition as a gift from his Protestant brother-in-law Ulrich Fugger, a great bibliophile, in return for advocating Fugger's early release from custody as a member of the Diet of Augsburg. Ulrich had been imprisoned for seven months in 1559 due to his massive debts. In 1563, Joachim of Ortenburg brought the Reformation to his county over the bitter resistance of his overlords, the Dukes of Bavaria. They responded by depriving Joachim of more and more of his assets, and following endless disputes before the Imperial Chamber Court, he was left with only about one square kilometer of land by the time of his death in 1600. Nevertheless, until 1806 Ortenburg remained the sole Protestant enclave in otherwise Catholic Bavaria.

Joachim of Ortenburg had no direct descendants at the time of his death. His title passed to his eldest great nephew, Henry VII, who died in 1603. Henry kept the first volume of the Bible, and passed it on to his son, Frederick Casimir. The latter, a strict Calvinist, had the depictions of God on the title page and in the woodcut containing a depiction of paradise removed. Since God the Father remains in place at the edges of the title page of the second volume, it may be assumed that this volume went instead to Henry VII's other nephew, George IV, who was inclined towards Lutheranism. By the mid-18th century, at the latest, the second volume appeared in the collection of the Zurich bibliophile Georg Heidegger. In 1819, it can be traced to the collection of the Paris publisher Antoine Augustin Renouard. After passing through private collections in England, Germany and Switzerland, it was not until 1986 that this volume could be reunited with the first volume, which had remained in the hands of the Counts of Ortenburg. MM

Literature
Fuchs 2013 · Seipel 2000, p. 246, cat. 222 (ill.) · Strohm 2013 · Tenschert 1978, pp. 255–265 (ill.)

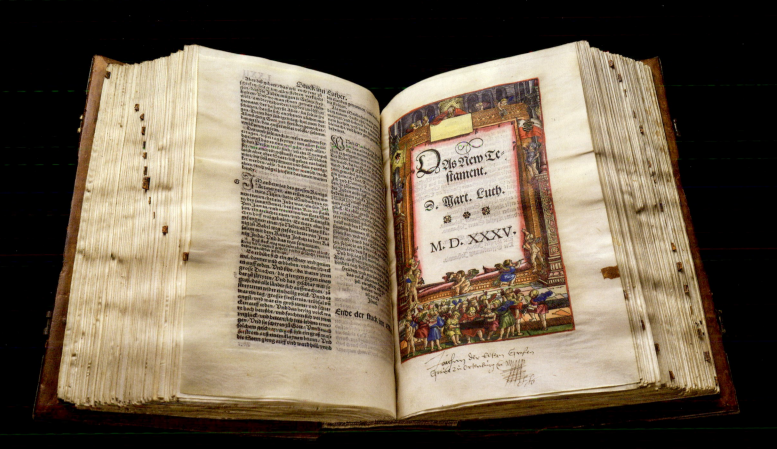

344 a

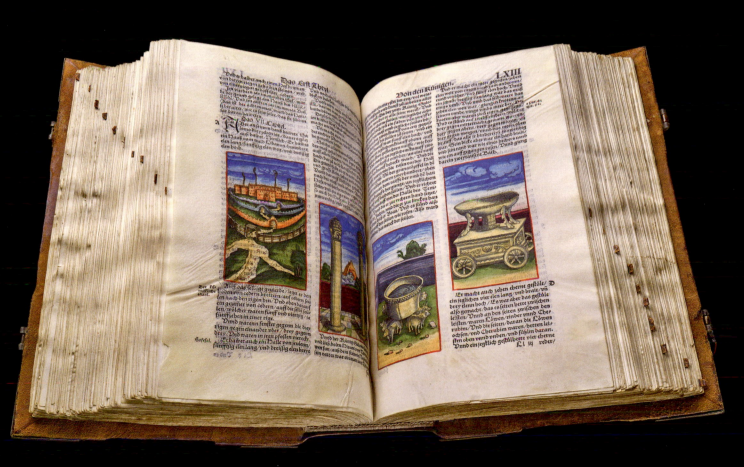

344 b

The Schmalkaldic League

After the Emperor rejected the *Augsburg Confession* at the Diet of Augsburg, the Lutheran members of the imperial estates were faced with a real threat of military intervention for officially being disturbers of the peace. To counter this, eight Protestant princes and eleven cities met in 1531 in the town of Schmalkalden to form a defensive alliance, in which they pledged to support one another if they were attacked for religious reasons. The League was to be headed by the Elector of Saxony and the Landgrave of Hesse.

As their numbers grew, the League evolved into the central platform of political Protestantism. Twelve more principalities and 18 cities were to join by 1546. Eventually, 17 free imperial cities and four towns of the Hanseatic League were represented.

The League was beset by difficulties from the outset, caused by diverging opinions about goals and procedures and a crippling lack of funds. By 1536, internal conflict had already led to the withdrawal of the Hanseatic town of Lübeck. When the opposing Catholic League was formed in 1538, this led to an accelerated polarization of the two camps. A major crisis erupted in 1545 when troops of the Schmalkaldic League unlawfully arrested Henry II of Braunschweig-Wolfenbüttel for joining the Catholic League.

The Schmalkaldic League never really constituted a unified organization. The Elector of the Palatine, who could have contributed a powerful standing army, was unsuccessfully wooed. Similarly, the King of France, who sympathized with the Schmalkaldic League, could never be convinced to formally join the cause. Then Landgrave Philip of Hesse, itching to enter into a bigamous marriage, promised the Emperor not to admit France, England or Cleves into the League. The biggest setback, though, was the defection of Maurice of Saxony to the imperial side. The League was never to recover from these blows.

Many princes of the Empire preferred to keep out of the conflict, but even those who remained neutral unambiguously warned the League not to take military action against the Emperor. Nevertheless, Charles V considered the Schmalkaldic League a dangerous opponent and did not rest until he finally defeated it in the Schmalkaldic War of 1546/47. The two leaders were captured in battle and released only after five years of imprisonment. In spite of this victory, the Emperor would ultimately fail in his ambition to end Protestantism. ASR

334

345

345

Philip Melanchthon and
Georg Spalatin
**The Augsburg Confession
(The oldest German version
of the Confessio Augustana)**

Between May 31 and June 15, 1530
30.6 × 21.9 cm
Thüringisches Hauptstaatsarchiv Weimar,
Ernestinisches Gesamtarchiv, Reg. E 129
New York Exhibition

The acute threat posed by the Turkish campaigns of conquest in southeast Europe and the reestablishment of unity between the Catholic and Protestant estates of the Empire were the most important issues for the Imperial Diet convened at Augsburg in 1530. The original intention had been for the Roman Catholics and the supporters of Luther to present their respective religious perceptions as negotiating partners for an equal standing. The ultimate decision, however, was to rest with Charles V. The Emperor had been crowned by Pope Clement VII only recently. He had also been provided with a comprehensive list of alleged errors of Luther's supporters by

Johannes Eck, a professor of theology from Ingolstadt who had already crossed paths with Luther in the dispute about indulgences, and who contributed to the phrasing of the papal bull against the Reformer.

This situation forced the reformers onto the defensive, and left them no choice but to support the veracity of their views with dogmatic articles of their own. Elector John of Saxony ordered a written summary of the positions of the Reformation to be drawn up in preparation for the assembly—basically a formal creed of the Protestant cause. After a thorough discussion among the theologians of Wittenberg, Philip Melanchthon, who was well known for his diplomatic acumen, was tasked with drafting a summary of Lutheran doctrine (cat. 282 and 346). The key tone of the paper aimed at a reconciliation of the two persuasions.

The Catholic estates, however, replied with a full rejection called the *Confutatio Confessionis Augustanae*. And worse, after lengthy and inconclusive negotiations between the two parties, Charles V roundly declared the confession of Luther's supporters to be refuted. The Edict of Worms, which had been suspended in practice following the Diet of Speyer in 1526, was put in effect again. Luther's supporters left the Diet in indignation, without signing the closing document of the Imperial Recess.

The *Confessio Augustana* would eventually receive full recognition under imperial law at the Diet of 1555 (once more held in Augsburg), together with the reply (*Apologia*) to the Catholic rebuttal penned by Melanchthon. With this step, the political reforms of the church organization which had been implemented by the supporters of the *Confessio Augustana* in their respective territories were finally legitimized. To this day, the *Augsburg Confession* remains one of the fundamental confessional documents of the Evangelical Church. DB

Literature
Amt der VELKD 2013, pp. 31–97 · Koch 1983 · Lohse 1979

346

346

Philip Melanchthon

Augsburg Confession and Defense of the Augsburg Confession

Wittenberg: Georg Rhau, 1531
Printed on paper, binding: half leather over wooden boards
19 × 15.5 cm
Stiftung Deutsches Historisches Museum, R 92/3233
VD16 C 4735
New York Exhibition

After the Edict of Worms was upheld at the Diet of Speyer in 1529 (cf. cat. 177), the members of the imperial estate who had already converted to the Protestant faith were legally on shaky ground. Charles V convened a Diet at Augsburg for the next year in the hopes of achieving a breakthrough towards his goal of unifying the Empire and the Church. The Protestant members of the imperial estates, led by Elector John of Saxony, assigned Philip Melanchthon to prepare a defense of the Reformation, as the Emperor had demanded (cf. cat. 345). The most important way in which this text was to differ from previous Protestant writings was its emphasis on the many ways in which the Catholic and Protestant faiths were in theological agreement. The German version of the *Confession* was read aloud to Emperor Charles V and the Electors, after which the written Latin version was handed over to the Emperor. Since Melanchthon kept working on the Latin version until the very end, there are textual differences between the two versions. The Cath-

olic Church responded to the *Confession* by presenting the *Confutation* (Refutation), principally written by Johannes Eck; the Protestants responded with the *Apologia* (Defense).

Although Charles V condemned the *Confession* at the Diet of Augsburg and upheld the 1521 Edict of Worms, one Latin and six German editions of the text appeared during the Diet. It was not until the next year that the dual Latin and German text edited by Melanchthon himself was published by Georg Rhau in Wittenberg, alongside the *Apologia* (in four versions), which represented the official edition of the text. The *Augsburg Confession* became a fundamental statement of faith when the Protestant estates combined to form the Schmalkaldic League, and was recognized by John Calvin in 1541. Alongside other confessions, the *Augsburg Confession* remains to this day the primary confession of faith for Lutheran churches in Germany and around the world. MM

Literature
Seipel 2000, pp. 259 f., cat. 247 (ill.) · Wenz 1996, pp. 351–498

347

Medal on the Constitution and Renewal of the Schmalkaldic League with Portraits of Landgrave Philip of Hesse and Elector John Frederick of Saxony

Ore Mountains, 1535
Silver, cast, looped
D 38.5 mm; weight 11.78 g
Foundation Schloss Friedenstein Gotha, 4.1/5741
Minneapolis Exhibition

Obv: VON · GOTTES · GNADEN · PHILIPS · LANTGRAVE · ZV · HESSEN ·
In field: · 1 · 5 · – · 3 · 5 ·
Bust of Philip from left with moustache, hat with plume. High-necked, strongly pleated shirt and doublet, on top robe with collar, necklace.
Rev: VON · GOTS · GNADEN · IOHANS · FRIDERICH · HERZOG · ZV · SA ·
In field: 15 – 35 · (The "3" is backwards)

Bearded bust of John Frederick in profile bareheaded. High-necked, strongly pleated shirt and doublet, on top a fur-trimmed robe.

The medal shows the portraits of the two founders of the Schmalkaldic League, Landgrave Philip I of Hesse and Elector John Frederick of Saxony. It is looped and thus was dedicated to the public political commitment of its bearer. The medal was made in 1535 on the occasion of the convention at Schmalkalden to renew the Schmalkaldic

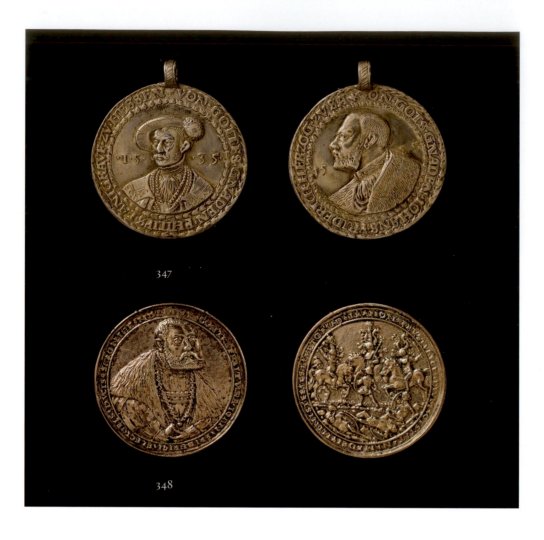

347

348

Wolf Milicz

Medal of Elector John Frederick the Magnanimous of Saxony

1536
Silver, cast
D 43.5 mm; weight 32.33 g
Foundation Schloss Friedenstein Gotha,
Münzkabinett, 4.1./1176
Minneapolis Exhibition

Obv: CONTRAFRAITWRA · IOAN[nis] · FRIDERICI ·
ELECTORIS · DVCIS · SAXONIAE · MDXXXVI ·
Half-figure picture of bearded John Frederick
from right front bareheaded. Vested in strongly
pleated shirt, doublet with slit sleeves and fur-
trimmed robe. Wearing collar of an order.
Rev: NON · FRVSTRA · GLADIVM · GESTAT · NAM ·
DEI · MINISTER · EST · VLTOR · AD · IR[am] · Three
cuirassed knights with helmets with arms of
Meissen, Electorate of Saxony and Thuringia in
combat with a foot soldier; two killed and one
wounded solider lying on the ground.

The specific occasion for the edition of this
medal was the reaffirmation of the Schmalkaldic
League through various resolutions adopted by
the convention in Frankfurt am Main and the Diet
in Schmalkalden in 1536. Although the interpre-
tation of this medal had been debated, it is gen-
erally believed to represent Elector John Frederick
the Magnanimous of Saxony in his role as sover-
eign over matters of church governance, which
the Wettin dynasty held from 1527 when the
church constitution was introduced. Wilhelm
Ernst Tentzel had already considered this inter-
pretation in his *Saxonia Numismatica* with regard
to two other jousting knight medals by Milicz
(1537 and 1542), but with slightly modified picto-
rial arrangements. He reasoned that "because
the medal (1536) was repeated in 1537 and 1542,
as we will see below, we should find something
that occurred in all three years, namely the
Schmalkaldic League." The decisive factor for
this interpretation is a Bible verse from Paul's
Letter to the Romans (13:4) as the circumscrip-
tion on the reverse, which played an important
role in Lutheran theology: "He [i.e. the ruler in
authority] does not bear the sword in vain; he is
the servant of God to execute his [God's] wrath
on the wrongdoer."
This verse documented the oversight responsi-
bilities of the sovereign over church matters,
which John Frederick apparently intended to em-
phasize as head of the Schmalkaldic League.
Those responsibilities, which also included the
fight against heretics and theologically straying
Christians, had already been cited by Luther in
his fundamental work published in 1520, *An
den christlichen Adel deutscher Nation* (To the
Christian Nobility of the German Nation).

League for another ten years and to adopt the
Constitution of Immediate Assistance and De-
fense, which governed the members' rights and
duties. Already in 1530/1, the League members
had concluded a treaty on mutual aid whose
scope, however, was at every party's discretion.
The Constitution, dated December 24, 1535, was
solemnly ratified on September 29, 1536 and
made the obligation of mutual assistance for all
members mandatory. This duty included mutual
support during the anticipated religious trials
before the Imperial Chamber Court, mutual mili-
tary assistance in the event of war and the joint
provision of "immediate assistance" in the form
of 10,000 infantry and 2,000 cavalry. In addition,
the Constitution defined the financial obligations
of the allies and stipulated that supreme com-
mand was to alternate at six-month intervals be-
tween the two leaders and commanders of the
League's troops, John Frederick and Philip.
According to Johann David, the medal was given
as a memento to "attending municipal envoys
and princely councilors and cavaliers." The
medal, in Tentzel's words is "the very first to de-
pict the portraits of the Elector and the Land-
grave of Hesse together and has circumscriptions
in German." The German circumscriptions—at a
time when Latin legends were customary—can be

interpreted as deliberate staging of a national
awareness in the spirit of Reformation thinking.
Aside from their significant iconographic con-
tent, medals as a propaganda medium could be
quickly circulated like printed broadsheets. They
could, also, occasionally contain imperfections.
The number "3" in the year 1535 on the medal
reverse is backwards, and John Frederick is erro-
neously titled Duke in the legend.
The medal portrait of Philip I has remarkable sim-
ilarities with a woodcut by Hans Brosamer of
1534, which supposedly served as the model.
UW

Literature
Bild und Botschaft 2015, pp. 284 f., cat. 102 (ill.) ·
Cupperi 2013, p. 62, fig. 32 · Marx/Hollberg
2004, p. 162, cat. 223 · Schuttwolf 1994 b,
pp. 19 f., cat. 4.17 (ill.) · Tentzel 1982,
pl. 7/VI

Considering the specific Bible quotation used in the context of the fight scene depicted on the medal, the three knights clad in armor and helmets with arms of Saxon territories should be interpreted as a metaphor for John Frederick's claim to power as leader of the of the Schmalkaldic League and as an autonomous sovereign with God-given rights. Additionally, the knights symbolize the highly effective fighting power of this Protestant defensive alliance. UW

Literature
Dethlefs/Gahlen 1986, p. 262, fig. 13 · Doerk 2014, p. 54, fig. 6 · Gaschütz 1985 · Schuttwolf 1994b, pp. 12 f., cat. 4.7 (ill.) · Tentzel 1982, p. 107, 9/I

349

Hans Brosamer
Duke George of Saxony, called the Bearded

After 1534
Woodcut, colored
Sheet: 40.5 × 30.3 cm; image with text: 40.5 × 30.3 cm; image: 39.2 × 29.9 cm
Foundation Schloss Friedenstein Gotha, 38,78
Minneapolis Exhibition

Above the portrait: Der Christenlich Fürst Hertzog Georg zu Sachsen etc. ward geboren den xxviij. Augusti/M.CCCC.LXXj (The Christian Prince Duke George of Saxony etc. was born on xxviij. Augusti/M.CCCC.LXXj)

Brosamer's woodcut is a frontal half-length portrait of Duke George of Saxony with his thick full beard, which he reputedly grew after his wife's death in 1534. His head is covered with a black beret. On the partially visible fur trim of his garment, he is wearing the Collar of the Order of the Golden Fleece, to which he was admitted in 1531. Duke George governed his domains commendably and strove with various German princes to reform the Church and notorious abuses, but he was a bitter enemy of Luther's teachings and Luther himself. He took extremely severe action against the peasant uprisings, since he held them to be a manifestation of Luther's pernicious influence. Luther's writings and ideas were strictly criminalized in George's domains. Upon learning in the last years of his life (his wife and sons having already died) that his younger brother and intended successor Henry had become a Lutheran, George sought to have his realm pass to the Habsburgs, something prevented only by his unexpected death on April 17, 1539. BS

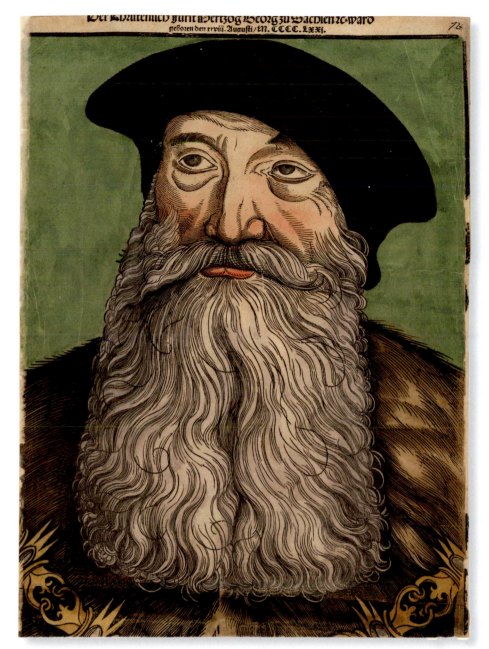

349

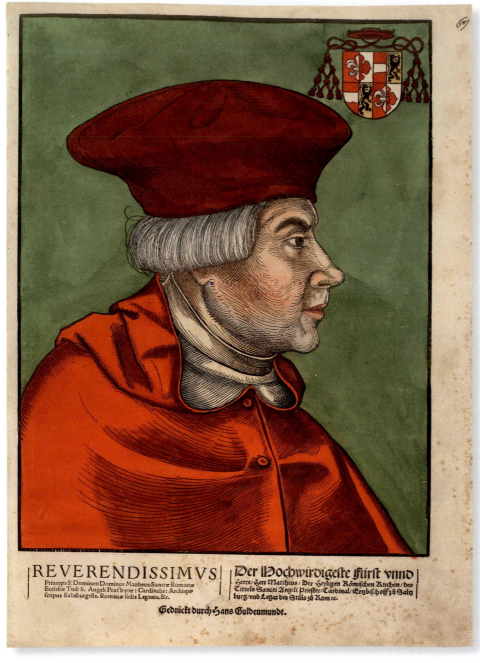

350

Literature
Geisberg 1974, vol.1, p. 386, no. G.420 (ill.) ·
Röttinger 1921, pp. 41 and 62, no. 31 (ill.) ·
Schäfer 2010, pp. 16 f. (ill.) · Schäfer/Eydinger/
Rekow (forthcoming), cat. 30 (ill.) · Schmidt
1930, p. 88 (ill.)

350

Erhard Schön (attributed)
Hans Guldenmund (printer)
Cardinal Matthew Lang
of Wellenburg,
Archbishop of Salzburg

Nuremberg, around 1534
Woodcut, colored, typographic text
Sheet: 40.2 × 29 cm; image with text:
37.5 × 25.6 cm; image: 33.7 × 25.6 cm
Foundation Schloss Friedenstein Gotha, 38,32
Minneapolis Exhibition

Beneath the portrait:
REVERENDISSIMVS / Princeps & Dominus:
Dominus Mattheus: Sanctae Romanae /
Ecclesiae T[i]tuli S. Angeli Praesbyter:
Cardinalis: Archiepi- / scopus Salisburgesis.
Romanae sedis Legatus. &c. [...]

This portrait forms a series with the portraits of
Pope Paul III and Cardinal Albert of Brandenburg
and appears to have only survived in the collec-
tion in Gotha. Cardinal Lang of Wellenburg is
portrayed in profile wearing a *mozzetta* and *bi-
retta*, and his coat of arms are in the upper right
corner. A thaler minted in Salzburg in the third
decade of the 16th century served as the model
for the woodcut.
Matthew (Matthäus) Lang came from an Augs-
burg patrician family that had fallen into poverty.
He studied theology and also occupied himself
with legal studies, leading him to Ingolstadt and
Tübingen and then to Vienna in 1493. He entered
the service of the Archbishop of Mainz, the Arch-
chancellor of the Holy Roman Empire of the Ger-
man Nation. There, he laid the foundation for his
later career, beginning by serving as the secre-
tary to King Maximilian I, the future Holy Roman
Emperor. He frequently traveled all over Europe
for his liege lord as an envoy in political affairs.
He began his career in the Church in 1496. Al-
though he was not consecrated as a priest until
1519, he climbed the career ladder in the Church,
receiving various parishes and provostships with
rich benefices, becoming bishop, and being ele-
vated to cardinal by Pope Julius II in 1511, as well
as in 1512 being named coadjutor of the reigning
Prince-Archbishop of Salzburg with the right to
succeed him.

Lang was surely one of the few prelates who recognized the magnitude and implications of Lutheran teachings and strove to thwart them in his own domains through reforms. Peasant uprisings in the territory of Salzburg in 1525–26 were ultimately put down. In the final years of his life, the cardinal endeavored to create a new bureaucratic state and a better territorial government. His primary aspiration, however, was to vigorously suppress Reformation beliefs by force, which had spread swiftly throughout all parts of the Salzburg region. Matthew Lang and his family were ennobled in 1498 and "von Wellenburg" was added to the family name. BS

Literature
Geisberg 1974, vol. 4, p.1240, no. G 1292 (ill.) · Hollstein XLVIII, pp.81 f., no.169 (ill.) · Röttinger, 1925, p. 190, no. 277 (ill.) · Schäfer/Eydinger/ Rekow (forthcoming), cat. 4 (ill.) · Schmidt 1930, p. 221, no.1292 (ill.)

Lucas Cranach the Elder
Judith Panels

1531
Mixed techniques on lime wood
Minneapolis Exhibition

351
Judith Dining with Holofernes

98.5 × 72.5 cm
Foundation Schloss Friedenstein Gotha, SG 674

Signature: on the tree trunk underneath the fork: winged serpent with elevated wings in yellow paint, facing right, and dated "1531"

352
The Death of Holofernes

98 × 73.6 cm
Foundation Schloss Friedenstein Gotha, SG 675

Signature: bottom right on the drum: winged serpent with elevated wings in yellow paint, facing right, and dated "1531"

The Old Testament Book of Judith tells of the Assyrian King Nebuchadnezzar II, who sought to subjugate all nations to his rule and required them to worship him as the sole deity. Those who refused to succumb to his rule faced death, plunder and devastating war at the hands of the tyrannical conqueror Holofernes. In order to take the well-fortified Jewish city of Bethulia, which was situated on the road to Jerusalem and therefore could not be bypassed, Holofernes at first tried to cut off the city's water supply. As the city was wracked by thirst, the elders decided that they would have to surrender unless there was a change in their precarious situation. However, the beautiful widow Judith rebuked her countrymen for their faintness of heart and took the matter "in the hand of a woman" (Judith 9:10–11). Dressed as a bewitching beauty, she went over to the camp of Holofernes, accompanied by her maid. Blinded by her beauty, Holofernes held a festive meal in order to get closer to her.

The painting *Judith Dining with Holofernes* shows the diners in the foreground. Sitting under an apple tree, Judith offers meat to the field commander, who is wearing a plumed hat. Soldiers and camp followers are gathered around the table. In the background is a fantastic landscape and on the horizon is a fortress on a mountain. In a simultaneous representation of the scene, Cranach lets us see inside Holofernes' tent, where the widow's murderous plan is carried out. While the party-goers enjoy themselves by playing dice, Holofernes, filled with lust, takes Judith into his tent. Drunk from the wine, however, he drifts off to sleep, whereupon Judith, with the help of her maid, cuts off his head with his sword and places it in a sack. Because of the pious Judith's heroic act, Bethulia was saved from its besiegers. Judith herself returned to her life as a chaste widow, and her maid was set free.

Cranach portrayed himself on the left, next to the banquet table and the apple tree. Cranach and his productive workshop used this theme for propaganda, turning out a large number of Judith panels showing the virtuous heroin in a single portrait, with a sword and severed head. In the year the Schmalkaldic League was formed, the artist's intention was to call upon the Protestant leaders to show courage and fellowship. As in the story of Judith (cf. Luther's foreword to the Book of Judith, 1534), it was necessary to defend the new faith against present dangers, such as the Turkish threat and the Emperor's allies in the old faith, as the Jewish people once did against the godless Babylonian King.

Martin Luther saw the Judith story as a fictional creation which, while not very credible from a historical perspective, embodies numerous Christian virtues in an exemplary manner, such as strength, chastity and humility.

Judith became a role model for the new faith. She was credited with "leading her life in a manner appropriate for a woman" (Uppenkamp, p. 76) because, as a widow, she is modest, considerate, honorable, faultless and very useful to the cause. But at the same time, she is provocative, cunning and seductive; after all, she entices Holofernes, gets him drunk and renders him defenseless. A "woman's weapons" must be used with caution, as Cranach seems to be warning with his raised finger in the Gotha collection painting. In this way, he places the Judith story within the category of works depicting the power of women. FK

Literature
Bild und Botschaft 2015, pp. 272 f., cat. 95 and 96 (ill.) · Brinkmann 2007, pp. 202 f., cat. 45 and 46 (ill.) · Kobelt-Groch 2005 · Schuttwolf 1994 a, pp. 22–24, cat. 1.4 and 1.5 · Uppenkamp 2014

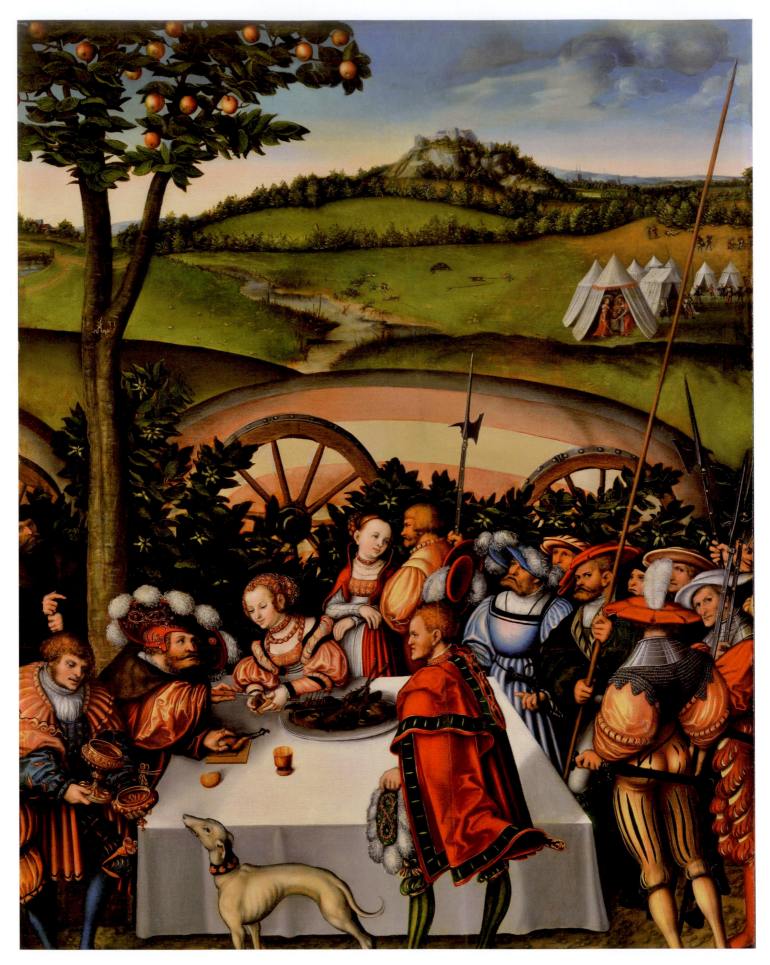

351

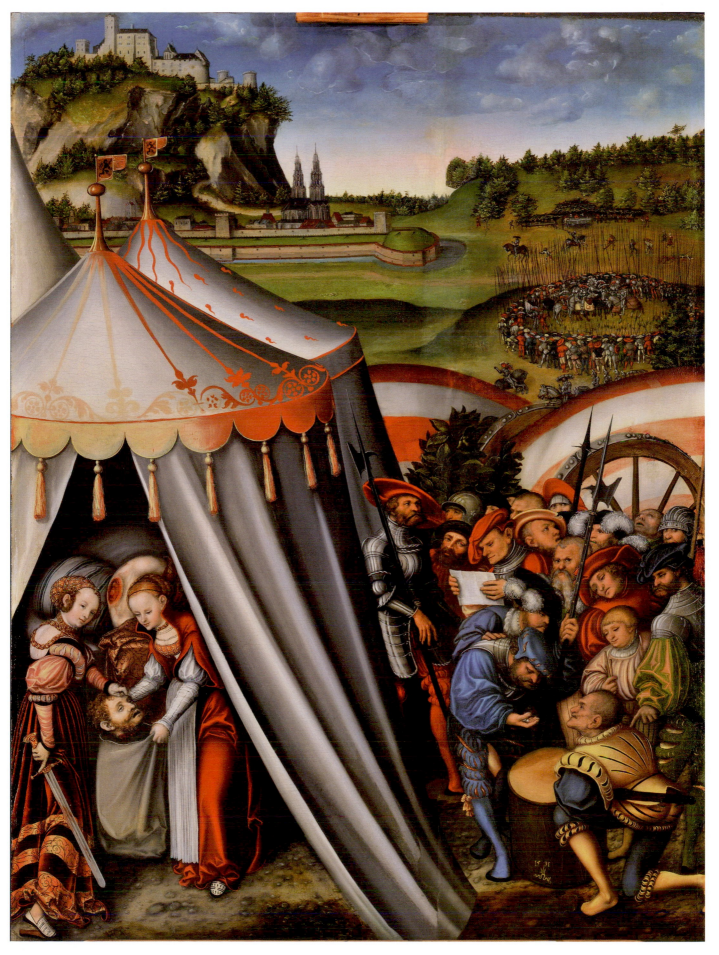

352

353

353

Martin Luther

The Schmalkaldic Articles

1537
31 × 21.5 cm
Thüringisches Hauptstaatsarchiv Weimar,
Ernestinisches Gesamtarchiv, Reg. H. 124,
ff. 36v–37r
New York Exhibition

Original title: Bedencken deß glaubens halben
und waruff uff kunfftigen concilio endtlich
zuvorharren [...] (Some Reservations Concern-
ing Faith [...])

When Pope Paul III issued a call for a Council to
be held in Mantua in 1537, John Frederick, the
Elector of Saxony, found himself in a difficult po-
sition. On the one hand, the Protestants had
clamored for a Council as a platform for political
decisions on pending religious questions, but on
the other hand, they could hardly support such a
gathering if it was conducted under the ultimate
authority of the Pope. John Frederick's advisors,
however, were urging him to attend. In this situa-
tion, the Elector asked his theologians to com-
pile arguments for the inevitable dispute with the
adherents of the old Church.

In December 1536, he instructed Luther "to elab-
orate, for the sake of the Christian doctrine and
religion, on which articles and particulars he
could compromise or concede with justification
and for the sake of unity, and in which cases he
should refrain from doing so (*der cristlichen lere
und religion halben herauszuarbeiten, inwieweit
und in welchen artickeln und stuck[en] vo[n*

*rechts] und einigkeit wegen zuweichen und na-
chzugeben sein mochte ader nit*)." The Reformer
was also asked to discuss these questions with
other theologians.

The Elector was planning to attend a meeting of
the members of the Schmalkaldic League (which
was scheduled for February 1537 in the town of
Schmalkalden), and he intended to base his ar-
guments in the inevitable debate of the council
question on the theologians' findings. He also
hoped that the confederates attending the meet-
ing would sign this document (which was later to
become known to history as the Schmalkaldic
Articles) to confirm their adherence to the
Lutheran creed.

On January 3, 1537, Luther sent the Elector the
requested articles, signed by himself, Jonas,
Bugenhagen, Cruciger, Amsdorf, Spalatin,
Melanchthon and Agricola. Melanchthon had
added the proviso that the primacy of the Pope
could be accepted under certain circumstances.
He would also argue for the adoption of the
Confessio Augustana as the foundation for a
common avowal of the Protestant creed at the
Schmalkalden meeting. Due to Melanchthon's
activities and the absence of Luther due to grave
illness, the articles were never actually read to
the participants of the meeting. Only the attend-
ing theologians debated them, with the majority
adding their signatures. The Reformer recovered
and had the document printed in 1538, ensuring
a wider distribution and acceptance.

In the end, the members of the Schmalkaldic
League declined to attend the Pope's council,
but the Elector's plan of having the attending
estates swear to the Lutheran creed in an act of
strict demarcation from the Catholic faith came
to naught. The Schmalkaldic Articles, however,
persisted: From the second-half of the 16th cen-
tury on they were counted as one of the funda-
mental documents of the Evangelical Church,
ranking alongside the *Augsburg Confession*. DB

Literature
Führer 2009 · Staatliche Archivverwaltung,
pp. 244 and 378 (ill.) · Volz 1931

354

354

Elizabeth, Duchess of Rochlitz

A Coded Message to John Frederick, Elector of Saxony

February 7, 1547
31.8 × 21.5 cm
Thüringisches Hauptstaatsarchiv Weimar,
Ernestinisches Gesamtarchiv, Reg L pg. 811 N 9
(37), ff. 77–78
Minneapolis Exhibition

This surviving encoded message from a secret
agent of the mid-16th century is a rare source and
a windfall for scholars of the Reformation. Eliza-
beth, the Duchess of Rochlitz, ran an intelli-
gence-gathering network for the Schmalkaldic
League, and risked her life in doing so. Her
brother, Landgrave Philip of Hesse, headed this
Protestant defensive alliance in cooperation with
Elector John Frederick of Saxony. The Duchess
herself was also a member, the only female one.
In addition, she financially supported the cause
and tried to mediate in the escalating conflict
with the Emperor.

When war broke out in 1546, she began to collect
information on the enemy advance, the respec-
tive strengths of imperial units and their provi-
sioning. This information was sorted, evaluated
and passed on to the commanders of the league.
Elizabeth was thus able to give timely warning
about the treacherous defection of Maurice of
Saxony to the Catholic side, and about planned
assassinations. She obtained this intelligence
from her own scouts, and from students, crafts-
men, citizens and travelers.

In order to conceal her communications, the duchess used a combination of deception and encryption. Her messengers would pose as butchers, for instance, or sew their messages into the lining of their shoes. Elizabeth also developed a code to further protect her communications, in which a symbol was substituted for each letter of the alphabet. A total of sixteen encoded messages from Elizabeth have survived. In the letter displayed here, she informs the Elector about two loads of salt for the imperial troops, who were obviously suffering from a lack of provisions. In addition, she recounts that some 500 horses had lately been stabled in the church and the cellar vaults of her castle at Rochlitz, and reports the Emperor's present position at Marienberg and Chemnitz, as well as the approach of his brother with a strong force.

Elizabeth had asked the recipients of her letters to destroy them, but it would appear that this precaution was not always observed. The risks of written transmission were such that messages could sometimes only be sent verbally. Elizabeth went to great lengths in such cases: On one occasion, she even inflicted a wound to herself so that she could summon the Elector's personal physician without arousing suspicion and entrust him with an urgent message. In the end, she was forced to leave Rochlitz when the enemy approached her residence. This deprived the Elector of his vital intelligence source at a crucial moment. Left without intelligence of the Emperor's position, he was surprised and defeated at Mühlberg and taken prisoner. ASR

Sources and literature
Rous 2014 · SHStAD, Bestand 10024, Geheimer Rat (Geheimes Archiv), Loc. 8607/15 · SHStAD, Bestand 12803, Personennachlass Elisabeth Werl, no. 4, no. 17 and no. 35 · WA 30, 11

355

355

1 1/2 Thaler on the Capture of Duke Henry the Younger of Brunswick-Wolfenbüttel in the Battle of Bockenem

Goslar, 1545
Silver, minted
D 52.4 mm; Weight 42,07 g
Luther Memorials Foundation
of Saxony-Anhalt, M 383
Minneapolis Exhibition

Obv: . IVSTVS . N . RELINQ . Landgrave Philip of Hesse, Elector John Frederick of Saxony and Duke Maurice of Saxony as cuirassed warriors with their respective escutcheons in hands. Above them a band with their names PHILIPV5 – IOHANI5.FRIDE – MAVRIT3
Rev: In field fifteen lines: · DES · ZI · / OCTOBRIS · ANNO / 1545 · WARD · HERT3O / G · HANNRICH · V · BRVNS / MIT · SEINEM · SON · KARLL · / BEI · BOCKOLM · DVRCH · DI · / KRISTLICHE · BVNT3 · OBERST · / LANTGRAF · PHILIPS · VAN · H / ESSEN · BEISEIN · HERT3OG · / MORIT3 · VAN · SACHSEN · E · / MIT · GROSER · HERES · KR / AFFT · ERLEGT · GEFFAN / GEN · VND · GEN · / KASSEL · GEF / VRT ·

The Duchy of Brunswick-Wolfenbüttel was particularly affected by the religious conflicts in the period. Duke Henry the Younger had maintained the Catholic faith for political and religious reasons, while the cities of Brunswick and Goslar committed to the Reformation and joined the Schmalkaldic League. Henry vigorously refused to grant them religious freedom and took military action against them so that the cities called on the Protestant defensive alliance for help.

The joint forces of John Frederick the Magnanimous, Landgrave Philip of Hesse and the city of Brunswick besieged the moated castle of Wolfenbüttel. The siege ended with Henry being put to rout and surrendering, and thus, the Duchy became Protestant. However, when Henry attempted to reconquer his hereditary lands, Emperor Charles V decreed at the Diet of Worms in 1545 that the Duchy should be put under the compulsory administration of the Empire until final clarification of the legal situation. Henry recruited new forces and moved towards Brunswick, where he renewed armed conflict with the Schmalkaldic League. The Hessian-Saxon troops encircled the armed forces of Henry and his son Charles Victor and forced them into capitulation, and the two were taken prisoners by Philip near Bockenem (Höckelheim) on September 29, 1545.

The medallion obverse impressively and powerfully depicts the three leaders and victors of the religious conflict. The reverse depicts the capture of Henry the Younger and his son by Landgrave Philip. The latter was to benefit additionally from the defeat of the duke in that he became a co-owner of the Brunswick silver mines in the Harz Mountains and was thus able to cover his war costs.

The medallion, sometimes mistakenly described in the literature as a medal, comes in different versions: as half, whole, one-and-a-half, two-fold and three-fold thalers, and as *Goldabschlag* with weights of 12 1/2, 10 and 7 1/2 ducats. This piece is a 1 1/2 thaler and, as indicated in the legend, the second die version. UW

Literature
Brozatus/Opitz 2015, vol. I,1, p. 454, cat. 648 (ill.) · Eichelmann 2010, pp. 61 f · Marx/Hollberg 2004, p. 174, cat. 246 (first die type)

356

Virgil Solis
Stefan Hamer (printer)

Defeat and Capture of Elector John Frederick I the Magnanimous of Saxony at Mühlberg

Nuremberg, around 1547
Woodcut printed from two blocks
Sheet: 31.9 × 77.5 cm, image with text:
30.3 × 75.3 cm; image without text:
28.6 × 75.3 cm
Foundation Schloss Friedenstein Gotha,
G35,30a/b
Minneapolis Exhibition

Above the image: Die Niderlag vnd gefengknus Hertzog Johans Friderich zu Sachssen eygenlich Abcontrafect. (The defeat and capture of Duke John Frederick of Saxony accurately depicted.)
Inscriptions in the picture:
Left sheet: Churfürst / Ducidialbo. [...] (Elector / Duke of Alba. [...])
Right sheet: Key. Meyste / Ferdinand. [...] (Imperial Majesty / Ferdinand [...])

The decisive battle between imperial Spanish troops under Emperor Charles V and Protestant troops under the leadership of the Saxon Elector John Frederick I the Magnanimous was fought at Mühlberg on the Elbe on April 24, 1547. The poorly led troops of the Elector and his allies were taken by surprise and suffered a crushing defeat. Despite resisting valiantly and being wounded, the Elector was captured, brought before Emperor Charles V and his companion the Duke of Alba, and then placed in captivity.
This woodcut presents a bird's-eye view of the environs of Mühlberg with the events of the battle, identifying the most important individuals, groups and places. The depiction conflates events that happened at different times on April 24. The left sheet is bordered by forest and shrubbery on the left side, stretching to the lower edge of the picture. Individual troops with respective labels are moving toward each other in combat in the central field. Elector John Frederick of Saxony is being taken prisoner on the horizon directly before a copse, while the Duke of Alba, kneeling before Emperor Charles V, is delivering the news of the victory. The right sheet depicts Mühlberg and the Elbe. Electoral soldiers are defending the city as Spanish troops approach, some of them swimming through the Elbe. The right side terminates with shrubbery and stands of trees.
A text explaining the scene is missing from the copy in Gotha. BS

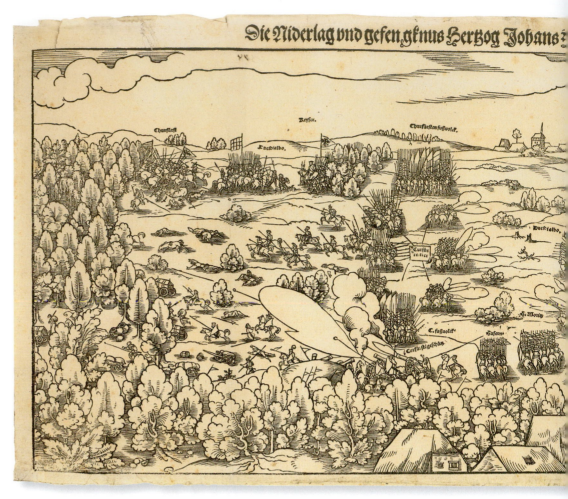

356

Literature
Bauer/Hellmann 2003, p. 204, cat. 3.24 (ill.) ·
Bild und Botschaft 2015, pp. 310 f., cat. 116 (ill.) ·
Geisberg 1974, vol. 4, p. 1278, no. G.1330 (ill.) ·
Schäfer/Eydinger/Rekow (forthcoming),
cat. 198 (ill.)

357

Matthes Gebel

Medal of Elector John Frederick of Saxony

n. d. (1532)
Silver, cast
D 45.5 mm; weight 30.08 g
Foundation Schloss Friedenstein Gotha,
4.1./1191
Minneapolis Exhibition

Obv: IO · FR · I · IO · I · RO · IMP – ELECT · PRIMOG · D · SAX ·
Bust of bearded John Frederick to right with high-necked, strongly pleated shirt and doublet. Triple link chain.
Rev: SPES · MEA · IN · DEO · EST·

Triple-helmeted escutcheon, squared, with the Duke of Saxony's shield at center.

This expressive medal portrait shows the young Elector, who assumed the office of Elector of Saxony after the death of his father, John the Steadfast, in 1532. This medal can be dated to the year

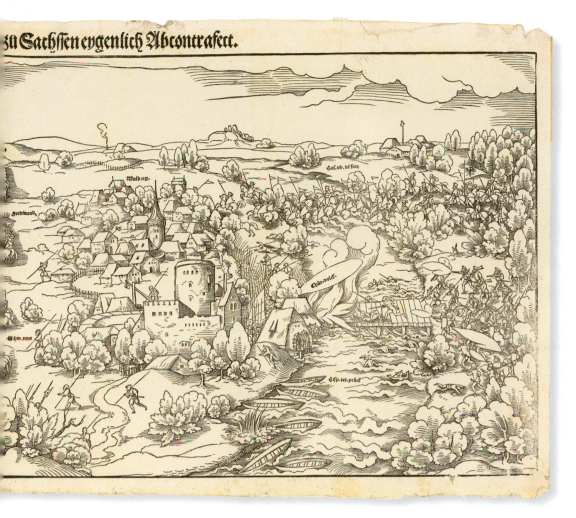

zu Sachssen eygenlich Abcontrafett.

357

of the rulers' transition and is a propaganda medium of the highest political significance considering that John Frederick assumed the electoral office against the societal background of denominational conflicts and the objection of the Electorate of Saxony to the election of Ferdinand as German King. In order to propagate and underline the claims of his dynasty to this high office, John Frederick commissioned his court painter Lucas Cranach the Elder in 1532/3 to produce a large number of portraits of himself, as well as of his father and uncle (cat. 44 and 47). This situation also gave rise to a triptych that impressively depicts him in a half-length pose with Frederick the Wise and John the Steadfast. Portraiture does not appear in this context as memorial art or a general dynastic representation but specifically in the service of current dynastic legitimization. The medal plays an equally important role in this context.

The reverse legend, "My hope is in God" (Proverbs 22:19) quotes the firm and unshakeable motto of the Elector as a follower and promoter of Lutheran Reformation.

Matthes Gebel's portrait of John Frederick is notably convincing through the precise rendition of

his facial features and the meticulously detailed garments and hair, wherein there is even a distinction between the hair of his head and facial hair. Medalist and wood carver Gebel was granted citizenship in Nuremberg in 1523 and operated a workshop in the city. He was among the most eminent and productive medalists of the German Renaissance. 350 medals can be attributed to him over a creative period of about 25 years. The dating of this medal to the year 1532 is based upon a stylistic comparison with a smaller version whose reverse legend is dated to this year. UW

Literature
Bild und Botschaft 2015, pp. 21 f. · Brozatus/ Opitz 2015, vol. I,1, cf. p. 325, no. 472 · Habich 1929–1934, vol. I,2, cat. 1080 · Schuttwolf 1994 b, pp. 27 f., cat. 4.28 (ill.) · Tentzel 1982, pl. 6,I

358

Unknown German artist
Elector John Frederick I the Magnanimous, Duke of Saxony

Around 1548
Woodcut, colored, typographic text
Sheet: 40.6 × 29.5 cm; image with text
37.5 × 28.4 cm; image: 34.7 × 28.4 cm
Foundation Schloss Friedenstein Gotha, G 15,56
Minneapolis Exhibition

Top edge of the print: Von Gotts Gnaden Johanns Friderich Hertzogk zu Sachssen des Heiligen Roemischen Reichs Ertzmarsschalck / vnd Chuerfuerst/Landtgraff in Dueringen Marggraffe zu Meissen / vnd Burggraff zu Magdeburgk ezt (By the grace of God John Frederick Duke of Saxony the Holy Roman Empire's Grand Marshall / and Elector /Landgrave in Thuringia Margrave of Meissen / and Burgrave of Magdeburg, etc.)

The Elector is portrayed full-length, mounted on a horse with magnificent trappings and riding towards the right. Attired in rich garments deco-

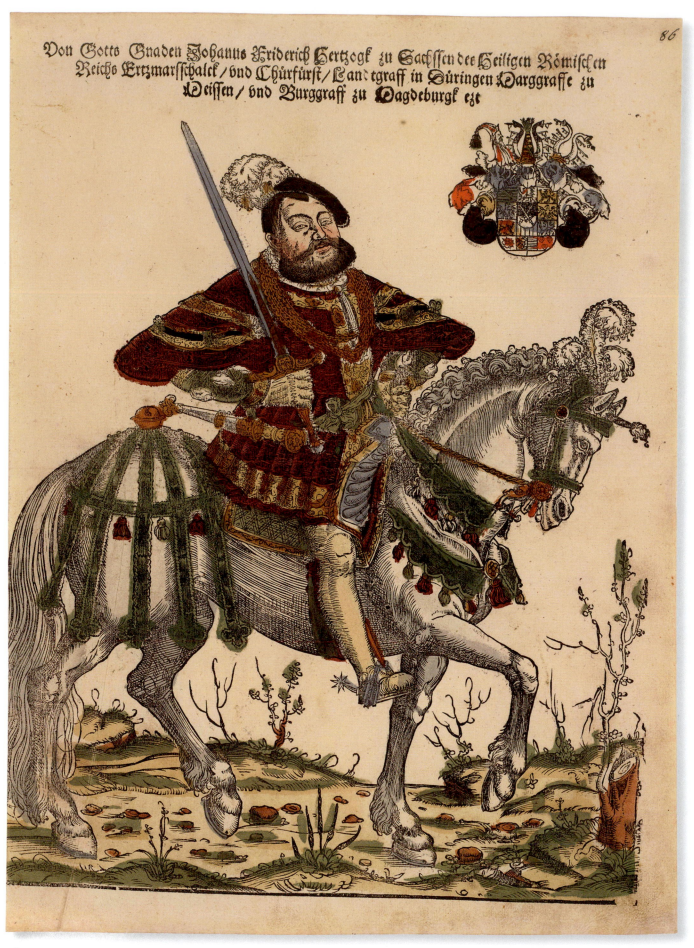

Von Gotts Gnaden Johanns Friderich Hertzogk zu Sachssen des Heiligen Römischen Reichs Ertzmarsschalck/ vnd Chürfürst/ Landtgraff in Düringen Marggraffe zu Weissen/ vnd Burggraff zu Magdeburgk etc

358

rated with braid and gold chains, he raises the electoral sword in his right hand. The arms of ducal Saxony with the three electoral swords are pictured on the top right beneath three crests. John Frederick not only assumed power in the electorate from his father John the Steadfast in 1532 but also the leadership role among the Protestants in the Empire. Emperor Charles V's imperial Spanish troops defeated the Elector's army and its supporters at the Battle of Mühlberg on the Elbe (cf. cat. 356). John Frederick was taken prisoner and stripped of the title of Elector. What is more, his domains were reduced radically and—just as the electoral title of which he was deprived—largely conferred on his cousin Maurice in Dresden. He spent the following years in captivity before being released in 1552 and moving to his palace in Weimar, where he died two years later.

This print is the pendant to a portrait of the Elector's wife, also depicted on horseback. It is dated 1548. Since John Frederick is still designated as "the Holy Roman Empire's Grand Marshall/and Elector...", the print must have been produced during the period of his deposition and captivity and the pendant print of his wife dated 1548 immediately afterward. BS

Literature
Schäfer/Eydinger/Rekow (forthcoming), cat. 54 (ill.)

359

Boot of Elector John Frederick the Magnanimous

Before 1547
Leather
81 × 40 cm (max. width of bootleg)
Foundation Schloss Friedenstein Gotha, Eth. 18S
Minneapolis Exhibition

Elector John Frederick I of Saxony, called "the Magnanimous," lost his position as Elector at the end of the Schmalkaldic War through the Wittenberg Capitulation of May 19, 1547. A few weeks earlier, the imperial army had launched a surprise attack and dealt a devastating blow to the forces of the Schmalkaldic League under his command at the Battle of Mühlberg, on the Elbe River. This decisive battle gave Emperor Charles V one of his greatest triumphs as a field commander. He took John Frederick as a prisoner and sentenced him to death. However, the death sentence was amended and commuted into lifelong imprisonment. Under the Treaty of Passau in 1552, which the Protestant princes negotiated

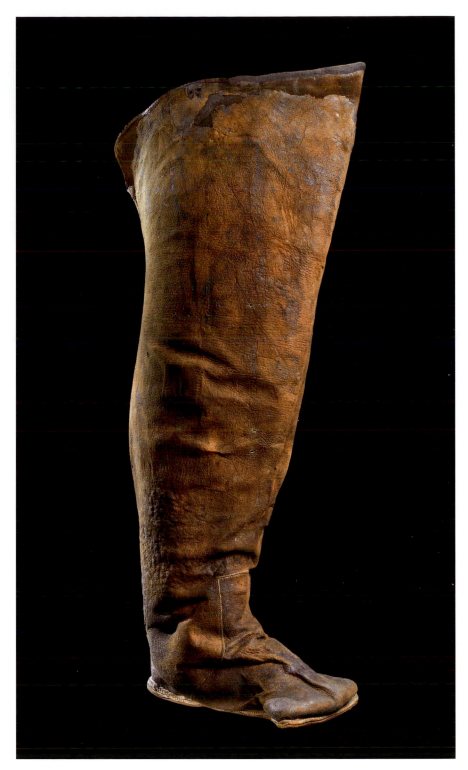

359

with King Ferdinand I, the brother of Emperor Charles V, John Frederick was finally freed.

The boots of the vanquished Elector, which were captured by the Emperor's troops at Mühlberg, were considered to be particularly valuable trophies and found their way to vaults in Munich and Madrid. According to historical sources, the public was mystified by the incredible width of the boots, which were so big "that a boy of four or five years could crawl in" (*Politische Historien*).

A century later, John Frederick's great-grandsons fought on the side of Gustavus Adolphus of Sweden in the Thirty Years' War. Following the successful conquests made by the Swedish forces in Bavaria in 1632, the young Dukes of Saxe-Weimar were rewarded with a significant share of the booty, including valuable items from the vaults of the Munich palace, among them the boots worn by John Frederick of Saxony. As a result of the Weimar partition of 1640, the boots finally came into the possession of Duke Ernest I of Saxe-Gotha and found their way into the vaults of Castle Friedenstein in Gotha, where they remain to this day. UD

Literature
Brandsch 2001, pp. 111 f., fig. 4.23 · Politische Historien 1773, p. 439 · Purgold 1938, p. 140 · Zeiller 1632, p. 283

360

Unknown Flemish artist

John Frederick the Magnanimous and a Spanish Captain Playing Chess

1548/49
Oil on oak
65 × 92 cm
Foundation Schloss Friedenstein Gotha,
SG 705
Minneapolis Exhibition

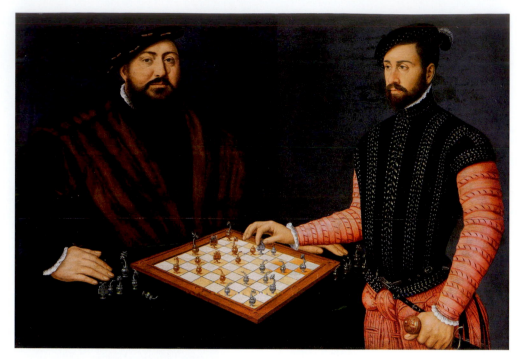

360

This painting was commissioned by John Frederick the Magnanimous during his captivity in Brussels (1548–1550). Since his court painter, Lucas Cranach the Elder, refused to heed multiple calls to follow him into captivity, the vanquished Elector was obliged to use a Flemish artist for this painting. It shows John Frederick and another man playing a board game. Clearly visible is the scar on his left cheek, which the Ernestine Elector received at the Battle of Mühlberg in 1547. Despite his disgrace, John Frederick confidently looks out at the observer. His imposing stature, with an arm resting on the table, underscores the steadfastness with which he defended the Lutheran faith and which he was now exhibiting in captivity. John Frederick's opponent is making a move with one hand while the other is firmly clutching the hilt of his sword. This gesture leads us to presume that his opponent, who is dressed in Spanish garb, might be charged with guarding the prisoner. However, inventory sheets from the 17th century identify him as the Duke of Alba,

who defeated John Frederick at the Battle of Mühlberg. The notion that his opponent might be Duke Ernest of Lüneburg can be ruled out. This assumption is based on a mid-16th century legend that John Frederick calmly challenged his friend, a fellow prisoner, to a game of chess after learning of Ernest's death sentence.

The painter is unknown, but the work has been attributed to Antonis Mor, as well as to Jan Cornelisz Vermeyen or his circle. The back of the painting originally bore the signature "PVI" or "VHP" (joined as a single glyph) "faciebat 1549." However, it was lost when the painting was restored; as a result, the signature was copied on a piece of paper that was then stuck to the back of the painting. John Frederick had the painting sent to his wife in Weimar, but he also gave another copy to the captain who is depicted with him here. ID

Literature
Bild und Botschaft 2015, pp. 322 f., cat. 123 (ill.) · Faber 1988, pp. 76–84 · Junius 1930 · Rollert 2014, pp. 57–60, cat. 15 (ill.) · Schuttwolf 1994 b, pp. 56 f., cat. 1.29 (ill.) · Brandsch 2001, pp. 76 f., cat. 1.57 (ill.)

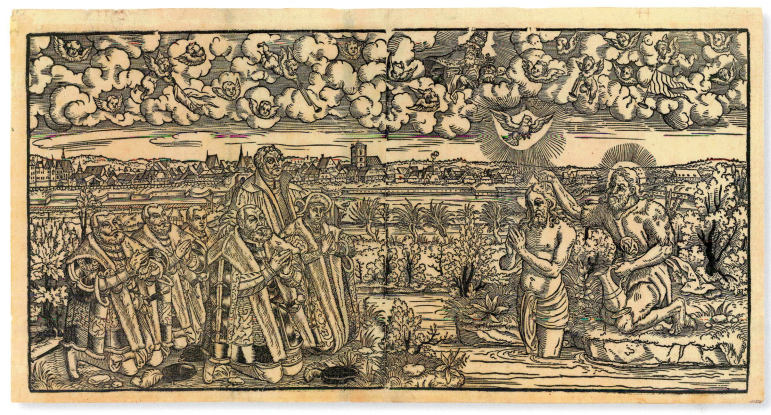

361

361

After Jacob Lucius
Baptism of Christ with the Family of Elector John Frederick and Luther

2nd-half of the 16th century
Woodcut
Sheet: 27.5 × 55.2 cm
Luther Memorials Foundation
of Saxony-Anhalt, grfl. XI 1127
Minneapolis Exhibition

John Frederick of Saxony, the former Elector, kneels with his wife Sibylle and three sons on the bank of a river before the Wittenberg skyline. The face of John Frederick bears the scar that he received in the Battle of Mühlberg. Standing behind the Elector and his wife is Martin Luther, with his right hand on the Elector's shoulder and his left hand pointing to the baptism of Christ in the Jordan River at the hands of John the Baptist. In the image, the historic landscape transforms into the biblical scene: the Elbe River becomes the Jordan River and Wittenberg becomes heavenly Jerusalem. Just as described in the account in the Gospel (Mark 1:9–11), the Holy Spirit hovers over Christ's head in the form of a dove, and God the Father sits enthroned in the clouds above.

The axisymmetric juxtaposition of the Elector's family and the biblical baptism scene is meant to indicate that those depicted, like Jesus, are children of God. Luther's presence identifies the Elector's family as belonging to the Lutheran faith. John Frederick paid for his resistance as leader of the Schmalkaldic League with the loss of the electoral office and large sections of his territories, including his electoral seat, Wittenberg. The missing double towers of the city church are reminders of the consequences of the war, as they were likely carried off in 1547 for strategic reasons.

This woodcut is a copy of an original by Jacob Lucius, which was created after the death of the Elector and his wife. In this image, the descendants of John Frederick profess their faith in Lutheranism and present themselves as exemplary believers, having lost their position and material assets because of their faith in Christ.
SKV

Literature
Koepplin 1983, pp. 362 f., cat. 482 · Schade 1983, pp. 422–424, cat. 43 · Slenczka 2015 a, pp. 129–131 · Slenczka 2015 b, pp. 256–259 and 280 f., cat. 2/20, 2/21 and 2/31 · Treu 2010, pp. 93 and 113 · Wolf 2015

362

Charles V
Emperor Charles V Imposes the Imperial Ban on Magdeburg

Augsburg, July 27, 1547
36 × 48 cm
Landesarchiv Sachsen-Anhalt,
U1, XXII No. 121
Minneapolis Exhibition

On July 27, 1547 Emperor Charles V imposed the imperial ban on the city of Magdeburg, thus depriving it of all of its privileges. This caused great financial and economic harm to the city. How could things have reached this point? The Reformation had become established in numerous territories of the Empire, but the legal status of Protestantism had not been settled adequately. The Emperor was suspected of planning a military attack to eradicate the Protestant faith. In response, under the leadership of the Elector of Saxony and the Landgrave of Hesse, the majority of Protestant princes and eleven cities established a defensive alliance, the Schmalkaldic League, in 1531. The city of Magdeburg was one of its members. The alliance suffered a crushing defeat in the Schmalkaldic War of 1546–47. Assuming himself to be at the peak of his power, Charles V demanded unconditional submission

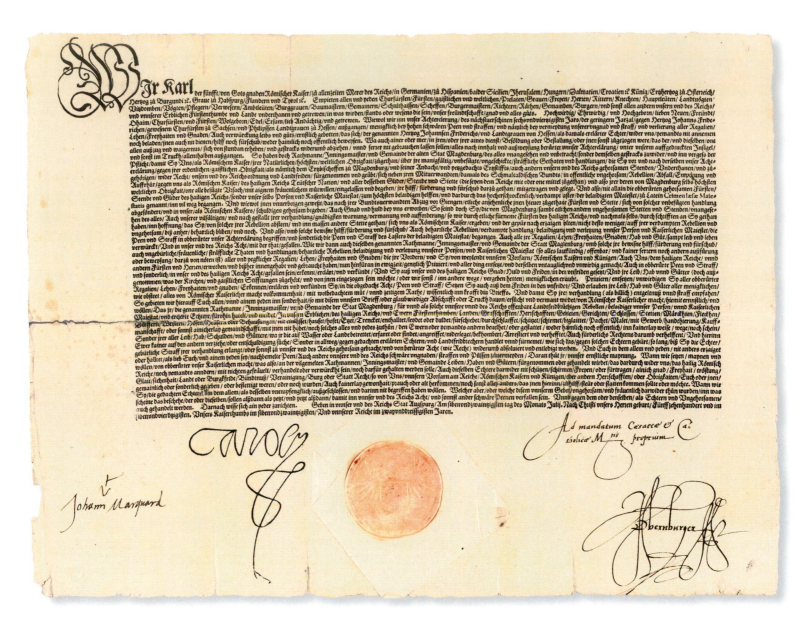

362

from every member of the alliance. Only Magdeburg refused to swear fealty to both the reinstated archbishop and the Emperor himself, since the demands for submission were linked with renunciation of the Protestant confession and the loss of all privileges.

Once the imperial ban was declared in the following July, Magdeburg was officially no longer part of the Holy Roman Empire's community of public peace. This had far-reaching consequences for the people of Magdeburg. Imperial estates were thenceforth not to enter any alliances, treaties or other agreements with the city. To make matters worse, its vital staple right was conferred on the Electors of Brandenburg and its

lay judges' bench was moved to the University of Frankfurt (Oder). What is more, the city and its residents could be attacked and plundered with impunity. Magdeburg thus lost its crucial source of trade revenue and the basis of its prosperity. Its standing as an imperial free city was also imperiled.

In the ensuing period, Magdeburg evolved into a center of Protestant resistance against the Emperor and the Augsburg Interim. Numerous tracts publicized the besieged city's resistance throughout the Empire. Leading Protestant theologians appealed from the self-proclaimed "Our Lord God's Chancellery" of Magdeburg for perseverance in the struggle for the Gospel. VR

Literature
Asmus 1999, p. 483 (ill.) · "… gantz verheeret!" 1998, pp. 134 f. (ill.) · Hoffmann 1885 · Kaufmann 2003 · Moritz 2009 · Rabe 1996 · Weber 1997

Luther saw himself as a prophet and considered his interpretation of Scripture to be the only correct one. This attitude explains his derogatory claims aimed at the Pope and his Church, the peasants, Jews, Turks and Anabaptists. Since 1518, Luther had nurtured the belief that the Catholic Church was controlled by the Antichrist. This was not just an allegation but a theological position for Luther. In opposition to the subverted papacy, he proclaimed a concept of an "invisible Church" that had preserved true Christian doctrine through the centuries, separate from official Church institutions.

The Anabaptist movement rejected infant baptism as unfounded in Scripture but demanded a conscious personal acceptance of faith by adults. With their belief in non-violence, they had already aroused the authorities' suspicions. Luther declared that they were possessed by the devil. From 1530, he demanded the death penalty for Anabaptists, which was justified, in his eyes, by the grave accusation that they had poisoned the world with blasphemy.

A similar theological idea can be discerned in Luther's attitude towards the Jews. As his doctrine of justification assumed that only those who believed in Christ could be redeemed, the Jews were automatically excluded. While Luther was confident in 1523 that his arguments would convince them that Jesus was indeed the Messiah, he would later come to the conclusion that the Jews had been rejected by God. In 1543, he penned a long, hate-filled treatise demanding their banishment and the destruction of their synagogues. He even went so far as to compare them with insects and used terms that can only be defined as "proto-racist."

Luther branded the Peasants' Revolt as rebellion. In his view, a true Christian had to willingly endure and suffer all injustice; as he was already free in spirit, any kind of actual resistance was illegal. In contrast, the Reformer promised heaven to those princes who died in the bloody suppression and even hailed them as martyrs. Interestingly, Luther classified the Turks as an eschatological instrument. Their attacks were thought to be in accordance with God's intention to make Christianity realize its transgressions and repent. The Reformer believed that the dominion of the Turks would eventually displace the Christian Roman Empire, and thereby initiate the end of days and the arrival of Christ. RK

363

Pancratius Kempff

Lord keep us Steadfast in thy Word

Magdeburg, between 1547 and 1549
Colored woodcut
Sheet: 21.8 × 34.6 cm
Luther Memorials Foundation
of Saxony-Anhalt, grfl VI 1040
Minneapolis Exhibition

Above: Ein Liedt / Erhalt uns Herr bei deinem Wort / etc. Sampt Eim schön andechtig / Gebet / Der heiligen Christlichen Kirchen Zu der hohen Ehrwirdigen und heiligen Drey Faltikeit / Got dem Vater / Gott dem Son / und Gott dem heiligen Geist / umb erhaltung bey dem wort der warheit und der Seligkeit / und umb Schutz widder die Feinde des Worts /| als Türcken und Bebst gestellet etc.
(A song / Lord keep us steadfast in thy word / etc. Including a worshipful prayer / To the holy Christian Church and the most venerable Holy Trinity / God the Father / God the Son / and God the Holy Spirit / To keep us steadfast by the Word of truth and salvation / And for protection against the enemies of the Word / In the person of the Turks and the Pope, etc.)
Titled (with no mention of Leonhard Jacobi) and identified on the bottom right: Durch Pancratius Kempff Brieffmaler (By Pancratius Kempff, letter painter.)
Accompanying text underneath the image: Erhalt uns Herr bey deinem / Wort / und steur des Bapsts un / Türcken mort [...] (Lord keep us steadfast in thy word / And curb the Turks' and papists' sword [...])
Prayer: Zu Gott dem Vater. Zu Gott dem Son. Zu Gott dem Heiligen Geist. / [...] (To God the father. To God the son. To God the Holy Spirit. / [...])

"A Children's song, to sing against the two archenemies of Christ and his holy Church, the Pope and the Turks" was composed by Luther in the year 1541. "Lord, keep us steadfast in thy word" was altered after the Schmalkaldic War into a Lutheran "battle song" for the defense of the true faith. In the song, Luther asks God to protect Christendom and to bring death upon its enemies, specifically "the Turks" and the Pope. Both stand for the Antichrist, and since 1548 the Pope also embodied the enactment of the Augsburg Interim, which was the decree issued by Emperor Charles V as an interim solution to the church crisis in order to bring the Protestant movement back into the Catholic Church following his victory at Mühlberg.
Magdeburg, where this broadside by Pancratius Kempff was published, was a center of publication of Lutheran print media critical of the Augsburg Interim. The sheet contains three verses from Luther's song, supplemented by two verses

from the pen of Justus Jonas. The prayer to the Trinity underneath the song is from the cleric Leonhard Jacobi of Calbe.
The associated image is divided horizontally into the heavenly and earthly spheres. It also takes on the three-column organization of the text block below. Above, surrounded by clouds, we can see God the Father, Jesus as Judge of the World and the dove of the Holy Spirit. These figures relate directly to the prayer underneath the text of the song. This division into three parts is repeated on the earthly plane, which contains three groups. In the middle, Christ sends with lightning bolts the enemies of Christendom, in the person of the Pope and officials of the Church of Rome, as well as a Turk, into the fires of hell. The group on the right consists of some elegantly dressed ladies; third from the right is likely Sibylle of Cleves (cf. cat. 51), the wife of Elector John Frederick (cf. cat. 50), as well as a pair of women whose hands are covering the heads of two praying children. Together with the group of men on the left, they represent the community and form a contrast to the knot of people in the middle of the picture. On the left we can see Jan Hus, Melanchthon, Cruciger and Luther. The latter is turned to Elector John Frederick, with his scar, and Philip of Hesse, and is pointing with his left hand at Christ, through whom alone salvation can be obtained. Luther's gesture forges a direct link between John Frederick and Christ, stressing the Elector's religious faith as a martyr of the Reformation. SKV

Sources and literature
Harms 1983, pp. 20 f., cat. 10 · Harms/Schilling/ Wang 1997, pp.12 f., cat. II, 6 · Kaufmann 2003, pp. 413 – 417, particularly note 892 · Veit 2006 · WA 35, 467, 19 – 468, 23

364

Martin Luther
Lucas Cranach the Elder
(illustrator)

Daß Jhesus Christus eyn geborner Jude sey
(That Jesus Christ was Born a Jew)

Wittenberg: Christian Döring(?), 1523
20.5 × 15.4 cm
Luther Memorials Foundation
of Saxony-Anhalt, CGH 89
VD16 L 4313
Minneapolis Exhibition

This work is one of Luther's responses to the question as to what is to be done if one's fellow man is not a Christian at all but a Jew. In contrast to his lectures on the Psalms in 1513/15, in which

Ein Liedt/ Erhalt vns Herr bey deinem Wort/etc. Sampt Ein schön andechtich

Gebet/ Der heiligen Christlichen Kirchen Zu der hohen Ehrwirdigen vnd heiligen Drey Faltikeit/ Got dem Vater/
Gott dem Son/ vnd Gott dem heiligen Geist/ vmb erhaltung bey dem wort der warheit vnd der Seligkeit/ vnd vmb schutz widder die feinde des Worts/
als Türcken vnd Bapst gestellet etc.

Erhalt vns HERr bey deinem Wort/ vnd steur des Bapsts vnd Türcken mord/ die Jhesum Christum deinen Son/ wöllen stürtzen von deinem Thron.

Beweis deine macht Herr Jhesu Christ/ der du aller herren bist/ Beschirm dein Arme Christenheit/ das sie dich lobe in ewigkeit.

Gott Heiliger Geist du Tröster werd/ gib deinem Volck einerley syn auff Erd/ stehe bey vns yn der letzten not/ gleyd vns ins leben aus dem tod

Ihr anschleg HERr zu nichten mach/ las sie treffen die böse sach/ vnd stürtze sie jnn die gruben ein/ Die sie machen den Christen dein.

So werden sie erkennen doch/ das du vnser Got lebest noch/ vnnd hilffst gewaltig deiner schar/ Die sich auff dich Verlesset gar.

Zu Gott dem Vater.

ACh lieber Vater/ du Got alles trostes/ aller gnaden vnd barmhertzikeit/ der du bist im himel/ vnd siehest/ Wie die gewaltigen auff erden/ als der türck vnd der Bapst/ sich vnter stehen/ Deinen lieben Son Jhesum Christum vnsern Herrn/ welchen du vns/ O gütiger Vater/ aus grundloser barmhertzigkeit geschencket vnd gegeben hast/ den bittern tod am Stam des Creutzs für vns zu leiden/ sein heiliges teures blut vmb vnser sünde willen zu vergiessen/ Vnd vom Teufel vnd ewigem verdamnis zu erlösen/ Von deiner rechten wilchs sein ewiger thron ist/ zu stürtzen/ Deine liebe Kirchen zu dempffen/ Vnd dein heiliges Wort aus zu roten/ wir bitten dich du starcker Got/ Der du sie machest/ allen rath/ allen gewalt der gotlosen vnd mechtigen auff erden/ Du wollest jren vnchristlichen greulichen furnemen steuren/ vnd wehren/ deine liebe Christenheit/ vnter dem schatten deiner flügel beschützen vnd beschirmen vnd bey deinem heiligen vnd allein seligmachende Wort gnediglich erhalten/ Durch Christum Jhesum deinen lieben Son vnsern HERR/ AMEN.

Zu Gott dem Son.

OHErr Jhesu Christe/ du Son des allerhögesten/ vnd Heiland der gantzen welt/ du Got der herscharen/ Der du fur vns durch dein heiliges leiden vnd sterben/ den ewigen Tod vberwunden/ den teufel gefangen/ die hell gestürmet/ Die sünde ausgelescht/ Vnd durch deine heilige aufferstehung vnd himelfart Die ewige selikeit vnd das ewige leben erworben vnd vns geschencket hast/ Wir bitten dich von gantzen hertzen/ Dieweil du sihest/ Wie sich deine abgesagte feinde/ Der Türcke vnd der Bapst/ so mutwillig widder dich aufflehnen/ Vnd deine liebe Kirchen/ Die du durch dein blut erworben hast/ so greulich verfolgen/ Du wollest dich nochmals/ wie du den zuuor vnd allezeit gethan hast beweysen/ jrem Blutdürstigen tyrannischen mutwillen wehren/ vnd furkomen sie stürtzen/ vnd deine werde Christenheit befrieden/ auff das sie dich lobe/ vnd dir dancken/ der du lebest vnd regierest mit Got dem Vater in einikeit des heiligen geists in ewigkeit/ AMEN

Zu Gott dem Heiligen Geist.

OHeiliger Geist/ du werder Tröster/ du ewiger glantz erleucht vnser hertzen/ vnd zünde sie an/ mit deiner gnade/ Das liebe Euangelium/ Das ewige Wort/ wilchs vns allein selig macht/ zu bekennen/ vnd hilff vns Das wir dabei mögen bestedig bleibe/ weiche jo nicht von vns du einiger tröster jn allerlei not vnd anfechtung/ sondern stercke vns mit deiner Almechtigen inwendigen krafft/ Das wir vns fur keinerley Tyrannei des Türcken vnd des Bapsts fürchten noch entsetzen mögen/ Verleihe vns eine ritterlichen Kampff des Glaubens widder alle/ vnsere feinde zu kempffen/ stehe vns bey Vnd hilff vns durch CHRistum Jhesum Vnsern lieben HERRN/ Wilchem sey Lob EHR Vnd Preiss in ewigkeit AMEN.

Durch Pancratius Kempff Brieffmaler.

364

365

Luther stated that he saw no future for the Jewish people, in 1523 he describes Jews as human beings. His call for dignified and non-violent treatment is striking in the context of his time.

This work is intended as both a defense of Luther's views and as a missionary text. The Catholic camp had accused Luther of denying the virgin birth and, by extension, the divinity of Christ. Refuting this allegation is the central theme of this work. At the same time, Luther expresses the hope that his arguments will "attract many Jews to the Christian faith" (WA 11, 314, 28). Luther attempts to prove, with biblical citations, that Jesus Christ appears in the Hebrew Bible, which Luther calls the "Old Testament," and that this text heralds the coming of Christ and the virgin birth. This is meant to prove that Jesus is the Messiah, and that the waiting of the Jews is futile.

This interpretation draws its roots from Luther's doctrine of justification. Since only faith in the life, death and resurrection of Jesus Christ can bring salvation, all of those who do not believe in Christ are ineligible for God's grace in accordance with Lutheran doctrine. Other interpretations, such as Jewish delight in the law, were refuted once and for all in Luther's opinion. It was clear to him that conversion was the only option available to the Jews. To Luther, Judaism itself was "in essence, no longer a legitimate religious option" (Kaufmann 2014).

What makes the 1523 work unique is that it calls for tolerance when dealing with Jews. His hope was that amicable, non-violent treatment would convince the Jews that Jesus was the true Messiah. This tone, which comes across like a pro-

phetic omen of the 18th-century Enlightenment, is supported by a reference to Romans 9. Luther argues that there is a particularly close relationship between Christians and Jews. Since the Jewish Christians in the time of the Apostles were able to convert the heathens primarily through their peaceful dealings with them, he states that this should be the rule for the contemporary mission to the Jews as well.

This text was widely disseminated in Luther's lifetime, with a total of ten contemporary editions. RK

Literature
Kaufmann 2014 · Lewin 1911 · Maurer 1953 · Osten-Sacken 2002 · Pangritz 2015 · Wallmann 2014

365

Lead Type with the Hebrew Letter מ ("Mem")

Wittenberg, Bürgermeisterstr. 5
Late-16th/early-17th century
Lead
Point size: 3.53 mm, type height: 24.53 mm, set width: 2.94 mm, nick level: 17.7 (from the top) 5.1 (from the bottom)
State Office for Heritage Management and Archaeology, Saxony-Anhalt
State Museum of Prehistory, HK 98:24665v17
Minneapolis Exhibition

Among the numerous lead printing types discovered at Bürgermeisterstraße 5 (formerly Jüden-viertel 25) (cat. 292) in the backfill of a latrine, one type in particular stands out: it is a printing type with the Hebrew letter מ (mem), and it is currently the only archaeological find of Hebrew type in all of Europe.

The printing of Hebrew works assumed increasing importance with the humanistic alignment of Wittenberg University under the reforms introduced by Philip Melanchthon. Hebrew letters were used in 1508 in Andreas Bodenstein's (known as Karlstadt) *Distinctiones sive formalitates thomistarum*, which was printed by George Rhau. In this work, Karlstadt included four Hebrew lines on folio 29 verso. But it was only through the teaching of Hebrew scholar Matthäus Aurogallus starting in 1523 that textbooks, such as his *Compendium Hebraeae Grammatices* (printed by Johann Rhau-Grunenberg in Wittenberg, 1523), and writings that Hebrew printing began to appear on a large scale.

Both the location and the dating of the items found in the filled-in latrine indicate that the lead types found at this site, including the Hebrew type, come from the print shop of Johann Krafft the Younger. His father, Johann Krafft the Elder, who at times assumed the Latinized name "Crato," was a printer in Wittenberg as early as 1546. In 1553, he acquired the property located at Jüdenviertel 25, where he opened his own print shop; prior to this, he had likely been working out of the print shop of Georg Rhau (cf. cat. 302). 840 printed works can be attributed to Krafft the Elder, including numerous works by Philip Melanchthon and a few Hebrew titles. After his death, the shop and the existing types were taken over by Krafft's eldest son, Zacharias, who before long was operating the business with his brother, Johann the Younger. Working together with a Jewish proofreader, the shop turned out Hebrew editions of the Pentateuch and the Book of Genesis in 1586, followed the next year by a complete Hebrew edition of the Old Testament. Johann Krafft continued the business alone after his brother's death in 1590. About 200 editions in German, Latin and Hebrew can be traced to him, with the latest dating to the year 1601. The types at the Krafft print shop continued to be used by other printers through 1609, although evidently not for Hebrew publications. MG

Literature
Berger/Stieme 2014b, particularly p. 288 · Miletto/Veltri 2003, pp. 93–111 · Reske 2007, 1087, particurlarly Johann Krafft the Elder; 1091 particularly Zacharias Krafft; 1092 particularly Johann Krafft the Younger

366

367

366

Biblia Hebraica (Hebrew Bible)

Venice: Daniel Bomberg, 1518
23 × 17 cm
Luther Memorials Foundation of Saxony-Anhalt,
ss 3391-3394
Minneapolis Exhibition

Luther had long believed that in order to understand the Holy Scriptures, knowledge of the original languages—Hebrew for the Old Testament and Greek for the New—was indispensable. In 1506 he bought a copy of Reuchlin's *Elementary Grammar for the Hebrew Language* (cat. 367). Before 1519 he acquired a Hebrew Bible which would accompany him all his life. Luther's copy, printed in Brescia in 1494, is preserved at the Staatsbibliothek zu Berlin and exhibits numerous traces of Luther's reading.
The Bible displayed here is one of the first printed masterpieces of Daniel Bomberg. Born in Antwerp, he moved to Venice in 1515. Although he was a Christian, he became a specialist in Hebrew printing, which he produced with a precision and elegance previously unseen. Several Jewish scholars helped him to ensure the quality of his books. His first edition of the Talmud was a milestone in the history of Jewish studies. The copy displayed belonged to Johannes Agricola, Luther's pupil and later opponent. MT

Literature
ADB 47, 1903, pp. 95–97 · Mackert 2014

367

Johannes Reuchlin
De Rudimentis Hebraicis
(The Rudiments of Hebrew)

Pforzheim: Thomas Anshelm, 1506
29.8 × 22 cm
Luther Memorials Foundation
of Saxony-Anhalt, Kn fl 4/8
VD16 R 1252
Minneapolis Exhibition

Johannes Reuchlin was in fact a lawyer but became famous as a humanist. He is known as the founder of Christian Hebrew Studies north of the Alps. His folio volume of more than 620 pages, designed to be an introduction to the Hebrew language, served many aside from Luther as the first foundation for learning the original language of the Old Testament. Since Hebrew is written from right to left, one reads the book (as what appear to us as) back to front, that is the introduction is on what we would call the final pages. In 1511, Reuchlin was embroiled in the so-called Jewish Book Controversy, when he wrote a report pleading for the preservation of the Talmud after a Jewish convert to Christianity had called for all Jewish writings to be burned. Reuchlin was opposed to this because, above all, he was interested in a Christian form of Kabbala, the esoteric Jewish method of interpreting the Bible. Despite his writings being condemned, he remained faithful to the Old Church. It is significant for the history of the Reformation that, following Reuchlin's recommendation, Philip Melanchthon, one of his relatives, was given the Chair of Greek in Wittenberg. MT

Literature
Leppin/Schneider-Ludorff 2014, pp. 603 f.

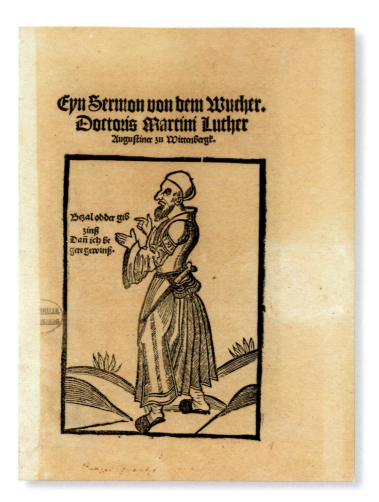

368

368

Martin Luther

Ein Sermon von dem Wucher (A Treatise on Usury)

Wittenberg: Johann Rhau-Grunenberg, 1520
20.5 × 15.4 cm
Luther Memorials Foundation of Saxony-Anhalt,
Ag 4° 188m
VD16 L 6447
Minneapolis Exhibition

The significance of economic questions for Luther has often been overlooked in the past. However, it is clear from the early date of composition of this work just how urgently Luther saw the need for a reorganization of this sphere of life. The essay is a new edition and expansion of a pamphlet originally published in 1519, therefore, it was often called the *Long Sermon on Usury*. In 1524, the material was once more revised and became the second part of Luther's comprehensive writing on business ethics, *On Trade and Usury*.

Beginning with Jesus' Sermon on the Mount, Luther viewed every form of money-trading with suspicion and placed it in the category of usury. Receiving interest was only valid in exceptional circumstances. He felt that overseas trade with luxury goods should be abolished and the large trading companies deprived of their power. However, Luther's rigor proved to be impractical and was not followed.

The woodcut title page illustration is problematic. It shows a caricature of a Jew with the caption, "Pay or give interest, for I long for profit." Even if Luther probably did not have direct influence on the design of the printing, it hints at the Reformer's animosity towards the Jews. MT

Literature
Leppin/Schneider-Ludorff 2014, pp. 764–768 ·
Treu 2008b · WA 6, 33, 36–60 [LW 45, 273–310]

369

Martin Luther

Von den Juden und ihren Lügen (On the Jews and Their Lies)

Wittenberg: Hans Lufft, 1543
19.8 × 15 cm
Luther Memorials Foundation
of Saxony-Anhalt, Ag 4° 227c
VD16 L 7153
Minneapolis Exhibition

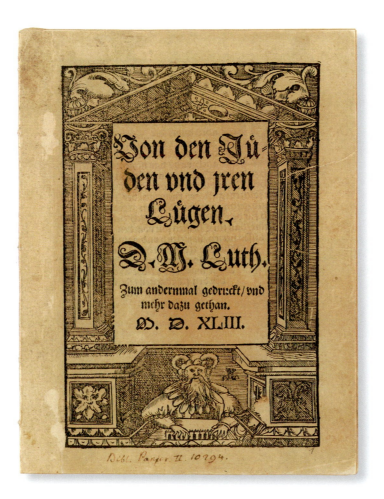

369

Towards the end of his life, Luther abandoned the hope he had entertained since 1523 that the Reformation would lead to a great and impressive conversion of the Jews to Christianity. Disillusioned, he produced three comprehensive publications in quick succession against the Jews, of which the one displayed here is the worst. Here he demanded that the political authorities should banish the Jews or at least destroy their synagogues and that they should be dispossessed and forced to do manual labor. He would not allow, however, their killing. Recent research has shown that the differentiation between a religiously motivated anti-Judaism and the racial anti-Semitism of the 19th century does not stand up to scrutiny. In Luther's case, one can certainly speak of a proto-racism, since he also would not recognize a baptized Jew as a Christian brother. Racial stereotypes were too deeply entrenched, to the extent that the myth was revived that Jews desired to shed Christian blood. At the same time, Luther's hatred was directed toward Christian exegetes who tried to understand the Old Testament on its own terms as the Bible of the Jews, rather than only as a prophecy of the coming Messiah, Jesus Christ. In Luther's lifetime, this agitation against the Jews found little resonance. Only two editions were printed in Wittenberg, as well as a Latin translation by Justus Jonas, which Luther apparently commissioned. MT

Literature
Kaufmann 2015, pp. 106–140 · WA 53, 415–489 [LW 47,123–306]

370

Tile Fragment of a Wall Fountain with a Depiction of Law and Grace and the Caricature of a Jew

Wittenberg, Luther House, Collegienstraße 54
1st-half of the 16th century
Earthenware, (interior/exterior) yellow-green glazing
5 × 3.5 cm
State Office for Heritage Management and Archaeology Saxony-Anhalt
State Museum of Prehistory, HK 667:243:260a
Atlanta Exhibition

This small but disturbing fragment of a green-glazed wall fountain was found in the garden of the Luther House (cf. cat. 236 and 238). It shows the crossed feet of the crucified Christ and to their right the profile of a leering head with hawk-beaked nose, deeply sunk eyes and lips pulled back to jeer. This hideous head wears a peaked hood, and just enough of his complicated cos-

370

tume survives which includes puffy sleeves, shoulder straps, and what seems to be an apron. A complete tile cast in the same mold survives in Nuremberg (fig. 12) and allows us to reconstruct the scene exactly. A specific variant of the theme of Law and Grace shown here depicts a crowd of demonic louts hurling insults at the martyred Savior. This detail, which Cranach, for instance, never painted, is shown in late medieval Passion imagery and includes a mocking Jew. Our figure's pointed hood identifies him as Jewish, and his complicated costume may even identify him as a temple priest. In medieval iconography, Jews are only distinguished from Gentiles by the badges and headgear they were forced to wear or by devilish attributes such as horns and tails. Influenced by humanism, Renaissance artists increasingly focused on what they saw as a typical facial physiognomy. This involved capturing expressions of emotion, but also including grossly stereotyped renderings of the features of social outcasts, such as criminals, beggars, Turks, and Jews. Thus, this hideous face was meant to thoroughly vilify a Jewish witness to the Crucifixion. It can be seen in the context of the emergence of viciously anti-Semitic caricatures and tropes, which haunt us to this day. LN

Literature
Gutjahr 2014, p. 24, fig. 8 · Katz 2008 · Wingenroth 1899

Fig. 12
Fragment, cat. 370, within a reconstruction drawing based on a tile from the Germanisches Nationalmuseum Nürnberg

VIII

Luther's Legacy

While the impressive physical remains and the compelling iconography of the early-16th century is a tribute to the cathartic impact of Luther and his Reformation, his legacy is less easy to illustrate. There is only slight evidence for the emergence of Lutheran relics, and drastic measures, including the decision to burn Luther's death bed in Eisleben in 1707, were deemed necessary to nip such veneration at the bud. The only widespread physical reminders of the Reformer are the countless copies and re-imaginations of Cranach's portraits that are the mainstay of Luther's memory.

Instead of physical relics, it is Luther's texts, sermons and songs that continue to inspire the faithful. Of course, it is his comprehensive and brilliantly successful Bible translation that is the centerpiece. It formed the basis of the layman's access to scripture that would lay the foundation for universal education and literacy that was a hallmark of early modern Protestant Europe. The impact of this mandated literacy can be seen by the fact that Luther's German, which he adapted from Saxony's bureaucratic idiom, has formed the basis for modern written, and increasingly spoken, German. This formative and unifying impact of the language of Luther's Bible would form the basis for German national sentiment in the succeeding centuries. However, his literary legacy goes well beyond his Bible, including his collected sermons, pamphlets, broadsheets and letters, as well as transcripts of his often remarkably witty table talk. While much of what he wrote and said has lost its impact though the enormous transformations of the intervening 500 years, and indeed a part was tarnished by the Nazis' attempts to use and abuse his legacy, it is his hymns which have stood the test of time so resiliently. In the original, but also in translation, they still manage to move and inspire Christians around the globe, and hardly a day passes without visitors being heard singing "A Mighty Fortress is Our God" on the grounds of the Luther House in Wittenberg. LN

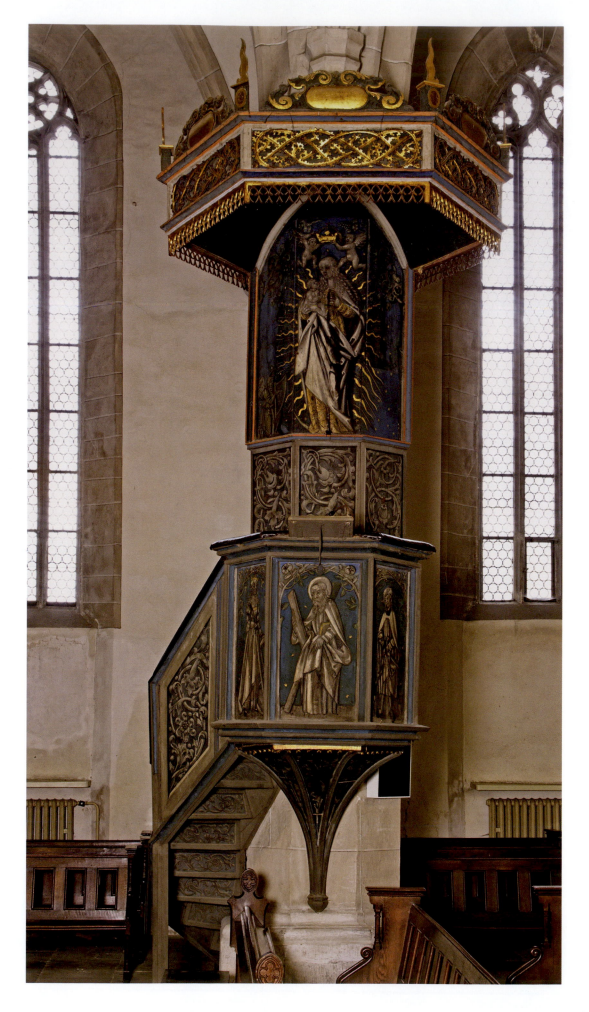

371

371
Pulpit of Luther's last Sermon

Central German workshop, 1518, with additions
from the 2nd-half of the 16th and 17th centuries
and from 1911
Oak, limewood and pine, paper, iron, tempera
or casein paint, partly gilded
H ca. 6 m
Evangelische Kirchengemeinde St. Andreas-
Petri-Nicolai, Lutherstadt Eisleben
Minneapolis Exhibition

"[Christ], you alone are my dear Lord and Master
[...], that and much more would be to pass on of
this gospel, but I am too weak, so we want to
leave it at that." Thus Luther closed his sermon
on the Gospel of Matthew (Mt 11:25–30) on Feb-
ruary 15, 1546. This sermon from the pulpit of the
St. Andrew's Church in Eisleben was to be his
last. The labored quote suggests the Reformer's
heart troubles had weakened him three days be-
fore his death.

The pulpit, the last one Luther preached from,
can be found in its original place to this day: the
second south column in St. Andrew's. The year
1518 written on the sounding board gives a date
for the completion of the pulpit. It survived the
past centuries almost unchanged, but the ex-
tremely steep steps were lengthened in the 19th
century to make the pulpit more accessible.
When the church was renovated in 1911, the State
Office for the Preservation of Historical Monu-
ments added a crown of baroque cherubs above
the sounding board.

The hexagonal body of the pulpit rises above a
console of profiled ridges. The grisaille painting
on blue background depicts Saints Catherine,
Andrew, Martin and John the Evangelist under
Gothic vines in a round arch form. The steps of
the staircase are also decorated with colored
vines. Between the body of the pulpit and the
sounding board, three sides of the church col-
umn are covered by painted panels. The lower
zone of these panels repeats the vine decora-
tion; the upper shows the Madonna clothed in
the sun on a crescent moon, being crowned by
angels. A blue field with stars applied in the
dome of the sounding board above the preacher
evokes the night sky. The gables and obelisks on
top probably date from the 17th century.

The paintings visible today differ from the pre-Ref-
ormation versions. Under the figures of the saints
there are older paintings. The inclusion of the
name saints of Luther and his wife Katharina
seems to be an example of early modern Lutheran
veneration. Saint Andrew stands for the church
itself and John the Evangelist for the Word of God
preached from the pulpit. The Madonna clothed
in the sun on the column is older and comes from
another context. She symbolizes the Church, that
is the fellowship of believers gathered around the
pulpit to hear the Word of God.

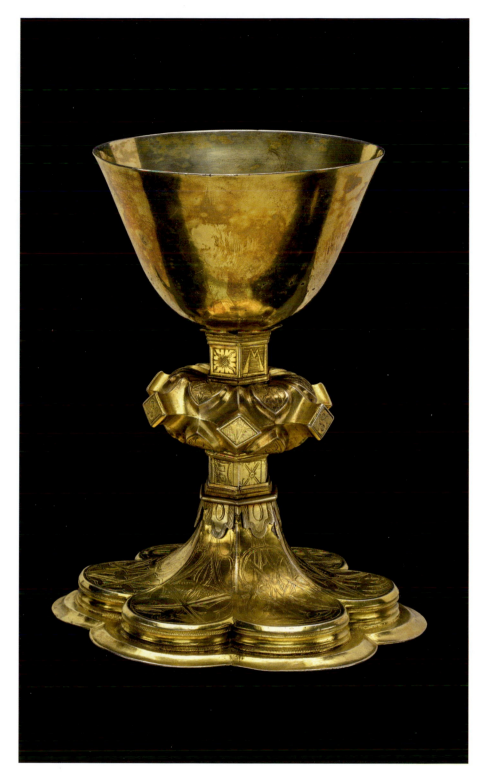

372

During the 18th century at the latest, the church limited the use of the pulpit. It was only used for sermons on three Luther memorial days: on his birthday and anniversary of his death, and on Palm Sunday, as well as for the festivities for the anniversary of the Reformation. After 1670, the high civil servant Johann Müller sponsored an "everyday pulpit" opposite the Luther pulpit on the southern column of the triumphal arch. The effort to conserve the Luther pulpit tells us that it was considered a memorial from an early stage. A piece of relief-embroidered cloth made from precious 15th-century choir gowns adorned the Luther pulpit. This unusual decoration is now displayed in a cabinet in the church. In the 19th century, preaching from the Luther pulpit resumed and continues to this day. SKV

Literature
Arnold 1845 · Berger 1827, pp. 155–157 · Brinkmann/Größler 1895 · Fabri 1794 · Kutzke 1912 · Kutzke 1917

372

Chalice from St. Andrew's Church in Eisleben

Saxony or Thuringia, 15th century
Silver, cast, embossed and engraved,
gold plated
H 16.5 cm, D 13.5 cm
Evangelische Kirchengemeinde St. Andreas-Nicolai-Petri Eisleben (on loan to Luther's Birth Place Museum, Eisleben)
Minneapolis Exhibition

Inscriptions in Gothic capital letters, on the rotuli of the node: "IHESUS", on the stem underneath the node: "AVE" and on the stem above the node: "MARIA"

At the beginning of the 16th century, St. Andrew's Church in Eisleben possessed a large and precious church treasury. Our evidence for this is not only the exquisite silk embroidered pulpit hanging made of late Gothic choir gowns, or the chasuble also displayed here (cat. 373), but a large number of Gothic chalices are also preserved, all of which suggest the considerable wealth of the church.
The sexfoil base with a profiled edge is richly decorated with engraved circle patterns. Every one of the six facets has a different decoration, in which there are repeated trefoils and quatrefoils with straight or curved bands. The flattened node is structured in twelve shield-form facets with tracery decoration, separated by rhomboid rotuli. The straight hexagonal stem is decorated with flower and star motifs along with the inscription. On the top sits a bell-shaped cup.

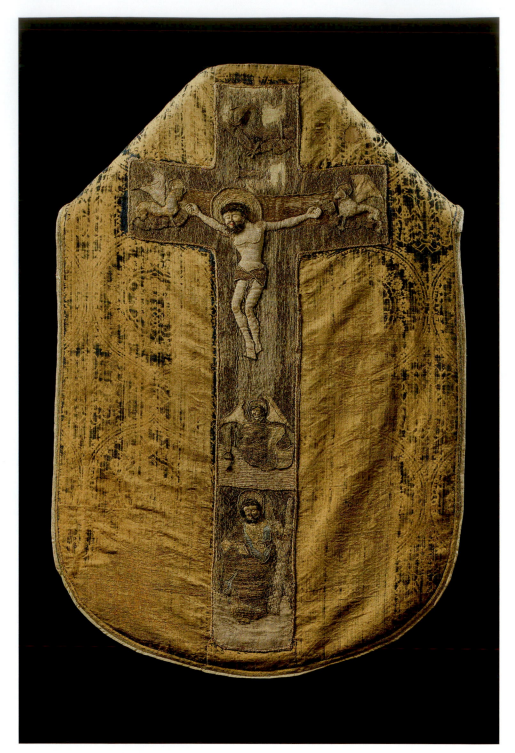

373

Martin Luther celebrated mass in Eisleben many times and not just at the end of his life. The chalice belonged to the vessels of the altar at St. Andrew's at the time that he served there. It is therefore entirely conceivable that the famous son of the town used the chalice himself. Today it has become a symbol of the lay chalice introduced in the Reformation and for the last Mass in the last place where Luther worked. SKV

Literature
Brinkmann/Größler 1895, p. 114, no. 6 · Seyderhelm 2001 · Treu 2014, pp. 20 f. and 102

373

Velvet Chasuble with Embroidered Cross and Depiction of St. Andrew

Central Germany, 1st-quarter of the 16th century
Woven fabric: blue-green silk-velvet
(north Italy); embroidery: silver leaf, various
colors of silk thread (central Germany?)
130 × 85 cm
Luther Memorials Foundation
of Saxony-Anhalt, GH K 16
Minneapolis Exhibition

A chasuble is the outermost liturgical garment worn by the celebrating priest during Holy Mass. This chasuble from Eisleben was made from precious silk-velvet. Its dark, blue-green pile stands in striking contrast with the orange-copper colored background of the fabric. Through prolonged use, the delicate velvet fibers have unfortunately been worn away in large areas.
The design is dominated by pomegranate motifs in rosettes and pointed oval forms. Materials with imaginative pomegranate patterns were very popular and desirable since the second-half of the 15th century. The fabric displayed is comparable with those from the period after 1500.
The back of the garment is decorated with an embroidered cross made of silver threads. Christ's slightly raised body was made separately in white half-silk satin and padded with fabric to create three-dimensionality. The other figures on the chasuble were individually prepared and attached in a similar way. The human heads are especially delicately rendered, with the hair made from silk threads wrapped around thin wires.
The crucified Christ is surrounded by the four winged animals of the Book of Revelation (Rev 4:1–11), which became symbols for the four evangelists. As arranged on the Eisleben chasuble, the eagle stands for John (above), the lion for Mark (left), the bull for Luke (right) and the angel for Matthew (below). Christ, in the center, embodies the unity of the four Gospels. According to the medieval interpretation, the symbols

373

also stand for the fourfold life-source of the Gospels flowing from the cross, or the Tree of Life. The Gospels are understood as the four rivers of paradise. The complex message of the picture is augmented by the representation of the apostle Andrew, recognizable by his distinguishing sign, the saltire. Because of this singular significance of the apostle, it seems likely that the chasuble was used for the mass on the main altar of the Church of St. Andrew in Eisleben. In this case, Martin Luther, who visited Eisleben many times to preach in the church, may have come into contact with this vestment. BP

Literature
Knape 1994

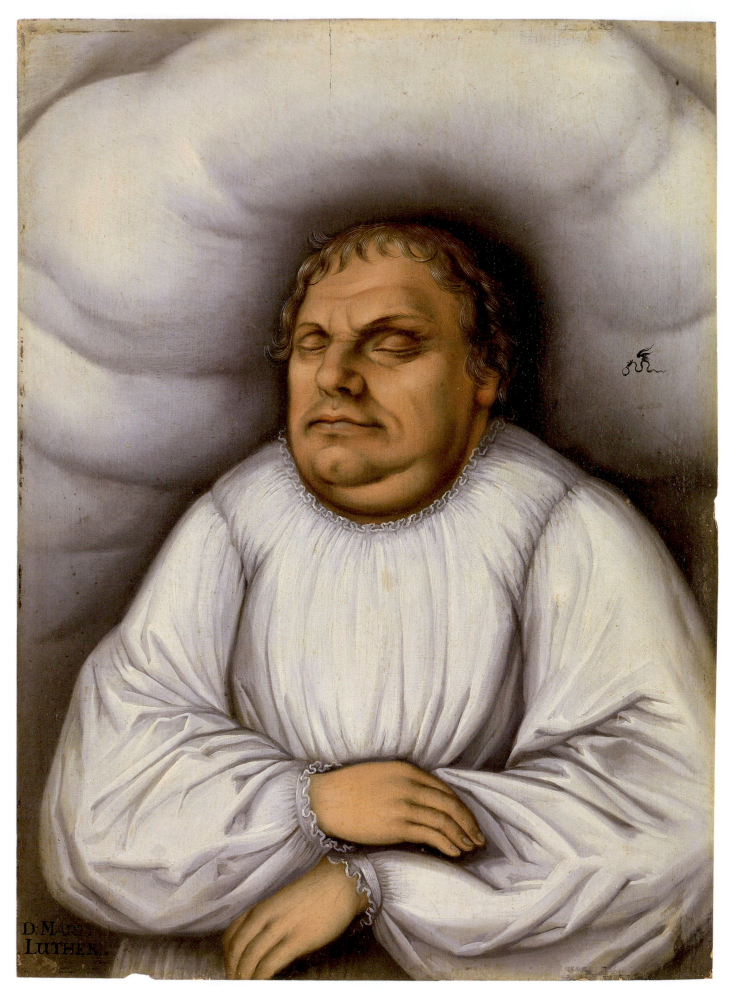

D.MART
LUTHER.

374

374

Lucas Cranach the Elder, copy
Martin Luther on his Death Bed

After 1600
Oil on oak
40.5 × 29.6 cm
Stiftung Deutsches Historisches Museum
Berlin, Gm 2010/1
Minneapolis Exhibition

Signed on the right-hand side with winged
serpent to the left

This Berlin painting is a later version of a com-
mon theme, the dead or dying Luther, which il-
lustrates the significance of this subject for the
history of the Church decades after Luther's
death. The close-up view underscores the inten-
tion of depicting Luther passing away gently,
resting on white cushions which look like heav-
enly clouds. This depiction is the visual comple-
ment to the eyewitness reports from the night
Luther died by Justus Jonas, a friend of Luther,
and the Mansfeld preacher Michael Caelius.
These reports, as well as the painting, mean to
refute the Catholic propaganda that Luther was
obliged to struggle with the devil, or that he went
to hell after his death. The peaceful expression
on the face of the deceased also alludes to
Luther's conviction that a firm belief in God and
the salvation is all a Christian needs to prepare
for a good and peaceful death. Since the fear that
death will come without warning was particularly
great in times of rapidly spreading plagues and
diseases, and in times of war and famine, people
in the late Middle Ages and the Early Modern era
would take precautions to ensure that they were
adequately prepared for a good death. The exten-
sive contemporary literature on *Ars moriendi,* the
art of dying, demonstrates the immense demand
for instructions on the proper way for Christians
to prepare for death (cf. cat. 97).

As a later copy, this painting is an indication of
the continuing theological significance and dis-
cussion surrounding Luther's death. The various
versions of Luther on his death bed are all based
on portraits by two painters. One was an un-
known artist from Eisleben who immortalized
Luther as he lay dying, or following his death, on
the night of February 18, 1546, and the other was
Lucas Furtenagel, who arrived the following day
from Halle to paint the dead Luther. Cranach
used one of these two models to paint this por-
trait in his own characteristic style. The version
which he actually had originally is a subject of
dispute among historians. One possible model
for the successful version from the Cranach work-
shop, which was eventually widely dissemi-
nated, is the pen and ink drawing of the dead
Luther that is attributed to Furtenagel, today in
the Kupferstichkabinett (Museum of Prints and

Drawings) in Berlin. With his version of the dead
Luther, Cranach the Elder, who had been Luther's
close confidant, created the model for the large
number of paintings, copper engravings and
woodcuts of the dead theologian which would
soon begin to be quickly and widely dissemi-
nated. This painting is based on a 1546 version
(Lower Saxony State Museum, Hannover) from
the workshop of Cranach the Elder, or of his son,
Lucas the Younger. BR

Sources and literature
Brinkmann 2007, pp. 196 f., cat. 42 (ill.) · Jonas/
Coelius 1546 · Dieck 1962 · Enke/Schneider/
Strehle 2015, pp. 244 f., cat. 2/13 (ill.) · Marx/
Mössinger 2005, pp. 480 – 486, cat. 43 (ill.) ·
Stuhlfauth 1927

375

House Sign of Luther's Deathplace

1506
Wood, carved, polychrome painting
54 × 28 × 21 cm
Lutherstadt Eisleben (on loan to
Luther's Death House in Eisleben), V 884
Minneapolis Exhibition

House signs *(Hauszeichen)* are specific symbols
which were prominently displayed on late and
post medieval buildings in Germany and West
Europe. They fulfilled a role comparable to the
heraldic devices of the nobility, but the designs
were probably derived from earlier family sigla.
These were usually simple and geometric, much
like masons' marks. Eventually, these symbols
were colored, carved in relief and embellished.
The house sign shown here is an example of this
evolution. It consists of a black-clad man holding
a heraldic shield, which in turn displays a geo-
metric family sign from the late Gothic era with
the letters "T" and "R." Below the shield is the
date 1506.

Both the initials and the date point to Tile Rinck,
a member of the town council and proprietor of
a smelting operation *(Hüttenmeister)* in Eisle-
ben, and the known date of the completion of his
house. Both the heraldic shield and the support-
ing figure show the self-aggrandizement which
was typical for rich burghers at this time; elabo-
rate house signs of this type had previously been
a privilege only of the knightly class. According
to the Spangenberg Chronicle, Martin Luther
died in Eisleben in 1546, in a house that lay
across from a fountain well in the marketplace,
and which had been built sometime after 1498
by Tile Rinck and afterwards belonged to his son-
in-law, Doctor Philipp Drachstedt. But since this
lawyer and smelting operator died in 1539, it was
impossible to verify, until recently, why Luther's

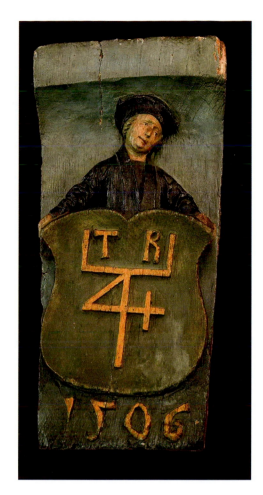

375

host in 1546 is explicitly named as one Johann
Albert in the sources immediately post-dating
the Reformer's last journey and death.

Fortunately, the last will of Philipp Drachstedt
has recently been discovered. According to this
document, Drachstedt bequeathed the house to
his son-in-law Hans Stahl, yet another operator
of a smelting enterprise. Stahl in turn permitted
his son-in-law, town clerk Johann Albert, to live
there. But the reorganization of local copper pro-
duction by the Counts of Mansfeld in the edict
known as the "*Feuerteilung* (Division of Smelting
Operations)" and the decline of copper prices
throughout the continent threw Hans Stahl and
the other smelting operators of Mansfeld into
debt. The house fell to Count Bruno II of Mansfeld-
Bornstedt, who razed it and used the lot to build
his town residence and chancery in 1570. Only
the cellars and a few walls of the previous build-
ings remained. Considering this, it is fortunate
that Rinck's house sign survived somehow; it is
the only remaining token of the house in which
Martin Luther passed away. AS

Literature
Stahl 2004, pp. 1 and 77 f. · Stahl 2006 · Stahl
2015

376

376

Cylindrical Jug from Luther's Death House

Late 16th century
Stoneware
H 23 cm; D 13.7 cm
Lutherstadt Eisleben (on loan to
Luther's Birth House in Eisleben), V 471
Minneapolis Exhibition

This jug is the only object to come from the actual house in Eisleben where Luther died, which no longer exists. Only the house sign, which has been preserved (cat. 375), gives evidence of the former building on the marketplace that was built in 1498 and burned down in the early-17th century.

The form and design of the glazed jug, which was made in Waldenburg after 1580, are very similar to those of the Merseburg mug (cat. 396). Starting in the mid-16th century, there was a transition away from round-bellied jugs and towards cylindrical vessels with a higher artistic quality. The reason for this change is the increased appearance of relief decorations in Waldenburg in the final-third of the 16th century, which were attached to the jug using panels, and therefore adhered better to cylindrical shapes. The themes of these decorations ranged from mythical beings to Reformation figures and coats of arms. In most cases, however, the themes were based on scenes from the Bible, as is the case for the jug from Luther's death house. The main decorations are framed by decorative reliefs at the foot and neck of the jug, the structure of which is created using rollers.

On the left side of the handle is an Annunciation scene. The archangel Gabriel, identified by the lily in his hand, points with his right hand at Mary, who is kneeling at a prayer bench, facing the angel. Standing on the bench in front of her, at chest height, is a vase, presumably containing lilies, which is an allusion to Mary's purity. A striking feature is the positioning of the bench in front of the canopy of the bed, creating a perspective effect. The Annunciation is followed by a scene from the Old Testament: after he is swallowed by a monstrous fish and has spent three days inside the creature, Jonah is spit out on a shore which is framed by harbor buildings. This scene, from Chapter 2 of the Book of Jonah, is considered by Christian theologians to have a direct connection to the Annunciation. While inside the fish, Jonah is lost and very close to death. With his salvation, he experiences "resurrection," in the figurative sense of the word, with clear parallels to the story of Jesus being resurrected after his death. RN

Literature
Adler 2005, p. 330 · Horschik 1978, pp. 68–73 · Scheidemantel/Schifer 2005 · Treu 2007, pp. 15 and 17 (ill.)

377

Martin Luther

Der Neüntzigst Psalm. Ein Gepet
Mosi was sterben sey und wie man
dem todt entpfliehe
(Psalm 90. Moses' Prayer on Dying
and how one can escape Death)

Nuremberg: Christoph Gutknecht, 1543
19.2 × 15 cm
Forschungsbibliothek Gotha der Universität
Erfurt, Theol 4° 00224l 01
VD16 L 4532
Exhibition Minneapolis

The commentary on Psalm 90 forms one of
Luther's most significant statements on death, a
topic with which he was perennially preoccupied.
Unlike flora and fauna that die in a natural order,
man's death is brought about through original
sin. Here Luther interprets Moses' dual concep-
tion expressed in the Psalm to both terrify the
unbeliever with the wrath of God, here used as a
synonym for death, but also to comfort the be-
liever through extolling the mercy of God's grace.
Thus, Luther likens death to sleep or a divine
chastisement, and through grace, that is, bap-
tism, the believer is offered redemption.
Luther's lectures on Psalm 90 were among the
final ones he gave at the University of Wittenberg
on anything other than the Book of Genesis. In
fact, Luther specifically focused his final lectures
on this singular Psalm and book of Moses, whom
Luther saw as the key source of divine wisdom
reflected in the prophets and apostles. The
Psalm lectures were offered in the fall and spring
of 1534–1535 and transcribed by Georg Rörer,
Caspar Cruciger, and Veit Dietrich; only Rörer's
manuscript transcription of the lecture still exists
(Jena, Thüringer Universitäts- und Landesbiblio-
thek, Ms. Bos.q.24k, ff. 235r–259v). The first
Latin edition was published in Wittenberg in 1541
as *Enarratio Psalmi XC*, and this German transla-
tion followed two years later. As with Luther's
other publications, the Latin edition was in-
tended for the theological elite while the German
translation was marketable to parish preachers
and secular readers alike. JTM

Sources
WA 40, III, 476–594 [LW 13, 75–141]

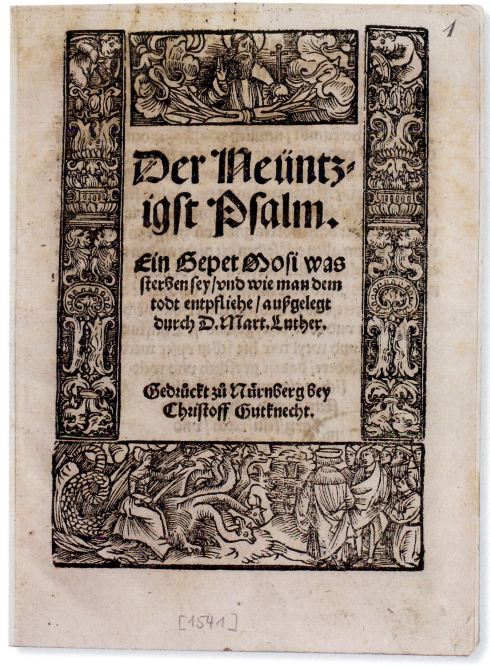

377

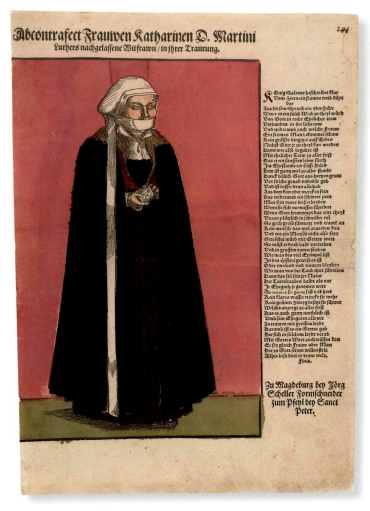

378

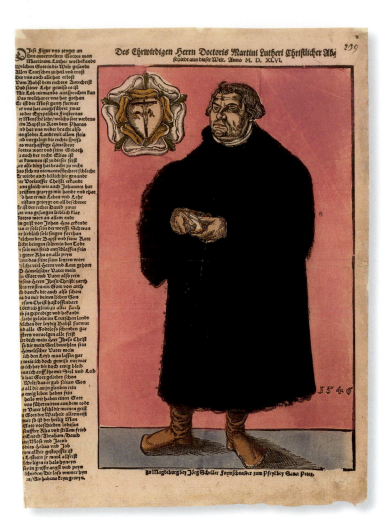

379

Prints Commemorating Martin Luther's Death

Unknown German artist, based on a model from the Cranach workshop
Jörg Scheller (block cutter)

Magdeburg, 1546
Woodcut, colored, typographic text
Minneapolis Exhibition

378

Katharina Luther, née Bora, in Mourning Attire

Sheet: 40.5 × 29.5 cm; image with text: 34.7 × 28.1 cm; image without text: 32.2 × 21 cm
Foundation Schloss Friedenstein Gotha, 38,12

Above the portrait: Abcontrafect Frauwen Katharinen D. Martini Luthers nachgelassene Witfrawn/in jhrer Traurung.
(Portrait of Katharina Dr. Martin Luther's surviving widow in mourning)
To the right of the portrait: Konig Salomo beschreibet klar / Vom Herrn ein fromes weib küpt dar [...]
(King Solomon clearly says / a pious wife is sent by the Lord [...])
Beneath the portrait: Zu Magdeburg bey Jörg Scheller Formschneider zum Pfeyl bey Sanct Peter.
(In Magdeburg at Jörg Scheller block cutter at Pfeyl near Saint Peter's)

379

Martin Luther

Sheet: 40.5 × 29.9 cm; image with text: 36.3 × 28.6 cm; image without text: 34.3 × 21.7 cm
Foundation Schloss Friedenstein Gotha, 38,11

Above the portrait: Des Ehrwirdigen Herrn Doctoris Martini Lutheri Christlicher Abschiedt aus dieser Welt. Anno M. D. XLVI.
(The venerable Doctor Martin Luther's Christian passing from this world. Anno M. D. XLVI.)
To the left of the portrait: DIese Figur vns zeyget an / Den auserwelten Gottes man [...]
(This figure shows us / the chosen of God [...])
Beneath the portrait: Zu Magdeburg bey Jörg Scheller Formschneider zum Pfeyl bey Sanct Peter.
(In Magdeburg at Jörg Scheller block cutter at Pfeyl near Saint Peter's)
In the picture: 1546

These two portrait prints commemorating the death of Martin Luther were produced in the year of his death. The typographic text on the left side of the portrait of Luther describing the Reformer's

blessed death was intended to refute his opponents who claimed that he had died in agony. The pendant to this print depicts Katharina von Bora in mourning attire. She is holding a small book in her hands and wearing a nearly floor-length, fur-trimmed cape over her dress. Her white cap trimmed with a long ribbon extending over her shoulder to the floor is typical mourning attire. The ribbon draped over her mouth is a visible sign of mourning, which "closes" her mouth. The verses printed to the side of the image are based on the Proverbs of Solomon. They call attention to the merits of a good and pious wife, the bond between the two spouses, and the mourning over the loss, when one of the two is called home by God.

The portrait of Katharina as a widow was presumably interchangeable with two similarly colored woodcuts of Philip Melanchthon and Johannes Bugenhagen from the same year, which are also in the print collection of Foundation Schloss Friedenstein. BS

Literature
Hoffmann 2015, pp. 21–24 (ill.) · Schäfer 2010, pp. 64 f. (ill.) · Schäfer/Fydinger/Rekow (forthcoming), cat. 122 and 123 (ill.) · Schuchardt 2015, pp. 135 and 137, cat. 62 (ill.) · Syndram/Wirth/Zerbe/Wagner 2015, vol. 1, pp. 292 and 294, cat. 221 (ill.) · Treu 1999 b, p. 362, cat. 3.0.1 (ill.)

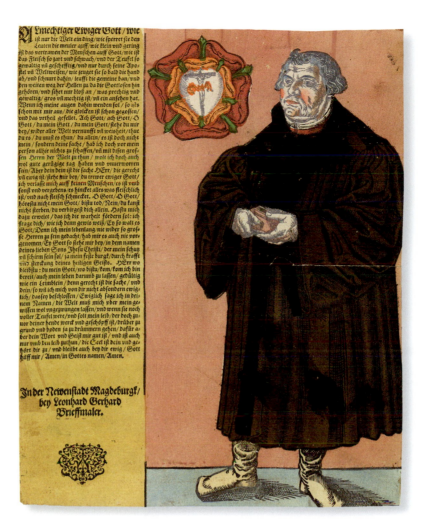

380

380

Leonhard Gerhard
Martin Luther and the Luther Rose

After 1546
Colored woodcut
Image: 33.4 × 26.7 cm
Stiftung Deutsches Historisches Museum, 1990/479.2
New York Exhibition

This depiction of the aged and corpulent Luther, wrapped in a robe and with square-toed boots on his feet, is similar to a smaller woodcut which was published by the workshop of Lucas Cranach the Younger in 1548. Not long after the death of the Reformer, this type of portrait began to establish itself as the standard commemorative picture. His gravestone in the Church of Saint Michael in Jena, which was cast in 1549, shows a similar pose in bronze relief (cf. cat. 384). Another likeness of Martin Luther which is comparable with the one above was produced in 1546 by Jörg Scheller, a printmaker who worked in Magdeburg. It was intended to be the companion to a woodcut image of Katharina Luther in the garb of a widow

(cf. cat. 378 and 379). The printing block cut by Jörg Scheller may well have been reused for a new edition of the commemorative print published by Leonhard Gerhard, an illuminator of broadsheets who worked in Magdeburg some years later. His exact life dates are not known, but two other surviving woodcuts by his hand are dated 1572. The depictions of Luther with his chosen seal, the Luther Rose, are identical on both of the prints, save for the coloration. The caption which Leonhard Gerhard chose, however, differs from Jörg Scheller's version. It appears on the left side of the full-body portrait, and he added his own publisher's signature to it: "*In der Newenstadt Magdeburgk / bey Leonhard Gerhard Brieffmaler* (In the new quarter of Magdeburg / by Leonhard Gerhard, illuminator of broadsheets)." He also omitted Scheller's original caption: "*Des Ehrwürdigen Herrn Doctoris Martini Lutheri Christlicher Abschied aus dieser Welt. Anno M. D. XLVI* (The Christian parting of the honorable doctor Martin Luther from this world)." Incidentally, both printmakers and illuminators of broadsheets were members of the guild of the grocers and minor shopkeepers. These would usually operate small shops where both their own and other publisher's prints were sold alongside diverse trinkets.

The long text which Gerhard placed on the left of the image cites an earnest prayer of the Reformer. In this, he emphasizes his divine mandate to seek for the truth, and justifies his initial reluctance to take a stand against the mighty of the world, but for the explicit command of God: "*O Gott / O Gott / hörestu nicht mein Gott / bistu tod / Nein / du kanst nicht sterben / du verbirgest dich allein. Hastu mich dazu erwelet / das ich die warheit fördern sol: ich frage dich / wie ich denn gewis weiß / Ey so walt es Gott / Denn ich mein lebenlang / nie wider so grosse Herren zu sein gedacht / hab mir es auch nie vorgenommen / Ey Gott so stehe mir bey / in dem namen deines lieben Sons Jhesu Christi / der mein schutz und schirm sein sol ...* (O God, O God, do you not hear me, my God? Are you dead? No, you cannot die; you are merely hidden. Have you indeed chosen me to champion the cause of truth? I ask you, as I know for sure, and as God is my witness, that I have never in my life thought to oppose such mighty lords, nor had I ever schemed to do so. So stand by me, Oh my God, in the name of your dear son Jesus Christ, whom I beseech to be my protector and defender ...)."

As a final embellishment, the Luther Rose is displayed to the left of the Reformer's head, taking

381

382

the place of a personal coat of arms. It had first appeared in 1524 on the title page of Luther's treatise *"Dass Eltern die Kinder zur Ehe nicht zwingen [...] sollen."* The Saxon prince and future Elector John Frederick had presented Luther with a ring bearing this emblem in 1530, when the Reformer visited the castle of Veste Coburg. Ever since, Luther had used this particular design of a rose—which came to be named after him—as a seal on his correspondence. LK

Literature
Oelke 1992, pp. 121–125 · Schuchardt 2015, pp. 53 and 135–137

381

Handle from Luther's Coffin

1546
Iron, wrought
7.7 × 27 × 11.5 cm
Luther Memorials Foundation
of Saxony-Anhalt, K 27
Minneapolis Exhibition

On May 16, 1913, the Wittenberg Castle Church sexton, Römhild, reluctantly handed over a long oval handle with two rings hanging from it, which he had "until then been keeping in the so-called model chamber of the Castle Church Tower." In 1892, when the interior of the Wittenberg Castle Church was being renovated and the floor plates had been removed, he had reportedly taken advantage of the opportunity, secretly and contrary to the express prohibition by Emperor Wilhelm II, to open Luther's crypt with the help of a second man in order to satisfy himself that the grave of the Reformer was not empty. After all, there had been a rumor since the 16th century that Luther's

corpse had been taken away shortly after his funeral to keep it away from the advancing troops of Charles V. It was only after the two men had resealed the crypt and hastily covered up their tracks that they realized that they had neglected to put back the handle, and they therefore decided to keep it. If the handle really came from Luther's crypt, it must have come from the internal wooden coffin, which was enclosed by a tin coffin.

This was not the first time, however, that Luther's grave was opened. Johann Andreas Silbermann, the son of the famous organ maker, reports in his 1742 travel journal that the custodian of the Castle Church told him about how the crypt had been opened a few years before when a new grave was laid in the vicinity. It was reportedly evident at that time that Luther's tin coffin had become heavily corroded. On the other hand, the alleged opening of the grave by the troops of Charles V after they took Wittenberg in 1547 is just a legend. MG

Literature
Meller 2008, p. 308, cat. F 5 · Treu 2008

382

Justus Jonas and Michael Caelius
Concerning the Christian Departure from this Mortal Life of the Reverend Dr. Martin Luther

Zwickau: Wolfgang Meyerpeck, 1546
20 × 29 cm
Luther Memorials Foundation
of Saxony-Anhalt, Kn A 176/1152
VD16 ZV 8748
New York Exhibition

The most important accounts of Martin Luther's death come from the eyewitnesses Justus Jonas and Michael Caelius (or Coelius). These accounts were published in 1546 in *Christian Departure*. Justus Jonas was Martin Luther's closest and most trusted collaborator and friend next to Philip Melanchthon. He had accompanied Luther to the Diet of Worms in 1521 and was appreciated by him as a translator of his works. Martin Luther sent him from Wittenberg, where Justus Jonas worked as a preacher and professor, to Halle in the Archbishopric of Magdeburg as the first Protestant preacher. Halle was the residence of the highest-ranking German cleric, Cardinal Albert of Brandenburg of the House of Hohenzollern. Michael Caelius was the preacher at the Schlosskirche (Castle Church) in Mansfeld.

According to the latest research, Martin Luther died in the house of his friend, Eisleben town clerk Dr. Philipp Drachstedt, on the Eisleben marketplace. We learn from Justus Jonas and Michael Caelius that Martin Luther opted not to take part in the final negotiations between the Mansfeld Counts on February 17, 1546, concerning legal and hereditary disputes, because he was not feeling well. The text gives a detailed report on what Luther did in his final hours, as well as the health problems from which he was suffering. Finally, shortly before his death, Justus Jonas and Michael Caelius asked him whether he was prepared to die trusting in Jesus Christ and to confess his doctrine. Martin Luther answered with a simple "yes," and drifted off to sleep. His face went pale, and his feet and nose were cold. At 2:45 AM, he drew his last audible breath and died peacefully.

Martin Luther was laid out on his bed in a white tunic until a tin coffin could be cast. On the early morning of February 18, Justus Jonas notified Elector John Frederick and the University of the death of Martin Luther. In a letter to the Count of Mans-

feld, the Elector indicated that he planned to bury Luther not in Eisleben, but rather in Wittenberg's Castle Church. At 2 PM on February 19, Martin Luther's body was laid in state at St. Andrew's Church in Eisleben's marketplace, where Justus Jonas preached the funeral sermon. The painter Lukas Furtenagel, a Halle native, was commissioned to create a portrait of the dead Luther. On February 20, Michael Caelius gave the second funeral sermon. After the sermon, around midday, the funeral procession left the city. The two funeral sermons were published together in 1546. AT

Literature
Kunze/Schilling/Stewing 2010, pp. 60 f. · Schubart 1917 · Stahl 2006, pp. 191–216

383

Lucas Cranach the Younger and workshop
Martin Luther

Around 1560–1580
Print assembled from 11 separate woodcuts
135 × 71.5 cm
Luther Memorials Foundation
of Saxony-Anhalt, impfl 5201
Minneapolis Exhibition

This monumental portrait of Martin Luther is composed of 11 separate woodcut prints. The Reformer is shown standing under an elaborate arch, dressed in a long robe with slit sleeves. His hand holds a book, the traditional attribute of scholars, but in this case also an obvious allusion to his own writings, especially the translation of the Bible into German. The lower border of the picture is formed by an empty plaque which was probably meant to hold a caption. The model for this portrait probably came from the Cranach workshop. About half a dozen of these woodcut prints survive today, but they must originally have been much more numerous, especially as they are known to have been reprinted in the 1580s.

The image succeeds admirably in depicting Martin Luther as a larger-than-life personality, not only through the sheer size of the image but through the elaborate architectural frame as well. It is hardly by accident that the folds of the robe of the statuesque Reformer run parallel to the fluting of the columns. Overall, the architecture of the frame resembles contemporary triumphal arches, and the honored parties are easily discerned: The left hand spandrel of the arch displays the Saxon coat of arms, and on the opposite side we find Luther's rose signet.

Luther's portrait is not the only one of its kind; similar images were produced of Philip Melanchthon and Jan Hus. By collecting all of these im-

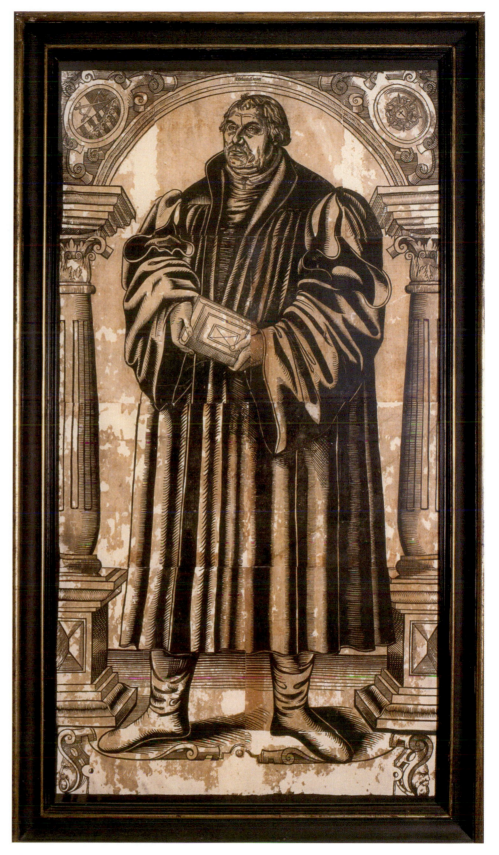

383

ages, one could assemble a small gallery of famous reformers. The series would have fit well among the galleries of ancestors or men of renown that were a popular kind of pictorial decoration from the late Gothic era on. DL

Literature
Enke/Schneider/Strehle 2015, pp. 239–242, fig. p. 243

384

Unknown sculptor,
after Lucas Cranach the Elder
Wooden Model
for Luther's Tombstone

1548
Limewood, polychrome
223 × 111 cm
Evangelische Andreasgemeinde
Erfurt
Minneapolis Exhibition

385

Heinrich Ziegler the Younger
Martin Luther's Tomb Plaque

1548
Bronze, partly colored, on a modern
oak wood kernel
220 × 116 cm
Evangelisch-Lutherische Kirchgemeinde Jena
Not exhibited

Frame inscription: Anno die xviii mensis Febrvary Revendvs Vir Mar/tinvs Lvthervs Theologia Doctor Constanter Etiam [...] Above Luther's head: Annos Amplivs Triginta Pie et feliciter texvisset Corpvs / vero eivs Hic Sepvltvm est. [...]

Elector John Frederick commissioned Erfurt bell founder Heinrich Zieglerto to make a bronze plaque for the grave of Martin Luther in the Castle Church in Wittenberg after Luther's death in 1546. Philip Melanchthon was instructed to compose an inscription for the monument. The full figure of Luther on the grave plaque follows a draft by Lucas Cranach the Elder who had established the life-size full figure portrait for portraits of rulers.
The grave image is comparable with a full figure portrait of Luther also created in 1546 (located in Schwerin), and a woodcut from the same year (cf. cat. 379). The wooden model and final grave plaque present this figure of Luther in mirror image. Luther is standing in his vestment, an academic gown. He is facing to the right, looking into

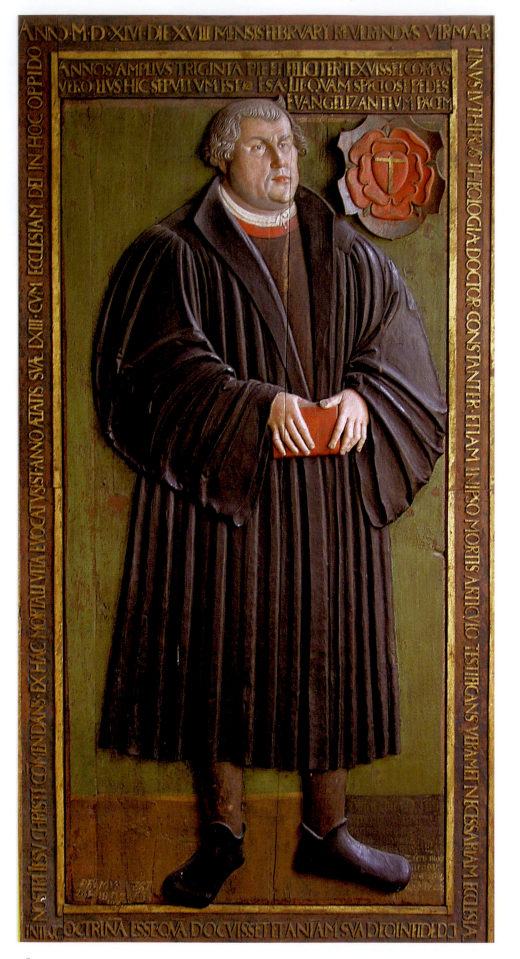

384

the distance and holding a book in his hands. Luther's coat of arms with the Luther Rose is at the top left (in the wooden model top right). One of the inscriptions is above his head and the other runs around the frame of the plaque. In addition to these inscriptions, which were also repeated in the cast, the wooden model includes a third block of text in Gothic script next to Luther's left foot.

The cast was completed in 1548, but because of the Protestant defeat in the Schmalkadic War, the Ernestines, as well as losing the electoral privilege, also lost land (the Electorate of Wittenberg) to their Albertine relatives. Therefore, the grave plaque was not installed in its planned place. Whilst in captivity, John Frederick managed to make arrangements for the grave plaque to be brought to Wittenberg. However, his sons decided to take it to Weimar in order to keep the memorial away from Maurice of Saxony, who had already attempted to buy it from the bronze founder Ziegler. After the bronze plaque had been stored in Weimar for some time, it came into the possession of the University of Jena through Duke John William and was displayed in St. Michael's Church in Jena.

The wooden model remained in Erfurt and was in the possession of the Hornung family. It has been displayed in the St. Andrew's Church since 1727. Generally, impressions for the sand or clay casting molds (necessary for casting bronze) were made using such carved models. The Erfurt wooden model of Luther's grave plaque is not only special because of its history, but also because such pieces are seldom found today. Only Luther's coat of arms is still colored on the bronze plaque. It was probably once more fully painted, resembling the color pattern of the wooden model. The latter's coloring comes from the 17th century but probably follows an older scheme.

The kind of bronze grave piece that John Frederick commissioned for Luther's burial place was like those usually reserved for higher nobility. The plaque employs the statesmanlike style of representation and is made from a precious metal. The location of Luther's grave in the choir of the Castle Church of Wittenberg, immediately next to the graves of rulers, was more than unusual for civilians like Luther. Therefore it makes sense to talk of Luther's grave setting being a "posthumous ennobling" by the Elector. SKV

Literature
Gutjahr 2008, pp. 306 and 309, cat. F 3 (ill.) · Hallof/Hallof 1992, pp. 41–44 · Schäfer 2010, p. 65 · Schuchardt 2015, p. 135, cat. 62 · Slenczka 2010 · Slenczka 2015, pp. 239–242, cat. nos. 2/10, 2/11, 2/12

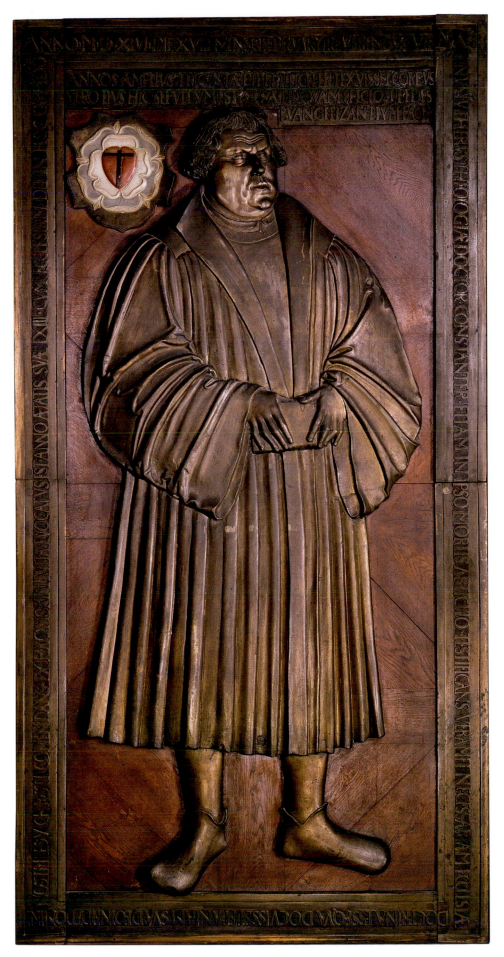

385

In Memory of Luther: Museum, Memorial and Relic

The commemoration of Luther began immediately upon his death when Justus Jonas's report of his final hours and several funeral sermons were published. One reason for this rapid reaction was the anticipation of rumors that Luther had been taken by the devil. Lukas Furtenagel drew the Reformer lying in state, which became the model for numerous death portraits produced by the Cranach workshop. A death mask was also taken, a wax cast of which is still preserved in the Market Church in Halle.

Luther's death place in Eisleben, the house at Markt 56, was marked with a memorial plaque and select visitors were allowed to view the deathbed and mug. Some "fans" would cut chips from the bed as souvenirs or to use as a miracle cure for toothache. This practice eventually came to resemble a pilgrimage, and the excessive idolization led to the burning of these relics in 1707.

While the house he died in has not survived, the rooms used by Luther in Wittenberg, Wartburg Castle and Veste Coburg are all important memorial sites. The sitting room in the Luther House was left as it was immediately after the Reformer's death. By the 17th century, it was called the Museum Lutheri. Today, it is known as the *Lutherstube* (the "Luther Room") and still contains furniture from Luther's time. The room Luther stayed in at Wartburg Castle was already called the *Dr. Martinus Stube* ("Dr. Martin's Room") in 1574. It is particularly famous for the ink stain on its wall, supposedly caused by an inkwell that Luther threw at the devil.

Sadly, both of these sites have been disfigured by visitors who left graffiti on the walls and furniture. Chips cut from the tables used by the Reformer became popular souvenirs, leading to the eventual loss of the table in the Wartburg room. Other items owned by the Reformer became objects of reverence. These include not only rings, mugs and clothes, but also the many letters and manuscripts that he wrote. The wooden objects carved from the wood of "Luther's Beech Tree" near Altenstein were revered for having an (indirect) association with the Reformer. Today, these mugs, reliefs, sculptures and other artifacts form a distinct group of memorial objects apart from "authentic" Luther relics.

The Luther memorial sites became tourist attractions in the 19th century. This trend, that continues today, has produced a mass of material paraphernalia and typical "tourist" souvenirs that are ironically popular today.
SKV

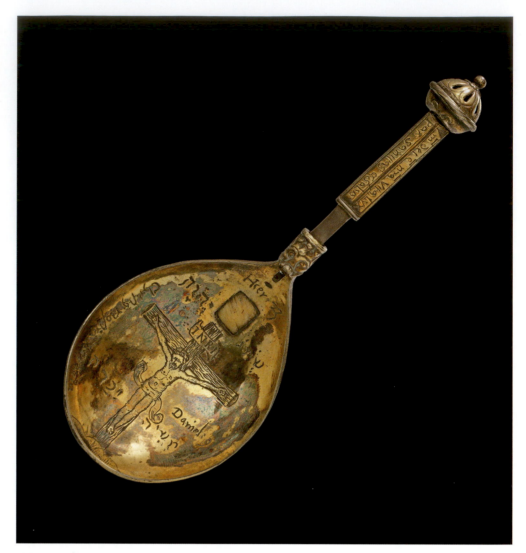

386

386

Martin Luther's Folding Traveling Spoon

Germany, 1st-quarter of the 16th century
Silver, gilt, without markings
L 13 cm; width of bowl: 4.5 cm
Wartburg-Stiftung Eisenach, KB0039
Minneapolis Exhibition

This spoon, with its large oval bowl and short angular handle, is typical for a traveling spoon at the time around 1500. Unlike today, it would have been held in a closed fist. The handle can be folded towards the convex side of the bowl, and the hinge can be secured by a pin mechanism, which here has the shape of a devil's head. The terminal knob of the handle is hollow, and it may once have been used for the storage of perfumed substances. The bowl is engraved with a Crucifixion scene and the legend "INRI." A square piece of horn is fitted into the bowl above this image. It was supposed to come from the fabled unicorn and offer protection against poisoning.

The outer surface of the bowl and the four sides of the handle bear Hebrew and Latin inscriptions: "The Lord is our justice / The Messiah will descend from Heaven/ Christ is our salvation / The word of God is our life, light, peace, health and salvation / The bread of heaven protects us and overcomes hell / He delivers the sons of God with supreme wisdom / If God is with us, who shall stand against us."

The spoon was given to Johannes Caspar Aquila (Adler) by Luther. A good friend and a collaborator in the translation of the Old Testament from 1524 to 1527, Aquila was indispensable in Luther's circle as an expert on Hebrew. He would go on to serve as a minister and superintendent in the town of Saalfeld. When he died in Schmalkalden in 1560, he left behind this former gift, which would later be owned by Emperor Wilhelm II and then donated to the collection of Wartburg Castle.
GS

Literature
Amme 1994, p. 37 (ill.) · Krauß/Schuchardt 1996, p. 230, cat. 172 (ill.)

387

Luther's Beer Mug

1st-half of the 16th century
Root wood, turned, silver rims, 1694
H 15.5 cm; D 11.2 cm
Luther Memorials Foundation of Saxony-Anhalt,
K 4a
Minneapolis Exhibition

"He who loves not wine, woman and song remains a fool his whole life long." Like the beer mug, this verse was attributed to Luther only after his death. In the case of the beer mug, the legend has undergone a large number of additions and embellishments. It comes as no surprise that this supposed verse of Luther's only dates back to the 19th century, the century in which the veneration and romanticization of Luther was at its high point.

This mug was transformed from an ordinary object into a "relic" in the year 1694 by the addition of silver rims at the foot of the mug and a hinged lid with thumb rest by the unknown P. B. Erfurth, to whom the engraving at the foot of the mug refers. Regardless of whether the mug can be ascribed to Martin Luther or his immediate environment, it was declared to be an object associated with Luther because of the inscription which has been added to the inner and outer edge of the lid. "God's word: Luther's teaching will not pass away on this or any other day" is written on the lid next to a portrait of Luther. The engraving on the outer edge of the lid reads as follows: "The late Mr. Luther used this jug at his table in Eisleben." Striking features of the mug include the acanthus pattern which adorns the edges of the rims and the empty crest which is engraved on the back side of the handle.

It seems possible that Luther or his guests may have used the tankard in view of the fact that drinking vessels came into increased use immediately after Luther's wedding with Katharina von Bora and the expansion of the old convent starting in 1525. His table talks with like-minded individuals meant that such tankards were used more and more on such occasions. Despite his criticism of degenerate alcohol consumption in the ruling houses, Luther would every now and then partake of beer which was brewed by his wife, as it helped him with his morning stool.

It may even be that Martin Luther made this jug himself. There is evidence that Luther ordered wood turning tools from Nuremberg in 1527 and that he even tried his own hand as a turner. It may be that his work found its way into the family household. Did he or didn't he? This question cannot be answered with certainty, but the idea that Luther himself might have held this mug in his own hands, or that he might have actually made it himself, helps us understand why this object was valued so highly as a "relic" through the years. RN

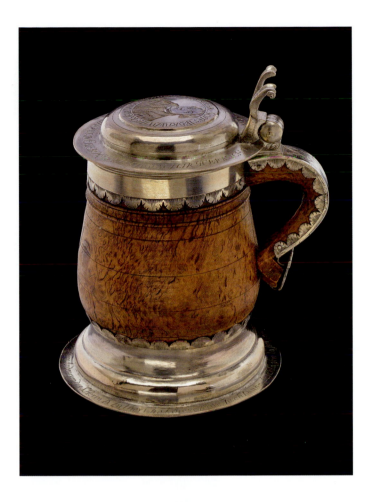

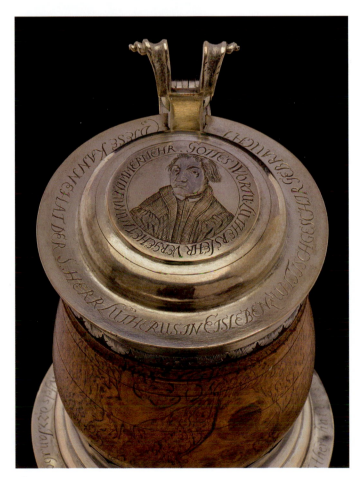

387

Literature
Joestel 2008, pp. 108 f. · Meller 2008, p. 316,
cat. F 17 (ill.) · Treu 2010, pp. 91 f. and 112 (ill.)

388

Swan Figurine

Eisleben, Hallesche Straße 4
17th century
Pipe clay
3 × 5 × 2.3 cm
State Office for Heritage Management and
Archaeology Saxony-Anhalt
State Museum of Prehistory, HK 1034:84:207
Minneapolis Exhibition

This small damaged pipe clay figure of a swan,
which is missing both its head and feet, was
found during excavations among the stones of a
17th-century gravel pavement in the courtyard of
the house adjacent to Martin Luther's birthplace
in Eisleben. Pipe clay figures of saints, like the
one found in the Luther household in Mansfeld
(cf. cat. 5), were commonplace in 16th and 17th
century Europe. They were produced in the thou-
sands as cheap souvenirs for pilgrims or as chil-
drens' toys. A swan figure is, however, hardly a
pilgrim's souvenir, and as it would have wobbled
on its small foot, this clay swan would have been
hard to play with. The swan does, however, play
a very important role as a symbol of Martin Lu-
ther. In the early 16th century, it was thought that
the 15th century Czech reformer Jan Hus (literally
John Goose) had mocked his executioners on his
way to the stake by saying "Today you will roast
a lean goose, but a hundred years from now you
will hear a swan sing, whom you will leave un-
roasted." This swan was soon associated with
Luther by his disciples but also, as quotes from
his table talks show, by the Reformer himself.
Hus, they thought, had prophesized Luther's suc-
cessful rebellion against Rome. After Luther's
death, the swan played an increasingly import-
ant role in Protestant iconography as the Reform-
er's symbol. At the same time, Luther's birth
house in Eisleben became a focus of Protestant
pilgrimage and would become Germany's first
historical museum. It seems highly likely that this
swan figure may have been made as a Lutheran
souvenir and sold to pious visitors, much like the
mementos of pilgrimage that Luther so utterly
rejected. LN

Literature
Matthes 2008, p. 89, fig. 9 · Meller 2008,
pp. 324 and 326, cat. F 35

388

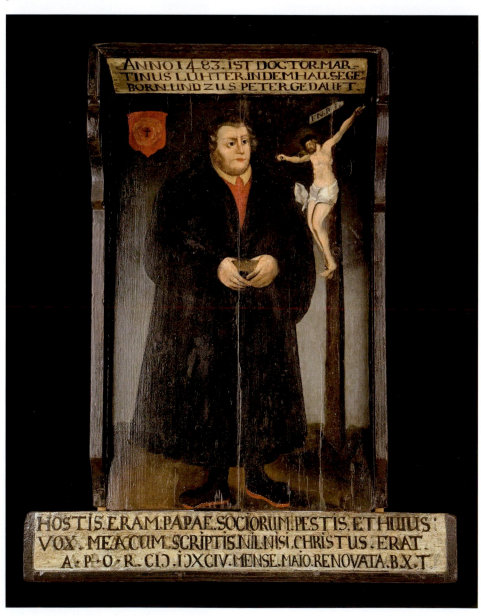

ANNO 14_83. IST DOCTOR.MAR-
TINUS LUHTER. INDEM HAUSEGE-
BORN.UND ZU S. PETER GEDAUFT.

HOSTIS. ERAM. PAPAE. SOCIORUM. PESTIS. ET HUIUS.
VOX. MEA CUM. SCRIPTIS. NIL NISI. CHRISTUS. ERAT.
A. P. O. R. CIƆ. IƆXCIV. MENSE. MAIO. RENOVATA. B.X. T

389

389

Unknown artist

"Unburned Luther"

1583
Oil on wood
99 × 55 × 14.5 cm
Luther Memorials Foundation
of Saxony-Anhalt, GH 2238
Minneapolis Exhibition

This painting depicts the Reformer standing dressed in a long black robe. A bit of color is added to the somber appearance by the red garment worn under the robe and the reddish brown soles of his shoes. His gaze is directed into the distance. To the right stands a crucifix.

The Luther Rose appears in the upper left hand corner. Martin Luther had used this signet to seal his correspondence since 1530, and he described it as the symbolic representation of his theology ("*Merkzeichen meiner Theologie*").

The picture was originally painted in the second-half of the 16th century as a decoration for the facade of Luther's birthplace. The protruding ledge on top was meant to protect it from rain in this exposed position. This ledge also bore a caption on its underside, where it would have been easier to read for a passer-by on the narrow street below. The inscription reads: "In the year 1483 Doctor Martinus Luther was born in this building and baptized at Saint Peter's (*Anno 1483 ist Doctor Martinus Luther in dem Hause geboren und zu S. Peter gedauft*)." A second wooden panel records a restoration made in 1594 and bears a Latin text that briefly summarizes Luther's achievement: "I was the enemy of the Pope and a pest unto his associates, my words, derived from scripture, were nothing but Christ himself (*Hostis eram Papae sociorum pestis et huius vox ea corum scriptis nil nisi christus erat*)."

The picture was removed in the 1680s. A short time afterwards, a fire raged through the town and destroyed the building. Its owner was heard to remark that the house might still be standing if the image had only been left in place. Quite obviously, she was assigning some kind of protective power to the picture of the revered Reformer. The building itself was eventually rebuilt as a school for the town's poor. But the picture of Luther was to experience, in the years to come, a story of its own as the sole surviving remnant of Luther's birthplace. The simple fact that the image had survived the conflagration evolved into a pious legend in which the picture had withstood the raging flames, which had been unable to harm it.

This version of the story was spread as early as 1718 by the Eisleben priest Justus Schoepffer in a book that was appropriately titled, "The Unburned Luther." It drew a comparison between the legend of the picture and the actual life and works of the Reformer: Just as the writings of Luther had been preserved from destruction by fire and the man himself had escaped being burned at the stake thanks to the grace of God, so did his image survive unscathed in the fiery inferno. Schoepffer attempted to support the credibility of his story by citing a large number of images about which similar stories had been told. While he was forced to turn to Catholic examples in order to find his reference material, he nevertheless managed to establish the Eisleben image of Luther as their Protestant counterpart. DL

Sources and literature
Neser 2009, p. 90 (ill.) · Schoepffer 1765 (ill.)

390

Unknown artist

Wooden Chalice, so-called
"Luther Chalice"

Altenstein/Thuringia, 19th century
Beechwood, turned, partially polychromed
H 25 cm (with cover); D 10 cm (base), 10 cm (cover)
State Office for Heritage Management and Archaeology Saxony-Anhalt
State Museum of Prehistory, HK 8202:1:1
Minneapolis Exhibition

Inscription under the cup: Aus Luthers Borne zog ich Saft. Zieh Du aus seinem Worte Kraft
below: Altenstein, den 18ten Juli 1841 (From Luther's spring I drank at length. Now you from his words draw strength)
below: Altenstein, den 18ten Juli 1841

The cup and base plate of this chalice-like vessel were made from a broad, bark-covered section of a tree, and the cover is also made from this material. The cup and base of the chalice, which are clearly composed of several pieces fixed together, are joined by a profiled stem. Both the base plate and the cover, which is equipped with a turned knob, are covered with a white substance that is meant to suggest moss or lichen. The aforementioned inscriptions can be found in black script on the two smooth bases of the cup. According to the inscription, the wood for the chalice comes from the Luther beech tree near Altenburg, which supposedly "witnessed" the feigned attack and kidnapping of Luther in 1521 when he was taken to Wartburg Castle. In the 19th century, at the latest, the tree and the nearby spring ("Luther's spring") in Glasbachgrund near Altenstein Palace in Thuringia became a popular vacation destination for Protestants. However, the Luther beech tree was torn apart by a hurricane-like storm during a solar eclipse on July 18, 1841. Duke Bernhard of Saxe-Meiningen donated the wood from the tree to the church in Steinbach and decreed that the wood may not be used for firewood, but must instead be processed in such a way as to commemorate the Reformer. Wood-turner Carl Munkel from neighboring Liebenstein was the only one authorized to make the popular "Luther tree items" from this wood, which were disseminated all over Europe "as sticks, cups, chalices, needle boxes, salt jars, inkwells, napkin stands, rulers, knitting drums, knitting caps, cans, boxes for women's items, etc." Even the leaves from the tree were dried and framed and placed on display in the Protestant church's parlor. However, relatively few of these Luther items have been preserved. Today, these items are predominantly kept at Veste Coburg and by the Luther Memorials Foundation of Saxony-Anhalt. A chalice very similar to the Halle chalice, with the identical verse but without an inscription indicating the place and date, is in the possession of the pastor's office of the Evangelical Lutheran church in Möhra. MG

Literature
Joestel/Strehle 2003, pp. 45 f. · Meller 2008 · Seib 1996, pp. 123–131, particularly p. 128, cat. 5

390

391

Wood Chip from a Plank of the Luther Room and Accompanying Note

16th century; paper: early-20th century
Wood, paper, yarn
Sliver: 3.2 × 0.25 × 0.1 cm; accompanying note:
13 × 9 cm
Luther Memorials Foundation
of Saxony-Anhalt, K 729a, K 729b
Minneapolis Exhibition

The adoration of Luther has borne some strange fruit. Aside from a large number of objects owned by Luther, both genuine and fake, the demand for Luther memorabilia was almost reminiscent of the veneration of saints as even the smallest objects enjoyed great popularity, particularly in the 18th and 19th centuries, such as ink blots allegedly made from Luther's inkwell, ragged pieces of the Wartbug Castle or Luther's room in Wittenberg, and even splinters of wood from the furniture and wood paneling of sites relevant to Martin Luther. For example, Johann Georg Keyßler reports in his "Neusten Reisen" [Recent Travels] of the belief among visitors to Luther's Death House in Eisleben that toothpicks made from Luther's death bed could cure tooth aches. He refers to Swedish mercenaries who followed this practice in the course of their occupation of Eisleben in the Thirty Years' War.

The "tradition" of visitors to Luther sites taking pieces of wood as souvenirs, a practice which has endured to this day, is demonstrated by a wood chip taken by an American tourist in Wittenberg, which has only recently emerged. A teacher at the Ogontz School for Young Ladies in Philadelphia, who is not identified by name, apparently took this small piece of wood during a visit to Europe in the early 20th century and brought it back to the US as a valued souvenir. The homemade envelope in which she kept the wood chip, sewed in with a piece of yarn, bears the inscription, "From floor near Luther's table Wittenberg." MG

Literature
Keyssler 1776, pp. 1117 f. · Laube 2011, pp. 216 f.

391

392

392

A Stove Tile with a Portrait of Martin Luther

Central Germany, around 1540 to 1560
Earthenware, green lead glaze
17 × 17.4 × 4.4 cm
Stiftung Dome und Schlösser in Sachsen-Anhalt, Kunstmuseum Moritzburg Halle (Saale), MOKHWKE00095
Minneapolis Exhibition

As reverence for the Reformer spread, it began to influence even the decoration of homes and mundane everyday articles, such as this surface stove tile. It depicts Luther in half profile and was probably made after the Reformer's death. The nearly rectangular tile is framed with a contoured border. The bust portrait itself is placed on a disc surrounded by an acanthus frieze that gives it the appearance of a medallion. The corner spandrels are filled with ornamental foliage. The inscription, "MARTNIV(S) / LVTER," runs parallel to the inner circumference of the medallion to the left and right sides of the bust. The portrait of Luther is slightly turned to the left in half profile, and his right shoulder protrudes from the background.

This type of portrayal of the Reformer in half profile and dressed in a robe and beret is reminiscent of the medallions made by Wolf Milicz, a type cutter who worked in St. Joachimsthal, a town in the Erzgebirge (Ore Mountains) region. The basic design of these images was, in turn, copied from the woodcuts of Hans Brosamer, which had found widespread distribution in central Germany. These again followed the portrait type established by Lucas Cranach the Elder in the early 1530s (cf. cat. 232). All of these images depict Luther in half profile, with a rounded, almost portly face, the characteristic wrinkles on his brow and a straight, small mouth.

The tile shown here was long thought to be a work of 19th-century historicism, but closer inspection revealed technical details that fully prove its 16th-century provenance. Identical examples of this type of tile have been documented in archaeological excavations. The examples found on Lot 8 of the Hainstraße in Leipzig, for instance, differ only in the floral ornaments of the corners. Overall, it is highly probable that this type of tile began to be produced shortly after Luther's death in 1546. This would place it among the earliest commemorative images of the Reformer to be produced by artisans. PJ

Literature
Kluttig-Altmann 2015 c, p. 13, fig. 1

393

Martin Luther

HaußPostilla. Uber die Sontags und der fürnemesten Feste Evanglie, durchs gantze jar (Sermons for Home)

Wittenberg: Johann Krafft the Younger, 1591
Paper, gold-embossed leather binding
33 × 21.5 cm
Forschungsbibliothek Gotha der Universität Erfurt, Theol 2° 336/2, front cover
VD16 L 4876
Minneapolis Exhibition

Among Luther's most popular devotional writings was his collection of exemplary sermons interpreting the Gospel and Epistle readings prescribed for specific Sundays and feast days of the liturgical year. Luther began composing the sermons during his stay at the Wartburg Castle in 1521/22. The book served pastors as a basis for their own sermons and was popularly used for private meditations at home up until the 17th century. Luther himself considered it his "very best book" ("allerbestes Buch"). Duke Frederick William of Saxe-Weimar ordered this copy with colored illustrations for his ten-year-old daughter Dorothea Sophia, who later in life was the administrator of Quedlinburg Abbey. A large number of colored broadsheets form an appendix. They include among other motifs portraits of Saxon princes, demonstrating a direct lineage from the early Medieval Germanic leader Widukind († about 807) to Elector Christian I (†1591), as well as portraits of 16th-century Lutheran theologians. The gold-embossed leather binding, most likely a work by Hans Krüger in Wittenberg, is colored in equal detail. It presents the symbiotic duo heading the Wittenberg Reformation in full-length portraits with Martin Luther on the front and Philip Melanchthon on the back. Each is holding an open book, but due to the painting, the words are no longer legible. From other existing books which were decorated with these same plates we know that the book in Melanchthon's hands contained his personal motto: "*Si deus pro nobis quis contra nos* (If God is for us, who can be against us, Rom. 8:31)." Inscribed in the book Luther is holding were the words: "*Pestis eram vivens moriens ero mors tua papa* (When I was alive, I was your plague; when I am dead, I will be your death, Pope)." On the verge of dying in 1537, Luther stated that these words should be written on his grave. The chosen words reflect the fact that the reformers were constantly engaged in bitter conflicts during their lives. DG

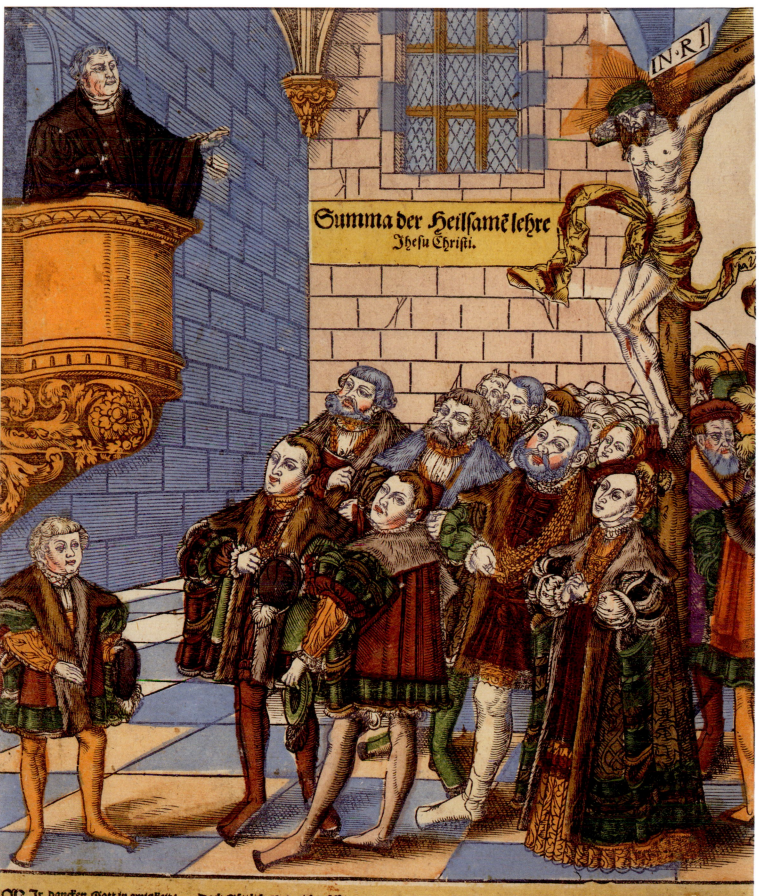

Summa der Heilſamẽ lehre Jheſu Chriſti.

Jr dancken Gott in ewigkeit/
Das er aus allem hertzeleit.
Vns hat gefürt durch seinen Son/
Welcher iſ͘ ꝛer gnaden trohn.
Die Sünd v̄ ꝛer Gottes zorn/

Doch Göttlich gnad viel gröffer war/
Die hat sich ausgegoffen gar.
Drumb hat Gott seinen Son gesandt/
Der faffet vns fein bey der handt.
Vnd fürt vns aus der Sünden reich/

Es koft in warlich auch sein Blut/
Das leschet er aus der Hellen glut.
Wenn er zu vns nicht kommen wer/
So hülff vns kein werck nimmermehr.

Ort zu in diesem Gottes ꝛ
Ich theil euch hie das abla
So hört mir zu v̄ ſchweiget ſ
Welcher Menſch ſelig werden n

400

Floral Verdure with Exotic Birds

Flemish, presumably Bruges, around 1530
Linen (warp), wool, dyed (weft), woven
81 × 186 cm
Stiftung Dome und Schlösser in Sachsen-
Anhalt, Kunstmuseum Moritzburg Halle (Saale),
MOKHWTE 00093
Minneapolis Exhibition

This tapestry is a rare surviving example of the precious Gobelin tapestries frequently imported from Flanders to central Germany. Cardinal Albert of Brandenburg, who resided in Halle, also had these sumptuous luxury goods, which were prevalent throughout Europe, imported in large quantities particularly between 1520 and 1532.
The realistically woven plants with fine gradations of color are reminiscent of work from Anton Segoon's atelier in the second-quarter of the 16th century. Albert's two "Brandenburg Tapestries" housed in the Bischöfliches Dom- und Diözesanmuseum in Mainz resemble this verdure most. Dutch tapestries from Enghien and Oudenraarde, frequently enlivened with animals, furnish stylistic comparisons as well. Such floral scenery evolved out of the floral backgrounds of late medieval figural tapestries. Flowering shrubs became established as an independent visual theme as is evident on Duke John William of Saxony's verdures in Wartburg Castle or Archbishop of Salzburg Matthew Lang of Wellenstein's heraldic tapestry.
Five flowering shrubs grow above a lawn before a dark green ground. The stylized flowers have been identified as carnations, poppies and South American *Alstroemeria*. Exotic birds and butterflies flutter among the shrubs. The rose-ringed parakeets and the sunbirds from western Asia have typical features. The butterflies are probably whites. The surrounding border displays a flower pole around which two colored ribbons are entwined.
A second piece of the tapestry cut off later has survived, which pictures a bowl of fruit in the flowering shrubs. Parrots or parakeets and snails are woven between strawberries, daisies and lilies of the valley. The two sections of the tapestry no longer fit together seamlessly. A center section with the client's arms has presumably been lost. The dimensions of the surviving sections, with a total length of 3.26 meters, allow no other conclusion than that they originally served as a wall hanging. Verdures were more than merely room decorations that created a cozy atmosphere. They also symbolized their owners' sophistication. A biblical meaning (Matt. 6:24–34) cannot be ruled out since the gorgeous flower nourishing the bird was considered to be particular praise of God. This is consistent with the new

Traces of the Reformation

JÜRGEN GRÖSCHL

"Planting a Garden to Make the World a Better Place"

Francke Foundations in Halle and the Emergence of the Lutheran Church in America

"Planting a garden from which one can expect a real improvement in all classes in and outside of Germany, and even in Europe and all other parts of the world," was the title of a project formulated by August Hermann Francke, in which he lays out and summarizes his plan to reform the whole world from his base in Halle. August Hermann Francke, a professor of biblical languages at the new University of Halle and a preacher in Glaucha, a suburb of Halle, founded a school for the poor in 1695 and, at the same time, he began providing for children without fathers (fig. 14). At first Franke had no major source of income or any capital, yet he developed complex social and pedagogical innovations that quickly attracted attention because of their modern conception. Within a very brief time, another city started to grow before the gates of Halle, at the center of which was the orphanage and a complex system of boarding schools. This school complex in turn incorporated businesses, bakeries, ale houses, a hospital and agricultural enterprises, all of which served to provide for the needs of the growing community. Libraries, public collections, astronomical observatories and a botanic garden were established for the schools, and the first Bible college in the world was founded here. The entire complex was later named after Francke. Attracted by the modern educational philosophy and Christian ideals of education that were widespread in the Francke Foundations and in the university, students from all over Europe streamed into Halle at this time. The numerous school, residential and commercial buildings on the foundation grounds provided space for more than 2,000 people to learn, teach, work and live (fig. 15).

The driving force behind this tremendous undertaking was the reformist impulse of Pietism, the most significant European Protestant movement since the Reformation, which set out to reform the Christian Church from the ground up. A deeper, more heart-felt piety, better education and the moral elevation of society were the fundamental demands expressed by Philipp Jacob Spener, who is considered to be the father of Lutheran Pietism, in his *Pia Desideria,* a small manifesto published in 1676. Francke, who was a close friend of Spener, became one of the most important proponents of Pietism. He was responsible for forming the "Halle" strand of Pietism, which was distinguished by its vigor and sustained focus on practical matters. The graduates

Fig. 15
Gottfried August Gründler,
the Francke Foundations · circa 1730

of the foundations went to work in many countries in many different fields within the spheres of religion, science, economics and engineering. The foundations had a web of connections extending to Scandinavia, the Baltic States and Russia, as well as Holland, Italy, Poland, Bohemia, Hungary, Switzerland and Great Britain. The first missionary undertaking in the history of the Protestant Church, the Danish-Halle Mission, left in 1706 bound for Tranquebar in southern India. These worldwide connections were supported and enabled by a widespread communication and information network.

Fig. 16
Johann Jacob Haid · John Martin Boltzius
(mezzotinto after a painting by Jeremias Theus),
1754

As a result, it can come as no surprise that Francke was also interested in the New World. After all, it was only a few years before his appointment in Halle that religious refugees founded the first German settlement in America at Germantown, which is now a suburb of Philadelphia. Since the early 1690s, Franke had been receiving information from the emigrants about conditions in Pennsylvania and Virginia and had been discussing the subject with Spener and other interested parties. He presented those traveling to America with extensive and detailed questionnaires that clearly indicate that his intention was to extend his reforming efforts overseas. He also cultivated new contacts: Francke took up a lifelong correspondence with the leading New England theologian Cotton Mather in Boston. The importance that he attached to his relationships with co-religionists across the Atlantic can be seen from a remark he made to his colleagues: "After all, the good ideas that we have exchanged will spread through all Christian congregations in America." Through Francke, the members of the Danish-Halle mission in India entered into correspondence with Mather, who was himself engaged in proselytizing to the North American Indians. In this way, an exchange of ideas developed in the first decades of the 18th century that spanned three continents. Francke also did not fail to provide practical assistance: Halle supported the emigrants from the Palatinate who had left their homeland *en masse* beginning in 1709 to settle in America by soliciting donations and above all by sending books.

Due to political circumstances, it was not until the next generation, under Francke's son and successor Gotthilf August Francke, that the Pietists were able to have a direct and formative impact on the Lutheran Church in North America. The radical expulsion policy of Archbishop Leopold Anton von Firmian resulted in the mass migration of more than 20,000 Protestants from Salzburg starting in 1731. This turn of events set all of Evangelical Europe in an uproar. The vast majority of the refugees found a new home in what was then East Prussia. Through the good offices of the Augsburg theologian Samuel Urlsperger, who was a close ally of the Halle Pietists, permission was obtained to settle a group of Salzburgers in the recently founded American colony of Georgia. In order to provide them with spiritual guidance, Urlsperger turned to Gotthilf August Francke to request suitable candidates. The latter appointed John Martin Boltzius (fig. 16) as pastor and Israel Christian Gronau as catechist for the future Lutheran congregation in Georgia. Boltzius and Gronau had worked in various institutions of the Francke Foundations during their studies in Halle and subsequently and had been influenced by those reformist ideas.

After a difficult voyage lasting almost two months, the emigrants finally reached the port of Savannah, at that time the capital city of Georgia, on March 12, 1734. That date is celebrated to this day by the descendants of the Salzburgers, who together formed the Georgia Salzburger Society, as marking the birth of the Lutheran Church in Georgia. After initial difficulties in choosing a location, the settlers were assigned a spot on the banks of the Savannah River, about 40 km northwest of Savannah, which they called Ebenezer ("stone of hope"). Despite numerous troubles, they built homes and planted crops. Boltzius and Gronau guided their community for the rest of their lives, not only in spiritual matters but in worldly affairs as well. Boltzius in particular, with his patriarchal personality, was able to give the community a Pietist stamp. He served as a pastor, educator, teacher and "orphan father;" in his negotiations with the leading officers of the colony, he proved to be a skilled politician when it came to representing the interests of his community, which with new additions had grown to over 1,000 people. He also proved capable when it came to directing the economy of

the settlement, developing far-reaching commercial projects and maneuvering Ebenezer into a leading position in Georgia's economy through the construction of grist- and sawmills, as well as a silk industry. He treated the indigenous Creek Indians with respect, and he decisively rejected slavery.

The Ebenezer orphanage, founded in 1737 and modeled after the orphanage in Halle, is considered to be one of the first orphanages on the American continent. It served as the model for the Bethesda Orphan Home, which was built in 1740 in Savannah by George Whitefield, one of the founders of Methodism. Also exemplary were the regular classes, in which up to 100 children took part, among them the first governor of the independent Georgia, John Adam Treutlen. It was the will of the individuals in Europe who were responsible for the community that Ebenezer should become a "New Jerusalem," whose light would shine on America's spiritual darkness. As a result, it was given generous material and financial support. Above all, the Francke Foundations sent medicine from their own pharmacy, Bibles, hymnals and Christian literature, as well as fabric to make clothing and personnel, including an urgently needed physician. The pastors in the community sent back detailed reports to Europe, which were printed in edited form and distributed to friends and potential donors. To the modern reader as well, these reports paint a vivid picture of life in colonial America in the 1730s to 1760s.

After Boltzius died, however, the settlement began to lose its spiritual cohesion. During the War of Independence, the settlement was repeatedly harried by opposing troops, and Ebenezer was unable to recover from the wanton devastation. Nevertheless, the Jerusalem Church, completed in 1769, is one of the few buildings in colonial-era Georgia that survive to this day, and it is currently home to the oldest continuing Lutheran congregation in the US. A reconstruction of the orphanage is now a museum and various monuments in the immediate vicinity and in Savannah testify to the accomplishments of the Salzburg immigrants and their spiritual leaders.

The situation in Pennsylvania was very different from the situation in the young colony of Georgia. In the three decades between 1726 and 1755 alone, more than 40,000 Germans settled in this colony, and by mid-century there were 60,000 German-speaking residents in all, making up almost half of Pennsylvania's total population. To be sure, there were adventurers and soldiers of fortune among these emigrants, and here and there were some shady characters who came to the New World to escape punishment for their crimes. People of this description shaped the European impression of the migrants. However, most of the emigrants were driven by a combination of economic, political and religious reasons to seek a new life for themselves far away from home. Pennsylvania seemed to many to be a desirable place for settlement, since it guaranteed a strict separation between the temporal and religious spheres and allowed freedom of religion for all Christian denominations. This freedom offered Lutheran immigrants extensive possibilities when it came to determining the practice of their faith and the organization of their congregation. But the result was that pastors, who needed to earn a living, were completely dependent on their congregations; those who displeased their congregations could be dismissed at any time with no recourse. As a result, hardly any respectable pastor could be found in Germany who was willing to go to Pennsylvania. In Halle as well, there was a long delay when the three German Lutheran congregations in the United States—Philadelphia, Providence and New Hanover—sent multiple letters to Gotthilf August Francke asking him to send them pastors. The circumstances of the Church in Pennsylvania

Fig. 17
N. Orr · Henry Melchior Mühlenberg, 1881

seemed too complex and the absence of any kind of structure appeared to preclude any chance of realizing the Pietist ideas of reform.

It was not until Henry Melchior Mühlenberg (fig. 17) declared to Francke that he was willing to follow his calling to the New World that the situation of the Lutheran communities in the colonies began to change. Mühlenberg came into contact with Pietist ideas emanating from Halle during his studies in Göttingen, and he spent time working as a teacher at the Halle orphanage schools. After a brief stay in Ebenezer, where he consulted with Boltzius, he reached Philadelphia in November 1742 and immediately after his arrival began his work organizing the Lutheran communities. He would ride on horseback through the wilderness from one farm to the next, and also exposed himself to the hostility of those opposed to his denomination. The first church he built, the Augustus Lutheran Church in Providence (now Trappe), was completed in 1745 and named in honor of August Hermann Francke. In a difficult learning process, in which Mühlenberg tried at first to apply European structures to the Lutheran communities in America and even proposed the younger Francke as the head of the church organization, Mühlenberg succeeded in 1748 in convening the first Lutheran Synod, which adopted a mandatory liturgy for all member communities. Finally, the adoption of the first Lutheran ecclesiastical constitution in 1762 cemented the permanent separation of the American Church from the leaders and structures of the European Church by granting congregation members extensive democratic powers based on a new understanding of congregant rights. On the other hand, the creation of a unified ministerium as a supreme body and utmost theological authority limited the dependence of the individual pastor on his congregation. This new ecclesiastical constitution was an important milestone in the formation of a Lutheran church organization and served as a model for other Evangelical communities in North America. In 1765, the Philadelphia congregation was transformed into a corporation based on a charter granted by the Governor of Pennsylvania. In this way, Mühlenberg was able to make the Lutheran Church independent and autonomous relative to other faiths and movements. Mühlenberg's commitment to the Church also involved an active participation in political affairs. In 1766, he gave a sermon dealing with the repeal of the Stamp Act. A petition to secure the rights of all religious bodies and organizations, which Mühlenberg brought in 1776 together with reformed clerics, found its way into the new Constitution of Pennsylvania after American independence was achieved.

Mühlenberg felt a personal connection with Halle. He sent his three sons to Foundation schools for their education, and all of them later left their mark on the early history of the United States of America: John Peter Gabriel Mühlenberg made a name for himself as a general in the American War of Independence and as a politician; Frederick Augustus Conrad Muhlenberg became Speaker of the House of Representatives and was a signatory of the Bill of Rights, the Articles of the US Constitution which guarantee fundamental rights for all Americans; Gotthilf Heinrich Ernst Muhlenberg won fame in the field of botany as the "American Linnaeus," and became a member of the Leopoldina, the German Academy of Natural Scientists.

Henry Melchior Muhlenberg is honored today as the founding father of the Lutheran Church in North America. Many places in the US are named after him, and several monuments have been erected in his memory. His importance is made especially clear at the entrance portal of the church of Muhlenberg College in Allentown, Pennsylvania, where there are two statues of equal height and size: Martin Luther and Henry Melchior Muhlenberg.

The Francke Foundations maintain relations with partners in the US to this day. A large number of American researchers and individuals visit Halle every year in order to learn more about their history. The historical collections that can be found in the archive and library provide the basis for joint publications and editing projects, workshops, conferences and exhibitions on both sides of the Atlantic. These projects continue the tradition and the legacy of the worldwide project of reform that began in Halle and carry it forward under modern conditions.

Henry Melchior Muhlenberg
**Erbauliche Lieder-Sammlung
(Collection of Uplifting Hymns)**

Germantown, PA: Michael Billmeyer, 1803
(3rd edition)
Luther Seminary Library, St. Paul, Minnesota,
BV481.L977 P384e3 1803 VAULT
Minneapolis Exhibition

Original title: Erbauliche Lieder-Sammlung zum
Gottesdienstlichen Gebrauch in den Vereinigten
Evangelisch-Lutherischen Gemeinen in Penn-
sylvanien und den benachbarten Staaten
(Collection of uplifting hymns for use in the
services of the United Evangelical Lutheran
Church in Pennsylvania and neighboring states.
Collected, arranged and submitted for publica-
tion by the German Evangelical Lutheran Minis-
terium of Pennsylvania)

406

Heinrich (Henry) Melchior Muhlenberg was ap-
pointed by the Francke Foundations in Halle
(Saale) to serve as preacher for three communi-
ties in Pennsylvania. In Philadelphia in 1742, he
began to work diligently to build an organized
Lutheran Church in the eastern United States. In
addition to an ecclesiastical constitution for the
churches in Philadelphia, which served as a
model for later documents, Muhlenberg com-
posed the *Muhlenberg hymnal*. His unpublished
version began circulating through America's
Lutheran churches in 1748. Muhlenberg was able
to see the first edition of his *Collection of Uplift-
ing Hymns* in 1786, one year before his death.
This printed collection became the first Lutheran
hymnal in the US. However, the New York Minis-
terium, as the only American Lutheran organiza-
tion, took over the collection in 1796 with the
intention of distributing this German hymnal to
all Lutheran churches in the US. The third edition,
printed in 1803, also included a picture of the
Luther statue on display at St. Mary's Library in
Halle facing the title page.
In 1661, Lucas Schöne was commissioned by
Peter Untzer, leader of Market Church in Halle, to
make a figure of Luther from the casts of his
death mask and hands from 1546. In a 1736 cop-
per engraving (in the style of Christian Gottlob
Liebe), we see Martin Luther sitting on a chair
and holding a quill pen. On the table in front of

him are paper and a Bible with the Luther Rose
on the cover. In the background, we can recog-
nize the windows of the old St. Mary's Library in
Halle, where the life-sized Luther figure was dis-
played until 1891. After a brief stay at St. Mary's
Church in Halle, the Luther figure was ultimately
dismantled in 1926. Luther's death mask and the
casts of his hands were transferred to the
church's sacristy.
While the reaction to the Luther figure was split
in the first-quarter of the last century, it was nev-
ertheless incorporated into the printing for the
first Lutheran hymnal in the United States, por-
traying Luther as a scholar.
We can assume that Muhlenberg, the patriarch
of the Lutheran Church in North America, had
seen the figure during his time as a student in
Halle (Saale). A product of its time, the seated
wax figure showed Luther as a scholar, which was
common in the 17th and 18th centuries, following
the example of wax figures of European princes
and kings. FK

Literature
Granquist 2015 · Kornmeier 2004 · Luther und
Halle 1996, pp. 32–35

LOUIS D. NEBELSICK

Expensive Grace

German-American connections in the lives and legacies of Dietrich Bonhoeffer (1906–1945) and Martin Luther King Jr. (1929–1968)

As the wave of exhibits, lectures, and celebrations of the 500th anniversary of Luther's 95 Theses reaches its crest in 2017, the question of Luther's relevance begs for our attention—especially in the context of German-American relations and engagement.

Dietrich Bonhoeffer in Harlem

We begin with the example of the Lutheran theologian Dietrich Bonhoeffer, who was executed for his participation in the foiled plot to assassinate Hitler, but who continues to inspire Americans who see fighting injustice as a Christian duty. This is in striking contrast to the majority of German Lutherans of the 1930s and 1940s, who saw themselves bound by Luther's doctrine of two kingdoms or governments, which obligated them to submit to secular authorities. Bonhoeffer and his Protestant allies in the "Confessing Church" rejected Hitler and his attempt to coerce the Church to conform to Nazi ideology and condone the discrimination and murder of the mentally challenged and the Jews. Accusing his opponents of advocating "cheap grace" (accepting forgiveness without repentance and ethical reform), Bonhoeffer made an eloquent and impassioned plea for discipleship and obedience to God's commandments, all implicit in human acceptance of God's grace. His subsequent opposition to Hitler and the German government led him to join the conspiracy to assassinate Hitler. When this failed, the Nazis executed him in the Flossenbürg concentration camp on April 9, 1945, only 11 days before Hitler's suicide in his Berlin bunker.

As a member of Berlin's social elite before World War I, Bonhoeffer—like many of his peers—became disillusioned with what he saw as the stale and tainted values of their parents, which had led to Germany's defeat in World War I and the ensuing collapse of bourgeois society. As a young theology student, he yearned for a Christianity that would grant him authenticity and agency. Initially, he was fascinated by neo-orthodoxy, as championed by the Swiss theologian Karl Barth, which cast aside the insipid world of Kantian-inspired religious rationalism in favor of the existentially demanding Kierkegaardian dialectic that stressed God's absolute otherness, the importance of belief, and the demand of obedience to God.

Yet young Bonhoeffer's trajectory towards resistance and martyrdom was given focus and galvanized by his experiences during his stay in New York in 1930, where he studied under and was inspired by the influential American theologian Reinhold Niebuhr, who opened his eyes to the social dimension of God's grace. A life-changing

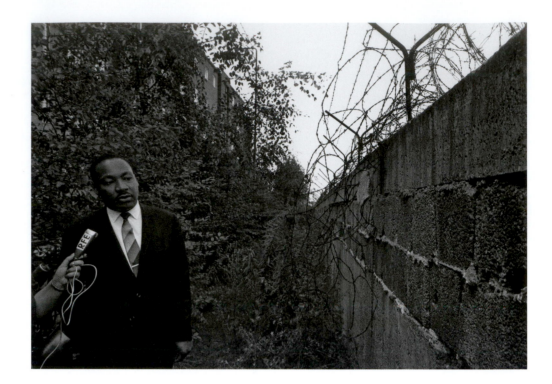

event for Bonhoeffer was his introduction to the Abyssinian Baptist Church in Harlem by his friend A. Franklin Fisher, an aspiring African-American minister. He was electrified both by the intense religious passion of the parishioners and the ethical vision of the church's pastor, the charismatic Rev. Adam Clayton Powell, who had coined the term "Cheap Grace," which would become Bonhoeffer's theological hallmark. Bonhoeffer would regularly attend services and teach Sunday school in his Harlem church until his return to Germany at the end of the year. Interestingly, Bonhoeffer's legacy has played a larger role in the USA than in his native Germany, and beginning in the mid-1960s he would inspire a wide spectrum of American intellectuals to see belief as the basis of ethical agency.

Martin Luther King Jr. in Berlin

"I would even go by the way that the man for whom I am named had his habitat. And I would watch Martin Luther as he tacked his ninety-five theses on the door at the church of Wittenberg." On the day before his assassination Dr. King stated his admiration for the courage and zeal of his namesake in his powerful "I've Been to the Mountaintop" speech of 1968. While there are various plausible versions of how he (and ultimately, his father) came to be named after Wittenberg's pioneering Reformer, it is clear that at the close of his life Martin Luther King Jr. acknowledged his ties to his 16th-century namesake with pride. Moreover, this avowal of his links to the Reformer was clearly foreshadowed on July 10, 1966, when in a remarkable reenactment he, a Protestant minister, posted 24 demands for an open housing policy on the doors of the Chicago's City Hall. Yet despite these entanglements, it was King's insistence that Christian freedom could only be enjoyed in a world of justice that set him radically apart from his namesake and would lead to his murder.

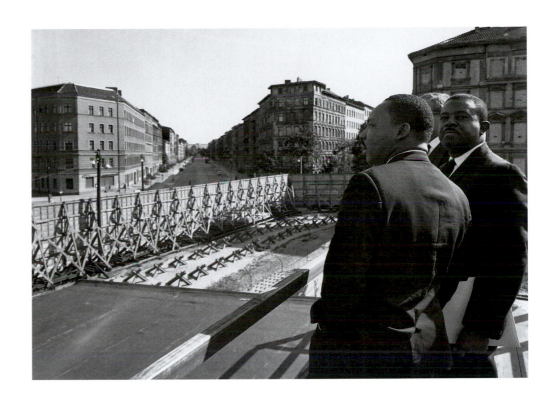

Fig. 19
Martin Luther King jr. (left) and Ralph Abernathy (right) looking at the Berlin Wall, Bemauer Straße, September 13, 1964

While there is no evidence that King was influenced directly by Bonhoeffer, the common roots of their fight against injustice and the martyrdom it entailed are more than clear. Both theologians readily acknowledged the influence of Reinhold Niebuhr on their understanding of religious ethics, and it is interesting to note that Bonhoeffer's student friend, A. Franklin Fisher, who had become pastor in a major Atlanta church, would join Martin Luther King Jr.'s campaign against bigotry and disenfranchisement in Georgia's capital in the late 1950s. While there is a general awareness that King's impassioned mission to cleanse the United States from the stain of racism has had an indelible beneficial impact on the fabric of American society, Americans know little of his immense popularity in Germany (a number of churches, schools, and streets are named in his honor) as a whole and his crucial impact on the struggle for freedom in Communist East Germany in particular. King had visited Germany in 1964 (fig. 19) and, responding to an invitation by an East Berlin Pastor, included a surprise visit to East Berlin in his agenda. There he was received by enthusiastic crowds that packed the city's main church, St. Mary's, to hear him preach and boldly question the injustice of the city's partition, claiming, "Here on either side of the Wall are God's children and no man-made barrier can obliterate that fact." While the Soviet style German Democratic Republic paid lip service to the achievements of King, particularly in the context of stressing the hypocrisy of the US propagation of freedom, care was taken to limit his impact on the regime's repressive realities. And indeed it was King's uncompromising stance against injustice and his exemplary use of effective nonviolent resistance that played a decisive role in inspiring church-led East German dissidents to openly voice their opposition to state repression and organize vast non-violent protests that would play a decisive role in toppling the East German government in 1989.

Bonhoeffer and King, shared German-American legacies

The German-American engagement in the lives and legacies of two Protestant ministers as different as Dietrich Bonhoeffer and Martin Luther King Jr. demonstrates the ongoing impact of Martin Luther's call to repentance in his 95 Theses and the development of his doctrine of Christian freedom in his famous pamphlet of 1520, *On the Freedom of a Christian*: "A Christian is a perfectly free lord of all, subject to none. A Christian is a perfectly dutiful servant of all, subject to all."

Literature
Bruns 2006 · Clayborn 1988 · Clingan 2002 · Höhn/Klimke 2010 · King 1999 · Lehmann 1988 · Williams 2014 · Roberts 2005 · Jenkins/McBride 2010

Fig. 20 (next page)
Letter from Dr. Martin Luther King Jr. to a white community leader and Unitarian minister in Atlanta, the Rev. Eugene Pickett. He had been a staunch supporter of King's civil rights campaign from its beginnings had just sponsored a fundraising dinner in King's honor. Martin Luther King Jr., a conscientious correspondent, thanks him for it.

It is interesting that King stresses the Judeo-Christian values that the two men share and expresses his unbroken belief in American democracy's ability to overcome bigotry and segregation. The upbeat tone of this letter is all the more astonishing as civil rights marchers in Selma, Alabama—alluded to at the beginning of the letter—had been cruelly beaten to a halt by the Alabama police on "Bloody Sunday" one week before the letter was written.

334 Auburn Ave., N.E.
Atlanta, Georgia 30303
Telephone 522-1420

Southern Christian Leadership Conference

Martin Luther King Jr., *President* Ralph Abernathy, *Treasurer* Andrew J. Young, *Executive Director*

March 15, 1965

Rev. Eugene Pickett
1145 Peachtree Street, NE
Atlanta, Georgia
30309

Dear Rev. Pickett:

In the rush of events surrounding Selma in our Alabama voting
project, I neglected to express my deep gratitude for your
sponsorship of the dinner honoring me on January 26. Please
accept this belated note of appreciation.

I must confess that few events have warmed my heart as did
this occasion. It was a testimonial not only to me but to the
greatness of the City of Atlanta, the South, the nation and its
ability to rise above the conflict of former generations and
really experience that beloved community where all differences
are reconciled and all hearts in harmony with the principles of
our great Democracy and the tenants of our Judeo-Christian
heritage.

Sincerely yours,

Martin Luther King, Jr.

Ks

407

Wilfried Fitzenreiter (design)
VEB coin of the GDR, Berlin
(production)
"Dietrich Bonhoeffer"
commemorative medal

Around 1972
D 6 cm; weight: 67.05 g
Tombac, minted (highly cupriferous brass)
Copies: 300

Circumscription, front side: DIETRICH
BONHOEFFER / 1906–1945, profile of Dietrich
Bonhoeffer
Inscription, reverse side: DASEIN / FÜR /
ANDERE – EHRENGABE / CHRISTLICH
DEMOKRATISCHE UNION DEUTSCHLANDS
(BEING THERE / FOR / OTHERS – TESTIMONIAL /
GERMAN CHRISTIAN DEMOCRATIC UNION)
Signature, front side: F
Stiftung Deutsches Historisches Museum
Berlin, N 2010/90
Atlanta Exhibition

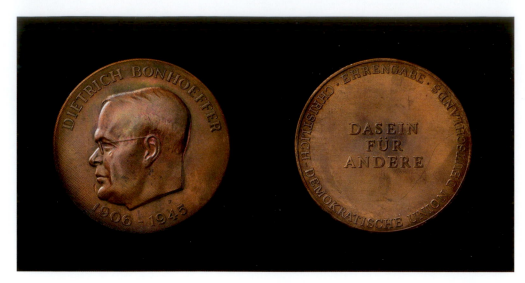

407

"He [Martin Luther] wanted a real unity of the Church and the West—that is, of the Christian peoples, and the consequence was the disintegration of the Church and of Europe; he wanted the 'freedom of the Christian man,' and the consequence was indifference and licentiousness; he wanted the establishment of a genuine secular social order free from clerical privilege, and the result was insurrection, the Peasants' War, and soon after the gradual dissolution of all real cohesion and order in society" (Kaiser 1983, p. 149).

Dietrich Bonhoeffer wrote these lines on Reformation Day in 1943, in the middle of the Second World War, in a prison cell in Fascist Germany. Bonhoeffer's principles were also interpreted after his death in a way different from how they were likely originally intended. In divided postwar Germany, there were different schools of thought with regard to the theologian. The GDR, for example, stylized him an "anti-fascist resistance fighter." This commemorative medal is meant to show that Bonhoeffer resisted the Third Reich in order to fight for the future which had now been realized in the socialist state. The Bonhoeffer medal was commissioned by Gerald Götting, the Chairman of the CDU, perhaps in response to the formation of the West German Bonhoeffer committee.

The medal was based on the designs of the sculptor Wilfried Fitzenreiter. The latter studied after the war at Burg Giebichenstein State University of Applied Art in Halle (Saale) and at the Academy of Arts in Berlin. Fitzenreiter established himself as a master medalist in East Germany with more than 450 medals and small reliefs, and was the recipient of the National Prize of the German Democratic Republic in 1981. RK/UD/FK

Sources and literature
Götting 1988 · Schulz 1983, p. 149 · Klein 2014

408

Ernst Weiss (medalist)
VEB coin of the GDR, Berlin
(production)

Medal for Dr. Martin Luther King Jr.

After 1968
Bronze, minted
D 6.3 cm; weight 91.98 g
Stiftung Deutsches Historisches Museum,
N 2010/93
Atlanta Exhibition

Inscription, top side: DR. MARTIN LUTHER
KING · 1929–1968
Inscription, reverse side: BLICKE
VORWÄRTS ! / SCHREITE VORWÄRTS – /
ZUR FREIHEIT / MLK (LOOK FORWARD /
MARCH FORWARD / TO FREEDOM / MLK)
Signature, top side: WEISS

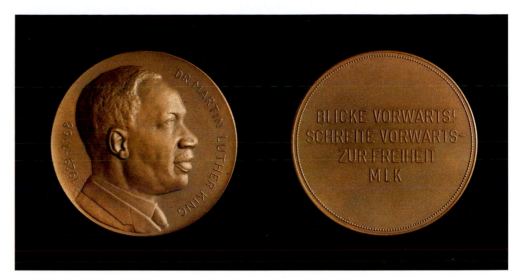

408

This medal for Dr. Martin Luther King Jr. was issued by the Christian Democratic Union (CDU) party of the German Democratic Republic, which since 1966 was under the leadership of Gerald Götting. Götting exchanged letters with King in 1964 and met him in person the same year at a conference in Geneva. A photograph of the two was repeatedly published in the daily newspapers of the GDR.

Götting made his career in the GDR as the Chairman of the CDU, eventually rising to become deputy to the Chairman of the State Council, Walter Ulbricht. Götting saw himself as a Christian humanist. In 1988, at an official ceremony on the occasion of the 20th anniversary of Martin Luther King Jr.'s death, he gave an address relating King's ideas to the treaty between Reagan and Gorbachev on the elimination of intermediate-range nuclear forces. He stated that King's legacy is now being implemented by the socialist states: "If the socialist states declare in their military doctrine that they will declare no state and no people as their enemy [...] then they can claim to be fulfilling the legacy of Martin Luther King under our terms." RK

Literature
Götting 1988 · Lapp 2011 · Müller-Enbergs 2006

LOWER SAXONY

MAGDEBURG

BRANDENBURG

EISLEBEN

SAXONY-ANHALT

WITTENBERG

MANSFELD

TORGAU

THURINGIA

SAXONY

WARTBURG EISENACH

ERFURT

HESSE

COBURG

RIVER MAIN

BAVARIA

WORMS

RHINE

DANUBE

BADEN-WUERTTEMBERG

LONDON

BERLIN

FRANKFURT AM MAIN

PARIS

JAN SCHEUNEMANN

Luther Sites Today

Luther and the Reformation that he launched are permanent fixtures of German memorial culture. The places where Luther lived and worked have attracted particular interest as locations where visitors can experience and come into contact with history. As early as the second-half of the 16th century, a common method of identifying with Martin Luther was to visit the original sites of the Reformation and Luther memorials. The Protestant identity manifested itself in a way of memorializing Luther that was tied to objects and places that formed part of the Lutheran tradition. In the early-19th century we hear of "Lutheran pilgrimages," voyages undertaken by American visitors into "Lutherland."

The museums, memorials and monuments that have been established at historic Luther sites are places of remembrances, as well as certification, documenting the Reformation as a historic event while at the same testifying to the enduring significance of Martin Luther. Since anniversaries have always been occasions when people of the present day seek to experience the past, a large number of visitors will be drawn to Luther sites when the Reformation celebrates its 500th anniversary in 2017. Those who want to follow in the footsteps of Martin Luther and visit the places where he lived and worked will find this little guide helpful. The text below serves this purpose, with a brief description of Luther's biography and the key stations of his life.

Eisleben/Mansfeld

Martin Luther's life began in Eisleben. At the time of his birth, November 10, 1483, his parents had only been living in the city for a few weeks. Martin's father Hans came from a well-to-do farming family from Möhra, in Thuringia. In 1479, he married Margarethe Lindemann from the town of Eisenach. The family moved to Eisleben in autumn of 1483. They were drawn to the city by the booming economy that the copper ore mining industry had triggered throughout the County of Mansfeld.

As early as the 16th century, Luther's Birth House was adorned with a wooden tablet with Luther's portrait (cf. cat. 389). However, the house was reduced to its foundations in a devastating city fire. With its reconstruction by the municipal authorities and the opening of a charity school in October 1693, the building also took on a memorial/representative function, as can be seen in the *Schöner Saal* (elegant hall) on the upper floor. There hang life-size portraits of Martin Luther and Philip Melanchthon, as well as the Electors of Saxony.

The building underwent thorough renovations from 2005 to 2007, including the addition of a modern museum annex. The permanent exhibition, *This is where I'm from:*

◀ **Map showing the Luther Sites**

Fig. 21
The Birth House in Eisleben

Martin Luther and Eisleben, contains information about the origins of the Luther family, the region's mining tradition and the business enterprises of Luther's father. The Luther family residence has been reconstructed on the ground floor of the house. The museum also provides insight into medieval piety and the religious practices of the late-15th century, and in particular to the theme of baptism, which was also a focal point at the predecessor to the present-day Church of St. Peter and St. Paul. This church, just a few steps away from the birth house, is where Martin Luther was baptized on the day after his birth and named after the saint whose feast is celebrated on that day, Martin of Tours. Parts of the original baptismal fount have survived to this day, and they can be seen today in the church in reconstructed form, with a new column base and bowl.

Although the Luther family moved to Mansfeld in 1484, Martin always felt a connection with the city of his birth. He stayed in Eisleben several times while serving as District Vicar for the Augustinian Order, such as in 1516 for the dedication of the St. Anne's monastery in Eisleben, at which monks' cells from Luther's time survive to this day.

A new museum was established in Mansfeld in 2014, including Luther's Parents' House, where the exhibition, *I'm a Child of Mansfeld,* is dedicated to Luther's childhood and youth. Through his engagement in the copper mining business, Luther's father was able to attain wealth and prestige (cf. cat. 1). He became a member of the Town Council and acquired property of his own. During roadwork in 2003, archaeologists discovered a refuse pit where some unique objects were found (cf. cat. 2–6, 11, 13, 15–18 and 24). Using these items, which include everyday objects, toys and uneaten food, it became possible to reconstruct and completely reassess the everyday life of the Luther family. Presumably in March 1491, Martin attended the elementary school in Mansfeld, where he learned reading, writing, mathematics, singing and Latin.

Fig. 22
Luther's Parents' House in Mansfeld

Magdeburg

Since Mansfeld's Latin school apparently did not meet the standards of the Luther family, young Martin was sent to Magdeburg in 1496 or 1497. Together with his friend Hans Reinicke, also a son of a Mansfeld mining entrepreneur, he attended the well-known cathedral school in Magdeburg, which was located in the immediate vicinity of the Cathedral of St. Maurice and St. Catherine. Because of its favorable location on the Elbe River, Magdeburg was a prospering commercial center at this time and the seat of the archbishop. Luther resided with the Brethren of the Common Life, who were called the "null brethren" in Magdeburg after the *nolle*, a type of cowl worn by the members of this lay community. While there, Martin Luther was compelled to sing and beg for his food.

Later on, Luther would stay in Magdeburg on two other occasions. In the summer of 1516, he visited the monastery in Magdeburg in his capacity as District Vicar of the Augustinian Hermits. The former monastery church, now called Wallonerkirche, is used to this day as a community church. In June 1524, Luther came once again to the metropolis on the Elbe. At the request of Magdeburg Mayor Nicolaus Sturm, he helped the Reformation establish itself in the city with his sermons at St. John's Church. The Luther memorial in front of the church (1886) is devoted to that event. A few weeks after his sermons, nearly all of the city's churches switched over to the Evangelical faith. As a result, Magdeburg became a bastion of Protestantism very early on, a fact that would have fatal consequences later. After the Schmalkaldic War, the city was besieged for more than one year in 1550–1551. In the Thirty Years' War, in which Protestants and Catholics struggled for spiritual mastery in Europe, imperial troops of the Catholic League captured the city in May 1631 and almost completely destroyed it. More than 20,000 people lost their lives in the process.

Fig. 23
Magdeburg Cathedral

Eisenach

Luther's stay in Magdeburg lasted barely a year. By 1498, his parents sent him to Eisenach, where he attended the St. George's Church parish school through 1501. Frequent changes from one school to another were not uncommon in those days. The fact that their choice fell upon this small Thuringian city is no coincidence: Luther's father Hans came from Möhra, which was not far away, and his mother was the daughter of a well-regarded family in Eisenach. During his time at school in Eisenach, Luther resided in a house owned by the Cottas, a family on the Town Council of Eisenach. Since the Cottas owned several houses in Eisenach, it is not entirely clear to this day whether the building that has been called the "Luther House" since the early-19th century, citing an "ancient tradition," is actually the house where Luther lived. The impressive structure dates back to the 13th century and is among the oldest and most beautiful half-timber houses in Thuringia. The magnificent Renaissance facade was created in the second-half of the 16th century. The Luther House owes its popularity as a memorial in no small part to the "Luther Cellar," a tavern in the old German style that opened on the ground floor of the building in 1898, where guests could go up to view the Luther rooms on the upper floor for a small fee.

Almost entirely destroyed in a bombing raid in November 1944, the house was rebuilt after the Second World War and, in 1956, it was established as a museum and

Fig. 24
The Luther House in Eisenach

memorial for the Evangelical Lutheran Church in Thuringia. It housed an exhibition on Luther's youth, as well as the collection of the Evangelical Parsonage Archive; it was a curiosity in atheist East Germany as a museum devoted entirely to church history. Today, the Luther House is operated by the Evangelical Church of Central Germany.

After extensive repairs and renovations, the Luther House has presented a completely new exhibition since 2015, "Luther and the Bible", which focuses on Luther's work translating the Bible. It examines the circumstances relating to the translation and inquiries about its impact. The subject matter of the exhibition extends into the 20th century and even shows the dark side of German church history, such as the Institute for the Study of Jewish Influence on German Church Life, which was founded in Eisenach in 1939.

Erfurt

After finishing school in Eisenach, Luther began his studies in Erfurt in 1501. With about 20,000 residents, Erfurt was a large city and was considered at the time to be one of the richest cities in the Holy Roman Empire, due to its location along key trade routes. The 17-year-old Luther registered for the Faculty of Arts of the university, which was founded in 1379 and became a major European university in the late Middle Ages, writing his name as "Martinus luder de mansfelt." The university remained in existence through 1816, and was reestablished in 1994. Hardly any parts of the original university buildings have survived. However, the university's main building, the *Collegium maius,* with its magnificent late Gothic keel arch gate, has been fully restored after being destroyed in the Second World War. During his four years at the university, Luther resided in the Georgenburse, a dormitory for students and professors of the university which had been built in the mid-15th century. The reconstruction of the dormitory began in the 1980's. After being completely remodelled, it opened in 2010 as a "Place of Study from Luther's Time," and its present-day exhibition provides insight into the highly regimented life of a student in the Middle Ages.

Fig. 25
Erfurt's Augustinian monastery

After Luther completed his baccalaureate examination in 1502 and completed his studies with the degree of Master of the Arts in 1505, he began to study law, as his father wished. Accordingly, he was on his way to a predetermined career in the law, but then a spectacular event brought him on a completely different course. In July 1505, Luther went to visit his parents in Mansfeld. On his way back, he encountered severe weather at Stotternheim, north of Erfurt. Frightened by a lightning strike, he threw himself to the ground in fear and called out to Saint Anne, the patron saint of miners, for help (cf. cat. 7 and 127). He vowed to become a monk and entered the Augustinian monastery in Erfurt, against his father's wishes, on July 17, 1505. A memorial plaque set up in 1917 on the occasion of the 400th anniversary of the Reformation recalls this episode and refers to the thunderstorm as the "point when the Reformation came to be."

Why Luther chose the Augustinian monastery is unknown. He may have been attracted by its ascetic lifestyle or by the close connection the monks had to the university. After his admission to the monastery, Luther served as a novice for one year. In 1507, he became a priest at Erfurt's St. Mary's Cathedral and read his first mass in the monastery's church. Luther's cell in the Erfurt monastery was a popular tourist destination even in the 16th century, but underwent several changes over the years and, in the 19th century, was redesigned in an historistic manner. Today, the reconstructed cell can be seen in its medieval frugality. It is part of the permanent exhibition, "Bible—Monastery—Luther", which can be viewed in what used to be the dormitory and which deals with the history of the Bible and the lives of the Augustinian monks.

Wittenberg

Martin Luther came to Wittenberg for the first time in 1508, as an Augustinian monk, in order to hold lectures on moral philosophy at the university, which had been founded in 1502 (cf. cat. 130, 132, 134–136 and 154–157). At the time, Wittenberg's population was about 2,000; Luther considered the city to be "on the edge of civilization" relative to the much larger city of Erfurt. Luther resided with the brothers of his order in the Black Monastery. After Luther moved from Erfurt to Wittenberg for good in 1511, this building, which later became known as the Luther House, became the center of life for Luther and his family for 35 years. When the monastery was dissolved, the building was given to Luther by the Elector as a gift. The room in which Luther would sit together with friends, visitors and guests and engage in lively discussions was built during renovations to the house between 1535 and 1538. These "table talks" were recorded, collected and catalogued by Luther's contemporaries, and first published in book form in 1566 by Luther's last assistant, Johannes Aurifaber. After Luther's death, Wittenberg University took over the building and used it as a dormitory. The conversion of the Luther House into a Luther memorial began after 1600, and in 1655, the Luther Room was referred to for the first time as a "Luther museum" (cf. cat. 242–244). The house has been open to visitors as a public museum since 1883. It has the world's largest collection of works relating to Reformation history. The exhibition "Martin Luther: his life, work and influence" contains information about the life and work of Martin Luther, as well as his day-to-day family life and the influence of the Reformation to this day.

In the immediate vicinity of the Luther House is the Melanchthon House. This house was built for the scholar Philip Melanchthon in 1536 as a gift from the Elector.

Melanchthon became a professor in Greek at the University of Wittenberg in 1518, at the age of 21. To him, strengthening the Christian faith was a fundamental requirement in education and child-rearing, and for this reason, his contemporaries dubbed him *Praeceptor Germaniae* (Germany's teacher). The collaboration between Luther and Melanchthon is legendary, especially in connection with the translation of the Bible, but equally legendary were the problems between the two. Luther disliked Melanchthon's at times cautious and considered manner, and the latter in turn was disturbed by Luther's quick temper, rudeness and sharp tongue. In 1845, the house was acquired by the Prussian government, which at first used it as a teachers' residence. In 1898/1899, the room on the first floor where the scholar studied and died became a memorial, supplemented by the room on the second floor, which was adorned with the coat of arms of his students. The permanent exhibition "Philip Melanchthon: life, work and influence", which opened in 2013 in a new museum, focuses on the circumstances of Melanchthon's life and family and stresses Melanchthon's role in the Wittenberg Reformation through manuscripts, printed works and paintings.

Luther preached God's word more than 2,000 times from the pulpit of St. Mary's Church; in addition to his duties as a university professor, he also worked as a preacher here from 1513. The interior of the church contains some outstanding artworks. Among the surviving objects is the baptismal font created in 1457 by the Nuremberg artist Hermann Vischer, in which the children of all well-known Wittenberg families

Fig. 26
Wittenberg Luther House

Fig. 27
Wittenberg's Castle Church

were baptized, including Luther's children, and which remains in use to this day. Without a doubt one of the most significant works to be created after Luther's death is the *Reformation Altar* by Lucas Cranach the Elder, which was likely dedicated in 1548 according to current research. It provides an illustration of Evangelical teachings and portrays the leading figures of the Wittenberg Reformation. Aside from Martin Luther and Philip Melanchthon, this group also includes Johannes Bugenhagen, who served as city pastor from 1523 and who applied the teachings of the Reformation to the everyday life of the community. The church has undergone extensive repairs in recent years in preparation for the anniversary of the Reformation in 2017.

Perhaps no structure is as symbolically intertwined with the history of the Reformation as Castle Church in Wittenberg. It was built between 1496 and 1509 as the northern wing of the residential castle built by Frederick the Wise. The church housed the Elector's extensive collection of relics, which was displayed once a year in an event involving the sale of indulgences (cf. cat. 106–119). Frederick the Wise organized innumerable masses in an effort to make Castle Church into a center of contemporary piety. More than 8,000 masses were read and over 40,000 candles were lit in the church every year. Castle Church also served as the church for the University of Wittenberg from 1507 to 1815, and it was here that Martin Luther received his degree as a doctor of theology in October 1512. Five years later, on October 31, 1517 (according to the later account by Philip Melanchthon) he nailed his 95 Theses protesting against abuses in the sale of indulgences to the door of Castle Church, in order to invite the members of the university to a debate on the subject (cf. cat. 145, 146 u. 397). The church's wooden doors no longer exist, since the castle along with the Castle Church burned down in 1760, during the Seven Years' War. A magnificent bronze door was created on the occasion of Martin Luther's 375th birthday in 1858, on which the text of the 95 Theses was written in Latin. After the entire castle complex was converted into a fortress in the early-19th century, Castle Church was redesigned between 1885 and 1892 into a hall dedicated to the praise and memory of the Reformation. It also served as a symbol of the new German Empire, which was created in 1871 under Prussia's Protestant leadership. Castle Church and Wittenberg Castle will be restored and with the addition of several new buildings by 2017. The associated construction project is considered to be the largest and most significant project relating to the Reformation festivities.

Worms

"Unless I am refuted by testimony of the scriptures or clear arguments, since I believe neither the Pope nor the councils, who have often been shown to err and contradict themselves, I am compelled by the words I have written. And as long as my conscience is captive to God's word, I neither can nor dare retract anything, for it is unsafe and a risk to salvation to go against conscience. God help me. Amen." With these words, Martin Luther ended his lengthy address at the Diet of Worms on April 18, 1521, in which he acknowledged his writings before the Emperor and the imperial estates and refused to retract them. This left Charles V no choice but to impose the imperial ban on Luther and, on May 8, 1521, to issue the Edict of Worms, which prohibited the reading and dissemination of Luther's writings (cf. cat. 177).

Fig. 28
Worms Reformation Monument

Since the publication of the 95 Theses in 1517, Luther was considered to be a heretic by the Roman Curia. After various efforts at mediation failed, the papal bull *Exsurge Domine* was delivered to him in October 1520, calling upon him to recant his theses within 60 days or face excommunication (cf. cat. 165–168). Once this deadline has expired, in December 1520, Luther burned the bull in the presence of professors and students in Wittenberg. In March 1521, Luther received word that he had been ordered to appear at the Diet of Worms. This voyage, which was not without danger and which Luther undertook with a sense of foreboding despite the fact that safe conduct had been afforded to him, became a triumphal march. Despite the prohibition, Luther stopped to preach in various places along the way, and he was received with euphoria everywhere he went. The enthusiasm was especially great in the city of Worms itself, which he reached on April 16, 1521. About 200 people were on hand to await Luther's arrival, and Luther took up residence in the Johanniterhof inn. The deliberations of the Diet of Worms took place in the hall of the imperial palace.

Both the Johanniterhof inn and the imperial palace were destroyed in 1689. A memorial to the 1521 Diet of Worms is the largest Reformation monument in Germany today. Designed by the Dresden sculptor Ernst Rietschel, it was dedicated in 1868 in a festive ceremony northwest of the cathedral. At the center of this square-shaped monument, which is built like a stage, is a sculpture of Martin Luther elevated above the other figures. Sitting at his feet are his forerunners, the Italian Dominican monk Girolamo Savonarola, the Prague theologian and preacher Jan Hus, English church reformer John Wyclif and Peter Waldo, the founder of the Waldensian movement. At the edges of the monument, are statues of Elector Frederick the Wise and Landgrave Philip of Hesse, temporal rulers who supported Luther, and Philip Melanchthon and Johannes Reuchlin, Luther's spiritual allies.

Fig. 29
Wartburg Castle, Luther room

Wartburg Castle Eisenach

On his way back from the Diet of Worms, Luther stopped first in Eisenach and then in Möhra, in order to visit relatives. On May 4, 1521, he left for Gotha. Near Altenstein, he was set upon by a group of knights, who took him prisoner and brought him to Wartburg Castle, located high above Eisenach. This incident had been arranged by Elector Frederick the Wise, who wanted to hide Luther in the castle for his own protection. Luther arrived at Wartburg Castle around 11 PM. He was received by Hans von Berlepsch, the officer in charge of the castle, who assigned him a modest cell on the upper floor of the bailiff's lodge and later became an important contact between Luther and the outside world. Luther grew his hair and beard while at the castle and dressed in a doublet and trousers in the style of a knight. As a result, the monk Martin Luther became the knight "Junker Jörg," whom his friends would have hardly recognized.

During his ten-month stay, Luther left Wartburg Castle only once, secretly traveling to Wittenberg in early December 1521. He undertook the trip because of rumors about the appearance of radical Reformation figures and changes to the Evangelical service. While in Wittenberg, he learned of his friends' desire for the Bible to be translated into German. He began the work immediately after returning to Wartburg Castle, and it took him just ten weeks to complete the translation of the New Testament based on the original Greek text (cf. p. 203 Bible translation and cat. 205–208). While there had been other German editions of the Bible before Luther, none of them has left such a lasting mark on the German language as has the Luther Bible.

From the numerous letters that Luther wrote from Wartburg Castle, we know how lonely he felt in exile, as well as the struggles and health problems that tormented him. Occasionally, he would even report hearing noises in the old walls and seeing the devil. The famous story about Luther throwing his inkwell at the devil is just a legend, but has been a popular story about Luther at Wartburg Castle since the 17th century. The ink stain on the wall of the Luther Room has been refreshed over and over again since that time. Although Wartburg Castle owes its current appearance in large part to its

"restoration" in the mid-19th century, the Luther Room is still in its original condition of the 16th century. The Wartburg Foundation has outstanding works from the Renaissance era, focusing in part on works by Lucas Cranach the Elder and his workshop.

Coburg

Veste Coburg is one of the best-known German castles. The city of Coburg came under the control of the House of Wettin in 1353. After 1485, it numbered among the Thuringian possessions of the Ernestine branch of that House, marking the southernmost tip of the Electorate of Saxony. Frederick the Wise arranged to have the castle renovated after 1500, giving it its current powerful appearance. The castle was renovated and expanded once again in 1533.

The city and castle attained importance above all because Martin Luther stayed here for half a year, from April to October 1530, during the Diet of Augsburg. Emperor Charles V, back in German lands for the first time since the 1521 Diet of Worms, sought to use the Diet of Augsburg in order to bring about a final settlement of religious questions between the Protestant and Catholic parties. Luther had traveled to Coburg from Wittenberg as part of the retinue of Elector John the Steadfast. However, since Luther had been excommunicated by the Pope and since the Emperor had imposed the imperial ban upon him, he had to constantly fear for his personal safety. As a result, it was not possible for him to take part in the Diet in person. He was therefore compelled to remain within the Elector's territory, from where he intervened in the confessional disputes in Augsburg through a lively correspondence with Melanchthon. These discussions culminated in the *Augsburg Confession*, the most important confessional document in Lutheranism (cf. cat. 345 and 346).

While at Veste Coburg, Luther occupied two rooms on the first floor of the late-Gothic High Chamber, in the eastern part of the castle, which he described as comfortable and pretty. Like his stay at Wartburg Castle 10 years earlier, Luther took advantage of his solitude to work intensively, turning out numerous theological texts

Fig. 30
Veste Coburg castle

and polemics. The rooms that are available for viewing today as the Luther Rooms were not created until 1921. They contain portraits of Luther from the Cranach workshops, as well as engravings and coins. Authentic furnishings from Luther's time no longer exist. One of the most valuable items in the Veste Coburg art collection is "Hedwig's Cup," which likely dates back to the 12th century and once belonged to Saint Elizabeth, Landgravine of Thuringia. The glass was part of the relic collection assembled by Elector Frederick the Wise in Wittenberg Castle and came into the possession of Martin Luther after the collection was dissolved in 1541.

Torgau

Fig. 31
Hartenfels Palace in Torgau

Once John became the Elector in 1525, Torgau became the most important seat for Electors of Saxony of the Ernestine line. The construction of Hartenfels Palace began in the 15th century and was completed in the 16th century, and it is one of the most important and best-preserved structures of the Early Renaissance period. The outstanding architectural element of the palace is the "Wendelstein" staircase, an exterior newel staircase without a main supporting pillar that was built from 1533 to 1536 and connects the two main floors of the eastern wing.

The Palace Chapel in the northern wing was consecrated by Martin Luther as the first Protestant church in October 1544. Luther stayed in Torgau 40 times. In May 1526, Elector John of Saxony and Landgrave Philip of Hesse forged the League of Torgau here, together with the City of Magdeburg, to oppose the Catholic Archbishop Albert. Together with the Wittenberg theologians Philip Melanchthon, Justus Jonas and Johannes Bugenhagen, Luther composed the *Torgau Articles* in 1530, one of the central confessional documents of the Reformation, which later found its way into the *Augsburg Confession*.

Torgau was the political center of the Reformation until the defeat of the Ernestine dukes in the Schmalkaldic War (cf. cat. 356). After the office of Elector was transferred to the Albertine branch in 1547 and the seat of power was moved to Dresden, Hartenfels Palace began to lose significance. The palace served only as an administrative building from then on. Today, it is used for large special exhibitions.

The grave of Luther's wife, Katharina von Bora, is located at St. Mary's Church in Torgau. She left Wittenberg with her children in December 1552 in order to escape an outbreak of the plague. She had an accident along the way and died as a result. The house where she lived and died now contains a memorial, the Katharina Luther Room, with information about her life.

Eisleben

At the end of January 1546, Luther left Wittenberg, accompanied by his three sons, and set out for the city of his birth, Eisleben. He had been called to mediate a dispute between the Counts of Mansfeld. The severe winter weather made the traveling difficult, and Luther suffered a heart attack shortly before reaching Eisleben. But his weak health did not keep Luther from preaching in Eisleben's St. Andrew's Church. The pulpit where Luther stood has been preserved almost unchanged to this day (cf. cat. 371).

Once the disputes between the Counts were nearing resolution, Luther wrote his wife and his colleagues that he would soon be returning to Wittenberg. But it was not

Fig. 32
Luther Death House in Eisleben

to be. Luther died in a house on the marketplace in the night of February 17/18, 1546 (cf. cat. 374 and 382). On the afternoon of the following day, his body was carried into the choir of St. Andrew's Church, to the ringing of bells. Justus Jonas, Luther's long-time ally and, since 1541, the preacher at St. Mary's Church in Halle, held a funeral sermon attended by a large number of Eisleben residents. Luther would have been buried in Eisleben if Elector John Frederick had not insisted on taking the body to Wittenberg, where he was finally buried on February 22, 1546, in Wittenberg's Castle Church (cf. cat. 381 and 384).

An inscription was added to Luther's Death House in Eisleben shortly after his death, along with a portrait of Luther. Interested visitors could enter the house to see the room where Luther died, with his bed and his cup (cf. cat. 375 and 376). Accordingly, Luther's death house very quickly became a Luther memorial. However, a cult surrounding objects associated with Luther's final days started to develop, rooted in popular superstitions, which induced theologians in 1707 to have these items burned. When modifications were later made to the building, the place where Luther actually died was forgotten. A mix-up in the 18th century ultimately resulted in the house on Andreaskirchplatz 7 being mistaken for Luther's death house. In 1862, Prussian King Wilhelm I acquired this property and ordered his Provincial Architect, Friedrich August Ritter, to convert the building into a Luther memorial. In the spirit of historicity, Ritter wanted to come as close as possible to how the building was in the 16th century. This involved adding stylistic and architectural elements from Luther's day, such as crown glass windows, half timber and wood paneling, as well as reorganizing the way the room is divided.

The new permanent exhibition at the Luther Death House museum, *Luther's Final Path,* which was opened in 2014 and since expanded with the addition of an annex, concentrates on Luther's final days and on his death. It looks at Luther's relationship with death and how his theology affected the death culture of the time (cf. cat. 377). The exhibition carries this theme forward to pose an existential question for all of us, that of our own death.

Literature
Badstübner-Gröger/Findeisen 1983 · Birkenmeier 2013 · Birkenmeier 2015 · Birkenmeier 2016 · Brecht 2013 · van Dülmen 1983 · Gretzschel 2015 · Junghans 1996 · Kreiker 2003 · Krauß/Kneise 2016 · Kuper/Gutjahr 2014 · Luther Stätten 1983 · Stätten Reformation 2014 · Rhein 2014 b · Rogge 1983 · Schilling 2012 · Treu 2014

The Institutions behind "Here I stand …"

The State Museum of Prehistory Halle

The State Museum is one of the most important archaeological museums in Central Europe. The imposing museum building was designed by the architect Wilhelm Kreis to recall the Porta Nigra in Trier and is the first building in Germany designed specifically for the presentation of prehistoric artifacts.

The vast collection with more than 16 million objects includes items of European and international ranking, such as the famous *Nebra Sky Disc* (ca. 1600 B.C.), the centerpiece of the permanent exhibition. As the earliest tangible visual depiction of the sky, the disc was included in the UNESCO Memory of the World Register in June 2013. Thanks to its remarkable find circumstances, its mysterious astronomical and mythological significance, as well as its timeless design, this once-in-a-century find manages to instill an undeniable fascination among its viewers.

Besides its permanent exhibitions, the State Museum of Prehistory regularly presents extremely successful special and state-sponsored exhibitions. These include "The Forged Sky" (October 15, 2004–May 22, 2005), "Saladin and the Crusaders" (October 21, 2005–February 12, 2006), "Finding Luther – Archaeologists on the Reformer's Trail" (October 31, 2008–April 26, 2009), "Pompeii-Nola-Herculaneum. Disasters at Mount Vesuvius" (December 9, 2011–August 26, 2012) or "3300 BC – The Mysterious Stone-Age Dead and Their World" (November 14, 2013–May 18, 2014), each of which attracted up to 300,000 visitors.

State Office for Heritage Management and Archaeology Saxony-Anhalt – State Museum of Prehistory
Richard-Wagner-Straße 9
D – 06114 Halle (Saale)
www.lda-lsa.de/
landesmuseum_fuer_vorgeschichte

The Luther Memorials Foundation of Saxony-Anhalt

Martin Luther's legacy and that of the Reformation are important to many people around the world. Preserving and communicating this legacy is the mission of the Luther Memorials Foundation of Saxony-Anhalt. The Foundation oversees five museums: The Luther House and the Melanchthon House in Wittenberg, the Luther's Birthplace Museum and the Luther's Death House Museum in Eisleben, as well as Luther's parents' home in Mansfeld, which reopened in 2014. All four houses in Wittenberg and Eisleben were declared UNESCO World Heritage Sites in 1996.

A public museum was installed in Luther's birthplace at the end of the 17th century, making it the oldest institution of its kind in Europe. The Reformer lived in today's Luther House in Wittenberg for more than 35 years. The house was opened to the public as a museum in 1883 and is currently the largest museum in world dedicated to the history of the Reformation.

The new annex built onto Luther's Birthplace, which has won five architectural awards and thus belongs to the most highly distinguished buildings in Germany, is a reflection of the preservative as well as contemporary-historical handling of buildings entrusted to the Foundation.

The Foundation is in the possession of uniquely diverse collections of books, manuscripts, medals, graphic art, and paintings related to Luther, the history of the Reformation and its reception.

The agency "Luther 2017" was founded under the umbrella of the Foundation as early as 2007. Thus the Foundation has been the key institution from the very beginning preparing for the Reformation's anniversary in 2017.

Lutherhaus Wittenberg
Collegienstraße 54
D – 06886 Lutherstadt Wittenberg
www.martinluther.de

Martin Luthers Geburtshaus
Lutherstraße 15
D – 06295 Lutherstadt Eisleben

Luthers Sterbehaus
Andreaskirchplatz 7
D – 06295 Lutherstadt Eisleben

Luthers Elternhaus
Lutherstraße 26
D – 06343 Mansfeld-Lutherstadt

Melanchthonhaus
Collegienstraße 60
D – 06886 Lutherstadt Wittenberg

The Deutsches Historisches Museum, Berlin

Stiftung Deutsches Historisches Museum
Unter den Linden 2
D – 10117 Berlin
www.dhm.de

The Deutsches Historisches Museum is Germany's national history museum. Situated in Berlin's historic district in the middle of the city, it presents 1,500 years of German history in a European and international context. The permanent exhibitions are shown in the Zeughaus, Berlin's historic armory, which is the oldest and most majestic Baroque building on the "Unter den Linden" boulevard, inviting visitors to enjoy an impressive historical tour from the beginnings of German history to the present. The wide-ranging special exhibits of the Deutsches Historisches Museum are presented on four levels in the modern exhibition hall designed by the internationally renowned Chinese-American architect I. M. Pei, the architect of the Louvre pyramid in Paris. The multifaceted exhibition program includes pivotal comprehensive exhibitions, such as "1914–1918. The First World War," which was installed in 2014, and socially relevant special exhibitions, such as the exhibition resulting from a cooperation with the Schwules Museum*, "Homosexuality_ies," in 2015. With these exhibitions, the Deutsches Historisches Museum is actively involved in contemporary debates and thus carries relevant topics into the center of its public's attention. A comprehensive education program, lectures, podium discussions, scholarly conferences, and workshops complement the exhibition program and make the Deutsches Historisches Museum a lively place to convey and discuss history.

The Foundation Schloss Friedenstein Gotha

At the end of the Thirty Years' War, Duke Ernest the Pious of Saxe-Gotha built Friedenstein Palace between 1643 and 1654. The largest castle of the early Baroque in Germany has never been destroyed; its state rooms dating to the Baroque, Rococo and Neo-Classical eras have been preserved in their original condition. The historic buildings—the palace, the chapel, the Baroque court theatre, the archive and the library—and the surrounding park with the Baroque orangery and the early landscape garden form a self-contained universe: the "Baroque Universe of Gotha." The *Kunstkammer* (cabinet of art and curiosities) formed the nucleus of the unique collections in the realms of art, nature, and history. Due to these unique art collections, Friedenstein Palace is regarded as the "Louvre of Thuringia."

For centuries the Dukes of Gotha amassed important treasures. The magnificent building of the Ducal Museum has had an eventful history since opening in 1879. Re-opening in October 2013 after a thorough restoration, the art collections are once again on display. In addition to one of Europe's oldest Egyptian collections with several mummies, visitors can enjoy a Chinese cabinet, precious Japanese lacquer work, ancient vases, jewelry, gems, and sculptures. Paintings include the so-called *Gothaer Liebespaar* (Gotha Courting Couple), masterpieces by Cranach, Rubens, and Caspar David Friedrich. This rich fine art collection includes rare graphics, sculptures by Adriaen de Vries and Jean-Antoine Houdon—the largest collection of works by this neoclassical sculptor outside of France—and a unique collection of Böttger stoneware and porcelain from Meissen, Japan and China.

Stiftung Schloss Friedenstein
Schloss Friedenstein
D – 99867 Gotha
www.stiftungfriedenstein.de

Minneapolis Institute of Art

In 2015, the Minneapolis Institute of Art (Mia) celebrated its 100th anniversary. Home to over 88,000 works of art representing 5,000 years of world history, Mia inspires wonder, stimulates creativity, and nourishes the imagination. With extraordinary exhibitions and one of the finest wide-ranging art collections in the United States, Mia links the past to the present, enables global conversations, and offers an exceptional setting for inspiration.

Remarkable works range from Roman sculptures to Renaissance painting to contemporary art and new media. Particular strengths include Old Master prints, 17th to 20th century European paintings and sculpture, American decorative arts, Chinese bronzes, jades, textiles and hardwood furniture, Japanese paintings and prints, African sculpture, European and American silver, and Native American beadwork.

On view in more than 140 galleries, and further accessible through innovative exhibitions, publications, and online resources, the collection lies at the core of the museum's mission. As a visitor-centered institution, the museum strives to be a welcoming environment where everyone can comfortably enjoy and learn about the triumphs of human creativity. At the same time, partnerships with other arts institutions worldwide, as well as electronic publications and a robust website, are transforming Mia into a global presence.

Minneapolis Institute of Art
2400 Third Avenue South
Minneapolis, MN 55404

The Morgan Library & Museum

The origins of The Morgan Library & Museum, one of the most renowned cultural institutions of New York, lie in the private library of the legendary financier Pierpont Morgan, one of the preeminent collectors and cultural benefactors of his time in the United States.

The Morgan Library was founded in 1906 and today is a major cultural attraction in New York. The complex includes three centuries of buildings, including a much-heralded addition in 2006 by architect Renzo Piano.

Today, more than a century after its founding, the Morgan serves as a museum, an independent research library, a music venue, architectural landmark, and a historic site. In October 2010 the restoration of the Morgan Library as well as the famous McKim building (architect Charles McKim) was completed. It served as Pierpont Morgan's personal library and forms the core of the institution.

In tandem with the 2006 expansion project, the Morgan Library now offers its visitors unprecedented access to its world-renowned collections of drawings, literary and historical manuscripts, musical scores, medieval and Renaissance manuscripts, printed books, photography, as well as ancient Near Eastern seals and tablets.

The Morgan Library & Museum
225 Madison Avenue
New York, NY 10016

Pitts Theology Library

Pitts Theology Library, one of Emory University's six instructional libraries, holds a distinguished collection of theological materials. With over 610,000 volumes, the library provides unusually rich resources for the Candler School of Theology and Emory University and has attracted international attention for some of its collections.

The Special Collections of the library are extensive, including over 130,000 rare or special books and nearly 2,500 linear feet of unpublished archival materials. These collections include especially over 3,500 books and several rare manuscripts documenting the history of the Protestant Reformation in Germany to 1570. This Collection was founded by Richard C. Kessler in November, 1987, and funded its growth in partnership with Emory University. Considered an American treasure, the collection boasts many one-of-a-kind pieces and is a valuable resource for churches and religious scholars. It holds the largest collection in the U.S. of 1,000 pieces of original writings of Martin Luther.

Pitts Theology Library
Candler School of Theology
Emory University
1531 Dickey Drive
Atlanta, GA 30322

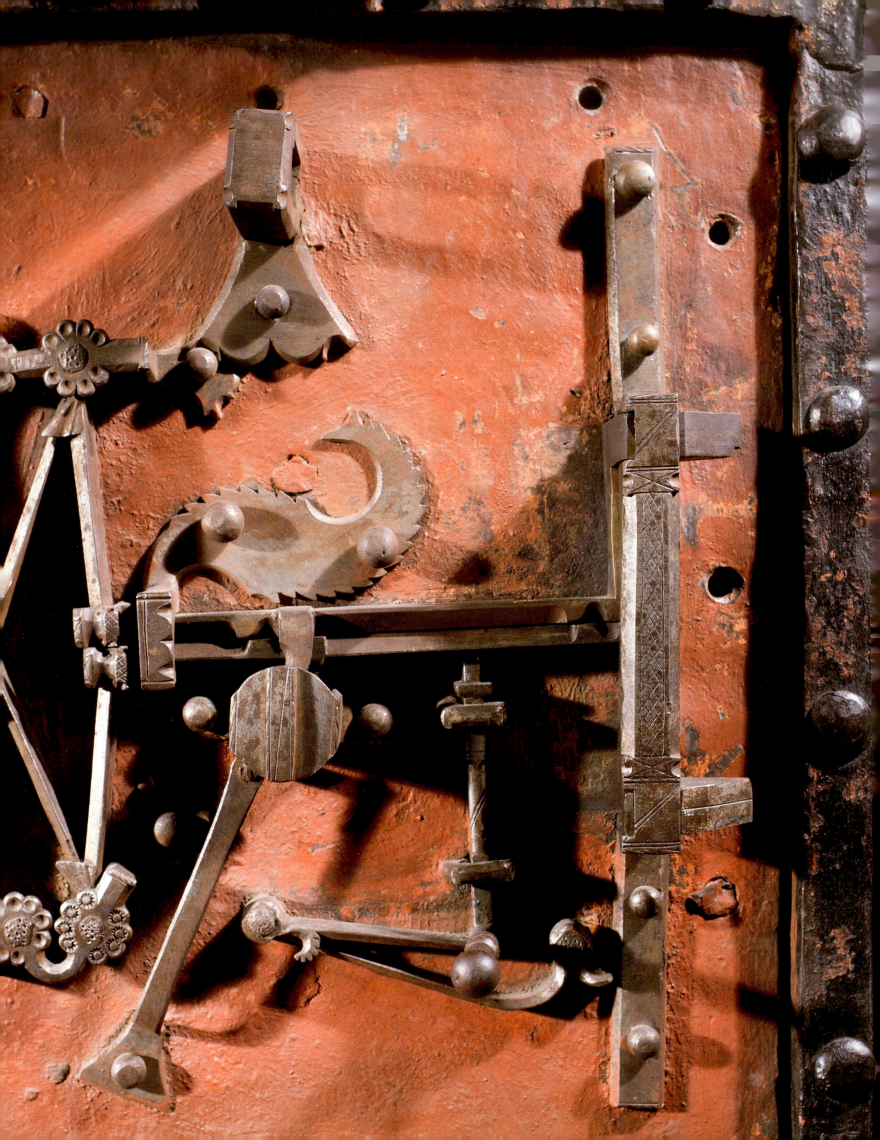

Lending Institutions

More than 30 institutions have opened their treasuries for the Luther exhibitions. Their loans have made it possible for us to compose such a cogent picture of the life, works, and legacy of Martin Luther as well as the cultural environment of the Reformation.

Lenders Europe

HMB – Historisches Museum Basel
Steinenberg 4
CH – 4051 Basel
www.hmb.ch

HMB – Historisches Museum Basel

The Basel Historical Museum is one of the largest and best known museums of its kind in Switzerland. The state-owned museum, which is housed in four separate buildings, is the most comprehensive collection on cultural history in the Upper Rhine Region.

The Museum in the Barfüsserkirche (Church of the Barefoot Friars) is dedicated to objects of craftsmanship and everyday life, with an emphasis on the Medieval, Renaissance and Baroque eras. The Museum of Domestic Culture in the Kirschgarten House displays rooms and furnishings of 18th- and 19th-century Basel. In the Museum of Music in the Lohnhof, five centuries of European musical history are brought to life. Housed in a barn of the former manor of Christoph Merian in Brüglingen, the Museum of Horsepower began in 1981 as a collection of carriages, and now documents the development of transport before the advent of combustion engines.

Städtisches Museum Braunschweig
Steintorwall 14
D – 38100 Braunschweig
www.braunschweig.de/kultur/museen/
staedtisches_museum

Städtisches Museum Braunschweig

The Municipal Museum of Brunswick was founded in 1861. With a collection of more than 27,000 objects from Brunswick's rich history, it is one of the largest museums of art and culture in Germany. The institution owes its existence to Carl Schiller, a historian and scholar who founded a society of collectors in 1859 and who began to gather objects of historical significance in the Duchy of Brunswick. In its main venue, the Löwenwall location, the museum displays a varied collection, which includes paintings from the 18th—19th centuries, works of craftsmanship such as furniture, porcelain and lacquer work, as well as ethnological objects and musical instruments. An exhibition on the history of Brunswick was opened in 1991 in the Old City Hall.

Kunstsammlungen der Veste Coburg

This medieval fortress enjoyed its heyday in the early-16th century as the palace of the Electors of Saxony. Martin Luther stayed here in 1530 at the time of the Imperial Diet of Augsburg. The castle that we see today is the result of alterations inspired by the Gothic Revival. The Hunting Room, which dates from 1632, is furnished with unique and sumptuous inlaid wood paneling. The Fürstenbau, or Ducal Palace, preserves the apartments of the last Duke of Coburg, which were furnished in the early-20th cen-

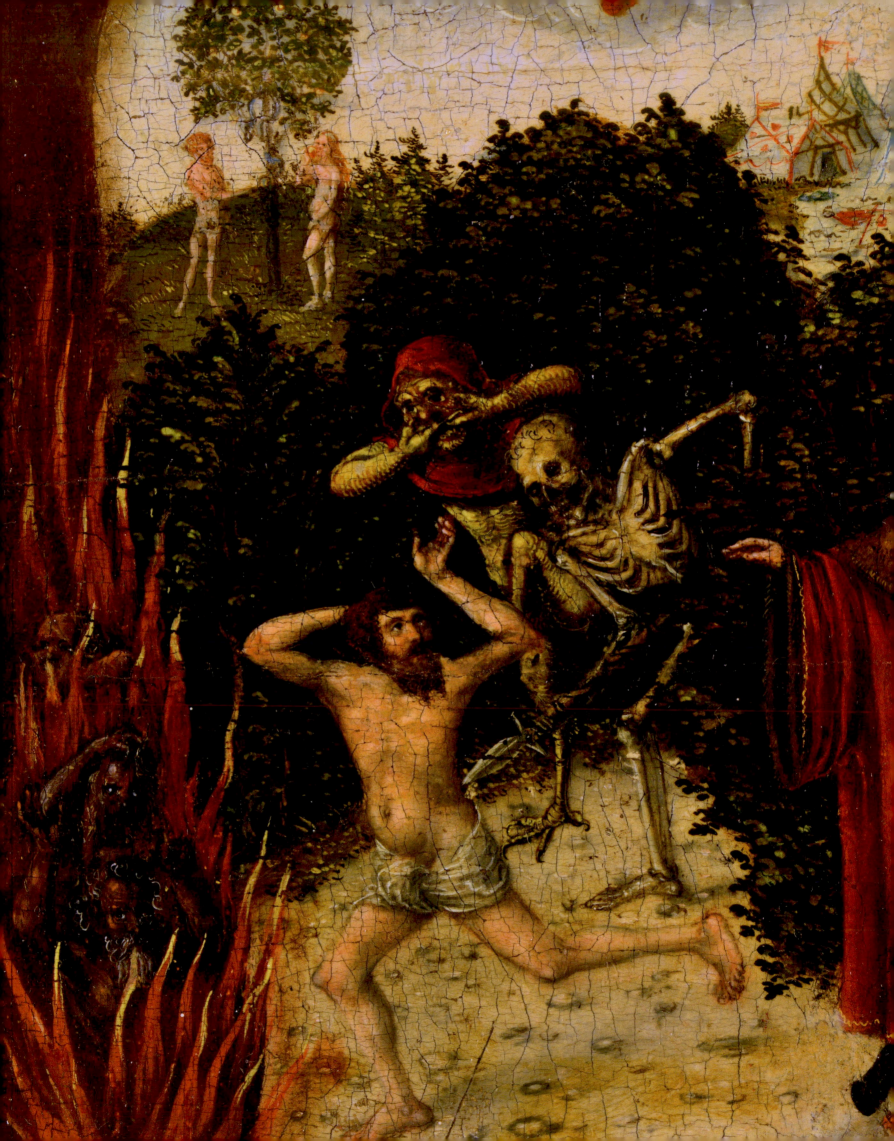

Veste Coburg
D – 96450 Coburg
www.kunstsammlungen-coburg.de

tury. The Veste Coburg also houses substantial collections of prints and drawings, Venetian glass, historical weapons, and an armory. Its highlights include the two oldest preserved carriages of the world, Baroque sleighs, and priceless works of the German Renaissance by Cranach, Dürer, and Grünewald.

Evangelische Kirchengemeinde St. Andreas – Nicolai – Petri, Lutherstadt Eisleben

The present-day congregation in Eisleben, Luther's birthplace, is entrusted with the preservation of the three medieval churches dedicated to Saint Andrew, Saints Peter and Paul and Saint Nicolas. The sites are of particular importance for the artistic and cultural legacy of the Reformation. The Church of St. Nicolas, which was built in the first-half of the 15th century, dominates the skyline of Eisleben to this day with its slender late Gothic spire. Martin Luther was baptized in the church dedicated to Saints Peter and Paul, presumably on November 11, 1483, by Bartholomew Rennbecher. This church has recently been restored and converted into a center for baptism. In the Church of St. Andrew, which was built in the 15th century, the pulpit from which Luther delivered his final four sermons in February 1546 has survived to this day. This uniquely authentic legacy of the Reformer's final public appearance was restored in 2016 with the generous support of the Minneapolis Institute of Art (Minnesota). Other sights include the main altar, the tomb of Count Hoyer VI of Mansfeld, and a drapery for the pulpit made from re-used 15th-century choir vestments, which is displayed in a showcase in the church today.

**Kirchengemeinde
St. Andreas – Nicolai – Petri**
Gemeindebüro
Andreaskirchplatz 11
D – 06295 Lutherstadt Eisleben
www.kirche-in-eisleben.de

Lutherstadt Eisleben

Eisleben, a town to which Martin Luther remained attached throughout his life, lies nestled in the Mansfeld basin amid the foothills of the Harz Mountains. First documented in 994 AD, it is one of the oldest urban settlements between the Harz and the Elbe River, and the principal town of the copper-mining district of the County of Mansfeld. Luther was born here in 1483, and he passed away here on February 18th, 1546, after delivering his final sermon in the Church of St. Andrew. The town adopted the epithet "Lutherstadt" (Luther's Town) in 1946. The two memorial sites, Luther's Birthplace and Luther's Death House, part of the Luther Memorials Foundation of Saxony-Anhalt, welcome visitors from all over the world. The objects displayed in these museums include loans from the municipal collections. Among these are several funeral paintings from the communal cemetery, which was established outside the walls of the town in 1533 at the suggestion of Martin Luther himself.

**Stadtverwaltung
Lutherstadt Eisleben**
Markt 1
D – 06295 Lutherstadt Eisleben
www.eisleben.eu

Evangelische Andreasgemeinde Erfurt

The Church of Saint Andrew in Erfurt became Protestant when the Reformation was introduced to the town in 1522. Its first Protestant minister was Melchior Weidmann, a fellow monk in Martin Luther's former convent. The first mention of this church is documented in the year 1182, but few traces of this Romanesque structure have survived. The building as it stands today was erected in 1203, and heavily altered according to prevalent tastes in the following centuries. In 1678, a new baptismal font was added, a pulpit altar was erected in 1679/1688 during Baroque alterations to the interior, and

Evangelische Andreasgemeinde Erfurt
Gemeindebüro
Andreasstraße 14 ·
D – 99084 Erfurt
www.andreasgemeinde-erfurt.de

comprehensive refurbishing is recorded for the years 1768/69. Since 1727, the church has been home to a highlight of Reformation art: A model for Martin Luther's epitaph carved from limewood in 1548.

Forschungsbibliothek Gotha der Universität Erfurt

The Gotha Research Library is one of the most prominent German libraries, with a substantial stock of historic manuscripts and books from the 16th through 18th centuries. The library is attached to the University of Erfurt. It forms part of the inspiring research environment of Friedenstein Castle in Gotha, which also encompasses the Gotha Research Centre of the University of Erfurt. Together, they provide an ideal venue for national and international research and exchange. The library is also an important element of the cultural heritage particularly of Thuringia but also of Europe in general. The core of this collection was provided by the former court library of Saxe-Gotha-Altenburg. It also holds the Perthes Collection with maps, archival material and a cartographic library which spans the 18th through late-20th centuries. The Research Library collects, preserves, and catalogs its source material and makes it accessible as a part of the shared cultural heritage of Europe. The sources are available to both researchers and the general public in original and digital versions.

Evangelische Marktkirchengemeinde Halle (Saale), Marienbibliothek

The Marienbibliothek (St. Mary's Library in Halle) is a church library belonging to the congregation of the Church of Our Lady. It contains historic, scientific and Protestant religious works. It was founded in 1552 by Sebastian Boetius, the principal minister of the Church of Our Lady, shortly after the Reformation was introduced to the city. For nearly 150 years, until the founding of Halle University in 1694, it remained the sole public library in the city. The Marienbibliothek is considered the largest and oldest continuously accessible Protestant church library in Germany. It was established in a dedicated library building in 1610, and from 1611 on it was administrated by a librarian appointed by the church wardens. Today, the library is housed in a typical purpose-built late 19th-century building. The library is a treasure-house of 15th to 19th-century scientific and scholarly literature in all disciplines. It also encompasses four substantial and complete private libraries of scholars from the 17th and 18th centuries as well as a minister's library from the 19th century.

Stadtarchiv Halle (Saale)

A turbulent history has shaped the Stadtarchiv Halle. The beginnings of the municipal archives were closely tied to the rise of the city council. The *Golden Bull* granted by Emperor Frederick II in 1232, which bestowed important privileges on this body, is the oldest such document to be preserved in Halle. The collection of the archive extends back to the early-14th century. It encompasses more than 1,000 documents, ranging from private contracts to papal edicts. Some 180 bequests of important individuals from the city's history are also preserved. While the documents were originally stored in strongboxes at the beginning of the 14th century, they are now preserved in modern storage facilities—a new building erected in 2004 and a restored former bank building—with some 4,000 meters of shelving.

Forschungsbibliothek Gotha
Schloss Friedenstein
D – 99867 Gotha
www.uni-erfurt.de/bibliothek/fb

Marienbibliothek Halle
An der Marienkirche 1
D – 06108 Halle (Saale)
www.verein-im-netz.de/
marienbibliothek-halle

Stadtarchiv Halle (Saale)
Rathausstraße 1
D – 06108 Halle (Saale)
www.halle.de/de/Kultur/
Willkommen/Stadtgeschichte/
Stadtarchiv/Aufgaben

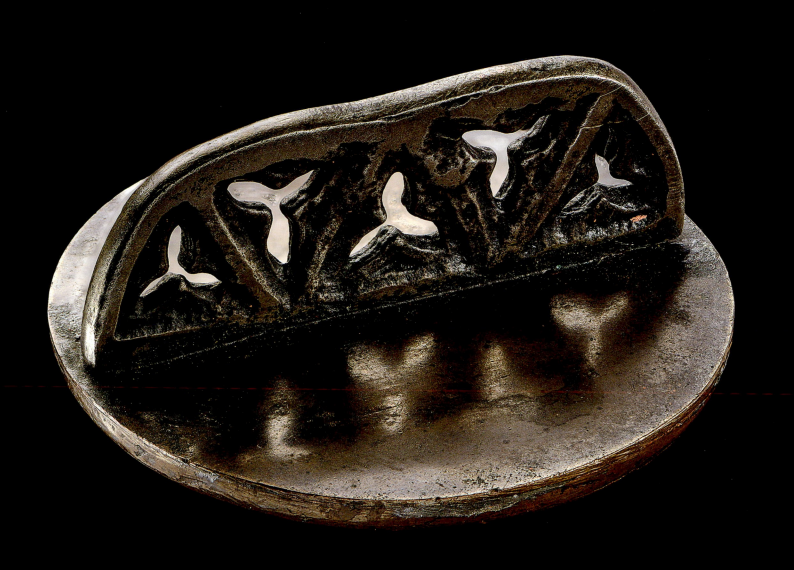

Stiftung Dome und Schlösser in Sachsen-Anhalt, Kunstmuseum Moritzburg Halle (Saale)

The Moritzburg Foundation is a museum that is just over one century old. The original collections evolved into six distinct departments dedicated to painting, sculpture, graphic works, photography, crafts and design as well as coins and medals. While the main emphasis lies on the art of the 20th and 21st centuries, there are substantial displays from earlier periods, from the Middle Ages to the 19th century, but also singular highlights from other eras. The building complex of the Moritzburg is one of the most impressive examples of late medieval castle architecture in Central Germany. It was originally built around 1500 as an ostentatious yet defensible residence for the Archbishops of Magdeburg, who had subjugated Halle only a few years earlier. Lying next to the city center, the complex was heavily damaged during a huge fire in 1637. During the following centuries the castle was used for a variety of purposes until it was rededicated as a museum in the early-20th century.

**Moritzburg Halle (Saale) –
Kunstmuseum des Landes Sachsen-Anhalt**
Friedemann-Bach-Platz 5
D – 06108 Halle (Saale)
www.stiftung-moritzburg.de

Universitäts- und Landesbibliothek Sachsen-Anhalt

The Universitäts- und Landesbibliothek (University and State Library) in Halle is home to a substantial collection of manuscripts and autographs. These include 49 full or partial bequests, 5622 single sheet prints (portraits and landscapes), 1600 incunabula, 350 rare books, and some 4000 documents. The manuscript inventory encompasses some 400 medieval pieces written in Latin, German, Dutch and the Romance languages, plus more than 550 musical sheets, and oriental and modern manuscripts of diverse origins. The map collection of the Universitäts- und Landesbibliothek consists of more than 40,000 individual maps and compilations. Users can also access a selection of historical and modern atlases and reference books on cartography.

**Universitäts- und Landesbibliothek
Sachsen-Anhalt**
August-Bebel-Straße 13/50
D – 06108 Halle (Saale)
bibliothek.uni-halle.de

Zentrale Kustodie der Martin-Luther-Universität Halle-Wittenberg

The Zentrale Kustodie was founded on October 18, 1979. Since then it has administered the art and cultural property of the university. In 2004 the art collection was enlarged with the collection of medals. The possessions of the Zentrale Kustodie include the Collection of Prints and Drawings which includes over 10,000 engravings and a small number of drawings from the 15th to the 21st centuries and the University Museum. This museum displays the insignia of the universities of Halle and Wittenberg as well as exceptional exhibits from other university collections spanning five centuries of university history.

**Martin-Luther-Universität Halle-Wittenberg
Zentrale Kustodie**
Universitätsplatz 11 (Löwengebäude)
D – 06099 Halle (Saale)
www.kustodie.uni-halle.de/

Das Universitätsarchiv der Martin-Luther-Universität Halle-Wittenberg

The University Archive, first mentioned in 1767, is responsible for the legacy of the Martin Luther University and its forbears. Among other things it collects, secures and curates documents, files images and estates pertaining to more than 500 years of the university's history and makes them publically available. With four "running kilometers" of archival material the University Archive of the Martin Luther University Halle-Wittenberg belongs to the largest university archives in Germany. The oldest documents date back to the 14th century.

**Archiv der Martin-Luther-Universität
Halle-Wittenberg**
Dachritzstraße 12
D – 6108 Halle (Saale)
http://www.archiv.uni-halle.de/

◀ cat. 136

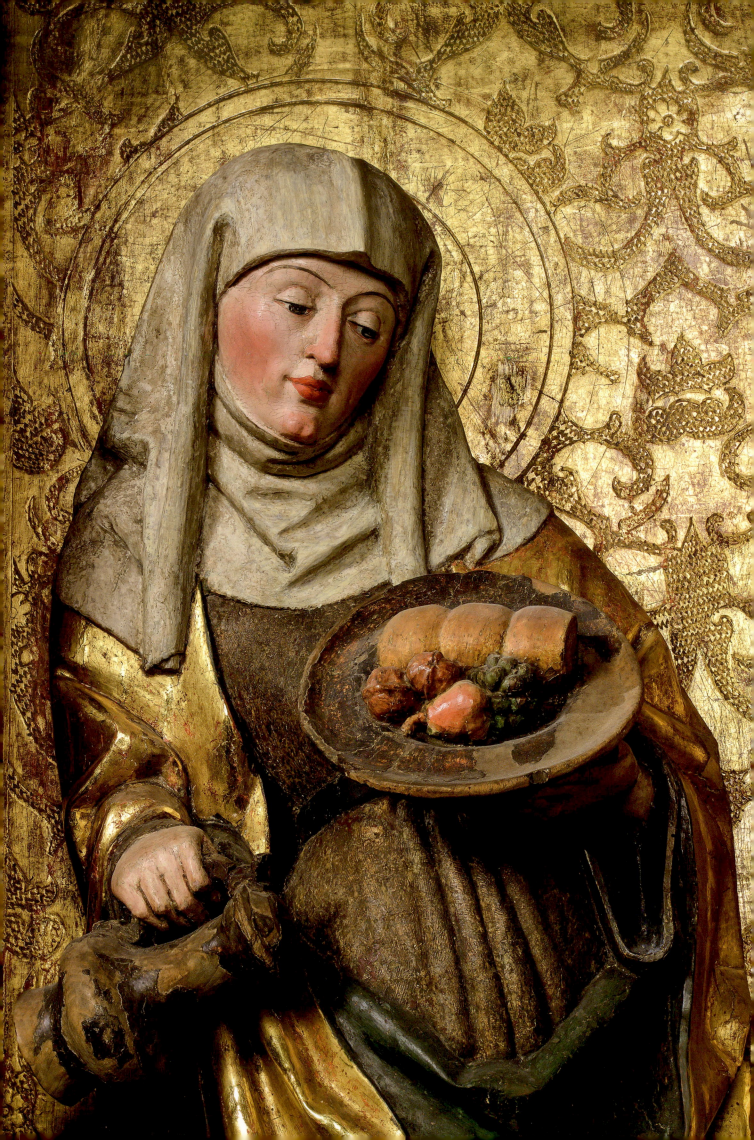

Wittenberg Seminary, Lutherstadt Wittenberg (Germany)

In 1816, a cabinet order of the Prussian King, Frederick William III, decreed the conversion of the former University of Wittenberg into a Lutheran seminary for preachers. The institution was inaugurated in the King's presence in 1817 with a Reformation Day ceremony. The seminary was furnished with the core inventory of the former university library. To this day, it remains one of the largest church libraries in Germany. It encompasses 160,000 volumes and some 80 current subscription journals. The inventory includes many deposits, among them twelfe medieval manuscripts, 500 incunabula, 10,000 prints from the 16th and 25,000 of the 17th century. Of particular importance are the special inventories of 10,000 dissertations written in Wittenberg, and the collection of 4,000 funeral sermons. Further highlights include book covers made by Wittenberg bookbinders, and volumes with marginal drawings and notes by members of the Leucorea University, among them Martin Luther and Philip Melanchthon. The library also encompasses an art collection, which includes 70 portraits of professors, reformers and Electors. A substantial inventory of graphic works is made up mostly of woodcuts and prints that depict individuals from the 16th through 18th centuries. The seminary also uses the former Castle Church of Wittenberg, which has served as the university's chapel, auditorium and burial place since 1507.

Evangelisches Predigerseminar Wittenberg
Schlossstraße 1
D – 06886 Lutherstadt Wittenberg
www.predigerseminar.de

Städtische Sammlungen, Lutherstadt Wittenberg

The Städtische Sammlungen located at the arsenal in Wittenberg look back upon a long history. The foundation for the historical collection of the city council was laid more than 700 years ago and grew to encompass the municipal archives and the historical and archaeological collections. In the early 1950s, the Melanchthon House was converted into a municipal museum. The council archives were stored here and made accessible to the public. But when the building was converted into a central memorial site for Melanchthon in 1967, the city council decided to establish a dedicated museum of municipal history, whose collections were housed and displayed in Wittenberg Castle from 1969. A part of this complex had already accommodated a museum of natural history and ethnology since 1948, yet another municipal institution, which was named after its founder, Julius Riemer. Today, the municipal collections are able to present exhibitions on history, natural history and ethnology in a total area of some 2200 square meters. A portion of the permanent exhibition on the history of Wittenberg is housed in the south tower of the castle, which Frederick the Wise had used as his personal living quarters around 1495.

Städtische Sammlungen
Wallstraße 1
D – 06886 Lutherstadt Wittenberg
www.wittenberg.de –› Kultur –›
Städtische Sammlungen

Kulturhistorisches Museum Magdeburg

The Kulturhistorisches Museum Magdeburg (Cultural History Museum Magdeburg), the successor of the former Kaiser Friedrich Museum, still resides in its original historical building which was opened in 1906. The museum's declared mission is to place the history of Magdeburg in its European context and to enable Magdeburg residents and outside visitors to appreciate the art and cultural history of Magdeburg and Europe. The most famous work of art in the Museum is the Magdeburg Rider. It was made around 1240 and is thus the oldest free standing equestrian sculpture north of the Alps. Together with two accompanying figures it is displayed in one of the most beautiful rooms in the city, the Cultural History Museum's medieval style Emperor Otto Hall.

Kulturhistorisches Museum Magdeburg
Otto-von-Guericke Straße 68–73
D–39104 Magdeburg
www.khm-magdeburg.de

Landesarchiv Sachsen-Anhalt

Abteilung Magdeburg
Brückstraße 2 · D–39114 Magdeburg

Abteilung Magdeburg · Standort Wernigerode
Lindenallee 21 · D–38855 Wernigerode

Abteilung Merseburg
König-Heinrich-Straße 83 · D–06217 Merseburg

Abteilung Dessau
Heidestraße 21 · D–06842 Dessau-Roßlau

www.landesarchiv.sachsen-anhalt.de

Stadtarchiv Mühlhausen
Ratsstraße 25
D–99974 Mühlhausen
www.muehlhausen.de/de/
stadt-buerger/stadt-und-geschichte/
stadtgeschichte/stadtarchiv

Bayerisches Nationalmuseum
Prinzregentenstraße 3
D–80538 München
www.bayerisches-nationalmuseum.de

The standing exhibition "Magdeburg – The History of the City" follows the turbulent history of the medieval metropolis up to its becoming the capital of the federal state of Saxony-Anhalt. Special exhibits about cultural and art historical topics are a regular feature of the house.

Landesarchiv Sachsen-Anhalt

The Landesarchiv Sachsen-Anhalt is the official archive of the state of Saxony-Anhalt. It serves as a repository for the official records of the ministries, departments and institutions of the modern state and its various predecessor territories. The oldest written records date to the 10th century. The inventory includes more than 55,000 documents and registers, 50 kilometers of records and 1.9 million photographs and film rolls. The Landesarchiv strives to make this material accessible to all users. As a provider of information to public, research, business and administration clients, the Landesarchiv is dedicated to the preservation and dissemination of the history and tradition of Saxony-Anhalt.

Stadtarchiv Mühlhausen/Thüringen

The Town Archive of Mühlhausen is housed in the venerable town hall, whose oldest parts date to before 1300 AD. Its architecture also displays Gothic, Renaissance and Baroque elements. The archive contains more than 200 meters of documents, records, chronicles, manuscripts and maps from the rich history of Mühlhausen, a free imperial city since the 12th century. Since 1900, a permanent exhibition has displayed relevant archival material in the unique rooms that were set aside in 1615 for the archive of the city. The painted and ornamented original 17th-century cabinets and strongboxes are a particular highlight. The inventory also includes substantial collections of historic seals, maps, posters, brochures, photographs, and newspapers (from 1786 on), as well as a large reference library.

Bayerisches Nationalmuseum München

Founded by King Maximilian II in 1855, the Bavarian National Museum is one of the major museums of art and cultural history in Europe. The nucleus of its collections was provided by the art collections of the Wittelsbach dynasty. The building was designed in the historicist style by Gabriel von Seidl around 1900. Its exterior and the rich historic furnishings of its rooms make it one of the most original and significant buildings of its kind. Visitors can admire objects of all European style periods, ranging from late antiquity to Art Nouveau. The permanent exhibition displays masterpieces of sculpture and painting, priceless ivories and goldsmith's creations, tapestries, furniture, arms, delicate china and a world-famous collection of nativity scenes.

Stiftung Dome und Schlösser in Sachsen-Anhalt, Domschatz Halberstadt

The purpose of the Stiftung Dome und Schlösser in Sachsen-Anhalt is the preservation of the cathedrals, churches, convents, castles and palaces and the objects of artistic and cultural significance in Saxony-Anhalt that have been entrusted to its care. This legacy

is administrated with particular regard to its significance on the general, ecclesiastical and artistic history of the state and its impact on the cultural landscape. The foundation is responsible for three castles, seven palaces, four cathedrals and a convent with an attached church. Among the objects of cultural significance, the treasure of Halberstadt Cathedral truly stands out: It is the largest collection of medieval art preserved in its original church context. This trove was amassed over the course of a thousand years, with most of the pieces intended for liturgical use or the decoration of the cathedral. Today, the inventory lists some 600 objects from the 5th through 18th century. They cover all the major categories of art: textiles, panel paintings, sculpture, furniture and objects of the goldsmith's craft, all of which can be admired in the cathedral itself or in its annex buildings. The textile collection forms a particular highlight: It consists of more than 300 objects, making it one of the most substantial collections in the world. A cope that was made nearly a thousand years ago and the rare Romanesque tapestries are among the best-preserved examples of their kind in Europe.

Thüringisches Hauptstaatsarchiv Weimar

The history of this archive goes back to 1547, when the Ernestine lineage of the Wettin dynasty established their residence in Weimar. The following centuries saw the development of three distinct archives. The first of these was the Gemeinschaftliches Hauptarchiv, the joint archive of the diverse branches of Saxony's Ernestine dynasty, which was created by the amalgamation of the records of the various Ernestine administrations. The second archive was the Zentralarchiv of the Ernestine Duchy of Saxe-Weimar, the secret central records repository of the state, which was first a Grand Duchy and then, after monarchy was abolished in 1918, the Free State of Saxe-Weimar-Eisenach. The third element was established in 1865 with the private archive of the Grand Dukes. After the state of Thuringia was founded in 1920, these separate archives were united under the title of Thüringisches Staatsarchiv in 1923.

Thüringisches Staatsarchiv Gotha

The Thüringisches Staatsarchiv Gotha was established after the foundation of the Duchy of Gotha by a branch of the Ernestine dynasty of Saxony in 1640/41. It concentrated the documents, registers and records of the territories and dissolved monasteries that formed the new Duchy, which had previously been stored in the Gemeinschaftlichen Hauptarchiv of the dynasty in Weimar. This secret archive was the central repository for the records of the *Geheimer Rat*, the privy council that ran the Duchy. In 1840, the archive was renamed Herzoglich Sächsisches Haus- und Staatsarchiv. Only with the abolition of monarchy were the records of the central departments of the Duchy of Saxe-Coburg-Gotha (founded in 1826) integrated into this archive. After the state of Thuringia was formed in 1920, the archive was renamed Thüringisches Staatsarchiv in 1923. After 1945, the archival records of the former Prussian district of Erfurt (established in 1816) were also incorporated. In 1976, the archive in Gotha was reduced to a dependency of the Thüringisches Hauptstaatsarchiv Weimar, but it regained its independent status and former title as the Thüringisches Staatsarchiv Gotha in 1994.

Stiftung Dome und Schlösser in Sachsen-Anhalt
Am Schloss 4
OT Leitzkau
D – 39279 Gommern
www.dome-schloesser.de

Thüringisches Hauptstaatsarchiv Weimar
Marstallstraße 2
D – 99423 Weimar
www.thueringen.de/th1/tsk/
kultur/staatsarchive/standorte/weimar

Thüringisches Staatsarchiv Gotha
Justus-Perthes-Straße 5
D – 99867 Gotha
www.thueringen.de/th1/tsk/
kultur/staatsarchive/standorte/gotha

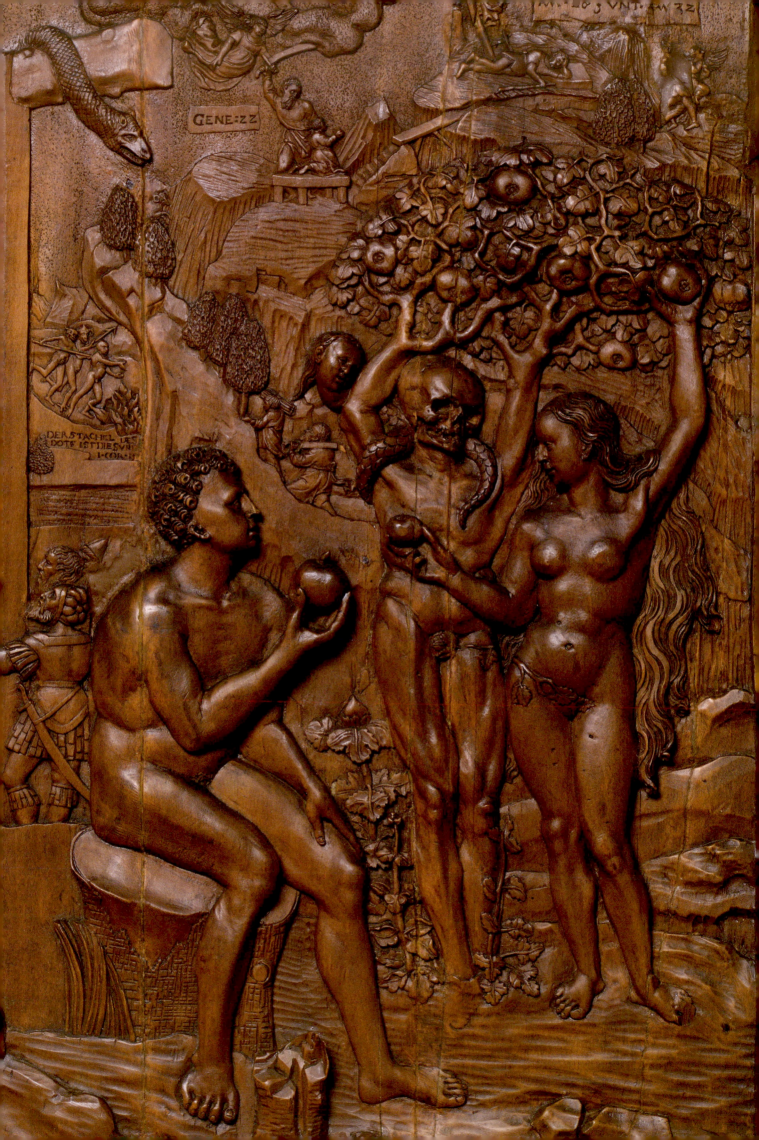

Scheide Library, Princeton University Library

Scheide Library, Princeton University Library
Firestone Library
One Washington Road
Princeton, NJ 08540
https://rbsc.princeton.edu/divisions/
scheide-library

Housed in Princeton University's Firestone Library since 1959 and bequeathed to Princeton by William H. Scheide in 2015, the Scheide Library is one of the greatest collections of rare books and manuscripts in the world. Founded by William Taylor Scheide in 1865 and comprising some 2,500 rare printed books and manuscripts, the library holds the first six printed editions of the Bible, starting with the 1455 Gutenberg Bible; the original printing of America's Declaration of Independence; Beethoven's music sketchbook for 1815–16, the only one outside Europe; Shakespeare's first, second, third and fourth folios; significant autograph music manuscripts of Johann Sebastian Bach, Wolfgang Amadeus Mozart, Ludwig van Beethoven, Franz Schubert and Richard Wagner; treasures of American history, such as a lengthy autograph speech by Abraham Lincoln from 1856 on the problems of slavery. The library is considered to be the most valuable gift in Princeton's history.

Luther Seminary Library St. Paul

Luther Seminary Library St. Paul
Gullixson Hall
2375 Como Avenue
St Paul, MN 55108
www.luthersem.edu/library

Luther Seminary, through a series of mergers covering more than half a century, represents the consolidation into one seminary of what at one time were six separate institutions. It is the largest of eight ELCA seminaries in the United States providing theological education to equip people for ministry.

The Luther Seminary Library, located in Gullixson Hall, offers access to about 250,000 print volumes, thousands of digital journals and a growing e-book collection to help you with research.

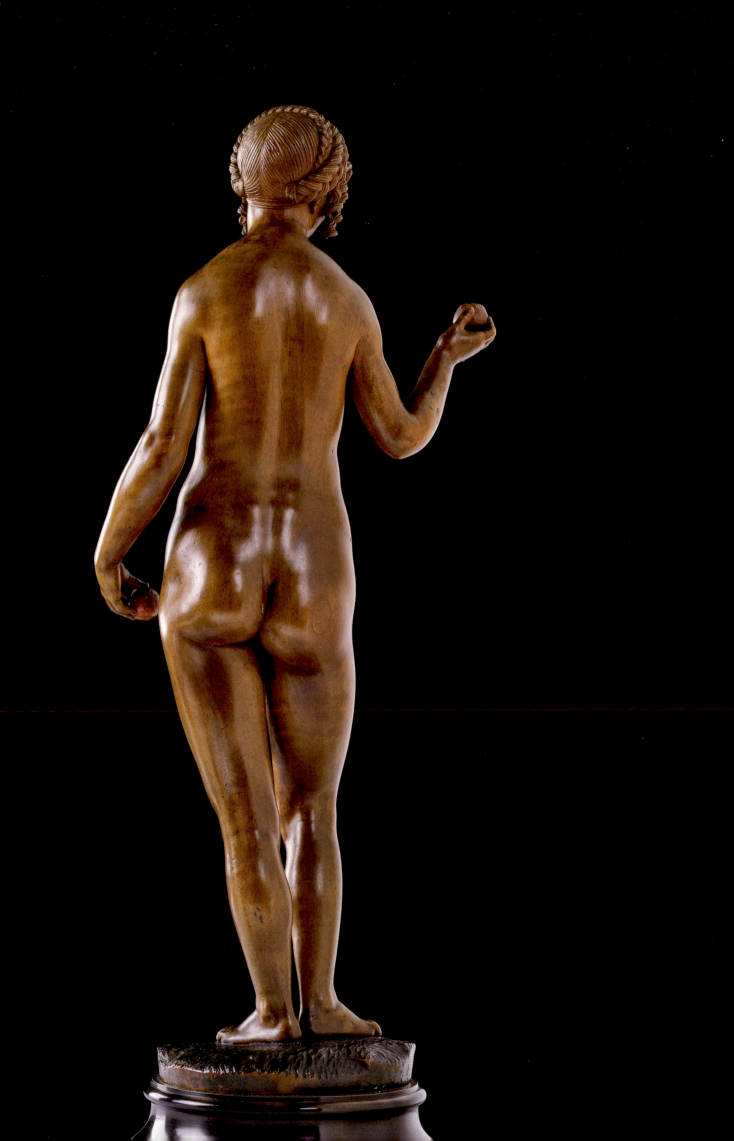

The Reformation Anniversary in 2017 — Special National Exhibitions in Germany

"Luther! 95 Treasures — 95 People"

May 13 through November 5, 2017
Luther Memorials Foundation of Saxony-Anhalt,
Luther House/Augusteum, Lutherstadt Wittenberg

The exceptional objects displayed in the first-half of this special exhibition show the evolution of Martin Luder, the young monk, into Luther, the Reformer who would change the world.

Who was this young man who boldly published his theses against the sale of indulgences and thereby started the Reformation?

The second part presents 95 different personalities and their relations with Luther and his work. Their biographies span the history of the Reformation from the 16th century to the present, and include people like Paul Gerhardt and Martin Luther King Jr.

"Luther and the Germans"

May 4 through November 5, 2017
Wartburg-Stiftung, Wartburg Castle, Eisenach

This comprehensive exhibition centers around the question of how every era of German history has formed its own unique picture of Luther. Relevant and incisive Reformation topics will be introduced in the context of cultural and political developments, creating a bridge between Luther's point of view and the present.

"The Luther Effect. 500 Years of Worldwide Protestantism"

April 12 through November 5, 2017
Stiftung Deutsches Historisches Museum, Martin-Gropius-Bau, Berlin

"The Luther Effect" is the first exhibition ever to present the story of how Protestantism became a global phenomenon, how it blossomed into rich diversity, and why potential conflicts would surface in its encounters with other cultures.

How did Protestantism influence other denominations and religions? In how far was it influenced by these contacts? And, finally, how did people come to accept, adapt and live this new faith?

Brandsch 2001
Juliane Brandsch (ed.): Ernst der Fromme (1601–1675). Bauherr und Sammler, exhibition catalogue, Gotha 2001.

Braun 1907
Joseph Braun: Die liturgische Gewandung im Occident und Orient nach Ursprung und Entwicklung, Verwendung und Symbolik, Freiburg im Breisgau 1907.

Brecht 1983
Martin Brecht: Martin Luther. Sein Weg zur Reformation 1483–1521, 2nd edition, Stuttgart 1983.

Brecht 1986
Martin Brecht: Martin Luther, 2 vols., Stuttgart 1986.

Brecht 2013
Martin Brecht: Martin Luther, 3 vols., unaltered reprint of the 3rd revised edition of 1990, Stuttgart 2013.

Breslauer 1997
Bernhard H. Breslauer: Tammaro De Marinis Rememberd, in Joseph Jung (ed.), "… am literarischen Webstuhl …" Ulrico Hoepli, 1847–1935: Buchhändler, Verleger, Antiquar, Mäzen, Zürich 1997.

Brinkmann 2007
Bodo Brinkmann (ed.): Cranach der Ältere, exhibition catalogue, Ostfildern 2007.

Brinkmann/Größler 1895
Adolf Brinkmann/Hermann Größler: Beschreibende Darstellung der älteren Bau- und Kunstdenkmäler des Mansfelder Seekreises (= Beschreibende Darstellung der älteren Bau- und Kunstdenkmale der Provinz Sachsen, vol. 19), Halle 1895.

Brozatus/Opitz 2015
Klaus-Peter Brozatus/Rainer Opitz (eds.): Reformatio in Nummis. Annotierter Bestands-Kat. der reformationsgeschichtlichen Münz- und Medaillensammlung der Stiftung Luthergedenkstätten in Sachsen-Anhalt, vol. 1.1, Osnabrück 2015.

Bruck 1903
Robert Bruck, Friedrich der Weise als Förderer der Kunst, in: Studien zur deutschen Kunstgeschichte, vol. 45, Strasburg 1903, pp. 202 f.

Brüggemeier/Korff/Steiner 1993
Franz-Josef Brüggemeier/Gottfried Korff/Jürg Steiner: mittendrin. Sachsen-Anhalt in der Geschichte, exhibition catalogue, Dessau 1993.

Bruns 2006
Roger Bruns: Martin Luther King, Jr: A Biography, Santa Barbara, CA 2006.

Bubenheimer 1985
Ulrich Bubenheimer: Luthers Stellung zum Aufruhr in Wittenberg 1520–1522 durch die frühreformatorischen Wurzeln des landesherrlichen Kirchenregiments, in: Zeitschrift der Savigny-Stiftung für Rechtsgeschichte 102, Kanonische Abteilung 71 (1985), pp. 147–214.

Bünz 2004
Enno Bünz: Das Ende der Klöster in Sachsen. Vom "Auslaufen" der Mönche bis zur Säkularisation (1521 bis 1543), in: Harald Marx/Cecilie Hollberg (eds.), Glaube und Macht. Sachsen im Europa der Reformationszeit. Aufsätze, Dresden 2004, pp. 80–90.

Burger 2014
Christoph Burger: Tradition und Neubeginn. Martin Luther in seinen frühen Jahren, Tübingen 2014.

Burkhardt/Küstermann/Otte 1883
Johannes Burkhardt/Otto Küstermann/Heinrich Otte: Beschreibende Darstellung der älteren Bau- und Kunstdenkmäler des Kreises Merseburg (= Beschreibende Darstellung der älteren Bau- und Kunstdenkmäler der Provinz Sachsen und angrenzender Gebiete, vol. 8), Halle (Saale) 1883.

Burnett 2011
Amy Nelson Burnett: Karlstadt and the Origins of the Eucharistic Controversy: A Study in the Circulation of Ideas, Oxford 2011.

Bury 2001
Michael Bury: The Print in Italy 1550–1620, London 2001.

Buske 2010
Norbert Buske: Johannes Bugenhagen. Sein Leben. Seine Zeit. Seine Wirkungen (= Beiträge zur pommerschen Landes-, Kirchen- und Kunstgeschichte, vol. 14), Schwerin 2010.

C

Cárdenas 2002
Livia Cárdenas: Friedrich der Weise und das Wittenberger Heiltumsbuch: mediale Repräsentation zwischen Mittelalter und Neuzeit, Berlin 2002.

Carson 1988
Clayborne Carson (ed.): The Autobiography of Martin Luther King, Jr., New York 1988.

Carswell 1998
John Carswell: Iznik Pottery, London 1998.

Christiani 1983
Franz-Joseph Christiani: Tetzels Ablaßkiste (= Städtisches Museum Braunschweig Miszellen, vol. 37), Braunschweig 1983.

Claus 2002
Helmut Claus: "…als ob die Engel Botenläufer gewesen seien." Wittenberg als Druckerstadt, in: Peter Freybe (ed.), Wittenberg als Bildungszentrum 1502–2002. "Recht lehren ist nicht die geringste Wohltat". Lernen und Lehren auf Luthers Grund und Boden (= Wittenberger Sonntagsvorlesungen 2002), Wittenberg 2002, pp. 75–102.

Clemen 1939
Otto Clemen: Die lutherische Reformation und der Buchdruck, (= Schriften des Vereins für Reformationsgeschichte, vol. 167), Leipzig 1939.

Cochlaeus 2000
Johannes Cochlaeus: Sieben Köpfe Martin Luthers vom hochwürdigen Sakrament des Altars, in: Adolf Laube (ed.), Flugschriften gegen die Reformation, vol. 2: 1525–1530, Berlin 2000, pp. 989–1021.

Coliva/Aikema 2010
Anna Coliva/Bernard Aikema (eds.): Cranach. L'altro rinascimento. A Different Renaissance, exhibition catalogue, Rome 2010.

Cordez 2006
Philippe Cordez: Wallfahrt und Medienwettbewerb, in: Andreas Tacke (ed.), "Ich armer sundiger mensch". Heiligen- und Reliquienkult am Übergang zum konfessionellen Zeitalter (= Schriftenreihe der Stiftung Moritzburg, Kunstmuseum des Landes Sachsen-Anhalt, vol. 2), Göttingen 2006, pp. 37–73.

Cottin/John/Kunde 2008
Markus Cottin/Uwe John/Holger Kunde (adap.): Der Merseburger Dom und seine Schätze. Zeugnisse einer tausendjährigen Geschichte (= Kleine Schriften der Vereinigten Domstifter zu Merseburg und Naumburg und des Kollegiatstifts Zeitz, vol. 6), Petersberg 2008.

Cottin/Kunde/Kunde 2014
Markus Cottin/Claudia Kunde/Holger Kunde (eds.): Thilo von Trotha. Merseburgs legendärer Kirchenfürst (= Schriftenreihe der Vereinigten Domstifter zu Merseburg und Naumburg und des Kollegiatstifts Zeitz, vol. 7), exhibition catalogue, Petersberg 2014.

Cranach-Bibel 1997
Die "Cranach-Bibel" (= PATRIMONIA, vol. 130),
pub. by the Kulturstiftung der Länder in
Verbindung mit der Anhaltinischen Landes-
bücherei Dessau, Berlin/Dessau 1997.

Crowther 2010
Kathleen M. Crowther: Adam and Eve in the
Protestant Reformation, Cambridge 2010.

Cupperi 2013
Walter Cupperi (ed.): Wettstreit in Erz.
Porträtmedaillen der deutschen Renaissance,
Berlin 2013.

Curry 2016
Andrew Curry, The Alchemist's Tale, in:
Archaeology, Jan./Febr. 2016, pp. 36–39.

D

Dethlefs/Galen 1986
Gerd Dethlefs/Hans Galen (eds.):
Die Wiedertäufer in Münster, exhibition
catalogue, 5th edition, Münster 1986.

Dieck 1962
Alfred Dieck: Cranachs Gemälde des toten
Luther in Hannover und das Problem der
Luther-Totenbilder, in: Niederdeutsche Beiträge
zur Kunstgeschichte, vol. 2, 1962, pp. 191–218.

Dipple 1996
Geoffrey Dipple: Antifraternalism and
Anticlericalism in the German Reformation.
Johann Eberlin von Günzburg and the Campaign
against the Friars (= St. Andrews Studies in
Reformation History), Cambridge 1996.

Dodgson 1980
Campbell Dodgson: Catalogue of Early
German and Flemish Woodcuts preserved in the
Department of Prints and Drawings in the
British Museum, 2 vols., reprint of the edition
London 1903–1911, Vaduz 1980.

Dörfler-Dierken 1992
Angelika Dörfler-Dierken: Die Verehrung der
heiligen Anna in Spätmittelalter und früher
Neuzeit, Göttingen 1992.

Döring 2006
Thomas Döring: Bibeldruck und Ablaßzettel.
Albrecht von Brandenburg als Auftraggeber für
den Buchdruck, in: Andreas Tacke (ed.),
Der Kardinal. Albrecht von Brandenburg
Renaissancefürst und Mäzen, vol. 2 (Essays),
Regensburg 2006, pp. 285–291.

Doerk 2014
Elisabeth Doerk (ed.): Reformatio in Nummis.
Luther und die Reformation auf Münzen und
Medaillen, exhibition catalogue, Eisenach 2014.

Dorigato 1986
Attilia Dorigato: Il Museo Vetrario Di Murano,
Mailand 1986.

Dräger 2011
Ulf Dräger: Idee Schatzkammer. Kostbarkeiten
und Raritäten aus der Moritzburg,
Stiftung Moritzburg, Kunstmuseum des
Landes Sachsen-Anhalt, Halle (Saale) 2011.

Dreier 1989
Franz Adrian Dreier, Venezianische Gläser und
"façon de Venise", Berlin 1989.

Drößler 1995
Stadt Zeitz (ed.)/Rudolf Drößler: Zeitz Stätte der
Reformation (I). Vom Beginn der Reformation
1517 bis zum Tod Bischof Philipps 1541,
Zeitz 1995.

E

Ebeling 1985
Gerhard Ebeling, Vorbemerkungen, in:
WA.B 18, pp. 139–142.

Eberle/Wallenstein 2012
Martin Eberle/Uta Wallenstein: Gothas Gold.
300 Jahre Münzkabinett, Gotha 2012.

Eichelmann 2010
Wolfgang Eichelmann, Hessische Münzen und
Medaillen: Gedanken und Betrachtungen zu
Münzen und Medaillen des Hauses Brabant,
Münster 2010.

Eichhorn 2014 a
Nicole Eichhorn: Frühneuzeitliche Glasfunde
von Grabungen in Wittenberg, Naumburg
und Annaburg, in: Harald Meller (ed.), Mittel-
deutschland im Zeitalter der Reformation.
Interdisziplinäre Tagung vom 22. bis 24. Juni
in Halle (Saale) (= Forschungsberichte des
Landesmuseums für Vorgeschichte Halle,
vol. 4), Halle (Saale) 2014, pp. 223–231.

Eichhorn 2014 b
Nicole Eichhorn, Glasfunde aus Wittenberg.
Frühneuzeitliche Hohl- und Flachglasfunde aus
Mitteldeutschland, dargestellt an ausgewählten
Fundkomplexen aus Wittenberg, Naumburg
und Annaburg, in: Harald Meller (ed.), Glas,
Steinzeug und Bleilettern aus Wittenberg
(= Forschungsberichte des Landesmuseums für
Vorgeschichte Halle, vol. 5), Halle (Saale) 2014,
pp. 9–148.

Eifler 2015
Matthias Eifler: Mittelalterliche liturgische
Handschriften aus den Bistümern Naumburg,
Merseburg und Meißen. Beobachtungen zum
Entstehungsprozess, zum Inhalt und zur
Verwendung in der Frühen Neuzeit, in:
Jahrbuch für mitteldeutsche Kirchen- und
Ordensgeschichte, vol. 11, 2015, pp. 335–375.

Eikelmann 2006
Renate Eikelmann (ed.): Conrat Meit. Bildhauer
der Renaissance, exhibition catalogue,
München 2006.

Eissenhauer 1992
Michael Eissenhauer: Bildnisse des Martin
Luther (1483–1546) und der Katharina von Bora
(1499–1546) [sic], in: Rosemarie Beier und
Gottfried Korff (eds.), Zeitzeugen. Ausgewählte
Objekte aus dem Deutschen Historischen
Museum, Berlin 1992, pp. 35–39.

Eule 1955
Wilhelm Eule: Mit Stift und Feder. Kleine
Kulturgeschichte der Schreib- und Zeichen-
werkzeuge, Leipzig 1955.

F

Faber 1988
Marion Faber: Das Schachspiel in der
europäischen Malerei und Graphik (1550–1700)
(= Wolfenbütteler Arbeiten zur
Barockforschung, vol. 15), Wiesbaden 1988.

Fabiny 1983
Tibor Fabiny: Martin Luthers letzter Wille.
Das Testament des Reformators und seine
Geschichte, Berlin 1983.

Fabisch/Iserloh 1991
Peter Fabisch/Erwin Iserloh (eds.): Dokumente
zur Causa Lutheri (1517–1521), vol. 2: Vom
Augsburger Reichstag bis zum Wormser Edikt,
Münster 1991.

Falk 2001
Alfred Falk: Mit Hörnern und Fanfaren, in:
Jahresschrift der Archäologischen Gesellschaft
der Hansestadt Lübeck, vol. 2/3 1997/1999,
2001, pp. 156 f.

Fastert 2004
Sabine Fastert: Individualität versus Formel.
Zur Bedeutung der Physiognomik in den
graphischen Porträts Albrecht Dürers, in:
Frank Büttner/Gabriele Wimböck, Das Bild als
Autorität. Die Normierende Kraft des Bildes,
Münster 2004, pp. 227–260.

Faust 2001
Ingrid Faust: Zoologische Einblattdrucke und Flugschriften vor 1800, 6 vols. (1998–2011). vol. 3: Paarhufer: Schweine, Kamele, Hirsche, Giraffen, Rinder, Stuttgart 2001.

Felmberg 1998
Bernhard Alfred R. Felmberg: Die Ablasstheologie Kardinal Cajetans (1469–1534) (= Studies in Medieval and Reformation Thought, vol. 66), Leiden 1998.

Fessner 2008 a
Michael Fessner: Die Familie Luder in Möhra und Mansfeld: Archivalische Überlieferungen zum Elternhaus von Martin Luther, in: Harald Meller (ed.), Fundsache Luther: Archäologen auf den Spuren des Reformators, exhibition catalogue, Stuttgart 2008, pp. 78–84.

Fessner 2008 b
Michael Fessner: Die Familie Luder und das Berg- und Hüttenwesen, in: Harald Meller/Stefan Rhein/Hans-Georg Stephan (eds.), Luthers Lebenswelten (= Tagungen des Landesmuseums für Vorgeschichte Halle, vol. 1), Halle (Saale) 2008, pp. 235–243.

Fessner 2014
Michael Fessner: Das Montanwesen in der Grafschaft Mansfeld zu Luthers Zeiten, in: Harald Meller (ed.), Mitteldeutschland im Zeitalter der Reformation. Interdisziplinäre Tagung vom 22. bis 24. Juni in Halle (Saale) (= Forschungsberichte des Landesmuseums für Vorgeschichte Halle, vol. 4), Halle (Saale) 2014, pp. 29–34.

Feuerstein-Herz 2005
Petra Feuerstein-Herz (ed.): Gotts verhengnis und seine straffe. Zur Geschichte der Seuchen in der Frühen Neuzeit, exhibition catalogue, Wiesbaden 2005.

Fey 2007
Carola Fey: Wallfahrtserinnerungen an spätmittelalterlichen Fürstenhöfen in Bild und Kult, in: Carola Fey/Steffen Grieb (eds.), Mittelalterliche Fürstenhöfe und ihre Erinnerungskulturen, Göttingen 2007, pp. 152–154, 324.

Fischer 1979
Thomas Fischer: Städtische Armut und Armenfürsorge im 15. und 16. Jahrhundert, Göttingen 1979.

Flechsig 1912
Eberhard Flechsig: Beschreibung der mittelalterlichen Holzbildwerke und Gemälde des Provinzial-Museum in Halle a. S., in: Mitteilungen aus dem Provinzial-Museum der Provinz Sachsen zu Halle a. S., issue 3, Halle (Saale) 1912.

Fleck 2010
Miriam Verena Fleck: Ein tröstlich gemelde. Die Glaubensallegorie "Gesetz und Gnade" in Europa zwischen Spätmittelalter und Früher Neuzeit (= Studien zur Kunstgeschichte des Mittelalters und der Frühen Neuzeit, vol. 5), Korb 2010.

Flemming/Lehmann/Schubert 1990
Johanna Flemming/Edgar Lehmann/Ernst Schubert: Dom und Domschatz zu Halberstadt, revised edition of 2nd edition published 1976 in Berlin, Leipzig 1990.

Flood 1998
John L. Flood: The Book in Reformation Germany, in: The Reformation and the Book, edited by Jean-Francois Gilmont, translated by Karin Maag, (= St. Andrews Studies in the Reformation), Aldershot 1998, pp. 21–103.

Flügel 1983
Katharina Flügel: Konsolidierung der protestantischen Bildthematik, in: Günter Schade (ed.), Kunst der Reformationszeit, exhibition catalogue, Berlin 1983, p. 369.

Förstemann 1841
Karl Eduard Förstemann (ed.): Album Academiae Vitebergensis, older series, in 3 vols. 1502–1602, vol. 1: 1502–1560, reprint Leipzig 1841.

Fraengler 1953
Wilhelm Fraenger: Dürers Gedächtnissäule für den Bauernkrieg, in: Beiträge zur sprachlichen Volksüberlieferung. Adolf Spamer zum 70. Geburtstag (= Veröffentlichungen der Kommission für Volkskunde, vol. 2), Berlin 1953, pp. 126–140.

Franz 1984
Günther Franz: Der deutsche Bauernkrieg, 12th edition, Darmstadt 1984.

Freydank 1933
Hanns Freydank: Martin Luther und der Bergbau, in: Zeitschrift für das Berg-, Hütten- und Salinenwesen im preußischen Staate, vol. 81, 1933, pp. 315 f.

Freydank 1955
Hanns Freydank: Nappian und Neucke, die beiden sagenhaften Gründer des Mansfelder Bergbaues, Halle (Saale) 1955.

Friedensburg 1917
Walter Friedensburg: Geschichte der Universität Wittenberg, Halle (Saale) 1917.

Friedensburg 1926
Walter Friedensburg (adap.): Urkundenbuch der Universität Wittenberg, Teil 1 (1502–1611) (= Geschichtsquellen der Provinz Sachsen und des Freistaates Anhalt, new series vol. 3), Magdeburg 1926.

Friedländer/Rosenberg 1932
Max J. Friedländer/Jacob Rosenberg: Die Gemälde von Lucas Cranach, Berlin 1932.

Friedländer/Rosenberg 1979
Max J. Friedländer/Jakob Rosenberg (eds.): Die Gemälde von Lucas Cranach, 2nd edition, Basel/Boston/Stuttgart 1979.

Friedländer/Rosenberg 1989
Max J. Friedländer/Jakob Rosenberg: Die Gemälde von Lucas Cranach, 3rd edition, Stuttgart 1989.

Fritz 1983
Rolf Fritz: Die Gefäße aus Kokosnuß in Mitteleuropa 1250–1800, Mainz 1983, online under www.slubdd.de/katalog?TN_libero_mab21211822 (last accessed on March 1, 2016).

Fuchs 2013
Walter Fuchs: Graf Joachim, der Luther Ortenburgs, in: Alfons Niederhofer (ed.), Ortenburg. Reichsgrafschaft und 450 Jahre Reformation 1563–2013, Ortenburg 2013, pp. 69–75.

Fuchs 2014
Thomas Fuchs: Einleitung: Buch und Reformation, in: Enno Bünz/Thomas Fuchs/Stefan Rhein (eds.), Buch und Reformation. Beiträge zur Buch- und Bibliotheksgeschichte Mitteldeutschlands im 16. Jahrhundert (= Schriften der Stiftung Luthergedenkstätten in Sachsen-Anhalt, vol. 16), Leipzig 2014, pp. 9–37.

Führer 2009
Werner Führer: Die Schmalkaldischen Artikel (= Kommentare zu den Schriften Luthers, vol. 2), Tübingen 2009.

Fuhrmann 2009
Hans Fuhrmann: Die Inschriften des Doms zu Halberstadt, Wiesbaden 2009.

Füssel 2012
Stephan Füssel: Die Lutherbibel von 1534. Eine kulturhistorische Einführung, Köln 2012.

G

Gaimster 1997
David Gaimster: German Stoneware 1200–
1900: Archaeological and Cultural History,
Containing a Guide to the Collection of the
British Museum, Victoria & Albert Museum and
Museum of London, London 1997.

von Gaisberg 2011
Elgin von Gaisberg: Die Stadt als Quelle:
Bildliche Überlieferung und baulicher Bestand,
in: Heiner Lück/Enno Bünz/ Leonhard Helten/
Dorothee Sack/Hans-Georg Stephan (eds.),
Das ernestinische Wittenberg: Universität und
Stadt (1486–1547) (= Wittenberg-Forschungen,
vol. 1), Petersberg 2011, pp. 30–48.

Gantet 2004
Claire Gantet: Visions et visualisations de la
Réforme: Le Songe de Frédéric le Sage et le
Songe de Nabuchodonosor, in: La Réforme
dans l'espace germanique au XVIe siècle –
images, représentations, diffusion, edited
by the Societé d'Emulation de Montbéliard,
Montbéliard 2004, pp. 149–170.

"… gantz verheeret!" 1998
"… gantz verheeret!" Magdeburg und der
Dreißigjährige Krieg. Beiträge zur Stadtgeschichte
und Katalog zur Ausstellung des Kultur-
historischen Museums Magdeburg, published by
the Kulturhistorisches Museum Magdeburg and
the Kunstmuseum Kloster Unser Lieben Frauen,
2nd edition, Halle (Saale) 1998.

Garbe/Kröger 2010
Irmfried Garbe/Heinrich Kröger (eds.):
Johannes Bugenhagen (1485–1558).
Der Bischof der Reformation, Leipzig 2010.

Garlin 2002
Clingan Ralph Garlin: Against Cheap Grace in a
World Come of Age: An Intellectual Biography of
Clayton Powell, 1865–1953, New York 2002.

Gaschütz 1985
Peter Gaschütz: Turnierritter oder Wiedertäufer,
in: Numismatisches Nachrichtenblatt, vol. 10,
1985, pp. 276–284.

Gehrt 2001
Daniel Gehrt: Ernestinische Konfessionspolitik.
Bekenntnisbildung, Herrschaftskonsolidierung
und dynastische Identitätsstiftung vom
Augsburger Interim 1548 bis zur Konkordienformel
1577, (= Arbeiten zur Kirchen- und Theologie-
geschichte 34), Leipzig 2011.

Gehrt 2015
Daniel Gehrt: Katalog der Reformationshand-
schriften. Aus den Sammlungen der Herzog von
Sachsen-Coburg und Gotha'schen Stiftung für
Kunst und Wissenschaft, Wiesbaden 2015.

Gehrt/Salatowsky 2014
Daniel Gehrt/Sascha Salatowsky (eds.):
Aus erster Hand. 95 Porträts zur Reformations-
geschichte. Aus den Sammlungen der For-
schungsbibliothek Gotha, exhibition catalogue,
Gotha 2014.

Geisberg 1930
Max Geisberg: Der deutsche Einblatt-Holzschnitt
in der ersten Hälfte des 16. Jahrhunderts. Die
Gesamtverzeichnisse, München 1930.

Geisberg 1974
Max Geisberg: The German Single-leaf
Woodcut: 1500–1550, revised and edited by
Walter L. Strauss, 4 vols., New York 1974.

Gieseking 2001
Martin Gieseking: Zur Geschichte des Noten-
drucks. Ein Überblick, in: Bernhard Müßgens/
Martin Gieseking/Oliver Kautny (eds.), Musik
im Spektrum von Kultur und Gesellschaft. Fest-
schrift für Brunhilde Sonntag (= Osnabrücker
Beiträge zur Musik und Musikerziehung, vol. 1),
Osnabrück 2001, pp. 339–353.

Gnaedig/Marquart 2012
Jeremie Gnaedig/Markus Marquart: Zwei hoch-
mittelalterliche Schreibgriffel aus Aschaffen-
burg, in: Archäologisches Korrespondenzblatt,
vol. 42, 2012, pp. 273–293.

Gößner 2006
Andreas Gößner: Die Anfänge des Buchdrucks
für universitäre Zwecke am Beispiel Witten-
bergs, in: Enno Bünz (ed.), Bücher, Drucker,
Bibliotheken in Mitteldeutschland: neue
Forschungen zur Kommunikations- und Medien-
geschichte um 1500, Leipzig 2006, pp. 133–152.

Götting 1988
Gerald Götting: »Redemanuskript von Gerald
Götting, Vorsitzender der CDU in der DDR
anlässlich einer Gedenkveranstaltung zum
20. Todestag von Martin Luther King« 1988,
Bundesarchiv, BArch DZ 9/2652.

Graf 2006
Friedrich Wilhelm Graf: Der Protestantismus:
Geschichte und Gegenwart, München 2006.

Granquist 2015
Mark Granquist: Lutherans in America: A New
History, Minneapolis 2015.

Grell 1997
Ole Peter Grell: The Protestant Imperative of
Christian Care and Neighbourly Love, in: idem/
Andrew Cunningham (eds.), Health Care and
Poor Relief in Protestant Europe, 1500–1700
(= Routledge Studies in the Social History of
Medicine, vol. 6), London 1997, pp. 43–65.

Gretzschel 2015
Matthias Gretzschel: Auf den Spuren von
Martin Luther, Hamburg 2015.

Grisar/Heege 1923
Hartmann Grisar/Franz Heege: Luthers
Kampfbilder, vol. 4 (= Hartmann Grisar (ed.),
Luther-Studien, vol. 6), Freiburg im Breisgau
1923.

Gritzner 1906
Erich Gritzner (adap.): Die Siegel der deutschen
Universitäten in Deutschland, Oesterreich und
der Schweiz (= J. Siebmacher's grosses und
allgemeines Wappenbuch, vol. 1, sec. 8, A),
Nürnberg 1906.

Grüber 1997
Pia Maria Grüber: Reformatorische Spottblätter
auf Papsttum und Klerus, in: Bilder und
Zeugnisse der deutschen Geschichte. Aus den
Sammlungen des Deutschen Historischen
Museums, Berlin 1997, vol 1, p. 49.

Gutjahr 2001
Mirko Gutjahr: Von einem Goldring vom
Lutherhaus in Wittenberg zu einem möglichen
Selbstbildnis von Robert Campin, in: Archäologie
in Sachsen-Anhalt, vol. 5/11, 2011, pp. 7–12.

Gutjahr 2014
Mirko Gutjahr: Lutherarchäologie, in: Harald
Meller (ed.), Mitteldeutschland im Zeitalter der
Reformation. Interdisziplinäre Tagung vom 22.
bis 24. Juni 2012 in Halle (Saale) (= Forschungs-
berichte des Landesmuseums für Vorgeschichte
Halle, vol. 4), Halle (Saale) 2014, pp. 19–28.

Guratzsch 1995
Herwig Guratzsch (ed.): Bestandskatalog.
Museum der bildenden Künste, Leipzig 1995.

H

Haag/Lange/Metzger/Schütz 2011
Sabine Haag/Christiane Lange/Christoph
Metzger/Karl Schütz (eds.): Dürer. Cranach.
Holbein. Die Entdeckung des Menschen:
Das deutsche Porträt um 1500, exhibition
catalogue, München 2011.

Haasis-Berner 1994
Andreas Haasis-Berner: Hörner aus Keramik – Wallfahrtsdevotionalien oder Signalhörner?, in: Zeitschrift für Archäologie des Mittelalters, vol. 22, 1994, pp. 15–38.

Häberlein 2016
Max Häberlein: Die Fugger. Geschichte einer Augsburger Familie (1367–1650), Stuttgart 2016.

Habich 1929–1934
Georg Habich: Die deutschen Schaumünzen des XVI. Jahrhunderts, 4 vols., München.

Hageböck 2003
Matthias Hageböck: Einbände von Lukas Weischner aus der Zeit nach 1579 in der Herzogin Anna Amalia Bibliothek, Weimar (Haebler I, p. 494), in: Einbandforschung 12, 2003, pp. 48–57.

Hallenkamp-Lumpe 2007
Julia Hallenkamp-Lumpe: Das Bekenntnis am Kachelofen? Überlegungen zu den sogenannten "Reformationskacheln", in: Carola Jäggi/Jörn Staecker (eds.), Archäologie der Reformation. Studien zu den Auswirkungen des Konfessionswechsels auf die materielle Kultur (= Arbeiten zur Kirschengeschichte, vol. 104), Berlin/New York 2007, pp. 323–343.

Hallof/Hallof 1992
Luise Hallof/Klaus Hallof: Die Inschriften der Stadt Jena (= Die deutschen Inschriften, vol. 33), Berlin 1992.

Hamel 1999
Jürgen Hamel: Die Kalenderreform Papst Gregors XIII. von 1582 und seine Durchsetzung, in: Hans Ottomeyer (ed.), Geburt der Zeit. Eine Geschichte der Bilder und Begriffe, exhibition catalogue, Wolfratshausen 1999, pp. 292–301.

Harms 1983
Wolfgang Harms (ed.): Illustrierte Flugblätter aus den Jahrhunderten der Reformation und der Glaubenskämpfe, exhibition catalogue, Coburg 1983.

Harms/Schilling/Wang 1997
Wolfgang Harms/Michael Schilling/Andreas Wang (eds.): Deutsche Illustrierte Flugblätter des 16. und 17. Jahrhunderts. Die Sammlung der Herzog-August-Bibliothek in Wolfenbüttel: Part 2 Historica, 2nd edition, Tübingen 1997.

von Hase 1935
Martin von Hase: Ein Mönchkalbdruck des Jacob Köbel in Oppenheim mit gefälschtem Impressum, in: Gutenberg-Jahrbuch, 1935, pp. 154–158.

Hauschke 2006
Sven Hauschke: Monumente der »alten Kirche«. Grabdenkmäler von Peter Vischer dem Älteren und Hans Vischer in Halle, Merseburg und Eisleben, in: Andreas Tacke (ed.), Der Kardinal Albrecht von Brandenburg. Renaissancefürst und Mäzen, vol. 2 (Essays), Regensburg 2006, pp. 365–377.

Heal 2013
Bridget Heal: The Catholic Eye and the Protestant Ear: the Reformation as a Non-Visual Event? In: Peter Opitz (ed.), The Myth of the Reformation (= Refo500 Academic Studies, vol. 9, ed. by Herman J. Selderhuis), Göttingen 2013, pp. 321–355.

Hecht 2007
Christian Hecht: Das Messopfer im Bild. Kardinal Albrecht von Brandenburg und die Darstellung der Gregorsmesse, in: Katholische Akademie in Bayern (ed.), "zur debatte", issue 5/2007, online under www.kath-akademie-bayern.de/tl_files/Kath_Akademie_Bayern/Veroeffentlichungen/zur_debatte/pdf/2007/2007_05_hecht.pdf (last accessed on March 29, 2016).

Heege 2002
Andreas Heege: Einbeck im Mittelalter. Eine archäologisch historische Spurensuche (= Studien zur Einbecker Geschichte, vol. 17), Oldenburg 2002.

Heger 1965
Günther Heger: Johann Eberlin von Günzburg und seine Vorstellungen über eine Reform in Reich und Kirche (= Schriften zur Rechtsgeschichte, issue 35), Berlin 1985.

Heise/Kunde/Wittmann 2004
Karin Heise/Holger Kunde/Helge Wittmann (eds.): Zwischen Kathedrale und Welt. 1000 Jahre Domkapitel Merseburg, exhibition catalogue, Petersberg 2004.

Heiser 2006
Sabine Heiser: Andenken, Andachtspraxis und Medienstrategie, in: Andreas Tacke, (ed.), "Ich armer sundiger mensch". Heiligen- und Reliquienkult am Übergang zum konfessionellen Zeitalter (= Schriftenreihe der Stiftung Moritzburg, Kunstmuseum des Landes Sachsen-Anhalt, vol. 2), Göttingen 2006, pp. 208–238.

Hendgen 2002
Viola Hendgen: Die frühen Bibeldrucke im deutschsprachigen Raum, in: Heinrich L. Nickel, 450 Jahre Marienbibliothek zu Halle an der Saale. Kostbarkeiten und Raritäten einer alten Büchersammlung, Halle (Saale) 2002, pp. 69–79.

Hendrix 1996
Scott H. Hendrix: Die Bedeutung des Urbanus Rhegius für die Ausbreitung der Wittenberger Reformation, in: Michael Beyer/Günther Wartenberg (eds.), Humanismus und Wittenberger Reformation: Festgabe anläßlich des 500. Geburtstages des Praeceptor Germaniae Philipp Melanchthon am 16. Februar 1997, Leipzig 1996, pp. 53–72.

Henkes 1994
Harold E. Henkes: Glas zonder glans. Vijf eeuwen gebruiksglas uit de bodem van de Lage Landen 1300–1800 (= Rotterdam Papers, vol. 9), Rotterdam 1994.

Hennen 2013
Insa Christiane Hennen: Reformation und Stadtentwicklung – Einwohner und Nachbarschaften, in: Heiner Lück/Enno Bünz/Leonhard Helten/Dorothee Sack/ Hans-Georg Stephan (eds.), Das ernestinische Wittenberg. Stadt und Bewohner (= Wittenberg-Forschungen, vol. 2), Petersberg 2013, pp. 33–76 (text) and pp. 21–28 (plate).

Hennen 2015 a
Insa Christiane Hennen: "Cranach 3D": Häuser der Familie Cranach in Wittenberg und das Bild der Stadt, in: Heiner Lück/Enno Bünz/Leonhard Helten/Armin Kohnle/Dorothee Sack/Hans-Georg Stephan (eds.), Das ernestinische Wittenberg: Spuren Cranachs in Schloss und Stadt (= Wittenberg-Forschungen, vol. 3), Petersberg 2015, pp. 313–361.

Hennen 2015 b
Insa Christiane Hennen: Die Ausstattung der Wittenberger Stadtpfarrkirche und der Cranach'sche Reformationsaltar, in: Heiner Lück/Enno Bünz/Leonhard Helten/Armin Kohnle/Dorothee Sack/Hans-Georg Stephan (eds.), Das ernestinische Wittenberg: Spuren Cranachs in Schloss und Stadt (= Wittenberg-Forschungen, vol. 3), Petersberg 2015, pp. 401–422.

Hentschel 2001
Kurt Henschel: Das Jahr 1512, in: Numismatisches Nachrichtenblatt 04/2001, pp. 123–125

Herbers 1990
Klaus Herbers: Der Jakobsweg, Tübingen 1990.

Herbst/Seibt 2012
Wolfgang Herbst/Ilsabe Seibt (eds.): Liederkunde zum Evangelischen Gesangbuch, issue 17, Göttingen 2012.

Hermann 1995
Michaela Hermann: Augsburger Bilderbäcker. Tonfigürchen des späten Mittelalters und der Renaissance (= Augsburger Museumsschriften, vol. 6), Augsburg 1995.

Hermle: Luther
Siegfried Hermle: Luther und die hebräische Sprache, www.bibelwissenschaft.de/stichwort/25188 (last accessed on February 20, 2016).

Hessen 1992
Hessen und Thüringen von den Anfängen bis zur Reformation, exhibition catalogue, Wiesbaden 1992.

Heydenreich 2007
Gunnar Heydenreich, Lucas Cranach the Elder: Painting Materials, Techniques and Workshop Practice, Amsterdam 2007.

Hintzenstern 1964
Herbert von Hintzenstern: Die Bilderpredigt des Gothaer Tafelaltars, Berlin 1964.

Hirte 2014
Christian Hirte: Die Schlacht bei Mühlberg als triumphales Bildereignis, in: Harald Meller (ed.), Mitteldeutschland im Zeitalter der Reformation. Interdisziplinäre Tagung vom 22. bis 24. Juni 2012 in Halle (Saale) (= Forschungsberichte des Landesmuseums für Vorgeschichte Halle, vol. 4), Halle (Saale) 2014, pp. 123–132.

Hoernes: Krimi
Martin Hoernes: Krimi um Cranach (upon the acquisition of the first volume 2010/2011), online under www.kulturstiftung.de/krimi-um-cranach (last accessed on January 25, 2016).

Hoffmann 1885
Friedrich Wilhelm Hoffmann's Geschichte der Stadt Magdeburg, new ed. by Gustav Hertel and Friedrich Hülße, 1st vol., Magdeburg 1885.

Hoffmann 2008
Claudia Hoffmann: Lutherzeitliche Ofenkacheln aus dem Bestand des Kulturhistorischen Museums der Hansestadt Stralsund, in: Harald Meller/Stefan Rhein/Hans-Georg Stephan (eds.), Luthers Lebenswelten (= Tagungen des Landesmuseums für Vorgeschichte Halle 1), Halle (Saale) 2008, pp. 201–208.

Hoffmann 2009
Claudia Hoffmann: Überlegungen zu Porträtdarstellungen auf Ofenkacheln des Spätmittelalters und der frühen Neuzeit aus Stralsund, in: Barbara Scholkmann et al. (eds.), Zwischen Tradition und Wandel. Archäologie des 15. und 16. Jahrhunderts (= Tübinger Forschungen zur historischen Archäologie, vol. 3), Tübingen 2009, pp. 305–315.

Hoffmann 2015
Helga Hoffmann: Das Weimarer Luthertriptychon von 1572. Sein konfessionspolitischer Kontext und sein Maler Veit Thiem (= Beiträge zur Thüringischen Kirchengeschichte n. s., vol. 5), Langenweißbach/Erfurt 2015.

Hofmann 1983 a
Werner Hofmann (ed.): Köpfe der Lutherzeit, München 1983.

Hofmann 1983 b
Werner Hofmann (ed.): Luther und die Folgen für die Kunst (exhibition Hamburger Kunsthalle, 11. November 1983–8. Januar 1984), München 1983.

Höhn/Klimke 2010
Maria Höhn/Martin Klimke: Breath of Freedom: The Civil Rights Struggle, African American GIs, and Germany, Basingstoke UK 2010.

Holesch 2014
Nadine Holesch: Steinzeug aus Wittenberg. Provenienz und Typologie der Funde aus dem Garten des Lutherhauses, in: Harald Meller (ed.), Glas, Steinzeug und Bleilettern aus Wittenberg (= Forschungsberichte des Landesmuseums für Vorgeschichte Halle, vol. 5), Halle (Saale) 2014, pp. 149–266.

Holler 2016
Wolfgang Holler, Cranach zeigt Luther. Eine Bildstrategie der Reformation, in: Christopher Spehr/Michael Haspel/Wolfgang Holler (eds.), Weimar und die Reformation. Luthers Obrigkeitslehre und ihre Wirkungen, Leipzig 2016, pp. 83–103.

Holler/Kolb 2015
Wolfgang Holler/Karin Kolb (eds.): Cranach in Weimar, exhibition catalogue, Dresden 2015.

Hollstein (with number of volume)
Friedrich W. H. Hollstein: German Engravings, Etchings and Woodcuts 1400–1700, 82 vols., Amsterdam [et al.] 1954–2014.

Holsing 2004
Henrike Holsing: Luther – Gottesmann und Nationalheld. Sein Image in der deutschen Historienmalerei des 19. Jahrhunderts, online publication http://kups.ub.uni-koeln.de/2132/ (last accessed on November 30, 2015), also a dissertation Universität Köln 2004.

Holtermann 2013
Bart Holterman: Pilgrimages in Images: Early Sixteenth-Century Views of the Holy Land with Pilgrims' Portraits as Part of the Commemoration of the Jerusalem Pilgrimage in Germany, unpubl. master's thesis, Utrecht 2013.

Holzinger 2013
Michael Holzinger (ed.): Martin Luther, Wider das Papsttum zu Rom, vom Teufel gestiftet, North Charleston 2013.

Hornemann 2000
Andreas Hornemann: Zeugnisse der spätmittelalterlichen Annenverehrung im Mansfelder Land, in: Rosemarie Knape (ed.), Martin Luther und der Bergbau im Mansfelder Land, exhibition catalogue (= Katalog der Stiftung Luthergedenkstätten in Sachsen-Anhalt, vol. 7), Eisleben 2000, pp. 307–326.

Horschik 1978
Josef Horschik: Steinzeug 15. bis 19. Jahrhundert. Von Bürgel bis Muskau, Dresden 1978.

Höss 1989
Irmgard Höss: Georg Spalatin 1484–1545: Ein Leben in der Zeit des Humanismus und der Reformation, 2nd edition, Weimar 1989.

Hrdina/Studničková 2014
Jan Hrdina/Milada Studničková: Sammelindulgenzen und ihre Illuminatoren – das Beispiel Mühlhausen, in: Frömmigkeit in Schrift und Bild. Illuminierte Sammelindulgenzen im mittelalterlichen Mühlhausen (= Ausstellungen des Stadtarchivs Mühlhausen, vol. 3; = Schriftenreihe der Friedrich-Christian-Lesser-Stiftung, vol. 29), Petersberg 2014, pp. 15–29.

Hülsen 1921
Christian Hülsen, Das Speculum Romanae magnificentiae, in: Collectanea variae doctrinae Leoni S. Olschki, München 1921, pp. 121–170.

Hütt 1971
Wolfgang Hütt, Albrecht Dürer 1471–1528. Das gesamte graphische Werk. Druckgraphik, Berlin 1971.

I

Iserloh 1962
Erwin Iserloh: Luthers Thesenanschlag. Tatsache oder Legende (= Institut für Europäische Geschichte Mainz, Vorträge, vol. 31), Wiesbaden 1962.

J

Jacobowitz/Stepanek 1983
Ellen S. Jacobowitz/Stephanie Loeb Stepanek: The Prints of Lucas van Leyden and his Contemporaries, exhibition catalogue, Washington 1983.

Jacobs 1894
Edouard Jacobs: Aus dem Rechnungsbuche des Wernigeröder Dechanten und bischöflich halberstädtischen und hildesheimischen Offizials zu Braunschweig Johann Kerkener (1507–1541), in: Zeitschrift des Harzvereins für Geschichte und Altertumskunde, vol. 27, 1894, pp. 593–612.

Jankowski 2015
Günter Jankowski: Mansfelder Schächte und Stollen. Bearbeitet und mit einer Einführung von Michael Fessner (= Forschungsberichte des Landesmuseums für Vorgeschichte Halle, vol. 6), Halle (Saale) 2015.

Jarecki 2004
Helge Jarecki: In Szene gesetzt. Der Sündenfall auf renaissancezeitlicher Keramik, in: Zeitschrift für Archäologie des Mittelalters, vol. 32, 2004, pp. 189–195.

Jarecki/Wunderlich/Thoss 2002
Helge Jarecki/Christian-Heinrich Wunderlich/Franziska Thoss: Der Lutherkrug von Merseburg. Landesmuseum für Vorgeschichte Halle, Fund des Monats Dezember 2002. Online unter www.lda-lsa.de/de/landesmuseum_fuer_vorgeschichte/fund_des_monats/2002/dezember/ (last accessed on November 15, 2015)

Jenkins/McBride 2010
Willis Jenkins/Jeniffer M. McBride (eds.): Bonhoeffer and King: Their Legacies and Import for Christian Social Thought, Minneapolis 2010.

Jezler/Altendorf 1994
Peter Jezler/Hans-Dietrich Altendorf (eds.): Himmel, Hölle, Fegefeuer. Das Jenseits im Mittelalter, exhibition catalogue, München 1994.

Joestel 1993 a
Volkmar Joestel (ed.): Martin Luther 1483–1546. Katalog der Hauptausstellung in der Lutherhalle Wittenberg, 2nd revised edition, Berlin 1993.

Joestel 1993 b
Volkmar Joestel: Das Wittenberger Heiltumsbuch von 1509, in: idem (ed.), Martin Luther 1483–1546. Katalog der Hauptausstellung in der Lutherhalle Wittenberg, 2nd revised edition, Berlin 1993, pp. 48–53.

Joestel 2008
Volkmar Joestel (ed.), Luthers Schatzkammer. Kostbarkeiten im Lutherhaus Wittenberg, Dößel 2008.

Joestel 2013
Volkmar Joestel (ed.): "Hier stehe ich!" Luthermythen und ihre Schauplätze (= Kulturreisen, vol. 10), Wettin-Lobejün 2013.

Joestel/Strehle 2003
Volkmar Joestel/Jutta Strehle: Luthers Bild und Lutherbilder. Ein Rundgang durch die Wirkungsgeschichte, Wittenberg 2003.

Jörgensen 2014
Bent Jörgensen: Konfessionelle Selbst- und Fremdbezeichnungen: Zur Terminologie der Religionsparteien im 16. Jahrhundert, Berlin/Boston 2014.

Junghans 1982
Helmar Junghans: Wittenberg als Lutherstadt, 2nd revised edition, Berlin 1982.

Junghans 1996
Helmar Junghans: Martin Luther und Wittenberg, München/Berlin 1996.

Junius 1930
Wilhelm Junius: Johann Friedrich der Großmütige in der Gefangenschaft, in: Der Cicerone, Halbmonatsschrift für Künstler, Kunstfreunde und Sammler, vol. 22, 1930, pp. 328–331.

Jürgensmeier 1990
Friedhelm Jürgensmeier: Kardinal Albrecht von Brandenburg (1490–1545). Kurfürst, Erzbischof von Mainz und Magdeburg, Administrator von Halberstadt, in: Berthold Roland (ed.), Albrecht von Brandenburg. Kurfürst, Erzkanzler, Kardinal (1490–1545), exhibition catalogue, Mainz 1990, pp. 22–41.

Jütte 1984
Robert Jütte: Obrigkeitliche Armenfürsorge in deutschen Reichsstädten der frühen Neuzeit: städtisches Armenwesen in Frankfurt am Main und Köln (= Kölner historische Abhandlungen, vol. 31), Köln 1984.

K

Kähler 1950
Ernst Kähler: Ein übersehenes Lutherfragment, in: Theologische Literaturzeitung, vol. 75, 1950, col. 170 f.

Katz 2008
Dana E. Katz: The Jew in the Art of the Italian Renaissance, Philadelphia 2008.

Kaufmann 2003
Thomas Kaufmann: Das Ende der Reformation. Magdeburgs "Herrgotts Kanzlei" (1548–1551/2), Tübingen 2003.

Kaufmann 2012
Thomas Kaufmann: Der Anfang der Reformation. Studien zur Kontextualität der Theologie, Publizistik und Inszenierung Luthers und der reformatorischen Bewegung, Tübingen 2012.

Kaufmann 2014
Thomas Kaufmann: Luthers Juden, Stuttgart 2014.

Kaufmann 2015
Thomas Kaufmann: Luthers Juden, 2nd edition, Stuttgart 2015.

Kieser 1939
Harry Kieser: Das große Gothaer Altarwerk. Ein reiches Werk deutscher Reformationskunst, Würzburg 1939.

King 1999
Mary Elizabeth King: Mahatma Gandhi and Martin Luther King Jr: The Power of Nonviolent Action, Paris 1999.

Klein 2014
Michael Klein: Märtyrer im vollen Sinne dieses Wortes, in: Evangelische Theologie vol. 67/6, 2014, pp. 419–432.

Klug 2012
Nina-Maria Klug: Das konfessionelle Flugblatt 1563–1580. Eine Studie zur historischen Semiotik und Textanalyse (= Studia Linguistics Germanica, vol. 112), Berlin/Boston 2012.

Kluttig-Altmann 2006
Ralf Kluttig-Altmann: Von der Drehscheibe bis zum Scherbenhaufen. Leipziger Keramik des 14. bis 18. Jahrhunderts im Spannungsfeld von Herstellung, Gebrauch und Entsorgung (= Veröffentlichungen des Landesamtes für Archäologie mit Landesmuseum für Vorgeschichte, vol. 47), Dresden 2006.

Kluttig-Altmann 2013
Ralf Kluttig-Altmann: Andacht oder Fasnacht? Eine frühneuzeitliche Keramikfanfare aus der Lutherstadt Wittenberg im überregionalen Fundkontext, in: H. Siebenmorgen (ed.), Blick nach Westen. Keramik in Baden und im Elsass. 45. Internationales Symposium Keramikforschung Badisches Landesmuseum Karlsruhe 24.–28. 9. 2012, Karlsruhe 2013, pp. 162–171.

Kluttig-Altmann 2015 a
Ralf Kluttig-Altmann: Archäologische Funde von Grundstücken der Familie Cranach in Wittenberg, in: Heiner Lück/Enno Bünz/ Leonhard Helten/Armin Kohnle/Dorothee Sack/ Hans-Georg Stephan (eds.), Das ernestinische Wittenberg: Spuren Cranachs in Schloss und Stadt (= Wittenberg-Forschungen, vol. 3), Petersberg 2015, pp. 363–399.

Kluttig-Altmann 2015 b
Ralf Kluttig-Altmann: Eine frühneuzeitliche Keramikfanfare aus Wittenberg im Kontext der Funde gewundener Hörner aus Deutschland, in: Harald Meller (ed.): Fokus: Wittenberg. Die Stadt und ihr Lutherhaus. Multidisziplinäre Forschungen über und unter Tage (= Forschungsberichte des Landesmuseums für Vorgeschichte Halle, vol. 7), Halle (Saale) 2015, pp. 93–131.

Kluttig-Altmann 2015c
Ralf Kluttig-Altmann: Lutherkacheln aus Bad Schmiedeberg, in: Harald Meller (ed.), Fokus: Wittenberg. Die Stadt und ihr Lutherhaus. Multidisziplinäre Forschungen über und unter Tage (= Forschungsberichte des Landesmuseums für Vorgeschichte Halle, vol. 7), Halle (Saale) 2015, pp. 13–18.

Kluttig-Altmann 2015d
Ralf Kluttig-Altmann: Produzent und Markt. Die Identifizierung keramischer Produkte des Spätmittelalters und der Frühneuzeit aus Bad Schmiedeberg im Wittenberger Fundbild, in: Harald Meller (ed.), Fokus: Wittenberg. Die Stadt und ihr Lutherhaus. Multidisziplinäre Forschungen über und unter Tage (= Forschungsberichte des Landesmuseums für Vorgeschichte Halle, vol. 7), Halle (Saale) 2015, pp. 245–295.

Knape 1994
Rosemarie Knape (ed.): Martin Luther. Geburtshaus, Eisleben 1994.

Kobelt-Groch 2005
Marion Kobelt-Groch: Judith macht Geschichte: zur Rezeption einer mythischen Gestalt vom 16. bis 19. Jahrhundert, München 2005.

Koch 1983
Ernst Koch: Die kursächsischen Vorarbeiten zur Confessio Augustana, in: Koch, E., Aufbruch und Weg. Studien zur lutherischen Bekenntnisbildung im 16. Jahrhundert, Berlin 1983, pp. 7–19.

Koch 1987
Rudi Koch (ed.): BI-Lexikon. Uhren und Zeitmessung, Leipzig 1987.

Koch 1990
Ernst Koch: Die "Himlische Philosophia des heiligen Geistes." Zur Bedeutung alttestamentlicher Spruchweisheit im Luthertum des 16. und 17. Jahrhunderts, in: Theologische Literaturzeitung, vol. 115 (1990), pp. 706–720.

Koch 1999
Ernst Koch, "Jenaer Beiträge zum Lutherverständnis," in: Christoph Markschies/Michael Trowitzsch (eds.), Luther – zwischen den Zeiten: eine Jenaer Ringvorlesung, Tübingen 1999, pp. 1–15.

Koch 2002
Ernst Koch: Das ernestinische Bibelwerk, in: Roswitha Jacobsen/Juliane Brandsch (eds.), Ernst der Fromme: (1601–1675), Staatsmann und Reformer, Bucha bei Jena 2002, pp. 53–58.

Koch 1981
Robert A. Koch (ed.): Hans Brosamer, the Hopfers. The illustrated Bartsch, vol. 17, New York 1981.

Koepplin/Falk 1976
Dieter Koepplin/Tilman Falk (eds.): Lukas Cranach. Gemälde, Zeichnungen, Druckgraphik, exhibition catalogue, 2 vols., Basel/Stuttgart 1976.

Köhler 2003
Anne-Katrin Köhler: Geschichte des Klosters Nimbschen. Von der Gründung 1243 bis zu seinem Ende 1536/1542 (= Arbeiten zur Kirchen- und Theologiegeschichte, vol. 7), Leipzig 2003.

König 1991
Gerhard König: Die Uhr, Geschichte Technik Stil, Berlin/Leipzig 1991.

König 2008
Sonja König: Wandbrunnen – Wasserblasen – Wasserkästen, in: Harald Meller/Stefan Rhein/ Hans-Georg Stephan (eds.), Luthers Lebenswelten (= Tagungen des Landesmuseums für Vorgeschichte Halle, vol. 1), Halle (Saale) 2008, pp. 101–111.

Kornmeier 2004
Uta Kornmeier: Luther in effigie, oder: das "Schreckgespenst von Halle," in: Stefan Laube/ Karl-Heinz Fix (eds.), Lutherinszenierung und Reformationserinnerung, Leipzig 2004, pp. 343–370.

Koschnick 1997
Leonore Koschnick (ed.): Bilder und Zeugnisse der deutschen Geschichte (= Aus den Sammlungen des Deutschen Historischen Museums, vol. 1), Berlin 1997.

Krabath 2001
Stefan Krabath: Die hoch- und spätmittelalterliche Buntmetallfunde nördlich der Alpen (= Internationale Archäologie, vol. 63), Leidorf 2001.

Krabath 2012
Stefan Krabath: Die Entwicklung der Keramik im Freistaat Sachsen vom späten Mittelalter bis in das 19. Jahrhundert. Ein Überblick, in: Regina Smolnik (ed.), Keramik in Mitteldeutschland – Stand der Forschung und Perspektiven. 41. Internationales Hafnereisymposium des Arbeitskreises für Keramikforschung in Dresden, Deutschland, vom 21. September bis 27. September 2008 (= Veröffentlichungen des Landesamtes für Archäologie, vol. 57), Dresden 2012, pp. 35–171.

Kranzfelder 1982
Ursula Kranzfelder: Zur Geschichte der Apothekenabgabe- und Standgefäße aus keramischen Materialien unter besonderer Berücksichtigung der Verhältnisse in Süddeutschland vom 18. bis zum beginnenden 20. Jahrhundert, München 1982.

Krauß 2010
Jutta Krauß (ed.): Beyssig sein ist nutz und not. Flugschriften zur Lutherzeit, exhibition catalogue, Regensburg 2010.

Krauß/Kneise 2016
Jutta Krauß/Ulrich Kneise: Martin Luther. Lebensspuren, Regensburg 2016.

Krauß/Schuchardt 1996
Jutta Krauß/Günter Schuchardt (eds.): Aller Knecht und Christi Untertan. Der Mensch Luther und sein Umfeld, exhibition catalogue, Eisenach 1996.

Kreiker 2003
Sebastian Kreiker: Luther. Leben und Wirkungsstätten, Petersberg 2003.

Krentz 2014
Natalie Krentz: Ritualwandel und Deutungshoheit. Die frühe Reformation in der Residenzstadt Wittenberg (1500–1533), Tübingen 2014.

Krischke/Grebe 2015
Roland Krischke/Anja Grebe: Wege zu Cranach. Kulturreiseführer, Halle (Saale) 2015.

Kroll/Schade 1974
Renate Kroll/Werner Schade (eds.): Hans Burgkmair 1473–1531. Holzschnitte, Zeichnungen, Holzstöcke, exhibition catalogue, Berlin 1974.

Krüger 2002
Kristina Krüger: Archäologische Zeugnisse zum mittelalterlichen Buch- und Schriftwesen nordwärts der Mittelgebirge (= Universitätsforschungen zur prähistorischen Archäologie, vol. 91), Bonn 2002.

Krügler/Wallraff 2015
Jürgen Krügler/Martin Wallraff: Luthers Rom. Die Ewige Stadt in der Renaissance, Mainz 2015.

Krühne 1888
Max Krühne: Urkundenbuch der Klöster der Grafschaft Mansfeld, Halle (Saale) 1888.

Krumhaar 1845
K. Krumhaar: Kampf Luthers gegen Heiligenanrufung, Bilderdienst und Reliquienverehrung, Eisleben 1845.

Krummel 1985
Donald W. Krummel: Early German Partbook Type Faces, in: Gutenberg-Jahrbuch, 1985, pp. 80–98.

Kruse 1983
Joachim Kruse (eds.): Illustrierte Flugblätter aus den Jahrhunderten der Reformation und der Glaubenskämpfe, exhibition catalogue, Coburg 1983.

Kruse 2000
Petra Kruse (ed.): Kaiser Karl V. (1500–1558). Macht und Ohnmacht Europas, exhibition catalogue, Bonn 2000.

Kuder/Luckow 2004
Ulrich Kuder/Dirk Luckow (eds.): Des Menschen Gemüt ist wandelbar: Druckgrafik der Dürer-Zeit, exhibition catalogue, Kiel 2004.

Kuhn 1942
Hermann Kuhn: Hans Reinhart. Ein Meister der mitteldeutschen Renaissance-Medaille, Halle 1942.

Kuhn 1936
Charles Kuhn: A Catalogue of German Paintings of the Middle Ages and Renaissance in American Collections, Cambridge 1936.

Kühne 1994
Heinrich Kühne: Vom Wittenberger Rechtswesen, von Scharfrichtern und ihren Tätigkeiten, Lutherstadt Wittenberg 1994.

Kühne/Bünz/Müller 2013
Hartmut Kühne/Enno Bünz/Thomas T. Müller (eds.): Alltag und Frömmigkeit am Vorabend der Reformation in Mitteldeutschland, exhibition catalogue, Petersberg 2013.

Kunde 2006
Holger Kunde (ed.): Der Naumburger Domschatz. Sakrale Kostbarkeiten im Domschatzgewölbe (= Kleine Schriften der Vereinigten Domstifter zu Merseburg und Naumburg und des Kollegiatstifts Zeitz, vol. 3), Petersberg 2006.

Kunde/Hörsch 2006
Holger Kunde/Markus Hörsch: Das Merseburger Kapitelhaus. Domschatz, Domstiftsarchiv und Domstiftsbibliothek (= Kleine Schriften der Vereinigten Domstifter zu Merseburg und Naumburg und des Kollegiatstifts Zeitz, vol. 4), Petersberg 2006.

Kunz 1998
Armin Kunz: Der Hofkünstler als Graphiker. Holzschnitte und Kupferstiche Lucas Cranachs d. Ä. in den Sammlungen der Lutherhalle, in: Druckgraphiken Lucas Cranachs d. Ä. im Dienst von Macht und Glauben, published by the Luther Memorials Foundation of Saxony-Anhalt, exhibition catalogue, Wittenberg 1998, vol. 1, pp. 41–156.

Kunze/Schilling/Stewing 2010
Volkmar Kunze/Johannes Schilling/Frank-Joachim Stewing (eds.): "Durchs Wort sollen wir gewinnen." Die Rudolstädter Medianbibel von 1541, Bad Zwischenahn 2010.

Kuper/Gutjahr 2014
Gaby Kuper/Mirko Gutjahr: Luthers Elternhaus. Ein Rundgang durch die Ausstellung, Wittenberg 2014.

Kuschel 2014
Franziska Kuschel: "Starke Frauen" der Reformation – Ausgewählte Biogramme, in: Simona Schellenberger/André Thieme/Dirk Welich (eds.), Eine starke Frauengeschichte. 500 Jahre Reformation, exhibition catalogue, Beucha 2014, pp. 29–35.

Kutzke 1912
Georg Kutzke: Die erneuerte Andreaskirche in Eisleben, in: Jahrbuch der Denkmalpflege in der Provinz Sachsen und in Anhalt/published on behalf of the Provinzial-Denkmäler-Kommission 1912.

Kutzke 1917
Georg Kutzke: Die Lutherkanzel der Andreaskirche zu Eisleben, in: Die Denkmalpflege, vol. 19, pp. 85–88.

L

Lang 2014a
Thomas Lang: "bucher gud unde beße" – Die Wittenberger Schlossbibliothek und der kursächsische Hof in der Regierungszeit Friedrichs des Weisen (1486–1525), in: Enno Bünz/Thomas Fuchs/Stefan Rhein (eds.), Buch und Reformation. Beiträge zur Buch- und Bibliotheksgeschichte Mitteldeutschlands im 16. Jahrhundert (= Schriften der Stiftung Luthergedenkstätten in Sachsen-Anhalt, vol. 16), Leipzig 2014, pp. 125–171.

Lang 2014b
Thomas Lang: "Zwischen Alltag, Kunst und Sünde." Tanz an den wettinischen Höfen um 1500, in: Harald Meller (ed.), Mitteldeutschland im Zeitalter der Reformation. Interdisziplinäre Tagung vom 22. bis 24. Juni 2012 in Halle (Saale) (= Forschungsberichte des Landesmuseums für Vorgeschichte Halle, vol. 4), Halle (Saale) 2014, pp. 133–151.

Lapp 2011
Peter Joachim Lapp: Gerald Götting – CDU-Chef in der DDR: eine politische Biografie, Aachen 2011.

Laube 2003
Stefan Laube: Das Lutherhaus Wittenberg – eine Museumsgeschichte, Leipzig 2003.

Laube 2006
Stefan Laube: Zwischen Hybris und Hybridität. Kurfürst Friedrich der Weise und seine Reliquiensammlung, in: Andreas Tacke (ed.), "Ich armer sundiger mensch". Heiligen- und Reliquienkult am Übergang zum konfessionellen Zeitalter (= Schriftenreihe der Stiftung Moritzburg, Kunstmuseum des Landes Sachsen-Anhalt, vol. 2), Göttingen 2006, pp. 170–207.

Laube 2011
Stefan Laube: Von der Reliquie zum Ding. Heiliger Ort – Wunderkammer – Museum, Berlin 2011.

Le Goff 2005
Jacques Le Goff: Kaufleute und Bankiers im Mittelalter, Berlin 2005.

Le Goff 2011
Jacques Le Goff: Geld im Mittelalter, Stuttgart 2011.

Leder 2002
Hans-Günter Leder: Johannes Bugenhagen Pomeranus – Vom Reformer zum Reformator. Studien zur Biographie (= Greifswalder theologische Forschungen, vol. 4), Frankfurt a. M. et al. 2002.

Lehfeldt 1891
Paul Lehfeldt: Herzogthum Sachsen-Coburg und Gotha, Amtsgerichtsbezirk Gotha, in: Bau- und Kunstdenkmäler Thüringens, issue VIII, Jena 1891.

Lehmann 1988
Hartmut Lehmann: Martin Luther in the American Imagination (= American Studies. A Monograph Series, vol. 63), Paderborn 1988.

Leppin 2006
Volker Leppin: Martin Luther, Darmstadt 2006.

Leppin 2013
Volker Leppin: Martin Luther. Vom Mönch zum Feind des Papstes, Darmstadt 2013.

Leppin/Schneider-Ludorff 2014
Volker Leppin/Gury Schneider-Ludorff (eds.): Das Luther-Lexikon, Regensburg 2014.

Leuschner/Bornschein/Schierz 2015
Eckhard Leuschner/Falko Bornschein/Kai Uwe Schierz (eds.): Kontroverse und Kompromiss – Der Pfeilerbilderzyklus des Mariendoms und die Kultur der Bikonfessionalität im Erfurt des 16. Jahrhunderts, exhibition catalogue, Dresden 2015.

Lewin 1911
Reinhold Lewin: Luthers Stellung zu den Juden: ein Beitrag zur Geschichte der Juden in Deutschland während des Reformationszeitalters, Berlin 1911.

Linde 2011
Gesche Linde (ed.): Luther, Martin. Von der Freiheit eines Christenmenschen, Studienausgabe, Ditzingen 2011.

Lindell 2011
Joanna Reiling Lindell: Faithful Impressions. The Thrivent Financial Collection of Religious Art, Minneapolis 2011.

Lohse 1979
Bernhard Lohse: Augsburger Bekenntnis, Confutatio und Apologie, I. Augsburger Bekenntnis, in: Theologische Realenzyklopädie, vol. 4., Berlin 1979, pp. 616–628.

Lohse 1995
Bernhard Lohse: Luthers Theologie in ihrer historischen Entwicklung und in ihrem systematischen Zusammenhang, Göttingen 1995.

Lohse 2012
Bernhard Lohse: Albrecht von Brandenburg und Luther, in: Friedhelm Jürgensmeier (ed.), Erzbischof Albrecht von Brandenburg (1490–1545). Ein Kirchen- und Reichsfürst der Frühen Neuzeit (= Beiträge zur Mainzer Kirchengeschichte, vol. 3), Frankfurt am Main 1991, pp. 73–83.

Luckhardt 1985
Jochen Luckhardt: Heinrich Aldegrever und die Bildnisse der Wiedertäufer, Münster 1985.

Ludolphy 1984
Ingetraut Ludolphy: Friedrich der Weise Kurfürst von Sachsen 1463–1525, Göttingen 1984.

Ludwig/Kunde 2011
Matthias Ludwig/Holger Kunde: Der Dom zu Naumburg. Großer DKV-Kunstführer, Berlin/München 2011.

Luther und Halle 1996
Martin Luther und Halle. Kabinettausstellung der Marienbibliothek und der Franckeschen Stiftungen zu Halle im Luthergedenkjahr 1996, (= Katalog der Franckeschen Stiftungen, vol. 3), Halle (Saale) 1996.

Luther Stätten 1983
Martin Luther. Stätten seines Lebens und Wirkens, Berlin (East) 1983.

M

Mackert 2014
Christoph Mackert: Luthers Handexemplar der hebräischen Bibelausgabe von 1495 – Objektbezogene und besitzgeschichtliche Aspekte, in: Irene Dingel/Henning P. Jürgens (eds.), Meilensteine der Reformation. Schlüsseldokumente der frühen Wirksamkeit Martin Luthers, Gütersloh 2014, pp. 70–79.

Maedebach 1972
Heino Maedebach (ed.): Lucas Cranach d. Ä. und seine Werkstatt: Gemälde, exhibition catalogue, München 1972.

Märchenschloss 2012
Märchenschloss Friedenstein Gotha erzählt, exhibition catalogue, published by the Stiftung Schloss Friedenstein Gotha, Halle (Saale) 2012.

Mariacher 1963
Giovanni Mariacher: Vetri italiani del Rinascimento, 2nd edition, Mailand 1963.

Maron 1980
Gottfried Maron: Bauernkrieg, in: Theologische Realenzyklopädie, vol. 5, 1980, pp. 319–338.

Marten 2010
Maria Marten: Buchstabe, Geist und Natur: die evangelisch-lutherischen Pflanzenpredigten in der nachreformatorischen Zeit, Bern 2010.

Marx/Hollberg 2004
Harald Marx/Cecilie Hollberg (eds.): Glaube & Macht. Sachsen im Europa der Reformationszeit, exhibition catalogue, Dresden 2004.

Marx/Kluth 2004
Harald Marx/Eckhard Kluth (eds.): Glaube & Macht. Sachsen im Europa der Reformationszeit, exhibition catalogue, Dresden 2004.

Marx/Mössinger 2005
Harald Marx/Ingrid Mössinger (eds.): Cranach, exhibition catalogue, with an inventory catalogue of the paintings of the Staatliche Kunstsammlungen Dresden compiled by Karin Kolb, Köln 2005.

Maseberg/Schulze 2004
Günter Maseberg/Armin Schulze (eds.): Halberstadt – Das erste Bistum Mitteldeutschlands. Zeitzeugnisse. Von Kaiser Karl dem Großen bis zum Großen Kurfürsten Friedrich Wilhelm von Brandenburg (= Veröffentlichungen des Städtischen Museums Halberstadt, vol. 29), Halberstadt 2004.

Matthes 2008
Christian Matthes: Ausgrabungen als stadttopographische Untersuchungen innerhalb und im Umfeld des "Luthergeburtshauses" in Eisleben, in: Harald Meller/Stefan Rhein/Hans-Georg Stephan (eds.), Luthers Lebenswelten (= Tagungen des Landesmuseums für Vorgeschichte Halle, vol. 1), Halle (Saale) 2008, pp. 79–90.

Matthias 2002
Markus Matthias: Me auspice – Unter meinem Schutz, in: Gunnar Berg/Thomas Bremer/Heinrich Dilly/Hermann-Josef Rupieper/Marianne Schröter/Udo Sträter/Claudia Wagner (eds.), Emporium. 500 Jahre Universität Halle-Wittenberg, exhibition catalogue, Halle (Saale) 2002, pp. 137–163.

Maué 1987
Hermann Maué: Die Dedikationsmedaille der Stadt Nürnberg für Kaiser Karl V. von 1521, in: Anzeiger des Germanischen Nationalmuseums Nürnberg, 1987, pp. 227–244.

Maurer 1953
Wilhelm Maurer: Kirche und Synagoge: Motive und Formen der Auseinandersetzung der Kirche mit dem Judentum im Laufe der Geschichte, Stuttgart 1953.

Maurer 1976
Wilhelm Maurer: "Reste des kanonischen Rechts im Frühprotestantismus." Die Kirche und ihr Recht: gesammelte Aufsätze zum evangelischen Kirchenrecht, Tübingen 1976.

Maurice 1976
Maurice, Klaus: Die deutsche Räderuhr: zur Kunst und Technik des mechanischen Zeitmessers im deutschen Sprachraum, München 1976.

Meier 2006
Esther Meier: Die Gregorsmesse. Funktionen eines spätmittelalterlichen Bildtypus, Köln 2006.

Meissinger 1952
Karl August Meissinger: Der katholische Luther, München 1952.

Meller 2008
Harald Meller (ed.): Fundsache Luther. Archäologen auf den Spuren des Reformators. Begleitband zur Landesausstellung "Fundsache Luther – Archäologen auf den Spuren des Reformators" im Landesmuseum für Vorgeschichte Halle (Saale) vom 31. Oktober 2008 bis 26. April 2009, Stuttgart 2008.

Meller/Mundt/Schmuhl 2008
Harald Meller/Ingo Mundt/Boje E. Schmuhl (eds.): Der heilige Schatz im Dom zu Halberstadt, Regensburg 2008.

Meller/Reichenberger/Wunderlich (forthcoming)
Harald Meller/Alfred Reichenberger/Christian-Heinrich Wunderlich (eds.): Alchemie und Wissenschaft des 16. Jahrhunderts. Fallstudien aus Wittenberg und vergleichbare Befunde (= Tagungen des Landesmuseums für Vorgeschichte Halle, vol. 14), Halle (Saale), forthcoming 2016.

Melzer 2015
Reinhard Melzer: Der Cranach-Bestand des Gotischen Hauses, in: Cranach im Gotischen Haus in Wörlitz, exhibition catalogue, Wörlitz/München 2015.

Mendelsohn 1907
Henriette Mendelsohn: Die Engel in der bildenden Kunst. Ein Beitrag zur Kunstgeschichte der Gotik und der Renaissance, Berlin 1907.

Merkel 2004
Kerstin Merkel: Jenseits-Sicherung. Kardinal Albrecht von Brandenburg und seine Grabdenkmäler, Regensburg 2004.

Metzger 2009
Christof Metzger: Daniel Hopfer. Ein Augsburger Meister der Renaissance, Berlin et al. 2009.

Michel 2014
Stefan Michel: Der Sammler, Herausgeber, Multiplikator und Händler von Luthers Bücher Georg Rörer: Ein Beitrag zur reformatorischen Buchproduktion, in: Enno Bünz/Thomas Fuchs/Stefan Rhein (eds.), Buch und Reformation: Beiträge zur Buch- und Bibliotheksgeschichte Mitteldeutschlands im 16. Jahrhundert, Leipzig 2014, pp. 173–190.

Michel 2009
Stefan Michel: 800 Jahre Christentum im Greizer Land. Einblicke in die reußische Kirchengeschichte, Greiz 2009.

Mielke 1998
Ursula Mielke: Heinrich Aldegrever. The New Hollstein German Engravings, Etchings and Woodcuts, 1400 – 1700 (= Friedrich W. H. Hollstein, vol. 3), Rotterdam 1998.

Miletto/Veltri 2003
Gianfranco Miletto/Giuseppe Veltri: Die Hebraistik in Wittenberg (1502–1813): von der "lingua sacra" zur Semitistik, in: Henoch, vol. 25, 2003, pp. 93–130.

Moeller 2000
Bernd Moeller: Die Reformation, in: Wilfried Seipel (ed.), Kaiser Karl V. (1500–1558). Macht und Ohnmacht Europas, exhibition catalogue, Bonn 2000, pp. 77–85.

Moeller 2008
Bernd Moeller: Thesenanschläge, in: Joachim Ott/Martin Treu (eds.), Luthers Thesenanschlag – Faktum oder Fiktion (= Schriften der Luthergedenkstätten in Sachsen-Anhalt, vol. 9), Leipzig 2008, pp. 9–32.

Moeller/Stackmann 1996
Bernd Moeller/Karl Stackmann: Städtische Predigt in der Frühzeit der Reformation. Eine Untersuchung deutscher Flugschriften der Jahre 1522 bis 1529 (= Abhandlungen der Akademie der Wissenschaften in Göttingen, Philologisch-Historische Klasse, series 3, no. 220), Göttingen 1996.

Moritz 2009
Anja Moritz: Interim und Apokalypse. Die religiösen Vereinheitlichungsversuche Karls V. im Spiegel der magdeburgischen Publizistik 1548–1551/52, Tübingen 2009.

Moulin 2014
Claudine Moulin: Ein Sermon vom Ablass und Gnade. Materialität: Dynamik und Transformation, in: Irene Dingel/Henning P. Jürgens (eds.), Meilensteine der Reformation. Schlüsseldokumente der frühen Wirksamkeit Martin Luthers, Gütersloh 2014, pp. 113–121.

Moxey 1989
Keith Moxey: Peasants, Warriors, and Wives. Popular Imagery in the Reformation, Chicago/London 1989.

Müller 1993
Heinrich Müller: Das Berliner Zeughaus. Vom Arsenal zum Museum, Berlin 1993.

Müller/Balz/Krause 1997
Gerhard Müller/Horst Balz/Gerhard Krause: Politik, Politologie – Publizistik, Presse, in: Gerhard Müller (ed.), Theologische Realenzyklopädie, Berlin/New York 1997, pp. 225–330.

Müller/Kipf 2008
Gernot Michael Müller/J. Klaus Kipf: Cochlaeus, Johannes, in: Franz Josef Worstbrock (ed.), Deutscher Humanismus (1480–1520). Verfasserlexikon, vol. 1, Berlin 2008, col. 439–460.

Müller/Kölling 1981
Heinrich Müller/Hartmut Kölling: Europäische Hieb- und Stichwaffen aus der Sammlung des Museums für Deutsche Geschichte, Berlin (East) 1981.

Müller/Kunter 1984
Heinrich Müller/Fritz Kunter: Europäische Helme aus der Sammlung des Museum für Deutsche Geschichte, Berlin (East) 1984.

Müller/Schauerte 2011
Jürgen Müller/Thomas Schauerte (eds.): Die gottlosen Maler von Nürnberg. Konvention und Subversion in der Druckgrafik der Beham-Brüder, exhibition catalogue, Emsdetten 2011.

Müller-Enbergs 2006
Helmut Müller-Enbergs: Götting, Gerald, in: Idem (ed.), Wer war wer in der DDR? Ein Lexikon ostdeutscher Biographien, Berlin 2006. Online under www.bundesstiftung-aufarbeit ung.de/wer-war-wer-in-der-ddr-%2363%3B-1424.html?ID=1049 (last accessed January 27, 2016).

N

Nagler 1919
Georg Kaspar Nagler: Die Monogramisten, vol. 5, München/Leipzig 1919 (reprint).

Naphy/Spicer 2003
William Naphy/Andrew Spicer: Der schwarze Tod, Essen 2003.

Neser 2005
Anne-Marie Neser: Luthers Wohnhaus in Wittenberg. Denkmalpolitik im Spiegel der Quellen, Leipzig 2005, pp. 69–101.

Neser 2009
Anne-Marie Neser: Luthers Geburtshaus in Eisleben – Ursprünge, Wandlungen, Resultate, in: Rosemarie Knape (ed.), Martin Luther und Eisleben (= Schriften der Stiftung Luthergedenkstätten in Sachsen-Anhalt, vol. 8), Leipzig 2009, pp. 87–119.

Neu-Kock 1988
Roswitha Neu-Kock: Heilige und Gaukler. Kölner Statuetten aus Pfeifenton. Sonderheft Kölner Museums-Bulletin (= Berichte und Forschungen aus den Museen der Stadt Köln), Köln 1988.

Neumann 1995
Hans-Joachim Neumann: Luthers Leiden: Die Krankheitsgeschichte des Reformators, Berlin 1995.

Neumeister 1976
Ingeburg Neumeister: Flugblätter der Reformation und des Bauernkrieges. 50 Blätter aus der Sammlung des Schlossmuseums Gotha, Leipzig 1976.

Neuß 1930
Erich Neuß: Das Hallische Stadtarchiv. Seine Geschichte und seine Bestände, Halle (Saale) 1930.

Nickel 2002
Heinrich L. Nickel (ed.): 450 Jahre Marienbibliothek zu Halle an der Saale. Kostbarkeiten und Raritäten einer alten Büchersammlung, Halle (Saale) 2002.

Niehr 2000
Klaus Niehr: Das Grabmal Hoyers VI. in der Andreaskirche zu Eisleben, in: Rosemarie Knape (ed.), Martin Luther und der Bergbau im Mansfelder Land, exhibition catalogue (= Katalog der Stiftung Luthergedenkstätten in Sachsen-Anhalt, vol. 7), Eisleben 2000, pp. 261–279.

Niemetz 2008
Michael Niemetz: Antijesuitische Bildpublizistik in der Frühen Neuzeit: Geschichte, Ikonographie und Ikonologie, Regensburg 2008.

O

Oehmig 1988
Stefan Oehmig: Der Wittenberger Gemeine Kasten in den ersten zweieinhalb Jahrzehnten seines Bestehens (1522/23 bis 1547). Seine Einnahmen und seine finanzielle Leistungsfähigkeit im Vergleich zur vorreformatorischen Armenpraxis, in: Jahrbuch für Geschichte des Feudalismus, vol. 12, 1988, pp. 229–269.

Oehmig 1989
Stefan Oehmig: Der Wittenberger Gemeine Kasten in den ersten zweieinhalb Jahrzehnten seines Bestehens (1522/23 bis 1547). Seine Ausgaben und seine sozialen Nutznießer, in: Jahrbuch für Geschichte des Feudalismus, vol. 13, 1989, pp. 133–179.

Oelke 1992
Harry Oelke: Die Konfessionsbildung des 16. Jahrhunderts im Spiegel illustrierter Flugblätter, Berlin/New York 1992.

Oelke 2001
Eckhard Oelke: Die Wirkungen des Bergbaus in der Region Mansfeld, in: 800 Jahre Kupferschiefer-Bergbau. Soziale und kulturelle Aspekte der Geschichte des Mansfelder Hüttenwesens (= Beiträge zur Regional- und Landeskultur Sachsen-Anhalts, issue 19), Halle (Saale) 2001, pp. 5–21.

Onlinesammlung SKD, Deckelpokal
Onlinesammlung SKD, Deckelpokal. Online under www.skd-online-collection.skd.museum/de/contents/show?id=117207 (last accessed on March 1, 2016).

Onlinesammlung SKD, Willkommpokal
Onlinesammlung SKD, Willkommpokal. Online under www.skd-online-collection.skd.museum/de/contents/show?id=117552 (last accessed on March 1, 2016).

Orme 2003
Nicholas Orme: Medieval Children, New Haven 2003.

von der Osten-Sacken 2002
Peter von der Osten-Sacken: Martin Luther und die Juden: neu untersucht anhand von Anton Margarithas "Der gantz Jüdisch glaub" (1530/31), Stuttgart 2002.

Ott 2014
Joachim Ott: Luthers Deutsche Messe und Kirchenamt (1526) – Historische, theologische und buchgeschichtliche Aspekte, in: Irene Dingel/Henning P. Jürgens (eds.), Meilensteine der Reformation. Schlüsseldokumente der frühen Wirksamkeit Martin Luthers, Gütersloh 2014, pp. 218–234.

Otto 1834
J(ohann) G(ottfried) Otto: Die Schloß- und Domkirche zu Merseburg; ihre Denkmäler und Merkwürdigkeiten, Merseburg 1834.

Ottomeyer/Czech 2007
Hans Ottomeyer/Hans-Jörg Czech (eds.): Deutsche Geschichte in Bildern und Zeugnissen, Berlin 2007.

Ottomeyer/Götzmann/Reiß 2006
Hans Ottomeyer/Jutta Götzmann/ Ansgar Reiß (eds.): Heiliges Römisches Reich Deutscher Nation 962 bis 1806. Altes Reich und Neue Staaten 1495 bis 1806, exhibition catalogue, Dresden 2006.

P

Paasch 2010
Kathrin Paasch (ed.): "… so über die massen sauber in rothen Leder eingebunden": Bucheinbände aus der Forschungsbibliothek Gotha, exhibition catalogue, Gotha 2010.

Paasch 2012
Kathrin Paasch (ed.): "Mit Lust und Liebe Singen": Die Reformation und ihre Lieder, exhibition catalogue, Gotha 2012.

Packeiser 2004
Thomas Packeiser: Umschlagende Fülle als Autorität des Einen: Abundanz, Inversion und Zentrierung in den Tafelaltären Heinrich Füllmaurers, in: Frank Büttner/Gabriele Wimböck (eds.), Das Bild als Autorität. Die normierende Kraft des Bildes, Münster 2004, pp. 401–446.

Pangritz 2015
Andreas Pangritz: Martin Luther – Judenfreund oder Antisemit, in: epd-Dokumentation vol. 39, 2015, pp. 17–24.

Panofsky 1948
Erwin Panofsky: Albrecht Dürer, 2 vols., 3rd edition, London 1948.

Paravicini 2005
Werner Paravicini: Drechseln, in: id. (ed.), Höfe und Residenzen im spätmittelalterlichen Reich. Residenzenforschung, vol. 15 II, parts 1 and 2, Ostfildern 2005, pp. 212–214.

Pauli 1974
Gustav Pauli: Hans Sebald Beham. Ein kritisches Verzeichnis seiner Kupferstiche, Radierungen und Holzschnitte, with amendments, additions and corrections by Heinrich Röttinger, reprint of the first edition 1901, 1911, 1927, Baden-Baden 1974.

Paulus 2000
Nikolaus Paulus: Geschichte des Ablasses am Ausgang des Mittelalters, Darmstadt 2000.

Pelgen 1996
Franz Stephan Pelgen: Zur Archäologie der Buchdruckletter. Neue Funde zur Schrift-gußgeschichte von (Kur-)Mainz, in: Gutenberg-Jahrbuch, vol. 71, 1996, pp. 182–208.

Peters 1994
Christian Peters: Johann Eberlin von Günzburg ca. 1465–1533. Franziskaner Reformer, Humanist und konservativer Reformator (= Quellen und Forschungen zur Reformations-geschichte, vol. 60), Gütersloh 1994.

Pick 1928
Berendt Pick: Bemerkungen zu deutschen Medaillen, in: Festschrift für Karl Koetschau. Beiträge zur Kunst-, Kultur- und Literatur-geschichte, Düsseldorf 1928, pp. 60 f.

Piltz 1983
Georg Piltz: Ein Sack voll Ablaß. Bildsatiren der Reformationszeit, Berlin 1983.

Pitts 1999
Pitts Theology Library/ Richard C. Kessler Reformation Collection (eds.): The Richard C. Kessler Reformation Collection – An Annotated Bibliography. Manuscripts and Printed Works, 1470–1522, vol. 1, Atlanta 1999.

Porter 1981
Jene M. Porter: Luther and Political Millenari-anism: The Case of the Peasants' War, in: Journal of the History of Ideas, vol. 42, 1981, pp. 389–406.

Pregla 2006
Barbara Pregla: Die Paramente Albrechts. Aus den Domschätzen von Merseburg und Halberstadt, in: Andreas Tacke (ed.), Der Kardinal Albrecht von Brandenburg. Renaissancefürst und Mäzen, vol. 2 (Essays), Regensburg 2006, pp. 349–363.

Pregla 2008
Barbara Pregla: Kasel Albrechts von Brandenburg aus rot-goldenem Seidengewebe mit Kreuz in Perlstickerei, in: Markus Cottin/ Uwe John/Holger Kunde (adap.): Der Merseburger Dom und seine Schätze. Zeugnisse einer tausendjährigen Geschichte (= Kleine Schriften der Vereinigten Domstifter zu Merseburg und Naumburg und des Kollegiatstifts Zeitz, vol. 6), Petersberg 2008, pp. 321–324.

Pregla 2015
Barbara Pregla: Die sogenannten "Marien-mäntelchen" des Halberstädter Domschatzes als Quellen der Frömmigkeitsgeschichte im Spätmittelalter, in: Enno Bünz/Hartmut Kühne (eds.), Alltag und Frömmigkeit am Vorabend der Reformation in Mitteldeutschland, exhibition catalogue (= Schriften zur sächsischen Ge-schichte und Volkskunde, vol. 50), Leipzig 2015, pp. 673–714.

Purgold 1937
Karl Purgold: Das Herzogliche Museum, Gotha 1937.

Purgold/Schenk zu Schweinsberg 1938
Karl Purgold/Eberhard Schenk zu Schweinsberg: Das Herzogliche Museum, Gotha 1938.

Puttrich 1844
Ludwig Puttrich (ed.): Mittelalterliche Bauwerke zu Eisleben und in dessen Umgegend Seeburg, Sangerhausen, Querfurt, Conradsburg, In: id. (ed.), Denkmale der Baukunst des Mittelalters in Sachsen, zweite Abt., vol. 2, Leipzig 1844.

Q

Quaas 1997
Gerhard Quaas: Jagdwaffen. Aus der Sammlung des Deutschen Historischen Museums (= Magazin. Mitteilungen des Deutsches Historisches Museums, issue 19, year issue 7), Berlin 1997.

R

Rabe 1996
Horst Rabe: Karl V. und die deutschen Protestanten. Wege, Ziele und Grenzen der kaiserlichen Reichspolitik, in: id. (ed.), Karl V. Politik und politisches System. Berichte und Studien aus der Arbeit an der Politischen Korrespondenz des Kaisers, Konstanz 1996, pp. 317–345.

Ranft 2002
Andreas Ranft: Katharina von Bora, die Lutherin – eine Frau von Adel, in: Zeitschrift für Geschichtswissenschaft 50, issue 8, 2002, pp. 708–721.

Raupp 1986
Hans-Joachim Raupp: Bauernsatiren. Entstehung und Entwicklung des bäuerlichen Genres in der deutschen und niederländischen Kunst ca. 1470–1570, Niederzier 1986.

Reetz 2014
Johanna Reetz: Judith und der Kaiser. Zeichen der Identifikation und Distinktion in einem Kachelkomplex aus Wittenberg, in: Harald Meller (ed.), Mitteldeutschland im Zeitalter der Reformation. Interdisziplinäre Tagung vom 22. bis 24. Juni 2012 in Halle (Saale) (= Tagungen des Landesmuseums für Vorgeschichte Halle, vol. 3), Halle (Saale) 2014, pp. 205–215.

Reformation in Anhalt 1997
Reformation in Anhalt. Melanchthon – Fürst Georg III., exhibition catalogue, published by the Evangelische Landeskirche Anhalt, Dessau 1997.

Reformation 1979
Reformation in Nürnberg. Umbruch und Bewahrung. 1490–1580, exhibition catalogue (= Schriften des Kunstpädagogischen Zentrums im Germanischen Nationalmuseum Nürnberg, vol. 9), Nürnberg 1979.

Reichenberger 2015
Alfred Reichenberger: Vom ewigen Wunsche Gold zu machen – eine angebliche Alchemisten-münze von Plötzkau, in: Harald Meller/Alfred Reichenberger (eds.), Geldgeschichten aus Sachsen-Anhalt, Halle (Saale) 2015, pp. 112–115.

Reichenberger/Wunderlich 2014
Alfred Reichenberger/Christian-Heinrich Wunderlich: Dr. Faustus in Wittenberg? Eine Alchemistenwerkstatt und die frühe Wissenschaft zu Zeiten Luthers, in: Museums-journal 2014. Mitgliederzeitschrift des Vereins zur Förderung des Landesmuseums für Vorgeschichte, Halle (Saale) 2014, pp. 13–15.

Reinhard 1980
Wolfgang Reinhard: Die kirchenpolitischen Vorstellungen Kaiser Karls V., ihre Grundlagen und ihr Wandel, in: Erwin Iserloh/Barbara Hallensleben (eds.): Confessio Augustana und Confutatio: der Augsburger Reichstag 1530 und die Einheit der Kirche; Internat. Symposion der Gesellschaft zur Herausgabe des Corpus Catholicorum in Augsburg from September 3 1979, Münster 1980, pp. 62–100.

Reinisch 2015
Jutta Reinisch: "Gesetz und Gnade" in Gotha.
Ein Relief Dells des Älteren, seine Bezüge zur
Allegorie Lucas Cranachs des Älteren und zur
zeitgenössischen Druckgraphik, in: Christopher
Spehr (ed.), Lutherjahrbuch. Organ der
internationalen Lutherforschung, vol. 82, 2015,
pp. 148–198.

Reinitzer 1983
Heimo Reinitzer: Biblia deutsch. Luthers
Bibelübersetzung und ihre Tradition,
Wolfenbüttel 1983.

Reinitzer 2006
Heimo Reinitzer: Gesetz und Evangelium.
Über ein reformatorisches Bildthema, seine
Tradition, Funktion und Wirkungsgeschichte,
2 vols., Hamburg 2006.

Reinitzer 2012
Heimo Reinitzer: Tapetum Concordiae.
Peter Heymans Bildteppich für Philipp I.
von Pommern und die Tradition der von
Mose getragenen Kanzeln, Berlin 2012.

Reske 2007
Christoph Reske: Die Buchdrucker des 16. und
17. Jahrhunderts im deutschen Sprachgebiet:
auf der Grundlage des gleichnamigen Werkes
von Josef Benzing (= Beiträge zum Buch- und
Bibliothekswesen, vol. 51), Wiesbaden 2007.

Reske: Weltchronik
Christoph Reske: Schedelsche Weltchronik, in:
Historisches Lexikon Bayerns, online unter
www.historisches-lexikon-bayerns.de/Lexikon/
Schedelsche Weltchronik (last accessed on
March 31, 2016).

Rhein 2014a
Stefan Rhein, "…das entscheidendste und
inhaltschwerste, was des Reformators Feder je
geschrieben" – Luthers Brief an Kaiser Karl V.
(28. April 1521), in: Irene Dingel/Henning P.
Jürgens (eds.), Meilensteine der Reformation.
Schlüsseldokumente der frühen Wirksamkeit
Martin Luthers, Gütersloh 2014, pp. 145–159.

Rhein 2014b
Stefan Rhein: Luther im Museum: Kult,
Gedenken und Erkenntnis, in: Heinz Schilling
(ed.), Der Reformator Martin Luther 2017. Eine
wissenschaftliche und gedenkpolitische Be-
standsaufnahme (= Schriften des Historischen
Kollegs München, vol. 92), München 2014,
pp. 245–259.

Richter 2009
Jörg Richter: Der Domschatz zu Halberstadt.
Führer durch die Ausstellung, Dößel 2009.

Rieger 2007
Reinhold Rieger (ed.): Luther, Martin:
Von der Freiheit eines Christenmenschen
(= Kommentare zu Schriften Luthers, vol. 1),
Tübingen 2007.

**Riepertinger/Brockhoff/Heinemann/
Schumann 2002**
Rainhard Riepertinger/Evamaria Brockhoff/
Katharina Heinemann/Jutta Schumann (eds.):
Das Rätsel Grünewald, exhibition catalogue
(= Veröffentlichungen zur bayerischen Ge-
schichte und Kultur, vol. 45/02), Augsburg
2002.

Ring 2003
Edgar Ring (ed.): Glaskultur in Niedersachsen.
Tafelgeschirr und Haushaltsglas vom Mittelalter
bis zur frühen Neuzeit (= Archäologie und Bau-
forschung in Lüneburg, vol. 5), Husum 2003.

Rippmann 2012
Dorothee Rippmann: Bilder von Bauern im
Mittelalter und in der Frühen Neuzeit, in:
Daniela Münkel/Frank Uekötter (eds.), Das Bild
des Bauern. Selbst- und Fremdwahrnehmungen
vom Mittelalter bis ins 21. Jahrhundert,
Göttingen 2012, pp. 21–60.

Ritschel 2007
Iris Ritschel: Christus und …? Ein legendäres
Paar auf Pergament im Schlossmuseum Gotha,
in: Andreas Tacke (ed.), Lucas Cranach 1553–
2003: Wittenberger Tagungsbeiträge anlässlich
des 450. Todesjahres Lucas Cranachs des
Älteren (= Schriften der Stiftung Luthergedenk-
stätten in Sachsen-Anhalt, vol. 7), Leipzig 2007,
pp. 75–98.

Roberts 2005
James Deotis Roberts: Bonhoeffer and King:
Speaking Truth to Power, Louisville, KY 2005.

Roch-Lemmer 2000
Irene Roch-Lemmer: Grablegen und Grab-
denkmäler der Grafen von Mansfeld im
16. Jahrhundert, in: Mitteldeutschland, das
Mansfelder Land und die Stadt Halle. Neuere
Forschungen zur Landes- und Regional-
geschichte. Protokoll des Kolloquiums zum
100. Geburtstag von Erich Neuß 28./29.5.1999
in Halle (Beiträge zur Regional- und Landeskul-
tur Sachsen-Anhalts, issue 15), Halle (Saale)
2000, pp. 156–172.

Roch-Lemmer 2005
Irene Roch-Lemmer: Andreaskirche Lutherstadt
Eisleben (= Schnell-Kunstführer, vol. 2050,
4th revised edition), Regensburg 2007.

Roch-Lemmer 2008
Irene Roch-Lemmer: Spätgotische Altäre in der
Stadtkirche St. Georg zu Mansfeld, in: Harald
Meller/Stefan Rhein/Hans Georg Stephan
(eds.), Luthers Lebenswelten (= Tagungen des
Landesmuseums für Vorgeschichte Halle,
vol. 1), Halle (Saale) 2008, pp. 223–231.

Rode 2005
Holger Rode: Mittelalterliche Steinzeug-
produktion in Bad Schmiedeberg, Ldkr.
Wittenberg, in: Archäologie in Sachsen-Anhalt,
vol. 3, 2005, pp. 34–41.

Rogge 1983
Joachim Rogge: Martin Luther. Sein Leben.
Seine Zeit. Seine Wirkungen. Eine Bildbiografie,
Berlin (East) 1983.

Rollert 2014
Doreen Rollert: Gottesfurcht und Lebenslust.
Die Sammlung holländischer und flämischer
Gemälde auf Schloss Friedenstein Gotha, Foun-
dation Schloss Friedenstein Gotha, Gotha 2014.

Rommé 2000
Barbara Rommé (ed.): Das Königreich der Täufer
(2 vols.), vol. 1, Reformation und Herrschaft
der Täufer in Münster, exhibition catalogue,
Münster 2000.

Rößler 2015
Martin Rößler: Die Wittenbergisch Nachtigall.
Martin Luther und seine Lieder, Stuttgart 2015.

Rosmanitz 2014
Harald Rosmanitz: Luther und die sieben Freien
Künste. Die Wittenberger Ofenkeramik und ihre
Bezüge zu Südwestdeutschland, in:
Harald Meller (ed.), Mitteldeutschland im Zeit-
alter der Reformation. Interdisziplinäre Tagung
vom 22. bis 24. Juni 2012 in Halle (Saale)
(= Forschungsberichte des Landesmuseums für
Vorgeschichte Halle, vol. 4), Halle (Saale) 2014,
pp. 193–203.

Roth Heege 2007
Eva Roth Heege: Konfession und keramische
Bilderwelt, oder: Spiegeln sich in der Ofen-
keramik des 16. Jahrhunderts im schweizeri-
schen Mittelland Einflüsse der Reformation und
der Gegenreformation? In: Carola Jäggi/Jörn
Staecker (eds.), Archäologie der Reformation.
Studien zu den Auswirkungen des Konfession-
swechsels auf die materielle Kultur (= Arbeiten
zur Kirchengeschichte, vol. 104), Berlin/New
York 2007, pp. 369–397.

Röttinger 1911
Heinrich Röttinger: Neues zum Werke Hans
Weiditz, in: Mitteilungen der Gesellschaft für
vervielfältigende Kunst. Beilage der "Graphischen
Künste," issue 3, 1911, pp. 46–52.

Röttinger 1921
Heinrich Röttinger: Beiträge zur Geschichte des
sächsischen Holzschnittes (Cranach, Brosamer,
der Meister MS, Jakob Lucius aus Kronstadt)
(= Studien zur deutschen Kunstgeschichte,
vol. 213), Strasburg 1921.

Röttinger 1925
Heinrich Röttinger: Erhard Schön und Niklas
Stör, der Pseudo-Schön. Zwei Untersuchungen
zur Geschichte des alten Nürnberger
Holzschnittes (= Studien zur deutschen
Kunstgeschichte, vol. 229), Strasburg 1925.

Röttinger 1927
Heinrich Röttinger: Die Bilderbogen des Hans
Sachs, Strasburg 1927.

Rous 2014
Anne-Simone Rous: Die Geheimschrift der
Herzogin Elisabeth von Rochlitz im
Schmalkaldischen Krieg 1546/47, in: Simona
Schellenberger /André Thieme/Dirk Welich
(eds.), Eine starke Frauengeschichte. 500 Jahre
Reformation, Markkleeberg 2014, pp. 47–52.

Rübesame 1981
Otto Rübesame: Der Bilderschmuck der
Wittenberger Matrikel, Halle (Saale) 1981.

Rudolph 2009
Harriet Rudolph: Moritz von Sachsen – Formen
und Funktionen der Herrschaftsrepräsentation
eines Fürsten an der Zeitenwende, in: Oliver
Auge/Gabriel Zeilinger (eds.), Fürsten an
der Zeitenwende zwischen Gruppenbild und
Individualität: Formen fürstlicher Selbst-
darstellung und ihre Rezeption (1450–1550),
Ostfildern 2009, pp. 367–394.

Ruh 1980
Kurt Ruh (ed.): Die deutsche Literatur des
Mittelalters. Verfasserlexikon, vol. II,
Berlin 1980.

S

Salatowsky/Lotze 2015
Sascha Salatowsky/Karl-Heinz Lotze (eds.):
Himmelsspektakel. Astronomie im
Protestantismus der Frühen Neuzeit,
exhibition catalogue, Gotha 2015.

von Saldern 1965
Axel von Saldern: German Enameled Glass
(= Corning Museum of Glass Monographs,
vol. 2), New York 1965.

Sander 2013
Jochen Sander (ed.): Dürer. Kunst – Künstler –
Kontext, exhibition catalogue, München 2013.

Satō/Schäfer 1995
Naoki Satō/Bernd Schäfer (ed.): Der deutsche
Holzschnitt der Reformationszeit aus dem
Besitz des Schloßmuseums/Museen der Stadt
Gotha, Tokio, The National Museum of Western
Art, Gotha 1995.

Saxl 1957
Fritz Saxl: Illustrated Pamphlets of the
Reformation, in: idem (ed.), Lectures (2 vols.),
vol. 1, London 1957, pp. 255–266.

Schade 1974
Werner Schade: Die Malerfamilie Cranach,
Dresden 1974.

Schade 1983
Günter Schade (Hrsg.): Kunst der Reformations-
zeit. Staatliche Museen zu Berlin, Hauptstadt
der DDR, exhibition catalogue, Berlin (East)
1983.

Schade 2003
Werner Schade: Lucas Cranach. Glaube,
Mythologie und Moderne, exhibition catalogue,
Ostfildern 2003.

Schade 2006
Werner Schade: Zwei Flügel des Altarwerkes
für den Westchor des Naumburger Doms,
in: Holger Kunde (ed.), Der Naumburger
Domschatz. Sakrale Kostbarkeiten im
Domschatzgewölbe (= Kleine Schriften der
Vereinigten Domstifter zu Merseburg und
Naumburg und des Kollegiatstifts Zeitz, vol. 3),
Petersberg 2006, pp. 130–137.

Schäfer 2010
Bernd Schäfer: Wahre abcontrafactur. Martin
Luther und bedeutende seiner Zeitgenossen
im grafischen Porträt des 16. Jahrhunderts,
exhibition catalogue, Gotha 2010.

Schäfer/Eydinger/Rekow (forthcoming)
Bernd Schäfer/Ulrike Eydinger/Matthias Rekow
(eds.): Fliegende Blätter. Die Sammlung der
Einblattholzschnitte des 15. und 16. Jahrhunderts
in der Stiftung Schloss Friedenstein Gotha,
2 vols., Stuttgart 2016 (forthcoming).

Schäfer 2008
Heiko Schäfer: Kachelmodel aus dem späten
15.–17. Jahrhundert von den Grundstücken
Langenstraße 16 und 17 in der Hansestadt
Stralsund, in: Bodendenkmalpflege in
Mecklenburg-Vorpommern, vol. 56, 2008,
pp. 285–321.

Schaich 2007
Anne Schaich (ed.): Himmlische Helfer.
Mittelalterliche Schnitzkunst aus Halle,
exhibition catalogue, Halle (Saale) 2007.

Schauerte/Tacke 2006
Thomas Schauerte/Andreas Tacke (eds.):
Der Kardinal. Albrecht von Brandenburg.
Renaissancefürst und Mäzen, exhibition
catalogue, 2 vols. (= Kataloge der Stiftung
Moritzburg, Kunstmuseum des Landes
Sachsen-Anhalt), Regensburg 2006.

Schaumburg 1997
Petra Schaumburg: Der Gothaer und der
Mömpelgarder Altar. Zur protestantischen
Ikonographie der beiden bilderreichsten
Tafelaltäre der deutschen Kunst, Göttingen
1997 (unpubl. Master's thesis).

Schefzik 2008
Michael Schefzik: Luther ganz privat, in:
Archäologie in Deutschland, 5/2008, pp. 18 f.

Scheidemantel/Schifer 2005
Dirk Scheidemantel/Thorsten Schifer:
Waldenburger Steinzeug. Archäologie und
Naturwissenschaften (= Veröffentlichungen
des Landesamtes für Archäologie mit
Landesmuseum für Vorgeschichte, vol. 44),
Dresden 2005.

Scherer: Luther bittet
Annette Scherer: Luther bittet Kurfürst Friedrich
III. um Bestätigung der Ordnung des Gemeinen
Kastens für die Stadt Leisnig, online under
www.reformationsportal.de/visitationsakten/
detailviews-und-pdf-export.html?tx_jomapser
vices_pi1002%5Baction%5D=detail&tx_
jomapservices_pi1002%5BjoDetail%5D=stat_
showcase_00000011&cHash=b31d6893846
ebda14a7ab2c48cd33d2b (Digitales Archiv der
Reformation) (last accessed on November 20,
2015).

Scherer: Luthers Testament
Annette Scherer: Luthers Testament mit einem
eigenhändigen Vermerk Philipp Melanchthons,
online under www.reformationsportal.de/visita
tionsakten/detailviews-und-pdf-export.html?
tx_jomapservices_pi1002%5Baction%5D=
detail&tx_jomapservices_pi1002%5BjoDetail
%5D=stat_showcase_00000004&cHash=
cae626f89cdda7e96c33671cd5923850
(Digitales Archiv der Reformation)
(last accessed on November 20, 2015).

Scheurmann 1994
Ingrid Scheurmann (ed.): Frieden durch Recht,
Mainz 1994.

Scheurmann/Frank 2004
Konrad Scheurmann/Jördis Frank:
Neu entdeckt. Thüringen – Land der Residenzen
(1485–1918), 3 vols., exhibition catalogue,
Mainz 2004.

Schild 1892
Dr. Schild, Denkwürdigkeiten Wittenbergs,
Wittenberg 1892.

Schilling 1994
Heinz Schilling: Aufbruch und Krise.
Deutschland 1517–1648 (= Das Reich und die
Deutschen, vol. 1,5), Berlin 1994.

Schilling 2012
Heinz Schilling: Martin Luther. Rebell in einer
Zeit des Umbruchs, München 2012.

Schilling 2013
Heinz Schilling: Martin Luther. Rebell in einer
Zeit des Umbruchs. 2nd revised edition,
München 2013.

Schlenker 2007
Björn Schlenker: Archäologie am Elternhaus
Martin Luthers, in: Harald Meller (ed.), Luther in
Mansfeld. Forschungen am Elternhaus des
Reformators (= Archäologie in Sachsen-Anhalt,
special vol. 6), Halle (Saale) 2007, pp. 17–112.

Schlenker 2008
Björn Schlenker: Ausgrabungen und
Forschungen am Elternhaus Martin Luthers
in Mansfeld. Neue Erkenntnisse zu den
Lebensverhältnissen des jugendlichen
Reformators, in: Harald Meller (ed.),
Luthers Lebenswelten (= Tagungen des
Landesmuseums für Vorgeschichte Halle,
vol. 1), Halle (Saale) 2008, pp. 91–99.

Schlenker 2015
Björn Schlenker: Ein bemerkenswerter
Kellerfund im Elternhaus Martin Luthers.
Befunde und Funde der frühen Neuzeit aus
Mansfeld, in: Harald Meller (ed.), Mansfeld –
Luther(s)stadt. Interdisziplinäre Forschungen
zur Heimat Martin Luthers (= Forschungs-
berichte des Landesmuseums für Vorgeschichte
Halle, vol. 8), Halle (Saale) 2015, pp. 263–320.

Schlenkrich 2007
Elke Schlenkrich: "Es will auch dem gemeynen
kasten beschwerlich furfallen, dass er alle
erhalten sol in sterbens zeiten". Pest und
Armenpolitik in sächsischen Städten des
16. Jahrhunderts, in: Oehmig, Stefan (ed.),
Medizin und Sozialwesen in Mitteldeutschland
zur Reformationszeit (= Schriften der Stiftung
Luthergedenkstätten in Sachsen-Anhalt, vol. 6),
Leipzig 2007, pp. 143–167.

Schlenkrich 2008
Elke Schlenkrich: "Hat regirt die Pest allhie".
Pesterfahrungen zur Lutherzeit in Mittel-
deutschland, in: Harald Meller/Stefan Rhein/
Hans-Georg Stephan (eds.), Luthers Lebens-
welten (= Tagungen des Landesmuseums für
Vorgeschichte Halle, vol. 1), Halle (Saale) 2008,
pp. 253–258.

Schlüter 2010
Marie Schlüter: Musikgeschichte Wittenbergs
im 16. Jahrhundert. Quellenkundliche und
sozialgeschichtliche Untersuchungen
(= Abhandlungen zur Musikgeschichte, vol. 18),
Göttingen 2010.

Schmalz: Spalatin
Björn Schmalz: Spalatin (Burckhardt), Georg,
in: Sächsische Biografie, ed. by the Institut
für Sächsische Geschichte und Volkskunde e.V.,
online under www.saebi.isgv.de/biografie-druck/
Georg_Spalatin_(1484–1545) (last accessed on
October 13, 2014).

Schmekel 1858
Alfred Schmekel: Historisch-topographische
Beschreibung des Hochstifts Merseburg, Halle
(Saale) 1858.

Schmidt 1930
Hugo Schmidt (ed.): Bilder-Katalog zu Max
Geisberg. Der Deutsche Einblatt-Holzschnitt in
der ersten Hälfte des XVI. Jahrhunderts. 1600
verkleinerte Wiedergaben, München 1930.

Schmidt-Hannisa 2005
Hans-Walter Schmidt-Hannisa: Eingefleischte
Passion. Zur Logik der Stigmatisierung, in:
Roland Borgards (ed.), Schmerz und
Erinnerung, München 2005, pp. 69–82.

Schmitt/Gutjahr 2008
Reinhard Schmitt/Mirko Gutjahr: Das "Schwarze
Kloster" in Wittenberg. Bauforschung und
Archäologie im und am Kloster der Augustin-
er-Eremiten und Wohnhaus Martin Luthers,
in: Harald Meller (ed.), Fundsache Luther.
Archäologen auf den Spuren des Reformators,
exhibition catalogue, Stuttgart 2008,
pp. 132–141.

Schneider 1967
Erwin E. Schneider: Der Türck ist der
Lutherischen Glück, in: Oskar Thulin (ed.),
Reformation in Europa, Berlin 1967,
pp. 105–114.

Schneider/Enke/Strehle 2015
Katja Schneider/Roland Enke/Jutta Strehle
(eds.): Lucas Cranach der Jüngere. Entdeckung
eines Meisters, exhibition catalogue,
München 2015.

Schnell 1983
Hugo Schnell: Martin Luther und die Reforma-
tion auf Münzen und Medaillen, München 1983.

Schoch 2011
Johann Carl Schoch: Kurze Nachricht von den
Merkwürdigkeiten des Naumburger Doms 1773,
completed by Karl-Heinz Wünsch (= Quellen
und Schriften zur Naumburger Stadtgeschichte,
vol. 4), Naumburg 2011.

Schoch/Mende/Scherbaum 2001
Rainer Schoch/Matthias Mende/Anna
Scherbaum (adap.): Albrecht Dürer. Das
druckgraphische Werk (3 vols.), vol. 1,
Kupferstiche und Eisenradierungen,
München 2001.

Schoen 2001
Christian Schoen: Albrecht Dürer: Adam und
Eva. Die Gemälde, ihre Geschichte und
Rezeption bei Lucas Cranach d. Ä. und Hans
Baldung Grien, Berlin 2001.

Schottenloher 1918
Karl Schottenloher: Die Druckauflagen der
päpstlichen Lutherbulle "Exsurge Domine".
Ein Beitrag zum Reformations-Jubiläum, in:
Zeitschrift für Bücherfreunde, vol. 9, 1918,
pp. 197–208.

Schrader 1972
Franz Schrader: Kardinal Albrecht von Branden-
burg, Erzbischof von Magdeburg, im Spannungs-
feld zwischen alter und neuer Kirche, in:
Remigius Bäumer (ed.), Von Konstanz nach
Trient. Beiträge zur Geschichte der Kirche von
den Reformkonzilien bis zum Tridentinum,
Wien 1972, pp. 419–445.

Schreiner 2003
Klaus Schreiner: Maria. Leben, Legenden,
Symbole, München 2003.

Schubart 1917
Christof Schubart: Die Berichte über Luthers
Tod und Begräbnis. Texte und Untersuchungen,
Weimar 1917.

Schubert 1968
Ernst Schubert: Der Naumburger Dom,
Berlin 1968.

Schubert 1993
Ernst Schubert: Die Quaternionen. Entstehung,
Sinngehalt und Folgen einer spätmittelalterlichen
Deutung der Reichsverfassung, in: Zeitschrift
für historische Forschung, vol. 20, 1993,
pp. 1–63.

Schubert/Görlitz 1959
Ernst Schubert/Jürgen Görlitz: Die Inschriften des Naumburger Doms und der Domfreiheit (= Die Deutschen Inschriften, vol. 6, Berliner Reihe 1), Berlin/Stuttgart 1959.

Schuchardt 1851–1871
Christian Schuchardt: Lucas Cranach des Aeltern, Leben und Werke, 3 vols., Leipzig 1851–1871.

Schuchardt 2015
Günter Schuchardt (ed.): Cranach, Luther und die Bildnisse, exhibition catalogue, Regensburg 2015.

Schulz 1983
Hansjürgen Schulz: Mit Luther im Gespräch. Heutige Konfrontationen, München 1983.

Schulze 2000
Ingrid Schulze: Protestantische Epitaphgemälde aus der Zeit um 1560/70 in Eisleben, in: Mitteldeutschland, das Mansfelder Land und die Stadt Halle. Neuere Forschungen zur Landes- und Regionalgeschichte. Protokoll des Kolloquiums zum einhundertsten Geburtstag von Erich Neuß am 28./29. Mai 1999 in Halle (= Beiträge zur Regional- und Landeskultur Sachsen-Anhalts, issue 15), Halle (Saale) 2000, pp. 131–155.

Schulze 2004
Ingrid Schulze: Lucas Cranach d. J. und die protestantische Bildkunst in Sachsen und Thüringen. Frömmigkeit, Theologie, Fürstenreformation, Bucha bei Jena 2004.

Schuttwolf 1994 a
Allmuth Schuttwolf (ed.): Gotteswort und Menschenbild. Werke von Cranach und seinen Zeitgenossen, exhibition catalogue, Teil I: Malerei, Plastik, Graphik, Buchgraphik, Dokumente, Gotha 1994.

Schuttwolf 1994 b
Allmuth Schuttwolf (adap.): Gotteswort und Menschenbild. Werke von Cranach und seinen Zeitgenossen, exhibition catalogue, Teil II: Renaissancemedaillen, Renaissanceplaketten, Statthaltermedaillen, Gotha 1994.

Schuttwolf 1995
Allmuth Schuttwolf: Schlossmuseum Gotha, Sammlung der Plastik 1150–1850, Gotha 1995.

Schuttwolf 2011
Allmuth Schuttwolf: Verlustdokumentation der Gothaer Kunstsammlungen, vol. 2. Die Gemäldesammlung, Gotha 2011.

Schwarz 2014
Reinhard Schwarz: Luther, 4th edition, Göttingen 2014.

Schwarz 2008
Verena Schwarz: Die ältere Geschichte des Lutherhauses im Spiegel der Kachelfunde, in: Harald Meller/Stefan Rhein/Hans-Georg Stephan (eds.), Luthers Lebenswelten (= Tagungen des Landesmuseums für Vorgeschichte Halle, vol. 1), Halle (Saale) 2008, pp. 209–222.

Scribner 1981
Robert W. Scribner: For the Sake of Simple Folk: Popular Propaganda for the German Reformation, Cambridge 1981.

Sdunnus 1994
Ursula Sdunnus (ed.): Historisches Museum Basel: Führer durch die Sammlungen, London 1994.

Seebaß 1978
Gottfried Seebaß: Antichrist IV: Reformations- und Neuzeit, in: Gerhard Krause/Gerhard Müller (eds.), Theologische Realenzyklopädie, Berlin/Boston 1978, pp. 28–43.

Seebaß 1983
Gottfried Seebaß: Die Bildung des Pfarrerstandes, in: Gerhard Bott (ed.), Martin Luther und die Reformation in Deutschland, exhibition catalogue, Frankfurt am Main 1983, pp. 410–412.

Seib 1996
Gerhard Seib: Die Lutherbuche bei Altenstein und die aus ihr gewonnen "Luther-Devotionalien, in: Hardy Eidam/id., "Er fühlt der Zeiten ungeheuren Bruch und fest umklammert er sein Bibelbuch...". Zum Lutherkult im 19. Jahrhundert, Erfurt 1996, pp. 123–131.

Seifert 2005
Oliver Seifert: Kunst und Brot: hundert Meisterwerke aus dem Museum der Brotkultur, München 2005.

Seipel 2000
Wilfried Seipel (ed.): Kaiser Karl V. (1500–1558). Macht und Ohnmacht Europas, exhibition catalogue, Bonn 2000.

Seiter 2011
Wolf Seiter: Bauernfest und Bauernkrieg. Überlegungen zur Ikonographie von Sebald Behams "Großer Kirchweih" von 1535, in: Jürgen Müller/Thomas Schauerte (eds.), Die gottlosen Maler von Nürnberg. Konvention und Subversion in der Druckgrafik der Beham-Brüder, exhibition catalogue, Emsdetten 2011, pp. 115–125.

Seyderhelm 2001
Bettina Seyderhelm: Funktion, Bedeutung und Geschichte der liturgischen Geräte, die in den evangelischen Kirchengemeinden erhalten worden sind, in: id. (ed.), Goldschmiedekunst des Mittelalters. Im Gebrauch der Gemeinden über Jahrhundert bewahrt, exhibition catalogue, Dresden 2001, pp. 136–145.

Silver 2003
Larry Silver: The Face is Familiar: German Renaissance Portrait Multiples in Prints and Medals, in: Word & Image, vol. 19.1–2, 2003, pp. 6–21.

Slenczka 2010
Ruth Slenczka: Bemalte Bronze hinter Glas? – Luthers Grabplatte in Jena 1571 als 'protestantische Reliquie', in: Philipp Zitzlsperger (ed.), Grabmal und Körper – zwischen Repräsentation und Realpräsenz in der Frühen Neuzeit. Tagungsband, online under kunsttexte.de, Nr. 4, 2010, http://edoc.hu-berlin.de/kunst texte/2010-4/slenczka-ruth-6/PDF/slenczka. pdf (last accessed on January 28, 2016).

Slenczka 2015
Ruth Slenczka: Cranach der Jüngere im Dienst der Reformation, in: Roland Enke/Katja Schneider/Jutta Strehle (eds.), Lucas Cranach der Jüngere. Entdeckung eines Meisters, exhibition catalogue, München 2015, pp. 124–137.

Smith 1994
Jeffrey Chipps Smith: German Sculpture of the Later Renaissance, c. 1520–1580, Princeton, NJ 1994.

Speler 1987
Ralf-Torsten Speler: Kunst- und Kulturschätze der Alma Mater Halensis et Vitebergensis, Halle (Saale) 1987.

Speler 1994
Ralf-Torsten Speler (ed.): 300 Jahre Universität Halle, 1694–1994. Schätze aus den Sammlungen und Kabinetten, Halle (Saale) 1994.

Speler 1997 a
Ralf-Torsten Speler (ed.): Melanchthon und die Universität. Zeitzeugnisse aus den Halleschen Sammlungen, Halle (Saale) 1997.

Speler 1997 b
Ralf-Torsten Speler, Zur Geschichte der Universität Wittenberg und ihrer Sammlungen, in: idem (ed.), Melanchthon und die Universität. Zeitzeugnisse aus den halleschen Sammlungen, Halle (Saale) 1997, pp. 21–38.

Spielmann 2003
Heinz Spielmann (ed.): Lucas Cranach. Glaube, Mythologie und Moderne, exhibition catalogue, Hamburg 2003.

Spinks 2015
Jennifer Spinks: Monstrous Births and Visual Culture in Sixteenth-Century Germany, London 2015.

Staatliche Archivverwaltung 1983
Martin Luther 1483–1546. Dokumente seines Lebens und Wirkens, Dokumente aus staatlichen Archiven und anderen wissenschaftlichen Einrichtungen der Deutschen Demokratischen Republik, Im Jahre des 500. Geburtstages Martin Luthers mit Unterstützung des Martin-Luther-Komitees, published by the Staatliche Archivverwaltung der DDR, Weimar 1983.

Stahl 2004
Andreas Stahl: Zur Authentizität des Luther-Sterbehauses in Eisleben, in: Denkmalpflege in Sachsen-Anhalt, vol. 12, 2004, pp. 77 f.

Stahl 2006
Andreas Stahl: Cyriacus Spangenberg als Chronist. Die Authentizität des Sterbehauses von Martin Luther, in: Stefan Rhein/Günther Wartenberg (eds.), Reformatoren im Mansfelder Land. Erasmus Sarcerius und Cyriakus Spangenberg (= Schriften der Stiftung Luthergedenkstätten in Sachsen-Anhalt, vol. 4), Leipzig 2006, pp. 191–216.

Stahl 2015
Andreas Stahl: Die Lutherstadt Eisleben als Residenzstadt der Mansfelder Grafen, in: Burgen und Schlösser in Sachsen-Anhalt, issue 24, Halle (Saale) 2015, pp. 316–347.

Stalmann 2011
Joachim Stalmann: Gesangbücher im Reformationsjahrhundert, in: Wolfgang Hochstein/Christoph Krummacher (eds.), Geschichte der Kirchenmusik in 4 Bänden, vol. 1: Von den Anfängen bis zum Reformationsjahrhundert, Darmstadt 2011, pp. 236–255.

Stätten Reformation 2014
Stätten der Reformation in Hessen und Thüringen. Kulturelle Entdeckungen, Regensburg 2014.

Steguweit 1990
Wolfgang Steguweit (ed.): Von der Kunstkammer zum Schloßmuseum Gotha. 350 Jahre Sammlungen für Kunst- und Wissenschaft auf Schloß Friedenstein, 3rd edition, Gotha 1990.

Steguweit 2012
Wolfgang Steguweit: Die Dreifaltigkeitsmedaille von Hans Reinhart d. Ä., in: Münzenrevue, vol. 12/2012, pp. 141–147.

Steller 2011
Katrin Steller: Der gotische Skulpturenfund vom Gouvernementsberg in Magdeburg, in: Wolfgang Schenkluhn/Andreas Waschbüsch (eds.), Der Magdeburger Dom im europäischen Kontext, Regensburg 2011, pp. 265–276.

Stephan 1987
Hans Georg Stephan: Die bemalte Irdenware der Renaissance in Mitteleuropa. Ausstrahlungen und Verbindungen der Produktionszentren im gesamteuropäischen Rahmen, München 1987.

Stephan 2007 a
Hans Georg Stephan: Keramische Funde aus Luthers Elternhaus, in: Harald Meller (ed.), Luther in Mansfeld. Forschungen am Elternhaus des Reformators (= Archäologie in Sachsen-Anhalt, special vol. 6), Halle (Saale) 2007, pp. 139–158.

Stephan 2007 b
Hans Georg Stephan: Keramische Sonderformen in Mittelalter und Neuzeit, in: Keramik auf Sonderwegen. 37. Internationales Hafnerei-Symposium, Herne 19. bis 25. September 2004 (= Denkmalpflege und Forschung in Westfalen 44), 2007, pp. 1–16.

Stephan 2008 a
Hans-Georg Stephan: Archäologie der Reformationszeit. Aufgaben und Perspektiven der Lutherarchäologie in Sachsen-Anhalt, in: Harald Meller (ed.), Fundsache Luther – Archäologen auf den Spuren des Reformators, exhibition catalogue, Stuttgart 2008, pp. 108–113.

Stephan 2008 b
Hans-Georg Stephan: Luther-Archäologie: Funde und Befunde aus Mansfeld und Wittenberg. Gedanken und Materialien zur Erforschung der Lebenswelt des Reformators und zur Alltagskultur Mitteldeutschlands im 16. Jh, in: Harald Meller/ Stefan Rhein/Hans-Georg Stephan (eds.), Luthers Lebenswelten (= Tagungen des Landesmuseums für Vorgeschichte Halle, vol. 1), Halle (Saale) 2008, pp. 13–77.

Stephan 2014
Hans-Georg Stephan: Von der Gotik zur Renaissance – Spätmittelalterliche Volksfrömmigkeit und Reformation, in: Harald Meller (ed.), Mitteldeutschland im Zeitalter der Reformation. Interdisziplinäre Tagung vom 22. bis 24. Juni 2012 in Halle (Saale) (= Forschungsberichte des Landesmuseums für Vorgeschichte Halle, vol. 4), Halle (Saale) 2014, pp. 153–176.

Steppuhn 2008
Peter Steppuhn: Glasproduktion und Glasprodukte an der Schwelle vom Mittelalter zur Renaissance, in: Harald Meller/Stefan Rhein/Hans-Georg Stephan (eds.), Luthers Lebenswelten (= Tagungen des Landesmuseums für Vorgeschichte Halle, vol. 1), Halle (Saale) 2008, pp. 131–142.

Stewart 2008
Alison G. Stewart: Before Bruegel. Sebald Beham and the Origins of Peasant Festival Imagery, Aldershot 2008.

Stogdon 1989
Nicholas G. Stogdon: Oh Happy State...!, New York 1989.

Stopp 1965
Frederick Stopp: Der religiös-polemische Einblattdruck "Ecclesia Militans" (1569) des Johannes Nas und seine Vorgänger, in: Deutsche Vierteljahrsschrift für Literaturwissenschaft und Geistesgeschichte, 1965, pp. 588–632.

Strauss 1981
Walter L. Strauss: Albrecht Dürer. The Illustrated Bartsch, vol. 10 (Commentary), New York 1981.

Strehle/Kunz 1998
Jutta Strehle/Armin Kunz: Druckgraphiken Lucas Cranachs d. Ä. Im Dienst von Macht und Glauben, inventory catalogue, Wittenberg 1998.

Strieder 1989
Peter Strieder: Albrecht Dürer. Paintings, Prints, Drawings, revised ed., New York 1989.

Strohm 2013
Albert Strohm: Graf Joachim und der Calvinismus in Ortenburg, in: Alfons Niederhofer (ed.), Ortenburg. Reichsgrafschaft und 450 Jahre Reformation 1563–2013, Ortenburg 2013, pp. 81–87.

Strouse 1999
Jean Strouse: Morgan: American Financier, New York 1999.

Stuhlfauth 1927
Georg Stuhlfauth: Die Bildnisse D. Martin Luthers im Tode, Weimar 1927.

Syndram/Wirth/Zerbe/Wagner 2015
Dirk Syndram/Yvonne Wirth/Doreen Zerbe/Iris Yvonne Wagner (eds.): Luther und die Fürsten. Selbstdarstellung und Selbstverständnis des Herrschers im Zeitalter der Reformation, exhibition catalogue, 2 vols., Dresden 2015.

T

Tacke 2006 a
Andreas Tacke (ed.): "Ich armer sundiger mensch": Heiligen- und Reliquienkult am Übergang zum konfessionellen Zeitalter (= Schriftenreihe der Stiftung Moritzburg, Kunstmuseum des Landes Sachsen-Anhalt, vol. 2), Göttingen 2006.

Tacke 2006 b
Andreas Tacke: Albrecht als heiliger Hieronymus. Damit "der Barbar überall dem Gelehrten weiche!", in: Thomas Schauerte/id. (eds.), Der Kardinal. Albrecht von Brandenburg – Renaissancefürst und Mäzen, vol. 2, Regensburg 2006, pp. 116–129.

Talbot 1971
Charles W. Talbot: Dürer in America: His Graphic Work. Exhibition at the National Gallery of Art, April 25–June 6, 1971, New York 1971.

Tamboer 1999
Annemies Tamboer: Ausgegrabene Klänge. Archäologische Musikinstrumente aus allen Epochen, Zwolle/Assen/Oldenburg 1999.

Tebbe 2007
Karin Tebbe (adap.): Goldglanz und Silberstrahl, exhibition catalogue, Nürnberg 2007.

Tenschert 1978
Heribert Tenschert: Illumination und Illustration vom 13. bis 16. Jahrhundert. Katalog XX zum 10jährigen Firmenjubiläum 1987, Ramsen 1987.

Tentzel 1982
Ernst Wilhelm Tentzel: Saxonia numismatica, Dresden/Frankfurt/Gotha 1714 (Reprint Berlin 1982).

Theuerkauff-Liederwald 1994
Anna-Elisabeth Theuerkauff-Liederwald: Venezianisches Glas der Kunstsammlungen der Veste Coburg – die Sammlung Herzog Alfreds von Sachsen-Coburg und Gotha (1844–1900), Lingen 1994.

Thönissen 2014
Wolfgang Thönissen: Luthers 95 Thesen gegen den Ablass (1517) – ihre Bedeutung für die Durchsetzung und Wirkung der Reformation, in: Irene Dingel/ Henning P. Jürgens (eds.), Meilensteine der Reformation. Schlüsseldokumente der frühen Wirksamkeit Martin Luthers, München 2014, pp. 89 f.

Tietz 2012
Anja Tietz: Der frühneuzeitliche Gottesacker. Entstehung und Entwicklung unter besonderer Berücksichtigung des Architekturtypus Camposanto in Mitteldeutschland (= Beiträge zur Denkmalkunde, vol. 8), Halle (Saale) 2012.

Treu 1991
Martin Treu: Die Lutherhalle Wittenberg, Leipzig 1991.

Treu 1999 a
Martin Treu: "Lieber Herr Käthe" – Katharina von Bora. Die Lutherin. Rundgang durch die Ausstellung (= Katalog der Stiftung Luthergedenkstätten in Sachsen-Anhalt, vol. 4), Wittenberg 1999.

Treu 1999 b
Martin Treu: Katharina von Bora. Die Lutherin. Aufsätze anläßlich ihres 500. Geburtstages (= Katalog der Stiftung Luthergedenkstätten in Sachsen-Anhalt, vol. 5), Wittenberg 1999.

Treu 2003 a
Martin Treu: Luthers Bild und Lutherbilder – ein Rundgang durch die Wirkungsgeschichte, Wittenberg 2003.

Treu 2003 b
Martin Treu: Martin Luther in Wittenberg. Ein biografischer Rundgang, Wittenberg 2003.

Treu 2007
Martin Treu: "Von daher bin ich" – Martin Luther und Eisleben. Ein Rundgang durch die Ausstellung im Geburtshaus, Wittenberg 2007.

Treu 2008 a
Martin Treu: Urkunde und Reflexion Wiederentdeckung eines Belegs für Luthers Thesenanschlag, in: Joachim Ott/Martin Treu (eds.), Luthers Thesenanschlag – Faktum oder Fiktion (= Schriften der Luthergedenkstätten in Sachsen-Anhalt, vol. 9), Leipzig 2008, pp. 59–68.

Treu 2008 b
Martin Treu: Martin Luther und das Geld, 2nd edition, Wittenberg 2008.

Treu 2008 c
Martin Treu: "Wie der Hund auf das Fleisch" – Theologie und Alltag bei Martin Luther, in: Harald Meller/Stefan Rhein/Hans-Georg Stephan (eds.), Luthers Lebenswelten (= Tagungen des Landesmuseums für Vorgeschichte Halle, vol. 1), Halle (Saale) 2008, pp. 365–367.

Treu 2010
Martin Treu: Martin Luther in Wittenberg. Ein biografischer Rundgang, 3rd edition, Wittenberg 2010.

Treu 2014
Martin Treu: "Von daher bin ich" – Martin Luther und Eisleben. Ein Rundgang durch die Ausstellung im Geburtshaus, 3rd edition, Wittenberg 2014.

Treu/Speler/Schellenberger 1990
Martin Treu/Ralf-Torsten Speler/Alfred Schellenberger: Leucorea. Bilder zur Geschichte der Universität, Wittenberg 1990.

U

Unteidig 2008
Günter Unteidig: Die Irdenware um 1500 in Grimma, in: Harald Meller/Stefan Rhein/Hans-Georg Stephan (eds.), Luthers Lebenswelten (= Tagungen des Landesmuseums für Vorgeschichte Halle, vol. 1), Halle (Saale) 2008, pp. 143–152.

Unverfehrt 2001
Gerd Unverfehrt: Gerissen und gestochen: Graphik der Dürer-Zeit aus der Kunstsammlung der Universität Göttingen, Göttingen 2001.

Uppenkamp 2014
Bettina Uppenkamp: Judith – Zur Aktualität einer biblischen Heldin im 16. Jahrhundert, in: Simona Schellenberger/André Thieme/Dirk Welich (eds.), Eine starke Frauengeschichte. 500 Jahre Reformation, exhibition catalogue, Beucha 2014, pp. 71–77.

V

Vahlhaus 2015
Ines Vahlhaus: Kleinfunde von der Grabung "Goldener Ring" in Mansfeld, in: Harald Meller (ed.), Mansfeld – Luther(s)stadt. Interdisziplinäre Forschungen zur Heimat Martin Luthers (= Forschungsberichtes des Landesmuseums für Vorgeschichte Halle, vol. 8), Halle (Saale) 2015, pp. 435–451.

van Dülmen 1983
Andrea van Dülmen: Luther-Chronik. Daten zu Leben und Werk, München 1983.

Vasold 2003
Manfred Vasold: Die Pest. Ende eines Mythos, Stuttgart 2003.

Veit 2006
Patrice Veit: Entre violence, résistence et affirmation identitaire. A propos du cantique de Luther "Erhalt uns Herr bei deinem Wort" aux XVIe et XVIIe siècles, in: Kaspar von Greyerz/ Kim Siebenhüner (eds.), Religion und Gewalt. Konflikte, Rituale, Deutungen (1500–1800), Göttingen 2006, pp. 267–304.

Volz 1931
Hans Volz: Luthers Schmalkaldische Artikel und Melanchthons Tractatus de potentate papae. Ihre Geschichte von der Entstehung bis zum Ende des 16. Jahrhunderts, Gotha 1931.

Volz 1970
Hans Volz: Der Traum Churfürst Friedrichs des Weisen vom 30./31. Oktober 1517. Eine bibliographisch-ikonographische Untersuchung, in: Gutenberg Jahrbuch, vol. 45, 1970, pp. 174–211.

Volz 1978
Hans Volz: Martin Luthers deutsche Bibel, Hamburg 1978.

W

Wagner 2014
Bettina Wagner (ed.): Welten des Wissens. Die Bibliothek und die Weltchronik des Nürnberger Arztes Hartmann Schedel (1440–1514), exhibition catalogue, München 2014.

Wahl 1935
Paul Wahl: Die Lutherbibel in Anhalt, in: Walter Möllenberg (ed.), Sachsen und Anhalt (= Jahrbuch der Landesgeschichtlichen Forschungsstelle für die Provinz Sachsen und für Anhalt, vol. 11), Magdeburg 1935, pp. 137–150.

Wallmann 2014
Johannes Wallmann: Die Evangelische Kirche verleugnet ihre Geschichte. Zum Umgang mit Martin Luthers Judenschriften Teil I, in: Deutsches Pfarrerblatt vol. 6, 2014, pp. 332–336 and 382–387, Teil II, in: Deutsches Pfarrerblatt, vol 7, 2014, pp. 466–469.

Warnke 1984
Martin Warnke: Cranachs Luther. Entwürfe für ein Image, Frankfurt am Main 1984.

Wäscher 1956
Hermann Wäscher: Die Seeburg am Süßen See. 2. Bericht über den Forschungsauftrag "Mittelalterliche Burgen in Mitteldeutschland" (= Wissenschaftliche Zeitschrift der Martin-Luther-Universität Halle-Wittenberg, year 5, issue 2), Halle (Saale) 1956.

Weber 1997
Matthias Weber: Zur Bedeutung der Reichsacht in der Frühen Neuzeit, in: Johannes Kunisch (ed.), Neue Studien zur frühneuzeitlichen Reichsgeschichte (= Zeitschrift für Historische Forschung, suppl. 19), Berlin 1997, pp. 55–90.

Welt 1976
Die Welt des Hans Sachs. 400 Holzschnitte des 16. Jahrhunderts, exhibition catalogue (= Kataloge der Stadtgeschichtlichen Museen der Stadt Nürnberg vol. 10), Nürnberg 1976.

Wendel 1908
Carl Wendel: Die Lutherbibel von 1541 in der Marienbibliothek zu Halle a. S., in: Neue Mitteilungen aus dem Gebiet der historisch-antiquarischen Forschung, vol. 23, 1908, pp. 387–392.

Wenz 1996
Gunther Wenz: Theologie der Bekenntnisschriften der evangelisch-lutherischen Kirche. Eine historische und systematische Einführung in das Konkordienbuch, vol. 1, Berlin 1996, pp. 351–498.

Werner 1961
Mechthild Werner: Aus dem Kunstbesitz der Martin-Luther-Universität Halle-Wittenberg, in: Wissenschaftliche Zeitschrift der Martin-Luther-Universität Halle-Wittenberg, Gesellschafts- und Sprachwissenschaftliche Reihe X/4, May 1961, pp. 1111–1130.

Westermann 1975
Ekkehard Westermann: Hans Luther und die Hüttenmeister der Grafschaft Mansfeld im 16. Jahrhundert: eine Forschungsaufgabe, in: Scripta Mercaturae, vol. 2, 1975, pp. 53–95.

Widmann 1972/73
Hans Widmann: Luthers erste deutsche Bibelübersetzung: Das September-Testament von 1522, in: Ebernburg-Hefte, series 6./7., 1972/73, pp. 42–65.

Wiessner 1997/98
Heinz Wiessner: Das Bistum Naumburg, unter Verwendung von Vorarbeiten von Ernst Devrient (= Germania Sacra new series, vol. 35,1–2), 2 vols., Berlin/New York 1997/98.

Wilhelmy 2000
Winfried Wilhelmy: Drache, Greif und Liebesleut'. Mainzer Bildteppiche aus spätgotischer Zeit (= Schriften des Bischöflichen Dom- und Diözesanmuseums Mainz, vol. 1), Mainz 2000, pp. 70–80.

Williams 2014
Reggie L. Williams: Bonhoeffer's Black Jesus: Harlem Renaissance Theology and an Ethic of Resistance, Waco, TX 2014.

Wimböck 2010
Gabriele Wimböck: Wort für Wort, Punkt für Punkt. Darstellungen der Kreuzigung im 16. Jahrhundert in Deutschland, in: Ulrich Heinen/Johann Anselm Steiger (eds.): Golgatha in den Konfessionen und Medien der Frühen Neuzeit, Berlin/ New York 2010, pp. 161–185.

Wingenroth 1899
Max Wingenroth: Kachelöfen und Ofenkacheln des 16., 17. und 18. Jahrhunderts im Germanischen Museum auf der Burg und in der Stadt Nürnberg (= Mitteilungen des Germanischen Nationalmuseums 1899), Nürnberg 1899.

Winkler 1986
Christine Winkler: Die Maske des Bösen. Groteske Physiognomie als Gegenbild des Heiligen und Vollkommenen in der Kunst des 15. und 16. Jahrhunderts, München 1986.

Wipfler 2000
Esther Pia Wipfler: "Wenn man auch sonst die Greber wolt ehren…". Zu den gemalten Epitaphien des Eisleber Kronenfriedhofes, in: Rosemarie Knape (ed.), Martin Luther und der Bergbau im Mansfelder Land, exhibition catalogue (= Katalog der Stiftung Luthergedenkstätten in Sachsen-Anhalt, vol. 7), pp. 281–305.

Wittenberger Gelehrtenstammbuch 1999
Das Wittenberger Gelehrtenstammbuch. Das Stammbuch von Abraham Ulrich (1549–1577) und David Ulrich (1580–1623), published by the Deutsches Historisches Museum, adapted by Wolfgang Klose with the assistance of Wolfgang Harms, facsimile and commentary volumes, Halle (Saale) 1999.

Wolf 2015
Anja Wolf: Die Taufe Christi von 1556. Einblicke
in die Arbeitsweise Lucas Cranachs des
Jüngeren, in: Anne Eusterschulte/Gunnar
Heydenreich/Elke A. Werner (eds.), Lucas
Cranach der Jüngere und die Reformation der
Bilder, München 2015, pp. 168–179.

Wolf 1959
Ernst Wolf: Eberlin von Günzburg, Johann,
in: Neue Deutsche Biographie vol. 4, 1959,
pp. 247 f., online under www.deutsche-
biographie.de/pnd118681540.html
(last accessed on December 12, 2015).

Z

Zimmermann 1925
Hildegard Zimmermann: "Beiträge zu Luthers
Kampfbildern", in: Mitteilungen der Gesell-
schaft für vervielfältigende Kunst, Beilage der
"Graphischen Künste", year 1925, issue 4,
pp. 61–67.

Zschelletzschky 1975
Herbert Zschelletzschky: Die "drei gottlosen
Maler" von Nürnberg. Sebald Beham, Barthel
Beham und Georg Pencz. Historische Grund-
lagen und ikonologische Probleme ihrer
Graphik zu Reformations- und Bauernkriegszeit,
Leipzig 1975.

Printed Sources
Books before 1800 and Critical Editions

Albinus/Göding 1597/1598
Heinrich Albinus/Petrus Göding: Auszug Der Eltisten vnd fürnembsten Historien, des vralten streitbarn vnd beruffenen Volcks der Sachssen [...], 2 vols., Dresden 1597/1598.

Fabri 1794
Johann Ernst Fabri: Beyträge zur Geographie, Geschichte und Staatenkunde, vol. 1, Nürnberg 1794.

Hortleder 1622
Friedrich Hortleder: Beschreibung des von Herrn Ernesten Herzog zu Sachsen Gotha gesammelten Cabinets alter und neuer Münzen, 4 vols., Weimar 1622.

Jonas/Coelius 1546
Justus Jonas/Michael Coelius: Vom Christlichen abschied aus dem tödlichen leben des Ehrwirdigen Herrn D. Martini Lutheri bericht durch D. Justum Jonam M. Michaelem Celium vnd ander die dabey gewesen kurtz zusamen gezogen, Wittenberg 1546.

Keyssler 1776
Johann Georg Keyssler: Reisen durch Deutschland, Böhmen, Ungarn, die Schweiz, Italien und Lothringen [...], 2nd edition, Hannover 1776.

MBW.T 2013
Melanchthons Briefwechsel. Kritische und kommentierte Gesamtausgabe, im Auftrag der Heidelberger Akademie der Wissenschaften, edited by Heinz Scheible, and since vol. T 11 by Christine Mundhenk, Stuttgart/Bad Cannstatt 2013.

Merian 1654
Matthäus Merian: Topographia und Eigentliche Beschreibung Der [...] Hertzogthumer Braunschweig und Lüneburg [...], Frankfurt 1654; digitized by the Herzog August Bibliothek in Wolfenbüttel, online under http://diglib.hab. de/drucke/6-11-1-geogr-2f/start.htm (last accessed March 1, 2016).

Nagel 1589
Abraham Nagel: Schüttlung deß vermeinten Christenbaums, vom Teuffel gepeltzt, unnd Fortpflantzung deß Edlen Lorberbaums, von Gott gepflantzt, im Landt zºu Francken: Sampt [...] Erörterung vier fürnemer Fragen, auff die [...] Fortpflantzung deß Catholischen Glaubens, [...] gerichtet. [...] Mit angehenckter [...] Erwenung, der neulich zu Wirtzburg verbrachten Christentauff. [...], Ingolstadt 1589.

Politische Historien 1773
Die Politischen Historien von Thüringen Meißen und Sachsen, welche der sächsische Patriot aus den bewährten Nachrichten in XI Stücken der studirenden Jugend in möglichster Kürze aufrichtig erzehlet, Leipzig 1773.

Schoepffer 1765
Justus Schoepffer: Unverbrandter Luther oder historische Erzählung von D. Martin Luther und dessen im Feuer erhaltenen Bildnissen, Wittenberg/Zerbst 1765.

RG 5
Repertorium Germanicum, vol. 5: Verzeichnis der in den Registern und Kameralakten Eugens IV. vorkommenden Personen, Kirchen und Orte des Deutschen Reiches, seiner Diözesen und Territorien (1431–1447), edited by Hermann Diener, Brigide Schwarz and Christoph Schöner, Tübingen 2004.

RG 7
Repertorium Germanicum, vol. 7: Verzeichnis der in den Registern und Kameralakten Calixts III. vorkommenden Personen, Kirchen und Orte des Deutschen Reiches, seiner Diözesen und Territorien (1455–1458), edited by Ernst Pitz, Tübingen 1989.

WA
Martin Luther: D. Martin Luthers Werke, kritische Gesamtausgabe (Weimarer Ausgabe), 120 vols., Weimar 1883–2009.

WA.B
Martin Luther: D. Martin Luthers Werke, kritische Gesamtausgabe (Weimarer Ausgabe), Briefwechsel, 18 vols., Weimar 1883–1985.

WA.DB
Martin Luther: D. Martin Luthers Werke, kritische Gesamtausgabe (Weimarer Ausgabe), Deutsche Bibel, 12 vols., Weimar 1906–1914.

WA.TR
Martin Luther: D. Martin Luthers Werke, kritische Gesamtausgabe (Weimarer Ausgabe), Tischreden, 6 vols., Weimar 1912–1921.

Zeiller 1632
Martin Zeiller: Germania Nv-Antiquia. Das ist: Reyßbuch durch Hoch und Nider Teutschland, auch benachbarte Königreiche, Fürstenthumb und Länder [...], Straßburg 1632.

Archival Primary Sources

Archive of the Christian Democratic Union, Document Archive—CDU in the GDR
(Soviet Occupation Zone of the German Democratic Republic)

- Department of Culture, Popular Education, Training 1966–1989, party chairman Gerald Götting – Art commissions
- Götting 1988
 Gerald Götting: "Manuscript speech by Gerald Götting, Chairman of the CDU in the GDR during a commemoration of the 20th anniversary of Martin Luther King," 1988, Bundesarchiv, BArch DZ 9/2652

Bayerische Staatsbibliothek, München

- Johann Walther: Wittembergisch deudsch Geistlich Gesangbüchlein, Wittenberg 1551; digitized, online under www.stimmbuecher.digitale-sammlungen.de/view?id=bsb00092623 (last accessed on February 15, 2016)

Domstiftsbibliothek Naumburg

- Kayser 1746
 Johann Georg Kayser: Antiquitates, Epitaphia et Monumenta ad Descriptionem Templi cathedralis Numburgensis collecta, 1746, manuscript

DStA, Domstiftsarchiv Merseburg

- Urkunde Nr. 513
- Urkunde Nr. 1049
- Urkunde St. Sixti, Nr. 101, 102

LASA, Landesarchiv Sachsen-Anhalt

- see object headings

RatsA WB, Städtische Sammlungen Wittenberg, Ratsarchiv (Council Archive)

- Kreis-Turnfest des Turnkreises IIIe der Deutschen Turnerschaft (Provinz Sachsen und Herzogtum Anhalt) (District Sport Festival of District IIIe of the German Sports Association) July 8–10, 1905, Wittenberg
- Ln. Urbar (alt) 2
- Ln. 2254
- Kämmereirechnung 1525
- Kämmereirechnung 1532

ThHStAW, EGA, Thüringisches Hauptstaatsarchiv Weimar, Ernestinisches Gesamtarchiv

- Reg. Bb 4361, f. 44r
 (invoice from May 10, 1533)

ThStAG, Thüringisches Staatsarchiv Gotha

- see object headings

SHStAD, Sächsisches Staatsarchiv – Sächsisches Hauptstaatsarchiv Dresden

- Bestand 12803, Personennachlass Elisabeth Werl, Nr. 4, Nr. 17 und Nr. 35
- Bestand 10024, Geheimer Rat (Geheimes Archiv), Loc. 8607/15

Sächsische Landesbibliothek

- Mscr.Dresd.R.307

Staatsbibliothek Berlin

- Johann Friedrich Petsch: Ein schönes christliches Lied von dem ehrwürdigen D. Martin Luther und seiner Lehre, Wittenberg 1546; digitized, online under www.resolver.staatsbibliothek-berlin.de/SBB-0000BBD900000000 (last accessed on February 15, 2016)

Thüringer Universitäts- und Landesbibliothek Jena

- Ms. Bos. q. 24k, ff. 235r–259v

UAHW, Archiv der Martin-Luther-Universität Halle-Wittenberg

- see object headings

Glossary

Absolution
A part of the sacrament of penance; the forgiving of sins

Albertines
One of the lineages of the Saxon House of Wettin, established in consequence of the dynastic split in 1485; obtained the electoral title in 1547

Altar benefice
Assets donated to establish and maintain an altar and the cleric servicing it

Anabaptists
A Christian movement which demanded adult Baptism, in the case of those baptized as infants, a renewal was deemed necessary (hence: Ana-baptists, re-baptizers)

Antichrist
New-Testament concept that only appears in the Epistles of John and 2 Thessalonians; the adversary of Christ who was expected to rule over the end of time; identified with the Papacy by Luther in 1520

Anti-Clericalism
Widespread criticism of the clergy that arose during the Middle Ages; usually targeting the lax ethical standards of priests and monks

Anti-Judaism/Anti-Semitism
A perception, based on the Gospel of John, that the Jewish people were the murderers of Christ; this view became one of the foundations of racist enmity against Jews in the nineteenth century

Antinomian Controversy
A theological controversy between "real" Lutherans (Gnesio-Lutherans) and the followers of Melanchthon concerning the role of Law in the life of the faithful

Apocalypticism
An interpretation of events as presaging the approaching catastrophic end of the world

Apostolic See
The designation for the seat of the bishopric of Rome and a synonym for the Pope's position of authority

Augsburg Interim
A law proclaimed at the Imperial Diet of Augsburg in June 1548; providing interim regulations for the Protestant estates until a council could be convened to resolve the religious dispute; its only concessions were the lay chalice and the marriage of clerics

Augsburg Confession
A document of confession presented by the Protestant imperial estates in 1530; the 28 articles explained their faith in the context of Scripture; still valid in Lutheran churches to this day

Augustinian Hermits/Mendicants, Friars
An order of mendicant friars that Martin Luther joined in Erfurt in 1505

Baptism
The sacrament of acceptance into the Christian community

Battle of Mühlberg
A battle fought on April 24, 1547 between the imperial and Saxon armies; Elector John Frederick was captured and forced to resign in the Capitulation of Wittenberg

Bishopric, Diocese
The area over which a bishop had religious (and sometimes political) authority

Body of Christ
A term used in the controversy over the Eucharist in which the definite relation between the physical body of Christ and the Host was hotly debated

Bohemian Brethren, Unity of the Brethren
An association of various religious groups (Waldensian, Taborite and Utraquist) in late fifteenth-century Bohemia that established a distinct fraternal church

Bowl, Cup
The upper part of a chalice

Broadsheet
A single-page print, often illustrated, often containing the latest news; an effective way of influencing public opinion in the Early Modern era

Brotherhood, Fraternity
An association whose male members performed pious works (common prayer, services, assistance for the sick, the helpless and travelers)

Calvinism
An appellation for the teachings of Jean Calvin, coined by his enemies but rejected by him

Canon
A standard or collection of normative rules

Canon
A cleric belonging to a collegiate or cathedral chapter who lives according to ecclesiastical rules

Canonist
A teacher of Roman-Catholic church law

Cardinal
The highest rank in the Roman Church below the Pope; often combined with a bishopric

Catechism
A manual for teaching the fundamentals of Christian belief; the Reformed churches use the Heidelberg Catechism of 1563

Catholicism
The self- conception of the Catholic Church as being universal and exclusive; an arrogant presumption in the eyes of the Lutherans

Celibacy
The obligation of the holders of church offices to remain unmarried; practiced predominantly in the Catholic Church

Chapter, Confraternity
A clerical community without the strict regulations of monkhood, but an obligation of common prayer

Chasuble
liturgical vestment

Christian Freedom
Luther's conviction derived from his reading of Galatians that the use of coercion in matters of faith was wrong; not applicable to strictly political affairs in his view

Church of England, Anglican Church
The official church that was established in England in 1529, encompassing Protestant theology and Catholic liturgy

Church Order
Regulations governing church matters for congregations

Colloquy of Worms
An attempt to return to religious unity made in Worms in 1557; it failed due largely to the conflicting positions among the attending Protestant theologians

Common Chest
The common budget of a church congregation from which all expenses were paid; an important tool for funding the communal care of the poor

Commoner
A contemporary term for the non-noble and non-clerical majority of the population, encompassing both peasants and townsfolk

Confessing Church
A movement of German Protestants under Nazi rule that opposed the officially sanctioned "German Christians"

Confessio Augustana
see Augsburg Confession

Confession
A term which came into use when Christianity split into three different churches (Catholics, Lutherans, Reformed)

Confessionalization/Confessional Age
A development in the sixteenth century that saw the widespread interference of religion in political, cultural and intellectual affairs

Confirmation
A Christian ritual that completes the grace bestowed by Baptism; a sacrament in the Catholic Church

Consecration
The consecration and transubstantiation of the Host in Catholic practice

Corporal
A textile for covering the altar

Council
A gathering of church prelates and the Pope to decide important church affairs

Council of Trent
A council, held in three sittings between 1545 and 1563 in the Italian city of Trent, which laid the foundations for the modern Roman Church

Councilors
The leading administrative officials of a territorial state; a professional group which increased its influence during the sixteenth century

Creed
A comprehensive summary of the fundamental tenets of Christian faith; the Augsburg Confession is based on early Christian creeds of the third and fourth centuries AD

Crossing, Intersection
The area where the nave and the transept of a church building intersect

Cuius Regio, Ejus Religio
"The religion of a territory is determined by that of its ruler" – the legal principle established by the Peace of Augsburg to determine the respective confessions of the Empire's many territories

Devotion
A meditative prayer

Devotional Image
A picture intended to focus devotion; in the pre-reformatory church, miracles would often be ascribed to such images

Diet
The irregularly convened assemblies of the estates of the Holy Roman Empire

Dispensation
A permission to deviate from general regulations of canonical law on an individual basis; often the privilege of papal authority

Disputation
A dispute conducted according to scientific principles and strict rules

Doctrine of the Two Realms, Two Kingdoms Doctrine
The distinction between the spiritual sphere of pure Christianity and the worldly sphere which is ruled by law and force; adapted by Luther from Augustine

Doctrine of the Three Orders
The hierarchy of the social orders in the early modern age; a division into the clergy, the nobility and the commoners (burghers and peasants) according to their respective functions

Doctrine of Justification
The insight, which Luther first derived from reading the epistles of Paul, that only faith in the promised grace of God ensures justification

Dogma, Dogmata
A binding doctrine on church matters set up by the Pope

Ecclesiology
The theological study of the Church

Ecumenical Christianity
A Greek word originally describing the entirety of populated earth; from the twentieth century on a collective term for all Christian denominations

Edict
A law proclaimed by the Emperor after approval by the imperial estates

Edict of Worms
An edict issued by Emperor Charles V at the close of the Diet of 1521 that placed Luther under an imperial ban; completely ignored by the Elector of Saxony

Eleutherius
Greek for the free or freed one, an academic appellation which Luther used in reference to his family name from 1517/18

Emperor
Head of the Empire, chosen by the Electors and crowned by the Pope

Enlightenment
An intellectual movement originating in eighteenth-century France that questioned the rationality of existing structures and perceptions

Enthusiasts
see left or radical wing of the Reformation

Epitaph
A memorial plaque for a deceased person, usually consisting of an inscription and an image

Ernestines
One of the lineages of the Saxon House of Wettin established in consequence of the dynastic split in 1485; held the electoral title until 1547

Eucharist
see Holy Communion, Eucharist, Host

Eucharistic Controversy
The controversy between Lutherans and Reformed Protestants on the question of the symbolic or real presence of Christ in the Eucharist

Evangelical
Self-appellation of the supporters of Luther and Calvin, denoting their adherence to a doctrine which closely followed the Gospel

Excommunication
The legal expulsion from the Church, pronounced by the Pope as a punishment that included the withdrawal of all rights and promises of salvation

Extreme Unction
The sacrament of compassion, administered to the dying in remembrance of the Passion of Christ; rejected by the Reformation as unfounded in Scripture

Famulus
A student, apprentice or assistant

Fiscal Officer
An executive officer of a medieval ruler or bishop

Floral Initial
The floral ornamentation of an enlarged initial letter in Gothic book illumination

Free Churches
Unlike official, state-controlled churches, these denominations evolved independently in the wake of the Reformation

German Christians
An association of German Protestants during the Third Reich (1933–45) that cooperated with the regime's official religious policy; opposed by the "Bekennende Kirche" or Confessing Church

German Peasants' War
A widespread and violent revolt of the German lower classes in 1525 that was crushed by the nobility; strongest in southern Germany and Thuringia

Gnesio-Lutherans
A derisive term for the opponents of Melanchthon's followers, who saw themselves as "true" Lutherans

Gospel
From Old English "godspel": good news; In Luther's view, this promise of God's grace and salvation contrasted with the Law of the Old Testament

Grace, Mercy
The unconditional love that God bears mankind in spite of its sins

Gravamina
Official complaints that the Empire lodged with the Curia during the fifteenth and sixteenth centuries; summarized by Luther in his treatise on the German nobility of 1520

Habit
The specific attire of religious orders

Hebrew Bible
A term for the first part of the Bible, the Old Testament

Heresy
A doctrine or belief contrary to the teachings of the church and the positions of authorities

Heretic
A teacher of heresies who deviates from the established order and doctrine

Hermeneutics
The theory and method of interpreting texts; in theology: the interpretation of Scripture by Luther

Holy Communion
see Holy Communion, Eucharist, Host

Holy Communion, Eucharist, Housel
A sacrament and the liturgical reenactment of the Last Supper of Jesus Christ; a frequent part of religious services; the Reformation emphasized its role in strengthening the bond of the congregation

Holy Mass, Mass
A term for the rite of the Eucharist used in Catholicism; derived from Latin *Ite, missa est*, the concluding words of the service

Holy Relics
A collection of relics; the sacred treasures of a church

Host, Bread
The wafer or bread consecrated during Mass; transformed into the body of Christ according to Catholic belief

Huguenots
A term used for French Protestants; subjected to persecution in France

Humanism
An educational movement originating in late-medieval Italy that attempted to revive the learning of antiquity; Erasmus of Rotterdam was one of its most important proponents

Hussites
Supporters of Jan Hus

Iconoclasm
The (spontaneous or organized) removal of devotional images and other ornaments from churches; a frequent occurrence in reformed areas

Idol
A man-made object of veneration; the term was often applied by Luther in criticism of excessive wealth

Imperial Ban
A proscription issued by the king or emperor in conjunction with the imperial courts of law and the electors which stripped the condemned of all rights and protection throughout the Holy Roman Empire

Imperial Chamber Court
The supreme court of law of the Holy Roman Empire

Imperial City, Free Imperial City
A city or town that was a direct subject of the Emperor; its representatives had the right to participate in imperial diets

Imperial Estates
The constituting political bodies of the Empire, made up of more than 300 church and lay princes, prelates, knightly orders, counts and lesser lords as well as the free imperial cities; all entitled to sit and vote in imperial diets

Indulgence
The remission of sins for the living and the deceased in exchange for pious works, prayer, or payment

Instruments of the Passion
The instruments with which Christ was tormented according to the story of the Passion

Interdict
The withholding of spiritual services and benefits as a punishment

Interim
A compromise between confessional parties on matters pending clarification by a council

Invocavit Sermons
Sermons held by Luther after his return from Wartburg Castle to quiet the situation in Wittenberg in March 1522

Justification by Works
Part of the Doctrine of Justification; the assertion that pious works will secure God's justification; rejected by Luther

Lay Chalice
The partaking of the wine by the lay members of the congregation; denied to them by the Roman Church since 1215; demanded by Hussites and the Reformation

Leaders/Captains of the League
The founders and official leaders of the Schmalkaldic League (1531–1547) (Landgrave Philip of Hesse and Elector John Frederick I of Saxony)

League of Gotha / League of Torgau
An alliance which was formed in 1526 to protect the Reformation in reaction to a compact made by Catholic princes in Dessau; the foremost members were Elector John of Saxony and Landgrave Philip of Hesse

Left or Radical Wing of the Reformation
A modern appellation for tendencies in the Reformation that were more radical than Luther and Calvin; mostly used to designate the Anabaptists

Leipzig Disputation
A theological dispute between Johannes Eck, Martin Luther and Andreas Karlstadt in 1519

Letter of Indulgence
A certificate confirming the acquisition of an indulgence

Liberal Arts
The seven Liberal Arts (Arithmetic, Geometry, Astronomy, Music, Grammar, Rhetoric, and Dialectic) have been viewed as the basis of intellectual education since antiquity

Liturgical Vestment
The attire worn by the clergy for services or Mass

Liturgy
Regulations governing the conduct of religious services

Luther's Rose
The signet used by Luther: A rose and cross enclosed by a golden ring; used from 1523 to mark his official printed publications

Luther's Eschatology
The doctrine and study of the final events occurring at the end of time; in Luther's view the return of Christ and the end of the world were imminent

Luther's Large/Small Catechism
A manual for children and preachers consisting of five principal sections (the Ten Commandments, the Creed, the Lord's Prayer, Baptism and Holy Communion)

Lutheran
Originally a derisive name given by the opponents of the Reformation to the followers of Luther, the term was adopted in a positive sense from 1530

Lutheran Protestantism
Churches which accept the Augsburg Confession as the basis of their teachings

Marburg Colloquy
An unsuccessful dispute on the question of the Eucharist held in 1529 between the Lutherans (Luther and Melanchthon) and the Swiss reformer Huldrych Zwingli

Mercenary Soldiers
A type of German paid soldier in the fifteenth and sixteenth centuries

Mining Rights, Regalia
The right to exploit mineral resources which formed a part of traditional royal or princely prerogatives

Modern Devotion
A religious movement of the fourteeth and fifteenth centuries that called for a renewal of Christian life through inward devotion and pious practices (such as caring for the sick and poor or teaching in schools)

Monk, Friar
A member of a spiritual fraternity dedicated by eternal vows to a life of poverty, austerity, chastity and obedience to the will of God

Monstrance
A precious ornamental vessel for displaying the Host; its use was abolished by the Reformation

Mysticism
The experience of the immediate presence of God; literature pertaining to this phenomenon

New Testament
The second part of the Bible which consists of the Four Gospels, the Acts of the Apostles, the Epistles and the Book of Revelation

Nodus, Knob
A knob ornamenting the stem of a chalice

Novitiate
A one-year period of preparation for new members of an order preceding the taking of vows

Nun
A female member of a religious order

Old Testament
see Hebrew Bible

Order
The subdivisions of monasticism which are mainly named after their founders and have different historical developments

Ordination
The appointment of a cleric to preach in a specified congregation; it replaced the ordination to priesthood

Ordination to Priesthood
A sacrament that, according to Roman tradition, can only be bestowed by a bishop to confer a new quality on a cleric; rejected by the Reformation and replaced by the ordination

Ottoman Empire
The territory controlled by the Ottoman dynasty (in Asia Minor, the Balkans, North Africa and the Crimea) from its capital in Constantinople

Pall
A linen cloth stiffened with cardboard for covering the Eucharist chalice

Pamphlet
A slim publication of between two and 16 pages, cheap and easy to publish, which dealt with current subjects; often sold by hawkers; a popular medium during the early Reformation era

Papal Brief
A papal edict less formal than a Bull

Papal Bull of Excommunication
The papal document that excommunicated Martin Luther in 1521

Papal Bull Threatening Excommunication
A formal document, issued by Pope Leo X in 1520, threatening Martin Luther with excommunication, publicly burned by him in response

Papal Church
A term used for the medieval Roman Church; employed by Luther to denounce his opponents

Pastor, Preacher
A church office introduced in the fifteenth century to increase the emphasis on preaching

Paten
The plate or bowl containing the Host during the Eucharist

Patriarch
The highest rank of bishop

Patrimonium Petri
The patrimony of Saint Peter; the possessions of the medieval Roman Church in central Italy, an alleged gift by Emperor Constantine

Peace of Augsburg
A law passed by the Imperial Diet of Augsburg in 1555 which conceded the free exercise of religion and the territorial integrity of the Lutheran estates

Penance and Reconciliation
A sacrament in the Roman Church that encompassed confession, absolution and reconciliation; rejected by Luther, who asked believers to change their way of living instead

Pericope
A selected Biblical text, intended for reading during sermons at a specific date in the liturgical year; a collection of such texts in a book

Philippists
Followers of Philipp Melanchthon; opponents of the Gnesio-Lutherans

Pietism
A movement striving for a renewal of Christianity, especially in the Lutheran Church of the seventeenth century, which was viewed as paralyzed by formal orthodoxy

Pilgrimage
The religious custom of visiting a site where relics or saints' burials are displayed; rejected by the Reformation

Pinnacle, Finial
Miniature spires in gothic architecture

"Posting of the Theses"
Martin Luther's public posting of ninety-five theses against the sale of indulgences on October 31, 1517; it remains a matter of debate whether the nailing on the door of the Wittenberg Castle Church actually occurred

Predestination
The doctrine that the fate of every human has been determined by God; in contrast to Calvin, Luther did not accept a predestination to damnation

Prelate
A cleric holding a leading position in the church (bishop, abbot, cardinal)

Priesthood of All Believers
A concept based on the principle of congregational churches which states that the faithful can perform the services of pastor and preacher on a reciprocal basis

(Prince) Elector
Noble rank entitling the holder to participate in the election of a new Emperor

Promise of Salvation
According to Luther's perception, God's promise of salvation in Christ is the foundation of Christian faith

Prophet
In the Old Testament, a bearer of God's revelations; in Christian tradition the last prophet is John the Baptist; Luther's adherents saw him as a prophet

Protestants
An appellation for the supporters of the Reformation used since the Imperial Diet of Speyer in 1529

Protestation at Speyer, Protest at Speyer
In 1529, a reformed minority group of the imperial estates protested against the majority, contesting the legitimacy of majority votes in matters of belief

Purgatory
An intermediate state between Paradise and Hell where the deceased undergo purification; rejected by Luther as unfounded in Scripture

Real Presence
Luther's doctrine of the actual presence of the body and blood of Christ in, with and under the elements of the Eucharist

Reformatio
Latin: a renewal or improvement; in the Middle Ages, this pertained mostly to institutions of the Church

Reformed Protestantism
The self-appellation of the followers of Zwingli and Calvin

Relics
Material remains associated with saints or objects which had somehow become the focus of religious devotion

Religious Dispute
see disputation

Retable, Reredos
A framing structure raised behind and above an altar; versions with two or more opening wings are called a "winged retable"

Revelation
The manifestation of God in Jesus Christ; for Luther, this was indissolubly connected to Scripture

Right to Resist
Luther originally held that any resistance to authority was forbidden according to Romans 13, but in 1530, he was convinced by Saxon jurists that the Protestant princes' military opposition to the Emperor was permissible

Roman Curia
The governing and administrative offices of the Holy See

Sacrament
A Christian rite for realizing the actual presence of God; in Luther's view, these had to be a combination of divine institution and a physical component; as penance did not fit this definition, it was rejected; eventually, the Reformation retained only two sacraments, the Eucharist and Baptism

Saiger Process
The separation of elements in a molten mass; part of the process of producing metals

Schism
The separation of a group from a church for non-doctrinal reasons

Schmalkaldic War
The war which erupted in 1546/47 between the Schmalkaldic League and the Emperor; it resulted in the strengthening of the imperial position against the Protestant princes and cities

Schmalkaldic Articles
A confessional treatise penned by Luther to serve as the theological basis of the Schmalkaldic League

Schmalkaldic League
The defensive association of the Protestant princes and cities which was concluded in 1531 in the town of Schmalkalden; defeated by the Emperor in 1546/47

Scholar
A student at a medieval college or university

Scholasticism
The strictly regulated medieval educational framework which placed great emphasis on the authority of texts and teachers

Scroll
A length of paper or parchment rolled up for storage

Seat of Mercy, Mercy Seat
A particular motif in sculpture and painting depicting the Trinity; God the Father holding a crucifix above which the dove of the Holy Spirit soars

Sede Vacante, Vacancy
The vacancy of the position (or seat) of a bishop, Pope or ruler

Sermon
A public lecture (in the vernacular) expounding a topic from the Bible; the principal part of any Protestant service

Social Orders
see Doctrine of the Three Orders

Sola Fide / Sola Gratia / Sola Scriptura / Solus Christus
The basic principles of the Protestant faith summarized in Latin phrases: by faith alone / by grace alone / by Scripture alone / through Christ alone

Staple Right
The obligation of merchants in transit to offer their goods for sale at specified locations

Superintendent
A Lutheran church office that replaced the former functions of bishops; as Lutheran rulers were also the head of the church in their domains, superintendents would be subordinate to them

Table Talks
Luther's companions had made notes of the table talks of the Reformer after his death; these were published in 1566 by Anton Lauterbach

Taborites
A group of radical Hussites named after the Bohemian town of Tabor

Territorial Lord
The ruler of a defined territory

Third Reich
The period of National Socialist rule in Germany (1933–45)

Transubstantiation
A Roman Catholic doctrine – the transformation of the substance of the Eucharist into the body and blood of Christ while retaining its outward properties, adopted by the Fourth Lateran Council in 1215; this view was rejected by the Reformers

Treaty of Prague
This treaty was concluded on October 14, 1546 between Emperor Charles V and Duke Maurice of Saxony; the latter promising the Emperor military support in return for the electoral dignity of Saxony and substantial parts of the Ernestine lands

Trefoil/Quatrefoil
An architectural ornament composed of intersecting circles; used in late Romanesque and Gothic windows and arches

Tridentine
Another name for the Council of Trent; often used to designate the resolutions which were passed by this assembly

Trinity
The consubstantial nature of God consisting of the Father, the Son and the Holy Spirit

Truce
A temporary agreement to maintain peace and settle conflicts

Turk Tax
A special tax raised in the Empire to finance defensive measures against the Turkish threat

Universal Monarch
A term used in Habsburg propaganda to describe the position of Charles V as the supreme ruler of the world, defender of Christianity and fount of law and justice

Universal Priesthood
see Priesthood of All Believers

Utraquists
A moderate faction of the Hussites who bore the lay chalice as their emblem; in the eyes of the Roman Church they were merely schismatic, not heretic

Vatican
The possessions of the Pope in Rome, to which were attached diverse territories in Italy (the Patrimonium Petri)

Vicar
A cleric who substitutes for a priest in diverse functions

Visitation
Latin: a visit; the formalized inspection of the conditions in a congregation; the practice was intensified by the Reformers after 1528

Vulgate Bible
Latin: widespread, common; the Latin version of the Bible which was derived from the Hebrew and Greek originals; the foundation of Roman Catholic doctrine

Waldensians
A heretical movement founded by the merchant Peter Waldo in the twelfth century that allied itself with the Hussites and strove to join the Reformation

Wettins, House of Wettin
The ruling dynasty of Saxony

Zwickau Prophets
During Luther's absence from Wittenberg in 1521, three craftsmen from Zwickau appeared and claimed to be the bearers of a special revelation

Index of Persons

A

Adolph II of Anhalt-Köthen (1458–1526), Bishop of Merseburg, opponent of Martin Luther

Agricola, Georgius (1494–1555), Polymath

Agricola, Rodolphus (1490–1521), Humanist

Agricola, Johannes (1494–1566), Student and friend of Luther, later his opponent

Albert III, called the Bold (1443–1500), Margrave of Meissen, Duke of Saxony, founder of the Albertine line of the House of Wettin

Albert [Albrecht] of Brandenburg (1490–1545), 1514: Archbishop of Mainz and Magdeburg, 1518: Cardinal, as a promoter of the sale of indulgences and the highest-ranking clerical office holder of the Holy Roman Empire, one of Martin Luther's leading opponents

Aldegrever, Heinrich (actually Hinrik Trippenmäker) (1502–between 1555 and 1561), Engraver, goldsmith, painter

Aleander, Girolamo (1480–1542), Papal Nuncio, Cardinal

Amsdorf, Nikolaus von (1483–1565), Reformer, first Lutheran Bishop of Naumburg (1542–1546)

Anne, Saint, mother of Mary

Anna Maria of Palatine Neuburg (1575–1643), Countess Palatine of Neuburg, Duchess of Saxe-Weimar

Anshelm, Thomas (around 1465–1523), Woodblock cutter and printer in Strasbourg, Pforzheim, Tübingen and Hagenau

Aprell, Peter (16th century), Augsburg paper and parchment supplier

Aquila (actually Adler), Johann Caspar (1488–1560), First Lutheran Superintendent in Saalfeld

Aquinas, Thomas (1225–1274), Dominican monk, philosopher, theologian, Doctor of the Church

Aristotle (384–322), Greek philosopher

Arnoldi, Bartholomäus (1465–1532), Theologian, philosopher, academic instructor and later opponent of Martin Luther

Athanasius (295–373), Saint, Patriarch of Alexandria, Doctor of the Church

Augustus (1526–1586), Elector of Saxony, from the Albertine line of the House of Wettin

Augustine (354–430), Saint, Bishop of Hippo, Church Father, philosopher

Aurach, Martha von (16th century), Wife of Johann Eberlin von Günzburg

B

Barbara, Saint, martyr

Barth, Karl (1886–1968), Reformed theologian

Baumgartner, Hieronymus (1498–1565), Mayor and church administrator of Nuremberg, originally slated to marry Katharina von Bora

Beck, Reinhard the Elder (died 1522), Strasbourg printer

Beham, Barthel (around 1502–1540), Woodblock cutter, engraver and painter in Nuremberg and Munich

Beham, (Hans) Sebald (around 1500–1550), Woodblock cutter, printmaker and painter in Nuremberg and Frankfurt a. M.

Bellarmine, Robert (1542–1621), Jesuit, Cardinal

Beringer, Jakob (16th century), Vicar at Speyer Cathedral, composer of a gospel harmony

Berlichingen, Götz von (around 1480–1562), Franconian knight

Bock, Franz (1823–1899), Curator of the Art Museum of the Archdiocese of Cologne

Boltzius, Johann Martin (1703–1765), Pietist pastor for the community of Ebenezer in Georgia

Bomberg, Daniel (1470/80–1549), Flemish printer, publisher of Hebrew writings

Bonhoeffer, Dietrich (1906–1945), Lutheran theologian, member of the Confessing Church

Bora, Katharina von (1499–1552), Came from Saxon rural nobility, nun. Following her escape from the Marienthron Cistercian abbey in Nimbschen (1523), she married Martin Luther (1525) and lived with him in the former Augustinian monastery in Wittenberg. She bore Luther six children (Johannes, 1526–1575, Elizabeth, 1527–1528, Magdalena, 1529–1542, Martin, 1531–1565, Paul 1533–1593, and Margarete, 1534–1570). Her successful management of the household played a major role in securing the family's livelihood. Katharina von Bora died from injuries she suffered in a road accident near Torgau while fleeing the plague. Her grave is located in Marienkirche (St. Mary's Church) in Torgau.

Brant, Sebastian (1457/58–1521), Lawyer, syndic and chancellor of Strasbourg

Breslauer, Martin, (1871–1940), Antiquarian bookseller

Brosamer, Hans (1495–1554), Painter, engraver, woodblock cutter

Bruegel (Brueghel) (around 1525–1569), Pieter the Elder, Flemish painter

Bugenhagen (also Pomeranus), Johannes (1485–1558), Reformer, pastor of City Church in Wittenberg (starting 1523), superintendent of the Saxon electoral district, founder of the Lutheran Church in Northern Germany and Denmark, Martin Luther's companion, friend and confessor. Bugenhagen officiated at his marriage to Katharina von Bora, baptized their children and gave Luther's funeral sermon.

Burgkmair, Hans the Elder (1473–1531), Painter, printmaker and woodblock cutter in Augsburg

C

Caelius, Michael (1492–1559), Mansfeld court chaplain, reformer

Cajetan, Thomas (1469–1534), Dominican monk, Cardinal

Calvin, John (1509–1564), Swiss reformer of French descent, theologically influenced by Luther, Melanchthon, Zwingli and Bucer. Calvin advocated a doctrine of predestination under which God bestows His grace upon some chosen people, while others are predestined to damnation. Calvin accepted only two sacraments as valid: baptism and the Eucharist, which he saw as a powerful symbol of Christ's presence through the Holy Spirit (spiritual presence). Calvin drafted a strict ecclesiastical ordinance for the city of Geneva.

Camerarius (actually Kammermeister), Joachim the Elder (1500–1574), Humanist, polymath, poet

Camerarius (actually Kammermeister), Joachim the Younger (1534–1598), Physician, botanist, natural scientist

Capito (actually Köpfel), Wolfgang (1478–1541), Theologian, reformer in Strasbourg

Carpzov, A family of Saxon scholars

Celtis, Conrad (1459–1508), Humanist scholar, poet

Charles V (1500–1558), of the House of Habsburg, was King Charles I of Spain from 1516 on. Was elected King of the Romans in 1519 as Charles V and was crowned Emperor in 1530 by Pope Clemens VII in Bologna. In 1556, he abdicated the Spanish crown in favor of his son Philip II and the imperial crown in favor of his brother Ferdinand I. He considered himself to be the protector of the western lands from the Ottoman Turks and as defender of the Roman Catholic faith. On May 8, 1521, Charles issued the *Edict of Worms*, which imposed the imperial ban on Luther and prohibited his writings. In the Battle of Mühlberg (1547), his army defeated the Schmalkaldic League. Charles V decreed the Augsburg Interim in 1548 in order to achieve his religious policy

objectives, but it fell through. Despite his concerns, the Peace of Augsburg was concluded on September 25, 1555, which recognized the Lutheran confession.

Charles Victor (1525–1553), Son of Duke Henry II of Braunschweig-Wolfenbüttel, fell in the Battle of Sievershausen

Chelidonius, Benedictus (1460–1521), Benedictine monk, Abbot of the Scottish Monastery in Vienna, humanist, poet

Christian I, Elector of Saxony (1560–1591)

Christopher, Patron saint of travellers, Holy Helper

Clemens VI (1291–1352), Pope

Clemens VII (1478–1534), Pope

Cochlaeus (actually Dobeneck), Johannes (1479–1552), Humanist, theologian, opponent of Luther

Conradin (1252–1268), Duke of Swabia, King of Sicily, last legitimate male heir of the Hohenstaufen dynasty

Cranach, Lucas the Elder (1472–1553), Painter and graphic artist, as of 1505: court painter to the Elector of Saxony, council member (1519–1549) and mayor of Wittenberg (elected 1537, 1540, 1543). There, he managed a large painting workshop and owned several properties, a pharmacy and a print shop. Cranach was a witness at Martin Luther's wedding to Katharina von Bora. Luther was the godfather of Cranach's youngest daughter Anna. Cranach's numerous portraits of reformers and of his employers shape our perception of key Reformation figures to this day.

Cranach, Lucas the Younger (1515–1586), Painter, second son of Lucas Cranach the Elder. After the death of his older brother Hans (1537), he took on a leading role in his father's workshop, which he managed starting in 1550.

Cruziger, Caspar the Elder (1504–1548), Reformer, Rector of the University of Wittenberg

D

Dante Alighieri (1265–1321), Italian poet

Dell, Peter the Elder (around 1490–1552), Sculptor

Dietrich, Hieronymus (died after 1550), Medalist

Dinteville, Jean de (1504–1555), French diplomat

Diocletian (between 236 and 245–312), Roman Emperor

Dorothy of Caesarea, Saint, virgin and martyr, Holy Helper

Dorothea Sophia of Saxe-Altenburg (1587–1645), Princess-Abess of Quedlinburg Abbey

Dryander, Johannes (1500–1560), Anatomist, mathematician, astronomer

Dürer, Albrecht (1471–1528), Painter, printmaker

E

Eberlin von Günzburg, Johann (1465–1533), Franciscan, reformer

Eck (actually Mayer), Johannes (1486–1543), Theologian, opponent of Luther

Elisabeth von Rochlitz, (1502–1557), Duchess of Saxony

Elizabeth, (1207–1231), Saint, Landgravine of Thuringia

Emser, Hieronymus (1478–1527), Theologian, secretary to Duke George of Saxony

Erasmus of Rotterdam, (1466–1536), Humanist and philologist

Erfurth, P. B. (active around 1694), Silversmith

Ernest (1441–1486), Elector of Saxony, Founder of the Ernestine line of the House of Wettin

Ernest I, called "the Pious," (1601–1675), Duke of Saxe-Gotha-Altenburg

Ernest II of Saxony (1464–1513), Archbishop of Magdeburg and Administrator of the Bishopric of Halberstadt

Ernest II (1745–1804), Duke of Saxe-Gotha-Altenburg

Esschen, Johannes van (died 1523), Augustinian monk in Antwerp, first martyr of the Reformation

F

Ferdinand I (1503–1564), Emperor, King of the Romans, Archduke of Austria, King of Bohemia, Croatia and Hungary

Firmian, Leopold Anton von (1679–1744), Archbishop of Salzburg

Fisher, Albert Franklin (1908–1960), African-American pastor, classmate of Dietrich Bonhoeffer at Union Theological Seminary in New York

Flacius "Illyrius" (actually Matija Vlačić), Matthias (1520–1575), Lutheran theologian

Flötner, Peter (around 1485–1546), Sculptor, gold- and sliversmith, graphic artist, medalist, architect

Francke, August Hermann (1663–1727), Pietist theologian, pedagogue, founder of the Francke Foundations in Halle

Francke, Gotthilf August (1696–1769), Pietist theologian, pedagogue, director of the Francke Foundations

Francis I (1494–1547), King of France

Frederick II, called "the Gentle" (1412–1464), Elector of Saxony

Frederick II (1676–1732), Duke of Saxe-Gotha-Altenburg

Frederick III, called "the Wise" (1463–1525), Elector of Saxony (as of 1486), Arch-Marshal and Governor of the Holy Roman Empire, patron of Martin Luther. Frederick the Wise ruled together with his younger brother, John the Constant. He founded the University of Wittenberg in 1502. After the death of Emperor Maximilian I In 1519, he waived his candidacy for the throne and instead supported Charles I of Spain, who received the imperial crown as Emperor Charles V; afforded Luther safe conduct to the Diet of Worms in 1521 and allowed him to stay under his protection at Wartburg Castle after the ban imposed by the Edict of Worms.

Frederick Augustus I, called "the Strong" (1670–1733), Elector of Saxony

Frederick Casimir (1591–1658), Count of Ortenburg

Frederick William I (1562–1602), Duke of Saxe-Weimar

Froben, Johann (1460–1527), Book printer, publisher

Füllmaurer, Heinrich (around 1505–1546), Painter

Fugger, Ulrich the Younger (1490–1525), Augsburg merchant

G

Gastel, Jörg (active around 1523–1525 in Zwickau), Printer

Gebel, Matthes (around 1500–1574), Medalist, woodcutter

George, Saint, dragon slayer, martyr, Holy Helper

George, called "the Bearded" (1471–1539), Duke of Saxony

George III, Prince of Anhalt-Plötzkau (1507–1553), Priest, reformer

George IV (1573–1627), Count of Ortenburg

Gerhard, Leonhard (active around 1572), Letter painter in Magdeburg

Gerung, Matthias (1500–1570), Painter, illuminator and woodblock cutter in Nördlingen and Lauingen

Ghinucci, Girolamo (1480–1541), Cardinal, *Auditor Camerae*, Nuncio in England

Giebelstadt, Florian Geyer von (around 1490–1525), Franconian knight, diplomat

Gregory XIII (1502–1585), Pope

Gregory I, the Great (540–604), Pope, Church Father, Saint

Gronau, Israel Christian (1714–1745), Pietist pastor in Georgia

Grumbach, Argula von (around 1492–1568), Reformation author

Guldenmund, Hans (active 1518–1560), Printer, letter painter in Nuremberg

Gustavus II Adolphus (1594–1632), King of Sweden

Gutenberg, Johann (1400–1468), Inventor of printing with movable type

Gutknecht, Jobst (active 1514–1542), Printer and publisher in Nuremberg

Güttel, Caspar (1471–1542), Augustinian Hermit, reformer

H

Hagenauer, Friedrich (around 1500–after 1546), Medalist

Hamer, Stefan (active 1516–1554), Letter painter and printer in Nuremberg

Henry II (1489–1568), Fürst von Braunschweig-Wolfenbüttel, Duke of Braunschweig-Lüneburg

Henry II of Reuss, called "the Posthumous" (1572–1635), Lord of Gera, Lord of Lobenstein and Lord of Ober-Kranichfeld

Henry IV, called "the Pious" (1473–1541), Duke of Saxony

Henry VII (1556–1603), Count of Ortenburg

Henry VIII (1491–1547), King of England

Helmschmied, Desiderius (1513–1579), Court armorer to Charles V

Heshusen, Tileman (1527–1588), Lutheran theologian

Hieronymus, Sophronius Eusebius [Jerome] (347–420), Saint, Church Father

Hirschvogel, Augustin (1503–1553), Artist, geometrician, cartographer

Hitler, Adolf (1889–1945), Dictator of the German Reich

Holbein, Hans the Younger (1497/98–1543), Painter

Höltzel, Hieronymus (documented around 1500–1532), Printer in Nuremberg

Hopfer, Daniel (around 1470–1536), Woodblock cutter, etcher, armor etcher, painter in Augsburg

Hoyer VI (1482–1540), Count of Mansfeld

Hus, Jan (1369–1415), Bohemian reformer

Hutten, Ulrich von (1488–1523), Humanist, poet, knight

J

James the Greater, Apostle

Joachim I (1509–1561), Prince of Anhalt-Dessau

Joachim (1530–1600), Count of Ortenburg

John I, the Steadfast (or Constant, 1468–1532), Elector of Saxony (as of 1525). He consolidated the Reformation in the Electorate of Saxony and, in 1529, was among the princes representing the Protestant minority at the Diet of Speyer (the Protestation), calling upon the Wittenberg theologians Martin Luther, Johannes Bugenhagen, Justus Jonas and Philip Melanchthon to draft the *Torgau Articles*, which in turn served as the basis for the *Augsburg Confession*. Together with Landgrave Philip of Hesse, was the leader of the *Schmalkaldic League,* which was formed in 1531.

John IV (1504–1551), Prince of Anhalt-Zerbst

John Frederick I, the Magnanimous (1503–1554), Last Ernestine Elector of Saxony (1532–1547). A decisive supporter of the Reformation; in 1547, John Frederick I and Landgrave Philip of Hesse led the army of the Schmalkaldic League against the Emperor's forces at the Battle of Mühlberg. The military defeat in this battle resulted in his being taken prisoner, the loss of large sections of his territory and his removal as Elector. When he was released from captivity in 1552, as a Duke, he moved his residence to Weimar.

John Frederick II the Middle One (1529–1595) was a prince from the Ernestine line of the House of Wettin. He held the title of Duke of Saxony.

Joanna I of Castille, called "the Mad" (1479–1555), Infanta of Aragón, Castille and León

Jonas, Justus (1493–1555), Theologian, Reformation figure, humanist

Julius II (1443–1513), Pope

K

Kachelofen, Konrad (1450–1529), Leipzig book printer, publisher

Kant, Immanuel (1724–1804), German Enlightenment philosopher

Karlstadt (actually Bodenstein), Andreas Rudolf (1486–1541), Reformer, Dean of the University of Wittenberg, leading figure of the Wittenberg Reformation during Luther's stay at Wartburg Castle

Kempff, Pancratius (active 1533–1570), Woodblock cutter, letter painter and printer in Nuremberg and Magdeburg (starting about 1550)

Kerkener, Johann (around 1480–1541), Dean of the Wernigerode monastery

T

Tauler, Johann (1300–1361), Dominican monk, mystic

Tetzel, Johannes (1465–1519), Indulgence preacher. Studied theology in Leipzig and entered the Dominican monastery there in 1489. In 1504, Tetzel began his work selling indulgences, at first for the Teutonic Knights. In 1516, he was named sub-commissioner by the Bishopric of Meissen for the sale of indulgences for the reconstruction of St. Peter's Basilica in Rome. Starting in 1517, Tetzel was engaged in the sale of indulgences in the Bishoprics of Halberstadt and Magdeburg at the behest of the Archbishop of Mainz, Albert of Brandenburg. His unscrupulous methods induced Luther to publish his 95 Theses against the sale of indulgences. Tetzel died of the plague in 1519 in Leipzig.

Thanner, Jakob (1448–1528/29), Book printer, bookseller

Thomas Aquinas (1225–1274), Saint, Dominican monk, scholastic

Treutlen, Johann Adam (1733–1782), First Governor of Georgia

Trotha, Thilo von (1443–1514), Bishop of Merseburg

Trutfetter, Jodocus (1460–1519), Theologian, rhetorician, philosopher, academic instructor of Martin Luther

U

Ulrich, Abraham (1526–1577), Superintendent General in Zeitz

Ulrich, David (1561–1626), Notary at the Imperial Chamber Court in Speyer

Untzer, Peter (17th century), Leader of St. Mary's Church (Marienkirche) in Halle

Urlsperger, Samuel (1685–1772), Lutheran theologian, Pietist

Ursentaler, Ulrich the Elder (1482–1562), Medalist

V

Leyden, Lucas van (1494–1533), Flemish painter and engraver

Vesalius, Andreas (1514–1564), Anatomist, personal physician of Charles V and Philip II

Vischer, Hans (1489–1550), Nuremberg sculptor

Voes, Hendrik (died 1523), Augustinian monk in Antwerp

W

Weiditz, Hans the Younger (active before 1500–around 1536), Painter, printmaker and engraver in Augsburg and Strasbourg

Weischner, Lukas (1550/55–1609), Bookbinder, librarian

Welcz, Concz (active around 1532–1551), Medalist

Werder, Lorenz (documented in the 1510s), Goldsmith, medalist

Whitefield, George (1714–1770), Priest, co-founder of Methodism

Widukind (died 807), Leader of the Saxons

Wilhelm II (1859–1941), the last German Kaiser (Emperor), King of Prussia

William of Ockham (1288–1347), Philosopher, late scholastic theologian

Wimpina, Konrad (1460–1531), Humanist, Roman Catholic theologian, founding rector of the University of Frankfurt (Oder)

Wolgemut, Michael (1434–1519), Painter and printmaker in Nuremberg

Z

Zwingli, Huldrych (1484–1531), Zurich reformer. Ordained a priest in 1506, Zwingli became pastor of the Grossmünster (Great Minster) Church in Zurich in 1519. In 1522, he published the first of his reformation writings, attacking the custom of fasting. At Zwingli's behest, the Zurich City Council revised school, church and marriage regulations and enacted laws to uphold public morals. Church icons were abolished, along with masses and priestly celibacy. In 1525, Zwingli published his confessional statement, Commentary on True and False Religion. Working together with Leo Jud, he translated the Bible into Swiss German between 1524 and 1529 (the Zürich Bible). On October 1–4, 1529, the Marburg Colloquy was held at the invitation of Landgrave Philip of Hesse, in which Zwingli and Luther took part. However, no agreement was reached as to the biblical foundations of the Eucharist. In 1531, Zwingli was taken prisoner and killed in the Second Kappel War.

Abbreviations

adap.	adapter
cat.	catalogue number
D	diameter
edn.	edition
ed(s).	editor(s)
fig.	figure
H	height
ill.	illustration
L	length
LW	Luther's Works
n. s.	new series
p(p).	page(s)
rev. ed.	revised edition
sec.	section
vol(s).	volume(s)
W	width
WA	Ausgabe (Weimar edition of Luther's works)
WA.B	Weimarer Ausgabe, Briefwechsel (correspondence)
WA.DB	Weimarer Ausgabe, Deutsche Bibel (German Bible)
WA.TR	Weimarer Ausgabe, Tischreden (Table Talks)

Illustration credits

Catalogue numbers

Atlanta, GA, Pitts Theology Library,
Emory University, Atlanta
121, 160, 341

Basel, HMB – Historisches Museum Basel
271

Berger, Daniel
302

Berlin, Stiftung Deutsches Historisches Museum
(Photos: Sebastian Ahlers, Indra Desnica,
Arne Psille)
27, 38, 43, 44, 52, 165, 167, 168, 177, 229, 230,
307, 315, 328, 330–337, 346, 374, 380, 397,
398, 407

Braunschweig,
Städtisches Museum Braunschweig
125

Coburg, Kunstsammlungen der Veste Coburg
32, 82, 203, 204

Dessau, Landesarchiv in Sachsen-Anhalt
153, 173, 222

Kulturstiftung DessauWörlitz FG
189 KsDW, Bildarchiv, Heinz Fräßdorf

Eisenach, Wartburg-Stiftung Eisenach
7, 72, 386

Erfurt, Evangelische Andreasgemeinde
Erfurt
384 (Photo: B. Clasens)

Gotha, Forschungsbibliothek Gotha
der Universität Erfurt
129, 144, 147, 148, 163, 180, 210, 212,
304, 377, 401

Gotha, Foundation Schloss Friedenstein Gotha
Ebhardt, Lutz: 45, 50, 51, 54, 55, 56, 77, 98, 103,
185, 227, 228, 351, 352, 358, 360, 378, 379,
Fuchs, Thomas: 102, 156, 282, 356,
Tan, Sergey: 12, 21, 26, 46, 49, 231, 232, 317,
323, 324, 338, 343, 349, 350

Gotha, Thüringisches Staatsarchiv Gotha
37

Halle (Saale), State Office for Heritage
Management and Archaeology Saxony-Anhalt –
State Museum of Prehistory
Lipták, Juraj: 2–6, 9–11, 13–19, 24, 25, 31,
33–36, 39–42, 53, 73, 75, 76, 78–80, 83–91,
93–95, 97, 99–101, 104, 106, 107, 124, 127, 128,
131, 132, 134, 136, 137, 139, 140, 142, 143, 158,
162, 171, 174, 178, 181–183, 186–188, 191–196,
205, 207, 209, 213, 214a and b, 215, 216 a and
b, 234–256, 258–269, 272–284, 286, 292,
298–301, 308–311, 325–327, 344 a and b,
347, 348, 355, 357, 359, 365, 366, 370, 372, 373,
376, 381, 387, 388, 390–394, 396, 399, 400,
402–405
Keil, Vera: 141
Ritchie, Marc: 295

Halle (Saale), Martin-Luther-Universität Halle-
Wittenberg, Universitäts- und Landesbibliothek
Sachsen-Anhalt, Halle (Saale)
149

Halle (Saale), Zentrale Kustodie, Martin-Luther-
Universität Halle-Wittenberg
138

Jena, Evangelisch-Lutherische Kirchgemeinde
Jena
385

Landesarchiv Sachsen, Archiv
1, 150, 172, 211, 221, 319, 362

Lutherstadt Eisleben, Städtische Sammlungen
22, 23

Lutherstadt Wittenberg,
Wittenberg Seminary
159, 199

Lutherstadt Wittenberg, Fotostudio Kirsch
395

Lutherstadt Wittenberg,
Städtische Sammlungen
219

Lutherstadt Wittenberg,
Luther Memorials Foundation of Saxony-Anhalt
20, 47, 58–70, 92, 120, 123, 126, 133, 146, 151,
152, 154, 164, 166, 169, 179, 184, 190, 198,
201, 202, 218, 220, 224–226, 288–290, 293,
294, 297, 303, 306, 312, 313, 316, 318, 320, 321,
329, 340, 342, 361, 363, 364, 367–369, 375,
382, 383, 389

Magdeburg,
Kulturhistorisches Museum Magdeburg
74 (Photo: akg-images)

Marburg, Bildarchiv Foto Marburg
371 (Photo: Uwe Gaasch)

Additional illustrations

The Exhibition Project "Here I Stand"

Luther Exhibitions USA 2016

A cooperation of the State Museum of Prehistory, Halle (leading institution), the Luther Memorials Foundation of Saxony-Anhalt, the Deutsches Historisches Museum and the Foundation Schloss Friedenstein Gotha

with the Minneapolis Institute of Art, The Morgan Library & Museum, New York, and the Pitts Theology Library of the Candler School of Theology at Emory University, Atlanta

with the support of the Foreign Office of the Federal Republic of Germany

 Federal Foreign Office

 Landesamt für Denkmalpflege und Archäologie Sachsen-Anhalt LANDESMUSEUM FÜR VORGESCHICHTE

 STIFTUNG Luthergedenkstätten IN SACHSEN-ANHALT

 DEUTSCHES HISTORISCHES MUSEUM

 Stiftung Schloss Friedenstein Gotha

Mia Minneapolis Institute of Art

The Morgan Library & Museum

 EMORY CANDLER SCHOOL OF THEOLOGY

General Director
Harald Meller
(State Office for Heritage Management and Archaeology Saxony-Anhalt – State Museum of Prehistory)

Project Steering Committee
Martin Eberle
(Foundation Schloss Friedenstein Gotha),
Ulrike Kretzschmar
(Stiftung Deutsches Historisches Museum),
Stefan Rhein
(Luther Memorials Foundation of Saxony-Anhalt)

Project Management
Tomoko Elisabeth Emmerling
(State Office for Heritage Management and Archaeology Saxony-Anhalt – State Museum of Prehistory)

Project Team
Ingrid Dettmann, Johanna Furgber, Konstanze Geppert, Katrin Herbst, Susanne Kimmig-Völkner, Robert Kluth, Ralf Kluttig-Altmann, Franziska Kuschel, Lea McLaughlin, Louis D. Nebelsick, Robert Noack, Anne-Simone Rous, Julius Roch, Stefanie Wachsmann
(State Office for Heritage Management and Archaeology Saxony-Anhalt – State Museum of Prehistory)

Academic Advisory Board
Mirko Gutjahr
(Luther Memorials Foundation of Saxony-Anhalt)
Louis D. Nebelsick
(State Office for Heritage Management and Archaeology Saxony-Anhalt – State Museum of Prehistory),
Martin Treu
(Lutherstadt Wittenberg),
Timo Trümper
(Foundation Schloss Friedenstein Gotha)

Public Relations
Tomoko Elisabeth Emmerling, Julia Kruse, Norma Literski-Henkel, Alfred Reichenberger
(State Office for Heritage Management and Archaeology Saxony-Anhalt – State Museum of Prehistory),
Marco Karthe, Carola Schüren
(Foundation Schloss Friedenstein Gotha),
Florian Trott
(Luther Memorials Foundation of Saxony-Anhalt),
Boris Nitzsche, Barbara Wolf
(Stiftung Deutsches Historisches Museum)

Design of Promotional Media
Klaus Pockrandt (Halle [Saale]), Brigitte Parsche
(State Office for Heritage Management and Archaeology Saxony-Anhalt – State Museum of Prehistory)

Exhibitions

"Martin Luther: Art and the Reformation",
Minneapolis Institute of Art,
October 30, 2016 through January 15, 2017

**"Word and Image:
Martin Luther's Reformation",**
The Morgan Library & Museum,
New York,
October 7, 2016 through January 22, 2017

**"Law and Grace: Martin Luther,
Lucas Cranach, and the Promise of Salvation",**
Pitts Theology Library of the Candler School
of Theology at Emory University, Atlanta,
October 11, 2016 through January 16, 2017

Exhibition Team Minneapolis
Kaywin Feldman, Duncan and
Nivin MacMillan Director and President

Matthew Welch,
Deputy Director and Chief Curator

Thomas E. Rassieur, John E. Andrus III
Curator of Prints and Drawings and Curator
of the exhibition *Martin Luther: Art and
the Reformation*

Jennifer Starbright,
Associate Registrar for Exhibitions

Rayna Fox, Executive Assistant to
the Deputy Director and Chief Curator

Jennifer Komar Olivarez,
Head of Exhibition Planning and Strategy,
Interim Department Head, Decorative Arts,
Textiles, and Sculpture

Michael Lapthorn, Exhibition Designer

Karleen Gardner, Director of Learning
Innovation

Kristin Prestegaard, Chief Engagement Officer

Alex Bortolot, Content Strategist

Aubrey Mozer, Corporate Relations Manager

Eric Bruce, Head of Visitor Experience

Juline Chevalier, Head of Interpretation and
Participatory Experiences

Michael Dust, Head of Interactive Media
and Senior Producer

Mary Mortensen, Senior Advancement
Executive

Eric Helmin, Graphic Designer/Digital Brand
Integration

Tammy Pleshek, Press & Public Relations
Specialist

Exhibition Team New York
Colin B. Bailey, Director;
the project was initiated in 2013 under
director William Griswold and continued
under Peggy Fogelman, Acting Director

John Bidwell, Astor Curator of Printed Books
and Bindings and Curatorial Chair

John T. McQuillen, Assistant Curator of Printed
Books and Bindings and curator of *Word and
Image: Martin Luther's Reformation*

John D. Alexander, Senior Manager of
Exhibition and Collection Administration,
and his colleagues, including Alex Confer,
Paula Pineda, Lindsey Stavros, and
Sophie Worley

Frank Trujillo, Associate Book Conservator,
Lindsay Tyne, Assistant Paper Conservator,
and James Donchez, Art Preparator

Marilyn Palmeri, Imaging and Rights Manager,
with Eva Soos and Graham Haber, Photographer

Patricia Emerson, Senior Editor

John Marciari, Charles W. Engelhard
Curator of Drawings and Prints, and
Jennifer Tonkovich, Eugene and Claire Thaw
Curator of Drawings and Prints

Patrick Milliman, Director of Communications
and Marketing, with Michelle Perlin und
Moriah Shtull

Linden Chubin, Director of Education, and
his colleagues, including
Anthony Del Aversano, Mary Hogan Camp,
Alicia Ryan, Jacqueline Smith, and Paula
Zadigian

Susan Eddy, former Director of Institutional
Advancement, and Anita Masi, Associate
Director of Development

Tom Shannon, Director of Facilities, and Jack
Quigley, Chief of Security

The exhibition was designed by Stephen
Saitas and lighting by Anita Jorgensen

Miko McGinty and her team,
including Paula Welling and Anjali Pala,
designed the exhibition graphics

Concept
Louis D. Nebelsick in collaboration with
Ingrid Dettmann, Susanne Kimmig-Völkner,
Franziska Kuschel
(State Office for Heritage Management and
Archaeology Saxony-Anhalt –
State Museum of Prehistory)

Adviser
Eike Jordan

Exhibition Team Atlanta
Richard Adams,
Head of Public Services

Rebekah Bedard, Reference Librarian
and Outreach Coordinator

Patrick Graham, Director

Armin Siedlecki, Head of Cataloging

**Exhibition Team
Germany**

Organization and Conceptualization
Ingrid Dettmann, Tomoko Emmerling,
Susanne Kimmig-Völkner, Robert Kluth,
Franziska Kuschel, Louis D. Nebelsick
(State Office for Heritage Management
and Archaeology Saxony-Anhalt –
State Museum of Prehistory)

Project Assistance
Susanne Kimmig-Völkner, Franziska Kuschel
(State Office for Heritage Management
and Archaeology Saxony-Anhalt –
State Museum of Prehistory)

Consultants
Kerstin Bullerjahn, Andreas Hille, Ralf Kluttig-
Altmann, Jan Scheunemann, Björn Schlenker,
(State Office for Heritage Management
and Archaeology Saxony-Anhalt –
State Museum of Prehistory);
Mirko Gutjahr (Luther Memorials Foundation
of Saxony-Anhalt);
Ute Däberitz, Bernd Schäfer, Timo Trümper,
Jekaterina Vogel, Uta Wallenstein
(Foundation Schloss Friedenstein Gotha);
Rosmarie Beier-de Haan, Sabine Beneke,
Leonore Koschnick, Sven Lüken, Matthias
Miller, Brigitte Reineke
(Stiftung Deutsches Historisches Museum);
Christian Philipsen (Stiftung Dome und
Schlösser in Sachsen-Anhalt);
Johanna Reetz, Holger Rode (Osterfeld)

Provision and Management of Exhibits
Andrea Lange, Roman Mischker, Irina Widany
(State Office for Heritage Management
and Archaeology Saxony-Anhalt –
State Museum of Prehistory);
Christine Doleschal, Petra Gröschl, Karin
Lubitzsch, Jutta Strehle (Luther Memorials
Foundation of Saxony-Anhalt);
Thomas Huck, Jürgen Weis
(Foundation Schloss Friedenstein Gotha)

**Conservation and Restoration,
Supervision and Advice**
Karsten Böhm, Heiko Breuer, Karoline Danz,
Friederike Hertel, Vera Keil, Katrin Steller,
Christian-Heinrich Wunderlich
(State Office for Heritage Management
and Archaeology Saxony-Anhalt –
State Museum of Prehistory);
Karin Lubitzsch, Andreas Schwabe
(Luther Memorials Foundation of
Saxony-Anhalt);
Michaela Brand, Kay Draber, Sophie Hoffmann,
Martina Homolka, Ulrike Hügle, Matthias Lang,
Elke Kiffe, Barbara Korbel, Antje Liebers,
Jutta Peschke
(Stiftung Deutsches Historisches Museum);
Helmut Biebler, Marie-Luise Gothe, Brigitte
Pohl, Gunter Rothe
(Foundation Schloss Friedenstein Gotha);
Sebastian Anastasow (Hundisburg);
Katrin Brinz (Halle [Saale]);
Eva Düllo (Berlin);
Thomas Groll (Magdeburg);
Angela Günther (Dessau-Roßlau);
Kerstin Klein (Halle [Saale]);
Andrea Knüpfer (Halle [Saale]);
Albrecht Körber (Dresden);
Andreas Mieth (Berlin);
Sybille Reschke (Leipzig);
Johannes Schaefer (Altenburg);
Peter Schöne (Halle [Saale]);
Ulrich Sieblist (Questenberg);
Christine Supianek-Chassay (Erfurt);
Hartmut von Wieckowski (Petersberg);
Beatrix Kästner (Meusebach)

Loan and Transport Management
Urte Dally, Susanne Kimmig-Völkner,
Franziska Kuschel
(State Office for Heritage Management
and Archaeology Saxony-Anhalt –
State Museum of Prehistory)

Transportation
hasenkamp Internationale Transporte GmbH,
Masterpiece International

The exhibition team would like to thank the
many colleagues—also those not mentioned
here—who have helped to make the exhibitions
in New York, Minneapolis, and Atlanta come
about.

Accompanying Publications

Editors
Harald Meller
(State Office for Heritage Management
and Archaeology Saxony-Anhalt –
State Museum of Prehistory),
Colin B. Bailey
(The Morgan Library & Museum),
Martin Eberle
(Foundation Schloss Friedenstein Gotha),
Kaywin Feldman
(Minneapolis Institute of Art),
Ulrike Kretzschmar
(Stiftung Deutsches Historisches Museum),
Stefan Rhein
(Luther Memorials Foundation of
Saxony-Anhalt)

Conceptualization
Ingrid Dettmann, Tomoko Emmerling,
Katrin Herbst, Susanne Kimmig-Völkner,
Robert Kluth, Franziska Kuschel, Louis D.
Nebelsick, Robert Noack, Anne-Simone Rous
(State Office for Heritage Management
and Archaeology Saxony-Anhalt –
State Museum of Prehistory)

Image Copyright Search, Image Editing
Robert Noack
(State Office for Heritage Management
and Archaeology Saxony-Anhalt –
State Museum of Prehistory)

Project Supervision at Sandstein Verlag
Christine Jäger-Ulbricht, Sina Volk,
Norbert du Vinage (Sandstein Verlag)

Design Concept
Norbert du Vinage (Sandstein Verlag)

Production
Sandstein Verlag

Printing and Finishing
Westermann Druck Zwickau GmbH

Coordination
Anne-Simone Rous, Katrin Herbst,
Susanne Kimmig-Völkner, Robert Kluth,
Louis D. Nebelsick
(State Office for Heritage Management
and Archaeology Saxony-Anhalt –
State Museum of Prehistory)

Volume Editor
Anne-Simone Rous
(State Office for Heritage Management
and Archaeology Saxony-Anhalt –
State Museum of Prehistory)

Expert Editing
Martin Treu (Lutherstadt Wittenberg),
Eva Bambach-Horst (Bensheim),
Susanne Baudisch (Dresden),
Kathleen Dittrich (Hinterhermsdorf),
Mareike Greb (Leipzig),
Barbara Fitton Hauß (Lörrach),
Carola Hoécker (Heidelberg),
James Matarazzo (Oxford, Großbritannien),
Katrin Ott (Jena),
Marion Page (Cirencester, Großbritannien),
Emanuel Priebst (Dresden),
Georg D. Schaaf (Münster),
Ulrich Schmiedel (Munich),
Karen Schmitt (Stuttgart),
Lutz Stirl (Berlin),
Timo Trümper (Foundation
Schloss Friedenstein Gotha),
Susann Wendt (Leipzig),
Kerstin Bullerjahn, Ingrid Dettmann,
Katrin Herbst, Susanne Kimmig-Völkner,
Robert Kluth, Ralf Kluttig-Altmann,
Franziska Kuschel, Anne-Simone Rous,
Jan Scheunemann
(State Office for Heritage Management
and Archaeology Saxony-Anhalt –
State Museum of Prehistory)

Proofreading

German
Anne-Simone Rous, Tomoko Emmerling,
Ingrid Dettmann, Katrin Herbst, Susanne
Kimmig-Völkner (State Office for Heritage
Management and Archaeology Saxony-Anhalt –
State Museum of Prehistory)

English
Jim Bindas and his colleagues Laura Silver,
Stephanie Martin, Heidi Mann (Books &
Projects, Minneapolis);
Louis D. Nebelsick, Tomoko Emmerling, Ingrid
Dettmann, Susanne Kimmig-Völkner, Lea
McLaughlin, Robert Noack, Anne-Simone Rous
(State Office for Heritage Management and
Archaeology Saxony-Anhalt – State Museum
of Prehistory)

Infographics: Research and Concept
Ingrid Dettmann, Susanne Kimmig-Völkner,
Robert Kluth, Franziska Kuschel, Robert Noack,
Anne-Simone Rous (State Office for Heritage
Management and Archaeology Saxony-Anhalt –
State Museum of Prehistory);
Jakub Chrobok, Barbara Mayer, Jan Schwochow
(Golden Section Graphics)

Infographics: Realization
Golden Section Graphics:
Jan Schwochow (managing director),
Jakub Chrobok, Barbara Mayer,
Anton Delchmann, Verena Muckel,
Jaroslaw Kaschtalinski, Katharina Schwochow,
Nick Oelschlägel, Daniela Scharffenberg,
Fabian Dinklage, Christophorus Halsch,
Annemarie Kurz (project management),
Anni Peller (proofreading)

Design
Simone Antonia Deutsch (Sandstein Verlag)

Image Processing
Jana Neumann (Sandstein Verlag)

Type
Gudrun Diesel (Sandstein Verlag)

Catalogue
"Martin Luther:
Treasures of the Reformation"

Volume Editors

German
Ralf Kluttig-Altmann (State Office for Heritage
Management and Archaeology Saxony-Anhalt –
State Museum of Prehistory)

English
Katrin Herbst (State Office for Heritage
Management and Archaeology Saxony-Anhalt –
State Museum of Prehistory)

Proofreading

German
Ralf Kluttig-Altmann, Ingrid Dettmann,
Tomoko Emmerling, Johanna Furgber,
Dirk Höhne, Susanne Kimmig-Völkner,
Lea McLaughlin, Anne-Simone Rous
(State Office for Heritage Management and
Archaeology Saxony-Anhalt – State Museum
of Prehistory); Saskia Gresse (Nuremberg)

English
Katrin Herbst (State Office for Heritage
Management and Archaeology Saxony-Anhalt –
State Museum of Prehistory),
John McQuillen (The Morgan Library & Museum),
Schneiders-Sprach-Service (Berlin)

Translations

English – German
Martin Baumeister (Nuremberg);
Michael Ebmeyer (Berlin);
Lea McLaughlin, Louis D. Nebelsick
(State Office for Heritage Management
and Archaeology Saxony-Anhalt –
State Museum of Prehistory);
Christiane Rietz (Leipzig);
Sigrid Weber-Krafft (Siegen)

German – English
Martin Baumeister (Nuremberg),
Krister Johnson (Magdeburg),
Schneiders-Sprach-Service (Berlin),
Samuel Shearn (Oxford, Großbritannien),
George Wolter (Halle [Saale])

Design
Norbert du Vinage (Sandstein Verlag)

Image Processing
Jana Neumann (Sandstein Verlag)

Type
Katharina Stark, Christian Werner,
(Sandstein Verlag); Kathrin Jäger

Maps
Birte Janzen (State Office for Heritage
Management and Archaeology Saxony-Anhalt –
State Museum of Prehistory)

Source Map:
Golden Section Graphics GmbH, Berlin

Cover Images

Catalogue
Lucas Cranach the Elder, workshop
"Martin Luther", 1528
Luther Memorials Foundation
of Saxony-Anhalt, G 16

Accompanying Volume
Lucas Cranach the Elder
"Martin Luther as an Augustinian Monk", 1520
Luther Memorials Foundation
of Saxony-Anhalt, fl IIIa 208

Frontispiece Images

Catalogue and Accompanying Volume
Lucas Cranach the Elder
"Law and Grace", 1529 (detail)
Foundation Schloss Friedenstein Gotha, SG 676

Foreword Images

© Thomas Köhler/photothek

Bibliographical
Information
Catalogue and accompanying volume

The Deutsche Nationalbibliothek holds a record
of this publication in the Deutsche National-
bibliografie; detailed bibliographical data can
be found under: http://dnb.ddb.de

This work, including its parts, is protected by
copyright. Any use beyond the limits of copy-
right law without the consent of the publisher
is prohibited and punishable. This applies,
in particular, to reproduction, translation,
microfilming and storage and processing in
electronic systems.

Catalogue
ISBN 978-3-95498-221-9 (German)
ISBN 978-3-95498-224-0 (English)

Accompanying volume
ISBN 978-3-95498-222-6 (German)
ISBN 978-3-95498-223-3 (English)

Both volumes in slipcase
ISBN 978-3-95498-231-8 (German)
ISBN 978-3-95498-232-5 (English)

© 2016
Landesamt für Denkmalpflege
und Archäologie Sachsen-Anhalt,
Sandstein Verlag

Made in Germany

Website and online / Poster exhibition

#HereIStand. Martin Luther, the Reformation and its Results

General Director
Harald Meller (State Office for Heritage Management and Archaeology Saxony-Anhalt – State Museum of Prehistory)

Project Steering Committee
Martin Eberle (Foundation Schloss Friedenstein Gotha), Ulrike Kretzschmar (Stiftung Deutsches Historisches Museum), Stefan Rhein (Luther Memorials Foundation of Saxony-Anhalt)

Project Management
Tomoko Emmerling (State Office for Heritage Management and Archaeology Saxony-Anhalt – State Museum of Prehistory)

Academic Advisory Board
Mirko Gutjahr (Luther Memorials Foundation of Saxony-Anhalt), Martin Treu (Lutherstadt Wittenberg), Timo Trümper (Foundation Schloss Friedenstein Gotha)

Coordination
Robert Kluth (State Office for Heritage Management and Archaeology Saxony-Anhalt – State Museum of Prehistory)

Concept
Robert Kluth, Katrin Herbst (State Office for Heritage Management and Archaeology Saxony-Anhalt – State Museum of Prehistory)

Curators
Robert Kluth, Anne-Simone Rous (State Office for Heritage Management and Archaeology Saxony-Anhalt – State Museum of Prehistory)

In Collaboration with
Ingrid Dettmann, Katrin Herbst, Susanne Kimmig-Völkner, Franziska Kuschel, Robert Noack (State Office for Heritage Management and Archaeology Saxony-Anhalt – State Museum of Prehistory)

and
Mareile Alferi, Johanna Furgber, Annemarie Knöfel, Mike Leske, Lea McLaughlin, Brigitte Parsche, Julius Roch, Stefanie Wachsmann (State Office for Heritage Management and Archaeology Saxony-Anhalt – State Museum of Prehistory), Niels Reidel (Foundation Schloss Friedenstein Gotha)

Concept and Realization Website and Infographics
Golden Section Graphics: Jan Schwochow (managing director), Jakub Chrobok, Barbara Mayer, Anton Delchmann, Verena Muckel, Jaroslaw Kaschtalinski, Katharina Schwochow, Nick Oelschlägel, Daniela Scharffenberg, Fabian Dinklage, Christophorus Halsch, Annemarie Kurz (project management), Anni Peller (proofreading)

3D Scans
Lukas Fischer in collaboration with: Robert Noack (State Office for Heritage Management and Archaeology Saxony-Anhalt – State Museum of Prehistory)

Poster Printing
Druck+Verlag Ernst Vögel GmbH, Stamsried

Design of Promotional Media
Alexander Schmidt (Halle [Saale]), Birte Janzen (State Office for Heritage Management and Archaeology Saxony-Anhalt – State Museum of Prehistory)

Translations
Christoph Nöthlings (Leipzig), Gloria Kraft-Sullivan (Burgdorf)

Thanks to

Markus Lahr, Vinn:Lab, Forschungsgruppe Innovations- und Regionalforschung, Technische Hochschule Wildau

Paul Daniels, Head of Arts and Archives, Luther Seminary, St. Paul

Google Docs

Stefan Hagemann

Henning Kiene, EKD

Martin Klimke

Paul Klimpel

Monika Lücke und Dietrich Lücke

Konrad Kühne (Archiv für Christlich-Demokratische Politik, Konrad Adenauer Stiftung)

Ulrich Mählert (Bundesstiftung zur Aufarbeitung der SED Diktatur)

Christine Mundhenk (Melanchthon-Forschungsstelle der Heidelberger Akademie der Wissenschaften)

Stefan Rohde-Enslin (museum-digital)

Christian Staffa, Evangelische Akademie zu Berlin

Michael Weyer-Menkhoff, Archiv der Berliner Stadtmission

Agnes Fuchsloch, Andrea Fußstetter, Ann-Kathrin Heinzelmann, Angelika Kaminska, Jan-Dirk Kluge, Ilka Linz, Wolfgang Röhrig, Nicola Schnell, Werner Schulte, Magnus Wagner (Stiftung Deutsches Historisches Museum)

Birte Janzen, Julia Kruse, Katrin Legler, Janine Näthe, Brigitte Parsche, Alfred Reichenberger, Anne Reinholdt, Monika Schlenker, Manuela Schwarz, Andreas Stahl, Bettina Stoll-Tucker, Anna Swieder (State Office for Heritage Management and Archaeology Saxony-Anhalt – State Museum of Prehistory)